...LLEGE OF ART & DESIGN

...I WALK

Illuminations

OTHER BOOKS BY LIZ HERON

Truth, Dare or Promise: Girls Growing up in the 50s (ed.)
Changes of Heart: Reflections on Women's Independence
Streets of Desire: Womens Fictions of the Twentieth–Century City (ed.)
A Red River

OTHER BOOKS BY VAL WILLIAMS

The Other Observers: Women Photographers in Britain,
1900 to the Present
Who's Looking At the Family?
Warworks: Women, Photography and the Iconography of War
The Dead (with Greg Hobson)

Illuminations

Women Writing on Photography from the 1850s to the Present

EDITED BY

LIZ HERON

AND

VAL WILLIAMS

I.B.Tauris Publishers
LONDON · NEW YORK

First published 1996

1 3 5 7 9 10 8 6 4 2

© Liz Heron and Val Williams 1996

Liz Heron and Val Williams have asserted their right
under the Copyright, Designs and Patents Act, 1988
to be identified as the editors of this work

First published in the United Kingdom in 1996 by
I.B.Tauris & Co. Ltd
Victoria House, Bloomsbury Square, London WC1B 4DZ

A CIP Catalogue record for this book is available from the British Library.

ISBN 1 86064 041 9

Printed and bound in Great Britain by
Biddles Ltd, Guildford and King's Lynn

Contents

Distant Voices: Fashion and Portraiture in the Studio in the Inter-war Years

Pictures and Stories: Documentary and Reportage in North America

History Lessons

On Photographers

Postmodernisms and the Politics of Looking

Decolonising the Image

Memories and Fictions

Acknowledgements

Thanks to our editor Philippa Brewster for her lively enthusiasm and her calming support at tricky stages of the project, to Kirsty Dunseath at Cape for the enormous help she gave with clearing permissions, and to our painstaking copy-editor Marion Steel.

Also special thanks to Terence Pepper (National Portrait Gallery, London); Martin Parr; Amy Rule (Center for Creative Photography, University of Arizona); Hildegarde Mahoney (Photographers Gallery Library, London); and Anthony Penrose (Lee Miller Archive).

Introduction

WHY WOMEN? Why leave men out of this ample and capacious selection? It must seem perverse when men have such an active and prominent presence in the world of photography. One good reason is that very self-perpetuating dominance. Women get lost, forgotten, overlooked. Yet they have been writing about photography since its beginnings – as historians and critics, biographers and teachers, journalists and practitioners – and intervening in the key debates of the last century and a half.

There are other reasons for our distinct gender bias, and these have more to do with the ways in which women's perspectives have advanced photographic criticism, enlarging its scope and focusing it more deeply.

Women critics of photography were few and far between in the nineteenth century. They feature scarcely at all in the books, journal articles and translated treatises listed in standard bibliographies such as Helmut Gernsheim's *Incunabula of British Photographic Literature 1839–1875*. Despite some major contributions as scholars and critics, they continued to be a minority in photographic literature throughout the twentieth century, up until the '70s – when a lot of things began to change for women and they started making unprecedented appearances all over the place. Of course, this was in the aftermath of all kinds of cultural shocks and tremors, and the world of photography too was shaken from its certainties.

The process of editing this book has confirmed that there is no such thing as a 'women's way' of writing. Women's responses – to the spirit of their times, to fashion, to public events and personal experiences – are necessarily varied. The nineteenth-century writer Lady Eastlake was deeply involved in the controversies surrounding the new and volatile medium of photography, and her intelligent, quizzical commentary is proof of this. Portraitist Julia Margaret Cameron's bold, stylish description of her photographic methods was very much in tune with a particular mode of self-promotion which existed in British photography until the Second World War. In a manner common among photographers writing about their lives in the 1940s and '50s, the entrepreneurial studio photographers Dorothy Wilding and Madame Yevonde used autobiographical fact to construct a lively public fiction.

During the years immediately after the First World War, photography enabled many young women to become financially self-sufficient. Established women photographers were frequently commissioned to explain the route to a career in photography in the assorted vocational handbooks which appeared at the time. Olive Edis's is one of many such articles which explore photography's potential as a means to women's professional independence.

In the first fifty years of this century, photography had no consistent critical

attention. While practitioners like Wilding, Yevonde, Cecil Beaton and Barbara Ker-Seymer, all working in London in the 1920s and '30s, received much publicity, their work had little importance for the art establishment. Because of this, the photographers' personal aesthetic agendas acquire particular significance. Their evidence is both frustratingly unreliable and peculiarly authentic: a kind of oral history unmediated by the machinery of criticism. To understand it fully, we must read between its optimistic lines, and look for omissions, for stories untold, for failures undeclared. These obscure figures, with their vanities and enthusiasms, can become vehicles for other desires and conclusions.

In speaking a history of photography, the texts in this book simultaneously challenge orthodoxies. Critical writing by women was sparse in the 1960s and early '70s, when a paternalist formalism dominated historiography and commentary in both Europe and North America. It is only in this context that we can situate the texts of a writer like Nancy Newhall – as those of an acolyte rather than a critic. Overwhelmed by the current orthodoxy of the master photographer, she became a worshipper of great men.

This cannot, therefore, be a feminist anthology; it does, however, take women as a starting-point. Moreover, by the late '70s its contributors are mostly writing from a perspective that takes feminism for granted, and in terms often framed by a new set of critical understandings. And the one impacts on the other. For this convergence was not just a matter of analytical tools becoming more refined with the development of contextual or structuralist models. Feminist thinking has elaborated concepts and theories of representation central to these critical processes; simultaneously, it has challenged photo-historiography for its gaps and misplaced emphases. But the issues go beyond women's visibility or the simple insertion of a female tradition; they entail a redefinition of visual perceptions.

And so to the politics of looking, the insights and the dilemmas wrought by a feminist reappraisal of the gaze. If the mechanisms of male voyeurism can only produce objectifying or imprisoning representations of the female face or figure, what options remain for reinvention or reinterpretation? Laura Mulvey's piece on spectatorship cites strategies for new ways of looking, in the work of Barbara Kruger and Victor Burgin, both of them examples of feminist theory translated into postmodern art practice. Abigail Solomon-Godeau measures the progress of Kruger, Cindy Sherman and other feminist artists in breaking with modernist art photography's dead-end aesthetics, while, nearly a decade later, Jan Avgikos traces the sustained centrality of feminism in Sherman's projects. The debates have flourished, in magazines such as *Afterimage*, *Exposure*, *Creative Camera*, *Artforum* and elsewhere.

For the European avant-gardes of the '20s and early '30s, the camera had seemed to offer new ways of seeing, transformative new visions matching the quickening pace of the machine age and promising a better world. Their perceptions of photography's possibilities made social, political and aesthetic connections that impinged on radical photography's '70s revival, and writing from these early avant-gardes offered founding texts for a new sphere of critical enquiry.

Several essays here examine the legacy of the Russian formalists and the

Bauhaus. Rosalind Krauss interrogates what the camera meant for Surrealism: a visual transposition of automatic writing, a precise intimation of what the random eye sees. What is woman's place within these unconscious structures? Cynthia Chris's piece on Joel-Peter Witkin highlights motifs of female blindness that echo Surrealist scenarios − scenarios that have a disturbingly active emphasis in the photographic art of Claude Cahun. Cahun was a little-known figure until recently, yet the only woman Surrealist to elaborate a significant body of photographic work, which in certain respects (her protean self-portraiture, the use of dolls) prefigures that of Cindy Sherman.

New ways of seeing have had to be stubbornly pursued in order to readjust dominant gendered perceptions, and those of race and class. The work done on representations of women has a bearing on wider debates around 'otherness' and 'difference' and on efforts to end the visual sovereignty of Western eyes as an optic for the world. Old histories can persist in writing the present meanings we read in photographs. Lucy Lippard and others engage with these questions in a recognition that cultural or ethnic difference requires to be explored in its complexity and heterogeneity if we are to avoid the subordinating simplicities of mere 'otherness'.

When we read Mary Warner Marien's meticulous dissection of Beaumont Newhall's *History of Photography* or Deborah Bright's deconstruction of the romance of landscape photography, we are witnessing a shift in theory that is also a decolonisation of a culture which properly belongs to us all. Women writing on photography over the last fifteen years have contributed some of its most iconoclastic texts. Reviewing the major Sebastiao Salgado exhibition in New York in 1992, the critic Ingrid Sischy displays an integrity which one would wish for more often when critics comment on the work of the famous and powerful. Likewise, Catherine Lord's piece on Diane Arbus is a highly informed attack on the curators, editors and biographers who have fetishised and refashioned this long-dead anti-heroine to suit their own ends. In this 'postmodernist' age, it has become unfashionable to emphasise women's issues, yet there is little doubt that without the pioneering feminist historiography of the 1980s some important later texts would not have been published. A space was opened for works such as Jeanne Moutoussamy-Ashe's history of black women photographers in the US, and Andrea Fisher's *Let Us Now Praise Famous Women*, from which we include an extract.

We have paid great attention to women's personal accounts of their work: Dorothea Lange's simple and direct story of how she came to photograph 'The Migrant Mother' in the 1930s, Margaret Bourke-White's somewhat desperate self-aggrandisement in her autobiography, Lee Miller's obvious relief not just at the Liberation of Europe, but for her personal liberation from the unadventurous wartime fashion photography of British *Vogue*. As editors, we did not aim to assemble a collection of writing by women about women; we wanted precisely to affirm the centrality of women's contribution to the development of ideas around photography, even while this contribution is marginalised and undervalued in ways identified by so many of this book's contributions. This very phenomenon of women's simultaneous effacement and presence in critical

discourse can and does frequently produce an enriched duality of perspective – derived from the necessity to speak from more than one place.

In a short piece included here from 1929, Tina Modotti observes that photography is multiple. Self-evident as this recognition may seem, throughout photography's history the status-conscious defence of it as a singular art has led to a parochialism that still permeates certain photographic institutions and a great deal of critical writing, rendering it culturally and intellectually narrow out of an anxiety to preserve artificial boundaries.

This anthology rests on a counter-critical response to that parochialism. From Modotti to Susan Sontag and the criticism of the '80s and '90s which has been informed by the insights of cultural theory, there runs a line of engagement with photography's multiple potential, its often wayward powers. Photographs have the power to shape our perceptions; they construct persuasive and insidious versions of the visual world. They can also move us or make us reflect. This power can reside in the snapshot, the news photograph, the survey document, the high street portrait . . . a power often unpredictably conjured by a shifting of context or the passing of time. Time acts on photographs because of their indexical relation to the real: the trace of what is lost, irremediably altered, or hitherto unknown in its visual particulars.

As our selection makes plain, the avant-gardes occupy a key place in photohistoriography. Photography's multiplicity, its malleability, its unique purchase on visual reality – these properties were the source of the avant-gardes' euphoric adoption of the camera. But what Moholy Nagy described as the 'unambiguousness of the real', the 'hygiene of the optical' was to be betrayed by the very non-neutrality of technology. New Objectivity's enhancement of the object raised commodity fetishism to a higher and higher power through advertising images which made further seductive borrowings from Surrealism. The 'hygiene of the optical', seen as liberating in 1925, can only sound sinister now, in the light of the late century's photo-surveillance and regulation techniques, and the surfeit of manipulated imagery which forms our daily visual landscape.

Expanding new technologies also suggest a further democratisation of the medium (it can make us all artists!). By a historical irony, these seem to return photography to a realm of scientific wizardry similar to that characterising its early-nineteenth-century heyday. Manipulations have always been implicit in the photographic process, but the possibilities now available for altering the image have become radically different.

The wider use of photography by visual and performing artists has combined with new technologies in ways which make the image a starting-point rather than a finite end, rendering the very notion of photography more elusive. Artists like Annette Messager, Hannah Collins and Sophie Calle use photographic images extensively, yet they cannot be described as photographers. The works which they produce often use found images from archives or mass media sources, becoming authored pieces only in their entirety rather than in their parts. And so the frame of criticism and analysis which defines then has moved away from a nexus of 'writing on photography' and has taken up a

wider focus on the visual arts. The photo-constructions of the Berlin Dadaists provide just one of the many historical precedents for this aspect of photography's multiplicity.

Much of photography's history has involved the rival claims of realism and manipulation, the photograph as transparent document or transformative instrument. Documentary photography has a history which began in Europe and, with the dislocating imperatives of fascism's rise on one side of the Atlantic and the New Deal on the other, was to flourish most actively in North America. Revolutionary politics, the fight against fascism, the Cold War and its military–industrial complex have shaped photography technically, socially and aesthetically. There is perhaps a shift now towards a European arena. Critical focus has altered in recent years, with the US ceasing to take the aesthetic lead. Critics and curators now look towards Europe, and most particularly to Germany, Spain and the Netherlands for signs of radical advance.

The decline of documentary and reportage and the ubiquity of advertising have reshaped the individual's relationship to photography in mass culture, while a massive industry has grown out of 'amateur' photography. The photographic images of the past are increasingly converted into a multi-purpose stock of image commodities, available to arbitrary and often conflicting readings, while in the present images proliferate faster and faster. More than at any time in history, we are surrounded by images, and never have their meanings seemed more puzzling or equivocal. Thinking about photography involves slowing down that image blur and engaging in a struggle over meanings.

LIZ HERON AND VAL WILLIAMS, *London 1995*

THE NINETEENTH CENTURY IN EUROPE

My dearest Miss Mitford, do you know anything about that wonderful invention of the day, called the Daguerreotype? – that is, have you seen any portraits produced by means of it? Think of a man sitting down in the sun and leaving his facsimile in all its full completion of outline and shadow, steadfast on a plate, at the end of a minute and half! The Mesmeric disembodiment of spirits strikes one as a degree less marvellous. And several of these wonderful portraits . . . like engravings – only exquisite and delicate beyond the work of the engraver – have I seen lately – longing to have such a memorial of every Being dear to me in the world. It is not merely the likeness which is precious in such cases – but the association, and the sense of nearness involved in the thing . . . the fact of the *very shadow of the person* lying there fixed for ever! It is the very sanctification of portraits I think – and it is not at all monstrous in me to say what my brothers cry out against so vehemently . . . that I would rather have such a memorial of one I dearly loved, than the noblest Artist's work ever produced.

<div align="right">

Elizabeth Barrett Browning
On the Daguerreotype

</div>

Alice Hughes

A Lady Photographer Who Never Photographs Men; A Talk with Miss Alice Hughes

(First published in *The Harmsworth Magazine*, London, Vol. 11, 1899)

Alice Hughes (c.1860–c.1945) was one of London's most successful studio portraitists in the later years of the nineteenth century. At one time, she employed over fifty assistants and process workers in her Gower Street studio.

Entirely self-promotional, this interview exemplifies perfectly the confidence and verve of a vigorous, successful self-made Victorian woman, active in a medium which appeared, at the time, to have endless possibilities.

O F THE MANY arts and crafts which have seen an extraordinary development during the sixty years of the reign of our Most Gracious Queen, there have been few which have undergone a more complete transformation than that of photography.

Who is not familiar with the daguerreotype taken during the thirties and forties? There the unfortunate sitter appeared as in a glass darkly, grotesquely like and yet unlike; and, it need hardly be said, with no attempt to procure a charming, still less an ideal, portrait.

Then came the cartes-de-visite in which a whole family appeared grouped on three by two inches of pasteboard. Nowadays photography can claim to be an art, and most people would very much prefer to have a fine photograph than an indifferent portrait of those they love; while no one, however stoic, cares to appear less good-looking than he or she is.

Miss Alice Hughes holds a peculiar, and it may be said a unique, place among the photographers of the day. Her work is invariably distinguished by qualities rarely found even in a portrait; for she has the gift, perhaps the most valuable of any in those whose mission it is to reproduce the human form divine, of taking her sitter at her best, and she is one of those who can claim the honour of having revolutionised modern photography.

If imitation is the sincerest form of flattery, Miss Hughes must indeed feel flattered, for even on the Continent her methods of posing, of lighting, and even of arranging her sitters, have been widely followed. She herself modestly ascribes most of her success to the fact that her father, the well-known portrait painter, Mr. Edward Hughes, greatly helped her, when she first opened her photographic studio, with his experience and advice.

'Yes, it is quite true,' she observed, 'that I never photograph men. When I

first made up my mind to become a professional photographer I decided to take only ladies and children, and I have not had any reason to repent my decision. For one thing,' she added, smiling, 'ladies, of course, make very much prettier pictures than do their husbands and brothers, and there is nothing I enjoy more than taking children, either alone or in groups. Although small folks are very often supposed to be difficult sitters, I have never found them so.

'Of course a great deal depends on a child's intelligence; little Prince Edward of York always seems to enjoy having his portrait taken, and I have been very successful with him. Like most children who have a good deal of character, he is very determined, and he always knows exactly what he wants; but he has most charming manners, and he has evidently been taught to be very considerate of the feelings and wishes of those about him.

'When photographing a little child the photographer's object is, of course, to make it assume a perfectly natural position and expression; there are no head-rests in my studio, and I do not believe in making sudden noises to arrest the child-sitter's attention. On the other hand, I have found my dogs a great element of success: a live animal amuses and arrests the attention of even quite a little baby, and often I have seen apathy change into cheerful intelligence when my poodle has made his appearance.'

'And have you any views on babies' and children's clothing?'

'Of course I have. I think children always look better in white, and I very much prefer in a photograph to see something of their neck and arms. A baby's neck is one of the prettiest things in the world, but you know I lay down no hard and fast rules about these matters. Often, however, on a warm day I have undone, or rather lowered, a baby's high frock with very happy results. Long clothes are rather trying to deal with, but even they can be made to look well in a photograph, if a little care be taken.

'One thing I must say: I do not ever care to take a little child in a hat or bonnet, and I may add that the more simply a child is dressed the happier the result. In this matter the Duchess of York sets a very good example to other mothers; the two little Princes and Princess Victoria always look thoroughly comfortable in their clothes, and this is more than one can say of many other children over whose garments much time and trouble has been spent.'

'I suppose your object in each case is to produce a photograph which really looks as if it had been taken from a portrait?'

'Of course I wish to produce an artistic effect, and as I think that this can be more easily achieved by means of what may be called the open-air back-ground, I suppose that this does often give my photographs the appearance of a painting.

'Again, I have very decided views as to what sort of clothes should be worn by those who are going to have their portrait taken.

'The majority of women, whatever be their age, look well in creamy white, and there is no doubt that soft, flowing draperies add immensely to the beauty of a photograph. Of course, in one matter, a photographer is, as compared with an artist, at a great disadvantage; no preliminary studies can be taken; the effect produced is final. I may, however, tell you that before posing a sitter, I always

make a brief study, as it were, of her personality; therefore I need hardly say that I always operate myself.'

'Then do you seriously mean that every woman who comes to have her photograph taken ought to wear a white dress?'

'She will be very much more pleased with the result; of that I feel quite sure. Of course white includes every pale colour, save perhaps the softer shades of red, which, as you probably know, always come out black in a photograph. A simple tea-gown, open at the neck, will often produce a very much better result than an elaborate stiff dinner-dress; and this type of costume has the further advantage of being dateless – that is to say, the photograph will not grow old-fashioned.

'I daresay you have noticed that many people nowadays are fond of being taken in a low dress and a large picture hat. This really may be called the revival of the Gainsborough or Joshua Reynolds type of photograph. I was the first to revive this style of portrait, which produces in many cases an exceptionally charming result.'

'I believe you also revived the fashion of ladies being taken with their children?'

'Yes. What can be more charming and more natural than the portrait of a pretty young woman with her baby in her arms, or with her children grouped about her? These groups of mothers and children have been extraordinarily successful, and people come to me again and again; in fact, in some cases, I have photographed every stage of a little child's life, from the time when it was three or four months old to that when it may be supposed to have reached the age of reason. By the way,' added Miss Hughes, laughing, 'in all my workrooms we always put the babies in front – they change and alter so terribly quickly. I sometimes tell my sitters that if they are in a hurry for their photographs they must be taken with their babies.'

'I suppose you prefer girl-babies as sitters?'

'In the matter of babies, I do not admit of favouritism. Even the tiniest are very individual, and I do not think that among the babies I have photographed there would be any two undistinguishable the one from the other. Of course I prefer to take children when they are a little older.

'By the way, it is curious to see how parents live again in their children. The little Duke of Leinster and his brother have all the delicate charm of their beautiful mother. Lord and Lady Granby's daughters have the artistic instinct, and, without any prompting, group themselves, even when sitting down on the floor, to the best advantage.'

'I suppose you take immense trouble over the posing of your sitters?'

'Yes; but in this matter I always follow my own instinct. If I think that a better picture can be achieved by placing my sitter right round, say throwing her head back over her shoulder, I immediately try the experiment. Most English girls are seen to greater advantage standing than when sitting.

'Of course I have a great many accessories. My backgrounds are painted to produce an effect full of light and shade.

'The unexpected is always happening in photography. Theoretically, a

drawing-room dress ought to make a charming costume; as an actual fact, it vies with the orthodox wedding-dress as being perhaps the most difficult of all costumes – of course I speak from the photographer's point of view.'

'I suppose you find feminine nature much the same all the world over?'

'Well, it is a curious fact that in some matters foreigners do differ very much from my own countrywomen. Even Americans – and I have a great many Americans among my clients – differ very much from their English sisters. Foreigners are noted for their lovely hands and arms; this is especially true of Spanish women. Among my most recent sitters has been the Infanta Eulalie, the little King of Spain's aunt. I think anyone looking at her portrait would divine that she is not an Englishwoman. Then again, I have taken the Princesses of the Orleans family, and they may be said to be typically French.'

'I suppose you have many royal sitters?'

'Yes, and, although perhaps people will be surprised to hear it, royal sitters are amongst the pleasantest people to deal with, owing to their exquisite courtesy and good breeding. I have taken several of the Queen's foreign grand-daughters, notably the Hereditary Princess of Saxe-Meiningen and the Duchess of Sparta.'

'I suppose you are very familiar with the technical side of your work?'

'Yes; indeed, before I became a professional photographer I had been an amateur for some years; in fact, my success in taking my friends really led me to take up this class of work. Now of course I employ an immense number of people – during the season as many as sixty at a time – but when I first opened my studio I did everything myself, even to the retouching and spotting.'

'I fancy very few people realise the immense trouble taken – or rather which should be taken – over every photograph properly produced. People always want their proofs in a great hurry, but I have always set my face against sending out any hurried work, and every one of my photographs passes through the hands of about fifty people before it finally reaches the sitter.'

One of the most interesting features of Miss Hughes' fine reception-rooms is a number of beautiful Louis Quinze screens covered with exquisite specimens of her work; many of the photographs, it may be said, are neither for sale nor reproduction.

Charming counterfeit presentments of the Princess of Wales and her daughters, including a delightful group of the Duchess of Fife with her little children, also unpublished portraits of the Duchess of Marlborough, of the Duchess of Portland and her children, and all the more noted beauties of both hemispheres, testify to the success of Miss Hughes in a branch of work hitherto little associated with women.

A specially favoured visitor may also find her way into Mr. Edward Hughes' fine studio, where the artist has just completed a singularly charming portrait of the late Duchess of Teck.

Although Mr. Edward Hughes' first picture was hung in the Academy when he was only fifteen years of age, the modern picture-lover will look in vain for his works on the walls of the Academy. Like Dante Gabriel Rossetti, and a small select group of other Victorian painters, Mr. Hughes is quite

content with the applause of the chosen few rather than with the admiration of the many; accordingly he is never dependent on times and seasons as are most artists. His paintings are occasionally exhibited at the Agnew Gallery, and the greater public had a chance of seeing one of his best pictures, that of the Princess of Wales, two years ago at the Guildhall, where it was exhibited by the special desire of the Prince of Wales.

Like his daughter, Mr. Hughes much prefers lady sitters and children. It was of him that the late Sir John Millais once observed, 'Very many people can paint a man, but Hughes can paint a lady'; and in future ages the beautiful work of this charming painter will do for the Victorian era what the brush of Sir Joshua Reynolds and Gainsborough achieved for the eighteenth century. Scarce a beauty of modern days but has sat to Mr. Hughes, and among his most successful portraits have been those of the Duchess of York, Georgina Countess of Dudley, Lady Naylor Leyland, the Duchess of Montrose, the Marchioness of Worcester, Mrs. Dudley Leigh, Lady Helen Vincent, and an exceptionally charming counterfeit presentment of the great American heiress, Miss May Goelet, who elected to be painted in the simplest of white tulle frocks, confined at the waist by a band of blue ribbon.

As to the all-important question of dress, Mr. Hughes shares, or maybe has inspired, many of his daughter's views on the subject. He considers that most women when choosing a gown in which to be painted should choose white in preference to any other colour. In many cases he himself designs the costume to be worn by his sitter.

IGNOTA.

Julia Margaret Cameron

Annals of My Glass House

(Extracted from *Annals of My Glass House*, Julia Margaret Cameron, 1874, pp. 180–7)

Few have given the photographic process such lustre as Julia Margaret Cameron (1815–79), in this piece first published in the catalogue of her 1889 London exhibition. Cameron's 'little history' is in part a description of her photographic methods and subjects, in part a riposte to the London critics who had accused her of slipshod techniques and self-seeking behaviour. Frequently portrayed by biographers as one of photography's eccentrics, Julia Margaret Cameron is revealed in this piece as a women of passionate emotions, enormous enthusiasm and acute self-knowledge.

MRS. CAMERON'S PHOTOGRAPHY, now ten years old, has passed the age of lisping and stammering and may speak for itself, having travelled over Europe, America and Australia, and met with a welcome which has given it confidence and power. Therefore, I think that the *Annals of My Glass House* will be welcome to the public, and, endeavouring to clothe my little history with light, as with a garment, I feel confident that the truthful account of indefatigable work, with the anecdote of human interest attached to that work, will add in some measure to its value.

That details strictly personal and touching the affections should be avoided, is a truth one's own instinct would suggest, and noble are the teachings of one whose word has become a text to the nations –

> Be wise; not easily forgiven
> Are those, who setting wide the doors that bar
> The secret bridal chamber of the heart
> Let in the day

Therefore it is with effort that I restrain the overflow of my heart and simply state that my first [camera and] lens was given to me by my cherished departed daughter and her husband, with the words, 'It may amuse you, Mother, to try to photograph during your solitude at Freshwater.'

The gift from those I loved so tenderly added more and more impulse to my deeply seated love of the beautiful and from the first moment I handled my lens with a tender ardour, and it has become to be as a living thing, with voice and memory and creative vigour. Many and many a week in the year '64 I worked fruitlessly, but not hopelessly –

> A crowd of hopes
> That sought to sow themselves like winged lies
> Born out of everything I heard and saw
> Fluttered about my senses and my soul.

I longed to arrest all beauty that came before me, and at length the longing has been satisfied. Its difficulty enhanced the value of the pursuit. I began with no knowledge of the art. I did not know where to place my dark box, how to focus my sitter, and my first picture I effaced to my consternation by rubbing my hand over the filmy side of the glass. It was a portrait of a farmer of Freshwater, who, to my fancy, resembled Bollingbroke. The peasantry of our island are very handsome. From the men, the women, the maidens and the children I have had lovely subjects, as all the patrons of my photography know.

This farmer I paid half-a-crown an hour, and, after many half-crowns and many hours spent in experiments, I got my first picture, and this was the one I effaced when holding it triumphantly to dry.

I turned my coal-house into my dark room, and a glazed fowl house I had given to my children became my glass house! The hens were liberated, I hope and believe not eaten. The profit of my boys upon new laid eggs was stopped, and all hands and hearts sympathised in my new labour, since the society of hens and chickens was soon changed for that of poets, prophets, painters and lovely maidens, who all in turn have immortalized the humble little farm erection.

Having succeeded with one farmer, I next tried two children; my son, Hardinge, being on his Oxford vacation, helped me in the difficulty of focussing. I was half-way through a beautiful picture when a splutter of laughter from one of the children lost me that picture, and less ambitious now, I took one child alone, appealing to her feelings and telling her of the waste of poor Mrs. Cameron's chemicals and strength if she moved. The appeal had its effect, and I now produced a picture which I called 'My First Success.'

I was in a transport of delight. I ran all over the house to search for gifts for the child. I felt as if she entirely had made the picture. I printed, toned, fixed and framed it, and presented it to her father that same day – size, 11 in. by 9 in.

Sweet, sunny-haired little Annie! No later prize has effaced the memory of this joy, and now that this same Annie is eighteen, how much I long to meet her and try my master hand upon her.

Having thus made my start, I will not detain my readers with other details of small interest; I only had to work on and to reap a rich reward.

I believe that what my youngest boy, Henry Herschel, who is now himself a very remarkable photographer, told me is quite true – that my first successes in my out-of-focus pictures were a fluke. That is to say, that when focussing and coming to something which, to my eye, was very beautiful, I stopped there instead of screwing on the lens to the more definite focus which all other photographers insist upon.

I exhibited as early as May '65. I sent some photographs to Scotland – a head of Henry Taylor, with the light illuminating the countenance in a way that

cannot be described; a Raphaelesque Madonna, called 'La Madonna Aspet-tante.' These photographs still exist, and I think they cannot be surpassed. They did not receive the prize. The picture that did receive the prize, called 'Brenda,' clearly proved to me that detail of table-cover, chair and crinoline skirt were essential to the judges of the art, which was then in its infancy. Since that miserable specimen, the author of 'Brenda' has so greatly improved that I am content to compete with him and content that those who value fidelity and manipulation should find me still behind him. Artists, however, immediately crowned me with laurels, and though 'Fame' is pronounced 'The last infirmity of noble minds,' I must confess that when those whose judgment I revered have valued and praised my works, 'my heart has leapt up like a rainbow in the sky,' and I have renewed all my zeal.

The Photographic Society of London in their *Journal* would have dispirited me very much had I not valued that criticism at its worth. It was unsparing and too manifestly unjust for me to attend to it. The more lenient and discerning judges gave me large space upon their walls which seemed to invite the irony and spleen of the printed notice.

To Germany I next sent my photographs. Berlin, the very home of photographic art, gave me the first year a bronze medal, the succeeding year a gold medal, and one English institution – the Hartly Institution – awarded me a silver medal, taking, I hope, a home interest in the success of one whose home was so near to Southampton.

Personal sympathy has helped me on very much. My husband from first to last has watched every picture with delight, and it is my daily habit to run to him with every glass upon which a fresh glory is newly stamped, and to listen to his enthusiastic applause. This habit of running into the dining-room with my wet pictures has stained an immense quantity of table linen with nitrate of silver, indelible stains, that I should have been banished from any less indulgent household.

Our chief friend, Sir Henry Taylor, lent himself greatly to my early efforts. Regardless of the possible dread that sitting to my fancy might be making a fool of himself, he, with greatness which belongs to unselfish affection, consented to be in turn Friar Laurence with Juliet, Prospero with Miranda, Ahasuerus with Queen Esther, to hold my poker as his sceptre, and do whatever I desired of him. With this great good friend was it true that so utterly

> The chord of self with trembling
> Passed like music out of sight.

and not only were my pictures secured for me, but entirely out of the Pros-pero and Miranda picture sprung a marriage which has, I hope, cemented the welfare and well-being of a real King Cophetua who, in the Miranda, saw the prize which has proved a jewel in that monarch's crown. The sight of the picture caused the resolve to be uttered which, after eighteen months of constancy, was matured by personal knowledge, then fulfilled, producing one of the prettiest idylls of real life that can be conceived, and, what is of far more importance, a marriage of bliss with children worthy of being photographed, as their mother

had been, for their beauty; but it must also be observed that the father was eminently handsome, with a head of the Greek type and fair ruddy Saxon complexion.

Another little maid of my own from early girlhood has been one of the most beautiful and constant of my models, and in every manner of form has her face been reproduced, yet never has it been felt that the grace of the fashion of it has perished. This last autumn her head illustrating the exquisite Maud

> There has fallen a splendid tear
> From the passion flower at the gate.

is as pure and perfect in outline as were my Madonna studies ten years ago, with ten times added pathos in the expression. The very unusual attributes of her character and complexion of her mind, if I may so call it, deserve mention in due time, and are the wonder of those whose life is blended with ours as intimate friends of the house.

I have been cheered by some very precious letters on my photography, and having the permission of the writers, I will reproduce some of those which will have an interest for all.

An exceedingly kind man from Berlin displayed great zeal, for which I have ever felt grateful to him. Writing in a foreign language, he evidently consulted the dictionary which gives two or three meanings for each word, and in the choice between these two or three the result is very comical. I only wish that I was able to deal with all foreign tongues as felicitously –

> Mr. — announces to Mrs. Cameron that he received the first half, a Pound Note, and took the Photographies as Mrs. Cameron wishes. He will take the utmost sorrow★★ to place the pictures were good.
> Mr. — and the Comitie regret heavily★★★ that it is now impossible to take the Portfolio the rooms are filled till the least winkle.★★★★ The English Ambassude takes the greatest interest of the placement the Photographies of Mrs. Cameron and Mr.— sent his extra ordinarest respects to the celebrated and famous female photographs. – Yours most obedient, etc.

The kindness and delicacy of this letter is self-evident and the mistakes are easily explained –

 ★★ Care – which was the word needed – is expressed by 'Sorgen' as well as 'Sorrow.' We invert the sentence and we read – To have the pictures well placed where the light is good.

 ★★★ Regret – Heavily, severely, seriously.

★★★★ Winkle – is corner in German.

The exceeding civility with which the letter closes is the courtesy of a German to a lady artist, and from first to last, Germany has done me honour and kindness until, to crown all my happy associations with that country, it has just fallen to my lot to have the privilege of photographing the Crown Prince and Crown Princess of Germany and Prussia.

This German letter had a refinement which permits one to smile *with* the writer, not *at* the writer. Less sympathetic, however, is the laughter which some English letters elicit, of which I give one example –

> Miss Lydia Louisa Summerhouse Donkins informs Mrs. Cameron that she wishes to sit to her for her photograph. Miss Lydia Louisa Summerhouse Donkins is a Carriage person, and, therefore, could assure Mrs. Cameron that she would arrive with her dress uncrumpled.
>
> Should Miss Lydia Louisa Summerhouse Donkins be satisfied with her picture, Miss Lydia Louisa Summerhouse Donkins has a friend who is *also* a Carriage person who would *also* wish to have her likeness taken.

I answered Miss Lydia Louisa Summerhouse Donkins that Mrs. Cameron, not being a professional photographer, regretted she was not able to 'take her likeness,' but that had Mrs. Cameron been able to do so she would have very much preferred having her dress crumpled.

A little art teaching seemed a kindness, but I have more than once regretted that I could not produce the likeness of this individual with her letter affixed thereto.

This was when I was at L.H.H., to which place I had moved my camera for the sake of taking the great Carlyle.

When I have had such men before my camera my whole soul has endeavoured to do its duty towards them in recording faithfully the greatness of the inner as well as the features of the outer man.

The photograph thus taken has been almost the embodiment of a prayer. Most devoutly was this feeling present to me when I photographed my illustrious and revered as well as beloved friend, Sir John Herschel. He was to me as a Teacher and High Priest. From my earliest girlhood I had loved and honoured him, and it was after a friendship of thirty-one years' duration that the high task of giving his portrait to the nation was allotted to me. He had corresponded with me when the art was in its first infancy in the days of Talbot-type and auto-type. I was then residing in Calcutta, and scientific discoveries sent to that then benighted land were water to the parched lips of the starved, to say nothing of the blessing of friendship so faithfully evinced.

When I returned to England the friendship was naturally renewed. I had already been made godmother to one of his daughters, and he consented to become godfather to my youngest son. A memorable day it was when my infant's three sponsors stood before the font, not acting by proxy, but all moved by real affection to me and to my husband to come in person, and surely Poetry, Philosophy and Beauty were never more fitly represented than when Sir John Herschel, Henry Taylor and my own sister, Virginia Somers, were encircled round the little font of the Mortlake Church.

When I began to photograph I sent my first triumphs to this revered friend, and his hurrahs for my success I here give. The date is 25th September 1866 –

My dear Mrs. Cameron –
This last batch of your photographs is indeed wonderful, and wonderful in two distinct lines of perfection. That head of the 'Mountain Nymph, Sweet Liberty' (a little *farouche* and *égarée*, by the way, as if first let loose and half afraid that it was too good), is really a most astonishing piece of high relief. She is absolutely alive and thrusting out her head from the

paper into the air. This is your own special style. The other of 'Summer Days' is in the other manner – quite different, but very beautiful, and the grouping perfect. 'Proserpine' is awful. If ever she was 'herself the fairest flower' her 'cropping' by 'Gloomy Dis' has thrown the deep shadows of Hades into not only the colour, but the whole cast and expression of her features. 'Christabel' is a little too indistinct to my mind, but a fine head. The large profile is admirable, and altogether you seem resolved to out-do yourself on every fresh effort.

This was encouragement eno' for me to feel myself held worthy to take this noble head of my great Master myself, but three years I had to wait patiently and longingly before the opportunity could offer.

Meanwhile I took another immortal head, that of Alfred Tennyson, and the result was that profile portrait which he himself designates as the 'Dirty Monk.' It is a fit representation of Isaiah or of Jeremiah, and Henry Taylor said the picture was as fine as Alfred Tennyson's finest poem. The Laureate has since said of it that he likes it better than any photograph that has been taken of him *except* one by Mayall, that '*except*' speaks for itself. The comparison seems too comical. It is rather like comparing one of Madame Tussaud's waxwork heads to one of Woolner's ideal heroic busts. At this same time Mr. Watts gave me such encouragement that I felt as if I had wings to fly with.

Gisèle Freund

Photography During the July Monarchy, 1830–1848

(Extracted from *Photography & Society*, 1974, English translation 1980)

Freund's varied photographic career embraced reportage for *Life* maga-
zine as well as portraits of literary figures such as James Joyce and
Virginia Woolf. She remains, however, most referred to as a nine-
teenth-century specialist. Her doctoral thesis at the Sorbonne in 1934
was published as *La photographie en France au dix-neuvième siècle* and
exerted a substantial influence on photo-historiography for decades to
come.

ON 15 JUNE 1839, a group from the Chamber of Deputies proposed that
the French government purchase the rights to the new invention of
photography[1] for public use. For the first time, photography made its
appearance in public life. A knowledge of the political parties and social groups
espousing the cause of photography gives yet another view of the relationship
between the changes in society and the development of photography.

Nineteenth-century revolutions in France were products of social changes
that accompanied the growth of capitalism. The liberal revolution of 1830,
which dethroned the oldest branch of the 'legitimate' dynasty and destroyed all
hopes of its restoration, supported the rising bourgeoisie and its claim to
'natural' power.

Massive economic changes took place during this period. The 1830 strike
among Parisian printers, precipitated by job cutbacks due to the installation of
improved machines, was only one indication of the dramatic changes in French
economic and social life.[2] Mechanization took hold throughout France during
Louis-Philippe's reign: the number of mechanical spinning wheels, for example,
grew from 466,000 in 1828 to 819,000 in 1851; there were only 250 power looms
in 1825, but little over twenty years later some 12,128 had been installed in France.[3]
Individual craftsmen were being replaced by machines; France's small, labor-
intensive factories were becoming machine-dominated industries; and French
society itself was becoming increasingly standardized.

Many French artisans were forced to join the ranks of the proletariat which,
in the early days of industrialization, meant a life of misery and complete
political insignificance. The petite bourgeoisie, or lower middle classes, also
became more numerous, but with the expansion of industry and commerce
they prospered along with the rest of the bourgeoisie, whose members were fast
becoming the pillars of the social order.

On 28 July 1831, a bourgeois Parisian proudly exhibited his portrait next to one of Louis-Philippe with the following inscription: 'There is no real difference between Philippe and me: he is a citizen-king and I am a kingly citizen.' This anecdote points up the new self-awareness of the bourgeoisie whose ideas and feelings had become profoundly democratic.[4]

Grocers, haberdashers, clockmakers, hatters, druggists – men 'enclosed in the little world of their shops,' with little means and just enough education to keep their account books – these were the members of the bourgeoisie who were to find in photography a means of self-expression conforming to their new ideals and economic status. Their place in society would determine the nature and direction of photography. This group established, for the first time, the economic base that allowed the art of the portrait to become accessible to the masses.

Just as fashion is set by society's higher classes before reaching the lower, so photography was first adopted by those members of the French ruling class who wielded the most power: industrialists, factory owners, bankers, politicians, writers, scientists, and all those who belonged to the intellectual elite of Paris. Then photography gradually filtered down through the lower middle classes as they became more influential.

Around 1840 France's total population was 35 million but only 300,000 had the right to vote.[5] The government, a constitutional monarchy known as the July Monarchy, was led by Louis-Philippe, a king who liked to dress in the clothes of the bourgeoisie and carry an umbrella. Members of the two Chambers were chosen by a small number of electors and were primarily industrialists and merchants.

Besides the government party, there were also members of the Legitimist and Republican oppositions in the Chambers. The Legitimist party, representing the nobles' and landowners' interests, no longer exerted the overwhelming power it once had. The Republicans, however, were an important influence in the political life of the day, particularly in the press. Their Paris newspaper, *Le National*, was as respected as the venerable *Journal des debats*, the organ of the party in power. The Republican members of the Chamber came from the bourgeois intellectual elite: writers, lawyers, army officers, civil servants, and others. They were, above all, patriots who despised the Treaty of Vienna of 1815, which was designed to keep France weak in the European balance of power, and who looked back fondly at the old Republic founded by the French Revolution.[6]

Intellectuals have always had both a role to perform in history and a special function in their own society. Separated by knowledge and culture, they can understand their relative historical position and choose their own course in life accordingly. They can have a more open view of the world, a vision not available to other groups of society restricted by political and economic status.[7] In the French parliament under the July Monarchy, intellectuals chose to represent the more humanitarian and liberal causes of the bourgeoisie. Although they did not constitute an entity strictly distinct from the bourgeoisie, they were the most forward-thinking representatives of the constitutional

government. Their answer to the weak contemporary political regime 'which, sensing its own weakness, had to hide behind the crown,' was bourgeois republicanism. Because they were part of the opposition, this group of intellectuals was not confined by the conservative politics of the *juste milieu* (the neoclassical conception of the Golden Mean, the happy middle ground). They were open to new possibilities.[8]

The liberal spirit is defined by an abiding faith in the potential of human intellectual and moral progress. Along with this faith in progress goes an effort to recognize the realities of the period in which one lives. Because of its flexible political position, the intellectual bourgeoisie, which attracted the artistic elite during the Revolution of 1848, could afford to be receptive to contemporary reforms and scientific or spiritual innovations. It also became the most competent judge of the potential of new business ventures. It is not at all surprising, then, that these intellectuals were the first to propose that the State acquire the rights to the new invention of photography and introduce the invention to the public.

The Republican party had a left-wing democratic faction[9] whose leader, François Arago, was an extraordinary scientist as well as politician. 'This scientist whom all of Europe admires is at the same time one of the most vigorous defenders of public freedom and the interests of the people,' wrote one journalist of the day. 'Since he has arrived in the Chamber of Deputies, he has opposed all the ministries and has fought against all reactionary and violent measures.'[10] Arago was one of the intellectuals most imbued with his party's platform of encouraging anything that might lead to progress. Not surprisingly, he was the first to understand the extraordinary role photography could play in the arts, the sciences, and other fields. It was Arago who most forcefully urged the Chamber to purchase this new process for the State. It is important to note that Arago's interest in photography was primarily scientific – the predominant position in the early days of photography.

All inventions are the result of experimentation and discovery on the one hand, and society's needs on the other. To these two factors, we should also add the inventor's genius and often just plain luck. All of these factors contributed to Joseph Nicéphore Niepce's invention of 1824.[11]

Born in 1765 at Châlon-sur-Saône, Niepce was the son of an influential lawyer whose connections extended to many of the most important families in Burgundy. His financial and social position, the cultural tradition in his bourgeois intellectual family, and his education all provided him with the time and background to pursue his scientific interests. He was not unlike many other 'gentlemen-scientists' who carried on their research in the châteaux and country homes of the leisured bourgeoisie, among whom scientific experimentation was frequently encouraged. In Arago's time no science was more fashionable than chemistry. A popular pastime, half experiment, half parlor game, involved attaching objects like flowers and leaves to pieces of paper treated with silver salts. When the paper was exposed to sunlight, the outline of the objects soon appeared in sharply contrasting black and white. However, these images disappeared rapidly because fixing techniques had not as yet been discovered.

During this post-Revolutionary era, the most firmly entrenched traditions began to falter, and life itself seemed like an experiment. The nobles and those of royalist tendencies, who had largely been excluded from political life and who, like Niepce, preferred to retire to their country estates, now found plenty of time to devote to their scientific experiments. Photography was already beginning to emerge from their work. In 1814, lithography reached France and suggested to Niepce the last steps of his own work. Living in the isolation of his country home, Niepce was unable to find the limestone necessary for his experiments with lithography. He began to use a metal plate instead of stone and sunlight in place of the lithographer's crayon.[12]

In 1826, after many failures, Niepce finally succeeded in developing a very primitive photographic process.[13] Not until several years later, however, did the painter Daguerre perfect Niepce's technique. Daguerre's invention of the diorama had drawn him into studies on the effects of light, and with his results he was able to make the new process available to everyone.[14] Although Niepce had spent a lifetime of money and energy on his photographic projects, he received no public recognition and died impoverished on 5 July 1833.[15] Daguerre, an acquaintance of Niepce, drew up an agreement with Niepce's son, Isidore, who received the invention as his only inheritance. Together, these two would exploit the discovery.[16]

Like Niepce, who had spent years looking in vain for financial backers, Daguerre was at first unsuccessful at finding the necessary support. Even an effort to go public ended in failure, as there was no way of convincing speculators to risk money on an invention that still did not inspire much confidence. The first photographic prints were difficult to appreciate because the image was affixed to a mirrored surface, which had to be held up against the light to be seen. And, in any case, lack of initiative among contemporary businessmen was typical of the period. Vast industrial expansion did not begin until the second half of the century. The businessman of the 1830s invested only in sure ventures and had little experience in speculation. The stock market was not yet the barometer of wealth into which it later evolved.

But, as the former promoter of the diorama and an ambitious and clever entrepreneur as well, Daguerre knew how to sell a discovery successfully. He asked that his name be featured in any publicity given to the invention. And he soon succeeded in making the invention a favorite subject of conversation at exhibitions and gatherings of high society.[17] Nor was it an accident that scientists became interested in photography during the 1830s, a period of great scientific progress. Fifteen years after its invention photography was at last introduced to the general public.

'Everything that leads to the progress of civilization, to the physical and moral well-being of man, ought to be the continuing goal of enlightened government. This government must rise to meet the fates of the citizens that are entrusted to it; those men who work toward this noble end should be honorably rewarded for their achievements.'[18] These words of Gay-Lussac, the French physicist, were typical of the liberal's attachment to the idea of progress. He delivered them in the Chamber of Peers six weeks after Arago had

presented his proposal on the invention of photography to the Chamber of Deputies. Passed unanimously by both Chambers, the law offered Daguerre, now considered the inventor of the 'Daguerreotype,' and Niepce's son Isidore, annuities of 6,000 and 4,000 gold francs respectively.[19] As was often the case at the time, the French government renounced its rights to a monopoly and left the invention open to the public. This gesture actually meant little: since the process was so simple, it would have been difficult to protect by any patent.

On 19 August 1839, having acquired the invention, the French government made the process public during a meeting of the Academy of Sciences.[20] The intellectual elite of Paris, composed of scholars and the most important artists of the day, filled the hall. 'As early as eleven in the morning the crowd was considerable. By three o'clock an actual riot blocked the doors of the Academy. All the notables of Paris were crowded into the section reserved for the public.' The presence of numerous foreign scholars at the lecture indicated the tremendous interest the invention had created in a short period of time and well beyond French borders.[21] Arago himself presented the details of the technique and outlined the extraordinary role photography was going to play in the development of the sciences to the attentive audience. 'How archeology is going to benefit from this new process! It would require twenty years and legions of draftsmen to copy the millions and millions of hieroglyphics covering just the outside of the great monuments of Thebes, Memphis, Karnak, etc. A single man can accomplish this same enormous task with the daguerreotype.'[22] The artist would discover in the new technique a valuable tool, and art itself would be democratized by the daguerreotype.[23] Arago read a letter of approval from the painter Delaroche. Astronomy would also benefit from this new invention: 'We can hope to make photographic maps of our satellite. In a few moments time one can achieve one of the longest and most difficult projects in astronomy.'[24] The numerous possibilities Arago presented in his speech summed up the immense importance of the invention. Arago's foresight was evident in his prophetic final remarks: 'When experimenters use a new tool in the study of nature, their initial expectations always fall short of the series of discoveries that eventually issue from it. With this invention, one must particularly emphasize the unforeseen possibilities.'[25]

Arago's presentation was an important Parisian event, reviewed with lively interest by all the newspapers. During the weeks that followed, Paris was taken by a mad spirit of experimentation. With equipment and accessories weighing as much as 220 pounds, Parisians set out to search for subject matter. Dusk was greeted with little enthusiasm: the sunset ended the day's experiments. At dawn, from many a window, amateur photographers could be seen cautiously trying to capture an image of a neighboring roof or a panorama of chimneys on the sensitized plate. Soon cameras were routinely aimed at monuments in most of Paris's famous squares; scientists were successfully repeating the inventor's procedures. Everyone was predicting the end of engraving, and the opticians who displayed the first cameras were besieged by prospective buyers. The daguerreotype was an inexhaustible subject at salons. It was the rage of Paris.[26]

As soon as the photographic process was made public, inventors came

along, each claiming to have discovered the process. In France, a civil servant named Bayard, and in England, the scientist Talbot, had both discovered a photographic process using paper: the first with silver iodide, the second with silver chloride. The fact that the photographic process was invented at the same time by three different individuals strongly suggests that photography responded to the needs of the time.

The new invention aroused the interest and curiosity of men at all levels. Yet, the initial technical primitiveness and the extraordinary expense involved made it temporarily available only to wealthy amateurs and scientists. Daguerre's invention, moreover, was very inconvenient. First of all, the light-sensitive silver plate could be used only after its exposure to dangerous iodized vapors.[27] In addition, the plate could only be prepared just before use and had to be developed immediately after exposure. Finally, exposure time was often more than half an hour. Arago indicated in his report that preparations alone took thirty minutes to three-quarters of an hour.[28] To photograph landscapes the early photographers had to transport large tents and portable laboratories because the chemical preparations had to be made at the site. Taking daguerreotype portraits required Job-like resignation from patient subjects during long waits in full sunlight. Beads of sweat dripping from the foreheads and cheeks of the subjects left unattractive lines on their powdered faces that inevitably showed up in the final pictures.[29] In addition to these problems, the daguerreotype had yet another basic disadvantage: the process resulted in only one plate, and copies could not be made. Built by Daguerre himself, and sold by the Paris optician Giroux, the first cameras were large and cumbersome, weighing 50 kilograms (over 100 pounds), including accessories. The price, no less imposing, varied between 300 and 400 francs, a sum very few could afford.

The tremendous public interest in photography as well as the early recognition of its economic importance led to the technical improvement of the process, and soon the price of cameras and equipment began to drop. Improvements began with the optical equipment. By the end of 1839, Baron Séguier was constructing a camera that weighed no more than 31 pounds and was to some extent portable. Around 1840, the opticians Chevalier, Soleil, Leresbours, Buron, and Montmirel developed equipment that could be produced at much lower prices, and by 1841 cameras were priced at 250 to 300 francs. Plates costing three to four francs just a year before were now selling for one to one and a half francs. Although annual sales in Paris had reached approximately 2,000 cameras and 500,000 plates by 1846, the number of enthusiasts was still limited by the price. Finally, the lens designed by the German optician Voigtländer became so competitive with French equipment that the French were forced to lower their prices and call the cameras they sold 'the German system.' The optician Leresbours's 1842 catalog listed the price as 200 francs.[30]

Reduced exposure time was another result of technical improvements. In 1839, the year photography was introduced to the public, the required sitting time was fifteen minutes in full sunlight. A year later, thirteen minutes in the shade were sufficient. By 1841, exposure was reduced to two or three minutes;

by 1842 to only twenty to forty seconds. Finally, a year or two later, the length of sitting was no longer a problem in achieving a photographic portrait.

The daguerreotype was a great success all over Europe, but it was in America that it took hold and developed into a prosperous business. At the end of 1839, Daguerre sent François Gouraud to the United States to organize daguerreotype exhibitions and to give lectures on the process. He was to promote the sales of the camera and other accessories manufactured under Daguerre's supervision by the Paris firm of Alphonse Giroux and Co. Daguerre's business interest explains his haste in introducing the invention abroad.

In 1840 American society had not yet become rigidly stratified, and initiative was the passport to success. Between 1840 and 1860, the period of the daguerreotype's greatest popularity, America was shifting from an agricultural to an industrial society as the result of numerous technical advances: refrigeration, the invention of the reaper, new developments in mass production, the expansion of the railroads, and other products of American ingenuity. It was the period of rapid urbanization in the East and of the gold rush and the frantic development of cities in the West. Proud of its success, the new country found in photography an ideal way to preserve and promote its accomplishments. Enterprising Yankees set up photographic 'saloons' in the cities and converted covered wagons crossing the Great Plains and the Rocky Mountains into daguerreotype studios. It is estimated that by 1850 there were already 2,000 daguerreotypists. Just a few years later, in 1853, some 3 million photographs were taken annually, while the total output between 1840 and 1860 was more than 30 million photographs. Daguerreotypes cost between $2.50 and $5.00, depending on their size. Americans were estimated to have spent between $8 million and $12 million in 1850 for portraits alone, representing 95 percent of photographic production.[31] In the young American democracy this new method of self-portraiture was perfectly suited to the pioneer taste, a taste proud of its achievements and eager to preserve them for posterity.

However, it was only when Daguerre's nonreproducible metallic plate was replaced by the glass negative that the conditions necessary for the development of the portrait industry were finally fulfilled. The wet plate collodion process, using glass negatives instead of copper plates, opened the way to mass production of photographic portraits. At the same time, it stimulated the development of such secondary industries as the manufacture of cameras, glass plates, and chemical emulsions. Soon the paper industry and smaller businesses were taking advantage of the new demand for picture frames and photograph albums. The daguerreotype thus gradually fell out of use and a new phase in the history of photography began.

Gen Doy

The Camera Against the Paris Commune

(First published in *Photography Politics* 1, 1979)

Gen Doy's essay advances the understandings inherited from Gisèle Freund's researches some forty years earlier. She looks at history's first forensic deployment of the camera to illuminate the limits of photography's democratisation in the period of the Second Empire in France. Although available to a rising bourgeoisie, the carte-de-visite, pioneered by Disdéri, was beyond the means of the Paris proletariat, for whom the camera was to be first and foremost an instrument of repression.

TWO MYTHS about photography have had a long history: that the camera is 'objective'; that the camera has had a 'democratizing' effect on the production and consumption of visual imagery. It was precisely during the period of the Second Empire in France (1852–1870) and the Commune (1871) that these very concepts of 'objectivity' and 'democratization' were being constructed around the growing social significance of photography. However they were by no means fixed, and the following study attempts to investigate this intermediate stage in the evolution of the photograph as a record of historical events, and the uses of such visual documentation.

First of all, it is necessary to summarize the historical and technical information relating to photography in 1871. The following account of the Paris Commune is intended to give a brief account of the historical data, concentrating on aspects which are relevant to the photographs reproduced here.

After an economically prosperous start, the Second Empire in France was beset by increasing financial difficulties in the later 1860s. Bonapartism, personified by Louis-Napoleon Bonaparte, was forced to make mildly liberal concessions to the working classes and bourgeois-liberal reformers. Its function was to maintain, as Marx correctly saw, a precarious equilibrium between classes under developed capitalism. However the disastrous imperialist war between France and Prussia in 1870 led to the rejection of the Empire by France, and a chauvinist Government of National Defence was formed by Adolphe Thiers. France continued to fight the Prussians, and the working classes of Paris under siege were thus isolated from the more reactionary rural areas of the country. When Paris heard that the Government had negotiated a peace with the enemy, an alliance formed between the working people of Paris and the nationalistic lower bourgeoisie against the reactionary Adolphe Thiers. Thiers surrendered to the Prussians leaving the Parisian National Guard as the most powerful armed body remaining in France. Following an abortive attempt

to disarm the Parisian populace, Thiers and his supporters withdrew to Versailles in order to marshall forces to crush insurgent Paris. Generals Thomas and Lecomte had been dispatched to Montmartre on 18 March 1871 to seize the cannons of the National Guard. Local people had protested, and the troops of the line had refused the generals' command to fire on the crowd of protesters, including many women and children. They had instead turned on their commanders and eventually shot them. This so-called barbarity on the part of the insurgents was frequently referred to by Thiers in his speeches, and was also mentioned on numerous occasions by the anti-Communard press. In fact it was one of the few occasions during the Commune period when the Parisians had not been sufficiently disciplined to spare their hostages. The other occasions when this occurred were during the bitter fighting in late May, when the Versailles troops retook Paris, and slaughtered indiscriminately all those suspected of being Communards. In retaliation, the Communards shot hostages they held in prison. During the short life-span of the Commune, declared on March 18 and brutally suppressed by force during 'Bloody Week' in late May, strategies for a working-class government were put into practice. Obviously the historical significance of the Commune has been differently interpreted according to the political views of its commentators. For Marxists, the Commune became the touch-stone for the analysis of practice and theory in revolutionary government. For the right, the Commune was to be either reviled or else ignored, and any traces of its existence quickly blotted out. For those who claimed to have no political affiliation, the 'facts' and 'documents' of the Commune and its existence could be presented 'objectively' in words or images. Many of these 'objective' images are, of course, photographs.

What technology was available for recording contemporary events in 1871 and how accurate was it? Photographers already had experience of recording contemporary history under conditions similar to those which were to be encountered in the Paris Commune. Roger Fenton had been dispatched on an official mission to the Crimea in 1855 to provide visual proof that the British Government was not mismanaging the war. He was told 'No dead bodies' in no uncertain terms. What appeared in his photographs may have been accurate enough, but the images themselves cannot tell us what is not included in them. In the days before photojournalism proper, the diffusion and marketability of 'news' photographs was uncertain. In addition to his government payments, Fenton had arranged with the dealer Agnew to publish a portfolio of the photographs on completion of the mission. Meantime, public interest was kept alive by Agnew who sold prints to the *Illustrated London News* on the condition that their wood-engravers preserved the character of the photograph, and a credit was given to Fenton.[1] At this time, the function of photographs in the illustrated press was limited to the role of the artist's sketch as a similar basis for the production of a wood-engraving to illustrate the report of a special correspondent who provided an 'eye-witness' account. The report and the illustration were intended to enhance one another. In the case of important events both were considered necessary. It was by this time technically possible to print photograph and text together in the paper, but newspaper proprietors

were unwilling to make the considerable financial commitments required for the development of the new machinery.

Thus in 1871 the large newspapers illustrated their coverage of the Paris Commune with wood-engravings executed by craftsmen after the drawings of artists present in Paris, who sent out their work from the besieged city either by balloon or through the lines of the troops surrounding the city. Many of the Parisian papers used photographs of ruined buildings as a basis for their illustrations reporting the aftermath of the Commune, but for technical reasons it was not possible in 1871 to photograph anything but static scenes. Fenton's Crimean War pictures tend to be posed and static, not only because he had been told to keep away from images of violence and bloodshed, but also because exposure times and the use of wet-plates requiring careful preservation and development made it impossible to take action pictures. This stage of photographic technique persisted during the Commune period. Consequently photographs taken of the Communards and their activities tend to be static, posed and out-of-doors, apart from true studio portraits of individuals, or 'faked' photographs, which sometimes show indoor scenes. (This last point is a good indication as to whether a photograph might be a 'fake' or not.) One tends to find images which show groups of Communards lined up on barricades, corpses ranged in their coffins, mug-shots of Communard prisoners, or desolate ruins of deserted burnt-out buildings.

At a time when the events taking place in Paris cried out for visual reporting, photography did not possess the technical means to do this. Some of the difficulties encountered by the news press in this situation can be seen in a cover from the *Illustrated London News* of June 24, 1871. In fact the editors have cleverly exploited the technical deficiencies of photography in the wood engraving on the cover. A photographer attempts to photograph the scene as firemen try to extinguish the flames which have already destroyed the building. The photographer stands in the midst of the chaos, accompanied by his young assistant who holds the plate ready for him. Neither the firemen nor the homeless mother and child in the foreground pay any attention to him. The 'objectivity' of the camera in this case suggests its invisibility, or perhaps even its irrelevance. In this case, the graphic artist gives a 'truthful' account of the scene which also includes, and comments on, the role of the photographer within it. Yet even so, the scene depicted probably occurred at the end of May, when the reactionary troops entered Paris, and the Commune was crushed during bitter fighting. It has taken roughly a month for the 'news' to appear on the cover of the paper.

In 1871, therefore, photography did not enjoy the powerful position vis-à-vis other graphic media which it enjoys today. While contemporaries accepted, for example, that the photograph would show a scene which 'really' took place, they obviously also accepted that a hand-drawn image could give a truthful account of events. What tended to happen was that photographs were sold as historical souvenirs, to back up the information that the public had already read and seen in the press.

What was the purpose of this visual material and what was its public? The

answers to these questions are complex, and not always possible to answer fully. In purely economic terms, for example, it would be fair to say that working-class people would not have been able to afford either photographs or illustrated papers except as a luxury. To give some examples – Disdéri brought the price of photographic portraits down dramatically in the early 1850s by exploiting the carte-de-visite format, 6 × 9 cms, and by using glass negatives to give multiple prints. This meant that twelve portrait photos now cost 20 francs as opposed to the previous rate of one large portrait for 50–100 francs.[2] As Gisèle Freund points out, quoting Disdéri, this brought photographic portraiture within the grasp of the petty bourgeoisie. However it certainly did not bring it within the reach of the working classes. The average daily wage of a working man at the end of the Second Empire was 3 francs, sufficient to buy 6 kilos of bread.[3] Jules Simon estimated at this time that a family of four living in Paris needed an income of 32–33 francs a week in order to live just above starvation level, and pointed out that only a minority of working-class families made even this amount of money.[4] Wages in craft-type work were, for example, bookbinding: men 3–8 francs a day, women 1–3.50 francs.[5] Photography itself was economically in the class of craftwork. For workers in photographic establishments the wages were: men 3–20 francs, women 1.25–6 francs a day.[6] This compares with wages of workers in printing trades. From this we can see that it was most unlikely that the working classes of Paris were used to visiting photographers' studios or buying photographs very frequently. Similarly the illustrated newspapers were probably beyond their reach although the most expensive, *L'Illustration*, sold for 75 centimes a copy. Like photography, the illustrated newspaper was the newly created province of the petty bourgeoisie, and all of the French illustrated papers (and indeed the foreign ones) were resolutely anti-Communard. As a comparison, Communard newspapers cost around 5 centimes, or 10 centimes for the illustrated *Caricature*.

It is also difficult to say who worked in photography during the Second Empire and Commune period. Fenton was the son of a wealthy mill-owner, banker and MP, and many of the early pioneers of photography had private means. However in the Second Empire in France, under the impetus of Disdéri's enterprising business sense, photography became a commercial success. Freund quotes Nadar in pointing out that all kinds of people now proceeded to set themselves up in the photography 'industry' (bohemians, drop-out students, failed lawyers, and so on) but since it was necessary to buy a camera and rent a studio, it is not likely that there were 'working-class' photographers.[7] However we should beware of a strictly economistic approach to the status and role of the photographer during the Commune. Many of the members of the Commune were obviously not working class in origin, but this did not prevent their commitment to the emancipation of working-class people.

The function of the photographic material varies and the following attempts to investigate the uses of photographs in the Commune period do not pretend to be exhaustive. It will be helpful to deal with them under several categories, although, as we shall see, these categories overlap.

Firstly there are photographs which might be loosely termed documentary records (bearing in mind reservations as to the problematic nature of documentation.) These images showed people taking an active part in the construction of their own history and proud to be shown in the act of doing so. As we have seen, for many of the people in these images, it would be a novelty and a privilege hitherto reserved for another class simply to appear in a photograph. They may have felt that the very fact of being photographed conferred a permanency on their achievements. For example the Commune decreed the destruction of the Vendôme column, which commemorated the military conquests of Napoleon I during the First Empire. On May 16 the Commune demanded that the column should be pulled down as 'a monument of barbarism, a symbol of brute force and false glory, an affirmation of militarism, a denial of international law, a permanent insult directed at the conquered by their conquerors, a perpetual attack upon one of the three great principles of the French republic . . .'[8] The Communards were obviously fully conscious of the important historical and political implications of this decision. A large number of photographs were taken of the actual destruction of the column, and the participants were carefully posed by photographers both before and after the operation to dismantle the monument. What the proud Communards did not realize was that only a few weeks later, the same photographers who had been so eager to immortalize them for revolutionary posterity were more than willing to hand over their prints to the authorities, so that the insurgents could be identified by the Versailles prosecutors.[9] Thus what might have been envisaged as the original purpose of the photographs could easily be subverted as soon as they were utilized for different political ends.

Similarly the Communards were photographed on May 15 when they demolished the private residence of Thiers. Thiers' possessions were auctioned in aid of the poor and bed linen and household utensils from the house were given to hospitals. The Communards were aware of the significance of this step and the appropriateness of their decision to destroy Thiers' property. During the Second Empire, Thiers had been receiving 200,000 francs a month from his official government appointments and his income from shares in the mine at Azin, where he had ordered the murder of several strikers. This monthly income represented the salary of a face-worker at the mine over a period of twenty-four years, supposing that the person's working life extended that long.[10]

Yet here again the intention of documentation can be subverted and reappropriated when the image is used in a different context. The Communards' attack on capitalist property was carried out consciously and hit their enemy where it hurt, i.e., in his pocket. A huge body of photographic material related to the Commune in fact went on sale after the repressive measures of 'Bloody Week', and were photographs of ruined buildings, either entirely deserted, or else with ghostly images of passers-by who had been too quick for the exposure time of the plate. These photographs were sold either in albums or else in smaller carte-de-visite format, as rather gory souvenirs of the disasters which had taken place during the Commune.

Photographs had been taken of ruined buildings during the Franco-Prussian War, but their function was rather different from the Commune ruins. Although the Versailles troops had shelled Paris for weeks, during the Commune, the conservative press conveniently played this down, while emphasizing the damage caused by the strategic burning of buildings carried out by Parisians during the last week of the Commune. Most of the buildings were burnt for military reasons, but some were obviously abhorrent to the Communards for ideological reasons. The finance ministry and debtors courts, for example, were obvious candidates for petrol bombs. However the bourgeois press recounted the destruction of the buildings as entirely the work of the vandals of the Commune, devoid of respect for the architectural achievements of civilized society, and bereft of a healthy respect for property. The Hôtel de Ville and the Vendôme column, destroyed by the Communards, were rebuilt afterwards in exactly the same way so as to efface memories of the Commune's existence as much as possible. Because of this the photographs of the burnt-out buildings preserve the memory of the Commune at the same time as they attempt to present the ruins as an indictment of their actions. It is important to note the large number of photographs taken of the ruined buildings. On the one hand, it should be borne in mind that technical considerations encouraged such subject matter. On the other, it indicates the concern for the material and for property which occupied the opponents of the Communards. Cluseret, a military leader of the Commune, stressed precisely the shift in emphasis between the war waged by the imperialist powers in 1870 and the struggle of the Communards in the following year. Their theatre of war was the city, where property, rather than people, was at risk: 'This is the reverse of bourgeois warfare where men, who cost nothing, are destroyed, and property, which costs a great deal, is respected . . . To ruin confidence in capital in all its forms should be the constant aim of class warfare.'[11]

It seemed to some contemporaries that the photograph was too 'objective'. It did not state its allegiances clearly enough and was perhaps too accessible. Was it not perhaps safer to use a medium which was traditionally associated with the property-owning classes if one wished to illustrate the attack on property during the Commune? Why not revert to oil painting, even when basing your picture on a photograph, and add an obscure caption for good measure? Then perhaps one can be sure of reaching only the 'right' public. This was the tactic of the reactionary academic painter Meissonnier, a favourite of the Emperor Napoleon III, who produced a commemorative painting after the Commune which he based on a photograph of the ruins of the Tuileries palace. The ruined palace is made to look 'sublime' and tragic in the manner of the ruins of ancient Greece or Rome. The classical heritage of civilized Europe lies in ruins, wasted by barbarian vandals. The imposing ruins are accentuated by the viewpoint, which exaggerates the scale of the buildings as we look upwards at them. Meissonnier preserves this perspective in his painting, adding a plaque and an inscription at the foot of the painting, which moralizes in Latin about vulgar mobs attempting to destroy the immortal values of culture. In the original photograph used by the painter, the chariot and figures are indeed seen

through the framing arch, but the horses and figure have their backs to the viewer as s/he looks through the Tuileries to the Arc du Carrousel. Meissonnier has executed the painting as if it were a photograph, therefore 'true' and 'real', but has turned the chariot and the victorious figure round to face the spectator in a much more effectively optimistic stance, coupling this with the addition of the plaque proclaiming, in the language of the educated upper classes, the ultimate defeat of the vandals.

Just as tourists flocked to visit the ruins of Paris after the defeat of the Commune, such images were intended as a terrible memento of the Communards' lack of respect for property, and the fate that awaits those who have the misfortune to share their misplaced ideals. Within a few weeks of the suppression of the Commune individual prints of ruins and albums of souvenir photos were listed in the *Bibliographie de la France*, which lists all books, prints and photos published in Paris. The text of one of these albums gives the general tone: 'Forever accursed be the evil days we have just traversed, and forever let the memory of them be preserved, by the pen, by the pencil, by the burin, by the camera, by the spoken word, by every means, so that generations to come may never forget the lesson of such events!'[12]

However there is another category of photographic material from the Commune period which does attempt to manipulate photographic 'objectivity' consciously. This category is made up of photographs composed from a number of negatives, sometimes from drawings or sketches with photographed figures stuck onto them and rephotographed, or even sometimes from photographs of streets with the characters painted onto them and then rephotographed. Many purported to show events and personalities of the Commune as they 'truly' existed and selected 'events' which could be used as propaganda for the Right. For example the killing of the two Generals Thomas and Lecomte was chosen to demonstrate 'evidence' of the brutality of the Communards. This composite photograph was among the many produced during the Commune by one Appert, whose address is given on the back of his prints as 24 Rue Taitbout. He was active both before and after the Commune, and his work includes studio portraits of dignitaries of the Second Empire as well as prominent members of the Central Committee of the twenty districts of Paris during the Commune, and the Commune executive itself. Some indication of his political allegiances can be gained from an inscription on the reverse of one of his prints in the Victoria and Albert Museum, which proudly proclaims his official appointment to such governmental bodies as the magistrature and the legislative body of the Empire, as well as his position as the painter-photographer to the Queen of Spain. Appert was among those photographers who were made welcome by the Communards – eager to pose for posterity on barricades and in ruins, but who later used the pictures for very different ends.

Appert was in fact one of the photographers who took mug-shots of the Communard prisoners at Versailles after the repression of the Commune, and these prints are among those he later used to manufacture his composite photographs, as well as material from the barricade photos.[13] Within a few weeks of the suppression of the Commune, these photos were on sale.

Obviously they were intended for the supporters of the Versailles government, probably as a memento of the terrible fate they might have met at the hands of the Commune, and to justify the scale of the killings during 'Bloody Week', when the Versailles forces killed between 25–40,000 Parisians. This figure puts the event presented to us in Appert's image into a context that is not, of course, suggested by the single photograph.

In the first of the execution scenes, Appert inserted the figures posed in the studio into a photograph of the street where the execution took place. Technically, as well as historically, the image is at fault. The exposure time required would have meant that at least some of the figures would have been blurred, and contemporary accounts state that the execution of the two generals was a much less orderly event than the 'posed' scene in this photograph. Yet to a public who, for the most part, believed the myth of the objectivity of the camera, and who, in any case, would be predisposed to accept this image as 'factual', Appert's photograph would reinforce anti-Communard prejudice.

Even more damning as an indictment of the actions of the Communards is a composite print showing the execution of the lawyer Gustave Chaudey, who had worked with the Commune in spite of some dubious actions on his part before March 18, e.g., ordering riflemen to fire on a crowd of demonstrators outside the Hôtel de Ville on 22 January 1871. As the Versailles troops threatened the city, Chaudey's opponents were prepared to sacrifice him while they had the chance. This image of the evil Communards, prepared to turn on their own supporters, was given the full treatment by Appert. Chaudey strikes a melodramatic pose in the courtyard of the prison where he is about to be executed. Within the rather doubtful box-like space of the enclosure, an impossibly located firing squad level their guns somewhere in the direction of the victim. The scale of the various figures as well as the difficulties which would have been involved in the lighting again indicate a faked photograph. Chaudey's execution did take place, but it was certainly not one of the most important events of the Commune period, and its selection as a moment worthy of documentation is certainly ideological and propagandist. Again it seems that the photograph would sell to a public who wanted visual confirmation of what they already believed.

Another example of Communard execution scenes shows Communards shooting 48 hostages in the Rue Haxo on May 26. By this time the Versailles troops were in Paris shooting thousands of victims indiscriminately. In desperation, and against the advice of members of the Central Committee, Parisian militants gave vent to their frustration and despair and shot some of the hostages they held. Appert's composite photo purports to show us this event as an example of the cruelties of the Communards, without any suggestion that in comparison, the atrocities perpetrated by the so-called legal government were far worse.

Once again, Appert's image presents a carefully constructed, orderly scene. Crowds of neatly dressed women line up with their male comrades to take aim at the hostages. Although more successful than the scene with the execution of

Chaudey, the precision and clarity of the picture at once arouses suspicion. As mentioned above, technical considerations prohibited the choice of scenes of action and movement. Appert's fakes were the only photographs on sale after the Commune which purported to show such events.

Appert certainly had a shrewd sense of what was topical in the weeks following the repression of late May. The activities of the Communards were sensational, but doubly so if they were carried out by women. Another composite photo by Appert supposedly shows the compound of the women's prison at Versailles. In fact it uses the photographs which Appert took in studio conditions for the Versailles authorities and re-assembles the individuals portrayed. The seated poses of many of the figures with folded arms would give this away, even if the original prints did not exist.[14] The pseudo-documentary quality of the image is underlined by the caption, which gives an exact place and date for the scene, and some of the main characters in the picture are identified by name below. For example, seated third from the left in the foreground is the cantinière Anna Rotchild. As she leans back, about to fall over backwards it seems, it is obvious that the chair back from the studio-portrait has been obliterated by Appert. Immediately to her left, two women are shown drinking, one straight from a bottle, and are no doubt intended to show the vulgar morals of the women of the Commune, and an antidote to the neatly dressed and attractively presented Mme Leroy, who is seated in the centre of the picture.

Unfortunately many of the Communards photographed after the suppression of their government were in more tragic circumstances still. Those prisoners who had escaped summary execution were marched off to Versailles only to face firing squads there. Those who could not be identified were photographed for police records. The original purpose of this image, then, was to furnish 'objective' recording of information. Ironically these mutilated corpses are the élite of the thousands shot by the Versailles government, most of whom were thrown half-dead into communal graves, quickly covered with quicklime, not even a statistic in the death toll, let alone recorded by an image and a number. The number of Communards shot during 'Bloody Week' cannot even be established to the nearest 10,000. Possibly there are among these corpses faces who were identified from earlier photographs and shot for that precise reason. Their very immobility tragically guarantees them perfect technical reproduction. They are orderly and carefully posed for the camera. In less perfect conditions, reliance on more traditional methods of visual representation was still necessary. For example the Communard illustrator and caricaturist Pilotell recorded the dead body of Raoul Rigault, a member of the Commune, as it lay in a gutter. The body lay exposed to the ridicule of passers-by, spat upon and defiled. In the circumstances, Pilotell had to make a quick recording of the scene without attracting too much attention to himself – photography would have been impossible. Hence the sketch. Yet Pilotell's attitude was very much that of the photojournalist. He inscribes the lower corner of the image: 'Seen by the author on the 24 May at 5 p.m. in the Rue Gay-Lussac'. The scene is thus securely documented. As mentioned above, photography had not

yet monopolized the aura of credibility at the expense of other media. In circumstances when photography could not be used, the spectator was still prepared to believe the truth of a drawing, or a wood-engraving, provided additional information was given by an accompanying newspaper report or an eye-witness.

Many other photographs of the corpses of Communards still exist. In view of their numbers it seems likely that they were on sale to the public, as well as furnishing information for police files. In this respect it is worth speculating as to the function they performed. They obviously made money for the photographer, for one thing. Perhaps also they were intended to serve as a warning, to set an example, much as the trials of Communard prisoners at Versailles were intended to do. However the real repression had been carried out in the form of executions in the working-class areas of Paris during 'Bloody Week'. The aftermath was only a tiny side show in terms of numbers of executions, but was crucial as a public demonstration of the triumph of the forces of reaction. Yet this is a dangerous manoeuvre. The images give the victims a tragic status and importance which goes against the intention of the authorities. In retrospect, these mangled corpses are a condemnation of the victors of 1871, not the victims.[15] Just as these images can have no unambiguous meaning for spectators who saw them in 1871, so their meaning changes for us according to our historical and ideological position today.

Just as 'objectivity' must be rejected when we discuss these images, so must the idea that photography democratized the production of visual imagery. As we have seen, probably the only time any of the working-class Parisians went anywhere near a camera was during the Commune, perhaps on barricades or at the destruction of the Vendôme column. Far more likely, their only encounter with the new 'democratic' medium was as dead bodies in police files. Gisèle Freund writes: 'The camera had definitely democratised the portrait. Before the camera artists, intellectuals, statesmen, white collar workers, employees of very modest means, were all equal. The desire for equality was satisfied at the same time as a desire for representation in all strata of the bourgeoisie . . . Henceforth on mantelpieces, coffee-tables, display cabinets, and walls, the bourgeois smiled benignly from his frame, and surrounding him were his favourite statesmen, men of letters, actresses etc . . . The photograph owed its popularity not only to the fact that it could furnish its public with a faithful image of individual appearances, but also because it had become the symbol of democracy.'[16] In some respects one is tempted to agree with this statement, but confronted with the images of the dead Communards one is forced to conclude that the 'democracy' of the photograph in 1871 was of a similar kind to the political 'democracy' of the bourgeoisie of the Versailles government. It worked within limits set by the class who owned it, and was intended to further bourgeois economic and ideological aims. The Commune itself had been foolish enough to play the game of bourgeois democracy, holding elections in Paris so that it might prove its 'legality', instead of organizing its military campaign and appropriating the capital deposited in the banks.

Appert's 'faked' photographs look so obviously propagandist to anyone who knows the background to the events they depict that it is difficult to imagine that they were accepted as faithful recordings of actual incidents. However it may be that the political stance of the people who bought such prints made them want to believe the reality of what they saw depicted, even if they did realize the images had been manipulated. Also, given the relationship of photography to other visual media available at the time, it may be that contemporaries in a materialistic and positivistic age were not inclined to question apparently transparent mechanisms of understanding visual images which were mechanically recorded. The status of the photograph at this time is an intermediate one. It can, at the same time, exploit *and* negate the myth of its perceptual innocence, its 'democratization' of what it records.

In situating ourselves in relation to a photographic image, we cannot avoid the recognition of our own ideological and political situation, *in spite of* the original purpose of the photograph. We have seen that, for example, the same images of Communards on the barricades in 1871 meant very different things to different groups in 1871. Similarly from a Marxist perspective we see the images produced during the Commune in a different way from the participants. Perhaps the most historically poignant image produced during the Commune is significant in what must surely be an unconscious way. A photograph was taken by Langerock of 29 Bld. des Italiens, and shows a Communard barricade on the Rue des Batignolles. In the deserted street are cannons and shells, neatly stacked, ready and waiting in front of some shop-fronts owned by someone by the name of Marx. The shops are inscribed 'Au Nouveau Né', literally 'At the sign of the new-born baby', and presumably sell baby clothes and nursery articles. The scenario aptly suggests the birth pangs of the new-born proletarian government during the Commune, with the cannon silently overlooked by the name of Marx in giant letters. Very few of the Communards were Marxists, although Marx was quick to support the Commune in his address to the First International, published soon after the fall of the workers' government. There were far more followers of Proudhon and Blanqui among the Communards than disciples of Marx and Engels. Nevertheless, the photographer has unconsciously captured what proved to be the true historical significance of the Commune in his image of this particular barricade. The Commune's significance has been fully understood only by the Marxist tradition, and its status as the first working-class government is due to the lessons it bequeathed to the Russian revolutionaries of 1917.

A reproduction of this print appears in a profusely illustrated book on the Franco-Prussian War and the Commune, published in 1901 by Armand Dayot, inspector of the Ministry of Fine Arts. The title page of his comprehensive work is headed by a quotation which proclaims: 'One day, the visual image will revolutionize the study of history'. Indeed this is true, if we can apply a politically conscious view of visual imagery to our contemporary situation, as well as to the past.

Since this essay was written some useful material on photography in later nineteenth-century France has been published, and the reader might find the following references useful.

A. Rouillé, 'Les images photographiques du Monde du Travail sous le Second Empire', *Les Actes de la Recherche en Sciences Sociales*, September 1984, no. 54, pp. 31–43; A. Rouillé and B. Marbot, *Le Corps et son Image. Photographies du Dix-Neuvième Siècle*, Paris, 1986; A. Rouillé ed., *La Photographie en France, Textes et Controverses: Une Anthologie, 1816–1871*, Paris 1989; C. Phéline, *L'Image accusatrice*, Paris, 1985, and, D. E. English, *Political Uses of Photography in the Third French Republic, 1870–1914*, Ann Arbor, Michigan, 1984.

For the study of issues surrounding the photographic representation of women Communards and the role of women as models and photographic workers in later nineteenth-century France, see my book *Studies in Women, Class and Representation*, Berg Publishers, 1995.

GEN DOY 1994

Maria Morris Hambourg

Extending the Grand Tour

(First published in *The Waking Dream: Photography's First Century: The Gilman Paper Company Collection*, Ed. Maria Morris Hambourg, Metropolitan Museum of Modern Art, New York 1993, pp. 84–90)

Few historians of nineteenth-century photography venture far beyond the fastidiously informational. Maria Morris Hambourg's essay (one of a series which accompanied the Metropolitan Museum of Art's exhibition *The Waking Dream* in 1993) is an inspiring example of how historiography, concisely written and sharply focussed, can illuminate photography's past.

SINCE the seventeenth century the British had traveled the Continent, gradually institutionalizing the Grand Tour; the objective was for the gentleman to get to sunny Italy and to stay as long as possible soaking up classical culture before returning home via Switzerland and, usually, France. During the early years of the nineteenth century the Napoleonic wars prevented such travel and the 'tourist,' a word born of that moment, was

obliged to travel farther afield – to Greece and Spain and other points around the Mediterranean Sea. The lure of the south and of Italy, so long the focus of northern Europeans, was not supplanted but extended, at first to the Mediterranean Basin, the homeland of the West. Then, when the ghostly frontiers of the Roman Empire had been retraced and the shores of the Mediterranean were resettled in the European imagination, the beckoning horizon was farther east, in the distant Orient.

As soon as photography was invented travelers equipped themselves with cameras to take on itineraries established by historical tradition and by the parameters of their country's influence. Perhaps the most prolific early touring photographer was George Bridges, who took instruction from Henry Talbot before embarking on a six-year voyage (1846–52) during which he made some seventeen hundred negatives. 'The grand object of all travelling is to see the Shores of the Mediterranean,' Bridges wrote. 'On these Shores were the four great Empires of the World, the Assyrian, the Persian, the Grecian, and the Roman. All our Religion, almost all our Law, almost all our Arts, almost all that sets us above savages, has come to us from the Shores of the Mediterranean.'[1] He neglected to mention that his travel plans were arranged to coincide with the voyages of his son, a British sailor on a tour of duty in the Mediterranean. Thus, Bridges left England under the wing of her Navy to reclaim with his camera the ancient cradle of her culture. This context flavored his views; in a photograph made on the Acropolis in 1848, Bridges shows us the recently restored temple of Athena Nike with a British sailor, probably his son William, lounging proprietarily on the steps.

If a certain imperiousness is often expressed in their pictures, the early traveling photographers were not animated by imperialistic designs but by conquest of another sort. Like Byron, Goethe, Chateaubriand, Lamartine, and Nerval, they sought to appropriate the foreign and exotic as antidotes to their highly civilized lives. Byron's 'land of lost gods,' Lamartine's 'homeland of [the] imagination,' and Nerval's 'country of dreams and illusion' were all the same place – a visionary recess away from familiar Europe, from strictures on behavior, cold climates, and busy enterprise. This remote locus floated in 'a great peacefulness of light,' Ruskin wrote, its many countries 'laid like pieces of a golden pavement into the sea-blue.'[2]

Part of the fantasy was release into a more sensual realm, in the lap of which lolled the Mediterranean woman, imagined to be inherently sensual and caressed by the sun. The delicious languour of this wondrous creature is embodied in Giacomo Caneva's photograph of a recumbent model. Another pleasure was to fold up the map of the present and to wander into a mazy past crowded with overlapping myths and memories, the vestiges of lost cultures. The deep satisfaction of the storied accumulation of superjacent epochs is surely the subject of Robert Macpherson's view of the Theater of Marcellus, just as his photograph of the Cloaca Maxima concerns not Roman plumbing but the persistence of the grotto as a garden retreat for overcivilized souls.

Suggestive, highly colored romantic dreams are not depicted in most of the photographs made around the Mediterranean in the 1850s, for such notions

were primarily the stimulus to travel, usually disappointed by the reality of the visit. Rather, the photographers' typical terrain was a vast expanse of time and space – a silent, immutable continuum stretching out under the sun, down beneath the sand, and back to the very origins of human civilization. Napoleon invoked the invisible perspective for French troops standing on the verge of the Egyptian desert in 1798 when he said: 'Forty centuries look down on you from the top of the Pyramids.'[3]

Interface between Africa and Europe and between Europe and Asia, and home of one of the most ancient Mediterranean cultures, Egypt had been annexed by all the major empires. Although Napoleon dreamed of repeating Alexander's feat, he failed to conquer Egypt; his incursion, however, brought the country directly within the sphere of European knowledge, initially through the team of savants he took on his campaign. The detailed results of their studies were published in twenty-three huge volumes lavishly illustrated with engravings, the *Description de l'Égypte* (1809–28). And the Société Asiatique, founded in 1822, made the investigation of Egyptian hieroglyphics, art, and archaeology a major preoccupation of French learning for the rest of the century.

The conquest of Egypt and the Near East through knowledge was the formative rationale for many photographs. The engineer Félix Teynard set out to update the *Description* with photographs, while Auguste Salzmann intended his pictures to settle a dispute concerning the Greek or Judaic origin of specific artifacts in Jerusalem. Louis de Clercq began his photographic tour of the Mediterranean to help illustrate an archaeologist friend's study of the Crusader castles, and Maxime Du Camp's expedition to Egypt and the Near East in 1849–51 enjoyed direct government patronage.

The journalist Du Camp first traveled to Egypt in 1844, realizing an adolescent dream born of a conversation with one of Napoleon's translators. Upon his return Du Camp persuaded his friend Gustave Flaubert to accompany him on a second visit and wrangled an assignment from the Ministry of Agriculture and Commerce for the young writer. This Flaubert merely regarded as a diplomatic passport without any bearing whatsoever on his essentially ruminative activities. Du Camp, having studied photography with Gustave Le Gray, secured a commission from the Ministry of Public Education to gather on his travels, 'with the aid of this marvellous means of reproduction, views of monuments and copies of inscriptions.'[4] The brief went on to specify that the government was interested neither in scattered sketches typical of those made by tourists nor in seductive photographic effects, but rather in faithful documents useful for study.

The difference between Flaubert's and Du Camp's response to Egypt is instructive, for it reveals the distinction between inspiration and factual accountability. In Egypt Flaubert dressed in a long loose shirt, and with his head shaved and wrapped in a tarboosh, he soaked up impressions of 'the old Orient, land of religions and flowing robes. . . . I live like a plant, suffusing myself with sun and light, with colors and fresh air.'[5] Du Camp, for his part, worked at accomplishing his commission. His photographs essentially conform to the

official line, forgoing the picturesque and impressionistic for the frontal, literal, and readily comprehensible. The most famous of his images is of the head of one of the rock-hewn effigies of Ramesses II beside the Nile at Abu Simbel. Swallowed to the chin by a mountain of sand, the colossus survives time; what is more, this still-potent past gazing on the present is as little affected by the human in its headdress as the eons would be by a blink in time. And yet Du Camp and his Corsican assistant, Sassetti, together representing contemporary Europe, are in the victor's seat, jauntily dominating king and kingdom for the camera and for its extended public. In 1852 one hundred twenty-five of Du Camp's photographs were published in the first commercially distributed volumes in France illustrated with original photographs.

Félix Teynard and John Beasley Greene, each working on his own, produced photographs that further advanced Orientalist studies, but however conscientious they may have been to make faithful documents, they frequently framed views that seem decidedly eccentric. Greene was a serious Egyptologist. At Medinet Habou he made papier-mâché impressions of inscriptions he had unearthed, which he also photographed, waiting patiently for the feeble light in the temple's recessed arcades to sufficiently expose his negatives. As the product of a student of archaeology, how, then, do we explain a photograph such as *Dakkeh*, in which a deep, jagged shadow wholly obscures the bottom half of the temple wall and threatens to engulf the figure of the pharaoh? As Greene did not crop or minimize the shadow, he presumably chose to make the picture as it is. What he shows us is the transit of the sun on the face of an ancient narrative, the shadow of a daily drama tracing time itself in an image that is less an archaeologist's notation than a poetic evocation of the demise of a civilization.

While the photographers' primary intentions were to unveil early civilizations, their photographs met expectations only halfway. Many of them actually unsettled the accepted accounts. What had been classified and measured and noted, what had been drawn in scrupulously detailed archaeological reconstructions – what was, in sum, agreed to be *known* about the sites – was now replaced with evidence that was contingent, fragmentary, and unquantifiable. Although these photographs constituted a growing museum without walls, the supposedly faithful 'documents' that composed it were rife with subjective impressions and inflections of European culture – so much so that it would be fair to say that the archaeology and geography of the photographers' imaginations had the upper hand on objective science.

The attitudes infused in the pictures have generally eluded detection because the best of these photographs are composed with an exquisite lapidary authority and because the age and monumentality of their subjects are easily confused with an unimpeachably august truth. But when the photographers left the Mediterranean for regions farther east, their Eurocentrism could no longer be disguised by the near-familiar, nor so comfortably reside in the architectonic and the ancient. And as they moved out of generalized spheres of cultural influence and into main currents of Western political ambition that were more

blatantly ethnocentric and dominative, the attitudes embedded in their photographs became more obvious.

Roger Fenton's photographic campaign during the Crimean War is an interesting case in point. One photograph shows Balaklava harbor, a beachhead where supplies were unloaded from British ships, and the partially completed railroad that would supply the army several miles inland. Another photograph shows a sweep of trackless, arid land surveyed by military officers – a terrain hardly desirable in itself but fiercely contested in the struggle of the French and English to defeat the Russians in their effort to gain control of the Black Sea and to extend their influence in the Middle East. Like the other photographs in Fenton's series, these tell very little about the Crimea, but they are eloquent of the dirty process and the inspiring vision of extending Western hegemony in the East.

Enraptured with the notion of material progress and capitalist enterprise, Western powers invested commerce with a divine right which justified their forceful incursions into other countries. The initial, partial conquest of India by the British was made by the East India Company, a mercantile venture. Many of the impressive photographs made in India in the 1850s were taken by men who worked for the company army. Notable among them were Dr. John Murray and Captain Linneaus Tripe, whose large views of Indian art and architecture were made to enlighten the West about the culture they were colonizing. When people appear in these photographs they do so in anonymity, for while India's magnificent past enriched the empire, its contemporary society was judged wanting by Western standards of material success and industrial mastery.

In 1857, when British-trained Indian soldiers rose up in the first large Asian revolt against the West, the British, who fully believed in their civilizing mission, regarded the uprising as a mutiny. A sympathetic portrait of Lord Canning, the governor general who put down the rebellion and became the first viceroy of India in 1858, shows him fully invested in his role as an entitled 'Lord of Humanity.' By contrast, the shocking pictures of the slaughtered Chinese defenders of Beijing in the second of Britain's Opium Wars to secure Chinese trade were the first photographs to open Western eyes to the horrific other side of imperialism.

The painstaking and costly practice of large-scale artistic photography by amateurs such as Murray and professionals such as Tripe reached its zenith in the late 1850s. The demise of this first flowering of travel photography coincided not only with shifts in imperialist economics and politics,[6] but also with the rise of commercial photographic firms, which, in turn, were threatened by tourists armed with cameras of their own. By 1870, Samuel Bourne, the best commercial photographer in India, saw that the artist's notion of quality – of the superbly crafted singular view – was being rapidly replaced by the public's pursuit of quantity. But, protested Bourne, '*One* good large picture that can be framed and hung up in a room is worth a hundred little bits pasted in a scrap book.'[7]

Instead of publishing impressive tomes of large views, as Du Camp,

Teynard, Greene, and de Clercq had done, the commercial photographer made pictures that were smaller in scale and easier to handle, and left the choice and order of the images up to the tourist. In the last quarter of the nineteenth century these firms rarely explored new lands, but rather made it their business to package the idea of 'otherness.' Though rarely imbued with great artistic merit, the photographs of picturesque sites pasted in travelers' albums by the thousands nevertheless made the very notion of 'otherness' familiar, ultimately bringing exotic landscapes and faces into a common patrimony.

By the end of the century the boundaries of the West had merged with those of other continents and what had been truly foreign was absorbed. One of the most salient registers of this continuing condition is the vast photographic encyclopedia of travel that subjects every monument, landscape, and people to its curious gaze and offers the armchair traveler a vicarious tour of the memory theater of the world.

Rosalind Krauss

Tracing Nadar

(First published in *October*, No. 5, 1978)

The portraitist Nadar (Gaspard-Félix Tournachon, 1820–1910) was well-placed by longevity and a chequered, somewhat picaresque career to survey his century's shifts and advances towards modernity. Rosalind Krauss's piece reminds us that photography was born out of a very different field of knowledge and perception from that of the twentieth century. The alchemical nature of the photographic process, its quasi-magical tracing of the visual world place it at a junction of the scientific and the supra-rational which can be lost sight of in the midst of later cultural and technological assumptions.

THOUGH IT was written toward the end of his life, Nadar's memoir, *My Life as a Photographer*, was undertaken at a point when its author's activity in the medium had far from ceased. That is why the title's insistence on pastness (in French it is *Quand j'étais photographe*), its declaration of a chapter's having closed, seems somewhat curious. But Nadar's past tense has less to do with his personal fortunes and the trajectory of his own career through time, than with his status as witness. The man born Gaspard-Félix Tournachon, who called himself Nadar, was aware that he had been present at

an extraordinary event, and, like the survivor of some natural cataclysm, he felt duty-bound to report on what it had been like, or even more than that, to conjure for his listener the full intensity – emotional, physical, psychological – of that experience. Nadar writes his memoir with the urgency of the eyewitness and the conscience of a historian. Every passage of the text reverberates with this sense of responsibility.

Which is why the book is so peculiar. For it is structured like a set of old wives' tales, as though a community had entrusted its archives to the local gossip. Of its thirteen chapters, only one, 'The Primitives of Photography,' really settles down to producing anything like a historical account. And although this is the longest chapter in the book, it comes nearly at the end, after an almost maddening array of peculiarly personal reminiscences, some of which bear a relationship to the presumed subject that is tangential at best.

Perhaps it is this quality of rambling anecdote, of arbitrary elaboration of what seem like irrelevant details, of a constant wandering away from what would seem to be the point that accounts for the book's relative obscurity. Published in 1900, it was never reprinted, and at this date its surviving copies are both very battered and very scarce.

The memoir on photography was hardly Nadar's only publication. The author of eleven other books, he was a frequent writer of short stories and a prolific essayist. His relation to the world of letters extended beyond the friendships he maintained with the most important writers of his day; it included an intimate connection to the craft of writing, to the patient and careful construction of meaning. If Nadar undertakes the writing of history in the guise of a novelist, that is because the set of facts he hopes to preserve against time are primarily psychological. 'People were stunned,' he begins, 'when they heard that two inventors had perfected a process that could capture an image on a silver plate. It is impossible for us to imagine today the universal confusion that greeted this invention, so accustomed have we become to the fact of photography and so inured are we by now to its vulgarization.

The immensity of the discovery is what Nadar wishes to communicate, not who did what and when. After listing the incredible stream of inventions that changed the course of nineteenth-century life – the steam engine, the electric light, the telephone, the phonograph, the radio, bacteriology, anesthesiology, psychophysiology – Nadar insists on giving pride of place, in terms of its *peculiarity*, to the photograph. 'But do not all these miracles pale,' he demands, 'when compared to the most astonishing and disturbing one of all, that one which seems finally to endow man himself with the divine power of creation: the power to give physical form to the insubstantial image that vanishes as soon as it is perceived, leaving no shadow in the mirror, no ripple on the surface of the water?'

What Nadar saw, from the vantage of 1900, was the conversion of this mystery to commonplace. And so a chapter was, literally, over, even though his own activity remained unchanged. If this was Nadar's historical message at the turn of the century, it repays our attention, especially now. For at this point, in our turn, we are realizing the immense impact of photography, the way it has

shaped our sensibilities without our quite knowing it, the way, for example, the whole of the visual arts is now engaged in strategies that are deeply structured by the photographic.[1] The symptoms of a cultural awakening to this fact are everywhere: in the recent flurry of exhibitions; in the surge of collecting; in the rise of scholarly activity; and in a growing sense of critical frustration about just what photography *is*. It is like the man who, finally accepting his doctor's diagnosis, turns around and demands to know the precise nature of his illness. Cultural patients, we insist on something like an ontology of photography so that we can deal with it. But Nadar's point is that among other things photography is a historical phenomenon, and therefore what it *is* is inseparable from what it *was* at specific points in time, from a succession of responses which were not uniform. In his memoir Nadar treats himself like an analytic patient, fixing on details and elaborating them, in order to recover a past that will be resonant with its own meaning.

The opening three chapters of the memoir exemplify this method. The first is occasioned by an object in Nadar's possession: the only known Daguerreotype of Balzac, which he had purchased from the caricaturist Gavarni. The second, triggered by the reality of long-distance transmission systems like telegraphy and radio, is the tale of a confidence trick played on him in the 1870s. The third is a seeming piece of trivia called forth by the certain success of aeronautical technology, which Nadar had always championed over aero-statistics, or ballooning. Entirely different in scope, and increasingly peripheral to the history of photography proper, the disparateness of these accounts, their appearance of moving into a subject only by backing away from it, make of these chapters a very odd sort of beginning. Yet there is a connection between them, an underlying theme that Nadar wishes to dramatize.

The story about Balzac revolves around the novelist's superstitious reaction to photography, a reaction that was issued somewhat pretentiously in the form of a theory. Describing Balzac's Theory of Specters, Nadar writes:

> According to Balzac's theory, all physical bodies are made up entirely of layers of ghostlike images, an infinite number of leaflike skins laid one on top of the other. Since Balzac believed man was incapable of making something material from an apparition, from something impalpable – that is, creating something from nothing – he concluded that every time someone had his photograph taken, one of the spectral layers was removed from the body and transferred to the photograph. Repeated exposures entailed the unavoidable loss of subsequent ghostly layers, that is, the very essence of life.[2]

Throughout the rest of this account Nadar's tone is affectionately mocking. Théophile Gautier and Gérard de Nerval had rushed to Balzac's side to become 'converts' to his Theory, and Nadar focuses more sharply on the affectations of their discipleship than on any suspicions of Balzac's own insincerity. The man of science, Nadar is magnanimous as he indulges the self-consciously assumed primitivist fantasies of his literary friends.

But the second chapter of the memoir is a replay of this fantasy, with its

terms somewhat changed. 'Gazebon Avenged' begins with a letter sent to Nadar in the 1850s from a provincial named M. Gazebon requesting a photographic portrait of himself. Nothing is unusual about this except that, on the assurances of a 'friend' of Nadar's, Gazebon expects the photograph to be taken in Paris while he himself remains in Pau. Deciding that he will not dignify this joke with an answer, Nadar forgets the whole business until twenty years later when a young man presents himself in Nadar's studio claiming to have perfected the means for executing Gazebon's demand: long-range photography (*photographie à distance*). While Nadar's companion, convinced by the technological jargon with which the young man supports his claim, gets more and more excited by the prospect of carrying out the experiment, Nadar himself waits for 'the touch' to come. When it does, Nadar pays out the money, knowing that he has been defrauded and that he will never see the young 'inventor' again. No explicit connection is made between this story and the Theory of Specters, but the psychological point of the story – Nadar's own, deep certainty that 'remote-photography' is an impossibility – is a variation on the Theory, from the point of view of Science. Photography can only operate with the directness of a physical graft; photography turns on the activity of direct impression as surely as the footprint that is left on sand.

It is this knowledge of the physical immediacy of photography that is given an emotional resonance in the story of 'The Blind Princess,' to which Nadar then turns. In the 1870s a blind woman is brought by her grown children to the studio to sit for her portrait. Because she is a member of the royal family of Hanover, Nadar takes the occasion to inquire after the young nobleman who had looked after him when Nadar was confined in Hanover two years previously, due to a rather grotesque ballooning accident. Nadar's interest in the other man had developed from their shared contempt for balloons and their joint conviction in the possibility of flight in craft that was heavier than air. Having heard that the nobleman had been exiled from Hanover because he had killed someone in a duel, Nadar asks one of the Princess's children if this is true. The drama of this question, which fortunately the Princess doesn't hear, turns on the fact that the victim of the duel was the sitter's eldest son, and though his death has been successfully hidden from the mother, Nadar's question could have revealed it to her. Remembering his own distress, Nadar closes the story with a series of reflections on the psychological consequences, and thus the potential power, of the circumstances of making a photograph: to the point where a life could be affected by the chance remark transmitted through 'a visit to a photographer's studio, in a strange city. . . .'

The focus of this ending is clearly on the kinds of changes that industrialization brings to every corner of society – collapsing distances, imploding separations of class – so that a French balloonist could be blown into the care of a German royal household, and a princess would engage in the new, social transaction of the photographic portrait-sitting. In thus dramatizing the intimacy of the photographic situation, Nadar fixes again on the physical proximity that is its absolute requirement, on the fact that no matter how any other system

of information transfer might work, photography depends on an act of passage between two bodies in the same space.

In these three chapters, then, Nadar circles around what seems for him to be the central fact of photography: that its operation is that of the imprint, the register, the trace. As semiologists we would say that Nadar is giving an account of the photographic sign as an index, a signifying mark that bears a connection to the thing it represents by having been caused, physically, by its referent. And we would go on to describe the limited field of significance available to that type of sign.[3] But Nadar was not a semiologist, and sure as he was of the indexical nature of the photograph, of its condition as a trace, the inferences he seems to have drawn from this were peculiar to his century rather than our own.

For the early nineteenth century, the trace was not simply an effigy, a fetish, a layer that had been magically peeled off a material object and deposited elsewhere. It was that material object become *intelligible*. The activity of the trace was understood as the manifest presence of meaning. Standing rather peculiarly at the crossroads between science and spiritualism, the trace seemed to share equally in the positivist's absolutism of matter and the metaphysician's order of pure intelligibility, itself resistant to a materialist analysis. And no one seemed more conscious of this than Balzac, author of the Theory of Specters.

When Barbey d'Aurevilly sneered that Balzac had made description 'a skin disease of the realists,' he was complaining about the very technique in which Balzac took the greatest pride and which allowed him to boast that he had foreshadowed the Daguerreotype. If written description was intended to skim the surface off a subject and transfer it to the novel's page, this was because of Balzac's belief that this surface was itself articulate, the utterly faithful representation of inner man. 'The external life,' Balzac wrote, 'is a kind of organized system which represents a man as exactly as the colors by which the snail reproduces itself on its shell.'[4] The endless reworking of this metaphor produces the kind of character in the *Comédie Humaine* about which one could write that 'his clothes suit his habits and vices so well, express his life so faithfully, that he seems to have been born dressed.'[5] Therefore, as eccentric and fanciful as the Theory of Specters might at first strike us, the notion of man as a series of exfoliating, self-depicting images, is only a more whimsical version of the model of the snail. And this model, with its intentional connections to biological study, was meant to carry the authority of Science.

As Balzac never tired of explaining, the physical description through which he was confident that he could trap the vagaries of character had been tested in the laboratories of physiognomy.[6] Whatever the relative obscurity of Johann Caspar Lavater now, *The Art of Knowing Man by Means of Physiognomy* (1783) had enormous prestige in the nineteenth century.[7] As the title implies, physiognomy involved the decoding of a man's moral and psychological being from those physiological features which were thought to register them. In this reading, for example, thin lips are the index of avarice. Balzac made it no secret that his own characters were built as much from raids on the ten volumes of Lavater's work as on recourse to his own observation.

Lavater himself had paved the way for Balzac's extension of physiognomy

to a system of indexical signs, or physical traces, that encompassed far more than the shape of a man's skull or the character revealing conformation of his mouth. The *Analytic Essays* from 1830, like 'The Study of Habits by Means of Gloves,' or 'The Physiology of the Cigar,' are elaborate Balzacian glosses on the kind of thing Lavater had in mind when he wrote:

> It is true that man is acted upon by everything around him; but conversely, he too acts upon his environment, and while modified by his surroundings, he in turn modifies them. It is on this basis that one can gauge the character of a man by his dress, his house, his furniture. Set within this vast universe, man contrives a smaller, separate world which he fortifies, entrenches, and arranges in his own fashion and in which we discover his images.[8]

In this view, character is like a generator of images, which are projected onto the world as the multiple cast shadows of the bearer. That Lavater's attention should have included the extremely minor art of silhouette making is not surprising insofar as these profile portraits were the literalization of the cast shadow. The very name of the 'physionotrace,' a type of silhouette produced in 1809 by quasi-mechanical means and included in most histories of photography as a forerunner of the aspirations (if not the actual process) that made the photograph inevitable, bears the mark of Lavater.

But the check that Lavater wrote for the systematic study of physiognomic traces could be cashed in other banks besides that of positivism. Balzac points to this when he speaks of the two sides of his interest, the one indebted to Lavater, the other focused on Swedenborg. And indeed, in *Mimesis*, when Erich Auerbach analyzes Balzac's technique he selects a passage in which both aspects present themselves. For behind the details of dress and bearing through which Balzac renders the *petit-bourgeois* avarice and cunning of Père Goriot's landlady, there gather a set of images drawn from an entirely different register of study, images that create 'the impression of something repulsively spectral.' These images, Auerbach writes, form 'a sort of second significance which, though different from that which reason can comprehend, is far more essential – a significance which can best be defined by the adjective demonic.' And he adds, 'What confronts us, then, is the unity of a particular milieu, felt as a total concept of a demonic-organic nature and presented entirely by suggestive and sensory means.'[9]

For the Theory of Specters to have issued from Balzac's pen, there needs only one ingredient to be added to the Lavater system of physiognomic traces, one element that will transform the physical manifestations of character into the idea of a man as a set of spectral images, or ghosts. That ingredient is light. Light was the means by which the seemingly magic transfer of the photograph was effected, the way in which one could, in Nadar's words, 'create *something* from *nothing*.' And light, the keystone in the Swedenborgian system, was the conduit between the world of sense impression and the world of spirit. It was in terms of a luminous image that the departed chose to put in their spectral appearances at the nineteenth-century séance. And after 1839 it required only a baby step in

logic to conceive of recording these apparitions photographically. 'Spirit photography' is described by Huysmans in *Là-Bas*, and in 1882 Georgiana Houghton quite seriously published a work entitled *Chronicles of the Photographs of Spiritual Beings and Phenomena Invisible to the Material Eye*. Surely one of the most grotesque, but revealing suggestions about the possible applications of photography was the notion, broached in the 1890s, of the 'post-mortem photograph.' Breathtaking in its loony rationality, it involved the reprinting of a photograph taken during life by using the crematorial ashes of the departed sitter. 'They will adhere to the parts unexposed to light and a portrait is obtained composed entirely of the person it represents.[10]

Now the spirit-photograph may have been a somewhat freakish idea and rather limited in its currency. But with the industrialization of portrait photography that took place in the 1860s came the wholesale production of deathbed photographs. The deathbed portrait is a phenomenon that most histories of photography acknowledge but pass by rather quickly. A combination of curiosity and embarrassment, very few of these objects survive relative to the enormous number that were made. Yet for the commercial photographer of the nineteenth century, the deathbed commission was one of the major staples of his practice.[11] It is our present-day inability to view this phenomenon as anything but ghoulish that indicates our own removal from a crucial part of photography's history: precisely that part Nadar hoped to evoke through his memoir.

The mysteriousness that surrounded the initial appearance of photography and permitted some of the more bizarre of its later practices is easy enough to patronize. But this sense of mystery is an aspect of the most serious aspirations of the early makers of photographs, Nadar included, and it is this seriousness which is harder to understand. Just as it is hard to understand as anything more than a piety of literary history the incredible, contemporaneous eminence of Swedenborg. It therefore might be helpful to draw a parallel between the initiation of Nadar's account of photography with a story of Balzac at his most Swedenborgian, and the inauguration of Immanuel Kant's career with a work called *Dreams of a Spirit Seer* – an unexpected text on Swedenborg.

In drawing this parallel I wish to point to more than just the prestige of Swedenborg – to the kind of fame and respect that was granted him in the late eighteenth century, and which made him a strangely persistent object of attention for the young Kant. As *Dreams of a Spirit Seer* makes clear, Kant's decision to take on Swedenborg as an adversary, to bother to attack the great visionary who was busy taking down dictation from the World of Spirits, arises from the way in which Swedenborg's solutions come as perfectly logical responses to the problems of eighteenth-century metaphysics. In Kant's eyes the system of Swedenborg's *Celestial Arcanum* is no more benighted than any other metaphysical system. Why not write about him, Kant asks, 'After all the philosophy which has helped us to introduce the subject is itself no more than a fairytale from the Wonderland of Metaphysics.'[12] And he concludes by saying, 'Questions which concern the nature of spirits, freedom, predestination and our future state, etc., at first arouse all our energies and reason, and lure us by the excellence of their

subject-matter into the arena of competitive speculations where we argue indiscriminately, decide, teach, reason, just as pseudo-knowledge dictates.'[13]

But the point about Swedenborg cuts much closer to the bone. No matter how preposterous the outcome of his endeavors, the question that animates them in the first place was utterly serious for the founder of analytic philosophy: how to find data by which to prove the existence of an intelligible (as distinct from a merely material or sensible) world.[14]

Swedenborg's labors as scientist-turned-mystic compose an incredible cadenza on the theme of intelligibility. They turn, as I have said, on the issue of light. Beginning from Newton's view of light as corpuscular – made of infinitely small particles – and adding this to the Cartesian notion that matter consists of particles that are indefinitely divisible, it was possible to think of light as a spectrum that begins in the world of the senses and shades off into the world of spirits. Insofar as the universe is permeated by light, some part of which is divine, it can be seen as a system of symbols, as a great hieroglyphics from which to read off the meaning of divinity. This legibility of the world is Swedenborg's message; the *Celestial Arcanum* is a massive demonstration of how propositions from the natural sphere are transformed into their correspondence in the spiritual one.

Thus the visible world is, once again, a world of traces, with the invisible charged with imprinting itself on the visible. 'It is a constant law of the organic body,' Swedenborg insisted, 'that large compounds or visible forms exist and subsist from smaller, simpler and ultimately invisible forms, which act similarly to the larger ones, but more perfectly and universally; and the least forms so perfectly and universally as to involve an idea representative of their entire universe.' Glossing this passage in 1850, Emerson explains, 'What was too small for the eye to detect, was read by the aggregates; what was too large, by the units.'[15] It is the visibility of the noumenal world which thus concerns Swedenborg, and the demonstration of the way this is possible by light's acting on phenomena to produce an image.[16]

Photography was born in the 1830s by, in Nadar's words, 'exploding suddenly into existence, surpass[ing] all possible expectations.' And into the initial responses to this event are folded the themes of Spiritualism. For photography was the first available demonstration that light could indeed 'exert an *action* . . . sufficient to cause changes in material bodies.'[17]

Those are the words of Fox Talbot, published in 1844 in *The Pencil of Nature*, a book laid out as an object lesson in the wonders and possibilities of photography. On the face of it there is no reason why Fox Talbot's statement about light should be read as anything more than the comment of a gentleman-scientist. Yet it is the curious nature of certain of the plates, which form the bulk of *The Pencil of Nature*, that induces one to hear in his statement the overtones of metaphysics.

Most of the plates are just what one would have expected of such a volume: views of buildings, landscapes, reproductions of works of art. But some of the images are rather peculiar. One of these, Plate VIII, is entitled 'Scene in a Library,' and what it presents, head-on and in close-up are two shelves of

books. Minimal in the extreme, there is nothing picturesque or in any other way esthetically arresting in this image. One turns, therefore, to the accompanying two-page text for an explanation of what it might mean:

> Among the many novel ideas which the discovery of Photography has suggested, is the following rather curious experiment or speculation. I have never tried it, indeed, nor am I aware that anyone else has either tried or proposed it, yet I think it is one which, if properly managed, must inevitably succeed. When a ray of solar light is refracted by a prism and thrown upon a screen, it forms there the very beautiful colored band known by the name of the solar spectrum. Experimenters have found that if this spectrum is thrown upon a sheet of sensitive paper, the violet end of it produces the principal effect: and, what is truly remarkable, a similar effect is produced by certain *invisible rays* which lie beyond the violet, and beyond the limits of the spectrum, and whose existence is only revealed to us by this action which they exert.
>
> Now I would propose to separate these invisible rays from the rest, by suffering them to pass into an adjoining apartment through an aperture in a wall or screen of partition. This apartment would thus become filled (we must not call it illuminated) with invisible rays, which might be scattered in all directions by a convex lens placed behind the aperture. If there were a number of persons in the room, no one would see the other: and yet nevertheless if a camera were so placed as to point in the direction in which any one were standing, it would take his portrait, and reveal his actions.
>
> For, to use a metaphor we have already employed, the eye of the camera would see plainly where the human eye would find nothing but darkness.
>
> Alas! that this speculation is somewhat too refined to be introduced with effect into a modern novel or romance; for what a dénouement we should have, if we could suppose the secrets of the darkened chamber to be revealed by the testimony of the imprinted paper.[18]

Throughout *The Pencil of Nature* the photographic plates serve to illustrate the arguments in the text in the manner of object lessons, demonstrations. The photograph of a haystack, for example, supplies the visual proof of Talbot's contention that the mechanical image can suspend an infinitude of detail in a single visual plenum, where natural vision tends to summarize or simplify in terms of mass. Since the above discussion of 'invisible rays' ends with a reference to novels, one wonders if the accompanying photograph of books is intended to represent these novels. Yet Talbot speaks of books that have not yet been written. So the status of the photograph as illustration becomes a bit more complicated.

Insofar as the photograph of books is the embodiment of a speculative projection, its role is on some level conceptual. But this is a role forced on the photographic object which is thoroughly integrated into the subject of this particular image. For as the container of written language, the book is the place of residence of wholly cultural, as opposed to natural, signs. To operate with

language is to have the power to conceptualize – to evoke, to abstract, to postulate – and obviously to outdistance the objects available to vision. Writing is the transcription of thought, not the mere trace of a material object.

And the kind of photographic trace Talbot postulates, in the way that he describes it, is also to be a transcription of thought, or at the very least, of psychological transactions ordinarily hidden from view. The photographs taken with 'invisible rays' will be able to reveal the activities that occur within a 'darkened chamber.' In the application Talbot projects for them, they will manifest not merely behavior itself, but its meaning. In this scenario of a trace produced by invisible rays, the darkened chamber seems to serve as a reference both to the camera obscura, as an historical parent of photography, and to a wholly different region of obscurity: the mind. It would indeed be a special kind of light that could penetrate this region 'through an aperture,' and by means of its emanations, capture what goes on there through a series of traces.

This kind of speculation in *The Pencil of Nature* is what I mean by the serious aspirations of some of the earliest photographers. The condition it assumes is the inherent intelligibility of the photographic trace – a condition that in turn depends on those terms of nineteenth-century thinking that I have been rehearsing: the physiognomic trace and its revelatory power; the power of light to transmit the invisible and imprint it on phenomena. For these things to be linked at all requires the marriage of science and spiritualism. We know this was a ceremony performed in many quarters in the period under discussion, and we know this union had many offspring. I am arguing that the initial conception of the photograph, as such, was one.

But where does that leave Nadar? He was after all not of Talbot's, or Balzac's generation. The 'primitives of photography' were his fathers and teachers, not his siblings. To judge from both his memoir and his photographic practice, the 'metaphysical' expectation left Nadar in a condition of a certain ambivalence. Deeply aware of the photograph's status as a trace, he was also convinced of its psychological import. That he was removed from a spiritualist reading of this import is obvious, not only from his treatment of Balzac's Theory but also from his singular refusal to participate in the deathbed portrait industry. Yet if he rejects the premise of this expectation, there are certain ways in which Nadar is interested in both acknowledging and using it as a theme: one of the very few deathbed commissions Nadar consented to was to photograph the deceased Victor Hugo, himself a frequenter of séances; and, for the subject of the first of his series of underground photographs, he chose the catacombs of Paris, where skeletons heaped one on top of the other trace in archeological fashion their own record of death; and, as if to pay this theme a special kind of homage, he begins his memoir with the Theory of Specters.

To criticize a subject is not necessarily to annihilate it. Sometimes, as with Kant's *Dreams of a Spirit Seer*, it is to carry it, transformed, into a new method of inquiry. And for Nadar the question of the intelligible trace remained viable as an *esthetic* (rather than a real) basis for photography. Which is to say that it is

a possible, though not a necessary, condition of a photograph that it render phenomena in terms of their meaning.

Nadar's early ambitions in this respect can best be documented in a series of photographs that he took when he and his brother Adrien Tournachon were still working together. Called 'Expressions of Pierrot: A Series of Heads,' this suite of images was entered into the photographic section of the 1855 Exposition Universelle where it won a gold medal. Depicting the face of Charles Debureau as he assumed the various facial gestures from his repertory of 'expressions,' the series of photographs becomes the record, and the doubling, of the mime's enactment of the physiological trace. Recent scholarship (I am referring to Judith Wechsler's study *Physiognomy, Bearing and Gesture in 19th Century Paris*)[19] focuses attention on the relationship between the science of physiognomy and the art of pantomime that was being drawn toward the middle of the nineteenth century. This means, for example, that in the plays he was writing for Debureau, Champfleury assumed the possibility of a performance that would fuse the physiological specificity of the character-revealing trace with the highly conventionalized gesture of the traditional mime.[20]

Now clearly, to render the physiognomic trace by way of the mime is to pass this phenomenon through an esthetic filter. For by the nature of his role as performer, the mime must transform the automatism of the trace, its feature as a kind of mechanical imprinting, into a set of willed and controlled gestures, into the language that Mallarmé would later designate as 'writing.'[21]

The explicit relationship between the mime's estheticising of the trace and photography's own, similar, highly self-conscious performance is drawn in the images of Debureau. In one of these, signed Nadar Jeune (Adrien Tournachon), the mime appears with a camera, miming the recording of his own image. In this work light, photography's own form of 'writing,' plays an important part. For while the mime is enacting his role in the image, a set of shadows constellate across his body as a simultaneously perceived and read subtext.

First, in the area of the head, Debureau's face, whitened by makeup, is further flattened by harsh lighting. This effect, added to the sharp shadow, which detaches the face visually from the underlying mass of the skull, intensifies the face's character as mask. A surface which, then, both belongs to the head and can nevertheless operate independently of it, the face-as-mask is the ground on which the physiognomic trace is rendered as a sign. To perform the physiognomic trace, Debureau had not so much to act as to artificially recompose his face – to achieve the thin lips of avarice, for example, in an ephemeral gesture that embodies physiognomy by 'speaking it.'

Second, the costume of Pierrot worn by the mime becomes the white field onto which cast shadows are thrown, creating a secondary set of traces that double two of the elements crucial to the image. One of these is the Pierrot's hand as it points to the camera; the other is the camera itself, the apparatus that is both the subject of the mime's gesture and the object of recording it. On the surface of the mime's clothing, these shadows, which combine the conventional language of gesture (pointing) and the technical mechanism of recording

(camera) into a single visual substance, have the character of merely ephemeral traces. But the ultimate surface on which the multiple traces are not simply registered, but fixed, is that of the photograph itself.

This idea of the photographic print as the ultimate locale of the trace is at work in this image in two different ways, and on two different levels of articulation. The first is on the level of the subject matter: the mise-en-scène of the image, so to speak. The second operates through a reflection of the role of the cast shadow: the operational fact of the image.

On the first level, we confront a performance of reflexiveness in which the mime doubles in the roles of photographer and photographed. Posed alongside the camera, he weaves that peculiar figure of consciousness in which the line that connects subject and object loops back on itself to begin and end in the same place. The mime enacts the awareness of watching himself being watched, of producing himself as the one who is watched. It is a doubleness that could not occur, of course, in the absence of this photograph of it. It is only because Debureau is the actual subject of the image for which he plays photographer, only by performing for the photographic mirror, that the issue of doubling arises. Obviously, were Debureau to perform his action on a simple stage, there would be no effect of doubling. He would merely be playing 'photographer.' Only if he were to play his gesture in front of a mirror would he be able simultaneously to enact the capture of his own image. But even then he would be rendered as two separate players: the one in 'life' and the one in the mirror. The photographic print, because it is itself a mirror, is thus the only place where an absolute simultaneity of subject and object – a doubling that involves a spatial collapse – can occur. The print is here defined, then, as a logically unique sort of mirror.

At the second, operational level, the theme of doubling and mirroring functions in relation to the shadows cast on Debureau's clothing. I have said that those shadows thrown by two separate objects (camera and gesture) combine on a physically distinct surface to produce a specific relationship, a meaning that points to the double persona of the mime. But the cast shadow itself is a type of trace that is the operational double of the photographic one. For the photographic trace, like the cast shadow, is a function of light's projection of an object onto another surface. In this image of Debureau, the idea of the mirror is carried into the semiological fabric of the work: the photograph is a mirror of the mime's own body in that it is a surface that will receive the luminous trace as a set of displaced signs, and more importantly, will constitute itself as the place in which their relationship can constellate as meaning.

Thus the aspirations working in this photograph are to surpass the condition of being the merely passive vehicle of the mime's performance. They are to depict the photograph itself as a complex sort of mirror. Echoing the theme of doubling through the agency of cast shadow, the photograph stages at one and the same time its own constitutive process as a luminous trace and its own condition as a field of physically displaced signs. Which is to say that doubling is not here simply recorded, but recreated through means

internal to the photograph, through a set of signs that are purely the functions of light.

In Talbot's brief speculation woven around the 'Scene in the Library,' the camera obscura emerges as a double metaphor for both recording mechanism and mind. In the photograph of Debureau, the connection implied by this metaphor is projected through the image of the mirror, itself a metaphor for that reflexive seeing which is consciousness. If the trace (the shadow) can double as both the subject and object of its own recording, it can begin to function as an intelligible sign.

In using terms like 'consciousness' or 'reflexiveness' to speak of this photograph of mime and camera, I am of course invoking the language of modernism. And this may seem unwarranted, given the direction that most photography was to take during the bulk of Nadar's lifetime. But in rehearsing the attitude towards the trace that was peculiar to an age that was simultaneously fascinated by science and spiritualism, I am trying to construct a very particular framework within which to set this image. The analytic attitude of which this photograph is a document has a very special genealogy, one that is relevant only to photography's own means of forming an image.

The kind of cultural frame that could have produced this photograph, that could have made the image of a mime next to a camera so extraordinarily resonant, is not only lost to us, but was, one feels, largely unavailable to Nadar as he wrote his memoir. Or at least it had become accessible to him only in memory. But Nadar's urgency in trying to recall that mood reminds us that esthetic media have surprising histories just as they have uncertain futures: difficult to predict, impossible to foreclose.

NEW VISIONS –
THE AVANT-GARDES
AND AFTER

Ute Eskildsen

Germany: The Weimar Republic

(First published in *A History of Photography*, Jean-Claude Lemagny and Andre Rouillé, Eds, Bordas, 1986; Cambridge University Press, Boston, 1987. pp. 141–9)

Ute Eskildsen has written widely on photography in Germany, where she is curator at the Folkwang Museum in Essen. This survey of the wide-ranging developments that took place in photography during the Weimar Republic documents a key phase in photography's history; a coalescence of technical advance and aesthetic exploration with social and political ferment.

ON 9 NOVEMBER 1918 the Kaiser was forced to abdicate. The timid attempts on the part of the military general staff to introduce reforms designed to democratise the monarchy had failed to prevent the workers and soldiers from revolting. This revolutionary movement directed against the representatives of the Kaiser's empire was countered by the social democrats with their policies of compromise, policies which were to prove decisive in the evolution of the Weimar Republic.

The end of Kaiser Wilhelm's empire dealt a sharp blow to the structure of German society. The new republican government had introduced universal suffrage. To ensure the protection of workers, the trades unions managed not only to enforce a law covering wage agreements but also to set up workshop committees to represent the workers. These social changes alarmed the bourgeoisie whose position was made worse by the serious economic and political difficulties in the years following the First World War. As a result of the economy's commitment to the production of armaments during the war, unemployment increased once peace was restored. Inflation too, increased alarmingly, reaching its peak in 1923.

But the radical social changes of the early twenties not only bred insecurity, they also challenged writers, artists and photographers to focus on contemporary developments in their work. The works and social impact of artists in the early twenties are stamped with a rejection of the past and a burning desire to pass beyond the culture of the Kaiser's time. This determination to turn away from the old traditions and the history of individual figureheads gave rise to many new ideas and utopias. The theme for reflection now was a 'new world' directed towards the future.

The 'New Objectivity'

THE QUEST for a new perspective in the domain of photography was expressed in slogans like 'a new point of view', 'the new photographer', 'a new perception'. But the determining notion – and not only in photography – was that of 'Sachlichkeit' (objectivity). This meant a type of photography that no longer represented its subjects in a diffuse fashion but instead aimed for precision, a precision that was accentuated with smooth, even glossy, paper. It thus stood in sharp contrast to the earlier 'art photography' which had been characterised by soft-focus images and subtle printing processes.

The new photographers refused to mask the technical nature of their means of expression any longer; they also rejected all the romantic imagery that had been popular hitherto. The concept of the 'neue Sachlichkeit' (new objectivity), defined in 1925 by G. H. Hartlaub as characterising the realist techniques of a number of painters of the twenties, was subsequently also applied to contemporary photography. The term expressed the desire for impartial analysis with the underlying hope that this objectivity would have a positive, clarifying effect. With changes in the social structure in Germany, a shift in the attitude towards technical progress also developed. In the mid-twenties, the hostile, almost fearful attitude previously manifested towards technical progress gave way to an enthusiasm bordering upon euphoria. As Germans looked with great interest towards the United States, technical achievement came to be regarded as not only the determining factor in social evolution but also the solution to all current politico-economic problems.

Exactitude in reproduction and the rediscovery of precision were the unmistakable hallmarks of the style of the 'new photographers' of the twenties. Two major tendencies emerged around the middle of this decade: the first, whose principal representative was Albert Renger-Patzch, set out to exalt the object in its structure, making full use of the photographic means that could underline that intention. The interest that Renger-Patzsch took in the original form of each of his subjects prompted him to select these from the industrial sector as well as from the natural world. The second direction was advocated by Laszlo Moholy-Nagy, a master of the Bauhaus and the most fervent champion of photography as a means of visual expression. He was also the most influential theoretician of the twenties. He defined this technical medium in terms of its interdependence with light: luminosity was the key to widening man's field of perception.

Both trends seized upon the exactitude of photography as a technical means of expression; it was an attitude that clearly reflected the ideology of objectivity current at the time.

These positions gave rise on the one hand to an abstract realism and, on the other, to a type of realist photography modelled on the commercial exploitation found in illustrated magazines. Between these two poles was the photography of the 'new observers', who were bent upon innovation.

In the field of the plastic arts, a number of groups were formed within

which the socio-political role of the artist was discussed. Concurrently, political attitudes hardened within the movement of worker-photographers, the difference here being that those involved were themselves undertaking to represent their own situation.

August Sander

THE COLOGNE GROUP of the 'progressive artists' included a rather marginal photographer whose methods of operation were not representative of the avant-garde. His name was August Sander.

He began to produce his series of portraits of German people, which he planned to publish as albums, in the early 1920s. It was a time when studio photographers were suffering from a fall in orders, a phenomenon due largely to the changing economic fortunes of the middle class. August Sander had left his native Linz in 1910 to establish himself in Cologne, where he had set about attracting a clientele drawn from outside the urban zone. This he found among the rural population of the Westerwald and the Siegerland. Perhaps his changing style resulted in part from this return to a landscape familiar to him since childhood, combined with the new conditions of photographing outside the studio. It was during these early years that he took a number of portraits of peasants, portraits which were free from all traces of sentimentality, and which he later included in his album devoted to 'Germans'.

In 1925, Sander wrote to Erich Stenger, the collector and historian of photography, seeking to interest him in his album, then in preparation. By this time he had already joined the group of 'progressive artists' mentioned above. It was in this circle of artists who sought to make photography an art with a social orientation, and in particular with one of its members, the socialist painter Franz Seiwert, that Sander was able to discuss his own conception of 'twentieth-century man' and his own photographs. He explained his ideas to Erich Stenger as follows: 'Pure photography allows us to create portraits which render their subjects with absolute truth, truth both physical and psychological. That is the principle which provided my starting point, once I had said to myself that if we can create portraits of subjects that are true, we thereby in effect create a mirror of the times in which those subjects live. . . . In order to give a representative glimpse of the present age and of our German people, I have collected these photographs into various portfolios, starting with the peasant and ending up with representatives of the intellectual aristocracy. This is then paralleled with an album which traces the evolution from village to modern urban concentrations. By using absolute photography to establish a record both of the various social classes and of their environments, I hope to give a faithful picture of the psychology of our age and of our people'.[1]

By about the mid-twenties, Sander had already started work on several albums, taking photographs of a series of people in the Rhineland.

Sander described himself as a documentary photographer but with the difference that he used the documentary truth of photography to create a

representation of higher interest. His vast plan for his photographs made it necessary for him to photograph with a consistency that would allow comparisons between his subjects. His method is essentially characterised by a deliberate confrontation between the photographer and the model facing him. The subject of the photograph is thus free to strike a pose. He is always shown in the context of his work and in his normal daily environment. The photograph thus conveys information about the original setting in which it was taken. Furthermore, the subject is always shown as part of his own environment, and usually with a serious expression – which indicates the unfamiliarity of the most of the people with being photographed.

In his *Men of the Twentieth Century*, Sander attempted a portrait of society, showing professions and social strata and classes, and thereby revealing the hierarchies which divided Germans of the Weimar Republic. In contrast to many of his colleagues, Sander was relatively unconcerned with experimental creativity and individual expression. In his work, the author remains in the background. He realised that the personal influence exerted by the documentary photographer lay not in creating an inventive image but in choosing it, in making a deliberate selection from reality. Without the particular gift for observation with which Sander surveyed the social scene of the twenties, this work of portraiture would not have succeeded in characterising the citizen of the Weimar Republic. The fact that comparisons between the portraits are possible gives each one an extra dimension within the context of the work as a whole, for the social role of the individual becomes comprehensible only in relation to the other portraits, which constitute a system of reference.

In 1927 Sander for the first time exhibited samples of his work, at the Cologne Kunstverein. The exhibition was followed by a first volume of photographs comprising sixty selected portraits, the last of which showed one of the unemployed (the volume came out in 1929).[2] In 1934, the Nazis confiscated the remaining copies of the edition, and the projected composite album, which was to have comprised forty-five collections of twelve photographs each, was discontinued. Over the next few years, Sander devoted more of his energies to landscape photography. His photographs were used to illustrate a number of slim volumes bearing the title *Deutsche Lande, Deutsche Menschen* (German places, German people), a theme in which he had already shown an interest and which could be marketed without attracting suspicion in the world of publishing and the press.

He continued to produce photographs for his great enterprise up until 1945. They included, among others, *Gefangene Politiker der Nationalsozialisten* (Political Prisoners of the National Socialists) and *Verfolgte Juden* (Persecuted Jews).

Publicity

IT WOULD BE difficult to form a judgement on German photographic production of the twenties without taking into account its fields of application and its market outlets. August Sander, the documentary photographer, earned his

living partly by accepting commissions from industry. The enthusiasm that photographic images aroused at this time – an enthusiasm by no means limited to Germany, of course – stemmed in part from the 'Weltanschauung' then undergoing such transformations and which regarded technical progress as holding the seeds of a better society. Photography was more than simply a medium through which to prove the existence of this 'new world' of architecture and industry, with all its new products and new means of production; it was a technical process increasingly used in new, expanding markets and it thus became an item of merchandise with a thousand possible applications. Photography's new clients included editors of illustrated magazines, designers and industrial businesses; while advertisements, brochures, posters, books and above all magazine reportage all testified to the new uses to which it could be put.

The London Convention of 1924 set out plans not only for revising the German monetary system but also for securing reparation payments in accordance with the Dawes Plan. Following this, between 1924 and the world economic crisis of 1929, Germany enjoyed a phase of relative stability: 'For the Entente powers have realised that only a prosperous German economy can guarantee that the reparation payments are made.'[3] It was also to that end that, in May 1924, a Wall Street consortium put up a loan of over 100 million dollars, which was followed by a new influx of foreign capital.

During this phase of relative stability, Germany was able to regain a footing in fields which it used to dominate, such as the chemical and the electrotechnical industries. 'The export offensive rested to a large extent upon the activity of large concerns such as I. G. Farben, Siemens, AEG, etc., in which a large measure of economic power was concentrated.'[4] By the mid-twenties, this power had been reinforced by concentrations of capital. The mergers that took place engendered not only concentrations of interests but also alliances with other branches of industry and with banks. The effect was to promote 'rational economic organisation' as well as cost-cutting through organisational restructuring.

In the early twenties many businessmen gave encouragement to contemporary artists by giving them advertising work. It was now that many artists who were experimenting in the field of photography discovered the promotional strengths of the photographic image. They utilised the photograph as an element of montage, as a photogram, or as a documentary shot in their advertising work. Many businesses of the period produced advertisements that testify to this use of photography; they include the following firms: Kaffee-Handel AG, Brême (Kaffee Hag), Günter Wagner Hanovre (Pelikan) Bahlsen, Hanovre (Bahlsen Kekse), Rosenberg and Hertz, Cologne (Forma Miederwaren [Forma Corsets]), and Bochumer Verein, Bochum (Bergbau und Gusstahlfabrikation [mining industry and cast steel manufacturing]). Max Burchartz, El Lissitzky, Richard Errell, Albert Renger-Patzsch and Maurice Tabard all either worked for these firms or offered them their photographs. The painter, designer and photographer Max Burchartz also wrote about the advertising techniques of modern times: 'The basic principle of advertising is invariably one of an active willing, using particular methods of suggestion, all of which

proceed in fundamentally the same fashion, in order to guide other wills – in fact, the greatest possible number of wills – towards particular well-defined actions'[5]

In a piece of *pro domo* publicity, Richard Errell, a colleague of Burchartz, congratulated himself on being able to reach the masses: it was here that the secret of success lay. In that respect nothing has changed; what has changed, though, is advertising practice. Today, advertising campaigns are preceded by market research studies. But even in the twenties an attentive eye was kept on the example of America, where spending on advertising was high and methods of diffusing publicity were discussed as seriously as were specialised methods of production.[6] The spectacular evolution of advertising in the twenties was related to the expanding market for newspapers, which were the basic vehicle used by the advertising industry.

The Press

NEW NEWSPAPERS and magazines were founded in Germany both immediately after the First World War and also in the mid-twenties. By the end of the Weimar Republic, three large newspaper groups existed: the conservative Hugenberg-Scherl syndicate and two republican presses, Ullstein and Mosse. Alfred Hugenberg was the commercial adviser who was chairman of the board of the Krupp firm in Essen from 1909 until the beginning of the First World War. He was also chairman of a number of business associations and, having recognised the peculiar power of the press even before the outbreak of the war, had taken action accordingly. In 1913, he had bought up a majority of shares in the Berlin publishing house of Scherl; he then set up a number of other publishing firms and also the Deutsche Lichtbildgesellschaft (German Photographic Company) and became a partner in a number of telegraph and advertising agencies and film companies. The 'Konzern Hugenberg' became the subject of many articles and much criticism during these years. The fears of his critics were confirmed in 1933, when Hugenberg became a minister in the first cabinet formed by Adolf Hitler.[7]

To form a clearer picture of the particular applications of photography, it may be useful to draw attention to the creation of the following newspapers: in 1923, the *Münchner Illustrierte Presse*; in 1926, the *Kölnische Illustrierte Zeitung*; in 1924, the magazine *Uhu* and *Die Koralle*. Some papers were connected with particular political parties: the *Arbeiter Illustrierte Zeitung*, founded in 1925, was close to the KPD (communists) and the *Illustrierte Beobachter*, founded in 1926, was the organ of the NSDAP (Nazis).

It was not only the widening range of possible clients that enabled the new generation of photographers to become active in new fields, but also new developments taking place in photographic techniques.

The Ermanox camera came into production in 1924 with a lens aperture of *f*/2, later improved to *f*/1.8. In the previous year the Leica had come out, in thirty-one models, and as from 1930 was available with interchangeable lenses.

Furthermore, the photosensitivity of photographic material increased to 17 DIN (40 ASA). The new instruments helped to transform the photographer's faculty of perception and to extend his field of operation. Pictures could now be taken at higher speeds and in extreme light conditions.

There were as yet no photographers employed on the staff of illustrated magazines. In certain cases individual publication contracts were signed. When Walter Bosshard went off to India in 1930 to produce a report on Gandhi, the contract the *Münchner Illustrierte Presse* negotiated with him gave it the exclusive German rights.[8]

When a photographer worked with a photographic agency, the latter would normally retain 40 to 50 per cent of the profit from publication of his work. This allowed him to leave the commercial side of his profession to others and gave him more time to devote himself to photography. On the other hand, it reduced his personal control over the way that his pictures were presented and distributed. In 1928, Simon Guttmann and Eduard Marx founded 'Dephot' (the German photographic service) in response to the growing demand for photographic documentation. The first to collaborate with this agency, which specialised essentially in the production of photographic stories, were the retoucher Hans Baumann (Felix H. Man), who had been an illustrator at Ullstein's, and Otto Umbehr (Umbo) from the Bauhaus. Among others who worked for it later, in some cases only for a short period, were Walter Bosshard, Kurt Hübschmann and Lux Feininger.

Up until the mid-twenties, the presentation of photographs in magazines remained much the same as in the prewar years. In 1926, photographic series were still being presented in a very static fashion. Meanwhile, however, it had become customary for the photographs which were supposed to attract attention to be set out framed in geometrically shaped spaces. Clearly, most effort was put into the layout of the cover, which was designed to persuade the customer to buy. Here, a number of different extracts and varying points of view on a single subject would deliberately be chosen and these would be accompanied by two or more photographs intended to underline the contrasts and links between the subjects treated. The reader's curiosity was aroused by two means: on the one hand, the cover's suggestion of a theme which made him want to read the report, and, on the other, the unusual form of presentation, which awakened a kind of voyeuristic curiosity.

By about 1929, the German bourgeois press could count on the services of a whole series of eminent 'observers'. International politics were the province of Erich Salomon. The Gidal brothers were especially adept at rendering visible the most diverse forms and levels of human communication. Umbo would produce an interesting report on any subject. André Kertész and Alfred Eisenstaedt took their photographs as distant observers. Martin Munkacsi concentrated on producing photographs each of which possessed a balanced form of its own and Wolfgang Weber favoured foreign travel. One of the photographers most in demand was Felix H. Man, who specialised in nothing in particular but was commissioned to produce for publication photographs covering the widest range of subjects among both the currents and the undercurrents of the times.

In the two principal German illustrated magazines, the *Münchner Illustrierte Presse* and the *Berliner Illustrierte Zeitung*, the trend was to peep into the corridors of power ('hinter den Kulissen') to spy upon politicians ('belauschte Politiker') or else to report on exotic foreign parts. Everything had become 'photographable' and the competition that existed between the various newspapers speeded up the headlong chase after anything sensational. Photographers revealed familiar things from new angles and were expected to discover new ways of looking at everyday social life. The most striking feature was the rich disparity of the photographs.

The juxtaposition of photographs makes it impossible for the conscious mind to establish links between facts. 'The very idea of photography does away with ideas.' That is how the critic Siegfried Kracauer in 1927 denied the illustrated magazine any virtues at all in making known the state of the world. But for him, the evil lay in photography itself since the resemblance between the image and what it represents 'blurs the historical outline of the latter'.[9]

The Worker-Photographers

A T THE OPPOSITE end of the spectrum from the bourgeois press, the *Arbeiter Illustrierte Zeitung* (*AIZ*), with communist leanings, appeared in the mid-twenties. It was founded in 1925, as an offshoot from *Russland im Bild*, a magazine which had been founded in 1921 under the auspices of the Internationale Arbeiter Hilfe (International Labour Defence) and which appeared in 1923–4 under the title *Hammer und Sichel* (Hammer and Sickle). The magazine, founded by and under the direction of Willi Münzenberg, was associated with the KPD although never a direct organ of the party. It appeared weekly in 1927, reaching a circulation of 240 000 copies.[10]

To realise Münzenberg's aim of making this political illustrated magazine counterbalance the bourgeois press, it was necessary to obtain photographs which illustrated the lives and working conditions of the proletariat, and not enough of these were forthcoming from the photographic agencies. Münzenberg had long since glimpsed the potential force of propaganda conveyed through pictures and had written a brochure explaining his views: 'Pictures are effective above all upon children, young people and the general as yet unorganised mass of workers, agricultural workers, small peasants and other similar strata who still think and react in a primitive fashion; as well as (producing) illustrations in the dailies and newspapers aimed at young people and at children, at women and at peasants, it is absolutely imperative to create and organise illustrated magazines aimed at the workers.'[11]

In the following year, 1926, the editorial staff of the *Arbeiter Illustrierte Zeitung* launched a competition, inviting their readers to provide the newspaper with photographic documentation. The same year, it was announced that a centre had been set up for workers who were amateur photographers. Its aim was 'to create an information sheet for the purpose of exchanging experiences and passing on individual photographic commissions to the workers' press as a whole.'[12]

On 1 September the first issue of *Der Arbeiter Fotograf, Mitteilungsblatt der Vereinigung der Arbeiter Fotografen* (The Worker-Photographer, Journal of the Association of Worker-Photographers) appeared. From the eighth issue onwards it adopted the subtitle of *Offizielles Organ der Vereinigung der Arbeiter Fotografen Deutschlands* (Official organ of the Association of the Worker-Photographers of Germany). Willi Münzenberg was its chief editor and director.

The editors of the *Arbeiter Illustrierte Zeitung* lost no time in using the organ to communicate to the amateur photographers ideas and tips relating to the practical aspects of photography: 'The worker photographer must become a reporter! When something happens at his place of work that is of interest to workers as a whole, he should look into it and produce an eyewitness account consisting of five or six pictures.'[13]

In practice, the *Arbeiter Illustrierte Zeitung*'s movement of worker-photographers set little value upon single photographs. The workers' findings were expected to be recorded in a series of pictures. As well as practical photographical advice, the worker was given information concerning his rights as a photographer and the 'illicit' practices of the police, who might sometimes seize his photographic material. From 1925 onwards, the Berlin police issued passes to photographers when cultural or other events took place. In 1928, this authority was handed over to a commission composed of representatives of the police and the professional organisations. From 1933 onwards, the only photographers admitted to such events were those who belonged to the compulsory association known as the 'Reichsverband Deutscher Presse' (Association of the German Press of the Reich) or to the 'Reichsausschuss der Bildberichsertatter' (Committee of the Photographer-Reporters of the Reich).[14]

The documentary photographs produced by the worker-photographer movement fell far short of fulfilling the hopes of the AIZ, even in 1929. After the May demonstrations, having received no more than six usable photographs, the AIZ launched an appeal to the photographers.[15] In her biography of Münzenberg, Babette Gross, who in 1926 became the first woman president of the movement, summed up the situation as follows: 'The photographs submitted by the worker-photographers were seldom fit for use and were on the whole of a quality far inferior to those of the press.'[16]

In contrast to the liberal press's practices regarding page layout, the AIZ editorial staff elaborated a synthetic montage technique for displaying its pictures. They recognised the extent to which the meaning of a photograph could be manipulated and thus used to convey a political message and to influence. They put their points across by deliberately combining and juxtaposing both texts and images or by setting in opposition photographs of contradictory content and explaining the contradiction in an accompanying text. Historical documents and photographs were frequently reproduced alongside contemporary photographs, to reinforce the persuasive force of the latter, and the text no longer confined itself to describing the photographs but further produced an interpretation of them that reflected the party line. The agitational methods of the AIZ assigned the photograph less inherent information value than did the bourgeois press. When it was a matter of representing abuses of justice, for

example, photographs reflecting personal situations would be printed and it was only in an accompanying commentary which conveyed the party line that the general social implications of the image would be drawn, with the aim of getting the reader to identify himself with the situation, and, if possible, take action.

In 1933, the worker-photographer movement was decimated by the national socialists. Its last official publication appeared in March. The newspaper staff continued to operate illegally and for a short period produced the *Reporter* magazine, in a reduced format, in order to circulate information. In its last issue, Erich Rinka, the secretary of the VDAFD ('Vereinigung der Arbeiter Fotografen Deutschlands') (Association of the Worker-Photographers of Germany), urged his readers to continue the struggle against the Nazis. The editorial staff of the AIZ emigrated to Prague where it battled on until 1938, under the aegis of the editor-in-chief, F. C. Weiskopf, adopting the title *Volks-Illustrierte* in 1935. (In 1939, Willi Münzenberg, who had fled to France as a refugee, was confined, as a German, in an internment camp. In 1940, he committed suicide there, when he learnt that the Vichy authorities were about to hand him over to the occupying power.)

John Heartfield

FROM 1930 ONWARDS, John Heartfield was one of the principal collaborators of the AIZ. (He had changed his German name of Herzfelde to its English equivalent in protest against the excesses of the prevailing German chauvinism.) His photographic compositions appeared monthly. They always referred to current political events and were printed in a central position or as leaders. With hindsight, we can today read into them a history lesson that went unheeded.

Since becoming a member of the KPD in 1919, Heartfield had been working for magazines and producing posters and brochures. Later, he also lent his services to the party's graphics studio in Berlin. Working with his friend the painter George Grosz, in the framework of the Berlin 'Club Dada', Heartfield put together the earliest photographic collages. Together, the two worked on numerous projects of which their 'dada montages', their collaboration on a number of magazines and their work with animated film represent but a small fraction. In 1917, in partnership with his brother Wieland Herzfelde, Heartfield founded the Malik publishing house, for which he produced photomontages to be used as book covers.

In 1924, he produced his first historical photomontage: *Nach zehn Jahren — Väter und Söhne* (Fathers and Sons Ten Years Later). It was exhibited in the window of the publishing house on the anniversary of the beginning of the war. That same year, together with Grosz and Erwin Piscator, he founded the 'Rote Gruppe' (Red Group) which later gave rise to the 'Assoziation Revolutionärer Bildender Künstler Deutschlands' (the Association of Revolutionary German Artists).

John Heartfield's creative work in the twenties was manifold. He always adopted a political slant, whether working in the cinema, in the theatre (as a designer), as an artistic collaborator on books, magazines or exhibitions, or (from 1930 up until the end of his exile in Prague) on the permanent staff of the *Arbeiter Illustrierte Zeitung*. This newspaper, with its vast circulation, provided his provocative statements with the vehicle and the distribution they needed. In the context of this study, John Heartfield must be seen as a marginal figure since he was not himself a photographer, but rather an artist who used the photographic image. His function was political and his work acquired meaning only through its application and distribution: to that extent he also remains an exception in the artistic context of the Weimar Republic.

Germany was not the only country where the practice of photography during the twenties played a determining role in the later evolution of photography and the extension of its field of application. As the political debates and social changes which mark the first phase of the Weimar Republic took place, changes were also taking place within the field of photography, where there was a noticeable reaction against earlier trends that had sought to mask the technical nature of photography behind a screen of conventions borrowed from painting.

By the mid-twenties, German photography was changing its relationship to reality. It swung optimistically towards technicality and the new objectivity which was to give rise to new modes of perception and representation. It was only in the late twenties that photography, now a means of representation with its own particular formal laws, was to acquire an economico-political significance, thanks to the growing outlets of the cultural market which helped to make it a more marketable commodity.

In the field of publicity and photographic illustration, both rapidly expanding, a fair number of photographers could, in the early thirties, style themselves 'perfekte Gestalter' (perfect creators) or 'entdeckende Reporter' ('discoverer' reporters). They were equipped with all the technical and aesthetic know-how and capabilities that photography could bring to bear in support of an idea.

All the same, the credit for the creation of illustrated reportage, starting from the basis provided by the photographic illustrations of the prewar magazines, should not go to photographers alone: their clients, magazine editors and managing directors, had been quick to recognise the photo-story as a method of representation that could exert a strong influence upon the public. The communist workers' movement had been quick to perceive the political effectiveness of the illustrated bourgeois magazines and had reacted accordingly. In its own paper, which was backed by the Republic's left-wing intellectuals as well as by the newly founded worker-photographer movement, it retaliated against the liberal and conservative press with its own political use of reporting, embracing the proletariat's point of view. 'And since a photograph can say more than a thousand words, every propagandist knows how to calculate the effects of tendentious photography. Right across the board, from the advertisement to the political poster, the image can attack, throw punches, strike right at the heart and, if well chosen, can express a new truth, but always only one.'[17]

The national socialists found ways of generally perverting forms by having them convey a new content: for instance, May Day was declared to be the Day of National Labour; and they certainly discovered particularly favourable conditions for doing so in the field of photography. The forms of representation and possible applications of photography which had been tried out during the years of the Weimar Republic were later put to effective use by the Nazi propaganda machine. Hitler's regime expelled the best journalistic photographers and the best editors of illustrated magazines; it wiped out the worker-photographer movement and, through its oppression, helped to smother further experimental approaches and visual progress in the field of photography.

Varvara Stepanova

Photomontage

(Written and circulated in 1928; first published in *Fotografie*, Prague, No. 3, 1973, and reprinted in *Photography in the Modern Era: European Documents and Critical Writings 1913–1940*, Ed. Christopher Phillips, Metropolitan Museum of Art/Aperture, 1989)

Varvara Stepanova (1894–1958) was married to Alexander Rodchenko. She was a leading figure in the constructivist movement, as a designer of textiles, costumes and stage sets. Precision and functionalism, the tenets of the constructivist approach to the application of artistic techniques, are seen by her as primary attributes of the camera, which can reproduce or manipulate with an accuracy unavailable to the 'imperfect method of drawing'.

A GROUP OF artists on the left artistic front have given their attention to the problems of production art.[1] This shift of interest has dictated a change in the basic method of work, that is, in the use of technique and artistic media to express documentary truth. Now we are using photography as a viable method of communicating realities.

In polygraphy[2] – more than in other forms of communication – images must transmit the phenomena of the external world. And this places considerable responsibility upon the artist. Periodicals, newspapers, book illustrations, posters, and all other types of advertising confront the artist with the urgent problem of how to record the subject in documentary terms. An approximate artistic design cannot meet this challenge, this need to provide documentary truth. The mechanical complexity of the external forms of objects and of our

whole industrial culture is forcing the artist concerned with production – the constructivist artist – to move from the imperfect method of drawing to the utilization of photography.

And so photomontage was born. Photomontage: the assemblage and combination of the expressive elements from individual photographs. In our country the first photomontages were created by the constructivist A. M. Rodchenko in 1922 as illustrations to I. A. Aksenov's book *Gerkulesovy stolby* (The pillars of Hercules). . . .[3]

The need for documentary truth is characteristic of our era, but it is not confined to mere advertising, as some people suppose. We now know that even artistic literature requires it. The first great work in photomontage (i.e., the one that played a definite and necessary role in the development of our book illustrations, book covers, and posters) was V. V. Mayakovsky's book with photomontages by A. M. Rodchenko.[4] From that time on, photomontage – as a new art form replacing drawing – has expanded greatly and has permeated the periodical press, propagandistic literature, and advertising. Because of its great potential this method is becoming very popular and much relied upon. It is quickly catching on in workers' clubs and in schools, where photomontage on wall notices can present a ready response to any topic of urgency. Photomontage is being used extensively in political campaigns, and from anniversary celebrations and parties right down to the decoration of offices and corners of rooms.

All our Soviet publishing houses . . . have accepted photomontage, and it is one of the commonest methods of typographical layout for book covers and posters. Photomontage is found even in movie posters. The years 1924–26 witnessed a general upsurge of interest in photomontage on the part of the Soviet press.

During its short life photomontage has passed through many phases of development. Its first stage was characterized by the integration of large numbers of photographs into a single composition, which helped bring into relief individual photo-images. Contrasts between photographs of various sizes, and to a lesser extent, the graphic surface itself, formed the connective medium. One might say that this kind of montage possessed the character of a planar composition superimposed on a white paper ground.

The subsequent development of photomontage has made clear the possibilities of using photography itself, as such. The photographic snapshot is becoming increasingly self-sufficient. (Of the distinguished works of this period one should single out *Istoriya VKP (b)* [History of the All-Union Communist Party], published by the Communist Academy in 1926. It utilizes a poster format with Rodchenko's photomontages, but the individual snapshots are not fragmented and have all the characteristics of a real document.) The artist himself must take up photography. He searches for the particular shot that will satisfy his objective – but montaging someone else's photographs will not fulfill his needs. Hence, the artist moves from an artistic montage of photographic fragments to his own distinctive shooting of reality.

This was the path taken by A. M. Rodchenko, the first photomontagist. From 1924 onward Rodchenko worked with his camera. Instead of the conglomerate photomontage, he used a montage of individual photographs or

a series of individual photographs. The value of the photograph itself came to assume primary importance; the photograph is no longer raw material for montage or for some kind of illustrated composition, but has now become an independent and complete totality. This increases the documentary value of photography and provides precise information on time and place in the created work. But it poses another problem — the need for a technique to express reality in characteristic and explicit terms.

In the final stage of photomontage we note that virtually every artist who has some connection with the polygraphic industry has equipped himself with a camera. Photography is the only medium that can provide him with the traditional method of drawing while allowing him to fix and record the reality around us.

Translated by John E. Bowlt

Dawn Ades

The Supremacy of the Message – Dada

(Extracted from *Photomontage* 1976)

The techniques of photomontage were inspired by a growing culture of mass-produced images that accompanied the machine-age technologies of the First World War. The Berlin Dadaists quickly saw the subversive potential of manipulating pictures. Although photomontage is now one of the commonplaces of advertising, it continues to have combative exponents; Dawn Ades's book traces a long line of photomontagists and their revolutionary beginnings.

THE INVENTION of photomontage among the Berlin Dadaists has been claimed on the one hand by Raoul Hausmann and Hannah Höch, and on the other by George Grosz and John Heartfield. Hausmann asserts that the germ of the idea was planted while he and Hannah Höch were on holiday in the summer of 1918 on the Baltic coast, where they saw in almost every house a framed coloured lithograph with the image of a soldier against a background of barracks. 'To make this military memento more personal, a photographic portrait had been stuck on in place of the head.' Hannah Höch has a more precise memory, recorded by Richter in *Dada: Art and Anti-Art*, of an 'oleograph of Kaiser Wilhelm II surrounded by ancestors, descendants, German oaks, medals and so on. Slightly higher up, but still in the middle,

stood a young grenadier under whose helmet the face of their landlord, Herr Felten, was pasted in. There in the midst of his superiors, stood the young soldier, erect and proud amid the pomp and splendour of this world. This paradoxical situation aroused Hausmann's perennial aggressive streak. . . .' Hausmann realized immediately that he could make pictures composed exclusively of cut-up photographs, and his excitement must have been due to the idea not just of a new technique, but of a technique in which the image would *tell* in a new way.

It was precisely this possibility that also interested Grosz. As he says in his rival statement, again quoted by Richter, about the origins of photomontage:

In 1916, when Johnny Heartfield and I invented photomontage in my studio at the south end of the town at five o'clock one May morning, we had no idea of the immense possibilities, or of the thorny but successful career, that awaited the new invention. On a piece of cardboard we pasted a mishmash of advertisements for hernia belts, student song books and dog food, labels from schnaps and wine bottles, and photographs from picture papers, cut up at will in such a way as to say, in pictures, what would have been banned by the censors if we had said it in words. In this way we made postcards supposed to have been sent home from the Front, or from home to the Front. This led some of our friends, Tretyakov among them, to create the legend that photomontage was an invention of the 'anonymous masses'. What did happen was that Heartfield was moved to develop what started as an inflammatory political joke into a conscious artistic technique.

Notwithstanding these interestingly different sources, the one in popular and comic arrangements of photographs, the other closer to collage, both Hausmann and Grosz seized on the possibilities of signification and on the subversive potential of the medium itself. This is how Hausmann was to describe it much later, in his lecture on the occasion of the first major exhibition of photomontage, in Berlin in 1931:

People often assume that photomontage is only practicable in two forms: political propaganda and commercial publicity. The first photomonteurs, the Dadaists, started from the point of view, to them incontestable, that war-time painting, post-futurist expressionism, had failed because of its non-objectivity and its absence of convictions, and that not only painting, but all the arts and their techniques needed a fundamental and revolutionary change, in order to remain in touch with the life of their epoch. The members of the Club Dada were naturally not interested in elaborating new aesthetic rules But the idea of photomontage was as revolutionary as its content, its form as subversive as the application of the photograph and printed texts which, together, are transformed into a static film. Having invented the static, simultaneous and purely phonetic poem, the Dadaists applied the same principles to pictorial representation. They were

the first to use photography as material to create, with the aid of structures that were very different, often anomalous and with antagonistic significance, a new entity which tore from the chaos of war and revolution an entirely new image; and they were aware that their method possessed a propaganda power which their contemporaries had not the courage to exploit. . . .

Towards the end of the war Berlin was a half-starved nightmare city, and there was increasing social and political chaos, which was to last until 1933; in 1918 Soviet Republics were briefly set up in several major German cities, including Berlin. Of the Berlin Dada Club, which included Huelsenbeck, Hausmann, Grosz, Wieland Herzfelde and his brother John Heartfield, Hannah Höch, Johannes Baader and, briefly, Franz Jung, only Herzfelde and Heartfield were founder members of the German Communist Party in 1918. But the group sided with the radical left wing against the middle-class republic of Ebert and Schiedemann and, after the defeat of the November Revolution, through the early months of 1919, were vociferous in their opposition. They produced many periodicals, news-sheets and pamphlets, for which conventional layout was clearly inappropriate, and typographical anarchy began. Heartfield's collage advertisement in the periodical *Neue Jugend*, June 1917, combined letters, newsprint and pencil marks at all angles, like his later *Dada Photomontage* of 1919, though here additional photographic material is included. The catalogue of the 1969 Photomontage Exhibition at Ingolstadt states that Grosz and Heartfield first used photos in collage in 1919, and that the cover by Heartfield of the single issue of the illustrated paper *Jedermann sein eigner Fussball* — which is a brilliant parody of conservative layout — was the first dated Dada photomontage, the vignette at the top first juxtaposing two photographs to make a new whole.

In artistic terms, Dada's constant chosen enemy was Expressionism, and in singling out its inwardness and Utopianism, and the emptiness of its rhetoric, Huelsenbeck, in the first Dada Manifesto of the Berlin group in 1918, called instead for an art 'which in its conscious content presents the thousandfold problems of the day, the art which has been visibly shattered by the explosions of last week, which is forever trying to collect its limbs after yesterday's crash. The best and most extraordinary artists will be those who every hour snatch the tatters of their bodies out of the frenzied cataract of life, who, with bleeding hands and hearts, hold fast to the intelligence of their time.' Photomontage perhaps comes closest to fulfilling Huelsenbeck's ideal. The visibly shattered surface of *Dada-merika*, or Heartfield's *Dada Photomontage*, is a truer image of a violent and chaotic society than, for example, *The Funeral of the Anarchist Galli*, a painting by the Futurist Carrà. And in using the very stuff of today's and yesterday's news, Dada was beginning to subvert the voice of society itself. Grosz's montage *My Germany*, for the unpublished anthology *Dadaco*, has some of the power of Heartfield's later work: Prussian soldiers are enthroned in the heart of a fat capitalist whose bland bald head sprouts snippets of the financial news. This is perhaps the first work to show the inglorious association of money and war, later to be a constant theme with Heartfield.

The first International Dada Fair, held in Berlin in 1920, included works by Arp, Picabia and Ernst as well as by the Berlin group. The highlight of the Fair, which led to prosecution, was the stuffed dummy dressed in a German officer's uniform with the head of a pig. But the stated theme was 'Art is dead! Long live the machine art of Tatlin!' The recurrent motif in the photomontages exhibited by Hausmann and Hannah Höch is the machine, yet their attitude to the machine is far from unambiguous. Beside *Dada Conquers*, which proclaimed the world victory of Dada, hung *Tatlin at Home*, demonstrating, apparently, the admiration and sympathy of the Berlin Dadaists for the new Production Art in Russia. However, Hausmann stated in 1967 that this was an accidental, haphazard accumulation of images, rather than a planned affirmation of 'machine art' – of whose manifestations, if any, in Russia, they had only the haziest idea. Leafing through an American review, Hausmann had come across a photograph of a man which, for no particular reason, 'automatically' reminded him of Tatlin. He was, however, more 'interested in showing the image of a man who only had machines in his head'. From this point, images were added to balance and expand this first idea: the dummy with soft, organic insides, the man turning out empty pockets ('Tatlin can't have been rich'), the boat's stern with screw-propellor adding the final touch. As in *Dada Conquers*, the background is painted, a steeply receding, platform-like floor which, together with other details and a certain oneiric quality, is reminiscent of the paintings of De Chirico.

Hannah Höch's photomontages, often considerably larger than those of Hausmann, Grosz or Heartfield, as in the case of *Cut with the Cake-Knife* of 1919, also appear more carefully composed and less obviously political than those of the latter. Cogs, wheels and other bits of machinery, street scenes and buildings are incorporated with heads and bodies, which are sometimes portraits of other Dadaists and are often grotesquely reassembled. Intricate details combine with dominant, startling images, all floating freely in space – another contrast with Hausmann's photomontages, where the preference is often for a distorted room-like space. Self-portraits are not uncommon with both Hausmann and Höch, whereas Heartfield rarely appears in his own works.

ABCD (1923–4) is like a swan-song of Dada, a scrapbook of Dada activities. Hausmann himself, in a photograph that appears more than once in his photomontages, declaims one of his phonetic poems ('ABCD'), and has a wheel-like monocle drawn on his eye. Numbered tickets from the Kaiser's jubilee recall provocative interruptions of official ceremonies; the Merz ticket commemorates Hausmann's friendship with Schwitters; and the tiny scrap of map in the top right shows Harrar, the town in Ethiopia where Rimbaud, Hausmann's favourite poet, acknowledged by Dada and Surrealism in general, lived after renouncing poetry. What is the birth to which Hausmann refers with the obstetric examination cut from the pages of a medical textbook – Dada itself?

Grosz and Herzfelde wrote in *Die Kunst ist in Gefahr*: 'Our mistake was to have concerned ourselves with art at all . . . We saw then the insane

end-products of the prevailing social order, and burst out laughing . . . We did not yet see that a system underlay this insanity.' It was precisely this system that Heartfield was to reveal and make comprehensible, the better to fight it.

Lucia Moholy

A Hundred Years of Photography

(Extracted from *A Hundred Years of Photography*, Pelican, Harmondsworth, 1939, pp. 161–7)

Lucia Moholy was born in Czechoslovakia and moved to Germany when she was eighteen. She married Laszlo Moholy Nagy and in the '20s collaborated with him on his experimental projects at the Bauhaus, as well as producing portraiture of her own. She wrote on photography during this period and continued to do so after emigrating to Britain in 1934.

A Hundred Years of Photography was published as a Pelican Special to mark photography's hundredth anniversary. It combines the impersonality of the specially commissioned survey with a very particular approach to photographic history – one informed by continental culture and the nexus of ideas and events within which photography developed. This short (182pp) book covers a lot of important ground, and although published over fifty years ago, it still makes some more recent attempts at introductory history look parochial.

This extract's account of the avant-gardes and photography is clearly constrained by the book's target of a popular readership. It is strange though to find Surrealism described as non-political. If this was because of its emphasis on poetic truth and personal liberation it can only remind us that the avant-gardes had differing agendas.

WHILE THE public mind was being saturated with the ideology and æsthetics of impressionist and – following this – neo-impressionist art, a new artistic creed was already on the way. It began with Cézanne, in France, who felt that painting lacked structural principles. His efforts to give shape to this idea and his extraordinary genius for colour and balance, won him the universal admiration of artists, at home and abroad. The movement, initiated by him, evolved into various branches in different countries, according to national character and circumstances. Expressionism in Germany and Cubism in France were both indebted to Cézanne. These

movements branched out again into schools with more or less abstract tendencies. A more recent form of abstract painting, Constructivism, arrived a few years later. Contemporary movements, although on distinct lines, were Futurism and Dadaism, both with political ideologies. Surrealism, evolved from Dadaism, is the newest of them all and non-political.

Photographs were used by Dadaists, and some of their colleagues who worked on similar lines, in the same way as engravings were later used by Surrealists. They cut them out, enlarged or reduced them and used them as parts or centres of newly composed pictures which they made up from various cuttings with additional drawing, painting and lettering, calling them 'Montage' or 'Collage.' The best representative of pure 'Photo-Montage' is John Heartfield.

Photography, further, has been adopted by a few abstract painters as a new medium by means of which they tried to give shape to their feelings of balance. They are Man Ray, living in France, and Moholy-Nagy, living in U.S.A. They took up the method of 'Photogenic drawing,' discovered by Schulze in 1727 and familiar to Fox Talbot before 1834, and applied it in their own way. The results are abstract pictures called 'Rayographs' – 'Rayograms' – 'Photograms' – 'Shadowgrams' – 'Skiagrams' and other names. Some among the abstract artists claim to have discovered the veritable principle of photography. They have, indeed, rediscovered the principle from which photography was originally evolved, and adapted it to their purposes of abstract expression. The question whether photography has been subjected to any influence of the abstract arts does not, therefore, arise with regard to these pictures. It was a process of assimilation, not of influence.

A kind of mutual influence took place between photography and futurist painting. One of the features of futurism was the effort to represent, in one painting, events which took place in separate moments, or various aspects of the same object which in reality could not be obtained simultaneously. (Car from inside and outside.) These efforts, no doubt, were in the first instance an effect of cinema-photography on painting. Later the influence was reversed: Futurist picture effects were obtained by printing one photograph – wholly or partly – on top of the other. It was a kind of combination printing, not, however, with the aim of obtaining one homogeneous picture, but a 'simultaneous' one. These simultaneous photographs have been used for depicting exciting moments such as the traffic in a large city and its dangers, and have – if well done – been very expressive and effective. (E.g., Ver Moï's Photographs of Paris.)

The abstract arts claimed that colours and tone values were expressive by themselves, quite apart from any object in the picture, comparable to sounds of music.

Photography, from its very beginning, and like any other art, has owed part of its effects to the artistic balance of its tone values. It can be taken for granted that photographers who were artists were conscious of the relations which had to be established between the object and its surroundings in the picture, if a harmonious effect was to be achieved. This was occasionally underestimated by

modern theoreticians, while the importance of their own theories for photo-graphy was over-estimated. With a mixture of impressionist and expressionist ideology they argued that the subject of the photograph was unessential, and that it was the balance of black, white and grey tones that mattered. This idea, taken at its face value, was exclusively æsthetic and overlooked the part of the object in the picture. It led to the extreme belief: 'Happy the photographer of whom it can be said that he knows how to change a dung heap into a gold heap' (1927).

With some photographers, mainly amateurs, this theory developed an over-consciousness of tone values and balance. Hence the great number of still-life and 'pattern' photographs between 1920–1930, with a minimum of object and a maximum of lights and shades, rhythm and balance in them. Whether the object was an egg or a tea-cup, a score of pins or a pair of gloves, a piece of silk or a heap of sand, a row of corn sheaves or pebbles on the beach, was of no importance if the lights and shades were well arranged, and the pattern well balanced.

At the same time, however, contrary to the primary æsthetic intention, the object, by being isolated from its natural surroundings, was endowed with a much greater importance than it originally possessed.

This was the beginning of a counter movement: photographers, after having been made over-conscious of tone values and balance, began to be more object-conscious than ever before. The object in the picture became self-assertive; and so did the details of the object. Nothing was without significance. The minuteness of detail became essential. Impressionist texture of paper surface and technique were rejected. The texture of the object, its own surface, were emphasised. Cuttings and unusual angles were in favour (the unusual angles being an effect of mixed – and rather contrary – influences: expression-ism, object-consciousness, etc.). It was the beginning of modern object photo-graphy, sometimes called 'straight' photography.

A revival of object-consciousness also took place in the arts. Leading cubist painters, like Picasso, again chose subjects from nature, and so did other abstract artists. For some of them the reversal was merely formal, for others it was a requirement of social life which, they felt, needed artistic expression. The term 'Neue Sachlichkeit,' which had been current in Germany for several years, originally referred to a small group of German painters. Its meaning was later extended and in particular applied to modern object or straight photography. In this capacity and without being translated, it has occasionally been used in photographic literature (e.g., Japanese Almanacks of Photography).

The high standard of technique, the perfection of material and the scientific methods, only recently introduced (Hurter and Driffield, Vogel, Scheiner, etc.), provided the technical foundation for modern object photography. The dominant position of the object in trade and industry, typical of the twentieth century, suggested the ideological part. The modern arts, emphasising the value of tone and balance, and the modern film, which in the meantime had reached a high level of perfection, contributed to the formal side. Skilful use of lights, natural or artificial, did the rest.

The principles – science, technique, domination of the object, sense of form and value of light – have since governed modern pictorial photography. The desired effects were intensified by enlarging the pictures to any size required. The final results found their most adequate sphere in modern advertising.

To a certain extent the same principles found their way into picture papers, books and, in a limited degree, into portraiture.

For the first time in the history of photography it was not only the shape, delineation and expression of the human face, but the sculptural details of the head and the texture of skin, hair, nails and dress which became attractive subjects to the photographer. For the first time he had the perfect apparatus, material, light and other implements at his disposal and he was prepared to make use of them. Experiences in object photography, and films – produced in Russia and America – which were shown in all cinemas, gave him inspiration for a kind of portraiture which was very remote from everything which had been done before. The number of these photographers has been considerable in Russia and Germany, less so in the western countries. To the general public in Western Europe this style appears strange and exotic. They find it interesting and worth discussing, but few of them wish to have their portraits taken in the same way. England, in particular, has conserved a strong taste for the soft-focused, gentle and placid portrait photograph of the Reynolds and Gainsborough style.

Typical representatives of a more realistic line are Shaw Wildman (London), Howard Coster (London), Helmar Lerski (Palestine), Lucia Moholy (London); soft-focused, smooth and lovely portraiture is represented by Cecil Beaton (London), Dorothy Wilding (London) and others.

Portraiture had been one of the most favoured subjects of photography until about the end of the nineteenth century. It covered more ground than all other sections together. Since the beginning of the twentieth century the progress made by scientific photography has been magnificent, and the section covered by it has been growing continuously. Scientific photography was going on during the war of 1914–1918, including aerial photography and other branches serving military purposes. Portraiture, however, suffered a setback, and has not been able since to recover its former significance. Many portrait photographers who used to do nothing but portraiture had to take on commercial work which promised a better turnover.

The advance of amateur photography was felt to be a menace a number of years ago, before this actually was the case. It has now conquered part of the field. Many jobs which were formerly reserved to professional photographers are now accessible to amateurs who own a modern camera and equipment. The perfection of apparatus, and the support amateur photographers receive from the trade through an increasing efficiency of the D. and P. stations, have in some sections thrown down the barrier between professionals' and amateurs' work.

The relation between the arts of painting and drawing on the one hand, and photography on the other, has gone through various stages of argument until

recently. Photography has been underestimated by some and overestimated by others. It seems to have now reached a position of mutual *laisser vivre*. David Low, the best of living cartoonists, expressed it as follows.★ 'Modern photography has made, and is going to make, life much more difficult in future for the more "literary" type of artist. It is all very well to talk slightingly about machine-made pictures, but we begin to find that when the machine is guided by a sensitive operator, surprising qualities of artistry may be infused into the results. I have seen photographs which entitle their makers almost to call themselves creative artists. While I anticipate that the future will see a vastly improved photography ousting more strictly representational forms of graphic art, real artists will not worry about it; they will merely be encouraged to move forward to fields beyond – fields they should have been exploiting long ago anyway.'

Lee Miller

I Worked with Man Ray

(First published in *Lilliput*, October 1941)

This is a remarkably self-effacing account of Lee Miller's time with Man Ray. Belying its title (which was more likely *Lilliput*'s rather than her own) it leaves her out of the picture altogether. Not only was she Man Ray's lover and his model for many of his most famous nudes and portraits, but she herself had a hand in the accidental discovery which led to the solarization process.

 At the time this article was published Lee Miller was photographing blitzed London; pictures which were soon to appear in the US in a book titled *Grim Glory: Pictures of Britain under fire*.

MAN RAY bought his first camera in order to reproduce his cubist paintings. That was in Paris in 1919. He became enslaved by the djinn in the black box, which in a second achieved the same effect as all his years of skilled draughtsmanship. He found the film's delicate infinity of tones accomplished what he had achieved after days of work, with his air brush. Temporarily he forsook painting and became in a short time a pioneer of modern photography.

 Man Ray, American born, is by nature neat, accurate, critical and ingenious. He not only studies his mistakes to improve his technique, but has

★ [In a letter to the author.]

sometimes contrived to put his errors to work for him. A laboratory accident, irretrievable disaster in someone else's hands, was the birth of a new and startling technique – solarization! A faulty lighting connection while developing a film accidentally exposed it to a strong light in the middle of the process. Ray realized the possibilities of this and soon turned it into a useful and predictable medium.

Man Ray has been called the photographers' photographer and the poets'. His friends and collaborators in Paris, in the twenty years after the last war, included all the prominent personalities in Modern Art activity – Cubism, Dadaism, and Surrealism. Picasso used his cameras and understood more; Man Ray made drawings for Paul Eluard to make into poems; Max Ernst made sculpture with gardening tools; Duchamps became chess champion; Breton discovered Mexico – everyone worked with everyone else. The interplay of ideas refreshed and stimulated everyone's work.

Together they made the first Surrealist film in which they all acted, and during this time Man Ray's influence in photography was spreading in widening circles over the world.

He believed that every advance in his medium should be made accessible to every other artist and generously told how he achieved his effects. Rayograms, which are shadow photographs without a camera, the underwater eeriness of the film *Etoile de Mer*, the elongation and distortion of his fashion pictures, solarization and more remote things to do with paper, chemicals and the quality of light became public property, and he pioneered against the soft focus lens, with its phoney smug gloss of artiness in the same spirit as the painters revolted against the sentimental forms of academic art.

He dislikes the 'candid camera' attitude in portraiture, as an invasion of privacy.

In some ways he manages to express his personal mood in a picture of even ordinary objects without rearranging or staging them – so that the picture never becomes a catalogue list of what was in front of his lens.

He dislikes elaborate cameras and prefers borrowing a child's box Brownie rather than burden himself with equipment when travelling. He freezes when someone says, 'What a wonderful lens you must have!'

Man Ray's lack of respect for his material and his irreverence of reality is in this tradition. Whether he paints by squeezing the tube directly on to the canvas in a solid wormlike squiggle, or patiently stipples his canvas for weeks; whether he just presses the button and lets someone else do the rest, or manipulates the prints and negatives in the lab himself, fiddling with formulae and control – he is interested in the end, not the means.

He is as contemptuous of the criticism 'facile' as he is of the implied compliment in the reverse.

He believes that the gods, looking from a height, find all surfaces smooth and clear, but an ant falling into the crevasses finds it all pretty horrid and a lot of work.

That every object and every person is beautiful, and that the artist's job is to find the moment, the angle, or the surroundings which reveal that beauty.

Rosalind Krauss

The Photographic Conditions of Surrealism

(First published in *October*, No. 19, Winter 1981, and reprinted in Krauss's collection of essays, *The Originality of the Avant-garde and Other Modernist Myths*, MIT Press, 1985, pp. 87–118)

In the second half of the '70s cultural criticism began to be influenced by theories of representation drawing on the linguistic and semiological studies of Sausurre, Derrida, Barthes and Lévi-Strauss. The structure of a work, rather than the artist's intentions or biography, became a key to meaning. Here, Rosalind Krauss uses structuralist tools to analyse the importance of photography within the Surrealist project of registering 'the marvellous'.

I OPEN MY subject with a comparison. On the one hand, there is Man Ray's *Monument to de Sade*, a photograph made in 1933 for the magazine *Le Surréalisme au service de la révolution*. On the other, there is a self-portrait by Florence Henri, given wide exposure by its appearance in the 1929 *Foto-Auge*, a publication that catalogued the European avant-garde's position with regard to photography. This comparison involves, then, a slight adulteration of my subject – surrealism – by introducing an image deeply associated with the Bauhaus. For Florence Henri had been a student of Moholy-Nagy, although at the time of *Foto-Auge* she had returned to Paris. Of course the purity of *Foto-Auge's* statement had already been adulterated by the presence within its covers of certain surrealist associates, like Man Ray, Maurice Tabard, and E. T. L. Mesens. But by and large *Foto-Auge* is dominated by German material and can be conceived of as organizing a Bauhaus view of photography, a view that we now think of as structured by the Vorkors's obsession with form.

Indeed, one way of eavesdropping on a Bauhaus-derived experience of this photograph is to read its analysis from the introduction to a recent reprint portfolio of Henri's work. Remarking that she is known almost exclusively through this self-portrait, the writer continues,

> Its concentration and structure are so perfect that its quintessence is at once apparent. The forceful impression it produces derives principally from the subject's intense gaze at her own reflection. . . . Her gaze passes dispassionately through the mirror and is returned – parallel to the lines made by the joints in the table. . . . The balls – normally symbols of movement – here strengthen the impression of stillness and undisturbed contemplation. . . . They have been assigned a position at the vertex of the picture . . . their

exact position at the same time lends stability to the structure and provides the dominant element of the human reflection with the necessary contrast.[1]

In light of the writer's determination to straightjacket this image within the limits of an abstracting, mechanically formalist discourse, the strategy behind a juxtaposition of Man Ray's photograph with Florence Henri's becomes apparent. Because the comparison forces attention away from the contents of the Henri – whether those contents are conceived of as psychological (the 'intense gaze' and its dispassionate stare) or as formal (the establishment of stillness through structural stability, etc.). And being turned from the photograph's contents, one's attention is relocated on the container – on what could be called the character of the frame as sign or emblem. For the Henri and the Man Ray share the same recourse to the definition of a photographic subject through the act of framing it, even as they share the same enframing shape.

In both cases one is treated to the capture of the photographic subject by the frame, and in both, this capture has a sexual import. In the Man Ray the act of rotation, which transmutes the sign of the cross into the figure of the phallus, juxtaposes an emblem of the Sadean act of sacrilege with an image of the object of its sexual pleasure. And two further aspects of this image bespeak the structural reciprocity between frame and image, container and contained. The lighting of the buttocks and thighs of the subject is such that physical density drains off the body as it moves from the center of the image, so that by the time one's gaze approaches the margins, flesh has become so generalized and flattened as to be assimilated to printed page. Given this threat of dissipation of physical substance, the frame is experienced as shoring up the collapsing structure of corporeality and guaranteeing its density by the rather conceptual gesture of drawing limits. This sense of the structural intervention of frame inside contents is further deepened by the morphological consonance – what we could call the visual rhyming – between shape of frame and shape of figure: for the linear intersections set up by the clefts and folds in the photographed anatomy mimic the master shape of the frame. Never could the object of violation have been depicted as more willing.

In Florence Henri's self-portrait there is a similar play between flatness and fullness, as there is a parallel sense of the phallic frame as both maker and captor of the sitter's image. Within the spell of this comparison, the chromed balls function to project the experience of phallicism into the center of the image, setting up (as in the Man Ray) a system of reiteration and echo; and this seems far more imperatively their role than that of promoting the formal values of stillness and balance.

It can, of course, be objected that this comparison is tendentious. That it is a false analogy. That it suggests some kind of relationship between these two artists that cannot be there since they operate from across the rift that separates two aesthetic positions: Man Ray being a surrealist and Florence Henri being committed to an ideology of formal rigor and abstraction received initially from Léger and then from the Bauhaus. It can be argued that if there is a kind of

phallicism in Henri's portrait, it is there inadvertently; she could not really have intended it.

As art history becomes increasingly positivist, it holds more and more to the view that 'intention is some internal, prior mental event causally connected with outward effects, which remain the evidence for its having occurred,' and thus, to say that works of art are intentional objects is to say that each bit of them is separately intended.[2] But, sharing neither this positivism nor this view of consciousness, I have no scruples in using the comparative method to wrest this image from the protective hold of Miss Henri's 'intention' and to open it, by analogy, to a whole range of production that was taking place at the same time and in the same locale.

Yet with these two images I do not mean to introduce an exercise in comparative iconography. As I said, the area of interest is far less in the contents of these photographs than it is in their frame. Which is to say that if there is any question of phallicism here, it is to be found within the whole photographic enterprise of framing and thereby capturing a subject. Its conditions can be generalized way beyond the specifics of sexual imagery to a structural logic that subsumes this particular image and accounts for a wide number of decisions made by photographers of this time, both with regard to subject and to form. The name that an entirely different field of critical theory gives to this structural logic is 'the economy of the supplement.'[3] And what I intend to reveal in the relatedness of photographic practice in France and Germany in the 1920s and '30s is a shared conception of photography as defined by the supplement.

But I am getting ahead of my argument. My reason at the outset for introducing my subject by means of comparison is that I wish to invoke the comparative method *as such*, the comparative method as it was introduced into art-historical practice in order to focus on a wholly different object than that of intention. The comparative method was fashioned to net the illusive historical beast called style, a prey which, because it was transpersonal, was understood as being quite beyond the claims of either individual authorship or intention. This is why Wölfflin believed the lair of style to be the decorative arts rather than the domain of masterpieces, why he looked for it — Morelli-fashion — in those areas that would be the product of inattention, a lack of specific 'design' — going so far as to claim that the 'whole development of world views' was to be found in the history of the relationship of gables.

Now it is precisely *style* that continues to be a vexing problem for anyone dealing with surrealist art. Commenting on the formal heterogeneity of a movement that could encompass the abstract liquifaction of Miró on the one hand, and the dry realism of Magritte or Dali on the other, William Rubin addresses this problem of style, declaring that 'we cannot formulate a definition of Surrealist painting comparable in clarity with the meanings of Impressionism and Cubism.'[4] Yet as a scholar who has to think his way into and around the mass of material that is said to be surrealist, Rubin feels in need of what he calls an '*intrinsic* definition of Surrealist painting.' And so he produces what he claims to be 'the first such definition ever proposed.' His definition is that there are two poles of surrealist endeavor — the automatist/abstract and the academic/

illusionist — the two poles corresponding to 'the Freudian twin props of Surrealist theory, namely automatism [or free association] and dreams.' Although these two pictorial modes look very unlike indeed, Rubin continues, they can be united around the concept of the irrationally conceived metaphoric image.

Now, in 1925 André Breton began to examine the subject surrealism and painting, and from the outset he characterized his material in terms of the very twin poles — automatism and dream — and the subject matter of Rubin's later definition.[5] If forty years afterward Rubin was so unhappy with Breton's attempt at a synthetic statement that he had to claim to have produced *the first such definition ever*, it is undoubtedly because Rubin, like everyone else, has been unconvinced that Breton's *was* a definition in the first place. If one wishes to produce a synthesis between A and B, it is not enough simply to say, 'A plus B.' A synthesis is rather different from a list. And it has long been apparent that a catalogue of subject matter held in common is neither necessary nor sufficient to produce the kind of coherence one is referring to by the notion of style.

If Rubin's nondefinition is a mirror-image of Breton's earlier one, this relationship is important, because it locates Breton's own theory as a source for the problem confronting all subsequent discussions. But Breton, as the most central spokesman for surrealism, is an obstacle one must surmount; one cannot avoid him, if the issue is to deal with the movement comprehensively — as one must if a synthetic notion like style is involved.

The same failure to *think* the formal heterogeneity of Miró and Magritte into something like stylistic unity plagues every effort of Breton as theoretician of the movement. Attempting to define surrealism, Breton produces instead a series of contradictions which, like the one between the linearity of Magritte and the colorism of Miró, strike one as being irreducible.

Thus, Breton introduces 'Surrealism and Painting' with a declaration of the absolute value of vision among the sensory modes. Rejecting the late nineteenth-century dictum that all art should aspire to the condition of music, an idea very much alive among twentieth-century abstract artists, Breton insists that 'visual images attain what music never can,' and he bids this great medium farewell with the words, 'so may night continue to descend upon the orchestra.' His hymn of praise to vision had begun, 'The eye exists in its savage state. The marvels of the earth . . . have as their sole witness the wild eye that traces all its colors back to the rainbow.' And by this statement he is contrasting the immediacy of vision — its perceptual automatism, as it were — to the premeditated, reflective gait of thought. The savageness of vision is good, pure, uncontaminated by ratiocination; the calculations of reason (which Breton never fails to call 'bourgeois reason') are controlling, degenerate, bad.

Besides being untainted by reason, vision's primacy results from the way its objects are present to it, through an immediacy and transparency that compels belief. Indeed, Breton often presents surrealism-as-a-whole as defined by visuality. In the *First Manifesto* he locates the very invention of psychic automatism within the experience of hypnogogic images — that is, of half-waking, half-dreaming, visual experience.

But as we know, the privileged place of vision in surrealism is immediately challenged by a medium given a greater privilege: namely, writing. Psychic automatism is itself a written form, a 'scribbling on paper,' a textual production. And when it is transferred to the domain of visual practice, as in the work of André Masson, automatism is no less understood as a kind of writing. Breton describes Masson's automatic drawings as being essentially cursive, scriptorial, the result of 'this hand, enamoured of its own movement and of that alone.' 'Indeed,' Breton writes, 'the essential discovery of surrealism is that, without preconceived intention, the pen that flows in order to write and the pencil that runs in order to draw *spin* an infinitely precious substance.'[6] So, in the very essay that had begun by extolling the visual and insisting on the impossibility of imagining a 'picture as being other than a window,' Breton proceeds definitively to choose writing over vision, expressing his distaste for the 'other road available to Surrealism,' namely, 'the stabilizing of dream images in the kind of still-life deception known as trompe l'oeil (and the very word "deception" betrays the weakness of the process).'[7]

Now this distinction between writing and vision is one of the many antinomies that Breton speaks of wanting surrealism to dissolve in the higher synthesis of a surreality which will, in this case, 'resolve the dualism of perception and representation.'[8] It is an old antinomy within Western culture, and one which does not simply hold these two things to be opposite forms of experience, but places one higher than the other. Perception is better, truer, because it is immediate to experience, while representation must always remain suspect because it is never anything but a copy, a re-creation in another form, a set of signs for experience. Perception gives directly onto the real, while representation is set at an unbridgeable distance from it, making reality present only in the form of substitutes, that is, through the proxies of signs. Because of its distance from the real, representation can thus be suspected of fraud.

In preferring the products of a cursive automatism to those of visual, imagistic depiction, Breton appears to be reversing the classical preference of vision to writing, of immediacy to dissociation. For in Breton's definition, it is the pictorial image that is suspect, a 'deception,' while the cursive one is true.[9]

Yet in some ways this apparent reversal does not really overthrow the traditional Platonic dislike of representation, because the visual imagery Breton suspects is a picture and thus the representation of a dream rather than the dream itself. Breton, therefore, continues Western culture's fear of representation as an invitation to deceit. And the truth of the cursive flow of automatist writing or drawing is less a representation of something than it is a manifestation or recording: like the lines traced on paper by the seismograph or the cardiograph. What this cursive web makes present by making visible is a direct experience of what Breton calls 'rhythmic unity,' which he goes on to characterize as 'the absence of contradiction, the relaxation of emotional tensions due to repression, a lack of the sense of time, and the replacement of external reality by a psychic reality obeying the pleasure principle alone.'[10] Thus the unity produced by the web of automatic drawing is akin to what Freud called the oceanic feeling – the infantile, libidinal domain of pleasure not yet

constrained by civilization and its discontents. 'Automatism,' Breton declares, 'leads us in a straight line to this region,' and the region he has in mind is the unconscious.[11] With this directness, automatism makes the unconscious, the oceanic feeling, present. Automatism may be writing, but it is not, like the rest of the written signs of Western culture, representation. It is a kind of presence, the direct presence of the artist's inner self.[12] This sense of automatism as a manifestation of the innermost self, and thus not representation at all, is also contained within Breton's description of automatic writing as 'spoken thought.' Thought is not a representation but is that which is utterly transparent to the mind, immediate to experience, untainted by the distance and exteriority of signs.

But this commitment to automatism and writing as a special modality of presence, and a consequent dislike of representation as a cheat, is not consistent in Breton, who contradicts himself on this matter as he contradicts himself on almost every point in surrealist theory. In many places we find Breton declaring, 'It makes no difference whether there remains a perceptible difference between beings which are evoked and beings which are present, since I dismiss such differences out of hand at every moment of my life.'[13] And as we will see, the welcome Breton accords to representation, to signs, is very great indeed, for representation is the very core of his definition of Convulsive Beauty, and Convulsive Beauty is another term for the Marvelous, which is the great talismanic concept at the heart of surrealism itself.

The contradictions about the priorities of vision and representation, presence and sign, are typical of the confusions within surrealist theory. And these contradictions are focused all the more clearly if one reflects on Breton's position on photography. Given his aversion to 'the real forms of real objects,' and his insistence on another order of experience, we would expect Breton to despise photography. As the quintessentially realist medium, photography would have to be rejected by the poet who insisted that 'for a total revision of real values, the plastic work of art will either refer to a *purely internal model* or will cease to exist.'[14]

But in fact Breton has a curious tolerance for photography. Of the first two artists that he claimed for surrealism proper – Max Ernst and Man Ray – one of them was a photographer. And if we imagine that he accepted Man Ray on the basis of the presumed anti-realism of the rayographs, this is in fact not so. Breton protested against characterizing the rayographs as abstract or making any distinction between Man Ray's cameraless photography and that produced with a normal lens.[15] But even more than his support for specific photographers, Breton's placement of photography at the very heart of surrealist publication is startling. In 1925 he had asked, 'and when will all the books that are worth anything stop being illustrated with drawings and appear only with photographs?'[16]

This was not an idle question, for Breton's next three major works were indeed 'illustrated' with photographs. *Nadja* (1928) bore images almost exclusively by Boiffard; *Les Vases communicants* (1932) has a few film stills and photographic documents; and the illustrative material for *L'Amour fou* (1937)

was divided for the most part between Man Ray and Brassaï. Within the high oneiric atmosphere of these books, the presence of the photographs strikes one as extremely eccentric — an appendage to the text that is as mysterious in its motivation as the images themselves are banal. In writing about surrealism Walter Benjamin focuses on the curious presence of these 'illustrations.'

> In such passages photography intervenes in a very strange way. It makes the streets, gates, squares of the city into illustrations of a trashy novel, draws off the banal obviousness of this ancient architecture to inject it with the most pristine intensity towards the events described, to which, as in old chambermaids' books, word-for-word quotations with page numbers refer.[17]

But photography's presumed eccentricity to surrealist thought and practice must itself be reconsidered. For it was not injected into the very heart of the surrealist text only in the work of Breton; it was the major visual resource of the surrealist periodicals. The founding publication of the movement, *La Révolution surréaliste*, bore no visual relation to the vanguardist typographic extravaganzas of the Dada broadsheets. Rather, at the instigation of Pierre Naville, it was modeled specifically on the scientific magazine *La Nature*. Conceived almost exclusively as the publication of documents, the first issues of *La Révolution surréaliste* carried two types of verbal testimony: specimens of automatic writing and records of dreams. Sober columns of test carrying this data are juxtaposed with visual material, most of it Man Ray's photographs, all of it having the documentary impact of illustrative evidence.

Naville's hostility to the traditional fine arts was well known, and the third issue of the journal carried his declaration: 'I have no tastes except distaste. Masters, master-crooks, smear your canvases. Everyone knows there is no *surrealist painting*. Neither the marks of a pencil abandoned to the accident of gesture, nor the image retracing the forms of the dream. . . .' But spectacles, he insists, are acceptable. 'Memory and the pleasure of the eyes,' Naville writes, 'that is the whole aesthetic.' The list of things conducive to this visual pleasure includes streets, kiosks, automobiles, cinema, and photographs.[18]

One of the effects of the extraordinary 1978 Hayward Gallery exhibition, *Dada and Surrealism Reviewed*, was to begin to force attention away from the pictorial and sculptural production that surrounds surrealism and onto the periodicals, demonstrating the way that journals formed the armature of these movements. Witnessing the parade of surrealist magazines — *La Révolution surréaliste, Le Surréalisme au service de la révolution, Documents, Minotaure, Marie, The International Surrealist Bulletin, VVV, Le Surréalisme, même*, and many others — one becomes convinced that *they* more than anything else are the true objects produced by surrealism. And with this conviction comes an inescapable association to the most important statement yet made about the vocation of photography: Benjamin's 'The Work of Art in the Age of Mechanical Reproduction,' and from there to one of the phenomena that Benjamin speaks of in the course of sketching the new terrain of art-after-photography, namely, the illustrated magazine, which is to say, photograph plus text.

At the very moment when Benjamin was making his analysis, the surrealists were quite independently putting it into practice. And that they were doing so is something that traditional art history, with its eye focused on works of fine art, has tended to miss.

If we add these two things together: namely the primacy the surrealists themselves gave to the illustrative photograph, and the failure of stylistic concepts derived from the formal, pictorial code – distinctions like linear/painterly or representational/abstract – to forge any kind of unity from the apparent diversity of surrealist production, the failure to arrive, that is, at what Rubin called an *intrinsic definition* of surrealism, we might be led to the possibility that it is within the photographic rather than the pictorial code that such a definition is to be found – that is, that issues of surrealist heterogeneity will be resolved around the semiological functions of photography rather than the formal properties operating the traditional art-historical classifications of style. What is at stake, then, is the relocation of photography from its eccentric position relative to surrealism to one that is absolutely central – definitive, one might say.

Now, it may be objected that in turning to photography for a principle of unification, one is simply replacing one set of problems with another. For the same visual heterogeneity reigns within the domain of surrealist photography as within its painting and sculpture. Quickly examining the range of surrealist photographic forms, we can think of 1) the absolutely banal images Boiffard created for Breton's *Nadja*; 2) the less banal but still straight photographs made by Boiffard for *Documents* in 1929, such as the ones made for Georges Bataille's essay on the big toe; 3) still 'straight,' but raising certain questions about the status of photographic evidence, the documentations of sculptural objects that have no existence apart from the photograph, which were immediately dismantled after being recorded (examples are by Hans Bellmer and Man Ray); moving, then, into the great range of processes used to manipulate the image; 4) the frequent use of negative printing; 5) the recourse to multiple exposure or sandwich printing to produce montage effects; 6) various kinds of manipulations with mirrors, as in the Kertész *Distortion* series; 7) the two processes made famous by Man Ray, namely solarization and the cameraless image of the rayograph – the latter having a rather obvious appeal to surrealist sensibilities because of the cursive, graphic quality of the images against their flattened, abstracted ground and because of the psychological status these ghosts of objects seem to have attained – Ribemont-Dessaignes calling them 'these objects of dreams,' Man Ray himself locating them more within the domain of memory by their effect of 'recalling the event more or less clearly, like the undisturbed ashes of an object consumed by flames';[19] 8) the technique Raoul Ubac called brûlage, in which the emulsion is burned (which literalizes Man Ray's evocative description of the rayograph), the process having arisen from an attempt to assimilate photography fully into the domain of automatic practice, just as the series of graphic manipulations that Brassaï made in the mid-1930s attempted to open photographic information to a direct relationship with a kind of automatist, drawn image.

Long as this list is, there is one form still missing from it, namely, photo-montage. This form, pioneered by Dada, was rarely employed by surrealist photographers, though it was attractive to certain of the surrealist poets, who made photomontages themselves. One important example is André Breton's 1938 self-portrait entitled *Automatic Writing*.

Breton's self-portrait, fabricated from various photographic elements, is not only an example of photomontage — a process distinct from combination printing insofar as the term refers, for the most part, to the cutting up and reassembling of already printed material — but it is also an instance of construc-tion *en abyme*. It is the microscope as representative of a lensed instrument that places within the field of the representation another representation that re-duplicates an aspect of the first, namely the photographic process by which the parts were originally made. And if Breton does this, it is to set up the intellectual rhyme between psychic automatism as a process of mechanical recording and the automatism associated with the camera — 'that blind instru-ment,' as Breton says. His own association of these two mechanical means of registration occurs as early as 1920, when he declared that 'automatic writing, which appeared at the end of the nineteenth century, is a true photography of thought.'[20]

But if an icon of the lens's automatism is placed inside this image entitled *Écriture-Automatique*, what, we might ask, of the concept of writing itself? Is that not entirely foreign to the purely visual experience of photography — a visuality itself symbolized as heightened and intensified by the presence of the microscope? Faced with this image and its caption, are we not confronted with yet another instance of the constant juxtaposition of writing and vision, a juxtaposition that leads nowhere but to theoretical confusion? It is my intention to show that this time it leads not to confusion but to clarity, to exactly the kind of dialectical synthesis of opposites that Breton had set out as the program for surrealism. For what I wish to claim is that the notion of *écriture* is pictured inside this work through the very fabric of the image's making, that is, through the medium of montage.

Throughout the avant-garde in the 1920s, photomontage was understood as a means of infiltrating the mere picture of reality with its meaning. This was achieved through juxtaposition: of image with image, or image with drawing, or image with text. John Heartfield said, 'A photograph can, by the addition of an unimportant spot of color, become a photomontage, a work of art of a special kind.'[21] And what kind this was to be is explained by Tretyakov when he wrote, 'If the photograph, under the influence of the text (or caption), expresses not simply the fact which it shows, but also the social tendency expressed by the fact, then this is already a photomontage.'[22] Aragon seconded this insistence on a sense of reality bearing its own interpretation when he described Heartfield's work, 'As he was playing with the fire of appearance, reality took fire around him. . . . The scraps of photographs that he former-ly manoeuvred for the pleasure of stupefaction, under his fingers began to *signify*.'[23]

This insistence on signification as a political act, on a revision of photo-

graphy away from the surfaces of the real, was preached by Bertolt Brecht, who said, 'A photograph of the Krupp works or GEC yields almost nothing about these institutions. . . . Therefore something has actively to be *constructed*, something artificial, something set-up.'[24] This was a position that was uncongenial to the proto-surrealist Max Ernst, who dismissed the Berlin dadaists with the words, 'C'est vraiment allemand. Les intellectuels allemands ne peuvent pas faire ni caca ni pipi sans des idéologies.'[25] But photomontage was nonetheless the medium of the *Fatagagas* and remained an abiding principal in Ernst's later work; and when Aragon wrote about the effect of the separate elements in Ernst's montages he compared them to 'words.'[26] By this he refers not only to the transparency of each signifying element (by contrast with the opacity of the pieces of cubist collages), but also to the experience of each element as a separate unit which, like a word, is conditioned by its placement within the syntagmatic chain of the sentence, is controlled by the condition of syntax.

Whether we think of syntax as temporal – as the pure succession of one word after another within the unreeling of the spoken sentence; or whether we think of it as spatial – as the serial progression of separate units on the printed page; syntax in either dimension reduces to the basic exteriority of one unit to another. Traditional linguistics contemplates this pure exteriority as that fissure or gap or blank that exists between signs, separating them one from the other, just as it also thinks of the units of the sign itself as riven into two parts – one irremediably outside or exterior to the other. The two parts are signified and signifier – the first the meaning of the sign, a meaning transparent to thought held within consciousness; the second, the mark or sound that is the sign's material vehicle. 'The order of the signified,' Derrida writes, stating the position of traditional linguistics, 'is never contemporary, is at best the subtly discrepant inverse or parallel – discrepant by the time of a breath – from the order of the signifier.'[27] For Derrida, of course, spacing is not an exteriority that signals the outside boundaries of meaning: one signified's end before another's onset. Rather, spacing is radicalized as the precondition for meaning as such, and the outsideness of spacing is revealed as already constituting the condition of the 'inside.' This movement, in which spacing 'invaginates' presence, will be shown to illuminate the distinction between surrealist photography and its dada predecessor.

In dada montage the experience of blanks or spacing is very strong, for between the silhouettes of the photographed forms the white page announces itself as the medium that both combines and separates them. The white page is not the opaque surface of cubist collage, asserting the formal and material unity of the visual support; the white page is rather the fluid matrix within which each representation of reality is secured in isolation, held within a condition of exteriority, of syntax, of spacing.

The photographic image, thus 'spaced,' is deprived of one of the most powerful of photography's many illusions. It is robbed of a sense of presence. Photography's vaunted capture of a moment in time is the seizure and freezing of presence. It is the image of simultaneity, of the way that everything within a given space at a given moment is present to everything else; it is a declaration

of the seamless integrity of the real. The photograph carries on one continuous surface the trace or imprint of all that vision captures in one glance. The photographic image is not only a trophy of this reality, but a document of its unity as that-which-was-present-at-one-time. But spacing destroys simultaneous presence: for it shows things sequentially, either one after another or external to one another — occupying separate cells. It is spacing that makes it clear — as it was to Heartfield, Tretyakov, Brecht, Aragon — that we are not looking at reality, but at the world infested by interpretation or signification, which is to say, reality distended by the gaps or blanks which are the formal preconditions of the sign.

Now, as I said, the surrealist photographers rarely used photomontage. Their interest was in the seamless unity of the print, with no intrusions of the white page. By preserving the body of the print intact, they could make it read photographically, that is to say, in direct contact with reality. But without exception the surrealist photographers infiltrated the body of this print, this single page, with spacing. Sometimes they mimicked photomontage by means of combination printing. But that is the least interesting of their strategies, because it does not create, forcefully enough, an experience of the real itself as sign, the real fractured by spacing. The cloisonné of the solarized print is to a greater extent testimony to this kind of cleavage in reality. As are the momentarily unintelligible gaps created by negative printing. But more important than anything else is the strategy of doubling. For it is doubling that produces the formal rhythm of spacing — the two-step that banishes the unitary condition of the moment, that creates *within* the moment an experience of fission. For it is doubling that elicits the notion that to an original has been added its copy. The double is the simulacrum, the second, the representative of the original. It comes after the first, and in this following, it can only exist as figure, or image. But in being seen in conjunction with the original, the double destroys the pure singularity of the first. Through duplication, it opens the original to the effect of difference, of deferral, of one-thing-after-another, or within another: of multiples burgeoning within the same.

This sense of deferral, of opening reality to the 'interval of a breath,' we have been calling (following Derrida) *spacing*. But doubling does something else besides the transmutation of presence into succession. It marks the first in the chain as a signifying element: it transmutes raw matter into the conventionalized form of the signifier. Lévi-Strauss describes the importance of pure phonemic doubling in the onset of linguistic experience in infancy — the child's dawning knowledge of signs.

> Even at the babbling stage the phoneme group /pa/ can be heard. But the difference between /pa/ and /papa/ does not reside simply in reduplication: /pa/ is a noise, /papa/ is a word. The reduplication indicates intent on the part of the speaker; it endows the second syllable with a function different from that which would have been performed by the first separately, or in the form of a potentially limitless series of identical sounds /papapapa/ produced by mere babbling. Therefore the second /pa/ is not

a repetition of the first, nor has it the same signification. It is a sign that, like itself, the first /pa/ too was a sign, and that as a pair they fall into the category of signifiers, not of things signified.[28]

Repetition is thus the indicator that the 'wild sounds' of babbling have been made deliberate, intentional; and that what they intend is meaning. Doubling is in this sense the 'signifier of signification.'[29]

From the perspective of formed language, the phonemes /pa/ or /ma/ seem less like wild sounds and more like verbal elements *in potentia*. But if we think of the infant's production of gutturals and glottal stops, and other sounds that do not form a part of spoken English, we have a stronger sense of this babbling as the raw material of sonic reality. Thus /pa/ moving to /papa/ seems less disconnected from the case of photographic doubling, where the material of the image is the world in front of the camera.

As I said above, surrealist photography exploits the special connection to reality with which all photography is endowed. For photography is an imprint or transfer off the real; it is a photochemically processed trace causally connected to that thing in the world to which it refers in a manner parallel to that of fingerprints or footprints or the rings of water that cold glasses leave on tables. The photograph is thus generically distinct from painting or sculpture or drawing. On the family tree of images it is closer to palm prints, death masks, the Shroud of Turin, or the tracks of gulls on beaches. For technically and semiologically speaking, drawings and paintings are icons, while photographs are indexes.

Given this special status with regard to the real, being, that is, a kind of deposit of the real itself, the manipulations wrought by the surrealist photographers – the spacings and doublings – are intended to register the spacings and doublings of that very reality of which *this* photograph is merely the faithful trace. In this way the photographic medium is exploited to produce a paradox: the paradox of reality constituted as sign – or presence transformed into absence, into representation, into spacing, into writing.

Now this is the move that lies at the very heart of surrealist thinking, for it is precisely this experience of *reality as representation* that constitutes the notion of the Marvelous or of Convulsive Beauty – the key concepts of surrealism.[30] Towards the beginning of *L'Amour fou* there is a section that Breton had published on its own under the title 'Beauty Will Be Convulsive. . . .' In this manifesto Breton characterizes Convulsive Beauty in terms of three basic types of example. The first falls under the general case of mimicry – or those instances in nature when one thing imitates another – the most familiar, perhaps, being those markings on the wings of moths that imitate eyes. Breton is enormously attracted to mimicry, as were all the surrealists, *Documents* having, for example, published Blossfeldt's photographs of plant life imitating the volutes and flutings of classical architecture. In 'Beauty Will Be Convulsive' the instances of mimicry Breton uses are the coral imitations of plants on the Great Barrier Reef and 'The Imperial Mantle,' from a grotto near Montpellier, where a wall of quartz offers the spectacle of natural carving, producing the image of drapery

'which forever defies that of statuary.' Mimicry is thus an instance of the natural production of signs, of one thing in nature contorting itself into a representation of another.

Breton's second example is 'the expiration of movement' – the experience of something that should be in motion but has been stopped, derailed, or, as Duchamp would have said, 'delayed.' In this regard Breton writes, 'I am sorry not to be able to reproduce, among the illustrations to this text, a photograph of a very handsome locomotive after it had been abandoned for many years to the delirium of a virgin forest.'[31] That Breton should have wanted to show a photograph of this object is compelling because the very idea of stop-motion is intrinsically photographic. The convulsiveness, then, the arousal in front of the object, is to a perception of it detached from the continuum of its natural existence, a detachment which deprives the locomotive of some part of its physical self and turns it into a sign of the reality it no longer possesses. The still photograph of this stilled train would thus be a representation of an object already constituted as a representation.

Breton's third example consists of the found-object or found verbal fragment – both instances of objective chance – where an emissary from the external world carries a message informing the recipient of his own desire. The found-object is a *sign* of that desire. The particular object Breton uses at the opening of *L'Amour fou* is a perfect demonstration of Convulsive Beauty's condition as sign. The object is a slipper-spoon that Breton found in a flea market, and which he recognized as a fulfillment of the wish spoken by the automatic phrase that had begun running through his mind some months before – the phrase *cendrier Cendrillon*, or Cinderella ashtray. The flea-market object became something that signified for him as he began to see it as an extraordinary *mise-en-abyme*: a chain of reduplications to infinity in which the spoon and handle of the object was seen as the front and last of a shoe of which the little carved slipper was the heel. Then *that* slipper was imagined as having for its heel another slipper, and so on to infinity. Breton read the natural writing of this chain of reduplicated slippers as signifying his own desire for love and thus as the sign that begins the quest of *L'Amour fou*.[32]

If we are to generalize the aesthetic of surrealism, the concept of Convulsive Beauty is at the core of that aesthetic: reducing to an experience of reality transformed into representation. Surreality *is*, we could say, nature convulsed into a kind of writing. The special access that photography has to this experience is its privileged connection to the real. The manipulations then available to photography – what we have been calling doubling and spacing – appear to document these convulsions. The photographs are not *interpretations* of reality, decoding it, as in Heartfield's photomontages. They are presentations of that very reality as configured, or coded, or written. The experience of nature as sign, or nature as representation, comes 'naturally' then to photography. It extends, as well, to that domain most inherently photographic, which is that of the framing edge of the image experienced as cut or cropped. But I would add, though there is no space here to expand on it, that what unites *all* surrealist production is precisely this experience of nature as representation, physical

matter as writing. This is of course not a morphological coherence, but a semiological one.

No account of surrealist photography would be complete if it could not incorporate the unmanipulated images that figure in the movement's publications – works like the Boiffard big toes, or the 'Involuntary Sculptures' photographed by Brassaï for Salvador Dali, or the straight image of a hatted figure by Man Ray made for *Minotaure*. Because it is *this* type that is closest to the movement's heart. But the theoretical apparatus by which to assimilate this genre of photograph has already been developed. And that is the concept of spacing.

Inside the image, spacing can be generated by the cloisonné of solarization or the use of found frames to interrupt or displace segments of reality. But at the very boundary of the image the camera frame which crops or cuts the represented element out of reality-at-large can be seen as another example of spacing. Spacing is the indication of a break in the simultaneous experience of the real, a rupture that issues into sequence. Photographic cropping is *always* experienced as a rupture in the continuous fabric of reality. But surrealist photography puts enormous pressure on that frame to make it itself read as a sign – an empty sign it is true, but an integer in the calculus of meaning: a signifier of signification.

The frame announces that between the part of reality that was cut away and this part there is a difference; and that this segment which the frame frames is an example of nature-as-representation, nature-as-sign. As it signals that experience of reality the camera frame also controls it, configures it. This it does by point-of-view, as in the Man Ray example, or by focal length, as in the extreme close-ups of the Dali. And in both these instances what the camera frames and thereby makes visible is the automatic writing of the world: the constant, uninterrupted production of signs. Dali's images are of those nasty pieces of paper like bus tickets and theater stubs that we roll into little columns in our pockets, or those pieces of eraser that we unconsciously knead – these are what his camera produces through the enlargements that he publishes as involuntary sculpture. Man Ray's photograph is one of several to accompany an essay by Tristan Tzara about the unconscious production of sexual imagery throughout all aspects of culture – this particular one being the design of hats.

The frame announces the camera's ability to find and isolate what we could call the world's constant writing of erotic symbols, its ceaseless automatism. In this capacity the frame can itself be glorified, represented, as in the photograph by Man Ray that I introduced at the outset. Or it can simply be there, silently operating as spacing, as in Brassaï's seizure of automatic production in his series on graffiti.

And now, with this experience of the frame, we arrive at the supplement. Throughout Europe in the twenties and thirties, camera-seeing was exalted as a special form of vision: the New Vision, Moholy-Nagy called it. From the Inkhuk to the Bauhaus to the ateliers of Montparnasse, the New Vision was understood in the same way. As Moholy explained it, human eyesight was,

simply, defective, weak, impotent. 'Helmholtz,' Moholy explained, 'used to tell his pupils that if an optician were to succeed in making a human eye and brought it to him for his approval, he would be bound to say: "This is a clumsy piece of work." ' But the invention of the camera has made up for this deficiency so that now 'we may say that we see the world with different eyes.'[33]

These, of course, are camera-eyes. They see faster, sharper, at stranger angles, closer-to, microscopically, with a transposition of tonalities, with the penetration of X ray, and with access to the multiplication of images that makes possible the writing of association and memory. Camera-seeing is thus an extraordinary extension of normal vision, one that supplements the deficiencies of the naked eye. The camera covers and arms this nakedness, it acts as a kind of prosthesis, enlarging the capacity of the human body.

But in increasing the ways in which the world can be present to vision, the camera mediates that presence, gets between the viewer and the world, shapes reality according to *its* terms. Thus what supplements and enlarges human vision also supplants the viewer himself; the camera is the aid who comes to usurp.

The experience of the camera as prosthesis and the image of it figuring in the field of the photograph is everywhere to be found in the New Vision.[34] In Umbo's self-portrait the camera is represented by a cast shadow whose relationship to the photographer's eyes involves the interesting paradox of all supplementary devices, where the very thing that extends, displaces as well. In this image the camera that literally expands Umbo's vision, allowing him to see himself, also masks his eyes, nearly extinguishing them in shadow.

Florence Henri's self-portrait functions in similar ways. There the camera's frame is revealed as that which masters or dominates the subject, and the phallic shape she constructs for its symbol is continuous with the form that most of world culture has used for the expression of supremacy. The supplement is thus experienced emblematically, through the internalized representation of the camera frame as an image of mastery: camera-seeing essentialized as a superior power of focus and selection from within the inchoate sprawl of the real.

Throughout Europe in the 1920s there was the experience of something supplemental added to reality. That this was coherently experienced and actively configured in the photography made with the supplementary instrument accounts for the incredible coherence of European photography of this period — not, as is sometimes suggested, its diffraction into different sects. But it is my thesis that what the surrealists in particular added to that reality was the vision of it *as* representation or sign. Reality was both extended and replaced or supplanted by that master supplement which is writing: the paradoxical writing of the photograph.

Therese Lichtenstein

A Mutable Mirror: Claude Cahun

(First published in *Artforum*, April 1992)

This and a number of other articles appeared in the US in 1992 on the
occasion of a New York exhibition of Claude Cahun's work. Thanks
to the publication, later that year, of François Leperlier's critical study,
Claude Cahun: L'Ecart et la Metamorphose, a great deal more is now
known about her after decades of relative obscurity.

The question of an elusive persona, a shifting identity, is however at
the heart of her work – the comparison with Cindy Sherman is
apposite. Cahun's body of work gives her a singular place in the
Surrealist movement, one at odds with male representations of
Woman. Perhaps the English translation (from Verso Books) of Leper-
lier's study will lead to a more widespread appreciation of her signifi-
cance.

It seems impossible, in fact, to judge the eye using any word other than
seductive, since nothing is more attractive in the bodies of animals and men.
But extreme seductiveness is probably at the boundary of horror.

– Georges Bataille, *Eye*, 1929

A DISEMBODIED eye stares into yours. Reflected on its surface is a shadowy
trace – an object, or more likely a person: the reflection of the observer
who observes it. This is an eye or 'I' that looks back at you as you look
at it, its self-aware gaze mirroring your gazing. The eye, a cut-out photograph,
is mounted within another image, a silver orb resting on the pedestal created by
a pair of hands and truncated forearms that come down to a base of two lips.
This silver sphere reflects the hands but distorts them, suggesting an anamorphic
projection, an image in a grotesquely transformative mirror. Between reflection
and object reflected are a distance and a difference.

More orbs, hands, and reflections circulate. In the foreground, a series of
spheres suggest celestial bodies, skyscapes, and breasts: to the left, another
silvery sphere rests on two stacked hands, its reflections once again suggesting
an eerie anamorphosis, and also a family of strange embryonic mutations that
plays with the notion of a divided, multiple self. To the right, another pair of
forearms and hands cups yet another sphere – this one a world globe. All is set
against a backdrop of the cosmos, complete with stars and astrological signs. At
top center is a double-headed bird, and the word *Dieu* (god), spelled in a
column from bottom to top. Macroscopic and microscopic worlds collide.

We are looking at an untitled photomontage, the frontispiece of *Aveux non avenus* (Unavowed confessions), a book written and illustrated in 1930 by Claude Cahun.[1] *Aveux non avenus* is an autobiographical collection of poems, aphoristic philosophical fragments, and recollected dreams, all reflections on the identity and androgynous sexuality of their author. It is illustrated by a group of photomontages – again, self-portraits of and by Cahun, bodily displacements and rearrangements in which she manipulates and plays with the representation of her own subjectivity. Self-portraits, in fact, circulate obsessively through all her work.

We may ask the same question the artist herself posed in these portraits: who is Claude Cahun? As the work suggests, there are many answers, but we can begin by saying that she was a little-known Surrealist photographer, writer, and objectmaker, as well as a translator and political activist. Her name was actually a pseudonym. Cahun was born Lucy Schwob, in Nantes in 1894, to a wealthy Jewish intellectual family. The Symbolist writer Marcel Schwob was her uncle – an early influence. But Cahun also began to follow Surrealism when it was new, collecting first editions of the Surrealist books of the '20s and '30s. She was familiar with André Breton's photographic supplements to books such as *Nadja* (1928): and she met Breton himself in late 1932, while both were participating in the Association des Écrivains et Artistes Révolutionnaires, a fusion of an artists' group and a communist trade union.

Cahun also participated in the Contre-Attaque group, which the Surrealists organized in response to the rise of Hitler and the spread of fascism in France. Contre-Attaque advocated an aggressive universal revolution, a new social order for workers and peasants in a union of Marxists and non-Marxists, and a class struggle against nationalism and capitalism.[2] This was as close as Cahun came to membership in a political party: she might best be described as a libertarian anarchist. But her political commitment extended throughout her life and work, and had an explicitly feminist subtext. In examining issues of female self-identity and subjectivity, before they were really formulated as such, Cahun was moving toward her own liberation.[3]

In 1936, with her stepsister and life-long companion, Suzanne Malherbe, Cahun moved from Paris to the Isle of Jersey, in the English Channel, where they had summered as children. (Malherbe often collaborated with Cahun, signing her own pseudonym, 'Moore,' to a number of projects.) Jersey was occupied by the Germans during World War II, and the two women mounted resistance activities such as writing and distributing anti-Nazi leaflets. Cahun was jailed for a time during this period. Indeed, so little was known about her life and work until recently that some believed she had perished in a concentration camp. Actually she survived the war, and died on Jersey in 1954.[4]

The ignorance about Cahun is such that there are source books on Surrealism that refer to her as a man. The error is unwittingly appropriate to her work,

with its complex representation of female sexual identity. Cahun's self-portraits provide an assortment of male and female images. In some photographs her hair is shaven or cropped, she wears a man's suit, and her gaze is frontal, somber, and assertive. In others she wears makeup and a dress – a dress like a rag doll's. She may also put on a mask, perhaps full face, perhaps covering only her eyes, while her head is surrounded by other masks. Such images reveal deliberate and self-conscious choices of persona.

A woman who represents herself as a man may express a desire for access to the kind of power that is part of male privilege in Western culture – or may not. One can dress androgynously and still maintain a relatively conventional sexual identity. Yet to the extent that such representations interrupt the restrictive gender roles assigned to women and men, they can set off complex repercussive chains of empowerment. And in Cahun's case, her androgyny was deeply linked to her lesbianism. It represented a courageous alternative under-standing of what it meant to be a woman. Just how radical a departure it was from the ruling orthodoxy of the Occupation years, and just how physically vulnerable it made her, may be judged from a passage in the diary of a German officer stationed in Jersey during the war:

> There are very few Jews in the islands. The two Jewish women who have just been arrested belong to an unpleasant category. These women had long been circulating leaflets urging German soldiers to shoot their officers. At last they were tracked down. A search of the house, full of ugly cubist paintings, brought to light a quantity of pornographic material of an especially revolting nature. One woman had had her head shaved and been thus photographed in the nude from every angle. Thereafter she had worn men's clothes. Further nude photographs showed both women practicing sexual perversion, exhibitionism and flagellation.[5]

Though less potentially dangerous to her, Cahun's boyish image was also shocking in the context of mainstream French Surrealism. The male Surrealists not only advocated heterosexuality but tended to be homophobic. They may have celebrated Woman as an inspirational muse, but when it came to women, or to any woman in particular, their attitudes were on the whole decidedly limiting. In Surrealist art, women are mostly conceived as a series of unreal stereotypes: as muse, as child, as femme fatale, as ideal. Simone de Beauvoir writes, 'Breton does not speak of woman as a subject deeply anchored in nature, very close to earth, she appears also to be the key to the beyond Truth, Beauty, Poetry – She is All: once more all under the form of the Other. All except herself.'[6]

The Surrealists were at least unified in their general opposition to bourgeois and fascist power structures. Their standard techniques of fragmentation, chance, collage, and montage, their disarticulations and reconstructions of materials, all produced 'nonorganic' artworks quite unlike the classical, 'or-ganic' work of art that establishment ideology could claim as virtually a 'natural' phenomenon to reinforce the status quo. In this sense Surrealist montage operates as a critique of the rationality of consumer capitalist culture.[7] And

Cahun was certainly influenced by this aspect of Surrealism. (She admired Max Ernst, and owned one of his photomontages, as well as a painting by Joan Miró.) But if the structures and techniques of her works resemble those of the male Surrealists, their content does not.

Cahun and the other female Surrealists of the '30s set out to represent their own identity.[8] But whereas artists like Léonor Fini and Leonora Carrington tended to portray women in conventional mythological and allegorical terms, Cahun constructed a bigendered or androgynous identity, photographing herself in a series of masquerades alternating between feminine and masculine personas. Her photomontages consist of fragmented body parts arranged totemically like rebuses that form no coherent whole. These displays of compartmentalized, disembodied fragments resemble the products of the Surrealist parlor game *Cadavre exquis*, or 'Exquisite corpse,' in which different artists would each write a phrase, or draw an image, to construct a composite sentence or drawing, the overall form of which they would grasp only when the work was completed.

Cahun often recycles the same photographs in different photomontages, or crops photographs she has used elsewhere as single images and recombines them in a kind of random graft. In doing so she is exploring a notion of the self as an accumulation of selves, or a shifting set of social relations, establishing a desta-bilized self-portrait that posits identity as contingent and mutable. The sense of multiple selves, of masquerade, of gender as a series of conventions, and also of narcissism in her work prefigures Cindy Sherman's photography – the black and white 'Untitled Film Stills' of the late '70s and the color images of the '80s and '90s, which stage stereotypical and historical feminine identities as self-portraits. Cahun's montages engage the viewer in an idea of identity as liberating transfor-mation, as constant becoming. The many birth images in works such as *I.O.U. (Self-Pride)*, ca. 1930, extend this sense of the self as ever new. But there is also the sad feeling of a soul wandering in limbo from one mask to another. Is this sexually indeterminate presence a liberated self or a self in crisis?

'A mask is not primarily what it represents, but what it transforms, that is to say, what it chooses not to represent. Like a myth, a mask denies as much as it affirms. It is not made solely of what it says or thinks it is saying, but of what it excludes.'[9] Claude Lévi-Strauss is writing about tribal masks as symbols of social cohesion – as symbols that *enforce* social cohesion. Cahun's masks reverse this function, for the psychological complexity to which they point actually interrupts the coherent social codes of gender identity. Her self-representations go against the grain of her and our society's constricting constructions of sexuality. In *I.O.U. (Self-Pride)*, two columns of over-lapping heads rise from a single wide neck. The different faces, of course, are all Cahun's. An encircling text reads. '*Sous ce masque un autre masque. Je n'en finirai pas de soulever tous ces visages*' (Under this mask, another mask. I will never be finished with carrying all these faces). Elsewhere, a prone headless statue with a broken penis (suggesting both hermaphroditism and castration) sprouts from its naval a vascular tree that grows Cahun's ear, hand, eye, and lips for leaves.

Masquerade in this work is part of a complex process of disengagement

from rigid, gender-specific roles and hierarchies. It creates a distance between Cahun and the overdetermined image of the female, enabling her to control her self-image by rupturing the closed polarities of masculine and feminine.[10] Cahun deploys her body as spectacle – but a spectacle of her own creation, a spectacle of distortion. Hence the anamorphic mirror reflections, the masks, and the shifts between masculine and feminine personas. The esthetic in these images has nothing to do with conventional ideals of beauty. Instead it verges on the grotesque, 'the estranged world,' in the words of Wolfgang Kayser, who sees the grotesque body as always in the process of becoming, a process never finished or complete.[11]

What are we to make of this grotesquerie? The silver orbs and the disembodied eye of the *Aveux non avenus* frontispiece suggest a heightened theatricality, a sense of playful magic, mystery, and otherworldliness, but also a distorted and alienated difference. These are mirrors that do not reflect a mimetic double. Cahun's mirrors diverge from those of the Lacanian mirror stage: instead of suggesting an idealized wholeness, as opposed to the fragmented self one feels oneself to be outside the mirror, these images and self-images suggest further distortions.[12] The picture they reflect is not comforting, but reveals the subject's identity as alienated and unintegrated in the world. It is as though, in recognizing, and affirming, and asserting one's difference, one's only avenue is to pass down the road of the grotesque.

Frequently in the history of anamorphosis, the figure represented is a skull, a memento mori, a reminder of death.[13] In Holbein's *The Ambassadors*, 1533, the world of the painting, the world of illusion, is posited as materially full, yet is slashed through with an anamorphic skull. An image of the decapitated English king Charles I, from 1649, demands a tubular mirror to correct its anamorphic distortion; at the point where one sets this mirror is a death's head. This kind of evocation of the life in death and the death in life also appears in Cahun's work. Embedded in her art like an anamorphosis is a nonsensical, eerie, uncanny return of the repressed, of that moment existing paradoxically before the symbolic, before the rationalization of language and image, of that primordial, pre-oedipal existence that must emerge within a foreign, frightening language. Cahun's recessional play of identities, masks, and illusions situates the viewer vertiginously at the boundary of horror.

Cahun's eye/I is a questioning one. It is narcissistically turned inward, but narcissism here is put in the service of examining the artist's own objectification as a woman. Is there an identity in the space between the masks? If so, what is it, and how is it representable? We sense in Cahun's work that moment before one recognizes oneself, a moment that remains with us in a terror beneath the surface. Shimmering upon the surface is a world locked into representation, a world that reflects us, constructs us, and conceals from us those psychic ambiguities and erotic uncertainties that we dare not admit.

Abigail Solomon-Godeau:

The Armed Vision Disarmed – Radical Formalism from Weapon to Style

(First published in *Afterimage*, January 1983)

In this essay Abigail Solomon-Godeau questions assumptions about Moholy Nagy's legacy to American modernism. Charting aesthetic and political alignments at the Bauhaus, she considers how its collectivist and anti-individualist values altered once transposed to the American context of the Chicago Institute of Design. The result is a valuable critical overview – from the New Vision of Russian Revolutionary art to the depoliticising climate of McCarthyism.

ART PHOTOGRAPHY, although long since legitimated by all the conventional discourses of fine art, seems destined perpetually to recapitulate all the rituals of the *arriviste*. Inasmuch as one of those rituals consists of the establishment of suitable ancestry, a search for distinguished blood lines, it inevitably happens that photographic history and criticism are more concerned with notions of tradition and continuity than with those of rupture and change. Such recuperative strategies may either take on photography *toute entière*, as in the Museum of Modern Art's exhibition 'Before Photography,' which attempted to demonstrate that photography springs forth from the body of art, or they may selectively resurrect the photography of the past, as in Alfred Stieglitz's exhibiting and publishing of the work of Hill and Adamson or Julia Margaret Cameron to emphasize the continuity of a particular aesthetic. Although a certain amount of historical legerdemain is occasionally required to argue that *a* evolves or derives from *b*, the nature of photography makes such enterprises relatively easy. An anonymous vernacular photograph may look quite like a Walker Evans, a Lee Friedlander may closely resemble a Rodchenko; put side by side, a close, but specious, relationship appears obviously, *visually* established.

Nowhere is the myth of continuity more apparent than in a recent Aperture offering, *The New Vision*, which traces the fortunes and fruits of the Chicago Institute of Design, or, as John Grimes puts it in his essay, 'The New Vision in the New World.'[1] Although the leitmotif of the book – both in the Grimes essay, as well as in Charles Traub's 'Photographic Education Comes of Age' – is the enduring presence and influence of the Founding Father, László Moholy-Nagy (and his founding principles), it is perfectly evident that most of

I would like to acknowledge the great help, both bibliographic and conceptual, given me by Christopher Phillips.

the photography that has emerged from the Chicago Institute of Design has little in common with the production, much less the ethos, of the Dessau Bauhaus. On the contrary, it seems to me that most of the photography that emerged from the Bauhaus of the diaspora is more closely linked to indigenous currents in American art photography than to the machine-age ethic that informed Moholy's thinking.

Such reflections are suggested by, among other things, the concluding sentence in the book's first (unsigned) essay, 'A Visionary Founder: László Moholy-Nagy,' which reads: 'The utopian dream Moholy worked for never became a reality, despite his dedication and energy, but his new vision was a powerful legacy, especially for photographers, who could see their "mechanical" art as the means for objective vision, optical truth, and personal enlightenment.'[2] Objective vision and optical truth were indeed linchpins of Moholy's program for photography, even as early as 1925. However, personal enlightenment was not only a notion utterly uncountenanced in Moholy's thinking, but the quotes around the word 'mechanical' – the precise attribute that made the camera a privileged image-making technology in the Bauhaus scheme of things – are an obvious signal of a profound *volte-face*.

The problems raised by the kind of photographic history proposed in *The New Vision* are compounded by what appears to be a general confusion about what is signified by photographic formalism. Most photographic *cognoscenti*, when asked what type of photography is represented by the Chicago Institute of Design, at least up to the early 1970s, will respond that it represents the 'Chicago School,' or 'formalism,' by which is intended a label that will describe such disparate photographers as Harry Callahan, Aaron Siskind, Ray Metzker, Art Sinsabaugh, Barbara Blondeau, or Kenneth Josephson. To the degree that formalism has undergone (I would argue) the same kinds of permutations and ruptures as did the Bauhaus/Chicago Institute of Design itself, it seemed a useful project to trace generally the radical formalism of Alexander Rodchenko as it was disseminated into Weimar *Fotokultur*, and its additional transformations as it was absorbed and modified in Moholy's practice, within the institution of the Bauhaus. Finally, I was curious to see how the formalism of Aaron Siskind, and some of the later graduates of the Chicago Institute related to that of their European forebears. That this forty-year period traces the change from an explicitly political and aggressively anti-expressionist production to its virtual antithesis is implicit testimony that photography, like all social and cultural production, is not merely the vessel, but is itself constitutive of ideology.

'All art,' wrote George Orwell, 'is propaganda, but not all propaganda is art.' The radical formalist photography forged in the Soviet Union in the span of years immediately before and immediately after the Russian Revolution disclaimed all aesthetic intent and instead defined itself as instrumental in nurturing a new, revolutionary consciousness. 'Art has no place in modern life,' wrote Alexander Rodchenko in the pages of *Lef* in 1928: 'It will continue to exist as long as there is a mania for the romantic and as long as there are people who

love beautiful lies and deception. Every modern cultured man must wage war against art as against opium.'[3] Refusing the appellation of art, and embracing the medium as an ideal instrument for perceptual renewal and social progress, the photographic work of Alexander Rodchenko and El Lissitzky has nonetheless come to signify more as art than as revolutionary praxis. Despite their having wholeheartedly consecrated their work to the task of social transformation, we view them now as having been — pre-eminently — artists. In this *a posteriori* aesthetic recuperation is inscribed a second death of radical Russian photography: its first effected in its native society by official suppression; its second determined by its rapid assimilation in Western Europe and the U.S. — a victim, one might say, of its own success. Diffused and defused, photographic strategies invented for the service of revolution were quickly conscripted for other uses, other ideologies. It is this latter fate that I wish to discuss here, in part because it reveals so clearly the profound mutability of photographic practice in general, and in part because the fortunes of formalist photography itself provide a paradigm of aesthetic institutionalization — from the barricades to the academy (so to speak) in less than three generations.

This particular migration from margin to center is by no means limited to photography, or even formalist photography. Leo Steinberg's observation that the 'rapid domestication of the outrageous is the most characteristic feature of our artistic life, and the time between shock received and thanks returned gets progressively shorter'[4] fairly describes the history of radical art movements in the twentieth century; no art practice has yet proved too intractable, subversive, or resistant to be assimilated sooner or later into the cultural mainstream. Examination of the transformations that occur when a given art movement or idea traverses frontiers and oceans, as well as time, is instructive for the way it compels recognition of the profoundly unstable nature of meaning in cultural production. This is demonstrated with particular clarity when we trace the passage of photographic forms from one society and context to another. Thus, while a historical understanding of the goals, conditions, and determining factors that produced constructivist and productivist photography can be obtained from any book on the subject, the ability to perceive a Rodchenko photograph or an El Lissitzky photomontage as their contemporaries did is as lost to us as though centuries rather than decades separated us from their images.

The radical formalism which inspired and informed the new Soviet photography had little to do with the Anglo-American variety that propelled the photography of Alfred Stieglitz, Paul Strand, *et al.* toward a fully articulated modernist position, although there were common grounds in the two formalisms — shared convictions, for example, that the nature of the medium should properly determine its aesthetic, and that photography must acknowledge its own specific characteristics. Deriving ultimately from Kantian aesthetics, Anglo-American formalism insisted above all on the autonomy, nonutility, purity, and self-reflexivity of the work of art. As such, it remained throughout its modernist permutations an essentially idealist stance. Such concepts, as well as related aspirations to universality and transcendence, accompanied by the parallel construct of the promethean artist, were, however, anathema to the

Russian formalists. Resolutely opposed to all metaphysical systems, the Russian literary critics who provided the theoretical basis for the movement focused their attention instead on a systematic investigation of the distinguishing components of literature: those elements, qualities, and characteristics of texts that defined literature *as such*.[5] The radical nature of this critical investigation lay in its strict materialism, impersonality, and anti-individualism, all essential aspects of constructivist and, later, productivist practice. The key concept of *ostranenie* – the making strange of the familiar – developed by Victor Shklovsky in 1916, was formulated solely in relation to literature, but had obvious applications to the visual arts, including photography. The defamiliarization of the world effected in prose and poetry, the renewal and heightening of perception that was understood to be the primary goal of literature, had its natural analogue in the ability of the camera to represent the world in nonconventional ways. Revolutionary culture required new forms of expression as well as new definitions of art, and the camera – both film and still – and its operator served as ideal agents of this new vision.

But while the art photography simultaneously emerging in New York posited a modernist aesthetic that insisted on photography as a medium of subjectivity – even while acknowledging its mechanical attributes – radical practice in both the Soviet Union and in Germany rejected absolutely the notion of the artist's function as the expression of a privileged subjectivity. This repudiation of subjectivity, personality, and interiority was linked not only to revolutionary tenets of collectivism and utilitarianism but to the widespread reaction against expressionism – 'a culture of mendacious stupidity,' in Raoul Haussmann's assessment. One did not, in fact, require Marxist credentials to reject expressionism: futurism, de Stijl, Zurich and Berlin dada, suprematism, and, of course, constructivism, all in one form or another defined their agendas in opposition to expressionist culture, insofar as its atavism, utopianism, and emotionalism were antithetical to the critical and socially oriented art movements that emerged after World War I. Moreover, the antitechnological stance of expressionism was totally at odds with the passionate enthusiasm for technology, modernization, and urbanism – all that comprised the machine-age ethos – which was to figure so prominently in both Weimar and Soviet culture.

For an artist like Alexander Rodchenko, not yet thirty at the time of the October Revolution, the internal logic of constructivism as well as the imperatives of revolutionary culture led inexorably to the repudiation of easel painting. 'The crushing of all "isms" in painting was for me the beginning of my resurrection,' wrote Rodchenko in 1919. 'With the funeral bells of color painting, the last "ism" was accompanied to its grave, the lingering last hopes of love are destroyed, and I leave the house of dead truths. Not synthesis but analysis is creation.'[6] A few weeks after the last 'laboratory' exhibition of the Moscow constructivists in 1921 ('5 × 5 = 25'), the twenty-five young artists, including Rodchenko (whose work was represented in the exhibition by his three 'last paintings' – three painted surfaces, one red, one yellow, and one blue), renounced 'pure pictorial practice' altogether, and instead embraced a wholly materialist orientation – productivism.[7] Osip Brik, the formalist critic

and theoretician closely linked to both Rodchenko and the poet Vladimir Mayakovsky, wrote yet another of the many obsequies for easel painting: 'We are practitioners — and in this lies . the distinctive feature of our cultural consciousness. There is no place for the easel picture in this consciousness. Its force and meaning lie in its extra-utilitarianism, in the fact that it serves no other function than "caressing" the eye.'[8] Although in part a resolution to the 'crisis of images' represented, on the one hand, by the absolutism of Malevich's *White on White* of 1918, and, on the other, by the effective closure of Rodchenko's 'last paintings,' productivism signaled

> a kind of return to the earth after the long cosmic flight of Malevitchian suprematism and the super-specialization in which non-objective art was recklessly engaged in the years 1915–1918. In fleeing the labyrinth of extreme theorization, the Productivists hoped . . . to lead art back into the heart of society.[9]

Indeed, it was precisely this intense engagement with the larger society at hand, as well as the belief that the artist must function as an active, socio-political being, that contrasted so dramatically with the almost ritualistically alienated stance of the expressionist artist. 'The aim of the new art,' wrote Ilya Ehrenburg in 1921, 'is to fuse with life,'[10] and productivist texts abound with exhortations that the artists turn from the museum to the street, from the studio to the factory. Echoing Mayakovsky ('The streets our brushes/the squares our palettes'), Rodchenko proclaimed:

> Non-objective painting has left the Museums; non-objective painting is the street itself, the squares, the towns and the whole world. The art of the future will not be the cozy decoration of family homes. It will be just as indispensable as 48-storey skyscrapers, mighty bridges, wireless, aeronautics and submarines which will be transformed into art.[11]

The productivists' stance was thus not so much anti-art, their more excited polemics notwithstanding, as much as it was opposed to the ghettoization of art as an activity of the privileged few for the production of luxury items. With the renunciation of easel painting, Rodchenko turned his attention to the range of materials, technologies, and practices that collectively constituted a reconciliation of creative energies with the felt needs of Soviet society. These activities were, perforce, those that existed in the public sphere: the design of exhibitions and pavillions (including the Workers' Club for the Soviet Pavillion at the 1925 Paris 'Exposition des Arts Décoratifs,' which introduced the work of the Russian avant-garde to Western Europe), furniture, textiles, theatrical design, typographic and graphic design, including posters, book covers, and advertising,[12] and from 1924 on – photography.

Rodchenko's photography drew equally from notions derived from the formalist circle, presumably through people such as Osip Brik and Sergei Tretiakoff, and from the precepts of productivism itself. Concerning the former influence, the concept of defamiliarization has already been cited. Additionally, Roman Jakobson's key concept of the 'laying bare of the device' – the inclusion

within the work of art of those material or formal elements that reveal its construction – was readily assimilable to a new photographic practice. Much of Rodchenko's most innovative photography from the 1920s is notable for its refusal of 'naturalized,' conventionalized viewpoints, the insistence that it was a camera lens and not a window pane that yielded the image. Worm's-eye, bird's-eye, oblique, or vertiginous perspectives relate not only to the strategy of defamiliarization, but to an affirmation of the apparatus itself as the agent of this vision.[13] Making the point even more emphatically are photographs by Rodchenko, such as *Chauffeur, Karelia* (1933), in which the photographer himself is represented in the image. Returning to the observation made at the beginning of this discussion – that photographic practices employed in one historical moment may have their significance altogether transformed when employed in another – it should be noted that Rodchenko's presence in the photograph has infinitely more to do with Dziga Vertov's inclusion of the film-making process in *The Man with a Movie Camera* than it does with Lee Friedlander's self-referencing devices.[14] What is being stressed is the manifest presence of the means of production, and, concomitantly, an implicit rejection of the popular perception of a photograph as either transparent or self-generated.

The productivist influences on Rodchenko's photography thus derived more from the mechanical-technical attributes of the medium than from its purely formal possibilities. The camera was obviously a fundamentally democratic instrument; it was easily mastered, produced multiple images relatively cheaply, and represented (like the airplane or radio tower, both powerful and pervasive symbols of technological progress) speed and science, precision and modernity. Most suggestive to Rodchenko, however, was the realization that the camera performed in an aggregate, analytic way, rather than in a unitary, synthesizing one. Rodchenko's statement that creation, not synthesis, was analysis, was based on his conviction that contemporary reality could not be adequately apprehended through essentializing syntheses. In 'Against the Synthetic Portrait, for the Snapshot' (1928), Rodchenko argued: 'One has to take different shots of a subject, from different points of view and in different situations, as if one examined it in the round rather than looked through the same key-hole again and again' – a notion equally central to the practice of the cubists. Posterity's physical knowledge of the historical Lenin would be known, Rodchenko added, not by a single exemplary oil painting, but through the hundreds of photographs taken of him, his letters and journals, and the memoirs of his associates. Thus, Rodchenko concludes: 'Don't try to capture a man in one synthetic portrait, but rather in lots of snapshots taken at different times and in different circumstances!'[15]

By the early 1930s, if not before, the photographic formalism pioneered by Rodchenko fell increasingly under attack. Leon Trotsky himself spearheaded the attack against the Opoyaz group (the literary formalists) in 1925 with *Literature and Revolution*. The *laissez-faire* artistic policy of the cultural commissar Anatoly Lunacharsky, which had sustained the extraordinary production of the Soviet avant-garde, did not long survive him. *Novy Lef*, in whose pages Rodchenko's photographs and photomontages had appeared, for which he had

written, and which had published Brik and Tretiakoff, suspended publication in 1930, and the field was eventually left to *Proletarskoe Foto* and the photographic equivalent of socialist realism.

Unlike many of his avant-garde companions of the revolutionary period, Rodchenko survived Stalinism, retaining his position as the dean of the metal-work faculty at Vkhutein. In 1936, submitting to anti-formalist pressure, he declared himself 'willing to abandon purely formal solutions for a photographic language that can more fully serve [the exigencies] of socialist realism.'[16] Four years later he returned to easel painting, whose subjects came to include mournful clowns. In the space of about fifteen years, Russian formalism had passed from an officially tolerated, if not sanctioned, art practice, conceived as a tool in the forging of revolutionary consciousness, to an 'elitist,' 'bourgeois,' 'decadent,' and 'counter-revolutionary' practice that condemned those who employed it to exile, silence, repudiation, or death.

But in the few years before the photographic formalism exemplified by Rodchenko was more or less effectively exterminated in the Soviet Union, it thrived, albeit in transfigured form, within the photographic culture of Weimar Germany. The diagonal compositions, suppressed horizons, tipped perspectives, bird's-eye and worm's-eye views, serial portraits, extreme close-up views, and various technical experiments with the medium had become, by 1930, relative commonplaces in that range of German photographic practice encompassing the popular press, advertising, photographic books, and exhibitions as well as the work of the photographic avant-garde. While much of this photographic activity tends to be unreflectively clumped within general categories such as the *Neue Sachlichkeit* (usually translated as the New Objectivity) or the New Vision (so-called by Moholy-Nagy), I am here concerned with that photographic practice which was most thoroughly informed by the Russian model. Although it is difficult to disentangle the skeins of influence within the cultural crucible of Weimar Germany as well as the various forces that acted upon each other and cumulatively formed the *Fotokultur* of the late 1920s, it is nonetheless clear that the 1922 Soviet Art Exhibition that took place in Berlin had an immense – and immediate – influence.

For the German Left – still in traumatized disarray after the abortive Communist revolutions of 1918/1919, the range of Russian art therein represented was greeted as a frontline communiqué of vanguard practice. To the twenty-seven-year old László Moholy-Nagy, an exile from the Hungarian White Terror (as were his compatriots Georg Lukács and Bela Balázs), then painting in a dadaist/abstract-geometrical vein, the constructivist work in the exhibition struck with the force of revelation. Reporting on the show for *MA* (Today), the Hungarian futurist publication, Moholy wrote: 'This is our century . . . technology, machine, Socialism . . . Constructivism is pure substance. It is not confined to the picture frame and pedestal. It expands into industry and architecture, into objects and relationships. Constructivism is the socialism of vision.'[17]

In terms of photography and photomontage, it was El Lissitzky who was most active in disseminating the new formalist photography and the precepts of constructivism. Through the trilingual magazine *Veshch/Gegenstand/Objet*,

which he published with Ilya Ehrenburg, as well as by his organization and design of such exhibitions as the extraordinary Cologne 'Pressa,' Russian formalist photography was siphoned into the pluralist brew of German photography. Any precise tracing of the course of the formalist photography theorized and practiced by Rodchenko and El Lissitzky as it was assimilated into German photography must await closer study. But bearing in mind that the function and ideology of such photography were integrally bound together, one can begin to distinguish important divergences by the time the New Vision photography became a dominant force.

At the time of the initial introduction of Russian experimental photography, which is generally dated to the early 1920s, German photography was divided between the retrograde pictorialism of the camera clubs, the rapid expansion of photography in the illustrated press, and advertising – a function both of new developments in camera technology (for example, smaller cameras and faster film, as well as improvements in photomechanical reproduction) and of the use of photomontage by the Left avant-garde (Raoul Haussmann, Hannah Hoch, John Heartfield, George Grosz, and others). Throughout the 1920s, German photography was, in effect, cross-fertilized by radical Russian photography, so that by 1929 and the Deutsche Werkbund 'Film und Foto' exhibition – a veritable *summa* of the New Vision – various constitutive elements of Soviet work had been absorbed and, depending on the particular practice involved, transfigured. In effect, the formalism imported into Weimar Germany became splintered into different, occasionally overlapping components. Thus, for example, the use of a vertical rather than horizontal perspective, which for Rodchenko was one particular optical strategy of *ostranenie* – an implicitly political application – was widely employed in Germany. There it signified, among other things, the modernity, urbanism, and technological glamour of elevators, skyscrapers, airplanes, and cranes. 'We all felt a demonstrative enthusiasm for lifts, jazz and radio towers,'[18] wrote Hans Joachim in 1930, and, of course, some of Moholy's best known photographs from the 1920s were aerial views shot from the Berlin radio tower. For Rodchenko, who had made aerial views shot from the Moscow radio tower, the tower itself was perceived as 'a symbol of collective effort.'

Indeed, the entire repertoire of Russian formalist photography was intended as the optical analogue to revolution – quite simply, a revolutionizing of perception in accordance with the demands of a revolutionary society. Although the romance of technology and urbanism was fully a part of Soviet culture, it was, at least in the early 1920s, closer to wishful thinking than to reality; this was, after all, a barely industrialized society devastated by revolution, famine, civil war, and foreign invasion, that required the services of Armand Hammer to manufacture even its pencils.

The formal innovations of Russian photography were nowhere more thoroughly grasped or intensively exploited than in the flourishing and immensely sophisticated German advertising industry. In his important essay on the photography of the *Neue Sachlichkeit*, Herbert Molderings discussed the implication of this phenomenon:

If we consider the 'new vision' in the context of its economic and social functions, what the historical content of the 'new realism' is becomes clear. Along with heavy industry, the machine which was its substratum and the new architecture which was its result, 'neo-realist' photography discovered the world of industrial products, and showed itself as a component of the aesthetic of commodities in a double sense, affecting both production and distribution. Such photographers as Burchartz, Renger-Patzsch, Gorny, Zielke, Biermann and Finsler discovered that an industrial product develops its own particular aesthetic only when the serial principle, as the general basis of manufacture, becomes pronouncedly visible.[19]

It requires but a single intermediary (photographic) step to the commodity fetish:

> Commodities also came to be shown from a different point of view, directly linked to the needs of advertising. The development of *Sachphotographie* — the photographing of individual objects — is recognized as an important achievement of photography in the twenties. . . . Objects hitherto regarded as without significance are made 'interesting' and surprising by multiple exploitation of the camera's technical possibilities, unusual perspectives, close-ups and deceptive partial views. . . . The advertising value of such photographs consists precisely in the fact that the objects are not presented functionally and contain a promise of mysterious meaning over and beyond their use-value: they take on a bizarre unexpected appearance suggesting that they live lives of their own, independent of human beings. More than all the fauvist, cubist, and expressionist paintings, it was applied photography which modified and renewed the centuries-old genre of the still-life of the twentieth century: pictorial expression of commodity fetishism.[20]

In the work of Albert Renger-Patzsch (pre-eminently the photographs reproduced in the 1928 *Die Welt ist Schön*), elements that are coeval with, if not derived from, Russian formalism are collapsed into an older, Kantian conception: the belief that immutable and governing laws of form underlay all the manifestations of nature as well as the works of culture (e.g., the built environment) and that the pictorial revelation of these unifying structures yields both significance and beauty. Thus, on the one hand, the book provides images of machinery, modern building materials, architecture, textures, and details, photographed to reveal that 'it is possible to regard a machine or an industrial plant as no less beautiful than nature or a work of art';[21] on the other hand, images of landscape, animals, and people, photographed to display and underline 'that which is typical of the species.'[22] The nature of this enterprise is not only essentialist but symbolist, a point made with some emphasis by Carl Georg Heise, who wrote the preface to *Die Welt ist Schön*:

> They [Renger-Patzsch's finest photographs] . . . are true symbols. Nevertheless we should not forget that it is basically nature and created life itself

which bears within it symbolic power of this kind, and that the work of
the photographer does not create symbols but merely makes them visible! . . .
the last picture is of a woman's hands, raised, laid lightly over one another.
Who can fail to recognize the symbolic character of this picture which
speaks with an insistence far more powerful than words![23]

Walter Benjamin immediately grasped the implications of Renger-Patzsch's
photography and was concerned to distinguish it from progressive and avant-
garde practice as exemplified by Moholy-Nagy, and from the work of August
Sander, Karl Blossfeld, or Germaine Krull:

> Where photography takes itself out of context, severing the connections
> illustrated by Sander, Blossfeld or Germaine Krull, where it frees itself from
> physiognomic, political, and scientific interest, then it becomes *creative*. The
> lens now looks for interesting juxtapositions; photography turns into a sort
> of arty journalism. . . . The more far-reaching the crisis of the present social
> order, the more rigidly its individual components are locked together in a
> death struggle, the more has the creative – in its deepest sense a sport, by
> contradiction out of imitation – become a fetish, whose lineaments live
> only in the fitful illumination of changing fashion. The creative in photo-
> graphy is capitulation to fashion. *The world is beautiful* – that is its watch-
> word. Therein is unmasked the posture of a photography that can endow
> any soup can with cosmic significance but cannot grasp a single one of the
> human connexions in which it exists, even where most far-fetched subjects
> are more concerned with saleability than with insight.[24]

It was, however, in the Bauhaus that the various tributaries of formalist
photography were systematically appropriated, theorized, and repositioned
with respect to the range of practices and applications that were promoted
pedagogically, artistically, and commercially. In much the same way that
Weimar Germany was itself a cultural transmission station, the Bauhaus – in its
various incarnations, and through its influential propagandists and productions
(exhibitions, books, films, magazines, architecture, typography, etc.) – was a
powerful cultural depot. With respect to photography, it is Moholy who is the
crucial figure, even though photography was taught as a separate course in the
Bauhaus only in 1929, and then not by Moholy but by Walter Peterhans.

Moholy had become friends with El Lissitzky in 1921, a year that witnessed
the Russian influx into Berlin; Mayakovsky, Osip and Lily Brik, Ilya Ehren-
burg, as well as artists like Nicholas Pevsner, Naum Gabo, and Wassily Kandin-
sky (hired to teach at the Bauhaus), who, although opposed in various ways to
the productivist wing, were nonetheless the standard-bearers of the new Soviet
art. By the following year, Moholy was making photograms in collaboration
with his wife, Lucia, and producing photomontages. He was also independently
repeating much of the same theoretical program as the productivists. Thus, in
1922, the year of his one-man show at the Sturm gallery, he included a group
of so-called elementarist compositions, which like Rodchenko's last paintings,
signaled not only a rejection of easel painting and its accompanying ethos of

originality and subjectivity, but the positive embrace of mechanical methods of production as well. Moholy described his project in strictly matter-of-fact terms:

In 1922 I ordered by telephone from a sign factory five paintings in porcelain enamel. I had the factory's colour chart before me and I sketched my paintings on graph paper. At the other end of the telephone the factory supervisor had the same kind of paper divided into squares. He took down the dictated shapes in the correct position.[25]

The following spring, Walter Gropius, the director of the Bauhaus, hired Moholy to become an instructor in the metal workshop, making him the exact counterpart of Rodchenko at Vkhutein. Moholy's arrival signified one of the first decisive shifts within the Bauhaus away from the earlier expressionist, utopian orientation aptly symbolized by Lionel Feininger's woodcut logo for the prospectus (a Gothic cathedral), under which Gropius's motto proclaimed, 'Architects, sculptors, painters, we must all go back to the crafts.' The atmosphere of the Weimar Bauhaus before the departure of its previous director, Johannes Witten, was almost the exact opposite of the functionalism and technologism associated with its later attitudes. The emphasis on crafts and artisanal modes of production in the curriculum was accompanied by vegetarianism, a vogue for oriental religions, and the occasional tenure of itinerant crackpots. Although consecutively expelled from the cities of Weimar, Dessau, and finally Berlin, and considered by the more conservative elements within local governments to be a very hotbed of Bolshevism, the Bauhaus tended to be viewed by the radical Left with a certain amount of contempt. The evaluation of *Starba*, the leading Czechoslovakian architectural periodical, was not atypical:

Unfortunately, the Bauhaus is not consistent as a school for architecture as long it is still concerned with the question of applied arts or 'art' as such. Any art school, no matter how good, can today be only an anachronism and nonsense. . . . If Gropius wants his school to fight against dilettantism in the arts, if he assumes the machine to be the modern means of production, if he admits the division of labor, why does he suppose a knowledge of crafts to be essential to industrial manufacture? Craftsmanship and industry have a fundamentally different approach, theoretically as well as practically. Today, the crafts are nothing but a luxury, supported by the bourgeoisie with their individualism and snobbery and their purely decorative point of view. Like any other art school, the Bauhaus is incapable of improving industrial production; at the most it might provide new impulses.[26]

By 1923, however, the Bauhaus had undergone a fairly substantial change of direction. No longer 'A Cathedral of Socialism,' but, rather, 'Art and Technology — A New Unity' was the credo. Notwithstanding the fact that the important international journals such as *De Stijl* and *L'Esprit Nouveau* still considered the Bauhaus too individualistic, decorative, and arty, Gropius was

resolved to make the Bauhaus a force in architecture, industrial design, and contemporary art. The change of direction and the implementation of Gropius's ideas became fully established only after the Bauhaus's expulsion from Weimar and its re-establishment in Dessau, housed in the landmark buildings that Gropius himself designed.

Given Moholy's patron-saint status in the history of modern photography and his undeniable importance in the propagation of his particular variety of formalism, it is important to remember that Moholy never thought of himself as a photographer – he certainly never referred to himself as such – and that much of his enthusiasm for photography was predicated (at least in the 1920s) on his conviction that the machine age demanded a machine-age art – functional, impersonal, rational. Formalism for Moholy signified above all the absolute primacy of the material, the medium itself. Thus if photography, and indeed all photographic processes including film, was defined by its physical properties – the action of light on a light-sensitive emulsion – formation could be distilled into a bare-bones recipe for the creation of exemplary works. Written out of this equation was not only any notion of a privileged subjectivity (in keeping with progressive avant-garde theory), but even the camera itself: 'It must be stressed that the essential tool of photographic practice is not the camera but the light-sensitive layer.'[27]

Moholy's codification of the eight varieties of photographic seeing in his 1925 Bauhaus book *Painting, Photography, Film* indicates to what degree his assimilation of Russian formalist photography tended toward a more purely theoretical and abstract rather than instrumental or agitational conception of 'camera vision':

1. Abstract seeing by means of direct records of forms produced by light: the photogram . . .
2. Exact seeing by means of the fixation of the appearance of things: reportage.
3. Rapid seeing by means of the fixation of movement in the shortest possible time: snapshots.
4. Rapid seeing by means of the fixation of movements spread over a period of time . . .
5. Intensified seeing by means of: (a) micro-photography; (b) filter-photography . . .
6. Penetrative photography by means of X-rays: radiography . . .
7. Simultaneous seeing by means of transparent superimposition: the future process of automatic photomontage.
8. Distorted seeing . . .[28]

Whereas the technical and formal possibilities of photography were for Rodchenko, too, a wedge to prise open conventionalized and naturalized appearance, a visual device against classical and bourgeois representational systems, for him these constituted specific strategies in the service of larger ends. In Weimar Germany, the photographic production oriented toward those ends was to be primarily that of the photomontagist John Heartfield, whose means, needless to say, were not those of the

formalists. To the degree that 'camera vision' became itself a fetishized concept in Weimar culture, the political implications of Russian formalist photography were sheared away from the body of New Vision photography.

Moholy's embrace of photography, like Werner Graff's or Franz Roh's, did not in any way distinguish between the uses, intentions, and contexts of photographic production having thus the dubious distinction of anticipating contemporary critical and curatorial practice by a good forty years. In exhibitions such as the seminal 'Film und Foto' and in publications such as Roh's *Foto-Auge* or Graff's *Es kommt der neue Fotograph!*, scientific, advertising, documentary, aerial, art and experimental, even police photography, were enthusiastically thrown together into an aesthetic emporium of choice examples of camera vision. Moholy's championship of photography, like that of his contemporaries, had finally more to do with the widespread intoxication with all things technological than it did with a politically instrumental notion of photographic practice. The camera was privileged precisely *because* it was a machine, and camera vision was privileged because it was deemed superior to normal vision. Herein lay the total reversal of terms that had historically characterized the art versus photography debate. 'The photographic camera,' wrote Moholy, 'can either complete or supplement our optical instrument, the eye.'[29]

Within the Bauhaus scheme of things, particularly in its Dessau days, photography existed merely as one of a number of technologies for use in the training of designers. Throughout the 1920s, Gropius sought to establish the Bauhaus as a source of actual production as well as a training ground for designers or a wellspring of ideas. In 1926 a limited company was set up by Gropius with a group of businessmen and the participation of some labor unions for the commercial handling of Bauhaus designs and products. Although the *politique* of the later Bauhaus remained collectivist, anti-individualist, and, of course, emphatically functionalist, these were not necessarily radical positions within the political spectrum of the Weimar Republic. Moreover, the Bauhaus Idea – it was referred to as such at the time – envisioned a society made better through the work of the architects, designers, and craftsmen it produced. This, then, was the legacy that Moholy carried with him when he resurrected the New Bauhaus in the distinctly American terrain of the city of Chicago.

Within his own career Moholy had traveled from the militantly avant-gardist, revolutionary milieu of the *MA* group in Budapest, to the constructivist circle around El Lissitzky in Berlin, to exile in Holland, and later England, to land finally (and improbably) in the Middle West. As an *emigré* artist and educator, his activities between 1937 and his death in 1946 were dominated by his efforts to reconstitute the Bauhaus and the values it represented in a time and a place light years removed from the culture and politics of Weimar Germany.[30] The contradictions that *Starba* had identified in the Weimar Bauhaus between the demands of industry and the conditions of craft, between the different assumptions governing the production of art and the practice of applied arts, remained unresolved and increasingly problematic in the American version. These contradictions underlay the conflicts that seem regularly to have

arisen between the expectations and assumptions of the New Bauhaus's initial sponsors (The Chicago Association of Arts and Industries, a consortium of businessmen, and Walter Paepcke, who was one of the principal supporters of the school until 1946) and Moholy's determination to transplant the Bauhaus Idea with as little compromise as possible. Similarly, these contradictions surfaced with every subsequent change of director, staff, enrollment, and student profile, While the curriculum of the Chicago Institute of Design remained basically comparable to its earlier German version (e.g., the first-year foundation course, the experimentation with various media, etc.), the nature of photographic teaching (and practice) became in time a distinct and discrete aspect of the Institute of Design, whose function was less linked to the imperatives of the industrial age than it was to those notions of art production that had preceded the establishment of the Institute in America by twenty years. Added to that was the fact that America after the Second World War was hardly a hospitable environment in which to transplant even the *bien-pensant* Leftism of the Dessau Bauhaus, and that American artists and photographers were in the process of implicitly or explicitly repudiating the politically and socially oriented practice of the previous decade, whose most developed expression had been in documentary form. How then was photographic formalism understood and expressed at the Institute? Was there, we might ask, a new inflection to formalism which made it substantially different from its earlier incarnations and might be seen to link Arthur Siegel, Harry Callahan, and Aaron Siskind? And what, if anything, made the Institute-based formalist practice similar to, or different from, the indigenous American variety – i.e., purist, straight photography – exemplified by Paul Strand after 1915, and the *f*/64 group in the following years?

Reflecting back on the various sea changes to which Russian photography had been subjected in Germany, what seems most conspicuous was the way various components of radical formalism were separated and factored into distinct discursive functions. Seriality, unusual close-ups, and isolated and dramatic presentation of the object were, as we have seen, promptly assimilated into advertising photography; defamiliarizing tactics such as unconventional viewpoints, the flattening and abstracting of pictorial space, all became part of the stylistic lexicon available to commercial photographers, art photographers, designers, and photojournalists – a lexicon, it should be added, that had, by the end of the war, assimilated surrealist elements as well. In a general way, formalism had become a stylistic notion rather than an instrumental one, an archive of picture-making strategies that intersected with a widely dispersed, heroicized concept of camera vision. In the work of Bauhaus and Bauhaus influenced photographers, one of the most durable legacies of Russian photography was the continued emphasis placed on experimentation. It was this latter characteristic that made Institute photography rather different from American art photography of the 1950s and 1960s. Whether through the encouragement of color photography, or through the various workshop exercises utilizing photograms, light modulators, multiple negatives, photo-etching, collage, and so on, Institute photography encompassed a broad

range of photographic technologies and experimentation that distinguished it somewhat from the dominant purism of East and West Coast art photography.

By the early 1950s, as the Institute became more firmly established and as the photography program gradually took pride of place in the curriculum — becoming, in fact, its principal attraction — the indigenous conditions and circumstances of American photography were themselves acting on the Institute. For Moholy, the pedagogical system of the Institute was conceived literally as a training program, a vocational system that would prepare designers, architects, and photographers to go into the world and in some vague, utopian sense, transform it. The enormously gifted Herbert Bayer, designing exhibitions, books, posters, and typography, employed by Walter Paepcke on the advertising series 'Great Ideas of Western Man' for the American Container Corporation, was the very model of what Moholy intended his alumni to become and accomplish. But after the initial influx of G.I. Bill students, who studied at the Institute with the expectation of working as commercial photographers or professional photojournalists, the gulf between commercial or applied photography and the progressively rarefied approach to photography coming out of the Institute widened. And although Arthur Siegel (who had been one of the first photography teachers hired by Moholy) moved back and forth between professional photojournalism, teaching stints, and his personal work throughout his career, this form of professional life was to prove more the exception than the rule.

What eventually emerged from the Institute as model careers for serious photographers were those of Henry Holmes Smith, Harry Callahan, and Aaron Siskind; that is to say, teachers of future generations of art photographers who would themselves end up teaching photography and, to a greater or lesser extent, pursuing their own photographic destinies within an expanding university and art-school network. This alone would have constituted a significant shift away from the Bauhaus Idea, inasmuch as up to that point, the *raison d'être* of the institution was the implementation of its program in the world of industry, design, and manufacturing. Indeed, the very notion of the artist-photographer producing images for a knowledgeable or peer audience was essentially at odds with the dynamic, public, and functionalist concept of photography sanctioned by the German Bauhaus.

Between 1946 — the year of Moholy's death — and 1951, when Harry Callahan hired Aaron Siskind, the assumptions and principles governing photographic production at the Institute were already being inflected and altered as much by the American cultural climate as by the very different goals and ideas of the American staff hired by Moholy. Arthur Siegel (who ran the photography department between Moholy's death and 1949) was, in certain respects, the transitional figure, having one foot in the Moholy camp and the other in a mystified, privatized approach to the medium. Published statements by Siegel are such a jumble of the two approaches that it is difficult to distill what he actually meant. Here, for example, is Siegel on his first tenure at the Institute:

My job, develop a four-year course of study for photographers. (With the help and hindrance of many students and teachers, I tried to weave the threads of European experimental and painting-oriented photography into the American straight technique of object transformation.) This attitude became a web of problems, history, and technique that, together with the whole environment of the school, provided an atmosphere for the gradually unfolding enrichment of the creative photographer. . . . Harry Callahan and Aaron Siskind carry on the rich teaching tradition that I inherited from Moholy-Nagy, Kepes, and others. . . . For if the fifties of photography had lyrical songs, part of the notes originated at the Institute of Design.[31]

Although it is difficult to pinpoint precisely when the nominally formalist framework of the Institute came to incorporate that very subjectivity which it had previously excoriated, Siegel's 'personal' work, as well as his statements, suggests that this shift in emphasis was well in place by the end of the 1940s. It is worth mentioning, too, that in Siegel's work one finds a combination of technical experimentation with the medium coupled with a rather ghastly self-expressive intent, illustrated by projects such as the series of color photographs made in 1951, collectively entitled 'In Search of Myself,' and undertaken, as John Grimes indicates, at the suggestion of Siegel's psychoanalyst.

Harry Callahan's arrival at the Institute in 1946 (he was hired by Moholy himself, shortly before his death) could only have confirmed this direction. A self-taught photographer for whom photography was, according to John Szarkowski, 'a semi-religious calling,'[32] and whose exposure to Ansel Adams and his work in 1941 was both revelation and epiphany ('Ansel is what freed me'),[33] Callahan was as far removed from the machine-age ethic of Bauhaus photography as anyone could possibly be. As early as 1941, with photographs such as the calligraphic study of reeds in water (*Detroit*, 1941), Callahan was singlemindedly developing a body of work that would probably have been little different had he never set foot in Chicago. Characterized by a consistent and intensely personal iconography (the face and body of his wife Eleanor) and great elegance and purity of design and composition, Callahan's photography had more in common with the work, of Minor White, or even Steiglitz, than it did with Moholy's. Although one could argue that certain kinds of work produced by Callahan after coming to Chicago – the collages, multiple exposures, series, and superimpositions – were the result of his exposure to Moholy's ideas and the Institute environment, some of this experimentation had, in fact, preceded his arrival. In any case, few would dispute that Callahan's influence on the future orientation of the Institute photography program was profound. Beyond any consideration of the direct influence of his photographs was the fact that he came to exemplify the committed art photographer – equally aloof from marketplace or mass media, content to teach and serve his muse. 'The interior shape of private experience,'[34] coupled with a rigorous concern for formal values, effectively constituted Callahan's approach to photography, and

this, more than any of Moholy's theoretical formulations, constituted the mainstream of American art photography through the 1960s.

That a subjectivized notion of camera-seeing should have come to prevail at the Institute by the 1940s is not surprising. Reflecting on the political and cultural climate of America in the ten years following World War II, it seems inevitable that the last tenet of radical formalism to have survived the ocean-crossing — I refer here to the belief that the camera was a mechanical (no quotes), objective, impersonal, and rational device fully in keeping with the imperatives of advanced, technological societies — should finally be engulfed by the dominant ethos of art photography. Surely one of the significant factors shaping all noncommercial photography by the end of the decade was that certain kinds of documentary practice had become politically suspect. The influential and politically Left-wing New York Photo League was included in the attorney general's list of subversive organizations by 1947, and many documentary photographers felt that their subject matter alone made them politically vulnerable.

Discussing this period in her essay 'Photography in the Fifties,' Helen Gee gives a particularly suggestive example in the case of Sid Grossman, the director of the Photo League's School and an acknowledged radical:

> Remaining virtually in hiding, afraid of the 'knock on the door,' he complained of no longer feeling free to work on the streets. He escaped as often as he could, seeking the solitude of Cape Cod. His work between 1948 and the time of his death in 1955 . . . shows a clean break, a complete change in subject matter. From the lively images of rambunctious teen-agers on the Coney Island beaches, he moved to contemplative scenes of sea and sand in Provincetown, a change which appears to be more psychological than geographic. While an extreme example of a shift from a documentary approach to a reflective, interior response to the world, it is symbolic of a change in sensibility that affected American artists, either consciously or unconsciously, during the decade of the fifties.[35]

It is interesting in this light to return to the Szarkowski essay on Callahan, which subtly suggests that Callahan's stature as an artist was somehow rein-forced by his refusal of the then-prevalent social documentary mode: 'Activist photography in 1941 seemed new, important, adventurous, and there was a market for it. Nevertheless, Callahan was not interested. For him, the problem was located at the point where the potentials of photography and his own private experience intersected. . . . His attitude towards this question has not changed.'[36]

But well before the machinery of HUAC, McCarthyism, and the Cold War had been put in place, American art culture was shifting away from agitprop production and the Popular Front program of solidarity with the masses towards the postwar embrace of an international modernism whose most exalted representatives and avant-garde elite were the abstract expressionist painters of the New York School.[37] For many American art photographers who had, in various ways, accommodated themselves and/or modified their work in

conformity with the concerns of the Depression years,[38] the later depoliticizing of American culture truly constituted a return to normalcy. The battle to legitimate photography as an art had been consistently waged in terms of the camera's ability to express the subjectivity and unique personal vision of the photographer, and with the postwar valorization of individualism, detachment, and originality, art photographers returned again to their historic agenda.

It is against this background that we need to survey what, *faute de mieux*, we might consider the Callahan-Siskind High Formalist period at the Institute, which may be said to have started in 1951 when Callahan hired Siskind after becoming head of the Photography Department in 1949. In an article on Chicago photography, Andy Grundberg points out that the two men 'overthrew or redirected much of Moholy's emphasis,'[39] although I am inclined to think that the process had begun under Siegel, or in any case, before Siskind's arrival. Grundberg further points out that

> As enrollment increased and a graduate degree program was added, the New Bauhaus curriculum was de-emphasized. The preliminary course, which mimicked Moholy's original progression in the medium – from photograms to paper negatives, multiple exposures, out-of-focus images, etc. – was retained but lost some importance. Callahan and Siskind both resisted emphasizing experimental techniques (Callahan: 'I didn't care anything about solarization and negative prints . . .'; Siskind: 'I had no interest in the Bauhaus philosophy. I found all that experimentalism stuff a little uncongenial to me.').[40]

The surprise is that the tradition of technical experimentation, including the mixing of media, remained as strong as it did in the post-Moholy Institute. But inasmuch as Callahan and Siskind were, for the ten-year period between 1951 and 1961, the dominant photographic influences in the school – both through their teaching and the prestige of their work – it is evident that whatever vestiges remained of the earlier concept of formalism and its resolutely anti-idealist substrata were entirely eclipsed by the subjectivization of vision championed and practiced by both men. It might be noted, too, that art photography of the early 1950s is represented by figures such as Minor White, Frederick Sommer (who spent a year at the Institute while Callahan was abroad on a grant), and Ansel Adams, and that *Aperture*, with White as its editor, was launched in 1952.

In retrospect, Aaron Siskind seems so perfectly to represent the cultural and photographic adjustment of the period that one is tempted to present him as the emblematic figure *par excellence* for art photography's postwar retreat from engagement with either social *or* political reality. It is not only in the fact of Siskind's abandonment of the social-documentary work of his Photo League days (exemplified by the Harlem Document project) and his shift to the production of the virtual abstractions from 1944 on that one sees the magnitude of the larger social transformation (Siskind, after all, continued to teach documentary photography at the Institute for years). Rather, the enormousness of the shift is signaled in Siskind's zealous embrace and assimilation of Clement

Greenberg's doxology of modernism — the *ne plus ultra* of Anglo-American formalism — as the theory and ground of his work. 'First and emphatically,' wrote Siskind in his 'Credo' of 1956, 'I accept the flat picture surface as the primary frame of reference of the picture.'[41] And two years later: 'As the language or vocabulary of photography has been extended, the emphasis on meaning has shifted — shifted from what the world looks like to what we feel about the world and what we want the world to mean.'[42] This interiorized *purified* notion of art-making is, of course, closely linked to similar attitudes current among the New York School artists with whom Siskind was allied, both by friendship and through dealers (he exhibited from 1947 to 1957 at the Charles Egan Gallery). In the same way that action was redirected from the political field to the field of the canvas among abstract painters, Siskind's arena became equally circumscribed. 'The only other thing that I got which reassured me from the abstract expressionists,' said Siskind in a 1973 interview, 'is the absolute belief that this canvas is the complete total area of struggle, this is the arena, this is where the fight is taking place, the battle. Everybody believes that, but you have to really believe it and work that way. And that's why I work on a flat plane, because then you don't get references immediately to nature — the outside world — it's like drawing.'[43]

What is striking about Siskind's enterprise is not simply that he produced photographs that look like miniature monochrome reproductions of Klines or Motherwells — if one believes taking a photograph to be just like making a drawing, why not? — but that the macho posturing, the heroicizing of self-expression is so extreme as to border on the parodic. Furthermore, there is manifest a stubborn, indeed a *perverse* denial of the material processes of photography, grotesquely dramatized and mystified into a Hemingwayesque litany of combat, struggle, fights, battles. Existential chest-thumping aside, that more than an enthusiastic conversion to Greenbergian formalism was involved in Siskind's rejection of the documentary mode (a mode which in no way precludes documentary pre-occupations, *vide* Walker Evans and Siskind himself) is suggested by Siskind's photographs of *writing*, and political writing at that.

> I've done a lot of them [torn political posters]. You may have seen some, they're big political slogans in huge letters, put on walls, and then someone comes along and paints them out and they make these marvelous forms. . . . That goes back to 1955, but since then I've found many more and the interest has gotten more complex, in that I began to realize to some extent that they are political. I wasn't interested in the politics. . . . I was interested in the shapes and the suggestibility of the shapes.[44]

It is tempting to see in the very extremity of this refusal of political meaning in the world the operation of mechanisms of denial and displacement: first, in the effacement of a specifically political text and the ingenuous denial of its political signification; and second, in the conflation of abstracted forms with transcendent meaning, thereby consigning political utterance to the aesthetic ether of suggestive shapes.

That the formalism espoused by Callahan or Siskind derives from an

idealist aesthetics rather than a materialist critical practice is obvious; that their
work relates more to the mainstream currents in American art photography
should be equally so. Somewhere between the American transcendentalist
version of formalism and the Soviet model lies Bauhaus photography: respons-
ive to certain aspects of revolutionary thought, but functioning within, and in
the service of, an advanced capitalist society tottering on the brink of Fascist
consolidation.

Most of what is meant by 'Chicago School' or specifically 'Institute
photography' is the work of photographers who emerged during the 1960s (ex-
ceptions would include Art Sinsabaugh, who graduated in the 1940s, Richard
Nickel, who graduated in 1957, and Ray Metzker, class of 1959). Neither
Siskind nor Callahan seems to have exercised direct influence on their students'
production, insofar as few of their students' work resembles their own. Rather,
the influence would appear to center around the assertion – provided as much
by example as by exhortation – that art photography, at the highest level,
represented the expression of a privileged subjectivity, whose relation to the
social world was at most that of cultivated *flâneur*, and the use of the formal
properties of the medium to express that subjectivity. Given that radical
formalism had been launched with a blanket repudiation of such notions, there
is finally very little that remains to link Soviet or Weimar photography with the
productions of the Institute. The pedagogic formalism which was developed
and refined throughout the 1950s and 1960s provided Institute photographers
with certain kinds of building blocks, frameworks, structures – or, at the most
trivial level, *schticks* – which, in a general sort of way, might be said to constitute
a recognizable look. The emphasis on 'problem solving,' the concept of serial
projects, interior framing devices, and other self-reflexive strategies, emphasis
on the design element in light and shadow and positive and negative space, dark
printing, certain types of subject matter, technical experimentation, acceptance
of color technologies, all are identifiable aspects of Institute formalism. This
type of work, and the precepts which inform it, has in turn been widely
propagated, largely because most art photographers end up teaching new
generations of art photographers. With the quantum leap in photographic
education that occurred in the mid- to late-1960s (the number of colleges
teaching photography expanded from 228 in 1964 to 440 in 1967), as well as the
growth of a photography marketplace, Institute photography was further valid-
ated and promoted.

There is, of course, no fair way to generalize about the range of work made
by as many (and disparate) photographers as Thomas Barrow, Barbara Blon-
deau, Linda Connor, Barbara Crane, Joseph Jachna, Kenneth Josephson,
William Larson, Ray Metzker, Richard Nickel, Joan Redmund, Art Sinsabaugh,
Joseph Sterling, Charles Swedlund, Charles Traub, and John Wood, to name
only the mere handful with whom I am familiar. I would, however, venture to
say that at its best, as in Josephson's 'History of Photography' series, an Institute
project is witty and intelligent, or, in Metzker's work, graphically striking,
but that at its worst – or average, for that matter – such photography reveals
only the predictable results of a thoroughly academicized, dessicated, and

pedagogical notion of formalism. In neither case, and on the spectrum of best to worst, is it likely to produce anything really interesting. For new art — art that is animated by new ideas and fresh perceptions — is what compels us to revise, alter, or reinvent our critical vocabularies, not reprocess ones from fifty years ago.

And though I am compelled to admit that, in comparison to what passes for formalist art photography nowadays, the Institute photographers cited above can seem mildly interesting, this can only be considered as damning with faint praise. The basic issue is whether Institute formalism, or its MoMA version, for that matter, has not become a *cul-de-sac*. The Institute tradition of experimentation and serial work notwithstanding, what one sees over and over again is a recapitulation of various devices and strategies which exist as guarantors of sophistication and mastery, but rarely exceed the level of academic, albeit accomplished, exercises. And inasmuch as so many of these photographers can be presumed to be serious, intelligent, and committed to their art, I wonder at what point they may begin to question whether the concerns of art photography may properly extend beyond the boundaries of the creative, the self-reflexive, or the subjective? As the tumbrels for the photography boom begin to be heard in the land, as the markets that have supported the post-1960s art photography begin to collapse like deflated balloons, the body of art photography produced in the past twenty years will be subject to ever more rigorous criticism, if it does not slip through the critical net altogether, consigned to oblivion. The formalism which sustained the best work of a Callahan or a Siskind has run its course and become useless either as pedigree or foundation. Walter Benjamin's prescient warning on the results of the fetishizing of the creative seems as applicable to present-day art photography as it was to the photography of Renger-Patzsch and his milieu which had, at the very least, the gloss of newness.

DISTANT VOICES: FASHION AND PORTRAITURE IN THE STUDIO IN THE INTER-WAR YEARS

Olive Edis

Photography, 1914

(First published in *Careers: A Guide to the Professions and Occupations of Educated Women and Girls*, The Women's Employment Publishing Co, Ltd., 1914)

Edis's contribution to this careers handbook for young women was written before she made her great documentary series on women's war service in northern France during World War I. Already distinguished as a studio portraitist, her work with the autochrome process remains an important segment of our photographic history. Edis was a skilled technician and committed to a photographic aesthetic; in this text, she urges young women to rise above the commercialisation and standardisation in photographic portraiture which she saw as endemic.

I T IS MORE than eleven years since the late Mr. H. M. Mendelssohn, one of the pioneers of artistic photography in England, said to the present writer, 'Portraiture is now in the hands of women.' The number of women who since that date have taken up this work in all its branches goes far to justify his remark.

As in other arts and crafts, every ounce of intelligence, culture and trained taste will help, to say nothing of that sympathetic interest in human nature which is a *sine quâ non* for the photographer who wishes to get the best portrait of Tom, Dick and Harry, as well as of the beautiful and well-dressed sitter who is herself a picture. An optimistic temperament, which refuses to be discouraged at the first sight of an apparently unattractive 'subject,' and which has the love that 'hopeth all things,' is another very necessary qualification.

It will be seen that I am speaking of the higher branches of portraiture, and I would not exact these qualifications for a 'sticky-back' photographer, who must fain reduce his work materials to a microscopic minimum, and then turn his 'stamps' out by machine. But it is especially the higher branches of artistic photography which are suitable for girls. The technique is not so difficult to master, and either a course at a school or an apprenticeship in a studio will secure that. But it is the personality of the worker that makes the good work, and this may be seen in quite a number of cases to-day, where the commercial and stereotyped style has been bravely set aside, and a much higher standard raised of what is really a good portrait.

To speak of London photography is not a very encouraging thing. The whole profession is now undermined by the reprehensible and regrettable custom of 'Invitation sittings.' Every girl who is about to be presented, every lady who is to attend at Court, needless to say, every person who has any real claim on public interest, and many a person who certainly has *not*, is inundated

with circulars from Bond Street and other firms in influential positions, offering
them a free sitting, and in most cases one or more gratis copies. What does this
mean? Of course it means that the firm hopes eventually for an order, as their
philanthropy would hardly extend so far as to do it out of pure generosity. But
what is the result? In numberless cases, the free sitting and the gratis copies are
accepted, and on a Court night the motors of the ladies invited run round from
studio to studio, and there the matter rests, as the sitter has so many photos
presented to her that she feels no more copies are necessary.

There is far more opening for enterprise in the provinces and in new and
growing suburbs, where children form the staple work, and have the very
common habit of coming back annually to be photographed. In this work, again,
a girl has a distinct advantage, as mothers generally like to bring their small people
to a lady. There is also far less outlay necessary than in London, where a heavy rent
is an enormous handicap, and where many sittings are necessary which can quite
well be dispensed with away from the centre of the great Metropolis.

But it is comparatively few who can aim at running their own studios, after
all, as the financial responsibility is certainly considerable. Unless a year's outlay,
including rent, rates and taxes, assistance and photographic expenses, can be
advanced, in addition to the furnishing outlay, it means a good deal of anxiety.
The materials have gone up steadily in cost: e.g., platinotype paper has practic-
ally doubled its price in ten years, and nearly all makers of plates put up their
prices in concert on June 1st last, so the expenses item does not grow less.

But what are the prospects for the girl who aims at getting a post in
someone else's studio? It is a much smaller certainty without the risks or the
possible profits which may fall to the lot of the girl who aims at having her own
business. The work seems to classify itself very much. Men are generally
supposed to be the only possible printers: they are certainly steady and reliable
at it, which is important; but the best printers I have experience of are girls.
Judgment and accuracy are the chief qualifications. Retouching is more and
more becoming girl's work, and there are many grades of skill and artistic sense
in this branch.

A general assistantship will give good all-round experience to one who
hopes eventually to have her own studio; but the difficulty is always in getting
experience in operating, as nearly every principal likes to do his or her own,
and will not trust an entire sitting to an employee. In all these posts £1 to 30/-
a week is considerably very fair pay. The few may attain to £2. A branch
managership will give the chance of operating, as well as a percentage on
profits; but there are not too many of these posts going. Many large firms
employ practically only one capable and salaried worker, and the rest of the
workroom may be entirely worked by apprentices.

Very often girls pay no fee, but receive 2/6 a week 'pocket money,' which
may rise to 6/- a week towards the end of their training, the employers only
engaging those who can live at home with their parents, and dispensing with
their services at the end of their apprenticeship.

The branches in which the larger salaries are earned are chiefly miniature
work and tinting. But these are not photography, and are really outside the

range of this paper, except that, as very many studios do have their colourists working regularly, a girl with some skill with her brush might make arrangements for an exchange of work and tuition. So-called silver-point, which involves pencil sketch work on the print, is also much in vogue and needs some artistic experience. This sounds as though the sum of the whole matter were, if you wish to make money out of photography – don't photograph!

The County Council have now added photography to their scholarship subjects, and these scholarships are often awarded irrespective of the particular bent of the girl. If the dressmaking or cookery scholarship vacancies are full for the year, the girl is drafted into photography.

If time and space permitted, a personal tribute to the delights of running a studio would include a kaleidoscopic reminiscence of the most varied and interesting experience which would convince the would-be photographer that, at any rate, it is a life worth living, with no monotony about it, and constantly bringing the worker in touch in a very pleasant way with humanity.

Madame Yevonde

Exhibitions and Commercial Work

(Extracted from *In Camera*, The Woman's Book Club, London, 1940, pp. 230–7)

Madame Yevonde (1893–1975) was active as a studio portraitist in London from 1916 until the late 1960s. In her 1940 autobiography *In Camera*, she describes the work which led up to her seminal 1935 exhibition *Goddesses and Others*, shown at her Berkeley Square studio. Though the tenor of Yevonde's writing seems almost casual, this belies the undoubted importance of the project. Richly coloured by the radical new Vivex process, extravagant and fantastical, the photographs showed society women posing as great figures from myth and legend. Yevonde, who had been an active supporter of the suffragette cause, used the photographs in *Goddesses and Others* to satirise current preoccupations with glamour and wealth, while at the same time, celebrating both.

VERY FEW PEOPLE have any knowledge of painting and our daily newspapers and periodicals, our hoardings and visits to the movies apparently supply us with a sufficiency of pictorial representation. There are, of course, exhibitions of paintings which are successful: being, in the main,

supported by the friends of the exhibitors who lack the moral courage to stay away; and attended by art students who believe they have something to learn from the study of other people's work. The rather dreary, overheated, under-ventilated, stagnant, must-not-talk-above-a-whisper sort of atmosphere that pervades most galleries is so depressing that it is indeed doubtful if it is possible for those who attend to experience any real upward surging of artistic emotion.

On the other hand, exhibitions are an excellent tonic to the exhibitor. The effort required is stimulating to the imagination and the dread necessity of producing something important by a certain date seems to release into the bloodstream forces which sometimes produce quite startling results. The fact that the results do not always appear quite as startling when hung in competition with others is of no consequence, for if their author recognises in them something better than, or different from his usual line, their object is achieved and also that of the exhibition.

As a selling mart the exhibition has its points, and I have sometimes had good results, though usually after the lapse of a considerable period of time. Probably the best results come from the one-man show. The atmosphere is sociable, there is no competition from other exhibitors, and visitors are under the personal supervision of the artist, and therefore more likely to remember his name.

I have had three 'one-man' shows. The first time I hired the Albany Galleries in Sackville Street. The rent was £5 a week, which included the printing of catalogues and the sending out of a thousand invitations. We sent out a supplementary five hundred from the studio. So I abandoned the thought of a formal opening and arranged instead the inevitable cocktail party before the private view. The exhibition was called vaguely 'Photographs by Yevonde'. The motive was to launch myself as a portraitist in Colour. I suppose it was the first one-man show of colour portraits to be held in this country. I had thought of asking a 'name' to write a few words on Colour Photography in the catalogue, but in the end decided to write them myself. They were, in effect, nothing but an apologia for the Colour Photograph, as yet in its infancy. However, the exhibition was such a success that we kept it open for a week longer than we had at first intended.

My next exhibition was after I had moved to Berkeley Square and was almost by way of being a house-warming. The disadvantage of holding an exhibition in one's own studio is that it delays work, unless there exists an extra room large enough to hang the prints and house the visitors. Also, one is not so likely to break fresh ground and enlarge one's circle.

This exhibition also was in Colour; for I had to fight continually for the recognition of the Colour photograph as a satisfactory medium for portraiture.

On this second occasion I turned to the classical for inspiration and the exhibition was called 'Goddesses and Others'. It was an interesting subject and gave great scope: from preparing the pictures I learnt a great deal.

I had chosen as a model for *Medusa* Mrs. Edward Mayer, a beautiful woman with eyes of the strangest and most intense blue. I realised that warm tones must

be avoided if I were to get an effective picture: Medusa was a cold voluptuary and sadist.

Her snakes were very difficult to come by. Someone suggested using live snakes but (although it was a tempting idea) I thought Mrs. Mayer would object and the snakes might not enter into the spirit of the thing. So Mrs. Ken Wood, the member of my staff, whose task it is to ferret out, beg, borrow, buy, hire or steal the strange things I am always wanting for my photographs, set out to collect snakes. 'Get rubber snakes,' I said, 'I have often seen them. They are bright green and you buy them in toy-shops.' So she went to Hamleys, Selfridges, Gamages, Whiteleys and Harrods, not to mention Woolworth's and Marks & Spencer's, and many other purveyors of children's delights; but it was the close season for rubber snakes. They were not in stock.

So two friends, to whom I had often turned in my troubles, made stiff little adders with black tape bound round wire, and gave them gold bead eyes and gold wire forked tongues. They were effective but too small and not numerous enough.

Then one day in the Strand I saw a man selling exactly what I wanted. They were sixpence each and I bought twelve for joy, although three would have been enough. They were snakes of bright green, made of rubber, with a hole in the tail for inflation. But the effect differed from my imagination, for when blown-up and coiled around the head they resembled small green motor tyres and not writhing snakes at all. So I took them to my friend Sandy and she deflated them and cut a large slice down each side and gummed the sides together. Then they refused to inflate and the air rushed out at the seams, leaving them creatures of no substance. However, she made the hole in the tail much larger and pushed in a cord, and through the cord a wire, so that the snake could be made to bend and serpentine at will. Then she painted them a dull greeny-black which gave them a sinister appearance. With sequins as their eyes and the help of the little black adders with the golden tongues we had at last a perfect head-dress for Medusa.

Having thus perfected the snakes, we painted the lips of Medusa a dull purple and made her face chalk-white. The background was vaguely sinister and unevenly lit and over one light I put a green filter. The effect was excellent.

Lady Campbell, wife of Sir Malcolm Campbell, posed as Niobe. Now Niobe was one of those over-proud parents. She had six sons and six daughters and was always praising them, and boasting about them to the other Goddesses, who became jealous, with the result that all her children were killed, and, as if that wasn't sufficient punishment, Jupiter turned Niobe to stone and she wept incessantly for her lost offspring.

I wanted to take a large head expressive of misery and suffering: no background, and nothing symbolic.

I have seldom seen more beautiful eyes than those of Lady Campbell, but we had to get them dim with tears and much weeping. We had great difficulty doing so. I always understood that Hollywood manufactured their tears with glycerine, but I was to find that glycerine tears would not 'stay put'. We mixed a little vaseline with the glycerine. This was better, but looked lumpy and not

sufficiently transparent. So we tried more glycerine, and unfortunately this time it got into the eyes and, mixing with the mascara on the lashes, caused such exquisite pain that Dolly wept real tears and for some minutes could do nothing but sit in misery, pressing her handkerchief urgently against the agony. When at last she was able to look up her eyes were bloodshot and her expression so miserable that I rushed the focus and was able to take a face expressive of the utmost sorrow and pain. This picture was in some ways the best in the exhibition.

Mrs. Anthony Eden posed as the Muse of History, in bare shoulders and a classical wig. Mrs. Beck took her full face with her face slightly turning away, against a greyish background with a silver star. Then I printed the three prints and tricked the three-headed effect by mounting.

Mrs. Gisborne posed for Psyche. Her mournful brown eyes, exquisite mouth and fair hair seemed to me to express the pleasure as well as the pain that Psyche was forced to endure.

It was the Bull for Europa that caused us the most trouble. Where would you begin to look for a replica of the bull (who was really Jupiter) who so fascinated Europa by his tameness and beauty that she mounted his back and rode away to her everlasting fame and delight?

We turned instinctively to the Natural History Museum, but those in authority were scandalised that we should want to take a bull away from a museum and put it in a photographer's studio. Then we telephoned Bovril. The man at the end of the line was sympathetic but unhelpful. Once, he said, they had a bull, but the moths had destroyed it. He would be happy to give us a poster, if it would help. Then we tried Rowland Ward. But he was scornful. The bull, he said, was a domestic animal and in England was never stuffed. He would supply us with a rhino or an elephant. Then we approached all kinds of colonial, emigration and travel bureaux. They offered elks, moose and antelopes, but of bulls they had none.

Next we went to the Army & Navy Stores. We had no better luck, but were put on the right track. In Camden Town there exists a wonderful emporium of stuffed animals, any of which may be hired for the day or week. And there, amid an array of rats and mice (stuffed for film purposes) we found our bull. For ten shillings and sixpence Mrs. Ken Wood was able to bring him back in a taxi with as much triumph as ever He felt when he galloped away with Europa.

Dorothy Wilding

In Pursuit of Perfection

(Extracted from *In Pursuit of Perfection*, Robert Hale, London, 1958,
pp. 24–5 and 17–18)

Dorothy Wilding (1893–1976), was active in London from 1914 to the
late 1950s. She became one of Britain's most successful and influential
studio portraitists, having trained as a retoucher with Ernest Chandler
at Walter Barnet's Knightsbridge studio. After a brief apprenticeship
with the American photographer Marian Nielson, she returned to
work as a retoucher with Richard Speight in New Bond Street, in
London's West End. These two extracts from her 1955 autobiography
In Pursuit of Perfection emphasise both the excitement of a young
photographer opening her first studio and the pragmatism of a woman
determined to learn the complex mechanics of her profession. Studio
portraitists of Wilding's era were well aware of the vanities of their
clients, and of the importance of the skilful reworking of the human
face which was so much a part of the retoucher's art.

THE ONE technical aspect of portraiture I couldn't teach myself was
retouching. Retouching is one of the many keys to perfect camera
portraiture. After I had got a grasp of the other keys, I soon realized that I
should have to be taught this particular craft carefully and thoroughly, not only in
order to reach the top of my chosen profession, but also in order to enable me to
produce a portrait, as the lens of my own eye saw it, and not as the lens of the
camera. In all modesty, subconsciously, I never dreamed of anything else but
the tops.

I must be slightly technical for a moment or two, if only to correct the
impression held by so many people that the main purpose of retouching is to
make a sitter more beautiful or handsome (according to sex!) than she or he is
in real life. It isn't that at all. It's more to make a portrait a fairer representation
of a sitter than it would be if a negative were left alone.

When photographing a human face in a studio a very strong light is
required to catch a fleeting impression – and expression – without getting
movement. Another thing – the strong artificial studio light exaggerates all the
lines and folds and creases in a face. It registers them much more harshly than
the naked eye. If you have seen a contact print of an untouched studio negative
you will know immediately what I mean. The effect is quite grotesque, and my
orders to my staff are, never to show them except to a very tiresome client –
and then only when they need a very bitter pill.

The most skilful retouching is necessary. The unfair exaggerations have to

be removed without the subtle personality of the face being in any way lost. This is a highly skilled job and must be learnt with the maximum of care and thoroughness. Makeshift and imperfect retouching is the badge of the bad photographer. . . .

At this fateful period of my budding professional life, I was sharing a home with four other London girls and I had quite a large bedroom to myself. It now served as my retouching studio as well. I bought a desk and fitted it out as a retoucher's equipment, and every evening after dinner I went to my den and worked on the negatives for all I was worth. It was monotonous and tiring work, especially after my long day at Speight's on the very same job, but it was the only way to fulfil my ambition, and I forced myself to stick it out. My reward was the satisfaction of doing a job of which I was now master and of counting the necessary pennies as they grew.

This they did at a satisfactory rate, and the day came, after weeks of day and night hard labour when I was able to count the sum of sixty pounds. It was very little, but yet enough, I calculated, to start me off at the game – especially when I told myself reassuringly that I could manage on my stock of clothes for at least twelve months. And at the end of twelve months – well, who knows? That was in the lap of the gods. Now I set off in search of a studio. Eventually I found just what I wanted in George Street, Portman Square, within the golden area of London's West End, but not too outrageously expensive or pretentious for my pocket and my debut. It had been used for seances and other meetings by one of the leading spiritualistic societies in London at that time. . . .

It consisted of an exceptionally big, long room, with also a big, long window facing north, and a kind of small extended annexe on the room, about four by six feet, which was passable for developing, printing . . . and very elementary cooking! I lived in the studio and to give me some hiding space I hung up a green curtain across each end of the room, one end to hide all my clothes and belongings and the other end to hide the backgrounds and photographic equipment. My choice of lightish green was very deliberate; it was a useful background for any colour and it harmonized with the economy oak furniture I bought. I couldn't afford a carpet to cover this large room, so, instead, I made do with a very thick cigar-brown felt, the kind usually used under luxurious carpets.

I had to sign a lease for the place, of course, and this momentous business was conducted with the joint owners, two Dutch-born business men who lived somewhat remotely behind Oxford Circus. They were most careful and even pernickety about protecting themselves in the lease. They had it drawn up in scrupulously legal form. I was tied up in every conceivable way. Looking back on it now, it is amusing to think that I was only twenty – a minor!

Eventually I signed the lease under their eagle gaze, and I was now proprietress of my own Studio!

Louise Dahl-Wolfe

Early Years

(Extracted from *A Photographer's Scrapbook*, Quartet Books, London, 1984, pp. 1–6)

Louise Dahl-Wolfe's career as a fashion photographer (active from 1933–60, principally in New York for *Harper's Bazaar* and *Vogue*) is well documented. In this extract from her autobiography, she describes her childhood and her introduction to photography in California. Of special interest to historians of women's photography are her connections with Annie Brigman and Consuela Kanaga as well as her friendships with Dorothea Lange, Edward Weston and Arnold Genthe.

I WAS BORN and raised in San Francisco over eighty years ago (and named L.E.A.D. for Louise Emma Augusta Dahl, because my mother had heard it was good luck if a child's name spelled a word). My parents came from Norway. My mother's father had lost a lot of money in the timber business and bought a farm in Iowa, sight unseen. My father was an engineer and came in 1872 to work designing engines in Reading, Pennsylvania, having left Norway to avoid military service. He was a man of very definite ideas; a fan, as I am, of Thomas Jefferson. My parents met and married in San Francisco, which was a marvelous city with its large Chinese population, and a great shipbuilding port. My father soon became the head of the marine engineering department of the Union Iron Works – later the Bethlehem Steel Company. Our family, my two sisters and I, would attend the christening of the ships on Sundays, and play was to pull out the ribbons of all the great names: the USS *Ohio*, or the USS *California*; my father's idea of entertaining a little girl was to take her to the shipyards.

One of my most vivid early memories is of the earthquake and fire of 1906, watching the endless stream of refugees fleeing to safety in the nearby hills. My job during the three days of burning was to sweep the deep ashes from the ledge on the garden fence.

Art School and Anne Brigman

PERSUADED by my sister and my art teacher, I became a student at the San Francisco Institute of Art on Nob Hill in 1914 – it was where the Mark Hopkins Hotel is now. Art school days consisted of cast and life drawing, painting and composition, anatomy, color, and design. We drew in charcoal in life class and erased our mistakes with the rolled-up inside of sourdough bread – the recipe of the gold miners of 1849.

I had the great good luck (and I believe in luck) to study with Rudolph Schaeffer, who taught the first course in color at art school, one of the most profound experiences for me. You have to study color like the scales of the piano. It's really scientific. Later you can depend on whether you have either taste or imagination.

The World's Fair opened in 1915 in America even though the war was raging in Europe. For the first time in America except for the 1913 Armory Show the great treasures in painting and sculpture were collected from Europe. We saw the Impressionists and the Post-Impressionists, the old masters and the modern painters – eye openers to the young art student. Around this time I had the chance to see Diaghilev's *Ballets Russes*, and was overwhelmed by the modern sets of Picasso, Braque, and Derain, together with the costumes of Bakst, the music of Stravinsky, and the dancing of Nijinsky. To me, this was the perfect synthesis of these three arts – dance, painting, and music.

I always wanted to be a painter. I'm a frustrated painter, you know. If I couldn't be a painter, I had hoped to go to New York after art school to study interior decorating, but my father died in 1919 and I stayed on, taking a job designing electric signs. It was frightfully boring and routine. And then a wonderful accident: a friend of the photographer Anne Brigman invited me to her studio. At that time photography was really not considered an art form. Brigman was part of the Stieglitz group (he devoted an issue of *Camera Work* to her photos) and they were working hard to get photography recognized. I was bowled over by my first look at Brigman's slides, her nudes taken in ice caves in the Sierra Nevada Mountains and in cypress trees on Point Lobos. I was overwhelmed by the possibilities of the camera, about which I had known nothing. Everything about the visit was impressive to me; for instance, the exotic color of her studio walls, which were wooden boards stained a red-violet hue of strong intensity. One rarely saw color like that although the Bay region was beginning to use modern color because of Schaeffer's influence. He had just come back from studying in Europe, bringing color theory with him. I had to get a camera! And I was soon spending all my earnings on photography.

I visited friends in Carmel and we all decided to become photographers. We'd pose in the nude for each other, using a Brownie box fixed-focus camera, and we had the film developed at the drugstore. We were so excited by the results that we took the film to Mr. Dassonville, a well-known photographer in San Francisco, and asked him to enlarge it. He tried to hide his amusement. I hoped he didn't recognize that I was one of the nude models. He told us kindly that our negatives were not good enough to enlarge, and that inspired me to buy a better camera, an Eastman with an F 7.7 lens and a film-pack back. The clerk took an interest in my effort, pointing out all my mistakes, and told me to learn to judge light on my ground glass before I made the exposure. There were no exposure meters and no panchromatic film yet, so one guessed. I underexposed, I overexposed, but I improved.

On the clerk's advice, I made my own enlarger by using my camera as a projector, fitting it into an opening in an apple box, and making a reflector with a large Ghiradelli chocolate box.

It was then that I met Consuela Kanaga, who worked as a photographer on the *Chronicle*. She persuaded me to buy a better camera when she saw my equipment – a used Thornton-Pickard English reflex, $3\frac{1}{4} \times 4\frac{1}{4}$, with a soft-focus Verito lens, which was most commonly used by the important photographers of the twenties. We roamed the city looking for bits of local color. I was discovering that San Francisco was full of photographers: Arnold Genthe, Francis Bruguierre (a member of Stieglitz's photo-secessionists), Dorothea Lange, and Edward Weston (whom we saw often).

PICTURES AND STORIES: DOCUMENTARY AND REPORTAGE IN NORTH AMERICA

Margaret Bourke-White

Life Begins

(Extracted from *Portrait of Myself*, Collins, London, 1964, pp. 141–52)

This extract from Margaret Bourke-White's autobiography *Portrait of Myself* (1964) describes Bourke-White's first assignments for the American picture magazine *Life*, which, more than any other, elevated photojournalists from journeymen to influential commentators on world events. In '*Life* Begins', Bourke-White (1904–71) recollects the excitement and pace of these formative months in the history of photojournalism and her position as a woman working in a very male profession.

'THE FIRST ISSUE of a magazine is not the magazine. It is the beginning.' With these words of introduction from the editors, *Life*'s Vol. I, No. 1, came into existence on November 23, 1936. A few weeks before the beginning, Harry Luce called me up to his office and assigned me to a wonderful story out in the Northwest. Luce was very active editorially in the early days of the magazine, and there was always that extra spark in the air.

Harry's idea was to photograph the enormous chain of dams in the Columbia River basin that was part of the New Deal program. I was to stop off at New Deal, a settlement near Billings, Montana, where I would photograph the construction of Fort Peck, the world's largest earth-filled dam. Harry told me to watch out for something on a grand scale that might make a cover.

'Hurry back, Maggie,' he said, and off I went.

I had never seen a place quite like the town of New Deal, the construction site of Fort Peck Dam. It was a pinpoint in the long, lonely stretches of northern Montana – so primitive and so wild that the whole ramshackle town seemed to carry the flavor of the boisterous Gold Rush days. It was stuffed to the seams with construction men, engineers, welders, quack doctors, barmaids, fancy ladies, and, as one of my photographs illustrated, the only idle bedsprings in New Deal were the broken ones. People lived in trailers, huts, coops – anything they could find – and at night they hung over the Bar X bar.

During the mornings I worked on the inspiring high earthworks of the dam. At noon when the light was too flat for photographs, I rode off on horseback through the endless level stretches which would be reservoir when the work was finished. When I had used the sun's last rays to the utmost, I would turn up at Bar X or the Buck Horn Club. The Buck Horn employed a college football star as bouncer, and at the Bar X the four-year-old daughter of the barmaid spent every evening seated on the bar. At a little distance from town in Happy Valley, I could photograph fancy ladies. Breakfast could always

be obtained in a tiny lunch wagon at the edge of an eroded gully. I ate the construction men's special – waffles piled with whipped cream and enormous pecans.

A telegram came from Dan Longwell, indicating that the editors were very uneasy about what should be the opening subject in the new magazine. He wanted to know what I had. I wired, 'Everything from fancy ladies to babies on the bar.' When the editors saw my pictures, they wrote the following introduction:

> If any Charter Subscriber is surprised by what turned out to be the first story in this first issue of *Life*, he is not nearly so surprised as the Editors were. Photographer Margaret Bourke-White had been dispatched to the Northwest to photograph the multi-million dollar projects of the Columbia River Basin. What the Editors expected were construction pictures as only Bourke-White can take them. What the Editors got was a human document of American frontier life which, to them at least, was a revelation.

These were the days of *Life*'s youth, and things were very informal. I woke up each morning ready for any surprise the day might bring. I loved the swift pace of the *Life* assignments, the exhilaration of stepping over the threshold into a new land. Everything could be conquered. Nothing was too difficult. And if you had a stiff deadline to meet, all the better. You said yes to the challenge and shaped up the story accordingly, and found joy and a sense of accomplishment in so doing.

The world was full of discoveries waiting to be made. I felt very fortunate that I had an outlet, such an exceptional outlet, perhaps the only one of this kind in the world at that time, through which I could share the things I saw and learned. I know of nothing to equal the happy expectancy of finding something new, something unguessed in advance, something only you would find, because as well as being a photographer, you were a certain kind of human being, and you would react to something all others might walk by. Another photographer might make pictures just as fine, but they would be different. Only you would come with just that particular mental and emotional experience to perceive just the telling thing for that particular story, and capture it on a slice of film gelatin.

There is nothing else like the exhilaration of a new story boiling up. To me this was food and drink – the last-minute feverish preparations, the hurried consultations with editors, not so much for instructions as to sense how they 'saw' the story, and to get that suggestion of a spine, that sense of structure, that indefinable, inspired plus which one somehow absorbs from the finest editors. Then the momentous decisions to make about supplies: which cameras, film, and what kind of lighting equipment to take.

Often in the explosive departures, I felt as though I had been tossed into a whirlpool with all the stuff and could only hope the essential items stuck to me.

Usually they did, largely because of Oscar Graubner – and later, other equally wonderful darkroom people watched over me.

There was always more than a person could do, it seemed, but I would find I somehow had done it and was on my way, breathing and recovering and relaxing and catnapping, and even with some research material, maps and clippings which I could read and study on the way.

In the beginning of *Life* there were only four photographers, and with the magazine coming out every week, there was a great deal to be done. We went on story after story, one after another, and our paths seldom crossed.

I came to know Alfred Eisenstaedt first – dear, gentle Eisie, with his great gift for piercing through to the hidden hearts of those he photographed, his masterful technique on the miniature camera which was then new in this country.

Tom McAvoy had worked for *Time* in Washington and was transferred from *Time* to prepublication *Life* magazine.

Peter Stackpole, a youngster then on the Pacific coast, had been so intrigued with the building of the exquisite Golden Gate Bridge that he took a marvelous series of photographs which caught the eye of *Life* editors, and he was given a job on *Life*.

Bostonian Carl Mydans was a newspaper reporter before he was a photographer. He narrowly missed being on the original *Life* photographic staff. He arrived on the scene one day after the first issue of *Life* hit the newsstands.

One of the finest things about working with *Life* was the way we were treated as adults. I was given an enormous amount of freedom of choice when it came to assignments. Sometimes the ideas originated with the editors and sometimes with me. If I dreamed up an idea for a story which I thought would be a good one, I researched it and hunted up people who could give me background on it, and then went to the editors with my idea. If they thought it made sense, they sent me out on it.

The larger portion of the story ideas came from the editors, but this did not mean that I had to accept them. Occasionally I turned a story down, but I did this only if I felt the idea was a synthetic one that originated in an office armchair and was not a slice of real life. But this was rare. Most of the assignments offered to me were exciting and tantalizing ones, and I was frequently picked out for the photo-essay type of story which I had felt was in a way my 'baby,' since doing the Fort Peck picture essay for the first issue of *Life*. When the editors called me in on a story which they referred to as the 'Bourke-White' type of story, this made me very proud.

Up to now I had never worked on stories where the news timing was of paramount importance, but my next batch of assignments had to do with people and events in Washington. Plunging into the news world was for me a very exciting thing. Although I had been thinking of picture stories in connection with news in the broad sense, that is, having a news peg with which to place the story in time and space, this had the now-or-never atmosphere. For

photographers, this was a world of its own, or rather, a war of its own, with added stress when the target had something to do with Washington, or the administration, or, most backbreaking of all, with the President himself. For picture sessions, a very limited amount of time was rigidly set, and photographers of all kinds were rabidly intent on squeezing every usable second out of the meager allotment.

Usually I was the only woman photographer, and the technique I followed was to literally crawl between the legs of my competitors and pop my head and camera up for part of a second before the competition slapped me down again. At least, the point of view was different from that of the others whose pictures were, perforce, almost identical, and, anyway, I've always liked 'the caterpillar view.'

It was surprising to discover that photographers whose work involved the news in any way formed a kind of caste system, with newsreels – the Brahmins – at the top, and the still photographers – the untouchables – at the bottom. Even on the bottom rungs, the newspapers stills ranked higher than the magazine stills. And when TV came along, another rung had to be added at the top of the ladder, and even these highest-caste photographers are split between black-and-white and color, with color on the topmost peak.

When President Roosevelt's second inauguration was to take place, Dan Longwell worked some persuasive magic and actually got me a little blue chip of cardboard which allotted to me a space on the high platform. Inauguration Day dawned with the heaviest rainfall since Taft became President in 1909. My photographer's sense impelled me to get to the spot very early, because I could see there would be the worst-possible photographic conditions to deal with. When I arrived on the dismal scene, I was fortunate to find a little boy to help me up with all my equipment to the highest stand, which was splendid indeed with its unbroken view to the inaugural platform on the White House portico. I had my largest cameras and tripods, knowing that long steady exposures would be necessary in this dullest of all possible daylight.

I got everything arranged and waited complacently for the other photographers to arrive. By now the crowds in the Capitol Plaza were packed so tight they formed a solid roof of umbrellas. We still had ten minutes before the show would begin, and I was wondering where my colleagues were. In less than another minute they appeared, scaling the platform like a pack of orang-outangs and taking up their places with their heavy gear. Suddenly I found myself being pushed away and had to cling to the handrail so I would not fall off the platform. A very aggressive young man, a movie photographer, walked up and pushed me aside so he could take the place where I had been standing. I brought out my ticket and he produced an identical one. My cries were drowned in the lashing rain, and there was no time for arguments anyway. The inauguration had begun. Immediately I made a run for one of the lowly still photographers' stands. This time there was no little boy to help me with cameras, but somehow I made it with the heavy gear and reached the humble platform just in time to catch the ceremony.

When it was over, one thing happened, so unexpected and wonderful that

I was sure it had saved the day for me. To the delight of the soggy crowd, President and Mrs. Roosevelt stepped into an open car, facing the rain along with the rest of us. By extraordinary good luck, the President's car passed within perfect focusing range of the spot where I stood. FDR was at his best, waving and smiling, and there could be no question that this was the key shot of my day. No one else, I was sure, had got anything else just like that. Joy overwhelmed me – until I got to the darkroom and saw that I had underexposed this negative so badly that only a trace of the image appeared, just enough to show how wonderful the picture would have been. But the general view of the inauguration over the sea of umbrellas, of which I had expected nothing – that *Life* used as a double-page spread.

The Louisville flood burst into the news almost overnight. I caught the last plane to Louisville, then hitchhiked my way from the mud-swamped airport to the town. To accomplish the last stretch of this journey, I thumbed rides in rowboats and once on a large raft. These makeshift craft were bringing food packages and bottles of clean drinking water to marooned families and seeking out survivors. Working from the rowboats gave me good opportunities to record acts of mercy as they occurred.

I found that three-quarters of the city was inundated. Down-town Louisville was a beleaguered castle surrounded by a moat. The office of the *Courier-Journal*, which was still managing to turn out newspapers, kept a kind of open house for anybody from the press, near or far, who had no place to lay his head. Reporters slept on desks or in any available corner on the floor. I staked out a claim to a desktop which seemed about my size, but it was a long time before I was able to go to sleep on it, because I was so busy photographing members of the press and their makeshift quarters. I was pleased that *Life* ran a spread on the working press.

This was one of the three most disastrous floods in American history, but, as always, the small things stand out in one's mind. On climbing through the second-story window of a pet shop, I was startled to find scores of canaries, their full-feathered wings spread out in the exquisite patterns of Japanese silks, beautiful even in death. Another sort of beauty in death, a beauty which was indeed in the eye of the beholder, I encountered when by chance I entered a funeral parlor and found the undertaker trying to find words to express his shock when he saw a body floating past his door, maneuvered it in with a long broom, and discovered it was a dear neighbor. He performed that last of all services, which he was so particularly qualified to perform, for his friend and, gesturing toward his worktable, said, 'Doesn't she look beautiful? I've made her look fifteen years younger.'

There was the irony of the relief line standing against the incongruous background of an NAM poster showing a contented family complete with cherubic children, dog and car, its printed message proclaiming, 'There's no way like the American Way.'

To me this mammoth flood was another bitter chapter in the bleak drama

of waste of our American earth, which I had watched unfolding and had tried to record since the drought. The juxtaposition of blowing soil and rainfall, of eroded farmlands and inundated cities, made an ominous continuing pattern.

In general, the farther away I am sent to cover an assignment, the better I like it. However, one of the most exciting episodes I ever had a chance to cover broke virtually under our office windows. It was a true-to-type old-fashioned muckraking story, unfolding just across the Hudson River, on the sprawling Jersey side. Tales were reaching us of reporters being beaten up, of photographers having their cameras snatched away from them and jumped on. It seemed almost as though Jersey City was fast becoming a private kingdom with its mayor as its ruler.

Mayor Hague was an outstanding member of a type of vanishing American. He was the last of the big city bosses. He was a mayor with whom no one could argue, whose last word was 'I am the law,' and he meant just that. With the country's largest per capita police force at his back, nine hundred strong, rare was the constituent who talked back.

For my part, I could hardly believe there would be any physical violence, but I was just as pleased when, on the first day, C. D. Jackson accompanied me across the river to make sure that I got started right. We were given a grand tour of nine miles of waterfront, the terminus for eight railroads, and a visit to the impressive Margaret Hague Maternity Hospital which the mayor had named after his mother. We were given a grandstand view from the balcony of a modern and dramatic delivery room, where we watched a baby being brought into the world by Caesarean section, something which neither C. D. nor I had seen before. Obstetrical care was given free to needy mothers, and for those who did pay, the charge was never higher than thirty-five dollars. I was glad to see the Mayor's concern that children in his city get a good start in life, but I was startled to find that his concern for the very young stopped abruptly at the doors of the hospital.

Almost within the long shadow of the Mayor's monument to his mother was a confused area of two- and three-storied houses of rickety wood, with outside stairways and a nightmarish, high, open wooden platform connecting one family dwelling with the next. It was whispered that this was the center of the child labor area, but no one used this phrase openly. It was benignly referred to as 'home industries.'

Under the rotting roofs of this dinosaur among residence buildings, many a white-faced child toiled away making artificial flowers, kept home from school because only with the help of the children could the family make two dollars and a half a day, the absolute minimum on which the entire family could keep itself alive. How I longed to get a camera inside one of these homes, but that would have to wait a bit.

At the beginning of my assignment, I was plainly the Mayor's pet. I accompanied him to all his speeches and sat in the front row and jumped up with flashbulbs ready when he made one of his authoritative gestures. As he

bellowed out his message, he stood against a background of striking banners, with slogans: CITIZENS OF JERSEY CITY ARE ALWAYS ONE HUNDRED PER-CENT AMERICAN, and REDS, KEEP OUT!

During these first days when I was *persona grata*, I enjoyed the dubious privilege of a police escort, which met me every day when I stepped out of the Hudson Tube, and tenderly moved my cameras from the subway car into the king-sized limousine waiting at the curb.

But once I had satisfied myself that everything I needed in the way of pictures on the Hague side of the ledger was taken, I managed to give my bodyguards the slip. I had arranged in advance for helpers who knew the waterfront well. Chief among these was a reporter from one of the Jersey City newspapers, who, since he could not use this material for his own paper, welcomed the chance to add his efforts to mine so the story would see daylight. Together we raced to the shipping docks, which I wanted to see again at closer range.

These docks were enormous and handled large quantities of shipments for foreign ports. At the dock I found many of the great crates that lay ready for shipment were addressed to cities in the Soviet Union, to Odessa and Sevasto-pol. One great piece of oil machinery – a giant cylinder bearing the stamp of Amtorg, the Soviet trading agency – made a dramatic and informative picture. It was so placed and so big on the dock that I could photograph it showing the Manhattan skyline right over it. This pinned down the location as the Jersey City waterfront beyond argument. Probably all this material was routine shipping, but I marveled at a despot who could thunder out to his constituents in the evening, 'Now is the time to strike at Red invasion,' and then do business with Red Russia next morning.

I was so afraid my police escort might catch up with me that I dared not complete a single roll of film. As soon as I got three or four shots on a roll, I dispatched one of my helpers over to New York with it. I knew that it was inevitable that I would be arrested before long, so I worked feverishly to expose all of the skeletons in the closet before I might be dragged away from the scene.

From now on, it was cops and robbers. I managed several shots in the rattletrap building, some showing three generations making lampshades, ceil-ings and walls dripping with highly combustible paper lampshade parts. Here I did not pause even to reload cameras, but handed them with the exposed films still inside to my helper, who stuffed them out of sight somehow and made his escape. I still had two cameras in reserve, and I was poking the lens of one of them into the cavelike dwelling of the violet makers – a place so snowed under with artificial violet petals that if anyone had struck a match, it would have fused off the whole building. I had just finished with violets when the city's finest caught up with me. I was taken straight to police headquarters. I was not beaten, and the cameras were not jumped on, but they might as well have been, because they were torn open, the film ripped out, which of course ruined them instantly on exposure to the daylight. I was able to watch this scene of destruction in comparative calm. Thanks to our pony-express system, the key shots were already crossing the Hudson River by ferry to safety in Manhattan.

Carol Squiers

Looking at *Life*

(First published in *Artforum*, December 1981)

The picture magazine techniques which were developed in Germany during the '20s, later spreading to France (in *Vu*) and Britain (in *Weekly Illustrated* and *Picture Post*), reached the US only some years later. *Life*, launched in 1936, marked the real coming of the picture paper to America. But *Life* was very different from its European counterparts; instead of British liberalism or the leftish anti-fascism of French and German photojournalism, its ethos was conservative, handing the nation a mythic version of itself bound within a tight set of ideologies. These added up to the 'American way'. Carol Squiers's article analyses how *Life*'s juxtapositions of image and text conformed to certain formulae in order to achieve an apparent coherence.

WHEN THE HISTORY of photography is rewritten, the entire development of photojournalism will have to be closely re-examined on its own terms. Thus far, the editorial innovations of the German picture press in the '20s and '30s and the stylistic contributions of certain great photographers have been highlighted. However, it is only part of the story to acknowledge and reproduce the superb pictures of Erich Salomon or Robert Capa, or to discuss individual editorial inventiveness. Photojournalistic pictures exist within the confines of very different publications with different points of view. The way in which any magazine uses pictures determines how and what those images mean. And assigning meaning is in essence what photojournalism is about.

The most significant picture magazine published in this country up until the early '70s was *Life*. It developed various strategies using pictures, headlines, captions, text, and story layout to communicate editorial messages about politics, the respective roles of men and women in society, and the burgeoning progress of American culture. Yet when pictures from *Life* are exhibited or reproduced in books, their original context is usually ignored. At best, the pictures are accompanied by titles or captions. But we cannot really understand the use to which those pictures were once put when they are haphazardly taken from their original layouts and redefined as pleasing singular entities. Although it has been repeatedly acknowledged that photographs do not communicate an absolute truth, they are still credited with the ability to do so. The 'meanings' of photographs are slippery and complicated, however, and any of them might be defined in more than one way. Explicit interpretation of photographs is determined mainly by the discourse that surrounds them.

The discourse about Henri Cartier-Bresson's pictures rests both in his own elucidation of the decisive moment and in the critical writing that has grown up around the idea; it has been almost wholly involved with esthetics. In the case of Robert Capa, much of the discourse has resulted from anecdotes about the life of the photographer himself, and from the glorification of certain pivotal pictures, such as that of the Loyalist soldier falling dead during the Spanish Civil War. But there was a different and specifically created text originally surrounding such photographs. The magazines that purchased or commissioned these pictures communicated editorial attitudes by caption and text that determined the readers' perceptions of the pictures. The removal of photojournalistic pictures from their original context to the world of isolated and discrete images points to the crux of the problem.

The majority of pictures taken for *Life* were made to be seen or used in a multi-image context supported by written material. In an endless hunt for individual masterpieces, the photographic/art community has chosen too often to take single pictures out of *Life*'s original context and to appreciate them for their formal beauty or anecdotal interest. We now know most pictures from *Life* in gallery-exhibition form, or as 'typically excellent' specimens of a photographer's output reproduced in books both scholarly and popular. However, to isolate solitary images, ignoring the picture stories for which they were carefully chosen, and commissioned, is to create a fiction. *Life* exerted a tremendous influence on national and international opinion through its photojournalism, but its aims and its content have often been separated.

Life was not the first picture magazine in the world, but it was overwhelmingly the most successful. Other picture magazines had been published in the United States previous to *Life*, but all had ceased publication by the late '30s. *Life* was an idea, however, whose time had come, in as much as, 'Around 1934 practically every newspaper man and his brother was carrying the dummy of a proposed picture magazine in his outside pocket.'[1]

Life's first issue was dated November 23, 1936, and it promptly sold out the entire press run of 466,000 copies. Because of mistakenly low advertising rates and its expensive, heavy, coated paper, *Life* produced an astonishing $6 million loss before it paid back Time, Inc.'s investment. *Life*'s immediate, calamitous success made magazine history. Far outstripping early predictions of 250,000 readers in 1936, its circulation soared to two million in less than three years.

The presiding consciousness at *Life* was Henry Luce. The son of American Presbyterian missionaries, Luce was born and raised in China. His father was part of the great sweep of ardent, late nineteenth century missionaries who spread over the globe preaching 'the transcendence of Christianity and the American culture.'[2] Henry enthusiastically took up the mission and at age four was dictating sermons to his mother and preaching to his playmates in the missionary compound. He served in high editorial positions on newspapers and magazines in both prep school and college. After graduation from Yale he worked as a legman for the imaginative Ben Hecht at Chicago's *Daily News*, and then worked with former classmate and future business partner Briton Hadden on the *Baltimore News*. During this period they conceived a publication

that would 'summarize the week's news in the shortest possible space.[3] By early 1922, when Luce was twenty-four, the two entrepreneurs went to New York with the dummy for what would a year later become *Time* magazine.

From the beginning Hadden shaped '*Time*style' (the progenitor of *Life*-style), 'the slicing, trimming, flavoring, coloring and packaging of the news to make it more interesting and more salable than it was in real life.'[4] Snappy, exaggerated verbs and adjectives were used to limn the characteristics of those *Time* wanted to flatter or ridicule. A politician could be portrayed as 'trim-figured' and 'keen-brained,' while his opponent was seen as 'flabby-chinned' and 'gimlet-eyed,' and the former 'strode' while the later 'shambled.'[5] In concert with this highly visual approach to the news, Hadden made one other discovery that would also be of immeasurable use to the later *Life* magazine: the 'mischievious' use of candid snapshots, which could be used, again, to flatter or ridicule.[6] The idea of news as raw material that could be visually coded and then buttressed by written explanation provided the first step in what would become *Life*'s style of reportage, based on the inventive, elastic manufacture and linkage of text and photograph.

As a captain of the modern press, Luce understood himself to be in control of 'the dominant mental and psychological environment of the people.'[7] In his three magazines, *Time*, *Life*, and *Fortune*, and in his many speeches, Luce took every opportunity to hammer home his views: a messianic belief in America and the American way of life (he once said of America that 'no nation in history, except ancient Israel, was so obviously designed for some special phase of God's eternal purpose'[8]); the celebration of free-enterprise capitalism (in a speech to Ohio bankers he said: 'Have no embarrassment about making too much . . . Every dollar you make is a patriotic contribution to the national debt . . . make money, be proud of it; make more money, be prouder of it'[9]); and a fanatical hatred of world Communism (in 1930 *Time* was already calling for 'an international Capitalist boycott of the Soviet State'[10]). In all of this he was the perfect spokesman for the blossoming expansionist American culture of the 1950s. Just as his rhetoric was heavy-handed and simple-minded, so too was its translation into the pictures which began to constitute the 'news.' The Godless Communists were a dark, monolithic entity whose threat could be shown in a two-page picture of the dictators Lenin and Stalin embalmed and displayed in a spotlit blackness for the Soviet masses to worship. Women were delightful, frivolous creatures whose essence lay completely on the surface where the camera could easily capture it – in the 'sensuous strength' of their stride, the 'sweetness' of their smiles, and in their 'perfect grooming.' *Life* gave equal time and thus equal importance to what it saw as the hovering Communist menace and to 'Broadway's Smartest Dumb Blonde.' As time went on, all subjects were similarly homogenized into the same spectrum of trivia.

As former editor Wilson Hicks of *Life* noted, more important than the concept of photojournalism, the enterprise or the talent, was 'the body of beliefs and convictions upon which the magazine was founded . . . It stood for certain things, it entered at once the world-wide battle for men's minds.'[11] Hicks never spelled out exactly what those beliefs were, but this passage

perfectly conveys the rigorously self-righteous tone of the magazine in general. *Life* made itself a virtual textbook for American political opinion, mass culture, and sex-role instruction.

In the prospectus for *Life* the magazine's didacticism and its interest in entertaining were presented as a function of visual representation from the outset. Luce's final version included these varied aims:

> To see life; to see the world, to eyewitness great events; to watch the faces of the poor and the gestures of the proud; to see strange things – machines, armies, multitudes, shadows in the jungle and on the moon . . . to see things thousands of miles away, things hidden behind walls . . . Things dangerous to come to; the women that men love and many children; to see and to take pleasure in seeing; to see and be amazed; to see and be instructed.
>
> Thus to see, and to be shown, is now the will and the new expectancy of half mankind.
>
> To see, and to show, is the mission now undertaken by LIFE.[12]

Embedded in this potpourri of manifest wonderment – the apotheosis of the visualized as enlightenment – are all the elements of a new visual ideology. By dint of his privileged access to the wishes of the Almighty, Luce was able to intuit the 'will' of mankind. And so, *Life* undertook the 'mission' of seeing and showing, reinvoking the ardent rhetoric of rectitude that echoed down from Luce's, and this country's, missionary past.

Life floundered to find direction for its first several years. But even in the early issues it had begun to define its approach to the use of photographs and text. Its definition of the news was similar to that of the tabloids: blood (young doctor and dog mangled by train), sex ('How to Undress in Front of Your Husband'), scandal (society woman shoots handsome husband to death), and evil or ridiculous foreign politicians ('The new salute of the French Radical Socialists . . . was the self-congratulatory gesture used by U.S. prizefighters on entering the ring'). The critic Bernard De Voto observed in 1938 that *Life* consisted of 'equal parts of the decapitated Chinaman, the flogged Negro, the surgically explored peritoneum, and the rapidly slipping chemise.'[13]

In the first issue of *Life* the reader was presented with a number of archetypal picture tales. In one, a young wife creeps out into the woods to give birth to a 'child of sin.' Three pictures spell out the illicit story. The first is a shot of the house where the pregnant Mrs. Crawford 'rose from her husband's bed' to go 'barefooted' into the woods to give birth. The second picture shows the couple together, gazing down at the baby, which the cuckolded husband lovingly holds. The caption informs us that 'all the world' believed along with Mr. Crawford that 'a big brindle bulldog had brought an unknown baby to the doorstep.' In the final picture a nurse tenderly holds the hapless infant because, 'Police took the baby and family opinion forced simple Mr. Crawford to give up his storytelling wife.' The use of vivid captions leads the reader through a tiny morality tale. The picture of the house shows the alleged site of the drama. The house operates both as potential for matrimonial bliss and as the site of the

depicted reality of brutal betrayal. Secondly we see the players: the smiling husband, the innocent baby, and the sinful, slovenly wife, whose nightgown slips suggestively off one shoulder. And as a finale we witness the intervention of the forces of good, the nurse and the police who will protect the innocent child while offstage the husband's unseen extended family exerts its superior moral influence on the side of righteousness, bringing the situation to a quick and satisfactory conclusion. The use of the empty site, such as the house, where meaning will be supplied by a caption alone, the loaded portrait shots of the significant players, whose contributions for good or ill are explained in the caption, and the tidy, theatrical conclusion (which can run to either tragedy or burlesque), are hallmarks of all *Life*'s picture stories, whether the subject was movie stars or political rebellion.

Although *Life* may have labored uncertainly until finding its way, Wilson Hicks admits that, 'Prior to publication, *Life* had become acquainted with the fact that when a picture story is being composed, pictures, though not a discursive medium, lend themselves to something of the same manipulation as words.'[14] The only pictures that seemed to *Life* unmalleable were those that contained 'too much style,' such as the work of Walker Evans or Edward Weston. André Kertesz' photographs were rejected by *Life* because they 'spoke too much.'[15] Such photographers were mostly consigned to the section entitled 'Photographic Essay,' differentiated from the rest of the picture stories that comprised the magazine. This is one of the reasons why many of the pictures originally published in *Life* in their typical picture stories and recently unearthed for exhibition seem so puzzling. Most are not significant photographs; they were made and selected to be part of a greater whole. As Hicks noted, it was 'not alone the picture for the picture's sake, but the picture for the idea's sake that counts,' and even bad pictures took precedence when they fitted into the editor's story idea,[16] though stylistically excellent pictures could be used as well. Pictures of varying quality and style could be unified by the layout and text to create integrated entities communicating *Life*'s position.

The lead story for the October 25, 1954, issue was called 'Hanoi's Red Masters Take Over.' It opens on the right-hand page with a large picture of Vietnamese troops waving their helmets and smiling. But the caption informs us that the Vietminh troops only 'follow the platoon leader's orders' to 'happily wave their sun helmets.' From the outset we understand that the Communists use coercion in order to exact a seemingly spontaneous outburst of enthusiasm. The puppet troops are lost even in victory without orders from their leader. A smaller picture of a group of women huddling together is captioned, 'Residents dutifully bearing Vietminh flag watch Reds enter Hanoi.' The use of a group of women is even more effective because of the greater vulnerability women exude. So both the helpless population and the military minions find themselves obeying orders from above, totally bereft of freedom. Employing very few elements – two pictures, two captions and a headline – *Life* set up the terms for their reportage (and our understanding) of this 'fateful' event – the final departure of the French from Hanoi after 68 years of occupation, and the Communists 'winning' finally bringing repression with them.

The following two-page spread contains six photographs: Vietminh troops entering Hanoi; Vietnamese refugees scrambling through the windows of a train leaving Hanoi; a French police chief briefing his 'Red successors'; two Vietnamese women reading graffiti in French, 'To Leave Is To Choose Freedom'; a man looking at posters of Communist leaders Ho Chi Minh and Malenkov; a street totally empty due to a daytime curfew. The overall effect is desolate and faceless. In these pictures most of the faces are totally obscured. The troops are out of focus, the scrambling refugees are seen from the back, the two women look away to read the slogan, and the man bends his head to study the pictures of his new 'masters.' In the picture of the police, although the faces are partially visible, it is the postures of the men that tell much more – the 'Reds' stand respectfully before the slightly dejected but regal departing French chief who imparts his wisdom. The sixth picture shows the empty streets where these virtually faceless people are left to confront their new political predicament.

The next and final two-page spread shows the departure of the French as 'A Lowered Flag Ends An Era.' Here the one-paragraph text informs us that: 'For French troops, still bitter about the way the whole delta area had been bartered to the Reds, the last days in Hanoi were filled with nostalgic ceremony.' The pictures emphasize the poignancy of the French position. On the left-hand page, two horizontal photos at the top and bottom show the 'crack' members of a Moroccan regiment passing in final review. These troops are also faceless, but as a group they form a soldierly unit, and their mettle is shown by their determined bearing. Their rifles, although somewhat askew, are tilted back sharply in right-shoulder-arms position. The effect of their ragtag but proud military presentation is heightened visually by a puddle that runs the width of the picture and throws back a vividly graphic reflection of the marching troops (in contrast to the more casually structured shots of the Vietnamese). The same mirroring device is used in the lower picture, where troops loaded into trucks towing 155mm howitzers begin evacuation. Sandwiched in between these two documents of stoic, soldierly defeat is a small picture of two French generals visiting the 'misnamed cemetery of conquest to pay tribute to the men who had died defending the delta.' Ornate headstones stretch back between the two elegant profiles, reiterating by their regular, rectilinear arrangement the ideal of an orderly and disciplined military presence now gone to its 'death.'

The last picture in the story is a full-page image captioned, 'In fading light French salute tricolor, lowered at Hanoi headquarters for last time.' The symmetrical, atmospheric picture shows two French soldiers in the foreground with their backs to us. They are bold, saluting brackets for the main action, where two men in the middle ground lower the flag as a line of doll-like troops erectly dot the far distance. It is 'fading light,' we assume, that is responsible for the hazy, grainy, almost Pictorialist quality of the photograph, giving the effect of viewing this final farewell through tear-filled eyes. A visual empathy is thus established with the disheartened French.

The written and pictorial information in this story partakes of a number of

typical strategies. Bitter anti-Communist rhetoric was pervasive, and helped shape the terms of this country's Cold War attitudes. Communist takeovers were a specially touchy subject for Luce himself, because of the fall of his beloved China, a fact alluded to in the Hanoi text. But this system of loaded, complex connotation was not reserved for politically important cases.

A relatively new subject of the time was the integration of Southern schools. After flipping through advertisements for cigars, hosiery, and water softener in the September 16, 1957 issue, we are confronted by a visually convulsive two-page spread entitled, 'Troubles Beset School Opening: Blows At Integration By A Small But Dangerous Minority.' The largest of four pictures shows a group of teenage boys apparently lunging wildly toward the viewer (the true object of their anger is unseen). Immediately we feel apprehensive. We look to the caption to learn that they are taunting a Negro girl who has started school under a new integration program. In a smaller picture the girl herself is seen, grimly staring ahead, seated in a crowded auditorium where a blurry figure in the aisle gestures crazily toward her. We learn she is the fifteen-year-old daughter of a theology professor and that in this photo she 'sits quietly, endures a further demonstration.' These two pictures use blurring as their style and their means of communication, but here it doesn't represent nostalgia as it does in the Hanoi picture. The blur of motion signifies the frenzied desperation of the troublemakers, just as the quietude of the young girl connotes her greater moral fiber. In the other two pictures, adults with open mouths jeer at several children. All energetic movement denotes negative attributes in this series of pictures.

The text of the story deals not only with integration, but also with the issue of reporting on the subject of integration itself. It opens by announcing that 'These pictures give evidence of the deep reactions in the South' to integration and how, although some Southerners had accused the press of distorting the situation, 'the photographic evidence was irrefutable.' The second paragraph describes this particular aspect of the integration story in just four sentences. 'The troublemakers were a small minority but a dangerous one.' (The trouble is thus localized, personalized, reduced to a few individuals rather than representative of the politics of an entire country. The pictures supposedly show us *those* individuals.) 'Frequently . . . the grown-up tormentors were not "people of substance in the community".' (What can you expect from less than sterling citizens?) 'The crudest jeers for the Negro students were those that came from their white schoolmates, who drew encouragement from adults.' (Children, when under the influence of irresponsible adults, cannot be held wholly responsible for their actions.) 'But from the white youngsters also came the first, sudden kindnesses.' (White Americans are basically decent. This story will have a happy ending. The pictures will show it.)

The next two-page spread in the story, headed 'A Governor Flouts Government of United States,' implicates a renegade state official as one of the 'troublemakers.' Surrounding two pictures of National Guardsmen facing down black students in Little Rock are individual portraits of the major players in this drama. Governor Orval Faubus of Arkansas leads the cast. He called out

the National Guard to prevent the federally sanctioned integration, thereby causing this incident. He is the only official who is shown smiling. Following him we see a federal judge, the Guard commander, a school superintendent, the U.S. Attorney General and aides, the 'dissenting' mayor of Little Rock and, finally, a grim-faced President Eisenhower disembarking from an airplane as he interrupts his vacation to confer on Little Rock. These kind of pictures are used mainly as identification, to reassure the reader that there is a full cast of important authorities fighting the problem at hand. In this case they are forced to line up against a governor, who is acting in defiance of United States law.

The third two-page spread, 'Determined Action – And Time – Aids Integration's Slow Rise,' introduces a hopeful note. The pictures show a white student erasing graffiti that says 'Nigger,' a 'non-violent' civil rights discussion between blacks and whites, and police confronting and arresting troublesome 'racists.' Already, the pictures tell us, the situation is being righted, with the law and the citizenry acting in tandem. The last picture on the page shows a group of black students in Tennessee, scene of mob violence the year before, as they 'walk to school without incident.' The message is that progress is slowly but surely made despite the presence of the minority of bigots and troublemakers.

The hopefulness of the third spread prepares the reader for the fourth and final spread, 'Once Within the Classrooms, Kindness and Fair Play Enter.' Here progress is proved as individual children, who have triumphed over the difficulties of integration and are now attending school unmolested, are pictured. The final full-page picture shows the professor's daughter from the beginning of the story, now receiving 'Friendship instead of taunts . . Assigned a homeroom group, she was joined after a lonely hour by girls who will be her classmates . . .' Sitting among them, 'she happily discusses courses.' The sole black girl in the picture, she giggles demurely, but it is unclear from the depicted situation what has provoked her mirth, since the rest of the girls look aimlessly about. But her smiling face is enough photographic evidence to show that in America, even gravely difficult situations can be *and will be* solved in a humane and even genial way. Despite its skewed reporting, *Life* was sympathetic to desegregation from the time of the first Supreme Court order in 1954.

The fact that it is a group of girls who have effected this victory is crucial as a bridge to the story immediately following: 'Backstage In Quest To Be Miss America.' As we leave the schoolgirls, who have finally begun to exhibit the sweetness and charity the readers of *Life* expect from girls, we proceed to pictures of slightly older girls also seeking a victory. Implied in the linkage of stories is the possibility that, as a black girl can now be accepted into a group of white students, so, too, may a black young woman someday be a contender for, and even a winner of, the title of Miss America. There aren't any black women to be seen in this display of hopefuls in 1957, but because of the closely associated spreads featuring girls and pageant contestants we receive a multilayered message about the personal advancement possible for all Americans and the values admired in American women. Warm-heartedness, a forgiving nature, patience, and a capacity for compromise are emphasized in both stories.

Separate pictures of the individual players are once again arrayed across two pages – Miss Arizona, Miss Missouri, etc. The first word of each caption (set in capital letters and in boldface) is the clue to reading this type of picture. Whereas the officials in the desegregation article were initially identified by profession as Federal Judge or State Executive, the contestants are identified by the little activities they perform in the pictures: Practicing, Primping, Plucking, Doodling, Buttoning, Strutting, Posing, Breakfasting. Hence, the contenders for 'fairest in the land' should involve themselves only with small, untaxing pastimes.

Men appear in three small pictures: John Barry **BREAKFASTING** with three girls to judge their personalities, a boy identifying the arriving girls is a **SCOREKEEPER**, while a boyfriend and father are **SEGREGATED** from the main all-girl activity. The men are identified very clearly in terms of their power or powerlessness in the situation. The use of the word segregated as a boldface caption on the page immediately following the desegregation article is an example of the way *Life* would use highly charged words or situations and by clever juxtaposition equate, diffuse, and trivialize a given event by the suggestion of alternate contexts or meanings.

The largest Miss America picture is an overhead shot of the contestants scrutinizing themselves in vanity-top mirrors as they get ready for the formal dress competition. The size of the picture and its sheer busyness indicates that this is critical examination to be made. In none of the pictures nor in the text is there any suggestion that the contestants need real concentration, talent, fortitude, or intelligence to participate in this event. Nor is there any real indication of tension or competition. What is communicated is only a fluttering, wistful, inconsequential series of minor but exciting actions which might lead to the title.

In the midst of this frothy, girlish excitement, we are already far away from the problems of black children in Southern schools. Through the careful juxtaposition not only of pictures and words but also of stories with radically different subject matter, the reader is relieved of the burdensome urgency of anxiety-producing news situations. (Wilson Hicks gives an example of this kind of strategy used within a single story in his explanation of the layout of a hypothetical story on a fatal avalanche. Midway his imaginary Managing Editor says: 'It goes pretty well. You get the rescued people first, then the rescue itself, then you get the fun at the end as relief.'[17]

In addition to the typical photo story, *Life* also ran longer illustrated articles. The fact that the images didn't have to be visually integrated the way they were in a picture story gave the editors the opportunity to take a different approach and use other kinds of pictures within the same article.

The cover story for the September 16, 1957, issue was 'Crime, Part II: What A City Should Expect From Police,' a profile of Cincinnati's model police force. Crime was not yet the pervasive and intricate topic it is today; nevertheless, it was an obvious disturbance in the body politic that had to be dealt with. And again *Life* began by depicting the officials who were ably coping with the situation. The color cover photograph shows the Cincinnati police chief

leaning on a switchboard and coolly talking on the phone. He stares stoically up into space over the reader's head, a model of self-possessed professionalism, regally distant and in control. The full-page color lead picture to the article shows a line of police cadets awaiting inspection, angling down the page toward the viewer. Everyone in the line turns his head stiffly to look toward the camera except for the cadet nearest the viewer, who looks away by looking straight ahead of him. By shifting his gaze away from us (as the chief shifted his, upward) he distances us, showing us his rugged, dedicated profile. The picture conveys order, sunshine, cleanliness and duty-bound strength.

The two pictures of uniformed policemen are self-consciously posed to communicate the serious, elevated nature of police in general. The long article that follows gives a brief description of 'the basic purpose of police work,' i.e., to reduce 'the opportunity for the occurrence of unwanted incidents by surveillance and conspicuous patrol . . . designed to give an impression of police omnipresence . . .' Turning the page we see six black-and-white pictures showing separate instances of the police in action; checking pawnshops for stolen goods, raiding a prostitute's room, doing shoplifting duty, aiding a child who has swallowed poison, two policemen receiving information from an informer, and two policewomen patrolling for runaway children, liquor law violations, and sex deviates. In five of the six pictures the police are in plainclothes. Unless we look closely, we do not even register the discrepancy between the textual information and the pictures of the police. At no point does the article explain or even mention the use of plainclothes officers. The black-and-white candid shots show us the nitty-gritty of everyday police reality, as opposed to the emblematic formality of the color pictures. The two together fuse into a picture of police as a whole, regardless of any inconsistency.

An additional section entitled 'Unforgettable Crimes' is dropped into the article, introducing a third (nonphotographic) pictorial strategy by using commissioned color paintings that illustrate a series of famous crimes. The paintings are not documentary but depict a particularly crucial (for the story) imagined moment in the criminals' lives (unavailable to the camera), such as the point when a train conductor realizes a young woman's luggage might be filled with something other than clothing (two dead bodies). The expressionist style and contrasting colors of the illustrations are well-suited to conveying danger and anxiety.

The introduction of sensational crimes that had nothing at all to do with Cincinnati added another layer of meaning to the article and to the pictures. Now we see that underneath the veneer of mundane police routine lurks a dangerous, hateful, bizarre, incomprehensible, exciting nightmare world of mythical criminality. We feel ourselves flushed with admiration for the police, for their bravery, their perseverance and tolerance, and their potentially glamorous exploits. On the page facing the last unforgettable (painted) crime we return to the article and the orderly columns of type topped by smallish black-and-white pictures of Cincinnati's daily beat: the police chief at a YMCA meeting, a cadet checking a towed car.

The story ends with a picture of the police chief and his wife gazing at their

adopted daughter with adoration. We see that the chief is in private life a loving man (in contrast to his stony-faced public visage on the cover of the magazine). This situation is implicitly what the police are protecting – the safety and sanctity of the nuclear family.

In all four of the picture stories just discussed, *Life* used the gestures of the individuals involved to tell, and to interpret, the story at hand. It was as a totality, a catalog or encyclopedia of human gesture to which meaning was imputed by captions enabling us to 'read' the pictures the way we were meant to read them. Through its concentration on individual drama and individuals caught in the 'web' of circumstance, *Life* showed its version of the workings of economics, politics, and history. By provoking empathy for the single innocent player, *Life* promoted rugged individualism as a substitute for a real understanding of historical occurences.

What *Life* did was to construct concrete visual representations of myths already present in American society and play them out using contemporary characters.

To isolate and extol individual photographs from *Life*'s stories is to misrepresent the point of that magazine. *Life* had an extraordinary ability to sanction and create myths as truth. It shaped American and international culture. It also shaped the image of America for the world. It is not important that single great pictures were published in *Life* (which they were), but that all the pictures used by the magazine worked as a system of communication that exerted an enormous influence and that has not been widely understood.

Dorothea Lange

The Assignment I'll Never Forget

(First published in *Popular Photography* 46, February 1960. Reprinted in *Photography: Essays and Images*, Ed. Beaumont Newhall, Secker and Warburg, 1980)

Dorothea Lange (1895–1965) was one of the most significant photographers to document the economic and social crisis in rural America in the 1930s. She came to prominence for her photographic work for the Farm Security Administration. Lange's 1936 portrait of a migrant agricultural worker with her children has become an icon of modern photography.

Photographers are rarely called upon to describe the events which lead up to the making of specific images, and Lange's recollections make a valuable contribution to our understanding of the practice of photography, and of its meaning.

WHEN I BEGAN thinking of my most memorable assignments, instantly there flashed to mind the experience surrounding 'Migrant Mother,' an experience so vivid and well remembered that I will attempt to pass it on to you.

As you look at the photograph of the migrant mother, you may well say to yourself, 'How many times have I seen this one?' It is used and published over and over, all around the world, year after year, somewhat to my embarrassment, for I am not a 'one-picture photographer.'

Once when I was complaining of the continual use and reuse of this photograph to the neglect of others I have produced in the course of a long career, an astute friend reproved me. 'Time is the greatest of editors,' he said, 'and the most reliable. When a photograph stands this test, recognize and celebrate it.'

'Migrant Mother' was made twenty-three years ago, in March, 1936, when I was on the team of Farm Security Administration photographers (called 'Resettlement Administration' in the early days). . . . It was the end of a cold, miserable winter. I had been traveling in the field alone for a month, photographing the migratory farm labor of California – the ways of life and the conditions of these people who serve and produce our great crops. My work was done, time was up, and I was worked out.

It was raining, the camera bags were packed, and I had on the seat beside me in the car the results of my long trip, the box containing all those rolls and packs of exposed film ready to mail back to Washington. It was a time of relief. Sixty-five miles an hour for seven hours would get me home to my family that night, and my eyes were glued to the wet and gleaming highway that stretched out ahead. I felt freed, for I could lift my mind off my job and think of home.

I was on my way and barely saw a crude sign with pointing arrow which flashed by me at the side of the road, saying PEA-PICKERS CAMP. But out of the corner of my eye I *did* see it.

I didn't want to stop, and didn't. I didn't want to remember that I had seen it, so I drove on and ignored the summons. Then, accompanied by the rhythmic hum of the windshield wipers, arose an inner argument:

> Dorothea, how about that camp back there?
> What is the situation back there?
> Are you going back?
> Nobody could ask this of you, now could they?

To turn back certainly is not necessary, Haven't you plenty of negatives already on the subject? Isn't this just one more of the same? Besides, if you take a camera out in this rain, you're just asking for trouble. Now be reasonable, etc., etc.

Having well convinced myself for twenty miles that I could continue on, I did the opposite. Almost without realizing what I was doing, I made a U-turn on the empty highway. I went back those twenty miles and turned off the highway at that sign, PEA-PICKERS CAMP.

I was following instinct, not reason; I drove into that wet and soggy camp and parked my car like a homing pigeon.

I saw and approached the hungry and desperate mother, as if drawn by a magnet. I do not remember how I explained by presence or my camera to her, but I do remember she asked me no questions. I made five exposures, working closer and closer from the same direction. I did not ask her name or her history. She told me her age, that she was thirty-two. She said that they had been living on frozen vegetables from the surrounding fields, and birds that the children killed. She had just sold the tires from her car to buy food. There she sat in that lean-to tent with her children huddled around her, and seemed to know that my pictures might help her, and so she helped me. There was a sort of equality about it.

The pea crop at Nipomo had frozen and there was no work for anybody. But I did not approach the tents and shelters of other stranded pea-pickers. It was not necessary; I knew I had recorded the essence of my assignment.

This, then, is the 'Migrant Mother' photograph with which you are so familiar. It has, in a sense, lived a life of its own through these years; it goes on and on. The negative now belongs to the Library of Congress, which controls its use and prints it. Whenever I see this photography reproduced, I give it a salute as to an old friend. I did not create it, but I was behind that big, old Graflex, using it as an instrument for recording something of importance. The woman in this picture has become a symbol to many people; until now it is her picture, not mine.

What I am trying to tell other photographers is that had I not been deeply involved in my undertaking on that field trip, I would not have had to turn back. What I am trying to say is that I believe this inner compulsion to be the

vital ingredient in our work; that if our work is to carry force and meaning to our view we must be willing to go all-out.

'Migrant Mother' always reminds me of this, although I was in that camp for only ten minutes. Then I closed my camera and *did* go straight home.

Andrea Fisher

A Crisis in the Intimate

(First published in *Let Us Now Praise Famous Women: Women Photographers For the US Government 1935–44*, Pandora, London and New York, 1987, pp. 131–9)

Andrea Fisher's book *Let Us Now Praise Famous Women* was one of a number of re-examinations of the history of women's photography to appear in the 1980s. This extract examines not only the position of women photographers within the paternalistic structure of government agencies in the 1930s and 1940s, but also examines debates which surround both the representation of women and the notion of the female gaze.

FOR VARYING periods between 1935 and 1943, Dorothea Lange, Marion Post Wolcott, Louise Rosskam, Martha McMillan Roberts, Marjory Collins, Pauline Ehrlich, Ann Rosener and Esther Bubley took photographs for the American government.[1] Amongst these, only the work by Lange and Post Wolcott has been exhibited, studied, and reproduced.[2] Yet the history of women's relations with documentary is far from one of simple exclusion.

Throughout this period, women were employed to take photographs though they were taking photographs from positions different from the men photographers. But the distinction of their position is not one of discrimination. They are not simply an occasional presence, employed as an excuse for a liberal tokenism. They were neither relegated to trivial or marginal roles, nor hidden from visibility.

Revelation hardly seems necessary in a context where Lange, at least, is widely hailed as a heroine of her moment, and Post Wolcott's work has recently received increasing attention. And what emerges within the massive visibility of these two is how little their positions had in common. On the contrary, it seems that the *difference* in women's positions was renegotiated at each juncture. At each point, the difference in their positions had quite distinct implications for both their access to the profession and the prevalent readings

of their work. Moreover, at each juncture, the position of the women photo-
graphers proved crucial in constructing shifting notions of documentary truth.

During the 'classic' period of FSA photography, from 1935 to 1937,
Dorothea Lange became a key figure in securing the humanism of document-
ary. She was repeatedly represented in popular journals as the 'mother' of
documentary: the little woman who would cut through ideas by evoking
personal feeling. Through her pathos for destitute rural migrants, the New
Deal's programs of rural reform might be legitimized, not as power, but as the
exercise of care. Her place in the construction of documentary rhetoric was
thus crucially different but every bit as important as Walker Evans', more
widely recognized as the paradigmatic figure of documentary. Where Evans
was thought of as the guarantor of honest observation, with his flat-lit frontal
shots, Lange was lauded as the keeper of documentary's compassion.

Marion Post Wolcott, hired by the FSA in 1938, played a crucial role in
negotiating a shift in the project and in the pictorial rhetoric of documentary.
The political coalition that had sustained New Deal reform was beginning to
strain; with the onset of the renewed 'Roosevelt Depression' in 1937, its
defectors increasingly questioned its efficacy. Post Wolcott was given a full-
time post in preference to Lange, precisely because she was charged with
inaugurating a very new work. As a woman, her brief was to assuage, with
positive records of the FSA's rural resettlements and of American life in general,
particularly through eulogies to the small town and the land.

The period from 1940 to 1943 was marked by wartime mobilization, and
returning economic prosperity. In the final period of documentary work done
by the FSA and the Office of War Information, Stryker took on a whole
number of women photographers: Martha McMillan Roberts, Marjory Col-
lins, Esther Bubley, Pauline Ehrlich, Louise Rosskam and Ann Rosener. It was
at this point that women photographers gained most free access to the profes-
sion, but by this point the demands of the agency had changed substantially.
They were hired to produce propaganda as versus documentation, recording
war work and the effects of war on civilian life. With attention turned to the
war, little was spoken of the women photographers and their work was rarely
by-lined. Yet women are insistently present in their photographs as the locus of
emergent desires: newly arrived in the city to work within the war effort,
dislocated and presented as sites of longing. Geographically, the women photo-
graphers worked mainly in the city, safe from an 'unladylike' outback. As
documentary became potentially a woman's work, it also became a very
different work.

Far from becoming the invisible victim of discrimination, the woman
photographer was prominently presented, initially as the mother and then as the
charming girl who would ease the strain of social conflict. And though a silence
surrounded the figure of the woman photographer in later years, that silence is
not indicative of her continuous refusal but of the conditions confronting her
in one particular moment.

Through vociferous public discourse, the woman photographer was posi-
tioned as mother, as charmer, and latterly as invisible. But in their incessant

repetition, these statements appear not as descriptions of roles wholly inhabited, but as attempts to fix positions which continually slipped away. They describe not positions held, but bids for position tendered amidst a confusion surrounding the difference of the woman photographer.

The flux in power provoked by the 1930s' social crisis was, at once, a flux in positions of personal identity. The collapse in consensus about the nature of society was, at once, a crisis in the intimate: a collapse in consensus about the identities of men and women. Countervailing claims on social power unfolded through a contest to define the nature of the crisis and thus the direction towards its cure. And with this social power would come the prerogative to name the positions in personal identity which lie within it.

The naming of the woman photographers was thus implicated in pervasive tensions surrounding positions of gender. And in its prominence, it took a crucial part in attempting to secure definitions of the feminine.

Through its claim to represent reality, documentary photography was at the centre of the flux in social power. And as participants in the production of these photographic truths, women, too, attempted to settle the uncertainties of social crisis. The relation of women to truth became equally their relation to power. For the prerogative to establish a truth was, at once, a status of power.

Yet, the uncertainty surrounding power was only redoubled by the uncertainty surrounding the nature of women. So, rather than securing women's power, the relation of 'woman' to 'power' only served to interrogate both terms.

The photographs change dramatically across the period, yet each in its moment became credible as transparent window on the world. From the mid-1930s to the mid-1940s, it was not just the pictured world which changed, but an entire approach to the making of pictures. It was not simply that the world had transformed from one of sacrificial mothers and hardbitten fathers in the 1930s to one of wholesome soldiers and moony office girls in the 1940s.

The locus of truth which had been gathered around one type of image disintegrated, and reformed around another and another. Where, in the mid-1930s, it had been flat lit frontal simplicity which guaranteed an untainted truth, by the mid-1940s it was self-conscious composition and languid pose. In the 1930s, the image emphatically fell away to reveal an agrarian expanse beyond; but in the 1940s one is held ambiguously between allusion to the 'real' of a city space, and an opaque undulation of image surface. The image itself partakes in the city's self-conscious play in artifice.

In the face of such marked transformations in style, exclusive claims to truth made by one idiom are thrown into question. Though each documentary style argued the supposed 'scientificity' of its camera, each returned with quite different results. The camera, as mechanical instrument, provided no assurance of a neutral and therefore consistent image.

The truth effect of documentary rests with a rhetoric woven around the image, continually traversing both its production and its reading. It was not the photographs alone which convinced the urban populace of a crisis calling for action in the countryside. They might equally have been understood as artistic

expressions of inner vision, as they were soon afterwards.[3] Their truth-effect
consisted in the complex intersection of the image with both pervasive claims
for the honesty of the instrument and the social reforming arguments which
accompanied them in newspapers, journals and exhibitions.

The meaning of the image thus became inseparable from these converging
rhetorics. And the prerogative to persuade with such a rhetoric lies with power.
Only with power may rhetoric be convincingly presented, not as persuasion,
but as objective report.

The Depression was a crisis in an entire regime of truth. As such, it was also
a crisis in authority. Newspapers, radio and government officials, the established
mediators of social information, had systematically downplayed or ignored the
extent of the crisis. In the wake of the 1929 crash, mass unemployment and
evictions in the city, and drought, foreclosures and destitute migrations in the
countryside were met with only minor monetary reforms from President
Hoover. There was neither relief provided for the unemployed, sick or home-
less, nor protection for their rights to organize.

The press was no longer believed by the people; it had fallen out of step
with its audience. The crucial event in this repudiation was the 1936 election.
More than 80% of the press opposed Roosevelt, yet he won by the highest
percentage ever. And that repudiation was not just passive cynism, but an
actively expressed hostility. When Roosevelt motored through Chicago after
his election the crowd was cheering not only in support of him, but jeering and
shouting slogans against the press. In electing him, they clearly felt that what
had been defeated was not only his opponent, but an entire informational
network.[4]

Irreparable rifts had opened between people's desperate experience and
fragmentary word-of-mouth knowledge of the crisis, and the anodyne view
offered by those in whom they had invested their trust. The collapse in their
credibility was, as a result, not simply a demand for better information from the
existing authorities. Acquiescence in having 'reality' mediated by those on high
erupted into a call to have reality speak for itself. The established 'reality' had
been predigested for the common man as its silent and invisible object. A
democratization was now demanded through the representation of the com-
mon man, by the common man.

It was in response to this pressing demand that the rhetoric of documentary
emerged. It became a rhetoric in which the photograph, as re-presentation, was
elided in the hope that its subjects could speak for themselves unimpeded.
Claims of particular types of image to achieve this transparency were vehe-
mently debated in a wide range of popular journals, symposia, radio discussions,
and social and political groups.

Far from its present seclusion within a 'profession,' the rhetoric of do-
cumentary was an insistent and pervasive speech. It was a speech impelled by a
crisis in power, and one which was consequently invested with multiple
attempts to supplant that power. Everywhere, the nature of reality, and there-
fore the means of its transformation were open to contest.

Within the workers' photography movement the crisis was construed

within the terms of class oppression and revolutionary change. Masses of demonstrators from cities all over the country were montaged together to visually comprise a combative class. Where the individual appeared at all, it was as heroic helm of that monolithic army. In early FSA photography, by contrast, the problem was constructed as natural. The wrath of nature had been visited upon helpless though virtuous victims. Its solution was sought through liberal reform, in which the government retained exclusive power over the salvation of private farmers. Visually, the victims remained atomized in their suffering: the focus of a comfortably aestheticized compassion. It appeared only human- itarian that they should become the objects of a powerful social benevolence.

Everywhere 'reality' lay open to contest; and everywhere the camera emerged as paradigm for truth. Even James Agee, searching for a literary language that would confront reality in *Let Us Now Praise Famous Men*, refers to the camera as a metaphor for the truth:

> all of consciousness is shifted from the imagined, the revisive, to the effort to perceive simply the cruel radiance of what it is . . . This is why the camera seems to me, next to unassisted and weaponless consciousness, the central instrument of our time . . . If I could do it I'd do no writing here at all. It would be photographs and the rest would be fragments of cloth, bits of cotton, lumps of earth, records of speeches, pieces of wood and iron, phials of odors, plates of food and excrement. A piece of body torn out by the roots might be more to the point.[5]

That quest which Agee so voraciously pursued overflowed the bounds of the political to permeate every pore of the social body. His urgency to 'see' went far beyond the correction of prior misguided myths. Its focus widened to aspects of existence never before visible as sites of passionate intensity. And this imperative to poetically catalog every mundane detail of the Depression's effects signalled the penetration of crisis into the unspeakably intimate.

Yet it is precisely in this intimate penetration that the relation of women to power achieves its complexity. With their access to documentary photography, women took a part in the exercise of power. But as the markers of difference, there is no neutered power on which women can simply lay their hands. A sequence of fictions and masks were invented through which women could be appointed positions.

Documentary was saturated in the values of individuality and equality, key tenets of social democracy. Its understanding was extended, not to the derelict dregs of society, but among individuals equal in their proud humanity. The power of social democracy was never directly open to Dorothea Lange. In relation to documentary's humanism, Lange could be only the 'mother,' and never 'humanity' itself. For 'humanity,' as seemingly gender neutral term can articulate its norms only through distinction from woman's difference. And in relation to the strained diplomacy of the latter day New Deal, Post Wolcott was specifically named as the charming girl who would unite all parties.

Though each enjoyed her tangential power over truth, the gaze of the camera immediately overturned even these differing positions in power. As

instrument of truth, the camera immediately laced a woman's vision with ambivalence, eliding their authorship in a rush to return them to objects of its gaze. The character of their photographs is repeatedly folded back to reveal the photographer as accessible display of womanhood. In the public eye, the meaning of their images was always inflected by the personas constructed for the women who had produced them. In relation to the gaze, the position of women is, at the very least, a duality: always simultaneously on both sides of the camera.

Moreover, in their images the women hint at a strength extending beyond this oscillation between positions dictated by a unified I/eye. They sidestep that spectrum that swings from subject of a gaze to she who is subjected to its power. Though in images which were perhaps not widely circulated, they begin to infer an identity which is manifold, and a power in qualities of presence rather than appearance.

The access of 'women' to 'power' immediately provokes a play in both terms. In relation to a crisis extending into the intimate, a discourse in 'power' and the singular positions afforded to 'women' insistently slips to reveal multiplicity as its excess.

Documentary did not simply trade on already established feminine stereotypes: be it the compassionate mother that Lange was supposed to embody, the sweet and vivacious girl with whom Post Wolcott was identified, or the unnamed figure who described woman as the locus of desire. To represent the 'reality' of the government's benevolence towards its stricken poor, it called forth the fiction of woman as mother. To articulate the 'truth' of a united nation returning to prosperity, it called forth the positive image of the energetic young girl.

As a form of enunciation, documentary requires a subject positioned in gender. The I/eye behind the camera becomes distinct and able to address a viewer, through the adoption of sexual difference. The photographer is never neuter, but someone who produces from the place of 'man' or 'woman.' And, like the identity of the subject in language, the gender of the photographer is neither natural nor secure; as the product of repression and artifice, it remains forever precarious.

Documentary called particular notions of the feminine into being, with all the resonance of its pervasive reach. Across its transformation, from classic FSA through positive records to the documentation of war work, a fluidity in gender was set in play. But having been opened to question and thus to change, the identity of gender remained always beyond definitive grasp.

The crisis in the regime of truth was not just a sweeping away of anchors in the so called 'public' sphere. The process could not stop with dismantling those massively visible social concepts: Economy and Society, Democracy and Class. A crisis in the conception of the real inevitably saturates the most intimate

aspects of one's bearings: the ability to daily take up and live, as if entirely natural and safely removed from the social, the positions of 'men' and 'women.' It was not just the identity of the social, but identity in the social which had fractured. Beyond the public clashes of workers and unemployed with police and vigilante armies, the crisis penetrated to less visible and little spoken circuits of power.

One might even say that the interpenetration of these registers of crisis comprised a collapse in the divide between the public and the personal, except that the speech of the decade itself was so insistently social. It so derided this crisis in the intimate that it remained very much a silenced sub-text. Yet the multiple attempts to fix the place of woman forms an undercurrent, just below the surface of this silence, and bears witness to the force of the flux they hoped to contain.

As a speech provoked by a precarious opening in power, and one which hoped to close the question with limited social change, documentary tries to place not only the truth of humanism, but with it the truth of human gender. It is not just a 'truth' produced by a gendered I/eye, but a bid to place the I/eye. It tries not only to inhabit the vacuum in authority with its democratic liberalism, but equally to inhabit the home with positions offered in sexuality.

In the FSA work of the mid-1930s, women were repeatedly presented away from social context and in caring relation to their children. In this way, motherhood was removed from historical contingency and made to appear a natural continuity. And this dogged insistence on the Mother is recycled, on another level,[6] in Lange's designation as the mother of her medium. Yet, seen in its relation to an urban audience, this insistence takes on the urgency of repudiation.

Though both men and women suffered staggering levels of unemployment during the Depression, the rate of unemployment in predominantly female jobs was lower than that for men.[7] It had been common for husband and wife to work, though the balance of breadwinning power lay with him; but that very concrete rehearsal of sexual identity was suddenly interrupted. In the face of this most intimate overturning, social reformers from the charitable left to the right campaigned for women to relinquish their jobs and confine themselves to the family.[8]

The incessant picturing of women with their children was never prioritized by Stryker for his photographers; it was not a conscious political device. But perhaps it arose, like the whole of Stryker's enterprise, as part of that widely felt nostalgia for a mythic American past: an American essence as natural as the land, and so located in an immutable rural family. But only for an urban audience could the land achieve this mythic status, and the rural mother the status of universal touchstone. Perhaps, too, that desire for lost plenitude found in the image of the Mother its most appropriate analogue.

Amongst the other photographic truths vying for ascendancy in the midst of crisis, the truth of gender remained equally uncertain. The cultural left counterposed the individualism of the FSA's poor with the montaged masses of a new class army. Yet its treatment of women remained fraught with

contradiction and ambivalence towards change. In awkward proximity to its female militants, it preserved the humanist ideal of woman as natural mother. Its representations thus unwittingly revealed a fissure between change and its containment. And in this overlapping, it made present an untenable simultaneity of femininities.

Photographed for strike sheets and trade union journals, women appeared on picket lines either alongside men, or in poses ritually struck by men before them. Their presence as women went almost without notice; but not because class militancy has assuaged the division of the sexes and forged a unique androgyny. Visually, and therefore politically, they were subsumed within conventions which had marked militancy as a male preserve. To become visible as militant, women were effectively made masculine. In this, their transformation was given articulate space and simultaneously rendered silent.

Alongside the militancy of the unions and of the organized unemployed, many groupings attempted social change on the cultural rather than economic level. Through work in the theater, in music, literature and the visual arts, they attempted to forge a fighting proletarian culture. Amongst those devoted specifically to a politics in culture, women were again formally accepted as equals. But in the emergent medium of photomontage, they appear, again imperceptably, amongst the embattled crowds; and where an individual is montaged as exemplary leader of that action, it is *he* who invariably vaunts his herculean brawn.[9] Cameos of both men and women, injured in the course of struggle, are inset alongside the crowds. But where the man is displayed as he fought, ragged, bandaged and bloody, the woman appears in untouched portrait – still somehow the unruffled object of a gaze.[10] Where individual women are given the breadth of a full page image, it is amongst their children as martyred mothers, wives of imprisoned 'class warriors.'

The need to continually re-place the feminine belies a confusion and a tension surrounding sexual difference. The need to masculinize the woman militant, and yet to preserve her difference as mother and as seen; the need to repeatedly perfect an icon of rural motherhood before an audience in the city hint intriguingly at slippages away from the place of the feminine. Far from fixing women's social position, they endlessly return us to a crisis in the truth of gender.

Eudora Welty

One Time, One Place

Eudora Welty is a Southern writer in the Gothic tradition, her novels and short stories distinguished by their strong sense of place. She was born in 1909 in Jackson, Mississippi. Her first job on completing her university studies was as a publicity agent for the Works Progress Administration during the Depression, but the photographs she took in this period were published only in 1971, as the book *One Time, One Place: Mississippi in the Depression: a Snapshot Album* (Random House, New York). This preface to the book was reprinted in *The Eye of the Story* (Virago, 1979), one of several collections of Welty's essays and reviews.

THESE PHOTOGRAPHS are my present choices from several hundred I made in Mississippi when I had just come home from college and into the Depression. There were many of us, and of those, I was also among the many who found their first full-time jobs with the Works Progress Administration. As publicity agent, junior grade, for the State office, I was sent about over the eighty-two counties of Mississippi, visiting the newly opened farm-to-market roads or the new airfields hacked out of old cow pastures, interviewing a judge in some new juvenile court, riding along on a Bookmobile route and distributing books into open hands like the treasures they were, helping to put up booths in county fairs, and at night, in some country-town hotel room under a loud electric fan, writing the Projects up for the county weeklies to print if they found the space. In no time, I was taking a camera with me.

In snapping these pictures I was acting completely on my own, though I'm afraid it was on their time; they have nothing to do with the WPA. But the WPA gave me the chance to travel, to see widely and at close hand and really for the first time the nature of the place I'd been born into. And it gave me the blessing of showing me the real State of Mississippi, not the abstract state of the Depression.

The Depression, in fact, was not a noticeable phenomenon in the poorest state in the Union. In New York there had been the faceless breadlines; on Farish Street in my hometown of Jackson, the proprietor of the My Blue Heaven Café had written on the glass of the front door with his own finger dipped in window polish:

At 4:30 A.M.
We open our doors.
We have no certain
time to close.

The cook will be
glad to serve U
with a 5 & 10 C
stew.

The message was personal and particular. More than what is phenomenal, that strikes home. It happened to me everywhere I went, and I took these pictures.

Mine was a popular Kodak model one step more advanced than the Brownie. (Later on, I promoted myself to something better, but most of the pictures here were made with the first camera.) The local Standard Photo Company of Jackson developed my rolls of film, and I made myself a contact-print frame and printed at night in the kitchen when I was home. With good fortune, I secured an enlarger at secondhand from the State Highway Department, which went on the kitchen table. It had a single shutter-opening, and I timed exposures by a trial-and-error system of countdown.

This is not to apologize for these crudities, because I think what merit the pictures do have has nothing to do with how they were made: their merit lies entirely in their subject matter. I presume to put them into a book now because I feel that, taken all together, they cannot help but amount to a record of a kind – a record of fact, putting together some of the elements of one time and one place. A better and less ignorant photographer would certainly have come up with better pictures, but not these pictures; for he could hardly have been as well positioned as I was, moving through the scene openly and yet invisibly because I was part of it, born into it, taken for granted.

Neither would a social-worker photographer have taken these same pictures. The book is offered, I should explain, not as a social document but as a family album – which is something both less and more, but unadorned. The pictures now seem to me to fall most naturally into the simple and self-evident categories about which I couldn't even at this distance make a mistake – the days of the week: workday; Saturday, for staying home and for excursions too; and Sunday.

The book is like an album as well in that the pictures all are snapshots. It will be evident that the majority of them were snapped without the awareness of the subjects or with only their peripheral awareness. These ought to be the best, but I'm not sure that they are. The snapshots made with people's awareness are, for the most part, just as unposed: I simply asked people if they would mind going on with what they were doing and letting me take a picture. I can't remember ever being met with a demurrer stronger than amusement. (The lady bootlegger, the one in the fedora with the drawn-back icepick, was only pretending to drive me away – it was a joke; she knew I hadn't come to turn her in.)

I asked for and received permission to attend the Holiness Church and take pictures during the service; they seated me on the front row of the congregation and forgot me; once the tambourines were sounded and the singing and dancing began, they wouldn't have noticed the unqualified presence of the

Angel Gabriel. My ignorance about interior exposures under weak, naked light bulbs is to blame for the poor results, but I offer them anyway in the hope that a poor picture of Speaking in the Unknown Tongue is better than none at all. The pictures of the Bird Pageant – this was Baptist – were made at the invitation, and under the direction, of its originator, Maude Thompson; I would not have dared to interfere with the poses, and my regret is that I could not, without worse interfering with what was beautiful and original, have taken pictures during the Pageant itself.

Lastly, and for me they come first, I have included some snapshots that resulted in portraits: here the subjects were altogether knowing and they look back at the camera. The only one I knew beforehand was Ida M'Toy, a wonderful eccentric who for all her early and middle years had practiced as a midwife. She wanted and expected her picture to be taken in the one and only pose that would let the world know that the leading citizens of Jackson had been 'born in this hand.'

It was with great dignity that many other portrait sitters agreed to be photographed, for the reason, they explained, that this would be the first picture taken of them in their lives. So I was able to give them something back, and though it might be that the picture would be to these poverty-marked men and women and children a sad souvenir, I am almost sure that it wasn't all sad to them, wasn't necessarily sad at all. Whatever you might think of those lives as symbols of a bad time, the human beings who were living them thought a good deal more of them than that. If I took picture after picture out of simple high spirits and the joy of being alive, the way I began, I can add that in my subjects I met often with the same high spirits, the same joy. Trouble, even to the point of disaster, has its pale, and these defiant things of the spirit repeatedly go beyond it, joy the same as courage.

In taking all these pictures, I was attended, I now know, by an angel – a presence of trust. In particular, the photographs of black persons by a white person may not testify soon again to such intimacy. It is trust that dates the pictures now, more than the vanished years.

And had I no shame as a white person for what message might lie in my pictures of black persons? No, I was too busy imagining myself into their lives to be open to any generalities. I wished no more to indict anybody, to prove or disprove anything by my pictures, than I would have wished to do harm to the people in them, or have expected any harm from them to come to me.

Perhaps I should openly admit here to an ironic fact. While I was very well positioned for taking these pictures, I was rather oddly equipped for doing it. I came from a stable, sheltered, relatively happy home that up to the time of the Depression and the early death of my father (which happened to us in the same year) had become comfortably enough off by small-town Southern standards and according to our own quiet way of life. (One tragic thing about the poor in Mississippi is how little money it did take here to gain the things that mattered.) I was equipped with a good liberal arts education (in Mississippi, Wisconsin, and New York) for which my parents had sacrificed. I was bright in my studies, and when at the age of twenty-one I returned home from the

Columbia Graduate School of Business – prepared, I thought, to earn my living – of the ways of life in the world I knew absolutely nothing at all. I didn't even know this. My complete innocence was the last thing I would have suspected of myself. Anyway, I was fit to be amazed.

The camera I focused in front of me may have been a shy person's protection, in which I see no harm. It was an eye, though – not quite mine, but a quicker and an unblinking one – and it couldn't see pain where it looked, or give any, though neither could it catch effervescence, color, transience, kindness, or what was not there. It was what I used, at any rate, and like any tool, it used me.

It was after I got home, had made my prints in the kitchen and dried them overnight and looked at them in the morning by myself, that I began to see objectively what I had there.

When a heroic face like that of the woman in the buttoned sweater – who I think must come first in this book – looks back at me from her picture, what I respond to now, just as I did the first time, is not the Depression, not the Black, not the South, not even the perennially sorry state of the whole world, but the story of her life in her face. And though I did not take these pictures to prove anything, I think they most assuredly do show something – which is to make a far better claim for them. Her face to me is full of meaning more truthful and more terrible and, I think, more noble than any generalization about people could have prepared me for or could describe for me now. I learned from my own pictures, one by one, and had to; for I think we are the breakers of our own hearts.

I learned quickly enough when to click the shutter, but what I was becoming aware of more slowly was a story-writer's truth: the thing to wait on, to reach there in time for, is the moment in which people reveal themselves. You have to be ready, in yourself; you have to know the moment when you see it. The human face and the human body are eloquent in themselves, and a snapshot is a moment's glimpse (as a story may be a long look, a growing contemplation) into what never stops moving, never ceases to express for itself something of our common feeling. Every feeling waits upon its gesture. Then when it does come, how unpredictable it turns out to be, after all.

We come to terms as well as we can with our lifelong exposure to the world, and we use whatever devices we may need to survive. But eventually, of course, our knowledge depends upon the living relationship between what we see going on and ourselves. If exposure is essential, still more so is the reflection. Insight doesn't happen often on the click of the moment, like a lucky snapshot, but comes in its own time and more slowly and from nowhere but within. The sharpest recognition is surely that which is charged with sympathy as well as with shock – it is a form of human vision. And that is of course a gift. We struggle through any pain or darkness in nothing but the hope that we may receive it, and through any term of work in the prayer to keep it.

In my own case, a fuller awareness of what I needed to find out about people and their lives had to be sought for through another way, through

writing stories. But away off one day up in Tishomingo County, I knew this, anyway: that my wish, indeed my continuing passion, would be not to point the finger in judgment but to part a curtain, that invisible shadow that falls between people, the veil of indifference to each other's presence, each other's wonder, each other's human plight.

Anne Tucker

The Photo League

(First published in *Creative Camera*, July/August 1983)

For fifteen years the Photo League was a New York-based forum for exhibition, debate and education. It began at the height of the Depression, an initiative born in an atmosphere of left-wing populism fostered by the New Deal. The Works Progress Administration, set up in 1935, was the largest New Deal agency, and although the bulk of its funds was ploughed into a programme of public building – roads, hospitals, schools, libraries and sanitation – what it is most remembered for is its creation of cultural projects involving many branches of the arts. Their task was to 'document America'.

By 1951, when the Photo League was eradicated by McCarthyism, it had already moved some distance away from the socially conscious impulse of its genesis, towards an emphasis on art photography. Anne Tucker's brief history of the League highlights its importance as a long-standing focus for the photographic community.

'In dreams begin responsibilities'
– Delmore Schwartz

IN 1947, its new name was *The Photo League, Inc.* but the last three letters spoke more of the institutional status it hoped to obtain, than what it had already established. For eleven years its name had been just the *Photo League* and while its photographic programme had achieved national recognition, it was still basically a local membership organisation working out of a rented loft in lower Manhattan. Now incorporation seemed appropriate because the League was in the midst of a capital campaign and a national membership drive. Its goal was to become a 'Center for American Photography' and it needed more money and a larger membership than it had ever previously achieved. Pushing itself out of wartime dormancy, it was striving to regain and then surpass its pre-war vitality.

Becoming an established, nationally recognised centre of photography was
an ambitious, even an audacious goal, but the League had always possessed and
acted upon audacious ambitions. Moreover, its goal and mood were consistent
with the postwar optimism of other Americans, and specifically its ambitions
were encouraged by others, more prominent than itself, who also cared about
the future of American photography and who felt that the Photo League would
contribute substantially to that future. Photographers Ansel Adams, Barbara
Morgan and Paul Strand and historians Beaumont and Nancy Newhall had all
agreed to become sponsors for the League and to help with its fund-raising
drive. Even Edward Weston, who rarely supported organisations, answered the
League's appeal positively. 'I am all for the Photo League', he wrote. 'Think it
has done great work for American photography. Of course use my name as a
sponsor, and may you expand as you hope and deserve to.' All of these sponsors
had worked with the League since the late 1930s, but their enthusiasm in 1947
was for the new League, the one it planned to become, the one Nancy Newhall
realised it was 'in embryo'.

Other than expanding its membership, the changes that the League pro-
posed in 1947 were not structural. It would still be a volunteer, membership
organisation of amateur and professional photographers who maintained a
headquarters, ran a school, directed exhibitions, published a newsletter, and
sponsored lectures and symposia. And the League would continue, as it always
had, to interrelate these activities. Lecturers would be invited who were
appropriate to the current exhibition, then its newsletter *Photo Notes* would
report on the lecture and ask someone to review the exhibition. Frequently one
of the League's sponsors, or someone equally well-known in photography
would write the review. The lectures and the exhibitions were also discussed at
the monthly membership meetings and in the classes. The activities outlined in
the 1947 by-laws also included classes, exhibitions, publications, lectures and
symposia, but the defined purpose of these activities was broadened and
restated, and to its sponsor's relief, the language of the by-laws was less political.

The Photo League's origin in 1936 (as well as its demise in 1951) was
generated by radical politics, and its initial energies were fueled by a desire for
social change and the belief that photography could affect social change. It
believed that photographers had an obligation to illuminate and to record the
world they lived in, and it saw its task as 'placing the camera back into the hands
of honest photographers, who (would) use it to photograph America'. To that
end, the original goal of the League had been to train documentary photogra-
phers and to encourage them to photograph, so its initial thrust had been to
strengthen its school and to foster documentary projects. All of the League's
other activities were conceived as educational support for this primary object-
ive. But the building momentum of these activities, and the paucity of other
serious photographic organisations, eventually gave the League a life of its own
apart from its service to documentary photography and apart from immediate
political ends.

In 1938, the League had proposed that it become 'A League of
American Photographers'; in 1947, it campaigned as 'A Center for American

Photography'. The difference between the two goals signifies an aesthetic shift. The former goal defines an alliance of individuals bonded together by a commitment to what they called honest photography and to what Paul Strand identifies as art's political ability 'to affect, move and unify great numbers of people'. The later goal was to establish a photography institution, 'a center for photography and related arts', and it was the physical and financial responsibilities of that centre which dictated the League's capital campaign in 1947.

While in 1947 the League was still predominantly an organisation of documentary photographers who believed in photography's persuasive powers, throughout the by-laws the League referred to creative rather than documentary photography. Its leaders' foremost priority shifted from the school programme to improving its headquarters and publications. *Photo Notes* which had always been a mimeographed monthly was upgraded to an illustrated quarterly magazine printed on an offset press. The school was no longer regarded as the training base for America's future documentary photographers but was more nebulously defined as 'an opportunity for its members to develop an interrelated and personal creative approach to photography'. Whereas originally the League had cared more about the social impact of its photographs than the identity and needs of their makers, after the war there was a shift from social to personal vision, from emphasising photography's potential as an instrument of social change to recognising its value as a tool for creative individuals. This was a shift counselled by Ansel Adams and the Newhalls, and a shift felt necessary to acquire a broadbased national membership, but before the League's perception of creative photography could be tested, before it could formulate the procedure for the changes it was proposing, the Photo League was blacklisted. Self-defense suddenly replaced audacious ambitions; instead of 'being alive to the future', the League was frozen in its past.

The League had been under surveillance by the Federal Bureau of Investigation since 1940 when one of the League's officers 'associated with known Communists' on a photographic trip through the mid-west. After initiating an investigation on the photographer in question, Sid Grossman, the FBI also began to investigate everyone, including the Photo League, with whom Grossman corresponded in Oklahoma City that summer. (As Executive Secretary of the League, Grossman had been receiving League announcements, issues of *Photo Notes*, and news of League events.) The FBI investigated Sid Grossman's life very extensively then closed its file on him in 1943, but their investigation of the Photo League revealed that some of the League's members, including Grossman, were also members of the Communist Party, and that one of those members allegedly reported the League's activities to 'higher ups' in the Communist Party. From this, the FBI concluded that the Photo League was a Communist front organisation, an organisation controlled by and acting on behalf of the Communist Party. Pursuant to this, in December 1947, just one month after the League had so optimistically incorporated, US Attorney General Tom Clark placed the Photo League on a list of organisations alleged to be 'totalitarian, Fascist, Communist or subversive'.

At first the photographic community rallied to the League's defense with

public declarations of outrage against the listing. Membership doubled. The League moved into a larger space and *Photo Notes* increased, as planned, in size and stature. There was some division, however, as to how the League should respond to the government's allegations. The members and sponsors who had been relieved by the less political language of the League's new bylaws, encouraged the League to deny all political purpose and to cease any attempt to use their photographs for political or social change. Overtly political photographs were considered inappropriate for an aesthetic organisation and these sponsors wanted the League to refute them.

Other members and sponsors felt no need to deny or apologise for the socially conscious photographs made by its members believing these concerns to be right and proper and none of the government's business. It seemed a gross distortion to regard the League as a political rather than as a photographic organisation. They stated in their press releases that the making of photographs was the primary purpose of the League and the political affiliations of its members had never been an issue of membership, only how serious its applicates were about photography. Actually, the release also stated, the blacklist made the League discuss the political affiliations of its members for the first time. The blacklist also forced the League to associate in a stance of self-defense with other organisations which were avowed political groups, that had also been listed.

With no specific charges beyond the listing itself, it was difficult to prepare a defense, but the best defense seemed to be to publicise all that the League had accomplished in the name of serious photography, and to emphasise how important it could become to the future of American photography. It was agreed that the best form of publicity was a retrospective exhibition reflective of the League's past and of its present talent. The survey *This Is The Photo League* opened 2 December 1948 with the work of 94 past and present members included. A catalogue was printed with an essay by Nancy Newhall and with 19 half-tone reproductions. Although the exhibition was well received by the photographic press, it was an inadequate defense against the government blacklist. Basically, the exhibition was fruitless, because the government had from the beginning regarded the League's interest in photography not as its primary purpose, but as a front for its political activities. The FBI neither discussed the photographs made and exhibited at the League, nor related its photographic events to those activities regarded as political. Photographic activities were matter of factly reported by the FBI agents, usually by copying the League's own reports from League publications. The FBI was also interested in those activities and alliances alleged to be politically motivated, such as any political involvements that its members and officers had outside of the League, and also political actions that the League supported or opposed, that were also supported or opposed by the Communist Party. As Cold War tensions increased, the FBI's reports were compiled with increasing zeal and detail. Thus the League, as seen through the FBI's reports, grew more, not less politically active after World War II.

Throughout 1948, as Cold War tensions had increased, the pressures of the

blacklist forced increasing numbers of League members to withdraw and membership began to decline, but the League managed to continue its exhibition and lecture programmes with the income from the school. Then, in April 1949, during the conspiracy trial of Communist Party officials, an informant named Angela Calomiris, referred to the Photo League as a Communist front organisation and testified that two members of the Photo League had introduced her into the Communist Party. She repeated the government's 'case' against the Photo League: that some of the political changes that the League supported were also supported by the Communist Party, that some of the League's members were also members of the Communist Party and that, according to Miss Calomiris, some of the League's members reported its activities to 'higher ups' in the Communist Party. There was no record of sedition, no acts approaching the 'clear and present danger' standard later set by the Supreme Court. But the government did not need to substantiate its claims of subversion.

Such public and publicised accusations of 'unAmerican' activity as 'association with known Communists' was more than was necessary in the times later to be known as the McCarthy era. Newspapers and magazines would no longer review the League's exhibitions or publicise its events. Without media coverage, it was impossible to reach the new audiences it had so optimistically courted. Also, anyone whose job required national security clearance, bonding or a passport – all of which were necessary to a photojournalist – could not belong to an organisation on the Attorney General's list. Association with a listed organisation was also unwise for anyone seeking a naturalised American citizenship. Membership continued to decline and the League's priorities became not growth, nor even political change, but staying alive. Without membership dues or school tuitions, the League was unable to pay its rent or support its programmes and it disbanded in the summer of 1951.

The Photo League was unquestionably a vital place, a photographic crossroads. It featured lectures, films and photographs central to American photography. It exhibited contemporary work and published photographic criticism which had no other outlet. Whether the Photo League could ever have realised its goal to become an influential, effective Center for American Photography, there is no question that the Photo League, as it existed through 1947, did encourage and stimulate those who participated in its programmes. Consuela Kanaga echoed the sentiments of other League members when she wrote that it had been a 'great and wonderful experience that helped me develop as a person and a photographer'. The Photo League is important because many fine and some great photographs were made by its members and under its auspices. This is evidence enough that the Photo League deserves a place, higher than it has yet to hold, in the history of American photography. But the compelling value of the League may be the education, not solely photographic, that it gave to a generation of young photographers in New York. The relevance of its history to us are the facts born of its dreams and the fate of its beliefs.

Elizabeth McCausland

Documentary Photography

(First published in *Photo Notes*, January 1939)

Elizabeth McCausland was an energetic and passionate critic, committed to a belief in photography's creative potential. She was also prolific, yet her many newspaper and magazine articles, written between the mid '20s and the late '40s, have been virtually forgotten.

She was a prominent activist in the Photo League, lecturing at its meetings and writing regular reviews for its newsletter, *Photo Notes*. Issues of *Photo Notes* in the '30s are alive with the excitement of beginnings, with a shared optimism about photography's potential for social action. The spirit of collectivity which animates its pages in those years had a second life in the '70s. McCausland's repudiation of the avant-gardes in this article in favour of documentary realism may seen crude now, but its was decidedly of its moment. The Photo League was founded in 1936; forty years later, in the first issue of the British magazine *Camerawork*, Jo Spence made a similarly urgent plea for a political photography that would reflect the real world.

THE RISE of documentary photography does not spring from fashion. Rather its rapid growth represents strong organic forces at work, strong creative impulses seeking an outlet suitable to the serious and tense spirit of our age. The proof that documentary photography is not a fad or a vogue lies in the history of other movements in photography. Before the documentary, the technical 'capricci' of Moholy-Nagy and Man Ray; before the 'photogram' and the 'rayograph,' the Photo-Secession; before that, the pictorialists. What came of these? From the abstract and surrealist tendencies, Cecil Beaton. From the Photo-Secession a few fine workers like Paul Strand, Edward Weston and Charles Sheeler, the best of their mature energies being best employed when they turn to newer and more objective purposes. From the pictorial school, the Oval Table.

Against this pattern of sterility, of ideas which could not reproduce themselves, we have the new function (and evolving from it the new esthetic) of documentary photography, an application of photography direct and realistic, dedicated to the profound and sober chronicling of the external world. To Lewis Hine, who thirty-five years ago was making photographs of child labor in sweat shops and textile mills, the vague tenets of pictorialism or the even less useful pusposes of the 'photogram' or 'rayograph' must be incomprehensible. To the hard-working photographers of the Farm Security Administration, the somewhat remote and abstruse manner of the spiritual heirs of the

Photo-Secession may seem too refined. To such a photographer as Berenice Abbott, setting down the tangible visage of New York in precise detail and lineament, the sentimental fantasies of a Fassbinder must be well nigh incredible.

The above is not intended as an *ad hominem* argument. The instances are noted merely to indicate different directions and purposes in photography. The reason that the difference may so clearly be illustrated is that the difference in ideas of the new photography and all the old styles is like the difference between two continents: it is a 'passage to India' to travel from the old to the new. We have all had a surfeit of 'pretty' pictures, of romantic views of hilltop, seaside, rolling fields, skyscrapers seen askew, picturesque bits of life torn out of their sordid context. It is life that is exciting and important, and life whole and *unretouched*.

By virtue of this new spirit of realism, photography looks now at the external world with new eyes, the eyes of scientific, uncompromising honesty. The camera eye cannot lie, is lightly said. On the contrary, the camera eye usually does nothing but lie, rationalizing the wrinkles of an aging face, obligingly overlooking peeling paint and rotting wood. But the external world is these facts of decay and change, of social retrogression and injustice – as well as the wide miles of America and its vast mountain ranges. The external world, we may add, is the world of human beings; and, whether we see their faces or the works of their hands and the consequences, tragic or otherwise, of their social institutions, we look at the world with a new orientation, more concerned with what is outside than with the inner ebb and flow of consciousness.

For this reason, a Farm Security Administration photograph of an old woman's knotted and gnarled hands is a human and social document of great moment and moving quality. In the erosion of these deformed fingers is to be seen the symbol of social distortion and deformation: waste is to be read here, as it is read in lands washed down to the sea by floods, in dust storms and in drouth bowls. The fact is a thousand times more important than the photographer; his personality can be intruded only by the worst taste of exhibitionism; this at last is reality. Yet, also, by the imagination and intelligence he possesses and uses, the photographer controls the new esthetic, finds the significant truth and gives it significant form.

This is indeed the vanguard of photography today. For the channels of distribution for truth are no more numerous for the photograph than for the printed or spoken word, the theatre, the moving picture, the arts generally. The censorship that in Hollywood has shifted from leg and kiss sequences to social themes operates also with the publications that use photographs – and by their use support the photographer. The opportunities for publishing honest photographs of present-day life in magazines or newspapers are not many; a Hearst press is not the only censor of truth.

For this reason, we find the strongest precedent for documentary photography in the work of the Farm Security Administration photographers and in the Federal Art Project 'Changing New York' series by Berenice Abbott. As in soil erosion and flood control, highway engineering, agricultural experiment stations and numerous other important technical activities, the best sponsor of

knowledge (even if on too limited a scale) has been the government. By combinations of circumstances that we shall not call lucky accidents, these pioneer ventures have been gotten under way and have broken ground for younger workers to till. Already the influence of the new spirit may be observed, as a more straight-forward quality pervades much of the work published, even in magazines not vowed to the documentary ideal.

What is this ideal, you have a right to ask. A hundred years ago when photography was born, an enthusiast cried, 'From this day painting is dead.' Nevertheless painting has survived till the present. Thus in the course of the past century certain confusions grew up around photography. In the case of D.O. Hill, there was no question as to why he took portraits; they were notes to be incorporated in a canvas with over two hundred figures. Julia Cameron was an elderly woman who pursued a hobby, incidentally turning out master-pieces of portraiture. Atget had no nonsense about him when he made 'documents pour artistes;' and certainly there was no faise estheticism involved when Brady went to the Civil War.

But at the turn of the century art got mixed with photography. Some inner insecurity of photographers (seduced, perhaps, by commercial appeals and selling talks) led them to precipitate the battle: 'Is photography ART'? Today progressive photographers are not especially interested in the point; it seems an empty issue. There is the whole wide world before the lens, and reality waiting to be set down imperishably.

Without prejudicing the case, we may say at once that photography is not art in the old sense. It is not a romantic, impressionistic medium dependent on subjective factors and ignoring the objective. It is bound to realism in as complex a way as buildings are bound to the earth by the pull of gravitation, unless we build aerial cities, cantilevering or suspending them in mid-air.

But this is certain from history – that forms and values change under the impact of new energies. The arts alter their modes of expression and their emphasis on subject matter, their ideology and their iconography, as society changes. Today we do not want emotion from art; we want a solid and substantial food on which to bite, something strong and hearty to get our teeth into, sustenance for the arduous struggle that existence is in eras of crisis. We want the truth, not rationalization, not idealizations, not romanticizations. That truth we get from reading a financial page, a foreign cable, an unemployment survey report. That truth we receive, visually, from photographs recording the undeniable facts of life today, old wooden slums canting on their foundations, an isolated farmer's shack, poor cotton fields, dirty city streets, the chronicles written in the faces of men and women and children.

Yet this truth is not an abstract statement, made in a desert with none to hear. The new spirit in art (if, after all the talk, we agree that photography is an art) represents a drastic reversal position from the attitudes of the twenties. One cannot imagine a Joyce or a Proust producing documentary photographs, if photography were their medium. On the contrary, one can think of a Thomas Mann finding documentary photography much to his liking, congenial as it is to the careful factual implementation of 'The Magic Mountain.'

Instead for prototypes, we turn back to the ages of realism, to Balzac, to Fielding, to Dickens, to a painter like Gericault who painted humble scenes of farm life as well as grandiose mythological scenes. A work of art, on this basis, must have meaning, it must have content, it must communicate, it must speak to an audience. The cult of non-intelligibility and non-communication is no longer fashionable; only a fringe of survivors makes a virtue of a phrase which is a dead issue.

For communication, the photograph has qualities equalled by no other pictorial medium. If one wishes to present the interior of a slum dwelling where eight people live in one room, the camera will reveal the riddled floors, the dirty bedding, the dishes stacked unwashed on a table, the thousand and one details that total up to squalor and human degradation. To paint each item completely would take a dozen Hoochs and Chardins many months. Here with the instantaneous blink of the camera eye, we have reality captured, set down for as long as negative and print will endure.

Actually there is no limit to the world of external reality the photographer may record. Every subject is significant, considered in its context and viewed in the light of historical forces. It is the spirit of his approach which determines the value of the photographer's endeavor, that plus his technical ability to say what he wants to say. First of all, there is no room for exhibitionism or opportunism or exploitation in the equipment of the documentary photographer. His purpose must be clear and unified, and his mood simple and modest. Montage of his personality over his subject will only defeat the serious aims of documentary photography. For the greatest objective of such work is to widen the world we live in, to acquaint us with the range and variety of human existence, to inform us (as it were forcibly) of unnecessary social horrors such as war, to make us aware of the civilization in which we live and hope to function as creative workers. This is a useful work, and as such beyond claims of mere personality or clique.

Jo Spence

The Politics of Photography

(First published in *Camerawork*, No. 1, 1976)

This piece, the lead article in the first issue of *Camerawork*, launched the magazine and set its agenda, stressing the camera's potential usefulness for those otherwise robbed of the means of self-representation, emphasising the need for control of the photographic image. Later issues of the magazine spelled out this commitment in a statement of intent by the editorial collective.

For a brief but hopeful period in the '70s (until the election of Thatcher's first government, and the severe erosion of arts funding), *Camerawork* played a vital part in photography's radical renaissance. It continued publication until 1987. Until her death in 1992, Jo Spence was an energetic activist in photographic culture, working on a variety of collective and collaborative projects, as well as developing a significant career as a photographic artist.

EVERY DAY, photographers produce countless images, most of which will never be seen by a mass audience. However, those that are seen, in newspapers, magazines and on high street hoardings play an important part in our lives. With their messages – both explicit and hidden – they help to shape our concepts of what is real and what is normal. They give us information about the sort of sex roles we are expected to play in society, contribute to our image of ourselves, to our expectations and to our fantasies.

Television, cinema and all visual media echo the same ideology. Continually repeated visual images, in time, become part of our stored experience. Images help us to believe that people are innately aggressive, intelligent, loving or lowly – according to their sex or race, or to the idea being sold to us. All this we tend to call 'human nature'. In fact what we see most of the time could more readily be labelled 'stereotyping' – long understood by cartoonists, illustrators, painters and actors. It is a series of visual signals and short cuts, established over a period of time and decodable within any given culture. Often before we can read or write we can learn to decipher whether people shown in images are happy or sad, rich or poor, powerful or weak, by understanding this non-verbal language.

It is important to look at the context from which these images spring and at the background of the people who produce them.

Current Trends in Commercial Photography

PHOTOGRAPHIC colleges, as part of their policy in trying to professionalize photography, are still tightening up their entrance qualifications for those wishing to study photography. They do this in liaison with the official bodies representing photographers. Once through the initial vetting, students then live and work for several years in the rarefied atmosphere of colleges in which there are no realistic deadlines or cares about the cost of materials and equipment, and in which they are in isolation from the feelings and needs of the majority of people whom they will use as subject matter. Here they learn to pass more examinations.

They are then released in great numbers onto the very competitive job market where the only bodies likely to be interested in their qualifications will be industry and government establishments. The remainder then chase the few other jobs available, become freelancers, set up their own businesses, or find some entirely different way to earn a living. Commercial photography is a competitive ratrace entirely geared to servicing the needs of contemporary consumer society.

Alongside this, photographic technology advances rapidly, with faster-acting materials and more expensive time-saving equipment. At the same time though, materials not considered commercially viable by manufacturers are slashed from catalogues and disappear forever. Photographers themselves are caught in the trap of improving their techniques, whilst at the same time, the content of their pictures becomes more stereotyped, transiently fashionable, semi-pornographic or obtuse. Sophisticated courses have even been devised to train photographers how better to exploit a situation in order to get people to relate more easily to the intrusive cameras, thus becoming more easily turned into objects.

Social Realism

CONCURRENT with commercial photography is the race to be more socially realistic in our picture making. More and more we are assailed with aesthetically cropped pictures of corpses, gun fights, starving children or the so-called important members of our society. With rare exception such photo journalism is seldom set in any meaningful social or political perspective. More often than not it is an unjustifiably voyeuristic and one-sided account of the stark situation in which many people are forced to live – or a superficial treatment of the joys and sorrows of celebrity life.

Photo journalists are employed mostly by magazines and newspapers, and they are tightly controlled by very few companies and publishing houses. Work is often edited beyond recognition or used out of context. Printed in the mass press, or alongside the hi-fi and sherry adverts in the colour supplements, this imagery eventually becomes just another commodity for us to thumb through in our search for distraction, or for the 'truth'.

Other photographers, interested in the problems of poverty and oppression, work for charities. There are now over 400 national bodies dealing solely with children; some of them now employ quite sophisticated techniques to attract our attention and make us feel guilty. Using international advertising agencies we are sold the illustrated saga of the under-privileged and those suffering from the 'cycle of deprivation' (or could we call it the cycle of exploitation?). Such appeals are usually graphically presented on glossy paper, tastefully designed, with suitably abject women or children on the covers. Usually such photographs are taken by people of a different social class from those depicted. These photographers have a difficult task; they are concerned with the plight of their subject matter, seeing the medium of photography as the only way in which they can help present a case for consideration. However, the major problem to be overcome is that in depicting people whom they (as outsiders) consider would benefit from the public stare, it is usually more profitable to show only the bleaker side of people's lives. However, such 'victims' can react very violently when faced with pictures of themselves as potential recipients of charity hand-outs. The integrity of photographers faced with this situation, and who are trying not to be patronising, hangs by a very fine thread. Eventually when such pictures (heavily edited) are used, they are accompanied by statements which dissociate themselves from politics. Such reports and appeals are financed by government or charities whose terms of reference seem to force the use of countless euphemisms or the total exclusion of the contradictions of local and central government policies, or the part played by profiteering in the texts accompanying photographs.

It is almost as if such appeals were all part of some secret ritual in which the 'facts' are presented for consideration, but presented in such a way that we remain mystified as to the real causes, or even end up blaming the victims!

Some Alternatives

GROUPS like REPORT and the Alternate News Service have now formed in order to service political newspapers, magazines and community presses. They concentrate on industrial and community action, showing solidarity among people, unlike the mass press which often depicts only the struggle of the individual. Other collectives have formed to record life in the neighbourhoods of working people, whilst others are recording social conditions and inequalities. Linked to statistics, or used in juxtaposition with glossy advertising myths or official documents, or alongside interviews with the people depicted, individual or national issues can be highlighted in order to reveal the lack of understanding of the planners and decision-makers who shape our destinies. Such work is also used away from galleries, in high streets, public meeting places and in education, as a mirror to show events considered 'unnewsworthy' by the national press.

Other photographers, because of their disillusionment with the highly

competitive job market, and because of a genuine identification with the need for social change, have gravitated towards alternative magazines and books. These cover a wide variety of issues ranging from community action, anti-psychiatry and radical social work, to feminism and children's rights. Such work has deeper political perspectives but it reaches a more limited audience. Generally there is very little financial reward from it, these photographers often having to supplement their income with other types of work.

Community Photography

THE most recent break with traditional fields of photography has been the use of photography as a TOOL by community activists. Already a well established field in North America, several photographers (singly or in groups) have now managed to obtain short-term grants or funds for the setting up of photographic units within community, neighbourhood or youth projects. Here photography can be explained to and used by laypeople. This is done by starting with simple cameras, or video, and then gradually working through to the more technically advanced equipment, linked to darkroom and printing skills. This puts photography into the hands of a lot of people who will eventually be able to dispense with the experts. This move has provoked some reaction from those who have fought for years to gain for photography the status of a Profession, elevating it via O and A Level exams and degree courses out of the grasp of the majority of people. But of course such policy is entirely in keeping with our hierarchical class society. The middle class mystifies and refines knowledge; at the same time it manages to rationalize its activity by convincing us that this is all in the interests of progress and economic growth. Photography as a tool is far removed from such attitudes because it negates elitism.

Community photographers are encouraging people to photograph each other, friends and family, then their social environment. This provides immediate feedback for discussion, provides aids for story-telling and reading, and makes it possible to look at the world differently. People can discover how to relate to themselves and to others more positively when armed with images of themselves – images which counteract the stereotypes usually seen in the mass media.

The main objective here is to enable people to achieve some degree of autonomy in their own lives and to be able to express themselves more easily, thus gaining solidarity with each other. It also helps to some extent to demystify media and to make the relationship much less of a one-way affair. This is a far cry from the passive and abject individual problems of those depicted in charity appeals. Basically though, they could be the same people – just totally different approaches. Agitators or objects of pity – which to choose?

What long-term results community activists can achieve with photography still remains to be seen. Funds and grants are hard to get (and much competed for) and are always given conditionally. Some photographers have already been threatened with the withdrawal of their funds because they have supposedly

gone too far. Hopefully people in their own neighbourhoods are not already so alienated from themselves and from each other that they will adopt techniques of dishonesty or exaggeration in their picture making. Those who have their roots in a neighbourhood cannot afford to photograph people as mere 'things'. They still have to live with each other after the pictures have been produced.

This has of course been a problem for photographers for a long time; however involved they are, they still have to gain the confidence of their subject matter in order to get their pictures (be they paid models or the unsuspecting general public). Then, having gained their objective, they can go back to their clients, potential markets, or private collections, more often than not closing the door on the lives of those with whom they were temporarily involved.

Common sense might tell us that this is often due to lack of time. Is it as simple as that? Or is it part of our demarcation of personal life and professional life?

Lee Miller

The Siege of St Malo

(An extract from *Lee Miller's War*, Ed. Anthony Penrose, Conde Nast Books, London, 1992, pp. 46–63. First published in *Vogue*, October 1944)

The career of Lee Miller (1907–77) has been the subject of much attention during the last decade. A fashion model who turned to photography (and worked with Man Ray in Paris during the 1930s), she was an avant-gardist, fashion photographer and, during the Second World War, a documentarist and photojournalist. In 1944, she travelled to Europe as a *Vogue* correspondent, taking photographs and writing articles on liberated Europe. This piece was written in August 1944 and conveys both the exhilaration and the horror of Miller's experience of war.

I PICKED UP a lift to St Malo, but it was just being evacuated by troops as being inside the bombline for the attack that afternoon. I scarcely looked around. It was just another destroyed area, and I couldn't stop to think that here were the places I had spent my last hours in France, nearly five years ago when I left the night before war was declared. I didn't look at the sentimental things this moment meant to me.

*'Saint-Malo, ville unique par la grandeur de ses souvenirs et par
son charme personnel, est, de plus, un délicieux centre d'excursions!'*

A company was filing out of St Malo, ready to go into action, grenades hanging on their lapels like Cartier clips, menacing bunches of death. Everybody was leaving as if from the proverbial doomed ship, without even cleaning up the bodies which lay along the streets. War was their business, and they went on in a sloping march across the town of St Servan to a small square before the *Mairie* – a nice little square if it had been Bastille Day, but hell now, with its dug-out shelters and hand-grenades. I went on to the command post in the boys' school – the telephone exchange and the wireless reception were on the courtyard balcony just outside the Major's office. I sat there and listened to orders and requests coming in on all sides – heaps of barracks bags were in one corner; they belonged to newly arrived replacements who were scheduled for battle already – reserve troops and headquarters staff off-duty lolled around in a series of school rooms off the balcony. The blackboards were still chalked with German-French lessons and German tourist posters decorated the walls.

In the next room the silly 1900 pictures of the 'Famille Durand' with their cats, canaries and crowded rooms were on the walls with a long pointer for reaching to the side-burned gent *'ce monsieur est un soldat'*. 'This gentleman is a soldier, notice his spurs, his *fusil, ses cartouches'* – *'et la plume de ma tante est sur la pupitre* of my uncle.' They were yellow with age and fly specked – nostalgic and more real than the LMS and GWR posters of British tourist beauties such as Bath and Coventry which filled the rest of the space. I wonder what they found to say about them.

In the Major's office, soldiers of all ranks came in and looked at maps and front elevations. There were sketches from prisoners' information and drawings of mined areas given by deserters. At the end of the balcony a captain was briefing his group. I leaned over the rail and listened to duties and orders being assigned – barriers and traps pointed out, signals explained, the height of an embankment, the cross-fire power of a set of guns.

On the railings of the courtyard steps was a group of strange GIs. They turned out to be Poles who had deserted from the fortress the night before to join our side and volunteer to guide our assault troops into the citadel. None of them spoke English, but there were a couple of our Polish-descended boys who were adequate and enthusiastic interpreters for me. They all had nearly the same story: forced army service, or else, with families as hostages. They joined and served with a minimum of good faith. One spoke French in a way, and I told them all I could about the Polish armed forces in Britain, all I had read in the papers about their bravery and daring as pilots, their gallantry and success with the girls – and I sweetly didn't say a word about their sinister political moves and reactionary motives.

They were thrilled to be going into battle on their own side. They had pals in the fortress who were longing for the same opportunity of escape – and they would rescue them.

Capt. Roland Penrose

Dearest—

They are cooking the final assault on the Citadel — I'm mixed up in the siege of St Malo and in a few moments, if I'm not forgotten in everyone's busy circles I'm going down to an OP inside the bomblines — to watch and take pictures, — naturally, I'm a bit nervous as it'll be 200 pounders from the air — ours — I know nothing will happen to me as I know our life is going on together — for ever — I'm not being mystic, I just know — and love you

<div align="center">Lee[1]</div>

It was time to go. I followed a wire to the mortar OP — they were making trial smoke shell shots, and correcting their aim and placing for the barrage they were going to lay down, called 'climbing a ladder'. I could hear voices from the little square where soldiers were waiting for battle. We were all well inside the bombline of the target.

Time passed slowly, slowly, tensely. A few lazy shots flipped on the fortress — near the pillbox — then in the great open breach which had been bitten out during another bombardment.

The boy at the phone said, 'They hear airplanes'. We waited, then we heard them swelling the air like I've heard them vibrating over England on some such mission. This time they were bringing their bombs to the crouching stonework seven hundred yards away. They were on time — bombs away — a sickly death rattle as they straightened themselves out and plunged into the citadel — deadly hit! — for a moment I could see where and how — then it was swallowed in smoke — belching, mushrooming and columning — towering up, black and white. Our house shuddered and stuff flew in the window — more bombs crashing, thundering, flashing — like Vesuvius — the smoke rolling away in a sloping trail. A third lot! The town reeled in the blast — a large breach had been made — and we waited for the next attack. It didn't aim so good — and hit into the houses to the left on the connecting strip to the citadel, setting fires — the following bombs corrected and smashed into the target, burying themselves for a silent moment before exploding. An oil bomb penetrated the breach and a slow, black vine of smoke climbed — lofty and promising — fuel or something burning inside the fort.[2]

There were flashes from delayed action bombs buried in the earthworks. The next wave was light incendiaries — a lot fell in the water to the right. Many hit the sloping earth towards us, and more into the fort. Our artillery started its barrage — the soldiers had started moving down the streets with the last air bombs, assembling between the burning buildings at the approach to the fort. The dry, fast cough of our machine guns echoed ghost-like. The enemy's two hundred rounds-a-minute cannons made savage probes — our mortars and smoke screen — pounded and drifted, our heavy guns battered into the moat — onto the fortress and around the pillboxes — our soldiers were leaving the houses. I could see them next to the orange tiled one, creeping down to the rocks and moving single file up the steep approach to the fort, while another

platoon crept from the houses to the rocks, crouching, waiting their turn. It was a heavy climb – and they were earth-coloured like the burnt soil they were traversing. I projected myself into their struggle, my arms and legs aching and cramped – the first man scrambled over the sharp edge, went along a bit, and turned back to give a hand in hauling up the others – on and on the men went up – veering off to the right – it was awesome and marrow freezing. The building we were in and all the others which faced the fort were being spat at now – ping, bang – hitting above our window – into the next – breaking on the balcony below – fast rapid queer noise – impact before the gun noise itself – following the same sound pattern – hundreds of rounds – crossing and recrossing where we were.

Machine gun fire belched from the end pillbox – the men fell flat – stumbling and crawling into the shelter of shell holes – some crept on, others sweeping back to the left of the guns' angle, one man reaching the top. He was enormous. A square shouldered silhouette, black against the sky between the pillbox and the fort. He raised his arm. The gesture of a cavalry officer with sabre waving the others on – he was waving to death, and he fell with his hand against the fort. The men were flowing away from the path he had followed – moving toward the left – it was retreat. Singly and together they picked themselves up and threw themselves down into another hole, stooping, hunched – scrambling, helping each other. There was silence – poised – desperate. I could hear yells from slopes – orders – directions with nightmare faintness. There was a great black explosion where the most forward men had been a minute before. Cezembre was firing on her sister fortress – shells which would not penetrate or injure the occupants but which could blast our men, who were oozing down the escarpment – and sliding down the path which they had so painfully climbed. Other bursts from Cezembre swept the sides of the fort. They were directed by telephone, probably from the Cité D'Aleth – they followed with hideous knowledge. One burst hiding and shattering the men at the bottom – our mortar fire was peppering the pillboxes to keep them silent – smoke screens and artillery pummeled the fortress just above our men to keep the Krauts from slaughtering them in retreat.

They got back among the houses – our machine guns keeping a steady tattoo – Cezembre's shells burst, hunting angrily in the rocks, slopes and buildings, hungry for more of the withdrawing soldiers. The Cité D'Aleth guns could not reach them there and turned more attention to us – we separated to different rooms – everyone was sullen, silent, and aching, like a terrible hangover. The men came back into the square – the ambulance men had the wounded, the dead had been left.

Captain Patterson who led the assault stamped back to the command post grim, bitter, dirty. I sat in one of the school rooms and kept seeing the little men fight up the hill. They were in front of me on the floor, the blackboard – on the posters on the ceiling higher and higher everywhere I looked. The dromomania of climbing; the square man waving his arm – the shell bursts sweeping them away. A pity, a brave pity.

A soldier asked me to come outside – there were three boys on the back of

a jeep. They were the Poles – the fourth was dead – the French-speaking one. Would I photograph them and the heap of his belongings on the front seat? And would I kiss them?

I squatted on the verandah with Captain Marcovitch who was to have gone up to the fort with the group which was just starting up from the rocks when the retreat began. They had been carrying ladders, torpedoes, flame-throwers – he was depressed – he had attacked it before and had hoped this time it'd be successful.

The command post was moving over to Old St Malo. The boys swept out of the school rooms and collected their gear. Captain White gave me a lift, I sat on his saddle which surmounted the barracks bags and we went gloomily to the Hôtel Univers, in the old town – too discouraged to notice the 88s plopping around the house tops on our way down the blasted boulevards – or care about the sunken ships – or burning warehouses.

> '*Entrons en ville, parcourons les petites rues bizarrement*
> *enchevêtrées, aux noms surannés*'.

There was no one in the Place Châteaubriand except a sentry. There were boots, munitions debris – there was barbed wire with booby traps where the café tables used to be in front of the now burnt out Hôtel Châteaubriand – the dead smelled and the dust swirled. The Hôtel Univers was almost intact – the 389th unit would move in there to sheets and wine – the streets were blacked with fallen masonry – it was like Malta – and as dangerous. Tall chimneys standing alone gave off smoke from the burning remnants of their buildings at their feet. Stricken lonely cats prowled. A swollen horse had not provided adequate shelter for the dead American behind it – flower pots stood in roomless windows. Flies and wasps made tours in and out of underground vaults which stank with death and sour misery. Gunfire brought more stone blocks down into the street – I sheltered in a Kraut dugout, squatting under the ramparts. My heel ground into a dead detached hand, and I cursed the Germans for the sordid ugly destruction they had conjured up in this once beautiful town. I wondered where my friends were, who I'd known here before the war – how many had been forced into disloyalty and degradation – how many had been shot, starved or what. I picked up the hand and hurled it across the street and ran back the way I'd come, bruising my feet and crashing into the unsteady piles of stone and slipping in blood. Christ, it was awful.

The soldiers were coming in under the archway – they fanned out, climbing walls with their phone wires – housekeeping in the back pantry – dragging guns up to the ramparts – cleaning their weapons – shaving in the information shop for tourists – the aid post in the court of the Châteaubriand – laughing, joking, teasing me – asking me to talk American they were so homesick. Finding souvenirs for me and going through the same routine about cameras as I'd heard in hospitals and battle and Piccadilly Circus. Hey lady take my picture, put it in the paper!

> '*Des temps héroiques, le château est le noble témoin.*'

The courtyard of the château was revolting. There were unexploded shells,

foetid cloying smells. The statue was there – on the left was the grave of an American who had died as prisoner – his helmet pierced through in two jagged holes. There were lines of Slav-looking carts in front of the bank door – where 200 million francs were stored. Subject troops, Russians, had driven these wagons to here and this disaster. The horses were dead and swollen in the stables – too big to be gotten through the door.

One or two of the buildings were hollow but in another there was a family who had refused evacuation in their sense of duty of guarding the bank – they stuck their heads through a geraniumed window. A very fat man in a white helmet, comptroller for the money, had been the first prisoner our boys took in coming into the town the afternoon before. He had heard a lull in the shooting and thought he'd scrape around outside to find some bread. He gave me a large brass megaphone which some GIs got off me the next day. The Germans had used it to bellow orders to the civilians.

The telephones were set up in the lounge writing room of the Hôtel Univers – the concierge's desk housed a couple of soldiers – the glass-roofed hallway to the dining rooms was somewhat broken and the palm trees were sere and disheveled. An oldish man in *sommelier* blue said that the owner of the hotel had told him to offer the Americans everything they wanted – the cellar was ours. We went down into the caves with candles, climbing through a court window over laundry bundles to look at bin after bin of Sauterne, Vouvray, magnums of Champagne, Bordeaux, Burgundy – the works. I had the job of picking out the wines for a few of the boys. They knew I read and understood the labels and they wanted to be sure to get the sweet ones. I gave them Graves and Sauterne. I took Vouvray and Pouilly, both beautiful – some wines from Beaune and some half bottles of Bordeaux, to which I had a sentimental attraction.

Nearly all the officers had gathered in the Major's room, No. 88 – he opened a bottle of champagne, aiming the cork at a helmet about as accurately as the bombers had done on the fort, and we drank from crystal glasses which I had polished on a bedspread. In the middle of learning their regimental song, a spectacular storm broke – drowning the gunfire in crashes and flashes, a deluge cleaning the bomb dust from the ruins.

By now I was out of film so I got permission to go into the photo shop at the end of the street and collect what I could use. There was no Rolleiflex stock, but plenty of Leica film – German produce – and all sorts of accessories. Down below there was, quite untouched, a complete developing and printing establishment with films of German soldiers in brave poses in front of their guns – still in the drying rack. There were three or four enlargers and automatic glazers. The chemicals were in the tanks, scummy and opaque. Like everywhere else there was no current or running water, but it looked like an answer to a prayer. Captain MacFarlane, who knew my family back home, a sergeant who had been a professional photographer before the Army, and I, set up shop to develop the films the boys had taken all the way through the Normandy campaign. I had learned photography in France, so the words and formulae were not mysterious to me, nor the weights and measures. We sloshed around

in the front room which had been bombed open to the light and worked with a GI torch in the back room. There were stocks of printing paper, but printing would have been impossible without a lot of finagling.

I tried another meal with the Major, but he was fetched away to count the 200 million francs or something, and I went back to Captain Frost's CA office, the ex-MP building, where I picked a tiny room. Four or five walls through the house from the direction of the 88s, and with a window small enough to black out with blankets so I might use one of the many Jerry candles I'd picked up and do some of this writing. It didn't work, because someone shot at the window anyway, so I lay in darkness watching the men climb the hill while a cat trapped somewhere howled its life away. It was a restless, bug-ridden night. Each time I'd decide to go downstairs to sleep in the cellar with Frank Nassburgh and Victor Onmann, sergeants on the Civil Affairs staff, another series of 88s would clatter around the house, and the hall was all glass so I didn't go. There were stooging enemy planes on reconnaissance, shots in the dark and footsteps of prowlers. I scratched my bites and played with Tarzan, a small kitten, in the total darkness. He seemed unconcerned and certainly had no more fleas than I had myself.

Jan Zita Grover

Star Wars: The Photographer as Polemicist in Vietnam

(First published in *Afterimage*, 1983)

In this essay, Jan Zita Grover examines the ways in which the Vietnam war has been represented through the work of photojournalists. Although the essay covers familar ground, and concentrates on photo-reportage at the expense of perhaps more intriguing photographic representations – by ingenious photographers, by the soldiers themselves, by military documentarists – it nevertheless provides an interesting starting point for further discussion of the iconography of war.

Trying to report a war without irony is a bit like trying to keep sex out of a discussion of the relations between men and women.
– Michael Arlen, *Living-Room War*

The doctor asked, 'Is this the first American correspondent killed in Indochina?' I said yes. He said, 'It is a harsh way for American to learn.'
– John Mecklin, on the death of Robert Capa,
May 25, 1954, in *Images of War*

THE AD appeared only once in *Afterimage*, in the April 1982 issue:

Submit photographs: To the *War Show*. Submit up to five war photographs of Central America or Vietnam. All formats acceptable, captions should be included. . . . Send to: *War Show*, Eye Gallery, 3321-A 22nd St., San Francisco, Calif. 94110.

Its timing coincided with a virtual torrent of new releases and re-releases on the Vietnam War – the sort of thing that casually goes by the title, 'spirit of the age' – and having followed the wavering fortunes of written and photographic coverage of Vietnam for some time, I wrote to the Eye Gallery to find out more about its proposed show. The exhibition's curator, Sandy Barlow, wrote back to tell me that she had hoped to receive snapshots from men who had served in Vietnam, but that so far her only responses had been from photojournalists. She would let me know when the show was mounted.

Almost a year passed. The country officially received back its prodigal sons in a curious ceremony dedicating the Vietnam Veterans Memorial in Washington (November 1982), and the *New York Times*, that bellwether of establishment liberalism, published an 18-page survey of 'The New Vietnam

Scholarship.'[1] Television, probably a better gauge of the war's new status as a politically neutral reservoir of appropriatable images and incidents, gave us *Magnum*, a series whose protagonist is a Vietnam vet given to flashbacks of life along the DMZ.

How would a gallery present photographs from Vietnam 10 years after the pull-out? Would they, god forbid, be overmatted, tastefully Neilsen-framed, presented as postmodernist media appropriations or as self-expressive art? What would a curator find to say about them?

I flew to San Francisco to find out.

That long disease, the Vietnam War, has entered a new phase. Seemingly drained white between 1965 and 1973 by blood and controversy, the body politic appeared within months of our official withdrawal to regain its health, rally, and move on to collisions with purely domestic ailments: the inflation, unemployment, and Watergate messes that were the war's moral and practical legacy. Its symptoms masked, the war and all its grievous questions lay quiescent for most of a decade. Novels and memoirs appeared, the finest of them treating the war as a hallucinatory adventure: Robert Stone's *Dog Soldiers* (1974), Philip Caputo's *Rumors of War* (1977), Michael Herr's *Dispatches* (1977), Tim O'Brien's *Going after Cacciato* (1978). But the anesthetizing-mythologizing work didn't begin until even later: now, however, at whatever level one searches out material on the war, whether in fiction, memoirs, photographs, or historical studies, the seeker after our fortunes in Southeast Asia finds the net of myth spreading.

At the basest level, vaguely Kurtz-like characters cut anarchistic swathes through a value-free jungle world in the masculine equivalent of Regency romances – novels like Jack Hamilton Teed's *Fire Force* and *The Killing Zone* ('Zebra's Men's Adventures').[2] Primitively constructed and crudely conceived, such fiction (first released in England in the late 1970s) makes no apology for its violence or its orientalist fascination with misery wrought upon The Other. Instead, it purveys fantasies of an Americanized Vietnam whose moral wilderness is more an occasion for achieving the voyeur's *frisson* of pleasurable terror than it is for scrutiny.

Higher up the ladder is Philip Caputo's novel, *The Horn of Africa* (1980), that fine war-memoirist's fictional working-out of the moral issues he saw men faced with in Vietnam. Half-way around the world and a decade later, his protagonists must confront Vietnam's moral dilemmas again:

> . . . I tried to explain to Moody that he represented everything Nordstrand despised, that his eyes were the eyes of the civilized world, compelled to watch the outrage by which Nordstrand demonstrated his scorn for its standards and won for himself a terrible liberation . . . as he resisted and overcame the restraining force that prevents us all from becoming murderers . . . [But] he did it at last, cut himself off entirely, reached escape velocity and boosted himself past the tug of society's moral gravity, out into the void.[3]

Photographers, of course, have also inquired into the meaning of our involvement in Vietnam, and polemicists in every medium have used the plastic powers of photographs to illustrate or prove arguments across the political spectrum.[4] The latest instance of this, Tim Page's *Nam*, I shall return to later. But at this point, I should like to describe the development of modern war photojournalism and to assess the ways in which coverage of the Vietnam War both continued earlier patterns of war photography and created new conditions and arguments peculiar to itself.

The modern *persona* and territory of the war photographer begin with Robert Capa. His nonchalance, his style of photography, his strategies for personal presentation of his work are still the baselines against which contemporary war photographers gauge themselves. Capa's first book, *Death in the Making: Photographs by Robert Capa and Gerda Taro*,[5] is an argument – sometimes ethical, sometimes *ad hominem*, by turns communist and socially conservative in sentiment – for the Spanish Loyalists' cause. We learn in various short sections of the book that this is 'The war of the man in the street' (photographs of urban and village workers), that 'An army is born' out of a just cause, that 'Spain's Wealth' is in her working people, that the Loyalists are 'Safeguarding the art treasures' threatened by Franco and the fascists' aerial bombings, that the Loyalists ally their hopes with the Russian Revolution ('Spanish ship *Potemkin*'), and that a 'New Army [is] on the way' in the persons of Spanish teen-agers formerly dedicated to nothing more politically rigorous than acquiring American jeans and listening to jazz.

In preceding wars, virtually all photographers were limited to, if not actively allied with, the cause of a single side; even so, their photographs did not make strong visual cases for the exclusive humanity of their host-side, save through captioning. This seems to me directly the result of that removed, transparent 'documentary' distance with which nineteenth- and early twentieth-century photographers approached their subjects – a technique inspired by a wish not to appear partisan but rather objective, olympian, detached – whether the subject were a ruined building, a field of corpses, a mustard-gassed horse or man.[6]

European photojournalism in the 1920s changed the point-of-view of the photojournalist from respectful witness to active participant. Coverage with the small camera in *Die Berliner Illustrierte, Die München Illustrierte* and their later French, English, and middle-European progeny reified the notion of photographer-as-activist: individual photographs and photo essays were constructed to emphasize the you-are-there quality of the committed participant, the man-in-the-midst-of-history. Low camera angles, extreme close-ups, cluttered, out-of-focus foregrounds leading vista-like to deep, sharply focused backgrounds; subjects caught unawares, mid-gesture; juxtapositions of two unrelated images that drew the viewer into complicity with the photographer and editor *against* the subjects depicted – an ironic understanding, that is, shared by all but the subjects – these devices created a sense of life captured *à point*. In technique, these were the visual analogues of devices common in the music and literature of the '20s, which also sought out and valued the ephemeral, the

epiphanic, the aleatory, the radical point of view as creator of meaning. Through them all, the photographer-reporter reminded his reader of the *persona* behind the picture.

In this sense, Robert Capa no more invented the conventions of modern war photography than nineteenth-century photographers of war invented ways of structuring their images: in both cases, the conventions for representation already existed and had merely to be applied. But Capa was the first photographer to apply these techniques widely to war. And his applications of the conventions developed in the 1920s by the photographer-as-participant have, in turn, become our generation's. His emphasis upon personalizing war through close-ups of individual faces, his use of juxtapositions to create a sense of war's irony, his low-angle, line-of-fire battle pictures and his highly partisan text and editing all stress the photojournalist's essentially priestly role: he or she suffers, risks, witnesses for all of us, bringing back the vision that for our salvation, we must all share. Capa even speaks of the correspondent's responsibility in religious terms reminiscent of the paradox of free will:

> . . . the war correspondent gets more drunk, more girls, better pay, and greater freedom than the soldier, but that at this stage of the game, having the freedom to choose his spot and being allowed to be a coward and not be executed for it is his torture. The war correspondent has his stake – his life – in his own hands, and he can put it on this horse or that horse, or he can put it back in his pocket at the very last minute.[7]

This priestly or scape-goating role taken on by the war photographer has its own irony: despite heroic risks in bringing back pictures, most people (as the sales records of volumes of war photographs suggest) do not wish to be reminded of war's brutality as an abiding reality – as an item of daily news, perhaps, but not as a bound reproach on coffeetable or bookshelf. Books of war photographs do not sell.

Capa's stylistic and ideological descendants in Vietnam War coverage are a mixed bunch. Nonetheless, in Marjorie Morris and Don Sauer's *And/Or, Antonyms for Our Age* (1967), Mark Jury's *The Vietnam War Photo Book* (1971), Philip Jones Griffiths's *Vietnam, Inc.* (1971), and Tim Page's *Nam* (1983),[8] it is fairly easy to see the lessons learned from Capa.[9]

The earliest photo book on the Vietnam War was not the creation of an individual photographer at all. Marjorie Morris, wife of John Morris, *Life*'s former picture-editor, produced the book as a protest. Apparently Marjorie Morris had the active assistance of many of the 49 photographers whose images appeared in the book;[10] from their work, she created a simple yet striking 'plea for peace.' The book's argument is constructed around sharp contrasts of misery and death in Vietnam and peace and plenty in America. However, unlike a dialectic, Morris's strategy does not imply a fusion of these two extremes into a workable third alternative: in fact, the book does not offer solutions of any kind – only a liberal's hope that *And/Or* will 'prod the reader to seek solutions,

to the Family Quarrel of Man.'[11] And although 'It almost goes without saying that the War pictures are from Vietnam,'[12] the images used make the war appear a great deal more generic than photographs in subsequent books do.

Part of this peculiar quality of Morris's selections derives from the lock-step contrasts she seeks to establish in her juxtapositions of America and Vietnam. It was necessary that she choose photographs with strong formal similarities: for the most part, that meant photographs whose composition is simple and direct, leaving little room for ambiguous interpretation. For example, an extreme close-up of a young girl screaming in ecstasy, *Watching the Beatles*, lies across the page from *Wounded Marine*, mouth open in a shout of pain. The expressions are similar, the promptings as different as innocence and experience. America and Vietnam: *Q.E.D.*

Other pairings consist of that rather gnomic brand of social documentary that characterizes Steichen's *The Family of Man* – representative American children, young men and women, and charming older couples – juxtaposed to anonymous Southeast Asians. As gut-wrenching as a few of the individual photographs can be, the patent manipulation of their having been forced into conjunction at all,[13] as well as Morris's distortedly idealized depiction of American realities in 1967,[14] make *And/Or* a polemic built on exceedingly shaky ground. Moreover, the choice of highly generalized photographs and/or photographs well known in other contexts (*i.e.*, six of the domestic images in *And/Or* had appeared in *The Family of Man* catalogue; others had appeared in John Morris's popular 'How America Lives' series in *Ladies' Home Journal*) creates an argument that calls attention less to the peculiar horrors of Vietnam than to its own ingenuity and to some categorical Horrors of War:

> This book looks like a gimmick, but give it the first five minutes it deserves and you may never again feel the same about Vietnam. The format is a juxtaposition of photographs of the Vietnam war against photographs of American peace, each carefully chosen to establish parallels of posture or setting. The visual counterpoint begins with the bleeding sores of battle with a scalpel of homeyness: A mother playing with her child on an apartment bed set against another mother cradling hers from sniper fire on the battlefield; a sneaker-shod boy sprawled on a living room couch, a barefoot Vietnamese sprawled dead in the mud. A simple idea, a moving execution.[15]

John Morris, in his introduction, sees this platonic representation of Peace and War as a good thing: '. . . in their savagery, their heroism and their pathos [the war photographs] are bitterly remindful of all wars ever fought.'[16] Morris's was an appropriate response for a family-of-man sensibility. But *And/Or* wholly lacked the specificity of those still photographs that came to embody the war in the popular press – a Buddhist monk incinerating himself (1963), Saigon's chief-of-police executing a suspected Viet Cong (1968), Ron Haeberle's photographs of the My Lai massacre (1968), napalmed children fleeing down a road (1972), Larry Burrows's wounded G.I. at a field station (1966), Kyoichi Sawada's Vietnamese family fleeing battle across a river (1965).[17]

Oddly, the most pervasive mode of meaning created by photographs placed in juxtaposition – the construction of irony – plays a very minor part in *And/Or*. The photographs' contents make the antonyms appear mutually exclusive, so no possibility of simultaneously entertaining their opposed meanings seems possible. Like most popular cultural artifacts, they reduce real complexities to exceedingly simple terms – significantly, this is the only Vietnam War photography book that does not integrate text with photographs, the better to present the enormity of the problems presented.

Subsequent books on Vietnam, as did Capa's 1938 *Death in the Making*, employ irony both as mode and meaning. As Paul Fussell so brilliantly hypothesizes in his *The Great War and Modern Memory*,

> Every war is ironic because every war is worse than expected. Every war constitutes an irony of situation because its means are so melodramatically disproportionate to its presumed ends. . . . I am saying that there seems to be one dominating form of modern understanding; that it is essentially ironic; and that it originates largely in the application of mind and memory to the events of the Great War.[18]

What, exactly, constitutes this 'modern understanding . . . that is essentially ironic'? Fussell appears to take his cue from the theory of literary modes developed by Northrop Frye in *Anatomy of Criticism*, where

> irony, as a mode, is born from the low mimetic; it takes life exactly as it finds it. But the ironist fables without moralizing, and has no object but his subject. . . . Tragic irony . . . becomes simply the study of tragic isolation as such. . . . Its hero does not necessarily have any tragic haemartia or pathetic obsession: he is simply somebody who gets isolated from his society.[19]

Whereas the tragic hero's fall is foreseeable, adumbrated in his character or circumstances, the ironic victim's fall is not:

> Tragedy is intelligible because its catastrophe is plausibly related to its situation. Irony isolates from the tragic situation the sense of arbitrariness, of the victim's having been unlucky, selected at random or by lot, and no more deserving of what happens to him than anyone else would be.[20]

Irony's victim, the scape-goat or *pharmakos*, is innocent of any crime or character defect commensurate to the enormity of his or her punishment or fall. Instead, it is guilt-by-association with a society that permits injustice to befall its members that confirms his or her fate.

If this sounds like an apt characterization of America's collective part in the Vietnam War, it may be because that war was conceived and played out – in its media and military conceptions, its creation of heroes, villains, scape-goats, actend climaxes, *entr'actes*, dying fall, and tearful epilogue – in terms of a drama of tragic irony.[21] Players and audience alike (the roles changed constantly) perceived each other across unbreachable gaps, each incapable of imparting his or her peculiar insights to the other: infantryman to officer; field-officer to staff;

staff to Washington; Washington to public; public to Washington, etc. – an ironist's dream, this great chain whose faulty synapses prevented the circuit from ever closing and consequently confirmed one's own isolated, superior (if often quite impotent) knowledge or perspective.

The civilian correspondent in Vietnam, lying somewhere between the high military's will-to-believe and the individual infantryman's no larger but differently limited information about the war, may have been in the most fluid position of all for seeing the war for what it was and thus for constructing its human meaning. Not surprisingly, the chief proponents of this theory are war correspondents themselves. For example, in *Dispatches*, Michael Herr describes the ease with which press writers and photographers could pass from fire-base to fire-base, from frontline to Saigon officers' club. But even with all the dark knowledge made possible by this experience, Herr writes,

> We'd all seen too many movies, stayed too long in Television City, years of media glut had made certain connections difficult.
> . . . A lot of things had to be unlearned before you could learn anything at all, and even after you knew better you couldn't avoid the ways in which things got mixed, the war itself with those parts of the war that were just like the movies, just like The Quiet American or Catch-22 . . . just like all that combat footage from television . . .[22]

The visual and verbal coverage I am examining here is characterized by the mongrel nature Herr describes. Some of it is directly seen and immediately, viscerally horrifying; much of it is derivative and filtered through older notions of heroics and war's traditional meaning, like David Douglas Duncan's Vietnam book, *War without Heroes*.[23] The most sustainedly interesting of it seems shaped by a purposeful irony, that compound of seeming innocence and real experience ('This is horrible!' 'Relax, it's only a movie') that Fussell sees as our patrimony from World War I.

Capa's *Death in the Making* employed ironic devices in the service of a high tragic ideal. Even when struck, visually or ideationally, by the incongruities and cruel paradoxes of war, Capa managed to place them within a larger context – loyalty to country, loyalty to the Loyalist cause – that gave them positive meaning. Those Vietnam photobooks employing Capa's approach – Jury's *The Vietnam War Photo Book*, Griffith's *Vietnam, Inc.* and Page's *Nam* – do so to less exalted ends. Their ironist's arguments and methods – the juxtaposition of two netural images or of image-and-text, their close-ups, their you-are-there framing and verbal posturing – are in the service of more disturbing visions than Capa's.

The war in these three volumes is not only between the largely unwitting Americans and the Vietnamese; it is between black and white G.I.s, between grunts and officers, between men who have seen action and paper-pushers in Saigon, between what men have seen and done and what they wish to remember of it. Jury, Griffiths, and Page concentrate not on battle but on the conflicts within one's own lines – racism and pacifism among the troops; the

squeaky-clean George Patton Jr., lost (or posing) in isolated thought in a field office, juxtaposed to human remains – a skeleton, a jerry-can, machine parts alongside Ambush Alley, the Taay Ninh–Dau Tineg road. The skeleton lies in a deepening depression cut out by its own decay: someone's life bled, then decomposed into this dry earth, pulling the bones in after it. Heroics are set up only to be shot down.

All three books employ the device first put to such telling use in Capa's *Death in the Making* of showing their readers a gallery of troops' faces. But where for Capa these handsome doomed youths were touched by the glory of their cause – photographed head-on in laughing, strong, heroic poses and accompanied by a text that dignified their sacrifice[24] – for photographers in Vietnam, portraits are instead a proof of war's futility – a sort of visual *Ave Caesar, morituri te salutant*:

> Shortly after I got back to 'Nam in '68, before mini–Tet, I realized that I wanted to shoot portraits and do a big piece, a book, anything, called 'The Eyes of Survival.' I'd go out for days . . . to get into the weirdest places – sometimes on assignment, likely as not, but just to get those faces, the eyes, didn't matter whose, just eyes and faces; it somehow seemed the right way to shoot the conflict.[25]

Too numb, too tired, or too stoned, these faces are those of irony's scape-goats rather than of ordinary men transfigured by a just cause. They are variously represented as dwarfed or obscured by the machinery of war, as withdrawn from their surroundings, eyes blank and inward. They transcend or escape Vietnam, not though ideological conviction, but through drugs, liquor, or whores.[26]

Despite these similarities in approach, Jury, Griffiths, and Page's books are very different in their conclusions. Griffiths, a Welsh conscientious objector whose coverage produced arguably the most powerful indictment of the Vietnam War, concentrates on the war's effects on its principal victims, the Vietnamese people. For Griffiths, the natural Vietnamese appear amid their rice crops and the foliage of their villages – a people whose stature is comparable to that of the natural world they live in (and almost invariably framed horizontally to emphasize the subjects' placement within nature). The dislocated/corrupted Vietnamese exchange their place amid nature for the despoilment of city streets and refugee camps (which are almost always framed vertically, the better to emphasize the dwarfing of these victims by the huge, impersonal forces of war, cities, and 'Americanization').

In Griffiths's photographs, Americans appear mostly as huge, looming, destructive presences that overpower and debase their Vietnamese 'allies.' When Griffiths portrays Americans on their own turf, they are shown as horrifyingly isolated – encapsulated in antiseptic, pre-fab war-rooms where Vietnam's tragic reality is magically ameliorated by that modern Maxwell's demon, the computer-based 'Hamlet Evaluation System.'[27]

Griffiths's view of American destructiveness and Vietnamese victimization/heroism is most effectively conveyed in juxtaposed double-page spreads.

For example, a thin, middle-aged Vietnamese woman makes her way toward the camera through a wilderness of destruction in Saigon after Tet; over her shoulders she carries pitifully few belongings – wash bowls, sieves, basket, kerosene stove, pots, a box of Tide; around her, heading in the opposite direction, stroll American troops. The road down the center of the photograph is heavy with mud; there is no refuge from devastation anywhere in sight. Turn the page: we are now 'inside the briefing room at the MACV headquarters in Saigon.' Four trig American officers sit at a broad, shiny conference table in the near dark, listening as a fifth, demonically lit from below, speaks from behind a podium. Looming out of the blacknesses are two slick, back-lit acrylic panels, not unlike those seen at stateside sales meetings. One is a graph titled 'Victims of VC Terroism,' the other, 'Pacification Objectives. . . .' Griffiths titles the photograph

> Pacification, alias 'Rural Reconstruction,' or 'Revolutionary Develop-
> ment,' or 'WHAM' ('Winning hearts and minds'), is Americanization.
> Inside the briefing room . . . where officers have the validity of their own
> perspectives reinforced.[28]

In Griffiths's photographs, American fighters as well as planners are fatally insulated from the reality and consequences of their actions. Seated at distant radar-control posts, shrouded in heat-resistant asbestos suits, helmeted, gog-gled, protected from the roar of their own plane engines, Americans are high-tech, casual killers, unlike their human-scale victims.

Griffiths's anger and power arise out of his conception of the war, which is on a far broader scale than Jury's and Page's. For Griffiths, the Vietnam War was a 'goldfish bowl where the values of American and Vietnamese can be observed, studied, and . . . more easily appraised [where] fundamental deficien-cies within the American system [can be observed].'[29] Thus, his images carry an exegetical weight as well as a merely visual one. It is not enough, for example, that we be presented with a photograph that shows the Otherness, the isolation of American 'liberators' from those they seek to 'liberate;' Griffiths must also point out that underlying significance which for him rounds out the politically mute photograph:

> Despite the official line that the people were there because they 'heroically
> refused to live with the communist knife at their throats,' those like the
> officer below recognized the resentment – not once did he take his hand
> away from his pistol while in the camp.[30]

Such open partisanship and tendentiousness on Griffiths's part struck Peter Prescott, *Vietnam, Inc.*'s only major American reviewer, as 'appallingly stupid':

> [Griffiths] is a Welshman who claims that Americans want to build a
> society ' "motivated" by personal greed' and that a truckload of Viet-
> namese are 'ARVN soldiers off to loot and rape in Cambodia.' Sir, how
> do you know? Griffiths should have learned what Cartier-Bresson knows:

the greatest photographs require no words at all. What Griffiths writes
would not be so embarrassing if his pictures were not as good as they are;
I think they compose, separately and together, one of the great photo-
graphic testaments of war.[31]

Prescott's distress over Griffiths's text is difficult to place – is it because of
Griffiths's seeming anti-Americanism? His naive, casual adducing of American
and ARVN intent? His violation of the conventions of reportorial objectivity?
His use of photographs as tools of political expression? His straining to propel
photographs into a larger and more ambitious context than mere photojournal-
ism? Or all of these?[32]

Jury's *Vietnam War Photo Book*, which also appeared in 1971, raises none of
these questions. In layout, individual photographs and text, it is close in form
to a private photo album. Where Griffiths's images frequently present their
subjects at the height of an action or in extreme situations, Jury's usually
illustrate the interstices between such moments – seconds in which little is
happening but much can nonetheless be seen.

The book, Jury writes, grew out of thinking about Robert Capa's war
coverage:

On a rainy night in Chu Lai, waiting for positive identification on the
body of a friend, I leafed through Robert Capa's *Images of War* and decided
the way to communicate what we all were experiencing was a book of
photographs.

My hope is Capa's – that the soldiers who look at these shots will be
able to say, 'That's how it was.'[33]

Jury's argument contrasts the grunts of 'The New Action Army' – a group who
'marched off unwillingly to an unwanted war' – to the officers and men in 'the
Rear, busily engaged in the Paper Clip War,' and visitors from stateside
(Washington and the USO), people for whom the war was an abstraction still
tinged with glamor and heroic meaning.

In most cases, Jury's photographs are printed two or more to a page; where
they are not, a text block often supplies the juxtaposition necessary to create the
author's intended irony.[34] For example, in one two-page spread, Bob Hope
laughingly disports himself with two mini-skirted troopers from his USO show,
white across the page, a chorus line of dancers in ass-baring adaptations of
Chinese dresses hoof their way provocatively (front and rear shots) across the
stage. Sandwiched between Hope and the chorus line is the text:

Raquel Welch started questioning an institution when she returned from
her 1967 Vietnam tour with Bob Hope.

'Sending girls like me to Vietnam to entertain the troops is like teasing
a caged lion with a piece of raw meat,' she said. 'I'm not criticizing our
boys' thoughts or feelings one bit, I'm just telling you that I know what is
going through their minds. There they are, fighting an aimless war in a
foreign land where they aren't wanted. . . . Deep down inside, I think it

would be best if stars like me stayed home and the Government sent off troupes of prostitutes instead.'

. . . In 1969, during his first show, Bob Hope said, 'Well, fellows, I've just talked with President Nixon . . .' and was booed. And everywhere he went there were peace signs and a strange smell in the air. The old trooper just didn't understand these new soldiers.[35]

Jury's choice of images to represent the front-line infantry stresses their pacifism[36] (peace signs everywhere – on culverts, kit-bags, artillery, helmets, even sprayed on a tree with shaving cream), their violence (human skulls, war-medallions, 'visiting cards' left on dead enemies), their drugginess their segregation by race, rank, and unit. So inverted are the values of this world that an operating-room scene in which two masked surgeons working over a sheeted patient prove to be performing heroic surgery on a German Shepherd seems only momentarily odd – it's actually SNAFU, Jury implies.

The dog photograph is one of few in Jury that resembles a traditional documentary image – the strange scene is photographed from a respectful distance that provides the viewer with a wide range of information about setting and subjects. Most of Jury's photographs instead move in single-mindedly on whatever interests him – a leather peace bracelet, military and home-made signs, a human skull wearing an Air Cavalry hat, an elaborate tablesetting at the Long Binh command mess. Jury's blunt, straightforward framing in these images is one of the qualities that links them to the personal photo album: one sense that it *is the subject alone* and not *the image that can be made using the subject* that interests him. Unlike Griffiths, who never lets go of his formal controls (and whose book, in consequence, has a uniformly contrasty, printed-down, spatially deep quality to it), Jury produces a *pastiche* of uneven appearance. His photographs are reproduced variously as pale and overexposed, dark and underexposed, both informal and snapshot-like and posed and self-conscious.

Far more than *Vietnam, Inc.*, *The Vietnam War Photo Book* is held together by its author's words. Lacking the coherence of either Griffiths's images or political analysis, Jury's book offers us an irony more absurd than tragic, because less remediable. For Griffiths, there *are* possible solutions: understand each other's culture better, learn from history, put one's domestic house in order before venturing into other people's. For Jury, the war, like life stateside, is 'a happening,' and all the pained intelligence in the world can't alter its absurdity.

Tim Page became one of the Vietnam War's legendary photographers not because he was good and got killed, like Robert Capa, Larry Burrows, Dana Stone, and Kyoichi Sawada, but because his apparent nervelessness – the stuff of movie heroism – was immortalized in Herr's *Dispatches*:

There were more young, apolitically radical, wigged-out crazies running around Vietnam than anyone ever realized . . . [Page] was bent, beaten, scarred, he was everything by way of being crazy . . . His talk was endlessly

referential, he mixed in images from the war, history, rock, Eastern religion, his travels, literature . . . but you came to see that he was really only talking about one thing, Page.[37]

Page's apoliticism and self-absorption are abundantly evident in *Nam*. More than any war book I have examined, *Nam* concentrates on the point of view of the photographer himself. Page's strongest photographs propel the viewer voyeuristically into the dangers that the photographer evidently sought out for himself (Herr: 'everybody said . . . that [Page] would go places for pictures that very few other photographers were going.'[38]) Their solipcism is evident in their lack of concrete information: instead of journalistic details, Page's photographs offer us only the opportunity *to be with Page* and feel what he feels. Flying over jungles in helicopters, we stare out the plexiglass window at featureless jungle, aware only of our altitude and the sense of space; we stare out over the shoulder of a machine-gunner as he views the track of strikes on the ground.

Once landed, our photographer is more impressive for the evident risks that he, our scape-goat/witness, is willing to take than for the content of the photographs themselves – in fact, the content *is* Page's risk. Robert Capa printed many obscure battle-photographs, too, but unlike his, Page's are not qualified by texts that establish their political or tactical/strategic importance. Instead, Page's comments have a deracinated quality to them that seems less apolitical (Herr's words) than amoral:

> . . . Being out there in the middle of it with all that gear fed everyone's Biggles syndrome. So many of the lethal gadgets had a pure and simple sexiness, the romance of power over life, ego-saving, black and white decisive life and death, the ultimate blast, the final wave on the best-equipped board in the surf.
>
> I am not sure if most, even in the depths of the soul-searching hawk and dove debates, really weren't out there mainly for the hell of it, for the kicks, the fun, the brush with all that was most evil, most dear, most profane; maybe in the end we were there because we had to be, because it was there.
>
> At least you could make the most, the best of it. It was the only scene/war we had and we were enmeshed above our heads in it; the camaraderie, the sheer adventure of it all, were the biggest isms that could ever frag our hearts and minds.[39]

Most of Page's most striking photographs were made in or around helicopters, which in his peculiar, jumpy patois are 'bringer[s] of life and death, the saving scythe of mini guns,' but more important, 'they make a great camera platform, but a better frame; the heart still flutters around them.'[40] Almost as effective are his photographs of aircraft carriers – 'A thousand planes, Skyhawks, Crusaders, Phantoms, Skyraiders, Intruders, Whales, COPs, a school of destruction.'[41] Page captures the 'simple sexiness,' as he puts it, of these *'perfect bathtub* toy[s]' as effectively as Griffiths (who is morally outraged by their bombing missions) captures something dark and totalitarian about them.

The difference is instructive. Griffiths's aircraft-carrier crew and pilots huddle low on the decks, huge skies piled up above them, each man looking grim and isolated. The captions accompanying Griffiths's photographs emphasize the waste and risk of the planes, the insulation of the sailors and pilots from the country and people they are destroying.[42] Page's color photographs – oddly soothing in their pastel hues – are sequenced to suggest movement; there is a fluidity to their placement across the pages that evokes the noise and nervous energy of the catapults and the men who service them. For the most part, Page's photographs are taken from a low, crouching position; thus the ship's crew dominates his images rather than being dwarfed by weaponry and nature, as they are in Griffiths's. Page's carrier sequence is centered upon a double-page spread of a Phantom about to be launched ('where else could a fish-eye lens be used to full effect'[43]). Phallic, monumental, the plane dwarfs its crew and seems, in its inhuman angles, points, and lifeless grey and black, as perfect a metaphor for military aggression as one could wish. Tellingly, Page's commentary on the carrier photographs is almost wholly confined to reciting the Navy's press releases on the 'perfect bathroom toy''s technical specifications.

Most of Page's photographs do not have the power of his helicopter images or the coherence of the aircraft-carrier sequence. It is only in that work which summons up the hideous attraction of brute power, that suggests the noise, confusion, and animal panic of war, that Page succeeds. Like his friend Herr, Page evidently sees the war in hallucinatory terms – as 'Rock and Roll Flash' (the title of one of *Nam*'s chapters) – and his writing effectively conveys this way of ordering experience, even when his visual images do not. The irony in his work is less pervasive than it is in Griffiths's and Jury's; Page, the ultimate phenomenological hero, just takes it all in, scrambles it up a bit, and spits it back out. Thus, his ironies arise unintentionally from the viewer's sense of interpreting, attributing meaning to images and commentary that Page himself cannot or does not interpret. Rather than allying ourselves with Page in an understanding withheld from his subjects, we look in on them both from a great distance. In a sense, Page appears to have taken Capa's role of photographer-as-witness to its butt-end: the witness-become-subject, a circuit closed to history.

Eye Gallery is out in the Mission District of San Francisco, an area that has something of a small-town feel to it. It's sunnier here, smaller-scale (there are no skyscrapers yet), and the street-life is distinctly more colorful than elsewhere in the city. The Mission is minority country: Latino, Irish, Samoan, gay, cheap-loft country. One sees lots of black leather, shiny plastic, canvas (this is New Wave/punk country too), polka dots, candy stripes, day-glo, sequins. Across the street from Eye, in what used to be an Irish funeral home, is the New College of California; around the corner is the San Francisco Women's Building. The air is charged with causes.

Eye is located in a small storefront on Valencia near 18th. The gallery had

been vandalized, its north window broken, several nights before 'The War Show' opened. The hole was covered now with black plastic and would remain so until the co-op's members (nine, 'but we're looking for more') could come up with the money to replace the glass.

'I'm coming from the '60s, when people really expressed themselves,' says Sandy Barlow. 'The idea for "The War Show" was to stimulate an apathetic public.' So she placed her advertisement – the same one that appeared in *Afterimage* – in *Stars and Stripes*, in *Soldier of Fortune* (for those who, like Philip Caputo's characters, can't come home again from Vietnam); she wrote to editors at *Time* and *Newsweek*, to ICP, to Magnum. Eventually, she made contact with Susan Meiselas, who sent color xeroxes from her book, *Nicaragua*,[44] and black and whites from El Salvador, with John Giannini and Mathew Naythons, both of whom photographed in Southeast Asia in 1973, with Mark Jury and a number of other photographers. The show would go up, fueled by photojournalists' political convictions or curiosity to see what their work looked like on gallery walls.[45]

The day of the opening, I sat in the gallery for an hour while Sandy Barlow typed wall labels across the street at the New College. Two vets wandered in off the street, one saying, 'I don't know if I want to look at these but I suppose I should, shouldn't I?' A former correspondent in Vietnam for the Sydney (Australia) *Morning Star* also stopped in. All of them volunteered that they had war photographs of their own at home.

The majority of the photographs in 'The War Show' were from the files of Richard Boyle, John Giannini, Mark Jury, Susan Meiselas, Mathew Naythons, Dana Stone (missing in Cambodia since 1970), and Eli Reed (the latter a Nieman Fellow at Harvard this year and formerly a San Francisco *Examiner* photographer), although there were also five prints by San Francisco book artist and moviemaker Bil Paul (*Tri-X Chronicles*) and by California State University/Sacramento photography instructor, Miguel Blanco.

The work was mounted modestly and invited reaction at an ideological rather than aesthetic level: 'The emphasis is on the infractions of human rights in both [Southeast Asia and Central America] as well as the human plight that occurs in all wars.' 'The human plight' was represented largely in the numbed reactions of the survivors of war: an old woman recounting the terrors of My Lai (Boyle), the faces of Cambodian refugee children (Naythons), the cycles of round-up, death, discovery, funeral, round-up (Reed, Meiselas – the latter in images from El Salvador). Shots of the dead abounded.

Despite the explicit content of the images, most of them were readable only after recourse to their wall labels. Miguel Blanco's portrait-studies, made during the course of five trips to his family's native El Salvador, only leapt into relief as *war* photographs when one read their captions, *e.g.*, 'Man searching for his family after bombing,' 'Boy who lost arm in crossfire in a city park.' Similarly, Richard Boyle's largely static photographs, taken at a cool documentary distance, strained at the inherent limitations of the single image: 'This soldier was one of the CIA paid and trained Khymer Serei death's head recon teams, that went on secret missions for the Americans. As a ritual, these troops ate the raw

livers of captured Khymer Rouge soldiers as a proof of their manhood.'
The image accompanying this caption merely depicted a smiling young
Asian in military uniform – an irony, but one that revolved about photographic
conventions and limitations rather than gaps in understanding among viewer-
photographer-subject.

The most successful photographs in 'The War Show' were ones that
represented the disparity between the subjects' experience and what we/the
photographer know. For example, Eli Reed's photographs from Central Amer-
ica – autopsied bodies, numbers rudely painted across their chests, waiting in
anonymity for identification and removal; books of torture victims' photo-
graphs, open for identification in a Guatemalan Human Rights Commission
office like so many parlor albums for *Titus Andronicus* – present us with the
cheapness of some lives and the relative privilege of others (the American
photographer, the government-sanctioned witness to all this horror, the impo-
tent witness).

'The War Show' didn't represent anything we don't already know about
war. What might have been its most illuminating aspect – the inclusion of G.I.s'
snapshots – failed to materialize. Despite Barlow's efforts to reach veterans and
draw out their own photographs, they remained – as last November's 'National
Salute to Vietnam Veterans' also suggested – largely isolated in their memories,
difficult to converse with about their experiences.[46]

But in its very lack of pretense, 'The War Show' succeeded: instead of
aestheticizing its material, instead of neutralizing its human meaning as part of
the Panzer-like drive to render all photographs marketable as decorative com-
modities, 'The War Show' presented a gritty, contentious argument for looking
at photographs as syntactical units in a moral argument. This is a position easy
enough for the critic to gun down, given the small size and uneven quality of
the work in this particular show, but it is an argument that needs to be made to
counterbalance the hermeticism of much recent work and much recent crit-
icism. The fact that many of the people who wandered into Eye's Valencia
storefront were not traditional culture-pilgrims on an aesthetic hike strikes me
as a telling mark of the show's success.

There are many more books published on the Vietnam War that have
employed photographs than I have discussed here, not a few of them published
by the government itself as *apologiae* for the war's conduct. In addition,
there exist many serial publications from what we might term the *Soldier-of-
Fortune* lobby – *Leatherneck Magazine*, divisional year-books – as well as a
decade's worth of popular magazine and newspaper coverage. Each of these
publications commissioned, chose, or both, photographic representations
that would fit its own argument about the war's meaning. To understand the
role photography played in shaping our perceptions of the war, we need to
examine all of the ways photographs were used in these institutions and
publications.

Out in California, at Norton ARB, the Department of Defense now stores

60,000 linear feet of still- and motion-picture photographs of the war in
Vietnam. If most of those images are like those printed in DOD's own
publications during the war years, they are mute, elliptical images similar to
those in Mike Mandel's *Evidence*. Sun and fill-in flash wink healthily over
pressed fatigues; a hand-shake; a Purple Heart; aviator sunglasses wink back at
the Graflex flash. No surprises there. But we don't know, really. How did the
Army, the Air Force, the Navy, the Marines, conceive of their own history in
Vietnam? What roles did photographs play in reifying these images?

HISTORY LESSONS

Berenice Abbott

Photography at the Crossroads

(First published in the *Universal Photo Almanac*, 1951)

Berenice Abbott worked in Paris as Man Ray's assistant, and while there discovered the photographs of Eugene Atget. Between 1935 and 1939 she photographed 'Changing New York' for the Works Progress Administration, a project much influenced by Atget.

She published this piece at a moment of crisis, not just for photography but for the values which had informed its practice until the end of World War Two. Post-Hiroshima and with the onset of the Cold War there was a retreat from the socially engaged documentary work of the preceding decades; a move away from the social and towards the subjective. Abbott is writing about aesthetic and technical considerations rather than social concerns, but the question of faith in the photograph as unfailing record is implicated in the social pessimism that is her context. She looks to the work of those earlier photographers whom she most admires for examples of what a 'straight' documentary image can achieve. Technical mastery – so that nothing gets in the way of the seeing eye – and a commitment to picturing a fast-changing world in its material immediacy were the tenets by which she drove her own work.

THE WORLD today has been conditioned, overwhelmingly, to visualize. The *picture* has almost replaced the *word* as a means of communication. Tabloids, educational and documentary films, popular movies, magazines, and television surround us. It almost seems that the existence of the word is threatened. The picture is one of the principal mediums of interpretation, and its importance is thus growing ever vaster.

Today the challenge to photographers is great because we are living in a momentous period. History is pushing us to the brink of a realistic age as never before. I believe there is no more creative medium than photography to recreate the living world of our time.

Photography gladly accepts the challenge because it is at home and in its element: namely, realism – real life – the *now*. In fact, the photographic medium is standing at its own crossroads of history, possibly at the end of its first major cycle. A decision as to which direction it shall take is necessary, and a new chapter in photography is being made – as indeed many new chapters are now taking the place of many older ones.

The time comes when we progress, must go forward, must grow. Else we wither, decay, die. This is as true for photography as for every other human

activity in this atom age. It is more important than ever to assess and value photography in the contemporary world. To understand the *now* with which photography is essentially concerned, it is necessary to look at its roots, to measure its past achievements, to learn the lessons of its tradition. Let us briefly span its beginnings – they were truly spectacular.

The people who were interested in photography and who contributed to its childhood success were most serious and capable. In the early years of the nineteenth century, a tremendous amount of creativeness and intelligence was invested in the new invention. Enthusiasm among artists, scientists, intellectuals of all kinds, and the lay public, was at a high pitch. Because of the interest in and demand for a new picture-making medium, technical development was astonishingly rapid.

The aesthetic counterpart of such rapid growth is to be seen in photographers like Brady, Jackson, O'Sullivan, Nadar, and their contemporaries. There was such a boom in technical progress, as has not been surpassed even today. The recently published *History of Photography* by J. M. Eder, translated by Edward Epstean, documents this acceleration in detail.

America played a healthy and vital part in the rise of photography. American genius took to the new medium like the proverbial duck to water. An extremely interesting study of photography in the United States – an important book for everyone – is Robert Taft's *Photography and the American Scene*. Here the material and significant growth of the medium is integrated with the social and economic growth of our country.

In photography, America neither lagged nor slavishly imitated, and we can boast of a sound American tradition. Portraits flourished as in no other country. The Civil War created a demand for millions of 'likenesses' of the young men marching off to the front. The newness of our country was of course another stimulus to growth, with many people sending pictures of themselves to relatives left behind in the westward movement, or to prospective brides and husbands in the 'Old Country.' The migratory, restless population of the United States flowed west, over the Alleghenies from Pennsylvania into Ohio and other states of the Western Reserve, past the Mississippi and into the west; and wherever they went, they left little hoards, little treasures of old photographs – invaluable archives for the historian today. In the winning of the frontier, photographers also played their part, going with U.S. Geologic Survey expeditions after the Civil War. Among these, William H. Jackson stands as a shining example.

This organic use for photography produced thousands of straightforward, competent operators, whereas in England there were comparatively few; apparently because a monopoly of all patents tied up the photographic process and prevented the spread of interest in and use of the new invention. Here in the United States, it was virtually impossible to make such a monopoly stick.

This ferment and enthusiasm produced fine results. Our daguerreotypes were superb. They were acclaimed all over Europe and systematically won all the first prizes at the international exhibitions. People were wild with enthusiasm for these realistic 'speaking likenesses,' and everybody was doing it. In fact,

anyone could afford the photograph, whereas before only the wealthy could pay the price to have their portraits painted. As a result, the photographic business flourished.

After a whole-hearted start with Yankee ingenuity, money got into photography along with pseudo-artists; commercialism developed with a bang. And as with any business which, as it grows, serves the greatest common denominator, so with photography. Cash took over. Instead of the honest, realistic likeness, artificial props with phony settings began to be used. A period of imitating the unreal set in. Supply houses sprang up, with elaborate Grecian urns and columns and fancy backdrops – all for the greatest possible show and ostentation. Retouching and brush work also set in. What was thought to be imitation or emulation of painting became rampant.

It need not be added that the imitation was of bad painting, because it had to be bad, dealing largely or wholly with the sentimental, the trite and pretty, the picturesque. Thus photography was torn from its moorings, the whole essence of which is realism.

Much of this was due to a terrible plague, imported from England in the form of Henry Peach Robinson. He became the shining light of photography, charged large prices, took ribbon after ribbon. He lifted composition bodily from painting, but the ones he chose were probably some of the worst examples in history. Greatest disaster of all, he wrote a book in 1869 entitled *Pictorial Photography*. His system was to flatter everything. He sought to correct what the camera saw. The inherent genius and dignity of the human subject was denied.

Typical of his sentimental pictures were his titles, and titles of other photographers of the period: 'Poor Joe,' 'Hard Times,' 'Fading Away,' 'Here Comes Father,' 'Intimate Friends,' 'Romantic Landscape,' 'By the Stream,' 'End of a Winter's Day,' 'Kiss of Dew,' 'Fingers of Morning.' If some of the subject matter and titles are not too far removed from some of today's crop of pictorialists, then obviously the coincidence of similar thinking has the same sentimental unrealistic foundation in common. This Robinsonian school had an influence second to none – it stuck, simply, because it made the practice and theory of photography *easy*. In other words, flattery pays off. Thus today there are still many photographers of the Pictorial School who continue to emulate the 'master' of 1869.

As a popular art form, photography has expanded and intensified its activity in recent years. The most noticeable trend has been the widespread publication of articles and books on *How-To-Do-It*. Yet what is more important now is *What-To-Do-With-It*. That very widespread distribution which gives photography much of its strength and power, demands that there be a greater sense of awareness on the part of photographers and editors alike.

Unfortunately, along with growth and the strength it signifies, goes the possibility of a decline in our photographic sensibilities and output. Actually, the progress of photography is frequently delayed by inadequate equipment, which needs fundamental, far-reaching improvement. This is not to condemn the industry as a whole, but rather certain segments of it, for their stationary outlook and lack of proper perspective. Photography gains much of its strength

from the vast participation of the amateur, and of course this is the market where mass production thrives.

But – it is high time industry paid attention to the serious and expert opinion of experienced photographers, and to the needs of the professional worker as well. This is important because a good photographer cannot fulfill the potential of contemporary photography if he is handicapped with equipment and materials made for amateurs only, or simply for a quick turnover. The camera, the tripod, and other picture-taking necessities, too often designed by draftsmen who never took a serious picture in their lives, must be vastly better machines if they are to free the photographer creatively, instead of dominating his thinking.

Many photographers spend too much time in the darkroom, with the result that creative camera work is seriously interfered with. The stale vogue of drowning in technique and ignoring content adds to the pestilence and has become, for many, part of today's general hysteria. ' . . . *and craftsmanship I set up as a pedestal for art; Became the merest craftsman; to my fingers I lent a docile, cold agility, And sureness to my ear. I stifled sounds, And then dissected music like a corpse, Checked harmony by algebraic rules.*'

Apart from the foregoing gripes, what then makes a picture a creative piece of work? We know it cannot be just technique. Is it content – and if so, what is content? These are basic questions that enlightened photographers must answer for themselves.

Let us first say what photography is *not*. A photograph is not a painting, a poem, a symphony, a dance. It is not just a pretty picture, not an exercise in contortionist techniques and sheer print quality. It is or should be a significant document, a penetrating statement, which can be described in a very simple term – selectivity.

To define selection, one may say that it should be focused on the kind of subject matter which hits you hard with its impact and excites your imagination to the extent that you are forced to take it. Pictures are wasted unless the motive power which impelled you to action is strong and stirring. The motives or points of view are bound to differ with each photographer, and here in lies the important difference which separates one approach from another. Selection of proper picture content comes from a fine union of trained eye and imaginative mind.

To chart a course, one must have a direction. In reality, the eye is no better than the philosophy behind it. The photographer creates, evolves a better, more selective, more acute seeing eye by looking ever more sharply at what is going on in the world. Like every other means of expression, photography, if it is to be utterly honest and direct, should be related to the life of the times – the pulse of today. The photograph may be presented as finely and artistically as you will; but to merit serious consideration, must be directly connected with the world we live in.

What we need is a return, on a mounting spiral of historic understanding, to the great tradition of realism. Since ultimately the photograph is a statement, a document of the *now*, a greater responsibility is put on us. Today, we are confronted with reality on the vastest scale mankind has known. Some people

are still unaware that reality contains unparalleled beauties. The fantastic and unexpected, the ever-changing and renewing is nowhere so exemplified as in real life itself. Once we understand this, it exercises a dynamic compulsion on us, and a photo-document is born.

The term 'documentary' is sometimes applied in a rather derogatory sense to the type of photography which to me seems logical. To connect the term 'documentary' with only the 'ash-can school' is so much sheer nonsense, and probably stems from the bad habit of pigeon-holing and labelling everything like the well-known 57 varieties. Actually, documentary pictures include every subject in the world – good, bad, indifferent. I have yet to see a fine photograph which is not a good document. Those that survive from the past invariably are, and can be recognized in the work of Brady, Jackson, Nadar, Atget, and many others. Great photographs have 'magic' – a revealing word that comes from Steichen. I believe the 'magic' photographers are documentarians only in the broadest sense of the word.

According to Webster, anything 'documentary' is: 'that which is taught, evidence, truth, conveying information, authentic judgment.' Add to that a dash of imagination, take for granted adequate technique to realize the intention, and a photographer's grasp will eventually equal his reach – as he turns in the right direction at the crossroads.

Mary Warner Marien

What Shall We Tell the Children?
Photography and Its Text (Books)

(First published in *Afterimage*, 1984)

Warner Marien's critique of two histories of photography identifies a particular crisis in photographic history in a postmodernist age. It looks at the ways in which influential post-war historians have emphasised notions of the master photographer and the masterwork at the expense of the social and cultural contextualisation of the medium.

P HOTOGRAPHY'S first modern histories were better than they ought to have been. Together with Helmut and Alison Gernsheim, Beaumont Newhall shaped the history of photography and the configuration of photographic meaning that remain largely intact today. The approach of the sociologist-photographer, Gisèle Freund, whose *La Photographie en France au Dix-Neuvième*

Siècle: Essai de Sociologie et d'Esthétique appeared in 1936, helped Newhall, but he was not aware of Robert Taft's *Photography and the American Scene*, which was published in 1938. He did know and use Heinrich Schwarz's monograph on David Octavius Hill, published in 1931 (Eng trans 1932).

Prior to Freund and Newhall, only J. M. Eder's technical history of early photographies and George Potonniée's more circumscribed *History of the Discovery of Photography* (1936) offered readers a chance to grasp the scope of photography's development. In photographic practice, the mists of pictorialism had been pierced by a wide-ranging experimentation, but the energy and diversity of practice was nowhere matched by scholarship. Memoirs and anecdotes filled library shelves.

Newhall's first book, *Photography, 1839–1937*, was written as the catalogue to a retrospective show in 1937 at the Museum of Modern Art.[1] Lewis Mumford penned the *New Yorker* review of the exhibit. In an otherwise positive review he made an observation that may surprise the contemporary reader. He suggested 'that the Museum of Modern Art is overreach[ing] itself in the matter of documentation.' Mumford writes: 'What is lacking in the present exhibition is a weighing and assessment of photography in terms of pure aesthetic merit – such an evaluation as should distinguish a show in an art museum from one that might be held, say, in the Museum of Science and Industry.'[2]

Did Beaumont Newhall, who has been criticized for aestheticizing photography,[3] leave aesthetic considerations out of his catalogue? Yes, and no. What Newhall did was to develop, through the writing of history, a documentary aesthetic as the dominant way to understand photography. He dismissed the question, Is photography art? as one tied to the reception of early photography and having only a historical interest. 'But we are seeking standards of criticism generic to photography,' he argued.[4] Those standards, Newhall continued, originate in the unique character of the photographic medium. 'Photographic esthetics are so closely combined with technique that it is almost impossible to separate the two.'[5] The painter and the photographer are alike in that they both desire to make a picture and 'both must know basic laws of composition, of chiaroscuro and color value.' But these laws must be applied 'in terms of the possibilities and limitations of . . . [the] medium.'[6] Newhall concluded that 'photography now uses compositional elements peculiar to itself; its vision is its own; its means of getting effects are so manifold that they have scarcely been explored.'[7]

The second edition of Newhall's book, titled *Photography: A Short Critical History*, followed just fifteen months after the exhibition catalogue. Only minor changes were made, but the aesthetic appreciation of photography was announced in the preface: 'The purpose of this book is to construct a foundation by which the significance of photography as an esthetic medium can be more fully grasped.'[8] Mumford had found 'an amazing omission' in Newhall's catalogue: Stieglitz was 'not represented in . . . [the] show by any of the work he . . . [had] done during the last twenty-five years.'[9] The second edition was dedicated to Stieglitz; its frontispiece was a 1934 Lake George photograph by

Stieglitz; and the section on the Photo-Secession, rewritten to emphasize the centrality of his work in and on behalf of photography, was retitled, 'Alfred Stieglitz.' Although these changes seem to portend a new aesthetic proclivity, they are largely restricted to the Stieglitz discussions. The totality of Newhall's second effort remained much like the catalogue.

The form of Newhall's *The History of Photography* was established in 1949. In Newhall's bibliography, the 1949 edition is counted as a third edition. But the differences between it and the previous publications of 1937 and 1938 are so extensive that it really should count as a first edition, as a new book. And so it is on the title page and its verso. Newhall himself considers the 1949 edition much improved.[10]

Mumford's call for an aesthetics of photography seems forgotten in the 1949 publication. Instead, Newhall plunges into documentation, using many more original sources than he did in the previous two publications. Indeed, the excision of photography from the art world is more pronounced than any aestheticizing in the previous two editions. Although Newhall writes that Charles Sheeler is 'first and foremost a painter,'[11] precisionism is not mentioned. Moholy-Nagy is here, but the Bauhaus isn't. The new objectivity is mentioned, but not defined.[12]

The savviest section of the 1949 edition has nothing to do with art, but dwells on the documentary, and what has continued to be called the anti-aesthetic.[13] Bolstered by the extensive use of quotations and a log of original sources, Newhall portrays photography as possessing a potential for heightened persuasiveness that grows not from an insular symbiosis between photographer and the potentialities of the photographic technique, nor through the sheer personal character or expression of the photographer and the social subject. Photographers are more like writers of fiction who resuscitate and enlarge social meanings than like painters who delight the eye. Newhall quotes Paul Rotha: 'Beauty is one of the greatest dangers to documentary,' and Glenway Westcott on Walker Evans: 'For me this is better propaganda than it would be if it were not aesthetically enjoyable.'[14] Newhall concludes: 'Documentary is, therefore, an approach, which makes use of the artistic faculties to give "vivification to fact" – to use Walt Whitman's definition of the place of poetry in the modern world.'[15]

Although he does not take the opportunity of the extended breadth of the 1949 edition to expose the generic aesthetics of photography, several enduring attitudes are apparent. The book is stabilized by the inclusion of original documents. Newhall brings to bear those documents and parts of documents that establish facts and a sketch of the photograph's time. He does not show much interest in philosophical musing. The thoughts of Lady Eastlake and Philippe Burty are quoted, but not their speculations on the influence of photography on the society and art.

In this edition of his history, Newhall establishes what he will prize in telling photography's story and that includes a time-honored reluctance to deal with the contemporary scene. His preference for straight photography can be adduced in his treatment of Oscar Rejlander and Henry Peach Robinson and

in his evaluation of Moholy-Nagy and Man Ray: 'The vision which led to these applications of the photographic technique is quite separate from the vision of those who seek to interpret with the camera the world of nature and of man. Viewing these photograms and solarized prints and distorted negatives, we are constantly reminded not of photographs, but of paintings.'[16] Inferior paintings, one suspects. Newhall quotes James Thrall Soby to the effect that these experiments have only historical interest.

In the 1949 edition, Newhall modelled a vital photographic realm removed from the world of modern and contemporary art. He chose to view photography more in its connections to documentary cinema and journalism rather than to art. That is not to say that Newhall prefers the news photo to the art photo. 'All news is not photogenic,' he has written. Moreover, 'great news photographs are not accidentally made.'[17] Nevertheless, in the 1949 edition, Newhall lets his readers know that photographs make bad paintings.

The 1964 edition of *The History of Photography*, probably the most familiar edition, assumed a larger format and benefited from more than a decade of Newhall's further thinking and research. It presented additional illustrations, many of them drawn from the collection of the George Eastman House, which Newhall, then director for six years, was helping to form. In this fourth edition, Newhall reworked the section on documentary, giving central consideration to Atget, both in his own right and as a figure influential for contemporary photographers. The chapter on abstraction was retitled, 'The Quest for Form.' While Newhall continued to use the quotations neutralizing the aesthetic importance of this direction of experimentation, he gave a wider account of the work of Man Ray and Moholy-Nagy.

In the fourth edition, André Kertész, August Sander, Richard Avedon, Jacques-Henri Lartigue, World War II, and the Korean conflict are in. Lisette Model, in the period when she was a revered teacher in New York City, is out. From the first, Newhall, trained in museum studies at Harvard under Paul Sachs, showed a continuing concern for pivotal shows and founding collections. The 1964 edition gives information, albeit brief, on the beginnings of the George Eastman House and the making of the collection at the Museum of Modern Art. A new section, 'Recent Trends,' awkwardly juxtaposed a section on technological advances, like photoelectric metering and the invention of the Polaroid-Land camera, with direction in photographic style, giving a strong indication of the extent to which photographic style had grown independent of technological progress. Newhall ascertains that the contemporary photography scene exhibits at least four inclinations: straight photography, the formalistic, documentary, and the equivalent. New names appear in this chapter, among them Minor White, Wynn Bullock, and Harry Callahan.

The definition of documentary, with which Newhall concludes, conflicts somewhat with his appreciation of documentary film in an earlier chapter. He writes that documentary is 'essentially a desire to communicate, to tell about people, to record without intrusion, to inform honestly, accurately, and above all convincingly. Subject is paramount. The final print is usually not the end product, but the intermediate step toward the picture on the printed page.'[18]

Forgetting his earlier words on the value of the anti-aesthetic, Newhall ac-
knowledges the toughness of Robert Frank's photographs, while despairing
that they lack 'the sense of compassion' that distinguished the work of the
Farm Security Administration photographers.[19] Though he has never claimed
to be all-inclusive, the 1964 edition seems to have been the place in which
Newhall could have reoriented his history to include more mass-mediated
photography than fashion photos or to consider, as art historians like Edgar
Wind were in those years, the effect of mechanical reproduction on the practice
of painting.[20]

As artists like Richard Hamilton, Robert Rauschenberg, and Andy Warhol
were beginning to use the photograph in pop-art expressions of its mass media
and advertising forms, Newhall seems to have made a decision to rule them out
of the confines of the book. It was, on balance, a decision consistent with his
historical approach. The exclusion of pop in the 1964 edition may be serious,
but it is also in keeping with the exclusion of precisionism, the Bauhaus, and
other art intersections of photography. These preclusions became acute, how-
ever, by the 1982 edition, because of the expansive use made of photographs in
various pop-art strategies throughout the intervening years.

The fifth and current edition of Newhall's *History* (1982) has undergone
extensive rewriting. The opening chapters on photography's prehistory, its
invention, and initial uses, have been broadened and refreshed with additional
research and illustrations. Throughout his texts, Newhall has been careful to
change and add photographs, in some ways mitigating the canon he himself
helped to create. In this latest edition, the criticism of Baudelaire has been
added to the chapter on art photography, but Newhall's interest in this text is
not photographic criticism.[21] Also, the photography of the Pre-Raphaelites and
Lady Hawarden is included. The 1964 chapter called 'The Faithful Witness' has
been retitled, 'A New Form of Communication.' It begins with an attempt to
balance art photography with documentary: 'In contrast to those who sought
to rival the painter with camera and lens, there were hundreds who used
photography quite simply and directly as a means of recording the world about
them.'[22] Where other authors, intent on showing the formal relationships
underlying all photography, would have emphasized composition and tone,
Newhall adopts a more neutral tone toward the photographs he discusses.

Pictorialism now merits an entire chapter, and Atget, the darling of do-
cumentary in the 1964 edition, has been demoted. In the midst of MOMA's
long-term promotion of Atget, Newhall's text works against voguishness. The
discussion of his work is appended to the section on straight photography. The
chapter, 'In Quest of Form,' has been enlarged to include Alexander Rodchen-
ko, Hannah Höch, Max Ernst, Paul Citroen, and El Lissitzky. At last, dada is
explained, and Newhall illustrates the politically charged work of John Heart-
field. Writing on the photogram in the 1964 edition, Newhall opined: 'One can
only agree with Sir Kenneth Clark's observation: "Whether or not one is in
sympathy with the style of negation, one must surely concede that the attempt
to make the camera, with all its powers of subtle record, aspire to the condition
of a blueprint was singularly ill judged." '[23] In the 1982 edition, the quotation

has been dropped, and the section is rewritten with greater depth and under-
standing of experimentalism.

In the 1938 version of the text, Newhall wrote that 'the scientific aspects
[of photography] are discussed only so far as they vitally affect the esthetic ends
of the medium.'[24] Nevertheless, through the 1964 edition, he included a
small section on scientific photography, whose 'pictorial quality . . . is a by-
product.'[25] In these texts, Newhall related that the durable, if seldom
announced, strategy in modern art is the appropriation of objects and images
from non-art sources. Moreover, he considered that scientific photography
echoed in the works of Marcel Duchamp, Giacomo Balla, and the futurists.
Inexplicably, at a time when space photography, radar imaging, and computer
enhancement have developed new audiences for photography, Newhall (or his
publisher) has vastly abbreviated the discussion of scientific photography in the
current edition. The chapter on color work, though, has been amplified, and
Newhall uses Edward Weston's *Waterfront* (1946), the frontispiece of the 1949
edition, to make the transition into the present. Along with Eliot Porter, whose
work caught Newhall's attention in the 1949 edition, he illustrates but does not
discuss William Eggleston, Stephen Shore, and Joel Meyerowitz.

This latest edition of Newhall has kept virtually all of the author's 1964
concluding statement. In it he expresses his approach to recent directions in
photography:

> While it is too soon to define the characteristics of the photographic style
> of today, one common denominator, rooted in tradition, seems in the
> ascendancy: the direct use of the camera for what it can do best, and that
> is the revelation, interpretation, and discovery of the world of man and
> nature. The present challenge to the photographer is to express inner
> significance through outward form.[26]

The burgeoning production of and interest in photography in the post-war
period demand that an author make choices among the themes, topics, trends,
and individuals discussed in a generalized text. Repeatedly, Newhall has an-
nounced that critical distance comes with the passing of time and that one
cannot make good judgments about recent work. Still, his treatment of 'New
Directions' will impress many as overly cautious. The benign analysis of four
trends (stylistic, formalistic, documentary, and the equivalent) set out in the
1964 edition has been scratched. Diane Arbus appears for the first time, and
Lisette Model is back. Jerry Uelsmann, Garry Winogrand, and Lee Friedlander
also make their first appearances. Duane Michals is represented by a 1969
narrative sequence.

Newhall's aversion to losing the uniqueness of photography in the world
of art is a constant underlying value in the text. The current edition of *The
History of Photography* contains no Richard Hamilton, Warhol, or Rauschen-
berg. One cannot learn through Newhall of the various photo-realisms of the
1970s nor of the ways that conceptual artists have used photography in the last
decade. For that matter, one cannot find out the extent to which events of the
late '60s and '70s, like happenings, performance art, and earthworks, were

integrally dependent on photography both as record and as a means of dissemination. Will these, winnowed by time, appear in the next edition of Newhall? Perhaps, but only if he and a great many others change their minds about a pivotal issue.

In the 1982 edition, Newhall writes:

> In the past few decades there has been considerable experimentation in combining the photographic process with other media, especially painting and drawing. In contrast to the master photographs taken by such recognized painters as Man Ray, Moholy-Nagy, and Charles Sheeler, who kept work done by the camera and that done by the brush strictly separate, today's practioners of mixed media so intertwine the media that the results seem to me to have little to do with photography, and lie outside the scope of this survey.[27]

The simplification of form in Sheeler's photographs and his paintings of Pennsylvania barns leads one to think that he didn't keep his brush work and his camera work as separate as even he might have thought. Whether or not Man Ray and Moholy-Nagy mixed media is irrelevant. A machine aesthetic informed Moholy-Nagy's photography as well as his sculpture, his cinema, and his painting, giving them a unity that transcends media differences. Beyond that is the artist's concern with the dynamic interplay of space and time. It makes about as much sense to argue that the rayograph, Man Ray's cameraless photography, should not be discussed with his lens work. In a 1975 interview, presumably while he was recasting the fourth edition, Newhall recognized that a historian must reserve the right to change his mind and noted that he had changed his with respect to photo-montage. 'I did not feel that photo-montage was a kind of photography,' he said. 'I now feel that it is important to include a passage on photo-montage because it wouldn't exist without photography, without the multiplication of imagery providing the material from which the monteur creates his montage.'[28] His revised outlook is apparent in the increased discussion of post-World War I experimentation. The same logic could be applied to pop uses of photography, because contemporary collage, montage, and bricolage also would not exist without photography.

It was Newhall's separation of photography from the damps of pictorialism and the margin of art history that, along with the work of the Gernsheims, Taft, and Freund, helped to make it a subject meriting independent consideration. Rather than aestheticizing photography, as some have claimed, Newhall documented it. It is ironic that the productive reluctance that forged photography's first modern histories by keeping it from being treated like a minor form of painting is now not representing the fullness of its history. Like all ironies, it makes strange bedfellows. Newhall's documentary emphasis aligns him with the postmodernist critics, like Abigail Solomon-Godeau: 'The shared conviction that the art photograph is the expression of the photographer's interior rather than or in addition to the world's exterior, is, of course, *the* doxa of art photography and has been a staple of photographic criticism almost from the medium's inception.'[29]

In a short article entitled 'Documentary Approach to Photography,' pub-lished in *Parnassus* (the predecessor of *Art Journal*) in March 1938, Newhall outlined his position on documentary in relation to art photography, a position which he has held since. Newhall acknowledged a distrust for 'elaborately self-conscious photographs[s]' like Rejlander's *Two Ways of Life*.[30] The notion that Newhall aestheticized photography has emerged from partial readings of his interpretations of photographs like those produced by the collectivity called Mathew Brady:

> Yet these pictures of the wrack and ruin of human bodies and nature and man's creations, these penetrating portraits of the men who planned and fought and died for the Union and for the Confederacy have more esthetic content than the compositions, lighted *à la* Rembrandt, which are signed 'Adam Salomon, sculpteur,' or the anecdotal composite prints of H. P. Robinson, often called the father of pictorialism.[31]

Out-of-context, a sentence like that seems soupy and romantic. In context, the point of such sentences is to underscore what has been a persistent value in Newhall's writing, that 'the work of photographers who have attempted to interpret subject-matter has usually been superior to the work of photographers who have deliberately set out to rival or equal the painter.'[32] When he has written about formal values, he has also emphasized that they are the incidental and secondary products of a unique medium:

> The documentary photographer is not a mere technician. Nor is he an artist for art's sake. His results are often brilliant technically and highly artistic, but primarily they are pictorial reports. First and foremost he is a visualizer. He puts into pictures what he knows about, and what he thinks of, the subject before his camera.[33]

Writing in the *Bulletin of the Museum of Modern Art* on the founding of the Department of Photography there, Newhall did betray an interest in great works that has informed his writing since. He noted the 'amazing growth' of photography in its second century, but also warned that

> there is danger in this amazing growth. Through the very facility of the medium its quality may become submerged. From the prodigious output of the last hundred years relatively few great pictures have survived – pictures which are a personal expression of their maker's emotions, pic-tures which have made use of the inherent characteristics of the medium of photography. These living photographs are, in the fullest meaning of the term, works of art. They give us a new vision of the world, they interpret reality, they help us to evaluate the past and the present.[34]

Masterworks and masterworkers interest Newhall, and they do so to the exclusion of work that may lack craft but is saturated with socio-political significance, like cartes, advertisements, and snapshots. But Newhall has been willing to see originality emerging from all quarters, including commerce. Rather than making it an art, Newhall has directly and indirectly claimed that

photography is a unique, hybrid medium, with its own aesthetic. Consequent-
ly, when photography began to truck with other media, it was photography
that transmogrified. A painting with photographs glued to its surface has
remained, somehow, a painting.

Photography is no more pure than the rest of modern art. Especially in the last
few decades, art has raised havoc with categorization by media. What should
one call a canvas that violates the sacred rectangle and undulates into the
viewer's space? Painting or sculpture? Should happenings be discussed in
history of theatre classes or in art history? Do Sherrie Levine and Barbara
Kruger belong in art history, photohistory, media studies, or criminology? The
gesamtkunstwerk, the work of art that merges media into a new form, may turn
out to be the characteristic art of the latter half of the twentieth century.

 Photography is being 'mainstreamed' into the museums, galleries, and
colleges through several forces. The vast societal nostalgia for things of the past
(and for a credible future), which made its appearance in the middle of the last
century, set off the voracious warehousing of art and non-art objects, including
photographs. The appetites of the art market have been pleasantly satisfied by
the museumization of photography. Today, artists who think nothing of
painting on metal, on bridge abutments, or on themselves are using it in a much
less self-conscious way, than, for instance, Moholy-Nagy did. There is so much
quotation – photography's forte – that photography has become inextricably
mixed into contemporary art, even when direct use of photographic processes
is absent. To accommodate photography's altered status, which has several vital
roots in surrealism, writers like Newhall cannot simply add a few paragraphs,
but will have to reconceptualize its art alliances. Ironically (again), it means
aestheticizing Newhall.

 For all of its international breadth, that is what Naomi Rosenblum has
attempted to do in *A World History of Photography*. Her debt, in fact the field's
debt, to Newhall, the Gernsheims, Taft, and Freund is acknowledged along
with more recent texts on art and photography, like Aaron Scharf's *Painting and
Photography* (1968) and Volker Kahmens's *Photographie als Kunst* (1973). Rosen-
blum perceives the role of *A World History of Photography* as a vehicle through
which the profusion of research in the last decade can be complied, a need
voiced by photo-historians.[35] The expanding geographical sphere in which
research topics in photohistory have been undertaken leads Rosenblum to a
more global approach. She writes: 'This book . . . is designed to distill and
incorporate the exciting findings turned up by recent scholarship in a field
whose history is being discovered daily. It summarizes developments in photo-
graphy throughout the world and not just in the areas of Europe and the
Americas that have in the past received almost exclusive attention.'[36]

 Recognition of research efforts published in the last decade is evidenced
with increasing frequency as the book proceeds. Rosenblum acknowledges a
reliance on articles that have appeared in *The History of Photography*. In addition
she has consulted Donald English's work on political photography in France

during the Third French Republic, Kirk Varnedoe's series on art and photo-
graphy that appeared in *Art in America* in 1980, Elizabeth Lindquist-Cock's
work with American landscapes, Elizabeth Ann McCauley's incisive catalogue,
Likenesses, the recent books on Stieglitz, some current writing on the German
and Russian avant-garde movements, and Abigail Solomon-Godeau and Mi-
chael Starenko on postmodern photography. She discusses photorealism, the
new topographics, pop-art uses of photography, and the integral role played by
the medium in earthworks, body art, and conceptualism. By implication,
Rosenblum concludes that photography is still photography despite artists'
mixing media:

> Photography's potential for personal expression has expanded radically in
> the past decade. Camera images have become transformed: besides the
> traditional two-dimensional monochromatic entity in shades of black and
> white – more often than not dealing with some facet of reality – the
> medium now embraces objects conceived in a variety of shapes, colors,
> and sizes, concerned with providing information, selling ideas and pro-
> ducts, moving people, making formal and analytic statements. New tech-
> nologies, new aesthetic theories, in concert with the enhanced role of the
> photograph as a marketable commodity, have influenced the way the
> medium currently is being used and perceived.[37]

As promised in the preface, the book is generously illustrated and includes
many lesser-known photographs. Black and white reproductions, together with
color works and technical drawings, add up to 803 illustrations. Rosenblum
includes nineteenth-century industrial photographs, a fine selection of daguer-
reotypes (which she compares to American naive painting), many instances of
popular photography in the last century, and an array of seldom-seen travel
photographs. Though this is a photographic history, not an art history, Rosen-
blum writes briefly about and posits several major intersections with painting.
Consequently, we learn about science and photography and its importance for
artists like Whistler, Degas, and Duchamp. Pictorialism is discussed in concert
with symbolist and tonalist painting. Rosenblum relates documentary photo-
graphy to realism in painting.

The result is a massive text, roughly double that of Newhall's 1982 edition.
Newhall's index runs seven and a half pages; Rosenblum's is a full twenty-four
pages. But is more really better? To handle greater amounts of data, Rosenblum
has broken the presumptive continuity of photography's story – something New-
hall seems loath to do. She organizes chronologically as well as by theme, moving
through portraiture, landscape, documentary, and art photography, as well as
scientific photography, fashion, and advertising. As a result, there is some overlap
in her chapters. This occurs in Newhall to a lesser degree, but for the same reason:
both use a masterworker's approach, so the long, varied, and productive lives of
some photographers, like Steichen and Stieglitz, require it. Three technical
histories, illustrated with clear line drawings, are partitioned from the major text.
Many photographers are profiled, that is, given roughly 500-word biographies,
similar to encyclopedia entries, at the end of each chapter.

A significant proportion of new research to which Rosenblum attempted to attune the text begs for a decreased emphasis on individuals and an increased analysis of collectivities, like popular photography, collections, and propaganda efforts. This reorientation is felt in Rosenblum's broad inclusion of non-art photography, but is mitigated by several other aspects of the book. The profiles, and many chains of names strewn in the text, do not challenge the historiography of individualism. The many new images elaborate Newhall's story, but do not reform its plot line. In some instances, the inclusion of seldom-seen photographs provides the author with an opportunity to draw non-art photographs into the art world. Here is Rosenblum on Baldus: 'His images established the paradigm documentary style of the era in that he brought to the need for informative visual material a sure grasp of pictorial organization and a feeling for the subtleties of light, producing works that transcend immediate function to afford pleasure in their formal resolution.'[38] On the other hand, her section on modern advertising's progressive foraging in the art world, as much the result of technological utopianism in the arts as avarice in the marketplace, demonstrates how much is lost by Newhall's resistance to the art intersections of photography.

In a way, we have come full circle from Eder to Rosenblum. Where Eder linked the technological progress of photography with its results, Rosenblum, by separating the technical dimension of photography beginning with its prehistory and inception, makes photography's social and artistic linkages seem incidental to technique. Perhaps it is too much to say that the modernist outlook, the intermeshing of photographic development with technical proliferation, is moribund in Rosenblum's work. She and her publisher may have devised the technical chapters to extend the book's use in the classroom. Nevertheless, this bifurcation is one with greater resemblances to the various treatises on pictorial photography at the turn of the century than to the work of Taft, Freund, Newhall, and even the Gernsheims.

Because Rosenblum promises 'to distill and incorporate the exciting findings turned up by recent scholarship,'[39] she is open to criticism for what she has not included. For example, the book may have gone to press before Ulrich F. Keller's study 'The Myth of Art Photography: A Sociological Analysis,'[40] but Rosenblum cites several other 1984 books and articles. A decade of Allan Sekula's many studies of photography, politics, and the politics of photography is missing. A World History of Photography is not the place to learn about the growth of photography criticism. Walter Benjamin is here, but André Bazin, Rudolf Arnheim, and Sigfried Kracauer are not. Roland Barthes is briefly quoted, but John Berger, Susan Sontag, Rosalind Krauss, Douglas Crimp, and Fredric Jameson, to name a few, are not.

At the outset, it seems as if Rosenblum is creating an alternative to Newhall. The end result, however, is closer to that of the Gernsheims' reliance on facts to assert their own significance, coupled with what might be called a Szarkowskian permissiveness. This is not to say that the book overlooks or makes light of disputes in the history of photography. It is, though, a work with little discrimination between photographies, and none of the toughness to

evaluate the worth of various photographies. On advertising Rosenblum writes:

> There can be little argument that in modern capitalist societies the camera has proved to be an absolutely indispensible tool for the makers of consumer goods, for those involved with public relations and those who sell ideas and services. Camera images have been able to make invented 'realities' seem not at all fraudulent and have permitted viewers to suspend disbelief while remaining aware that the scene has been contrived . . . As in the past, the photographs deemed exceptional often reflect current stylistic ideas embraced in the arts as a whole and in personally expressive photography in particular; indeed, the dividing line between styles in advertising and in personal expression can be a thin one, with a number of prominent figures working with equal facility in both areas.[41]

The book is so evenhanded and full of equanimity that one is reminded of the chorus from Gilbert and Sullivan's *Mikado*: 'And I am right, and you are right, And all is right as right can be.' The effect, borrowing again from *The Mikado*, is the substitution of lists of names for analysis and ideas. Unlike Szarkowski, Rosenblum does not deemphasize contextual concerns by stressing photography as a means of personal expression. Section by section, there is more suggestion of the social background in *A World History of Photography* than there is in the Gernsheims' book or in Newhall. But the place of photography in the sweep of western cultural history is never achieved. The book's analyses are fractured with too many facts.

A World History of Photography parallels the efforts in art history to update the field in a generalized text. The latest editions of Gardiner's *Art Through the Ages* and Hartt's *Art: A History of Painting, Sculpture, Architecture* include women artists and incorporate recent scholarly findings on broad topics like mannerism and impressionism. Each work illustrates the necessarily limited possibilities for the additive process. Each has probably stretched the skin of the generalized text as far as it will go. In principle, one can expand each element of an aggregate; in practical terms, the result is a heterogeneous assemblage, whose parts are better than the whole. It lacks a level of generalization and discrimination from which to see the parts as a galaxy. A second edition of Rosenblum would probably break into two volumes, becoming more like an encyclopedia in range and tone.

Just as the new Gardiner and Hartt texts do not constitute a feminist art history, although they include more women artists than do other texts, the Rosenblum text does not constitute the new history of photography so often called for, even though it includes more data on non-art uses of photography than Newhall. The liberal spirit of live and let live, the spirit that says that all arts and all cultures are equally valuable, informs Rosenblum's book, as, in fact, it informs much of photohistory. The result is a watery relativism, in which leaving out any photography or photographer means casting a judgment in the absence of criteria. Ultimately, that's taste turned inside out. Permissiveness is no more revelatory than elitism, and it furnishes no alternative to the masterworks-masterworkers approach.

Early on, Newhall realized that his angle of vision was different from that of the Gernsheims, which he saw as 'more archaeological and encyclopaedic' and 'loaded with far more material' than his own work: 'It was a deliberate decision on my part to make my book fit into the more literary type of history, and to try a very difficult thing, which I still have not completed to my satisfaction: tracing the stylistic development of photography and its relationship to other media.'[42] As they have appeared, his various editions have been praised for their comprehensiveness,[43] meaning that the history of photography as written by Newhall was comprehensible, that is, it had the intelligibility of a well-told story. Though he has been criticized for omitting important photographers,[44] Newhall's awareness is that of a historian or, rather, an art historian schooled more in the historiography of Jacob Burckhardt, Dvorcák, and his friend, Heinrich Schwarz, than Ernst Gombrich. He has said: 'I think the historian must never fix his plans only on the past – he must have an overall feeling of the importance of history.'[45]

Those who have not shared Newhall's concern with the overall story of photography, or who have been annoyed at his omitting so many photographers, have read omission as disapproval. They have an alternative in Rosenblum's book. The cost, however, is that of coherence. Rosenblum's book interpolates the crisis of outlook felt in photostudies. The diversity of ideas and images, a substructure without a superstructure, reflects both the increased data and the tumble of conflicting contemporary ideas about photography.

Even now, despite a rosy market, much critical attention, and many university courses, the prejudice against photography runs strong outside the museum/art school/art press nexus. Photography has developed a not unwarranted Cinderella complex, while becoming the belle of the ball. Those wicked stepsisters are real, and there is malice in the palace.

In 1954 Beaumont Newhall proposed to teach a course on the history of photography in the Art Department at the University of Rochester. But the Committee on Academic Policy had other ideas. 'Not Possible,' they responded. 'This is not a trade school. Photography cannot be possibly considered as a proper discipline for the Department of Arts and Sciences.'[46]

There are courses in photohistory at major colleges and universities today, but they are usually taught by those trained in other fields, like photographic technique, journalism, art history, and literary history, who teach photohistory along with other topics. There are plenty of museum people and academics who still think that photography – all photography – is a rude technology, whose hands are soiled daily with the mundane and the horrific. Here is Roger Scruton on photography *and* film:

> Photography, precisely because it does not represent but at best can only distort, remains inescapably wedded to the creation of illusions, to the creation of lifelike semblances of things in the world. Such an art, like the art of the waxworks, is an art that provides a ready gratification for fantasy and in so doing defeats the aims of artistic expression.[47]

He goes on to consider that film and photography, being 'too persuasive at the level of mere realization' create fantasies rather than meanings on the order of Racine and Shakespeare. Writing on war photography in the January 3, 1986, issue of the *Times Literary Supplement*, Michael Ignatieff pins W. Eugene Smith for 'self-importance.' While granting that 'it is just this excess of hubris which intense moral vision demands,' Ignatieff insists that 'photography bearing this load of moral ambition only risks being pretentious.'[48]

To put it bluntly, one should not mistake the vast postwar enthusiasm for photography and its history as evidence that the humanists have found it a serious cultural form, one with the ethical capacity of painting or literature. Museums collect everything from antique cash registers to vernacular architecture; universities teach courses in rock 'n' roll and the new music; the lubricious chic of the galleries dictates that nobody will be caught dead saying anything derogatory about the new. Nevertheless, a short dip into college catalogues, the records of the art auction houses, or the programs of any of the big-city symphony orchestras will reveal a relatively static set of cultural priorities.

Those who teach photographic studies are not alarmed. Whatever other social dreams lie shrivelled on the beach, the notion that photography is the true democratic medium, providing a means of record, communication, and expression to a host of users, is one that runs deeper than the desire to see photography as art. While trying to achieve museum acceptance and corollary academic status, many who study and teach photography have reiterated fears about academization, museumization, and claimed that the medium's strength derives from its independence. This complex of ideas has been absorbed in photohistory, making it an egalitarian among the elitists.

That is one reason why photohistory has never quite fit into the scheme of things in the humanities. With the exception of the antiquarians, who, until recent years, have managed to keep their heads low, photohistorians are a forebearing lot. The conservatism that often passes for judgment and common sense in philosophy, history, literary studies, and art history and criticism, is a rare commodity in photohistory. Not even the modernist art historians have been so enthusiastically ecumenical, so ready to embrace the full compass of the medium. Imagine a medievalist (other than Thomas Hoving) who also teaches Laurie Anderson.

Of course, all has not been congenial in photohistorical studies. But the general outlook has continually undermined theoretical considerations, as well as valuations, often putting photography at odds with the discriminations of traditional humanistic study. When Beaumont Newhall suggested that to address the question, Is photography art? involved 'the risk of falling into philosophical quagmires,'[49] he was predicting the outlook of the majority of photohistorians, for whom the distilled facts of what they consider to be a unique medium have been sufficient. What one hears from those who make photographs and many of those who study them is an impatience with the contemporary invasion of rewarmed French Neo-Platonism, because it separates photographs from the idea of photography and because it aligns photography with literature, philosophy, and criticism, deracinating it, while making it more inaccessible.

While recognizing that not all photography is art, photohistorians have lacked critical and theoretical means, as well as the broad historical and cultural framework necessary, to keep photohistorical studies from being subsumed by other disciplines. Literary criticism, semantic theory, feminist theory, psychoanalytic theory, as well as art history, offer to explain not just photohistory, but the history of photohistory. When writers like Weston Naef draw parallels between painting and photography, based on stylistic similarities like vantage point and composition, they are implicitly helped along by the weakness of the social history of art and the absence of a general socio-political history of photography from its inception to the present.[50] The subject, unmoored, responds quickly to the steering winds of the academy, the art press, and the marketplace. What seems like an invasion to many of those who make and study photographs is seen by social historians, like David Nye, as an inherent problem within photohistory. Nye, whose recent book attempts to understand the corporate photography at General Electric, came away with the observation that photography's modern histories, influenced by literary and art-historical models, overstressed individual creativity and neglected the sociology of photography. Rather than Newhall and the Gernsheims, Nye turned to Sontag, Pierre Bourdieu, and Barbara Rosenblum.[51]

In his *New York Times* article, 'Two Camps Battle over the Nature of the Medium,' Andy Grundberg notes that connoisseurs, who extoll an aesthetic appreciation of photographs, are now on the defensive against contextualists, who insist that photography's social history and societal ramifications have been obscured by preciosity and academic pettifogging.[52] That battle is being played out under a looming question: Can one continue to argue, via the generalized text, for example, that the use of photographic processes by artists to make art, has much to do with the societal uses of photography, from the early portrait daguerreotype to all of its modern mass-media applications? Recontextualizing the travel photography of Maxime DuCamp or the industrial photography of Baldus, even recognizing the financial return to Kodak in popularizing pictorialism, will not in themselves reformulate the history of photography. Like the deep-cored moments of time presented by art-historians like T. J. Clark and Thomas Crow, these efforts expose the social linkages of artifacts, but do not necessarily rewrite history. Contextualists face not the absence of social facts, but the frustration of so many social facts and the insufficiency of archival work, however punctilious, to form itself into a revisal.

There are many impediments to a radical revising of photography and its history. It is difficult to see how such a history can emerge while so few photohistorians are familar with social and political history, competing historiographies, or the new critical perspectives. Indifference to history, bred by distrust of accepted judgments, the substitution of culture for history, or the replacement of historical inquiry by relentless parody and irony, are unlikely strategies through which to achieve a revision of photography. At the same time, it is difficult to see how a new history will emerge through ersatz Marxism, which threatens to enucleate the promise of social analysis with glib and giddy determinism, while making the study of photography increasingly

remote. The inflation of formalist values and the aestheticizing of photographs are matched in their distortions by mechanistic models of the socio-political matrix in which photography occurs. The multiple causations and autonomous space that Louis Althusser posited for social events and the relatively independent role that Ralph Miliband has deduced in the modern state serve as examples of the sophisticated historical outlook that might correct the over-determined character of some studies of photography and society.

There is no doubt that the Stieglitzian dream of an art photography, reinforced by the notion that all photography is in some way art, has fostered connoisseurship at the expense of social history. But the greater impediment is the conviction, braced by nearly 150 years of repetition, that photography is an anti-elitist, inherently democratic medium. It has proved no more democratic than the word. Similarly, an impediment is also present in the insistence that photography is somehow unique, an unprecedented hybrid of art and science. If in practice, not in theory, photography is a unique medium, that uniqueness must be spelled out, not articulated as a matter of faith, and it must be brought to bear equally on art photography, non-art photography, and mass-media photography. Further, one has to wonder how far any new history of photography can come if it perpetuates the intellectual divorce between photographs and the idea of photography. It is now possible to write about photography without ever viewing a photograph: the semanticization of the image.

Ultimately, all revisionists face the indeterminable question of how they relate to their times. Do paradigm shifts occur by nudging history forward, or only when the nurturing basis has prepared the way for the new view? More than a decade of calling for a new history of photography has not produced the metahistory, which says nothing about the worthiness of the calling. Revisions emerge not so much in good times, but when a belief in societal possibilities runs high. There could never have been a Horkheimer, Marcuse, Fromm, Benjamin, or Adorno without the vigor of the Frankfurt School, and the goal of an alternative society. Even in the era of gene splitting, we cannot make the *zeitgeist* reproduce in captivity. There will be a new history of photography, but right now it seems that we can only predict fragments of the past.

Val Williams

Crowned with Thorns
Creative Camera 1965–1978

(First published in *Creative Camera*, No. 321, April/May 1993)

This essay, written for the twenty-fifth anniversary of Creative Camera magazine, traced, by use of oral history interviews and archive material, the history of *Creative Camera*'s early years. A vital catalyst in the revival of independent art-based photography in Britain, *Creative Camera* was, during these years, a staunch defender of a formalist ethic.

To place *Creative Camera* in the history of post-war British photography it is necessary to go back four years, prior to 1968 when it was founded, to *Camera Owner*. This magazine was effectively the house journal of the camera club world. Even before journalist Bill Jay began his radical term as its editor, in December 1965, it was possible to trace the tremors that were to prepare the ground for metamorphosing *Camera Owner* into *Creative Camera* in 1968.

This process began under the direction of the South African, Jurgen Schadeberg with features such as 'The American with the Flexible Eye', an illustrated interview with documentary photographer John Benton-Harris. He was profiled as a representative of the new-wave of transatlantic photographers about to re-invigorate the medium in the UK.

As editor, Jay transformed *Camera Owner*, as if by stealth, into the undisputed organ of new British art photography. But as an early contributor he accepted the established agenda, seemingly without question. In the early sixties photography was either a hobby or a profession; the notion of an 'art photography' was untenable. By the time Jay took over as editor the stage was set for a dramatic change and this was heralded by the decision to bill *Camera Owner* as 'the first non-technical photo-magazine'. This disavowal of the importance of technique was fundamental as art photography began to assert itself during the late sixties and early seventies. Though other initiatives and other publications were to play strategic roles in reviving photographic consciousness in Britain during these years, it was the restless and exclusive dialectic of *Camera Owner*/*Creative Camera* which set the aesthetic agenda of a decade.

When Bill Jay began transforming *Camera Owner* into the sleek, charismatic conveyor of a new photographic evangelism that would be rechristened *Creative Camera*, he was operating in a vacuum. Britain's own remarkable and innovative photographic history had been lost. Elegant and fragile, the important experimenters of the twenties and thirties, people such as Beaton, Barbara

Key-Seymer and Madame Yevonde, had all but disappeared from cultural memory. By 1966 all that remained of a consciousness of a photographic tradition in Britain were memories of the layouts of such Germanicised mass circulation magazines as *Lilliput* and *Picture Post*. During the late 1950s the sole attempt to place non-commercial photography before an interested public was by Norman Hall's *Photography* magazine. Hall was an aficionado of humanistic reportage and *Photography* contained work from Europe including romantic French street scenes by Robert Doisneau and the laconic, highly-crafted photographs of Cartier-Bresson. In the annual *Photography Year Book* Hall featured work by William Klein, Horst, Imogen Cunningham, Herbert List, Albert Renger-Patzsch, Edward Weston and Berenice Abbott – albeit scattered among a peculiar assemblage of European and American high amateurism as poorly selected single images.

In *Photography* all photographers were judged to be equal and not until the emergence of *Creative Camera*, as a purist reforming force, did the concept of either the 'master photographer' or the 'master work' appear in Britain. A significant corollary existed in the ways in which photography was exhibited and profiled from the mid-fifties to the mid-sixties in Britain. Roger Mayne's Southam Street photographs caused some comment when shown at the ICA in 1956, as did Ida Kar's exhibition at the Whitechapel four years later. The Modfot group (which at one time included the likes of Don McCullin, Bill Jay and Sir George Pollock) also made important attempts to reinstate photography into the mainstream of British culture. Mayne himself had emerged as a curator far in advance of his time. The touring shows which he produced for the Combined Societies (CS) group included work by Barbara Morgan, Minor White and Paul Strand.

Bold as they were, such initiatives lacked confidence and backing; those who pioneered them were defensive, almost paranoiac as they perceived the hostility and indifference to their plans of the English art establishment. Photography, tentative and bruised after the collapse of its pre-war confidence, needed more than the enthusiasm and intelligence of people such as Mayne – it required the backing of a force that considered photography as a true religion, rather than an under-represented art form. Under Bill Jay's editorship, prompted by the uncompromising photojournalist Tony Ray-Jones, *Camera Owner* then later *Creative Camera* had the credentials to become the bible of the new photography. Jay and Ray-Jones, a convert of Alexey Brodovitch's radical workshops in New York, rearranged and rewrote the history of photography in Britain. Their interventions were both dynamic and zealous and seemed to be aimed at winning a place for themselves, and their opinions, in the footnotes of history. In pursuit of this they were instrumental in coining a new syntax. From the beginning *Creative Camera* was a complicated code book, decipherable only to the initiated.

For many photographers and editors *manque*, the Bill Brandt exhibition of 1970 was the crucial spark that lit the torch of new photography in Britain. Organised by John Szarkowski of New York's MoMA, and shipped over to Britain to hang on the brutalist concrete walls of the recently opened Hayward

Gallery, it had acquired the talismanic quality that all things of American origin seemed to have in those days. It was British photography bewitched, re-invigorated, brought back to life by a touch of transatlantic magic. Such ennoblement, the importance of American approval, the emergence of mass-ively influential figures such as Szarkowski, all play a major part in the story of *Creative Camera* at a time when Bill Jay was instrumental in remaking British photography. If the Hayward's Brandt exhibition illuminated, briefly but blindingly, the potential of British photography, then it was *Creative Camera* which went on to explore and constantly justify photography's right to be represented within visual art institutions in Britain.

For a short but significant period, Bill Jay found himself in almost complete control of the photographic agenda in Britain. Like an itinerant preacher, he toured the country bringing the gospel of Modernism to art colleges and camera clubs, constantly emphasising photography's value and vigorously championing this cultural underdog. For some of those who attended those lectures, Jay's was a new and unique voice, prognosticating from a cultural wilderness. As a student in the early seventies at Manchester Polytechnic, Martin Parr remembered Jay as 'generating enormous excitement with a missionary zeal.'

For photographers of Parr's generation, already disillusioned by an archaic, unimaginative system of photographic education, Jay provided not only informa-tion, but the context within which contemporary photography could be assessed. Even more importantly, he gave these young photographers a sense of belonging to a movement. The photographic establishment, as represented by the Royal Photographic Society, the camera clubs and an unenlightened and sluggish education system, had never seemed less relevant. As early as August 1966 Jay had set out *Camera Owner*'s rationale. '*Camera Owner*,' he wrote, 'exists to encourage the good that there is and to improve the bad . . . we will welcome those who see those who reject the stereotyped image and, to use a terribly abused phrase, we welcome the *artist* of the camera whether he is traditionalist or modern – so long as he is good.'

Quoting Alfred Stieglitz, he declared: 'Photography is my passion: the search for truth my obsession.' Passion and obsession were to become the watchwords for *Creative Camera* for more than another decade.

Despite Jay's anguished efforts to win recognition for art photography, there was something immensely appealing about being the underdog; for Jay and his circle in London, photography's marginality held a potent appeal. Photo-graphy had been persecuted, excluded from the art establishment, martyred even. It was something that needed to be saved and redeemed. During the sixties Jay formed an allegiance with David Hurn, a former fashion photo-grapher, who had abandoned glamour for hard-edged photojournalism. Jay, too, had been involved in the glamour business, setting up photo sessions with nude models in rented London studios and selling day tickets to amateur photographers. Emerging from this sixties miasma as new purists, Jay and Hurn, abetted and informed by the apocalyptic vision of Tony Ray-Jones, promul-gated a photographic doctrine which readily encompassed values not associated

with British Neo-Romantic art – with all its overtones of loss, desire and despair – but derived from a puritan, Americanised vision of the 'real' world. The photography which these three propelled towards the pages of *Creative Camera* was one in which form mattered more than feeling, in which even the elegiac, angst-filled photography of Brandt became an exercise in formalist aesthetics. British photography, lost in confusion, poorly represented and spurned by a post-war intelligentsia, was set to be remodelled by a Bohemia of young men who saw themselves as mavericks, apostates, guerrilla fighters, resistance leaders, knowing members of a select, familial elite. There was a euphoric sense of belonging.

For Jay, and those of his coterie, photography became both a cause and a way of transcending the limitations of a messy world handed down to them from a pre-war generation. It was family, brotherhood, a secret place where only those who knew the password could go. Writing of the medium a decade later, Peter Turner (Jay's immediate successor at *Creative Camera*) encapsulated these feelings: 'Great photographs have taken me further and deeper than I could go alone . . . At its most potent, this medium, with all the connotations of absolute verity that we have come to associate with it, can be the means by which we are able to see the unseen.'

By 1967 *Camera Owner* had begun to assume the identity which, looking back, made its successor, *Creative Camera*, such a remarkable and tendentious publication throughout the 1970s and beyond. In a fine modernist gesture, a sign of true allegiance to the ethos of fine printing and black and white, Jay gave *Camera Owner* its first silver cover. Instantly, the magazine assumed the significance of a precious object. In September 1967 *Camera Owner* ran an interview and photo-essay by David Hurn, and a piece on André Kértesz, significantly titled 'A Photographer Rediscovered'. Hurn's elegant documentary scenes of British life, together with Jay's photographic archaeology (evinced by his 'rediscovery' of Kértesz), made this issue a model for the future. The history of photography that Jay was to explore was one of old masters become obscure, a dissertation on the nature of greatness. Even in those days *Camera Owner* tended towards the messianic – an echo, perhaps of the strident tones of such self-styled gurus of photography as Brodovitch and Szarkowski.

By winter 1966 *Camera Owner* was already beginning to shake off its amateur readership (though right till the end of the 1970s *Creative Camera* would continue to be a magazine for practitioners by practitioners) and had begun to run book reviews and interviews which highlighted the aesthetic achievements of individual photographers. Not so much 'how to' do it but 'how it should be done'. Bill Brandt's *Shadow of Light* was reviewed in December, with much emphasis on Brandt's formalism: 'His nudes on the beach are particularly fine – when model merges with pebble, her body becoming a part of the landscape.' The *Camera Owner* Postal Circle was set up, encouraging readers to join 'with a dozen or so companionable friends' to 'learn how to make more creative pictures.' But the preparations for *Camera Owner* becoming *Creative Camera* were arduous. For outside the small London-based circle of initiates stood *Camera Owner*'s established readership, the serious

amateurs whose primary interest was technique. Reader's letters admonished the editor to 'have responsibility to your readers'. One such appealed to him to 'point out to them a serious consequence of shooting with a fisheye, super wide-angle lens. No instruction book will dare tell the truth.'

Discouraging as this may have been for Jay, he continued to pursue a policy of presenting great works by great men to those who agonised over misuse of lenses. An illustrated piece on the war photographer David Douglas Duncan in February 1967 was followed by an examination of the career of the American art photographer Aaron Siskind. Two issues later, in April 1967, the *Camera Owner* Opinion Page carried an attack on photography exhibitions which extolled high technique: 'If you solarise a shot of a cat,' wrote Carl Wildeblood, 'all you succeed in doing, nine times out of 10, is to make the cat look silly.' Weird juxtapositions became common during this period, when *Camera Owner* was torn between being a 'how to' magazine with a penchant for soft porn, and a serious art journal. For example, the July 1967 issue contained not only a thoughtful review of John Szarkowski's *The Photographer's Eye* but a whole page of advertisements for 'adult' books and home movies. In August that year a new title appeared above a cover picture of a Bill Brandt nude: *Creative Camera Owner*. By February 1968 the transition was complete and *Creative Camera* was born. Even now the magazine looks modern. In the confined world of sixties photo publishing it must have been a revelation.

Jay left *Creative Camera* in 1969 after what he calls 'a conflict of opinion' with its founder/publisher Colin Osman, and went on to found the short-lived *Album* magazine. *Album* abandoned *Creative Camera*'s lingering amateurism completely but closed some twelve issues later. Although the story of *Album* is outside the parameters of this essay, its demise represents a minor tragedy in the emergence of the new publishing in British photography. Though Jay brought to it the same fervour as before, funds for the new initiative soon ran out and he was operating once more in a wasteland. In 1970 he accepted an offer to study under Van Deren Coke at the University of New Mexico, and decided to stay in the United States to teach history of photography after graduating. Ironically enough, the man who had been seen as the 'saviour' of British photography had become an exile.

Peter Turner was a student at Chiswick Polytechnic when Bill Jay was battling for change in Doughty Street. His enthusiasm for photography began in his adolescence when he studied Brandt's books in his local library and bought *Photography*. Turner's growing interest in photography ran parallel with a fascination with the burgeoning pop culture of the early sixties.

When Turner joined *Creative Camera* in 1969, the new magazine was already emerging as the house journal of the new British photography. With Turner as the new helmsman, *Creative Camera* soon became a mecca for young British photographers; a portfolio in its pages became a real goal. At the turn of the decade *Creative Camera* was more than a small photo magazine. It was a rallying call, a safe house for independent photography.

Turner, who represented a different generation to Jay, has vivid memories of those early years: 'There were no photography galleries in England then, so

Creative Camera was the only outlet. An endless stream of people with interesting pictures came into the office. The magazine was the centre of things. It was terrific!' Turner's recollections betray the multi-faceted debt that British photophiles, such as himself and Jay, owed to the United States which must have seemed the antithesis of tradition-bound, class-bound post-war Britain. It is a telling fact that the editorship of the tenth-anniversary issue of *Creative Camera* was entrusted to an ex-pat American, Bill Messer. Though still in contact with Jay and Ray-Jones, Turner began to make his own allegiances. He met Gerry Badger, 'an architect working for the GLC', who one day brought to the pokey Doughty Street offices a copy of *American Photographs* by Walker Evans. It was a revelation. Badger, with his trenchant formalist views on photography, would become *Creative Camera*'s major critic, and Turner's close associate for the next two decades. 'What we did,' Turner remembered in an interview of 1990, 'was to take it upon ourselves to re-invent photography.' *Creative Camera* became the nexus around which was formed a new photographic culture directed by a privileged few. 'It was wonderful, we were a group,' recalls Turner. 'Work and socialising were very much intertwined. We were winning a great and glorious fight.'[1]

Interestingly, perhaps inevitably, given the machismo of the sixties art scene, those who gathered around Turner were primarily men in their early twenties who possessed a highly developed sense of youthful masculinity. That older group of photo activists, that included Roger Mayne and Sir George Pollock, was excluded. Turner remembers, 'I was separated from them by a generation gap. Also by arrogance. They seemed irrelevant.' Perhaps women too seemed irrelevant because they never seem to figure in accounts of the times. 'My role, as I saw it,' Turner wrote some years later, 'was to introduce our readers to the most exciting work – historic and contemporary – I could find from anywhere in the world. The list of "firsts" we published reads like a register of twentieth-century photography; at least as it was perceived then.' For Turner and those who gathered around him, the medium of photography was the message.

Whereas Bill Jay had toiled in a cultural desert, Peter Turner soon found himself at the centre of some remarkable new initiatives that would put art photography on the map. Following decades of neglect, the Arts Council of Great Britain, under the direction of Barry Lane, its first Photography Officer, began supporting the exhibition and publishing of photographs. A Photography Committee was set up in the early seventies that allocated funds to support the new initiatives. Another indication of change was the founding of the Photographers' Gallery in 1970, under the Directorship of Sue Davies. Meanwhile the young photographer's group, Co-optic (of which Turner was a leading member) formed to exhibit and produce postcards. Most importantly, British photographers now had access to funding through the ACGB's Bursary Scheme. The finance that British photography so seriously lacked in the 1960s was at last available as the ACGB and other funding bodies made efforts to become more egalitarian and modern. For all its history, photography was perceived as a 'young' medium and youth was fashionable. Even so, *Creative*

Camera nurtured an ambivalent, almost hectoring attitude towards its younger constituency. In an editorial of 1972 Turner wrote pessimistically: 'The number of good photographers under 21 that we know is minute. The number under 25 is painfully small.' Here again was the coded message; no-one defined what 'good' photography was; perhaps it was something one should already know, maybe intuitively. *Creative Camera* was preaching to the converted and conversion, by its very terms of reference, is a mystical process. Unlike other magazines of the era (notably *Camerawork* and *Ten.8*) *Creative Camera* defiantly considered photographic debates about 'issues' to be beyond its parameters. Its position as an unequivocal defender of new Modernism had already been established, first by Jay, then reinforced by Turner. Its momentum relied on passionate rhetoric, a certain sense of wonder, and a potent ethos of hero worship. The puritanism and machismo that Jay and Ray-Jones stamped on it became an enduring feature until the end of the seventies. *Creative Camera* seldom recognised the presence of any other debates surrounding photography except the one concerning formalist aesthetics. Whatever was shown – from Jo Spence to Winogrand, from Ray-Jones to Brian Griffin – became part of a coherent, modernist whole. Inclusion in the magazine was, by the use of some elusive yardstick, to be judged as 'the best'. A photograph was a photograph was a photograph. For all its apparent modernity, *Creative Camera* was traditionalist at heart. It had an old religion as potent as witchcraft.

Creative Camera remained independent for over a decade, thanks to the financial support of publisher and co-editor Colin Osman. Its rise, in the seventies, from house journal of British photography to institution, reflects the upward mobility of photography in British culture in that vital decade, from a rather shabby trade to a bona fide art form. Though there were minor changes in the format of *Creative Camera*, notably the sophistication of Peter Turner's picture editing skills, Bill Jay's sixties model remained virtually intact. *Creative Camera*'s stance was supported by the members of the exceptionally powerful Photography Committee (of which Turner was a highly active member during the seventies) which included Paul Hill, Bill Gaskins and David Hurn, who shared Turner's attachment to 'master' photography. Again, women were noticeable for their absence. Dynamic and evangelical, this group was highly effective in putting British photography firmly on the state funding agenda. Proactive and directorial, rather than responsive, the committee shaped the whole appearance of British independent photography throughout most of that decade. A particular type of anti-intellectualism pervaded both the Photography Committee and *Creative Camera* during those years. Turner, Jay, Hurn (in common with many of those who worked in British photography at the time) were, in many ways, self-made people for whom formal training in the historiography and theory of photography had not been available. They were intoxicated by a sense of having arrived almost out of a sense of destiny.

By the time Peter Turner's first editorship came to an end in 1987, the structure and arrangement of photography in Britain was changing rapidly. An emerging consciousness of women's work and all the questions that such work posed, new theoretical readings of photography by the mass media – all of that

challenged modernist doctrines. When the Photography Committee was dissolved in 1979 a significant power structure was broken.

Writing in the Introduction to the 1988 anthology *Photo Texts*, Peter Turner and Gerry Badger declared themselves 'photographic obsessives'. At the height of Post-Modernism, they delighted in their 'old fashioned' stance, as lovers (at a time when romance was not in vogue) of photography 'as a major means of creative expression, with its own peculiar virtues, problems, characteristics and potentialities.' Photography seen through this piece of writing had become not simply an old friend, but a very intimate relation, a family member. Looking through their written pieces (often excerpted from the pages of *Creative Camera*) they reflected on their power to 'summon up ghosts and demons, fond remembrances of times past.' Looking through the issues of *Creative Camera* which were published during these years, the magazine emerges as a contemporary elegy, a bold tale of adventure and search, with its own cast of heroes, its own demonology, its own paralysing sense of loss and desire. Creating its own myths, writing its own story, *Creative Camera* (and before it late issues of *Camera Owner*) became a classic and enthralling text book of brotherhood, a narrative of obsession and romance.

Susan Sontag

On Photography

(Extracted from *On Photography*, Allen Lane, 1977, pp. 131–8)

On Photography began as a single essay – followed by others – which Sontag wrote for the *New York Review of Books*. The essays have a digressive relation to one another, rather than developing distinct ideas or themes. This extract comes from the book's final section, 'The Image-World'.

Although much praised, at its publication *On Photography* met with a hostile reception in some quarters of the photography world. This is perhaps unsurprising, given the defensive stance of the art photography establishment.

IT CANNOT BE a coincidence that just about the time that photographers stopped discussing whether photography is an art, it was acclaimed as one by the general public and photography entered, in force, into the museum. The museum's naturalization of photography as art is the conclusive victory of the century-long campaign waged by modernist taste on behalf of an

open-ended definition of art, photography offering a much more suitable terrain than painting for this effort. For the line between amateur and professional, primitive and sophisticated is not just harder to draw with photography than it is with painting – it has little meaning. Naïve or commercial or merely utilitarian photography is no different in kind from photography as practiced by the most gifted professionals: there are pictures taken by anonymous amateurs which are just as interesting, as complex formally, as representative of photography's characteristic powers as a Stieglitz or an Evans.

That all the different kinds of photography form one continuous and interdependent tradition is the once startling, now obvious-seeming assumption which underlies contemporary photographic taste and authorizes the indefinite expansion of that taste. To make this assumption only became plausible when photography was taken up by curators and historians and regularly exhibited in museums and art galleries. Photography's career in the museum does not reward any particular style; rather, it presents photography as a collection of simultaneous intentions and styles which, however different, are not perceived as in any way contradictory. But while the operation has been a huge success with the public, the response of photography professionals is mixed. Even as they welcome photography's new legitimacy, many of them feel threatened when the most ambitious images are discussed in direct continuity with *all* sorts of images, from photojournalism to scientific photography to family snapshots – charging that this reduces photography to something trivial, vulgar, a mere craft.

The real problem with bringing functional photographs, photographs taken for a practical purpose, on commercial assignment, or as souvenirs, into the mainstream of photographic achievement is not that it demeans photography, considered as a fine art, but that the procedure contradicts the nature of most photographs. In most uses of the camera, the photograph's naïve or descriptive function is paramount. But when viewed in their new context, the museum or gallery, photographs cease to be 'about' their subjects in the same direct or primary way; they become studies in the possibilities of photography. Photography's adoption by the museum makes photography itself seem problematic, in the way experienced only by a small number of self-conscious photographers whose work consists precisely in questioning the camera's ability to grasp reality. The eclectic museum collections reinforce the arbitrariness, the subjectivity of all photographs, including the most straightforwardly descriptive ones.

Putting on shows of photographs has become as featured a museum activity as mounting shows of individual painters. But a photographer is not like a painter, the role of the photographer being recessive in much of serious picture-taking and virtually irrelevant in all the ordinary uses. So far as we care about the subject photographed, we expect the photographer to be an extremely discreet presence. Thus, the very success of photojournalism lies in the difficulty of distinguishing one superior photographer's work from another's, except insofar as he or she has monopolized a particular subject. These photographs have their power as images (or copies) of the world, not of an individual artist's consciousness. And in the vast majority of photographs which get

taken – for scientific and industrial purposes, by the press, by the military and the police, by families – any trace of the personal vision of whoever is behind the camera interferes with the primary demand on the photograph: that it record, diagnose, inform.

It makes sense that a painting is signed but a photograph is not (or it seems bad taste if it is). The very nature of photography implies an equivocal relation to the photographer as *auteur*; and the bigger and more varied the work done by a talented photographer, the more it seems to acquire a kind of corporate rather than individual authorship. Many of the published photographs by photography's greatest names seem like work that could have been done by another gifted professional of their period. It requires a formal conceit (like Todd Walker's solarized photographs or Duane Michals's narrative-sequence photographs) or a thematic obsession (like Eakins with the male nude or Laughlin with the Old South) to make work easily recognizable. For photographers who don't so limit themselves, their body of work does not have the same integrity as does comparably varied work in other art forms. Even in those careers with the sharpest breaks of period and style – think of Picasso, of Stravinsky – one can perceive the unity of concerns that transcends these breaks and can (retrospectively) see the inner relation of one period to another. Knowing the whole body of work, one can see how the same composer could have written *Le Sacre du printemps*, the Dumbarton Oaks Concerto, and the late neo-Schoenbergian works; one recognizes Stravinsky's hand in all these compositions. But there is no internal evidence for identifying as the work of a single photographer (indeed, one of the most interesting and original of photographers) those studies of human and animal motion, the documents brought back from photo-expeditions in Central America, the government-sponsored camera surveys of Alaska and Yosemite, and the 'Clouds' and 'Trees' series. Even after knowing they were all taken by Muybridge, one still can't relate these series of pictures to each other (though each series has a coherent, recognizable style), any more than one could infer the way Atget photographed trees from the way he photographed Paris shop windows, or connect Roman Vishniac's pre-war portraits of Polish Jews with the scientific microphotographs he has been taking since 1945. In photography the subject matter always pushes through, with different subjects creating unbridgeable gaps between one period and another of a large body of work, confounding signature.

Indeed, the very presence of a coherent photographic style – think of the white backgrounds and flat lighting of Avedon's portraits, of the distinctive grisaille of Atget's Paris street studies – seems to imply unified material. And subject matter seems to have the largest part in shaping a viewer's preferences. Even when photographs are isolated from the practical context in which they may originally have been taken, and looked at as works of art, to prefer one photograph to another seldom means only that the photograph is judged to be superior formally; it almost always means – as in more casual kinds of looking – that the viewer prefers that kind of mood, or respects that intention, or is intrigued by (or feels nostalgic about) that subject. The formalist approaches to photography cannot account for the power of *what* has been photographed, and

the way distance in time and cultural distance from the photograph increase our interest.

Still, it seems logical that contemporary photographic taste has taken a largely formalist direction. Although the natural or naïve status of subject matter in photography is more secure than in any other representational art, the very plurality of situations in which photographs are looked at complicates and eventually weakens the primacy of subject matter. The conflict of interest between objectivity and subjectivity, between demonstration and supposition, is unresolvable. While the authority of a photograph will always depend on the relation to a subject (that it is a photograph *of* something), all claims on behalf of photography as art must emphasize the subjectivity of seeing. There is an equivocation at the heart of all aesthetic evaluations of photographs; and this explains the chronic defensiveness and extreme mutability of photographic taste.

For a brief time — say, from Stieglitz through the reign of Weston — it appeared that a solid point of view had been erected with which to evaluate photographs: impeccable lighting, skill of composition, clarity of subject, precision of focus, perfection of print quality. But this position, generally thought of as Westonian — essentially technical criteria for what makes a photograph good — is now bankrupt. (Weston's deprecating appraisal of the great Atget as 'not a fine technician' shows its limitations.) What position has replaced Weston's? A much more inclusive one, with criteria which shift the center of judgment from the individual photograph, considered as an example of 'photographic seeing.' What is meant by photographic seeing would hardly exclude Weston's work but it would also include a large number of anonymous, unposed, crudely lit, asymmetrically composed photographs formerly dismissed for their lack of composition. The new position aims to liberate photography, as art, from the oppressive standards of technical perfection; to liberate photography from beauty, too. It opens up the possibility of a global taste, in which no subject (or absence of subject), no technique (or absence of technique) disqualifies a photograph.

While in principle all subjects are worthy pretexts for exercising the photographic way of seeing, the convention has arisen that photographic seeing is clearest in offbeat or trivial subject matter. Subjects are chosen because they are boring or banal. Because we are indifferent to them, they best show up the ability of the camera to 'see.' When Irving Penn, known for his handsome photographs of celebrities and food for fashion magazines and ad agencies, was given a show at the Museum of Modern Art in 1975, it was for a series of close-ups of cigarette butts. 'One might guess,' commented the director of the museum's Department of Photography, John Szarkowski, 'that [Penn] has only rarely enjoyed more than a cursory interest in the nominal subjects of his pictures.' Writing about another photographer, Szarkowski commends what can 'be coaxed from subject matter' that is 'profoundly banal.' Photography's adoption by the museum is now firmly associated with those important modernist conceits: the 'nominal subject' and the 'profoundly banal.' But this approach not only diminishes the importance of subject matter; it also loosens

the photograph from its connection with a single photographer. The photographic way of seeing is far from exhaustively illustrated by the many one-photographer shows and retrospectives that museums now put on. To be legitimate as an art, photography must cultivate the notion of the photographer as *auteur* and of all photographs taken by the same photographer as constituting a body of work. These notions are easier to apply to some photographers than to others. They seem more applicable to, say, Man Ray, whose style and purposes straddle photographic and painterly norms, than to Steichen, whose work includes abstractions, portraits, ads for consumer goods, fashion photographs, and aerial reconnaissance photographs (taken during his military career in both world wars). But the meanings that a photograph acquires when seen as part of an individual body of work are not particularly to the point when the criterion is photographic seeing. Rather, such an approach must necessarily favor the new meanings that any one picture acquires when juxtaposed – in ideal anthologies, either on museum walls or in books – with the work of other photographers.

Such anthologies are meant to educate taste about photography in general; to teach a form of seeing which makes all subjects equivalent. When Szarkowski describes gas stations, empty living rooms, and other bleak subjects as 'patterns of random facts in the service of [the photographer's] imagination,' what he really means is that these subjects are ideal for the camera. The ostensibly formalist, neutral criteria of photographic seeing are in fact powerfully judgmental about subjects and about styles. The revaluation of naïve or casual nineteenth-century photographs, particularly those which were taken as humble records, is partly due to their sharp-focus style – a pedagogic corrective to the 'pictorial' soft focus which, from Cameron to Stieglitz, was associated with photography's claim to be an art. Yet the standards of photographic seeing do not imply an unalterable commitment to sharp focus. Whenever serious photography is felt to have been purged of outmoded relations to art and to prettiness, it could just as well accommodate a taste for pictorial photography, for abstraction, for noble subjects rather than cigarette butts and gas stations and turned backs.

ON
PHOTOGRAPHERS

Catherine Lord

What Becomes a Legend Most: The Short, Sad Career of Diane Arbus

(First published in *Exposure* 23.3, Fall 1985. Reprinted from *The Contest of Meaning*, Ed. Richard Bolton, MIT Press, 1989 & 1992, pp. 111–23)

The life and work of American documentary photographer Diane Arbus (1923–71) has become, since her death by suicide, a focus for intense speculation and objectification in both the specialist press and in the wider media. Catherine Lord's essay, which looks back on a number of attempts to define Arbus's career by a variety of curators and editors, examines the voyeurism of biographers and the curatorial urge to constantly remodel and refashion the photographic archive.

Meanwhile, please get me permissions, both posh and sordid . . . The more the merrier. We can't tell in advance where the most will be. I can only get photographs by photographing. I will go anywhere.[1]

<div align="right">Diane Arbus to Esquire, 1959</div>

IF HISTORY weighs like a nightmare on the brains of the living, it's only natural that the living try to shake off sleep altogether. Or so I explain what a young photographer told me, not very long ago, about his work – large color pictures of the inhabitants of one of Southern California's rural ghettos. His photographs, in my reading, were resolutely beautiful, obsessively formalistic, and, despite the titillated inclusion of those physical and psychological problems which the poor cannot afford to conceal, uninformative.

Which I said, awkwardly, confusing diplomacy with verbiage.

'Well,' he retorted, 'other people want to know what a white middle-class kid like me is doing ripping off his subjects.'

'What do you tell them?' I asked.

'I photograph them *because* they're weird. They're not like me. And if you're thinking that I'm as bad as Diane Arbus, I'm not. She fucked people like that. I don't.'

I laughed – as much at the effort to combat guilt with photo history as at finding myself conned into the moral indulgences racket. Still, the photographer's remark stayed with me, a symptom of the dilemmas of documentary photography as well as an omen of the current state of Arbus lore, of the nightmare that weighs upon the brains of those for whom the 1960s, the decade when Arbus made the photographs that made her a legend, are for all practical

purposes the property of a dead generation. Guilt in search of a pedigree causes ideological hairsplitting; nightmares, Marx might also have mentioned, recur.

This particular nightmare is of a woman turned into a legend that won't turn back into history. And therefore one has to ask what the history is, and why the woman could become a legend. What was made of Diane Arbus? What is her legacy? What does she mean, this woman whom every photographer knows with the passion of fascination, or denunciation, or both at once, this woman who can be incorporated into such extraordinary rationalization, this woman said to have 'redefine[d] both the normal and abnormal in our lives,' to have changed 'the character of photography,' to have 'altered the terms of the art she practiced,' to be 'blessed with . . . the essential skill of an original artist'? [2] What does she *mean*, a photographer who has become enough of a legend in nonspecialist households that her most famous photographs can sell in soft-sculpture versions on the Christmas market, that she herself might become the subject not just of an off-Broadway play, but of an MGM feature film, starring perhaps Diane Keaton, perhaps even Barbra Streisand?

Someone told me a story about an inveterate liar and I didn't know whether to believe it. It's the same with what I am about to tell you. Above all, I do not want to make you cry.[3]

Diane Arbus, 1966

Woman then stands in patriarchal culture as a signifier for the male other, bound by a symbolic order in which man can live out his phantasies and obsessions through linguistic command by imposing them on the silent image of woman still tied to her place as bearer of meaning, not maker of meaning.[4]

Laura Mulvey, 1975

The neutral outline, the biography of the woman and the artist, is easily enough traced. Diane Arbus was born in 1923 in New York City. Her father, David Nemerov, was the son of Jewish immigrants from Kiev; he would eventually own Russek's Fifth Avenue, the rather flashy fur and women's clothing store founded by his father-in-law. Arbus's childhood surroundings were affluent – large apartments on Park Avenue and Central Park West, trimmed with such requisites as servants, governesses, and summer camps. Arbus later called the scene 'nouveau.' She received an excellent formal education at the progressive Ethical Culture and Fieldston schools, as did her older brother, the poet Howard Nemerov, and her younger sister, René Sparkia, a sculptor of decorative plastic-topped tables, among other things. Arbus graduated from Fieldston in 1940, but chose not to attend college.[5]

In 1941 she married Allan Arbus; she was eighteen, he was twenty-three. They had met when she was thirteen and he was a pasteup boy in Russek's advertising department. It had been a romance of which the Nemerovs did not

at first approve. The Arbuses would have two daughters – Doon, born in 1945, and Amy, born in 1954. In 1946, after Allan had been discharged from the army, where he received photographic training, the Arbuses began to work together in fashion photography. They started with Russek's account, the moral support of David Nemerov, and perhaps some financial backing from the Arbus family.[6] Diane Arbus conceived the approach to be taken in the photographs; Allan Arbus did the actual shooting. At first, they lived by a sort of monetary brinksmanship, but gradually they became more successful, and their work appeared in magazines such as *Seventeen, Glamour,* and *Vogue.*

Diane Arbus, who had been photographing outside the fashion business since at least 1943, grew to hate the studio routine. She quit in 1956, after bursting into tears when a dinner guest asked her to describe her day. She went to study with Alexey Brodovitch, art director of *Harper's Bazaar,* but detested his workshops. Then, in 1957, she began two years of study with the photographer Lisette Model. It proved a turning point, as well as the beginning of an intense friendship. By 1959 Arbus was taking her work to magazine editors. Between the summer of 1959 and 1960, she moved, with her two daughters, to a separate apartment; the Arbuses remained friends and divorced in 1969.[7]

In 1960 the first Arbus portfolio appeared in print: *Esquire* published six photographs, with an accompanying text, intended to reveal the extremes of New York life. Arbus was thirty-seven. In 1961 five 'eccentrics' appeared in *Harper's Bazaar,* again with a short Arbus text.[8] Arbus received Guggenheim fellowships in 1963 and 1966. A few of her photographs of 'American rites, manners, and customs,' as she described her Guggenheim project, were exhibited at the Philadelphia College of Art in 1966, along with those of other Guggenheim photography fellows from the years 1937 to 1965.[9] Arbus had first shown her work to John Szarkowski, director of the photography department at New York's Museum of Modern Art, in 1962. Though he included three of her pictures in his *Recent Acquisitions* for 1965, her big break came in 1967, when Szarkowski included thirty-two of her portraits in *New Documents.* Lee Friedlander and Garry Winogrand were also included in the exhibition, but Arbus received a room of her own and most of the attention – from the *New York Times* to *Newsweek.* The latter tabbed her as a photographer of 'the margins of society' and quoted a remark of hers that would become part of the lore: 'Freaks were born with their trauma. They've already passed it. They're aristocrats.'[10] In 1967 she also exhibited at the Fogg Museum, in Cambridge, Massachusetts.

That is the extent of Arbus's public career as an artist during her lifetime. Between 1967 and July 1971, when she committed suicide at the age of forty-eight, she neither exhibited her photographs nor published more of what might be called her personal work, though her magazine assignments continued to appear.

In July 1972 Walter Hopps included Arbus in the Venice Biennale, making her the first American photographer ever to be represented there. In October 1972 Doon Arbus published a short tribute to her mother in *Ms.* magazine.[11] Whatever Doon's good intentions in rendering such an homage, the *Ms.* text

added fuel to the legend. It also provided advance publicity for the MoMA retrospective which would open that November and for the accompanying Aperture monograph, edited by Doon and Marvin Israel, former art director of *Harper's Bazaar* and a close friend of Diane Arbus. The text in the monograph consisted of Arbus's own words, drawn from a highly edited version of a master class she taught at Westbeth in 1971, with a few inserts from a 1969 interview with Studs Terkel.[12]

More than a quarter of a million people saw the Arbus retrospective – *before* it left MoMA to tour the United States, Canada, Japan, Australia, and New Zealand, from whence it returned in 1979, having been installed in a total of forty-three museums and galleries. The monograph has sold over a hundred thousand copies and is now in its tenth edition; the retrospective was discussed everywhere, with varying degrees of acumen and information.[13]

In 1974 Marvin Israel published a one-page homage to Arbus that added the memories of another intimate to the legend. By the following year, critical attention had begun to subside in volume. In 1975, then, for all practical purposes, the cult was running on highly edited evidence: the tributes by Doon Arbus and Marvin Israel, the 112 prints shown in the MoMA retrospective, of which 39 were printed posthumously, and, for the real addicts, those early *Esquire* and *Harper's* portfolios.[14]

In 1977 the Helios Gallery in New York mounted a show of 108 Arbus photographs. Most were the classics from the MoMA retrospective; on public view for the first time, however, were many early photographs: smaller 35 mm. images that had preceded the trademark 2 1/4 inch negatives enlarged to 16 by 20 inches; a Coney Island series from 1958–60; a series on female impersonators from 1962; and photographs of a Southern country doctor and his patients commissioned by *Esquire* in 1968. In 1980 *Picture Magazine* devoted an entire issue to seventeen Arbus photographs, which the editors claimed, inaccurately, had hitherto been unpublished. The issue coincided with exhibitions at the Robert Miller Gallery, New York, and the Fraenkel Gallery, San Francisco. No text whatsoever accompanied the photographs, a renunciation of critical pretensions which the editors explained away as gracefully as possible: 'Since PICTURE is primarily concerned with the photographic image and the fidelity of its reproduction, we have acceded to the preference of the Estate of Diane Arbus that this monograph be published without accompanying text.'[15]

In 1984 appeared two large, if not major in the ideal sense of the term, books on Arbus. Patricia Bosworth's *Diane Arbus* is the unauthorized biography. *Diane Arbus: Magazine Work*, edited by Doon Arbus and Marvin Israel, with text by Thomas Southall, is a sanctioned version of one aspect of Arbus's career. (I should say here that Thomas Southall, in his acknowledgments, generously thanks me for my help, which consisted of discussing with him the existence of correspondence between Arbus and Peter Crookston.) Southall's book serves as the catalogue for an exhibition of ninety-two prints which will travel to fourteen cities in the United States. The Arbus legend still holds sway: the catalogue had to be reprinted, due to popular demand, even in its prepublication stage.[16]

Clearly, it's difficult to preserve an entirely objective tone, and I haven't explained what all the fuss is about, much less what Diane Arbus might *mean*.

> I think I have a slight corner on something about the quality of things. It's very subtle, and I don't know if it's world shaking, but it's just I guess I've always had a terrific conceit, and one of my conceits is that when I was young I used to think that I was kind of . . . not a lodestone exactly . . . more like that I was the perfect temperature, the perfect thermometer for the times.[17]
>
> Diane Arbus, 1969

> The preoccupation with the individual artist is symptomatic of the work accomplished in art history – the production of an artistic subject for works of art. The subject constructed from the art work is then posited as the exclusive source of meaning – i.e., of 'art', and the effect of this is to remove 'art' from historical or textual analysis by representing it solely as the 'expression' of the creative personality of the artist. Art is therefore neither public, social, nor a product of work. Art and the artist become reflexive, mystically bound into an unbreakable circuit which produces the artist as the subject of the art work and the art work as the means of contemplative access to that subject's 'transcendent' and creative subjectivity.[18]
>
> Griselda Pollock, 1980

Patricia Bosworth is as convenient an entry point as any. Having previously 'done' Montgomery Clift, she is now cashing in on another haunted soul. She covers not even everything I have summarized thus far, at much greater length. Aurelia Plath could have produced this biography, had she not found another calling: it is a dreadful book – badly written, sloppily edited, interminable. Bosworth had no inkling of the rationale for documented sources, no ideas about biography, no discernible notion of why anyone might want to read a biography of an artist, nothing but a nodding acquaintance with the history of photography, and no grasp of historiography, which is, after all, the basic issue here. Five years of interviews have spawned this breathless accretion of facts, laced with so many dubious facts, or pointless facts, that even the verifiable facts, to say nothing of the important facts, become tarnished. Unfortunately, so few 'facts' on Arbus have been released – the photographs having been left to speak for themselves (which photographs are celebrated for doing badly) – that this book will doubtless sate the appetite of the curious and the careless.

As I said, it is difficult to remain neutral, but then my objective is history, not neutrality, and they are not to be confused. A coward about nightmares, I dissect the Bosworth book to reveal hagiography gone berserk.

Leaving aside the more complicated issues of methodology, Bosworth's job as a biographer was to inform herself, as broadly as possible, about Diane

Arbus's life, working environment, and family background. She did not suc-
ceed, although this was not entirely her fault. She seems to have read some but
not all of the printed material on Arbus; one can't really tell, for the book has
no bibliography.[19] She interviewed or corresponded with, she says, about two
hundred people, but she had little help from Lisette Model and none at all from
Allan, Doon and Amy Arbus, Richard Avedon, and Marvin Israel.[20] Since these
individuals were of pivotal importance in Arbus's adult life, it is not surprising
that the sections on her childhood are more reliable. Bosworth did have the
cooperation of Gertrude and Howard Nemerov, Renée Sparkia, and a few key
teachers at the Fieldston School.

But more reliable is not *reliable*. Bosworth's internal model of narrative
prose, I suspect, is something like the gothic novel – an amalgam of description,
dates, and dialogue that moves the hypnotized consumer down the path of
vicarious pleasure to a formulaic climax. Should there be a lull in the action
(due to a paucity of character motivation, or the need to plod through
establishing data before getting back to twists in the romance), why, writers
have their secrets: ladling on the adjectives, injecting psychological asides to
win sympathy for boring but necessary personages, creating small moments of
pseudo-suspence, even just skipping the dreary dates. That's the formula.
Arbus's life, and art appreciation at its most syrupy, fit it perfectly.

Bosworth apparently thinks, or was told, or convinced her editors, that in
the interests of eliminating pedantry from a book aimed at a 'general' audience,
she need only reveal the source of material framed by quotation marks. This
'rule' lets her get away with a lot, for she can indulge herself in description
while picking and choosing dialogue (the only thing, after all, which ever
appears between quotation marks in the conventional novel).

Thus, selecting two early pages (12–13) at random, we learn, directly from
Howard Nemerov, that David Nemerov was 'power-using,' that Howard and
Diane felt 'protected, privileged,' that they sometimes had physical fights, that
Howard had no theories 'as to how or why we became what we became.' We
learn directly from Diane Arbus that she thought her father was 'something of
a phony.' These are the hard facts. We also learn, in quotes, from an unnamed,
uncited 'Nemerov cousin' (all rules, even nonrules, are made to be broken) that
'Howard doted on Diane' and that she was 'gorgeously intuitive,' while he was
'intellectual.' We learn, in quotations, from an unnamed, uncited Russek's
'buyer' that 'If you got in David Nemerov's way, he'd walk all over you.' We
learn, not in quotes, but from the loquacious narrator, that David Nemerov
could be both 'charming' and 'brutal,' that Howard and Diane were insepar-
able, that they ate in silence, that Diane was once frightened by a French goat,
that Howard and Diane were 'obedient, well-behaved little children,' that they
hated being compared, that Diane's motto, which she read on a nickel and said
every night at bedtime, was 'In God We Trust,' and that Howard was 'strong
and quiet and so handsome she liked to just look into his face.'

Disregarding entirely the notion of *significant* facts (a goat? – even a *French*
goat . . .), Bosworth has managed to sneak in some heady stuff. The informa-
tion directly attributable to Arbus and her brother conveys only their feeling

of having been privileged children, a certain ambivalence toward their father, and Howard's reluctance to theorize about the past (or more likely, considering Nemerov's work, his distaste for facile explanation). The undocumented information, the information attributable by default to the imaginative faculties of Patricia Bosworth, conveys paternal 'brutality' and a doting brother-sister couple who manifest the perfect male/female division of roles – even, in the sister's mooning, a certain physical attraction.

This is highly suggestive material, introduced by innuendo. It is the staple of Bosworth's technique, and though I have neither the space nor the stamina to analyze the entire book in such detail, I would like to outline certain problematic issues which arise from Bosworth's amateur psychologizing. Inscribed in the compilation of minutiae which constitutes this biography (the number of cats Robert Frank had, Lisette Model's lifelong devotion to her husband, Howard Nemerov's opinion of Hamilton College, Allan Arbus's knack for finding affordable Manhattan housing, Diane Arbus's penchant for ratty fur coats and *Jules et Jim* . . .) are notions of women, art, and history which should not be left unremarked. I am making these notions explicit precisely because Bosworth is *not* the only photographic commentator who abides by them. She is a grossly irresponsible writer, but the ideas she carries to excess infect most versions of photographic history, and certainly, most interpretations of Arbus's work.

There is, to start with, the character constructed to explain how the Diane Arbus who began as the coddled daughter of *nouveau riche* Jewish parents ended as the Diane Arbus who followed transvestites home to seedy hotels and frequented nudist camps in New Jersey. Bosworth's solution has the elegance of tradition: blame the woman.

The problems were there all along. Not only did the teenage Arbus dote upon her brother, she also fantasized about committing incest with her father (p. 27; Bosworth does not reveal how she divined Arbus's desires) and wore her future husband's underwear, or so Bosworth says 'the salesladies' at Russek's informed her (p. 38). ('The salesladies' remain anonymous; did Bosworth really track down more than one?) Bosworth soon observes that Arbus did not shave her legs and that, in rebellion 'against her parents' preoccupations with cleanliness . . . [she] chose to wear no deodorant' (p. 39; no source is given for this data on the artist's grooming habits). Moving up to the early married years, we learn not merely about an early affair Arbus fell into and the high frequency of the Arbuses' lovemaking (p. 98; a friend's memory of something Diane Arbus had said), but that among Diane Arbus's 'dark and perverse' sexual fantasies was rape (p. 94; just something Arbus once confided to another friend, unnamed this time). We learn (p. 102) that it may not after all be true that Doon was conceived on the sand dunes of East Hampton. (Why bring it up then? A little extra *frisson*? A weakness for bad puns?) Shortly before the birth of the Arbuses' second child, we learn (p. 106) that Arbus 'particularly enjoyed menstruating – when her womb cramped up, when warm, wet blood coursed between her thighs.' (A source for this revelation? Why bother to ask?)

We are then told about Arbus's grief when her husband fell in love with

another woman (p. 153; attributed to a friend who prefers to use a pseudonym), and it is suggested that 'a succession of very attractive women' seemed at home in the Arbus studio (p. 175; a neighbor's recollection). The story thus moves naturally, the forces of retribution having been deployed – after all, it was Diane Arbus who had first been unfaithful – to her haunting the subway at all hours, cultivating a 'palpable' erotic rapport with a Mexican dwarf (p. 193; Bosworth's interpretation of the well-known photograph of said), acting out her bisexuality (p. 205; the hypothesis of the filmmaker Emile de Antonio, who felt uncomfortable accompanying Arbus and two other women to the movies), concluding that one-night stands were 'terrific sex' (p. 206; no source), and taking pleasure in her increasingly 'aggressive' sexuality (ibid.). The saga is interspersed with chatty anecdotes about Arbus's dalliances, sexual and other-wise, with her various subjects.

In sum, Diane Arbus was weird. She may have started out as a nice Jewish girl, but it obviously takes more than family. Women, or rather this construc-tion, 'Diane Arbus,' can only go so far in the quest for meaningful lives. Otherwise they end up demonstrating that they are, as it has always been said, whores. Or creatures of insatiable sexual appetites. Beings who cannot tran-scend the physical. Freaks.

This raises the second problematic motif in Bosworth's book: class. Because if Arbus had been just an ordinary female freak who cleaned houses, say, for a living, the story wouldn't have the same charm. Arbus was brought up to know better. Whatever her actual financial situation as an adult, therefore, she could somehow always have *afforded* to know better. From this derives a useful dramatic tension, especially in the bookselling trade: the really interesting freaks, Arbus's famous pronouncement to the contrary, aren't born with their trauma – *they create it.*

Again, this is a subtext inscribed (or, more accurately, interred) in the accretion of detail: the furs and the chauffeurs and the governesses and the piano lessons and the trips to Europe and the dancing classes and the white gloves and the psychoanalysts and the smoking jackets and the dinners and the 'baroque' furniture meticulously recounted. In general, price tags are the only thing missing, though Bosworth tosses them in whenever she can.[21] It doesn't really matter. Whatever the total, it signifies money. And money, *nouveau* though it be, fascinates Bosworth. She would probably have been happier had the Nemerovs been Guggenheims, but sometimes one has to make do. Thus, even after business mistakes and the Great Depression had cost David Nemerov a considerable sum, Bosworth never fails to lavish attention on the objects with which he chose to reduce his remaining capital (e.g., a Palm Beach residence). When the budget won't stretch far enough, she simply flashes back to the good old days.

But money propels the story in contradictory ways. On the one hand, it lends color, a sort of romantic cachet, as if, this being America, high income demonstrated a spiritual predisposition to the exceptional. On the other hand, those very same dollars are used to prove an *arriviste* vulgarity, the egregious conflation of money with social rank that induces the purchase of a Rodin

ashtray, crimson carpets, or reproduction of French antiques. The important thing, however, is that to Diane Arbus thereby accrue the benefits of both a white-gloves-and-governesses nature and the rejection of conspicuous-consumption nurture. One or the other of the dual impulses can be invoked when convenient, particularly since the sage operates without the benefit of an analytical framework incorporating the notion of class. ('Classy,' an adjective which attaches itself with some frequency to David Nemerov, is not the same thing.)

Beyond the level of anecdote and a few paragraphs of cultural history, Bosworth ignores the economic, social, and political milieu of the Eastern European and Russian Jews who arrived in New York shortly before the turn of the century and there rose to wealth. In Bosworth's history, that class is demoted to a tribe: the Nemerovs, Arbus's Fieldston schoolmates, Richard Avedon, and Marvin Israel are virtually the only members, and their folklore is used to reinforce the preestablished struggle between the romantic and the vulgar. This set-up allows Bosworth to take the best of both possible worlds and win a quick shortcut to real class. It works like this. Though Arbus, in crude financial terms, was downwardly mobile, her transcendence of the 'humiliatingly gross kingdom'[22] she inherited meant a corresponding upward mobility of the mind – a return, if you will, to the spiritual *function* of white-gloves-and-governesses breeding. Arbus rebelled against money to become an aristocrat.

And that, in turn, would not be particularly interesting (who, really, gives a damn about impoverished nobility?) unless it meshed so perfectly with the rehashed romanticism that determines the notion of an artist to which Bosworth subscribes. In brief, great art exudes directly from the lonely souls of those endowed with a unique vision. By definition and from birth, this type of soul is cursed to the exact degree it is blessed. It's a simple exchange-value formula: if this type of soul didn't cater to society's instruction, edification, delight, and occasional enrichment, society would deem it pathological, or, if the soul wasn't lucky enough to be born into at least the middle class, ignore it. Omitted from this schema are several crucial elements: the circumstances which enable the production of art, the production of art as a form of work, and the artist as a social being.

Bosworth, in her breathless fashion, takes the romantic construction of the artist well past the point of absurdity: true aristocrats of the spirit (read 'artists') must die. Adopting the strategy of classical hagiography, Bosworth goes back as far as she can to find, or invent, miracles. Always, Arbus had 'longed to scrutinize the perverse, the alienated, the extreme' (p. 130; no source). When she was a toddler, she identified herself with the underdog, the outsider, seeing 'herself in [small children] – isolated creatures, secretly raging' (p. 15; no source). When she encountered derelicts as a teenager, she identified 'with these strange, sad people's isolation – their aloneness' (p. 30; no source). Concomitantly, she had long wanted to be a 'great sad artist' (p. 51; an unfinished autobiography).

The parade of relatives, friends, acquaintances, and bystanders who serve afterwards to mirror the glare of genius reinforce the theme of Arbus's

attraction to extremes, invariably remarking on her talent, brilliance, vision, and genius. Some go so far as to say she was a goddess. The spiritual virtues, laboriously compiled, overwhelm; the end, presumably the price of wanting so much, is foreshadowed with an equally heavy hand. Alexey Brodovitch admonishes Arbus that the period of creativity seldom lasts more than eight years (p. 123). A lover recalls, with emotion, that one afternoon in bed he saw Arbus's face turn into a death's-head (p. 95). Finally, we are told, in 'terror over her increasing responsibilities' and 'to perfect her art,' Arbus cut herself off from friends and admirers (p. 311). She was 'lonely, she was alone – and she would fall into despair' (p. 312). The suicide follows shortly, along with the – well, 'vulgar' is the accurate word – report of a rumor that Arbus photographed herself dying.

The nominal point of this soap opera, difficult as it may be to remember, is the elucidation of an artist's career. In fact, however, the only contexts beyond the personal provided for Arbus's descent into doom are silly accounts of the New York art world and photographic history. In the former, to paraphrase one of Bosworth's more detailed renditions (p. 145), assorted abstract expressionists dance all night and play the bongos to illustrate artistic vitality and good cheer in the 1950s. In the latter, Bosworth's ignorance of photographic history is perhaps best demonstrated by quoting in its entirety the only passage which might be said to represent her theoretical overview (pp. 123–24):

> Now that she was freer, Diane began a study of photography back to the world's first photograph: by Joseph Niepce, a view from the window of his blurred French garden circa 1826. [Were nineteenth-century gardens blurry, or was that the impressionists?] In time Diane would become familiar with the dreamy nineteenth-century portraiture of Julia Cameron, with Mathew Brady's documentation of Civil War battlefields. She would read about Paul Strand's switch from pictorialism to Cubist-inspired photographs in the 1920s; she would study Lewis Hine's powerful pictures of children working in coal mines. Hine's bleak images would impress her more than Stieglitz's gorgeous cloud formations. Stieglitz believed that photographs could be metaphorical equivalents of deep feelings. He also believed that the fine print, the excellently made photograph, was the criterion of a good photograph. Diane did not believe that. Which is why she responded to the work of her contemporaries Louis Faurer and Robert Frank, who were experimenting with outrageous cropping and out-of-focus imagery. But Diane was even more impressed by Lisette Model's studies of grotesques, especially the grotesques of poverty and old age which she documented with almost clinical detachment.

When needed later to liven up the facts, some of these same luminaries, joined by Weegee and Avedon, make cameo appearances and quick exits. They personalize the sort of history in which Arbus flirts with the decisive moment and then converts to the more 'real' snapshot aesthetic, works in her darkroom with 'trays holding strange-smelling chemical solutions' (p. 67), and makes 'lovely still-lifes' (p. 120), or pictures which are metaphors for 'the emptiness and pretension of her past (p. 198).

One could go on and on about Bosworth's ignorance[23] and her predilection for morbid smut. The point, however, is that the book is a closed circle. Bosworth's lack of training in either photography or conventonal art history simply makes blatant the usual tautologies of the monograph *genre*: the life generates significance for the art, which is in turn referred back to the life. Unconstrained by academic etiquette, Bosworth takes the usual interpretation of Diane Arbus to its logical extremes. The photographs are 'explained' by constructing Arbus herself as a freak, and their power, from which derives their value as art, is legitimated by her suicide.

Compared to this, *Diane Arbus: Magazine Work* is a relief, unmarred by adjectival hyperbole or so much as a hint of sensationalism. Quite the contrary, it is introduced by what can best be described as an apology for the sensation caused by the 1972 Aperture monograph. According to the editors, Doon Arbus and Marvin Israel, the monograph, 'as a depiction of [Arbus's] career, for which it has since been held accountable, is misleading.' Thus another monograph, a scholarly one this time, intended to combat the exaltation of the Arbus oeuvre as mysterious, inexplicable, introduced into the world, like Athena, fully formed. *Magazine Work*, we are told in the editor's introduction, 'is about work as a process rather than a series of isolated achievements and about the evolution of a distinctive photographic style that grew out of ingenuity, eclecticism, and the simple necessity of getting the job done.' Though some of Arbus's commercially produced pictures are now considered her 'personal' work and were included in the MoMA retrospective – *Widow in Her Bedroom, New York City, 1963*; *Mother Holding Her Child, New Jersey, 1967*; *Brooklyn Family on Sunday Outing, 1966*; *Family on Lawn One Sunday, Westchester, 1968*; and *King and Queen of a Senior Citizen's Dance, N.Y.C., 1970* [24] – the goal here is to untangle the commissioned and the voluntary in order to illustrate the background for the development of the more important artistic achievements. The 1972 monograph, in Doon Arbus's and Marvin Israel's minds, contains some of her 'best work.' Still, the magazine photographs are 'of interest in themselves, and constitute an experience that contributed a great deal to the development of her style, her technique, and the way she thought about photographs and subject matter.'[25]

Despite this rather awkward separation, which Thomas Southall partially redresses in his text, *Magazine Work* is unquestionably, commendably useful. It contains more reliable information than anything yet published on Arbus, including reproductions of most of her commercially commissioned projects, a bibliography of all her published photographs, and crucial texts that were never printed (e.g., on nudists and on Hubert's Museum). Most of all, it is useful for Southall's careful, factual essay. He brings in a significant amount of primary source material, quoting extensively from Arbus material in the *Esquire* archives as well as from her correspondence with Peter Crookston, with whom she began working in 1967, when he was deputy editor of London's *Sunday Times Magazine*, and with whom she continued working after he became editor of *Nova* in 1969. Moreover, Southall uses footnotes, doesn't gush, and utters not a syllable about cursed souls. Instead, within the bounds of conventional photohistory, he tries to establish a material base for Arbus's production in the

spheres of art and journalism, though obviously focusing on the latter, particularly the expectations and requirements of Arbus's editors. He traces the evolution of specific projects, and he addresses, to a limited extent, Arbus's earnings and economic requirements.

Southall argues that Arbus's entry into the magazine world of the early 1960s came exactly at the time when various publications were redefining journalism, promoting a more personal, more upbeat, catchy style to compete with the encroachments of television. It was the decade of the 'New Journalism,' and the search for a new image was on. Though Arbus had never before been published, Harold Hayes, assistant to the publisher of *Esquire*, was sufficiently taken with her portfolio to consider assigning her *all* the pictures for a special issue on New York. (*Esquire* backed down to the six portraits in 'The Vertical Journey.') It is also an indication of the priority placed on a novel style that *Harper's Bazaar* immediately took 'The Eccentrics' when *Esquire* killed the project. Arbus continued to work with these two magazines, as well as with *Show, Glamour, The New York Times Magazine, Essence, Harper's Magazine, Holiday*, and, after 1967, the London *Sunday Times Magazine* and *Nova*.

The *New Documents* exhibition in 1967 brought Arbus much attention, but with the exception of her projects for Crookston, no tangible boost in assignments. After 1969 her assignments began to decline, in part because of staff changes at various publications that eliminated the personal contacts upon which Arbus had relied. Southall, however, suggests an equally important reason:

> In the early 1960s, some editors regarded Arbus as someone who could be used to gain the trust of a subject who might have been defensive when confronted by a photographer with a more established reputation. By the end of the 1960s, Arbus's style had become well known. Additionally, it certainly did not help her to have the public, potential sitters, and editors increasingly associate her work with controversial subjects.[26]

It was at this juncture that Arbus tried other ways to make money: teaching, printing a portfolio of her pictures (she sold five at $1000 apiece), applying for grants (she received none after her 1966 Guggenheim), taking on related projects (notably the preliminary research for MoMA's *Beyond the Picture Press*), and thinking, at the urging of the French publisher Robert Delpire, about doing a book.

Magazine Work's Diane Arbus is very different from the Diane Arbus of the first monograph, to say nothing of Bosworth's Arbus – which is in no way surprising, since a correction of the myth was the explicit intention of the *Magazine Work* editors. The revised Diane Arbus is a working woman. Dramas of husband, children, separation, and divorce do not figure in the freelance bustle. The pampered childhood is ignored; the word 'suicide' is not used. Rebellion, innate perversity, the seduction of extremes, a woman's quest for sexual and personal liberation, or any other psychologistic theorizing are likewise omitted. This Diane Arbus has a job to do – hustling assignments, getting things down in writing, charming editors (and she was marvelously,

wittily persuasive), compromising about ideas, arguing over money, worrying about the next project. This Diane Arbus, an unquenchable source of story leads, pursues everything from midgets to skeleton collectors with the same diligence and equanimity. For her, distinctions between art and commerce are not always functional: it helped as much to have a press pass to get to The Mystic Barber as it did to the Daughters of the American Revolution, whether or not one project brought a page fee and the other didn't.

The idea was to photograph and get the work out. Hopefully, money would thereby come in, and even if its actual arrival caused aesthetic twinges ('When I make money on a photograph I immediately assume it's not a good photograph'[27]), they hardly seem to have deterred Arbus. There is no evidence that she ever lost time worrying about whether to submit her personal work to a magazine or to an art museum. Indeed, she appears to have been supremely untroubled by combining the two spheres, as the separation was even pertinent to her, exhibition opportunities being scarce before the market boom in the late 1960s. Instead, one gets the impression from *Magazine Work* that the world lacked room enough for Arbus' boundless energy. *No* distribution mechanism could have accommodated her projects. Like all good artists of yore, this Diane Arbus is on the move, and neither she nor Southall ever paused to wonder where she is going, or why.

But the operative myth here – sober though Southall is, responsible to dates and external constraints and stylistic developments – is once again basically the notion of art as a closed system. Facts are marshaled to enhance a reputation already established, not to question or transform it. This may well be less a matter of Southall's inclinations than a happy coincidence of Aperture's publishing philosophy and the wishes of the Estate of Diane Arbus. If any one thing characterizes the former, it is the valorization of individual artistic genius by the excision of photography from meaningful political or social contexts. As to the Estate, if any one thing has been abundantly evident in the fourteen years since Arbus's death, it is the policy of maintaining strict control over scholarly, critical, or curatorial texts as a price for rights to both literary and visual material. The control has meant an artistic reputation unsullied by any substantial injections of new data or by *critical* analysis effectively backed by visual material. Even given this new monograph, what compels attention is not how much more we now know about Arbus, but how much remains to be learned. Leaving aside, for example, notes and other unpublished texts, Arbus left behind 7500 rolls of contact-printed film, as well as about 1000 *finished* prints. No more than 400 of the latter, at a charitable estimate, have been made available by the estate.[28]

In *Magazine Work* both Aperture and the Estate of Diane Arbus provide supporting information about someone already impeccably credentialed as a Great Photographer. It is not in the interest of either party to examine the credentials themselves, much less the mechanisms of certification. Thus, excellent though Southall's text is in its *genre*, the result is a new monograph that lacks any substantially new reading of Arbus's career. Ironically, this makes *Magazine Work* much duller than its subject. Precisely because the book is

scholarly without confronting the act of writing history, *Magazine Work* fuels the legend without considering the circumstances which enabled the legend, without even wondering whether those old nightmares will recur.

Amy Rule

Tina Modotti: Letters to Edward Weston

(Extracted from *The Archive*, No. 22, January 1986, Center for Creative Photography, University of Arizona)

Despite the high market value now placed on her work, Tina Modotti's achievements as a photographer have been paradoxically overshadowed by her status as legend. The glamour of her association with Edward Weston, as lover and model, then as apprentice, her noted beauty and the dramatic events of her life all invest her with such an aura of sexuality and heightened presence that her work by comparison occupies less space than its qualities merit. Weston's photographs of her play an obvious part in this process of constructing Tina the beauty, Tina the legend at the expense of a Tina seen without the contradictions of attachment to him.

These were Modotti's last letters to Weston, written in a period when their love affair was in the past; Weston was living in California and Modotti's partner Julio Antonio Mella had been assassinated in January 1929. The concluding letters illuminate the difficulties Modotti faced in Berlin after her deportation from Mexico, and they cast an interesting sidelight on photographic activity in Weimar Germany.

THE DECISION Edward Weston and Tina Modotti made in 1926 to live apart seems in retrospect insignificant in comparison to the distance fate put between them in 1929. The fact that Modotti was living in Mexico and Weston in California had not altered their shared concerns for friends, work, and each other. Weston still expressed worry over the flu that Modotti had caught, and Modotti still teased him about his good-looking sons. But after 1929, it was as if these two lives were on speeding trains going in opposite directions.

In mid-January 1929, Weston moved to Carmel to open a studio. The change from Glendale, already part of the urban sprawl of Los Angeles, was a relief. He began photographing the cypress trees, rocks, and kelp of Point Lobos while continuing his commercial portrait business and participating in the cultural life of the Carmel area. There was an atmosphere of tolerance for eccentricity and support for creativity. There was money around and taste and the time to display both at many social events. Weston began a new relationship with Sonya Noskowiak who was herself a photographer and who had worked for Johan Hagemeyer.

For Modotti, 1929 started out well. She was in love with the young Cuban

revolutionary Julio Antonio Mella whom she had met the year before at a demonstration protesting the execution of Sacco and Vanzetti. They had been living together for about five months, Mella working as a journalist and Modotti as a translator for *El Machete* and as photographer for *Mexican Folkways*. Their life was disrupted unexpectedly on January 10th when Mella was shot and killed while he and Modotti walked home late at night. Evidence pointed to an assassin who was an agent of the right wing government of Cuba, but Modotti's apartment was searched by the police, her letters and photographs confiscated, and a campaign begun in the newspapers to implicate her in Mella's murder. After weeks of police questioning and vilification in the press, the case against Modotti was dropped. Her letters to Weston during this period, if there were any, are lost, but he mentions the news in his daybook.

> Startling news has come from Mexico. Tina is featured in the headlines of every paper, even in California papers, as the only witness to the assassination of a young Cuban communist, Mella. Indeed, she was more than witness, the boy's beloved it seems, and walking with him when he was shot. The murder may cause a break between the Cuban and Mexican governments. My name was brought in, but only as having gone to Mexico with Tina. Poor girl, her life is a stormy one.[1]

And later, 'A letter from Tina disclosing her strength through a terrible ordeal: she has maintained and proved her innocence.'[2] Modotti described her situation in Letter 29.1 and adds, 'I cannot afford the luxury of even my sorrows today.'

Modotti's affair with Mella though brief, came at an important junction in her life. We sense his importance to her in the photographs she made of him as a monumental, romantic profile against the sky, and as a rather idealized corpse with peaceful, slightly smiling lips.[3] She also photographed the object that must have most clearly held his aura for her, his typewriter. In one of the reproductions of this print, the paper in the carriage can be read to say, '. . . inspiration . . . artistic . . . in a synthesis . . . exists among the . . .'

On February 5, 1930, the newly inaugurated President of Mexico, Pascual Ortiz Rubio, narrowly escaped an attempt on his life. The man who had fired the gun was arrested, but this did not satisfy the government. The government began rounding up its opponents, and among these was Tina Modotti. After being jailed for two weeks, she was deported to Germany.

LETTER 29.3

Typed, signed letter

Mexico D. F., September 17th [1929]

Dearest Edward:

Que te pasa? porqué tan silencioso?[1] Is all well with you? do drop me a few lines soon and tell me how you and Brett are; as you see I am still in Mexico but it is so disagreeable to not know how much longer one is

allowed to remain, it makes it almost impossible to make any plans for work, but of course the wisest attitude is to simply go on, do everything one intends to do as if nothing was ever going to happen to spoil one's plans.

Listen Edward, do you remember the name of that retoucher that worked for us for years, here, before that lame one? I remember that he did very good work, though he charged high, but I am so desperate that I would pay any price in order to get decent work. Perhaps he is not in the city any more, any way I would like to investigate, and I cannot do it because I do not remember his name.

I am sending you a few of the snapshots done in T[ehuantepec],[2] forgive me but I am just sending you from the ones I happen to have duplicates on hand, of course I have many more done while there, but alas, mostly are in the same condition as the ones I am sending you, either messy or moved, all the exposures had to be done in such a hurry, as soon as they saw me with the camera the women would automatically increase their speed of walking; and they walk swiftly by nature.

I am going to send you three or four more prints in case there is time to add them to the exhibit. I shall do it in the next week.

Today I received a lovely letter from that dear Mrs. Witte,[3] from Germany; do you ever hear from them? Tell me Edward, do you ever think any more about going to Europe? Wouldn't it be a thrill if in some future day we should meet there? You know I feel pretty sure that ere long I will be going there; everything tends that way and to tell you the truth I begin to feel restless. At home we are planning to send mamacita back, but I believe I already mentioned that.

I am thinking strongly to give an exhibit here[4] in the near future, I feel that if I leave the country, I almost owe it to the country to show, not so much what I have done here, but especially *what can be done*, without recurring to colonial churches and charros and chinas poblanas, and the similar trash most fotographers have indulged in. Don't you think so dear? By the way had I ever told you that I was offered the position of official photographer of the National Museum, some months back? Well tempting as the offer was, I could not accept it. Many have criticised me for the refusal but both as a member of the party and as companion to [Julio Antonio] Mella it would have been impossible, the government here did nothing absolutely to bring about justice, when they had all the opportunity in the world, they had the most responsible one of the guilty in their hands and they let him go free.[5] Anyway, as far as work is concerned I have always plenty of it, in fact more than I can do, considering that I cannot give all my time to photography.

Well dear one, I must close now, with a big hug to you and to Brett! Tenderly always!

Next day.

Is it not remarkable? Last night I wrote you the preceding page and before I had time to mail it, this morning the post man delivered me a well

known envelope with better known handwriting! I am delighted to have heard from you!

I shall deliver Dr. A. B. Cecil's letter to Diego [Rivera] today.[6] Now about his exhibiting I know that he has hardly anything to show, you know that he does not indulge much in canvas painting and the few he does he sells almost immediately. Zeitlin[7] sold him one for 750.00 Dollars just from photograph because D[iego] did not feel like sending the painting on approval. Now Zeitlin is on the verge of selling him an other one in the same way. You can see that what the wealthy clients really are after, is his *name*, for how can you explain choosing a painting just from a photograph of it.

Contemporary to your letter an other one came from the curator of the Berkeley Museum, asking me to send on the pictures; she evidently does not know they are already in your hands.

Had I not told you Diego had gotten married? I intended to. A lovely nineteen year old girl, of german father and mexican mother; painter herself.[8] A VER QUE SALE! His new address is: *Paseo de la Reforma 104.*

But the most startling news about D[iego] is an other one, which will be spread through all the corners of the world tomorrow, no doubt you will know of it before this letter reaches you: Diego is out of the party. Only last night the decision was taken. Reasons: That his many jobs he has lately accepted from the government – decorating the Nat. Palace, Head of Fine Arts, decorating the new Health Department are incompatible with a militant member of the p[arty]. Still the p[arty] did not ask him to leave his posts, all they asked him was to make a public statement declaring that the holding of these jobs did not prevent him from fighting the present reactionary government. His whole attitude lately has been a very passive one in regard to the p[arty] and he would not sign the statement, so out he went. There was no alternative. You see there are so many sides to this question, we all know that he is a much greater painter than he is a militant member of the p[arty] so the p[arty] did not ask him to give up painting, no, all they asked him was to make that statement and live up to it. We all know that all these positions were trusted upon him by the gov. precisely to bribe him and to be able to say: The reds say we are reactionaries, but look, we are letting Diego Rivera paint all the hammer and sickles he wants on public buildings! Do you see the ambiguity of his position?

I think his going out of the party will do more harm to him than to the p[arty]. He will be considered, and he is, a traitor. I need not add that I shall look upon him as one too, and from now on all my contact with him will be limited to our photographic transactions. Therefore I will appreciate if you approach him directly concerning his work.

Hasta luego dear.

LETTER 30.1

Typed, signed letter

Tampico, Feb. the 25th [1930]
On board the 'EDAM'

My dear Edward:

I suppose by now you know all that has happened to me, that I have been in jail 13 days and then expelled. And now I am on my way to Europe and to a new life, at least a different life from Mexico.

No doubt you also know the pretext used by the government in order to arrest me. Nothing less than 'my participation in the last attempt to kill the newly elected President.' I am sure that no matter how hard you try, you will not be able to picture me as a 'terrorist,' as 'the chief of a secret society of bomb throwers' and what not. . . . But if I put myself in the place of the government I realize how clever they have been; they knew that had they tried to expel me at any other time the protests would have been very strong, so they waited the moment, when, psychologically speaking, the public opinion was so upset with the shooting[1] that they were ready to believe anything they read or were told. According to the vile yellow press, all kinds of proofs, documents, arms, and what not, were found in my house; in other words everything was ready to shoot Ortiz Rubio and unfortunately, I did not calculate very well and the other guy got ahead of me . . . this is the story which the mexican public has swallowed with their morning coffee, so can you blame their sighs of relief in knowing that the fierce and bloody Tina Modotti has at last left for ever the mexican shores?

Dear Edward, in all these tribulations of this last month, I often thought of that phrase of Nietzsche, which you quoted to me once: 'What doesn't kill me, strengthens me,'[2] and that is how I feel about myself these days. Only thanks to an enormous amount of will power have I kept from going crazy at times, as for instance when they moved me around from one jail to another and when they made me enter a jail for the first time and I heard the slamming of the iron door and lock behind me and found myself in a small iron cell with a little barred skylight, too high to look out from. An iron cot without mattress, an ill smelling toilet in the corner of the cell and I in the middle of the cell wondering if it was all a bad dream.

Well it would be impossible for me to go into details about all the impressions and experiences of these past weeks, some time I hope to relate them verbally.

Now I am on my way to Germany. Please drop me a few lines to this address: Chotopatoya, Friedrich Strasse 24-IV, Berlin S.W. 48 Germany. But don't put my name on the outside address; use two envelopes and put my name on the inside one.

They gave me only two days, after the 13 of jail, to get my things ready; you can imagine how I left everything. Fortunately my friends all helped me so much; I can't tell you how wonderful they have all been to me.[3]

I am still in a kind of a haze and a veil of irreality permeates over everything for me; I suppose in a few days I will be normal again but the shocks have been too brutal and sudden.

I trust all of you are well; receive a tender and loving embrace from someone who loves you very much.

Tina

LETTER 30.2

Handwritten, signed letter on stationery printed with scythe/corn/bandolier photograph in green ink

New Orleans, March the 9th [1930]
U.S. Immigration Station

My dear Edward –

First of all will you please overlook and forgive this paper?[1] It was a gift to me but I find it very messy – still I use it for lack of other at present.

I cannot even remember when I wrote you last, so much has happened in these past weeks and such unexpected things too – as for instance my presence here – but I have gotten to the point where I just accept philosophically what comes along – You know the old saying: 'It never rains unless it pours'; Well that just about fits my condition at present. I thought that after 13 days in jail in Mexico City – followed by two days, (all I was granted to get my things ready) and after being taken to Veracruz and put on a boat, via Europe, my troubles would be over – but no indeed – in the first place I learned that the boat employed one month and a half for a voyage that could be done in three weeks – but since on this boat, passengers are accidental, and its specialty is cargo we stop at all the following ports: Veracruz – Tampico – New Orleans – Havana – Vigo – Coruña – Boulogne Sur Mer, and at last Rotterdam. This would not be so bad if I travelled as a normal passenger, but in my condition of expelled by the Mex. Gov. I am strictly watched in all ports and not allowed to touch shore – excluding this port where the U.S. Im. authorities brought me here, and here I am relegated for eight days, that is till the damned boat gets through its loading and unloading.

I hope Edward, that you enjoyed a good laugh when you heard I was accused of participating in the attempt to shoot [President Pascual] Ortiz Rubio – 'who would have thought it eh? Such a gentle looking girl and who made such nice photographs of flowers and babies – .' I can just imagine comments of this order being made by readers of Mexico's yellow press on reading all the sensational 'informations' headed by huge titles on the front pages, calling me 'la inquieta agitadora comunista' 'la celebre fotografa y comunista' and so forth – 'El Universal' of Mexico City among other things, published the following: ' . . . in the house of Tina Modotti, the authorities found documents and plans which clearly indicate that her intention was to commit a crime similar to Daniel Flores in the person of our President, Jug.

[?] P[ascual] Ortiz Rubio; and her not having carried out her intention is only due to the fact that Daniel Flores got ahead of her . . . ' (Can you beat that?)

The truth of the whole matter is this: the Mex. Gov. was eager to expell me but they needed a good pretext, so they took advantage of the attempt to shoot O. R. and profited from that psychological sentimental-hysterical state public opinion is full of during any public commotion – .

I am wondering dear if I have already written you all this – perhaps so – as I said before I have forgotten when I wrote you last – .

The place I am in now is a strange mixture between a jail and a hospital – a huge room with many empty beds in disorder which give me the strange feeling that corpses have laid on them – heavy barred windows and door, constantly locked this last one. The worst of this forced idleness is, not to know what to do with one's time – I read – I write – I smoke – I look out of the window into a very proper and immaculate american lawn with a high pole in the center of it from which top the Stars and Stripes wave with the wind – a sight which should – were I not such a hopeless rebel – remind me constantly of the empire of 'law and order' and other inspiring thoughts of that kind – .

The newspapers have followed me, and at times preceded me – with wolf like greediness – Here in the U.S. everything is seen from the 'beauty' angle – a daily here spoke of my trip and refered to me as to a 'woman of striking beauty' – other reporters to whom I refused an interview, tried to convince me by saying they would just speak 'of how pretty I was' – to which I answered that I could not possibly see what 'prettiness' had to do with the revolutionary movement nor with the expulsion of communists – evidently women here are measured by a motion picture star standard – .

Well, my dear I must stop now – the bell is ringing for supper – and the matron (who suffers from diabetes, poor soul) will come for me any minute to escort me to the dining room where she doesn't take her eyes off of me for fear this 'terrible radical' might escape and infest the country with her poisonous propaganda – .

As soon as I have an address I shall send it to you from Europe – till then au revoir my dear – always my devotion to you and a big hug to Brett.

Tenderly

Tina

LETTER 30.4

Typed, signed letter on letterhead stationery printed with Modotti's name

Berlin, May the 23d, 1930

My dear Edward:

I wonder why this silence from you?[1] Did you receive my letter of the 14th of April? It seems I have written you since then also, though I am not sure, I keep track of the letters I send and only the 14th of April is

annoted; perhaps the feeling that I have written to you more is due to the many many times I have thought of you, during all my photographic troubles here. Have I told you of my surprise on arriving here to discover that throughout all Europe different sizes are used altogether for films, papers, cameras, etc. That was my first trouble. I kept awake at nights wondering what to do: either I should have sold my graflex or order films from the U.S. I decided to do the last of these two things since nobody would have interest in my graflex on account of its format. Naturally I could not afford to buy another camera unless I could first sell this one. Then came the problem of all my negatives 8 by 10. I brought absolutely nothing from Mexico outside the graflex. I needed a printing frame 8 by 10 and have had to have it made to order. Paper that size I have had to order in larger quantities than I wished to, otherwise the factory here would not cut it special. You would be surprised perhaps to know that most photographers here still use glass plates.[2] Then there is the trouble of different standards of measurement: you know, not grains, but grammes. A hell of a mixed up affair. And on top of it all, the difficulty of the language! I tell you I have almost gone crazy.

I had the hope, on arriving here that I would be able to make arrangements with some other photographer, or photographers' association, where I could go to do my work; I even went to see the manager of the Eastman Co. but nothing came out of it. So I had to buy an enlarging apparatus and enough 'tools' to work with. I did this unwillingly, since I wanted to feel that I could pick up and go whenever I felt like it (or whenever I was forced to . . .) now I feel in a way tied down to my dark room. (which by the way is not ready yet, that has been an other hellish problem) I needed to find a furnished room (since I absolutely refused to invest in furniture also) with an other smaller room next to it, *with water*. I underlined the water part, because one ought to be in Berlin to realize the difficulty of finding rooms with water. At last I have what I needed; of course, the furnished room is not fit for a studio, but since I am going to try getting along without making portraits, I don't need a studio.

Oh Edward dear, how I longed for you to help me out during these past weeks! Just to talk to you and discuss these nasty affairs with you would have helped me; I have felt like giving up photography altogether, but what else can I do?

[page two letterhead of Modotti's name has this typed comment below it.]

(It seems pretentious, and I dislike using this paper, with such 'estridentis-ta'[3] lettering, but I have no other.)

[letter continues]

Even in photography, I don't yet know just what to do. I said a moment ago that I am going to try getting along without making portraits; partly because I prefer not to, and partly because competition here is so great, and the prices so cheap that I do not feel valiant enough to step in and compete. Of course

I am talking about really excellent portrait work; were it just the trash turned out in Mexico by the photographers we both know, I would not even give them a thought and just go ahead, but this is really excellent work and I don't see how and why they almost give it away.

I have been offered to do 'reportage' or news paper work, but I feel not fitted for such work. I still think it is a man's work in spite that here many women do it; perhaps they can, I am not aggressive enough.

Even the type of propaganda pictures I began to do in Mexico is already being done here; there is an association of 'workers-photographers' (here everybody uses a camera) and the workers themselves make those pictures and have indeed better opportunities than I could ever have, since it is their own life and problems they photograph. Of course their results are far from the standard I am struggling to keep up in photography, but their end is reached just the same.

I feel there must be something for me but I have not found it yet. And in the meantime the days go by and I spend sleepless nights wondering wondering which way to turn and where to begin. I have begun to go out with the camera but, *nada*.[4] Everybody here has been telling me the graflex is too conspicuous and bulky; everybody here uses much more compact cameras. I realize the advantage of course; one does not attract so much attention; I have even tried a wonderful little camera, property of a friend, but I don't like to work with it as I do with the graflex; one cannot see the picture in its finished size; perhaps I could get used to it, but anyway buying a camera now is out of a question since I have had to invest in the enlarging apparatus. Besides a smaller camera would only be useful if I intended to work on the streets, and I am not so sure that I will. I know the material found on the streets is rich and wonderful, but my experience is that the way I am accustomed to work, slowly planning my composition etc. is not suited for such work. By the time I have the composition or expression right, the picture is gone. I guess I want to do the impossible and therefore I do nothing. And yet I shall have to decide soon what to do, for although I can still afford to 'take it easy' for a while, this cannot go on for ever. Besides, my mental state is not a very pleasant one. If only I had somebody with whom to tell all my troubles, I mean somebody who could understand them, like you could Edward.

I was advised not to give an exhibit[5] till fall, that being the better time; by then I ought to have something of Germany to include, which would all be very good, if only I begin to work soon. Otherwise all I will have is 'merda.'

The weather has been so nasty, cold, grey miserable; the sun only appears at moments; one cannot really rely on it, you can imagine how I feel after the weather I am accustomed to, both in California and Mexico. Well, there is nothing to do but go ahead; I recall often that wonderful line from Nietzsche you told me once: What does not kill me strengthens me. But I assure you this present period is very near killing me.

I see the Wittes once in a while. They are wonderful friends to have and their kindness to me is like a ray of sunshine. And yet I don't tell even them

all my troubles, I am terribly scrupulous being a new comer here. I feel constantly that I must solve my own problems and not bother friends too much. And yet I have done nothing in this letter but tell you all my problems but you are far away and certain things nobody but you can understand; besides you must not worry about me; I will find a way out somehow and perhaps by the time this reaches you I will be in a more settled state of mind. So please dear don't let this interfere with your own problems and worries; but do drop me, if only a line, for I am hungry for your words.

If you have not yet but intend sending the Wittes one of your photographs, please do not mention their lost ones; I am afraid they will resent my having told you.

Always my devotion to you,

Tina

and best regards to Brett and Sonya!

Tina Modotti

On Photography

(First published in *Mexican Folkways*, Vol. 5, No. 4, Mexico City, 1929)

Tina Modotti first arrived in Mexico in 1922 and settled there the following year with her lover Edward Weston. Although she learned her craft as his apprentice, her photographic work soon took its own directions, inflecting Weston's formalist aesthetic with a subject matter shaped by political perceptions – of class and gender, of revolutionary ferment in Mexico. The following short article reflects the same optimism invested in the camera's potential as a tool for new ways of seeing that characterised the European avant-gardes. It is an attitude inseparable from Modotti's belief that photography's merits derived from its *multiple* aspects.

ALWAYS, when the words 'art' and 'artistic' are applied to my photographic work, I am disagreeably affected. This is due, surely, to the bad use and abuse made of these terms. I consider myself a photographer, nothing more. If my photographs differ from that which is usually done in this field, it is precisely because I try to produce not art but honest photographs, without distortions or manipulations. The majority of photographers still seek 'artistic' effects, imitating other mediums of graphic expression. The result is a

hybrid product that does not succeed in giving their work the most valuable characteristic it should have – photographic quality.

Whether or not photography may or may not be a work of art comparable to other plastic creation has been much discussed in recent years. Naturally, opinions differ. There are those who do accept photography as a medium of expression on a par with any other and there are others who continue to look myopically at the twentieth century with eighteenth century eyes, incapable of accepting the manifestations of our mechanical civilization. But, for us who use the camera as a tool just as the painter does his brushes, adverse opinions do not matter. We have the approbation of those who recognize the merits of photography in its multiple aspects and accept it as the most eloquent, the most direct means for fixing, for registering the present epoch.

To know whether photography is or is not an art matters little. What is important is to distinguish between good and bad photography. By good is meant that photography which accepts all the limitations inherent in photographic technique and takes advantage of the possibilities and characteristics the medium offers. By bad photography is meant that which is done, one may say, with a kind of inferiority complex, with no appreciation of what photography itself offers; but on the contrary, recurring to all sorts of imitations.

Roberta McGrath

Re-reading Edward Weston – Feminism, Photography and Psychoanalysis

(First published in *Ten*.8, No. 27, 1987)

Edward Weston's photographs – of nudes, shells, peppers and assorted vegetable forms – cannot but be viewed as highly sexualised formal representations. Roberta McGrath's feminist critique uses psychoanalytic models to pinpoint intensely voyeuristic and fetishistic mechanisms in Weston's shaping of these images.

EDWARD WESTON is, perhaps, unusual in that unlike many other photographers his work has been dominated by his own writing. In his diaries (published as *The Day Books* in 1961 and 1966[1]) he records his life through his photography, his sons, his appetite for women and health foods, and his dreams.

Despite this body of knowledge, his photographic work is most commonly accounted for in terms borrowed from modernist art criticism. Emphasis is placed firmly on formal qualities; a purifying of the visual vocabulary; and truth to the (photographic) medium. From such received and well-worn criticism we learn how Weston emerges from the murky depths of nineteenth-century pictorialism into the blinding light of twentieth century modernism. The trajectory traced is that of a star. To quote Buckland and Beaton, Weston was 'a man ahead of his time'[2] who then arose from obscurity to fame via New York.

As the dominant ideological ruse of twentieth century art criticism, modernism has functioned not only to suppress any concern for the wider social matrix of which all cultural production is part, but has also hidden issues of class and race and – crucially – those of gender.

For beneath all the fancy talk of the universal genderlessness of art, as women we know that such truths are meant for MEN ONLY. Such knowledge is kept suppressed. How else could the illusion be preserved that the real meanings of art are universal, beyond the interests of any one class or sex?[3]

It is clear that a feminist art criticism cannot afford to have any truck with modernist discourse. Lucy Lippard has described the feminist contribution to modernism as precisely a *lack* of contribution.

It is therefore not accidental that in the title of this essay I place feminism before photography and psychoanalysis. The task which faces feminist practice is double-edged. On the one hand we must work to de-construct male paradigms, and on the other to construct female perspectives. Both are necessary if we are to change those traditions which have silenced and marginalised us.

To this end feminist scholarship has turned attention to a vast array of discursive practices as a means of understanding not just women's economic oppression but also our oppression within patriarchal culture. Much of this work has come about as a result of the women's movement in the late '60s and early '70s, and owes a debt not only to Marxism, but also to psychoanalysis and linguistics.

While Marxist analyses of culture have contributed greatly to an understanding of representations it must be recognised that as a body of theory it cannot answer all the questions. For feminists, of course, the problem is that Marxism takes no account of the sexual division of labour. The Marxist subject is a genderless and universal one. For psychoanalysis the problem is that the Marxist subject is alienated only in a capitalist society which supposedly prevents us from becoming 'whole' beings.

If Marxism proposes that struggle exists between classes (class division of labour) then feminism proposes that struggle exists between sexes (sexual division of labour); and psychoanalysis proposes that struggle exists within ourselves. The unconscious provides evidence of this. The psychoanalytic subject is one which instead of being coherent, whole, complete is always already alienated, split, fragmentary. Entry into the world is at a price. The human subject is one which is

always lacking and hence always desiring to fill a gap which is, by very definition, unable to be filled.

Psychoanalysis has also been important for feminism in providing evidence that subjects are formed through sexuality. Sexual difference, masculinity and femininity, is not biologically determined but socially, psychologically and culturally constructed. For Simone de Beauvoir, 'one is not born a woman. But rather one becomes a woman.'[4] The question is 'not what woman is, but how she comes into being?'[5] Such ideas may seem to be a far cry from the work of Edward Weston. But as we shall see, within his work we can read the traces of such debates: we can read attitudes to Marxism and psychoanalysis as well as to women.

Having said that, there is no doubt that such theoretical accounts would have sat very uneasily with Weston himself. In his Day Books he records attending a John Reid Club meeting in the '30s and the call to 'realise dialectical materialism'. This had little appeal for Weston who believed passionately that 'the individual adds more or combines more than the mass does. He stands out more clearly, a prophet with a background, a future and strength'. Weston was, of course, writing himself into art history, carving out the mould which others would diligently fill in. As such Weston becomes an artist, a genius – perhaps even a saint within orthodox photographic theology.[6]

But of all approaches to photography, the psychoanalytic was the most vehemently rejected – not just by Weston, but by the women who surrounded and defended him. For example, Nancy Newhall regarded his promiscuity as signal evidence that there were no sexual connotations in his work. 'His plethora of love shows that he had no need to seek erotic forms in his work.'[7]

And Weston's second wife and model Charis Wilson insisted that the inclusion of models' faces in the photographs of nudes would have reduced what she, and he, perceived to be a universal theme to a portrait of a particular individual: 'If the face appears, the picture is inevitably a portrait and the expression of the face will dictate the viewer's response to the body.'[8] This would interrupt what she and Weston believed to be the aesthetic appreciation of naked beauty. The *body* of the woman was, for them both, one of only three perfect shapes in the world. (The other two were the hull of a boat and a violin . . .) The compulsion to choose such forms as perfect was understood within the formalist aesthetics of modernism: We must never speak of *content*.

But the denial of the role of the unconscious and the psychological drives can in no way eradicate them. They are there to be seen, not so much in the pictures, but in the encounter, in the relationship, in the gap between artist and object, a gap which neither an art history nor a technological history can bridge. This is the place of production: both material work carried out in the darkroom and work carried out in that other dark space, the unconscious.

Precisely because psychoanalysis occupies a unique space between nature/culture, between the biological/the social, it can provide a way out of this stagnant binary logic of dominant photographic history, criticism and practice into an area which is less mapped out. After all, as Rosalind Coward says: 'The invisible is not simply anything at all outside the relationship between objects

posited and a discourse. It is within the discourse, it is what the light of the discourse scans without picking up its reflection. In the fullness of the (photographic) text there are oversights, lacunae . . .'[9]

Because photography is a medium which seems to be purged of all traces of its production and because it offers us so much to see, most writing on photography concentrates on this world as seen through photographs as if it were a transparent medium, rather than concentrating on *how* those images are *produced*. But what interests me here is precisely those gaps, those oversights. If we borrow a term from psychoanalysis (dream-work: condensation and displacement which underlies the dream) we could say that what is missing, what is rendered obsolete in photo-criticism is the *photo-work*. Of course, photographs are not dreams. They have an advantage in that they can satisfy the unconscious desires of many people. What I am suggesting is that psychoanalysis may provide a route out of this double-bind. I say *might* because it can only do so on one condition: namely, that it provides a materialist psychoanalytic understanding of the apparatus of photography. It is perfectly possible to produce idealist psychoanalytic interpretations. The revelation of latent content or the psycho-biography can be accommodated in art appreciation. Those are not my concerns here. It is not my intention to prove that Weston is in some way a 'perverse' rather than 'straight' photographer. Far more is at stake.

I now, therefore, want to turn to this photographic work and to the language of photography itself.

Close Encounters

Taking a photograph is a way of making sense of the world. It imposes an order, a unity upon the world which is lacking. To take a photograph is to exercise an illusory control, a mastery which is characteristic of voyeurism. But the sexual connotations of the verb are also obvious: the slang for carnal knowledge. It implies a physical penetration of the other while the photograph is a penetration of the space of the other. For Weston this taking, whether photographic or sexual, was closely linked and well-documented.

In his Day Books he records how photographic sessions were frequently interrupted. The eye was replaced by the penis, making a photograph by making love. It is here that we begin to see an oscillation between photography/sex, (between the print/the real). But we need to pause over this because the penis and the eye are not interchangeable. The satisfaction of one must mean the denial of the other. However, for the male the eye is often a substitute for the penis since its satisfaction is intimately linked to the possibility of an erection.

Photography has an obvious role in this web of pleasures. The voyeur and the photographer must at all costs maintain a distance from the object, and the photograph ensures this distance par excellence. To move too close, to touch would put an end to scopic mastery and lead to the exercise of the other drives, the senses of touch and hence to orgasm.[10] Thus, the photograph acts not so

much like a window on the world as a one-way mirror where the tantalising object of desire remains just out of reach so close, and yet . . . (We should also note Weston's fascination with Atget's photographs of windows.) Moreover, the photograph allows the voyeur to look without fear of retribution. Unlike the woman herself the photograph is portable, can be referred to at will, and is always a compliant source of pleasure. Without this scenario the camera is another device of denial and retention (which is always fully a part of pleasure). But there is a complication. The camera itself, 'the body', 'the lens' (eye), 'equipment' can become an object of love, *a fetish*, a re-assuring object that affords pleasure and that the photographer may know more intimately and with less danger than the woman who is likely, one way or another, to put an end to his erection. Weston often refers to his camera as his 'love', reminiscent of the traditional ascription of femininity to photography, as female as a 'hand-maiden', a box with an aperture that passively receives the imprint of an image – but only in negative.

In his diary Weston makes the following slip: 'I made a negative – I started to say nude . . .' This analogy of negative to nude is significant since the implication for both is a certain lack: the minus sign, the horizontal, the hyphen or gap. It also suggests woman as less than, more incomplete; possessing, perhaps, only a negative capacity.

This lack is one which can be made good by photography. Weston describes photography as 'seeing plus'. Is it through the print ('which will remain *faithful* to the negative') that he can compensate the woman/the world for their lack? Is this the vertical crossing through of the horizontal, the turning of this minus sign into the plus?

But in speaking of voyeurism and fetishism, I am getting ahead of my argument. And to understand them we need to introduce a third and even more unpleasant term: castration.

In 1938 Stieglitz wrote to Weston: 'For the first time in 55 years I am without a camera.' Weston replied, 'To be without one (to be what one might call camera-less) must be like losing a leg or *better* an eye.'[11] Not worse, *better*. Castration – and by analogy – death, are clearly in the air. It indicates Weston's desire (attested to elsewhere in the notebooks) to usurp Stieglitz the Father of Modern Photography. Weston visited Stieglitz in 1922 and it is well known that he never received the recognition from Steiglitz which he so desperately desired.

It also attests to Weston's own fears of castration: the loss of a leg or an eye (perhaps the third leg in Charis's description of Weston's Graflex camera as 'a giant eye on three legs'[12]). This is a reference to the myth of Oedipus in which blindness is symbolic of castration. Within this scenario the mother is photo-graphy: and Stieglitz and Weston are the rivals for her attention. This makes sense of the closing lines of the same letter in which Steiglitz wrote to Weston of his cameralessness. He continued: 'Waldo Frank said some years ago, "Steiglitz, when you're dead, I'll write your biography". I wondered how much he knew about me and why wait till I'm dead? But all I said was: Frank, my biography will be a simple affair. *If you can imagine photography in the guise of*

a woman and you'd ask her what she thought of Steiglitz, she'd say: He always treated me like a gentleman. So you see that is why I am jealous of photography.'[13]

Photography comes in the guise of a woman; and for woman the ultimate accolade is to be treated as an honorary man.

Castration, simply put, is a fear of damage being done to a part of the body (primarily the male body) which is considered to be a source of pleasure. In Freudian psychoanalysis the fear supposedly arises from seeing the mother's genitals and the realisation that some people do not have the penis. To the small boy who knows nothing about anatomy this provides evidence that castration is possible (he believes that his mother has had the penis and through some misdemeanour has lost it). This leads to the phantasy of the all-powerful mother (who does not lack) and to women as symbols of castration. This threat posed by women can be dealt with in two ways: through voyeurism (subjecting women to a controlling and unreturned gaze) *and* through fetishism (the displacement or substitution of the anxiety onto a re-assuring object which comes to stand in for the missing penis). The fetish, of course, has no value in itself. The reverence which the male feels for it is for the erection which it maintains. For Weston, photography in the form of the camera, was 'that pleasurable extension to the eye': both it and the faithful photographic print become fetishes; necessary props.

Voyeurism and fetishism are both inscribed on the photographic arrangement. Photographs themselves are curiously like fetishes requiring a disavowal of knowledge. We know that they are only flimsy scraps of paper but we over-invest them with meanings. Moreover, photographs come to stand in for the missing object. The condition for the photograph is precisely the absence of the real object.

The major benefit of interposing the camera between his eye and the nude was to gain a more fundamental knowledge of reality. According to Weston: 'The discriminating photographer can direct its (the camera's) penetrating vision so as to present his subject in terms of its basic reality. He can reveal the essence of what lies before his lens with such insight that the beholder will find the re-created image more real and comprehensive than the actual object.' This is the search for the elusive and impossible real. In photography the infinite number of photographs, the quest for the 'one' attests to the drive to collapse signifier into signified, the photograph into reality: to make a photograph which has no other, a phantasy moment of suppression of separateness, which closes the gap – and the compulsion to close this gap becomes paramount. The pleasure, and indeed the problem for the voyeur is one of how to maximise the pleasure of looking. This aesthetic requirement can partly be found by technical expertise. I mentioned earlier that 'taking' the photograph involved the penetration of the space of the other. The pleasure/problem is one of how to deepen this penetration; how to make the piece of paper more three-dimensional and consequently more real.

f/64

W ESTON BELONGED to a group of West Coast photographers who adopted the name f/64. This referred to a technical device – the aperture which achieves maximum depth of field with sharpest possible focus. It combines microscopic detail with telescopic depth. We could also describe it as a heightening of visual qualities which excite and invoke (without allowing) the sense of touch. Retention, we remember, is fully a part of pleasure.

This deeper penetration of the real could be further enhanced in the process of 'printing up'. By 1927 Weston was citing the advantages of using high gloss paper. It would 'retain most of the original negative quality'. Moreover, he went on, 'I can print much deeper without fear of losing the shadows.' He saw this as a logical step in his 'desire for photographic beauty'. Beauty frequently has its roots in sexual stimulus. The gloss of the paper mimicked the glassy quality of the plate negative, but shine also connotes a moistness which is associated with sex, and similarly, glossy paper seemed to adhere, bind with the image. It fused with the image in an imaginary moment of pleasure. This is what Weston means when he says, 'paper seems to compete with the image instead of becoming part of it.' Signalled here is the desire for a mythic fusion (as in sex) between photography and the real: the desire to suppress the gap between the subject and the object of desire, between the negative and the print, between the subject's own body and the other's body, ultimately the phantasy moment of orgasm. (The latest book on Weston is entitled *Supreme Instants*.)[14]

Perhaps we can now begin to understand Weston's love of daguerreotypes: a mythic one-ness at the 'birth' of photography. We should not underestimate the language which photography has adopted. If we pursue the metaphor of the natural birth then Fox Talbot's paper negative marks the break-up of the dyadic relationship. And we can also understand Weston's favoured method of printing, what is referred to as contact printing. It was an attempt to preserve an aura of originality.[15] In this process the negative bonds with the paper, the hard surface of the glass plate with the softness of the paper and from this union the issue of a print. It was Jean Cocteau who coined the idea that art is born of an incestuous union of the male and female elements *within* the male. Weston felt that the role of women in his life was to 'stimulate me, fertilize my work'.[16] Ben Maddow, Weston's biographer, speaking of the Weston/Wilson relationship claims that 'great nudes were born from this childless marriage'.[17] Weston was a prolific photographer having made some 60,000 prints of which, incidentally, nudes make up the largest category.

Honour, Power and the Love of Women

ACCORDING TO Freud, the artist achieves what would otherwise remain phantasies, 'honour, power and the love of women'. It was Weston's work that enabled him to realise such invisible fantasies, brought to light through work done in the dark, under a cloth gazing at a ground glass screen, and work done later in the darkroom. Hollis Frampton has written that the work is of someone compelled to sexualise, even genitalise everything.[18] This makes sense of Freud's symbolic topography of genitalia in *The Interpretation of Dreams*. Landscapes, woods, trees, hills, caves, water and rocks come to 'stand in' although the gender to which they refer is by no means obvious (a cigar, as Freud says, is sometimes just a cigar). Freud names only two objects which are never confused (a box and a weapon); on the whole there is ambiguity. It is the context which provides meaning. Symbols tend to be hybrid, and those images which most satisfied Weston were those invoking the fusion of male and female. Excusado, The Nude Back, Shell and Pepper No. 30 achieve this status. It is worth noting that Pepper No. 30 was the all-time best-seller. The others are not so successful in concealing their origins. Weston described the pepper as 'a hybrid of different contractile forces . . . pulling against each other'. It is clear what this suggests. But Weston also ate these 'models' after he had lovingly polished and photographed them. It was part of the ritual consumption of flesh. He saw it 'not as "cannibalistic". They become part of me . . . enrich my blood.' Weston makes everything which constructs a world – 'girls to fuck, food to eat . . . trivia, oddities . . . earth to walk on . . . skies to put a lid on it all.'[19] This is also reminiscent of the way in which he talked about women, each in turn fertilising his work, but it also suggests another moment of imaginary unity: the phase prior to meaning when for the child separations from the m/other is temporarily suppressed by feeding the infant from the breast.

From Voyeurism to Fetishism

A SIMILAR UNITY is, of course, met in the single process of the daguerreotype. This marks the fetishistic axis of Weston's oscillation. Those early photographs were thought to have the power to see into the human character. For Weston, the camera 'searches out the actor behind the mask, exposing the contrived and the trivial for what they are', and 'all she wants is sex; all her gestures are directed by sex'. This is tinged with the language of punishment and investigation that is characteristic of voyeurism. Hence the oscillation in the work between the female body as form (pleasurable and complete) and the other axis: the sadistic cutting of the image. This latter aspect is achieved in numerous ways. In many of his photographs there is a literal cutting, the implication of cutting, the cutting of the frame, and the more subtle cutting produced by shadow. Enjoyment of the nudes is ensured through the erasure of the threatening gaze of the woman, either through a literal beheading,

aversion or covering of the eyes, as if she did not know that she was the object of your gaze. She does not look, pretends she is not being looked at, and at the same moment we know very well that she knows. She is the one to be looked *at* without looking herself. The denial to look is also, by implication the denial of woman's access to the production of knowledge. One of Weston's friends touches upon the importance of photographic *work*, of instruments when he asks for 'spectacles to see as you do, scissors such as you use to cut prints'.[20]

At work in all this is the story of the Medusa, and the implication for the protective, fetishistic print are clear. Like the Medusa herself, the camera has the power to suspend movement, to arrest life, to cause a sort of death by freezing a moment in time.

The woman must not return the gaze, and Weston cannot turn the camera's gaze upon himself. It is hardly surprising to find that there are *no* self portraits. Weston keeps the symbolic register for himself. The Nude as a category is reserved solely for women (there are some of his sons but crucially before puberty). We provide evidence of body, that natural, raw material which he will fashion into culture. Women are kept in the imaginary. How then can we begin to speak of the historically invisible, inaudible, the powerless; the position of women within patriarchal discourse? In psychoanalytic terms we are the 'nothing to be seen', or at best 'not all'. And yet the puzzle is not simply our exclusion from discourse but our very inclusion as both marginal (out of sight) and central (on display). As Mulvey states 'the paradox of phallocentrism is that the idea of (the) castrated woman stands as lynch-pin to the system.'[21]

There have been several feminist strategies in response to this problem. The first and the least interesting is the attempt to fill in some of the holes in the discourse; to paper over the cracks by inserting more women into the existing structure as phallic mothers who do not lack. (Honorary men.) Such moves are largely a denial of sexual difference: a plea for access to the patriarchal structure: the most common result is to tack on a few more exhibitions or lectures on women photographers.

A second strategy is the refusal to contribute to patriarchal discourse; a rejection of the structure altogether as an attempt to build a specifically feminine discourse in opposition to patriarchy. This also poses problems. How can one know what that might be?

The feminine is not the same as feminist. How can we be certain that it will not simply construct a parallel ideology where 'men' has been replaced by 'women'? The recent Barbara Kruger poster suggests to us that 'we don't need another hero', but it could equally have read 'we don't need another heroine'. The task at hand is to understand first and foremost how 'woman' (as a sign) functions within patriarchal discourse, and this task is one of dismantling. While we can hardly claim that the edifice of patriarchal (photographic) discourse lies in ruins, the 'cracks' are starting to appear. Structurally, its foundations can no longer be said to be sound.

Nancy Newhall

Ansel Adams: The Eloquent Light

(First published in *Aperture*, No. 2, New York, 1963)

The writer and curator Nancy Newhall (1908–74) was a passionate advocate of formalist photography. For a brief period during the Second World War, she was curator of the fledgling photography department of New York's Museum of Modern Art. Though her writing now seems perhaps to show too much partiality to those she deeply admired, and too little critical edge, her enthusiasm and passion did much to propel photography from the margins to the centre of American culture.

Nancy Newhall's collaboration, as writer and editor, with the landscape photographer Ansel Adams (1902–84) was an important partnership, which was sustained until Newhall's death.

SNOWLIGHT, stormlight, foglight, rain that itself becomes drops of light, autumn leaves that become cascades of light, twilight and the rising moon – all these and many more are eloquent for Ansel Adams. And dawn is the greatest light of all. Time for him is a continuum wherein the moment of death is the moment of birth. 'Photography,' he once wrote, 'makes the *moment* enduring and eloquent.' The moment he seeks for his photographs is the moment of revelation, when in a passing light or mood he sees his subject in a new significance. In such photographs 'the external event' and 'the internal event,' as Coleridge said must happen in art, become one. The dates of their making drop away. They stand at the confluence of past and future; they become timeless.

Behind such images can be felt Adams's deep love of music and the severe discipline acquired during the years he studied to become a concert pianist. 'I have been trained,' he wrote to a friend, 'with the dominating thought of art as something almost religious in quality . . . I existed only for the quality of art in relation to itself – the production of beauty without other motivation.' To him in his maturity, as a professional photographer: 'The negative is the score; the print is the performance.'

Into composing the score he puts the full force of his imagination. He has close to total perception; crossing a threshold, meeting a person, entering a new region, the myriad disparate facets of presence strike him simultaneously with almost physical force. He is like a man dancing on barbs until he discovers how he can make this character, mood, or meaning inform a photograph. Reality surrounds him with what he calls 'configurations in chaos.' From these vague shapes, kinetically observed, the photographer selects, composes, intensifies,

and transforms until he achieves 'an entirely new and different experience which is remote from actuality in many ways.' With his uncanny sensitivity, speed, and power of visualization, Adams evokes from chaos his aerial images wherein beauty is discovered in a seemingly limitless range of forms, effects and emotions. Most artists throughout their lifetimes pursue only a relatively few forms; Adams is protean.

If it is a poet who perceives the aerial image, it is an arithmetician who converts it, as well as 'the perversity of the inanimate' will let him, into a negative. Then further transformations take full orchestra. Adams once compared the experience of 'a truly fine print to the experience of a symphony – appreciation of the broad, melodic line, while important, is by no means all. The wealth of detail, forms, values – the minute but vital significances revealed so exquisitely by the lens – deserves exploration and appreciation. It takes time to *really* see a fine print, to feel the almost endless revelations of poignant reality . . .' By this time, people in most of the countries of the world have found themselves transfixed before a photography by Ansel Adams.

Through the changing idealisms of the decades, Adams has emerged more and more himself, his vision and message increasing in depth and power. Both vision and message were formed by his first day in Yosemite Valley, when he was fourteen. Since that day in 1916, he has rung the quality of all the experiences and achievements of his life against the majesty of the Sierra Nevada, John Muir's 'range of light,' and the immensity of the Pacific.

This exhibition indicates the scope and versatility of his work. He produces fine books and brochures wherein the typography is distinguished and the reproductions of facsimile strength. He experiments with a new process which, he declares, 'has already revolutionized the art and craft of photography – and is still barely across the threshold of development.' He applies his skill and intelligence to the functional purposes of commercial illustration, and some of the photographs he makes on such assignments rank with his finest creative work. He abstracts – or 'extracts,' as he prefers to call it – from humble and common objects a formal brilliance and rich decoration. He photographs people with humor, insight, compassion, and a sculptural intensity. And over and through all these, through the places he loves, California, Yosemite and the High Sierra, the Southwest, Hawaii, Alaska – run his huge themes – 'forces familiar with the aeons of creation and the aeons of the ending of the world.'

In his work the immense and monumental, the exquisite and lyrical, the luminous and the sombre, the tragic and the ecstatic appear together. He is not afraid of emotion or of beauty. 'We are passing through an age of the denial of beauty. . . . I am not ashamed to use this term, beauty; I do not consider that it is limited to the pretty, the precious, the esoteric or the shallow. It is the ingredient that determines the ultimate function . . . the ingredient of excitement and revelation.'

Most contemporary art seems to him 'peripheral.' He is deeply disturbed by 'the sour negations, oblique obscurantisms, and the slick evaluations so common in the arts of our time.' He wonders why so many artists should be 'mostly concerned with the expression of their egos.' For himself, 'There is too

much clear sky and clean rock in my memory for me ever to wholly fall into self-illusion.'

He states his credo: 'I believe in growing things and in things which have grown and died magnificently. I believe in people, and in the simple aspects of human life, and in the relation of man to nature. I believe man must be free, both in spirit and society, that he must build strength into himself, affirming 'the enormous beauty of the world' and acquiring the confidence to see and express his vision. And I believe in photography as one means of expressing this affirmation . . .

'To photograph truthfully and effectively is to see beneath the surfaces . . . Impression is not enough. Design, style, technique – these too are not enough. Art must reach further than impression or self-revelation. Art, said Alfred Stieglitz, is the affirmation of life. And life, or its eternal evidence, is every-where.

'Some photographers take reality as the sculptors take wood or stone and upon it impose the dominations of their own thought and spirit. Others come before reality more tenderly and a photograph to them is an instrument of love and revelation. A true photograph need not be explained, nor can be contained in words.

'Expressions without doctrine, my photographs are presented here as ends in themselves, images of the endless moments of the world.'

Ingrid Sischy

Good Intentions

(First published in *The New Yorker*, 9 September 1991)

Sischy's review of Sebastião Salgado's retrospective exhibition *An Uncertain Grace* is an eloquent deconstruction of the concept of the 'concerned photographer'. In her *New Yorker* essay, she suggests that Salgado's lyrical interpretations of his subjects undermines rather than dignifies them. She also explores some intriguing issues of curatorship and the difficulties inherent in presenting photojournalism as 'Art'.

SEBASTIÃO SALGADO is the photojournalist of the moment. His reputation has been on the ascent, and although the heyday of photojournalism is past, his career proves that there is still a hunger for the kind of social-documentary picture stories that flourished in magazines in the thirties, forties, and fifties. In a relatively short time, he has had a number of books published,

his images have been used prominently in major news stories, and there have been heavily publicized exhibitions of his work. He has, in fact, had two shows this year, only six weeks apart, at New York's International Center of Photography. In the spring, the uptown branch of I.C.P. housed Salgado's travelling retrospective 'An Uncertain Grace,' which originated at the San Francisco Museum of Modern Art; and this summer at I.C.P.'s midtown branch one could see 'Kuwait Epilogue,' an exhibition of his shoot of oil-well fire fighters in Kuwait, done right after the Gulf War, and, in another room, his photographs of gold miners in Brazil, many of which had just been on view in the retrospective uptown.

It's rare for a photographer to be as widely trumpeted as Salgado. And it's rare – even rarer today than it was in the past – for a working photojournalist's pictures to be shown in a museum. That limiting, fragmenting system which divides people who use the medium into categories – fine-art photographers or commercial photographers or news photographers – may have had many exceptions and challenges over the years, but it's still firmly in place. No matter that, for instance, a photographer's imagery is highly inventive, and stands on its own: if it was originally produced on assignment, he or she is still pigeon-holed as 'less' than an artist, and has a harder time being taken seriously than someone whose pictures are first seen in an art gallery. Salgado's photographs, though, have been welcomed in a variety of milieus. They are generally the result of self-assigned projects, and they look as carefully composed as still-lifes. Indeed, this 'art' quality has contributed greatly to the work's success as photojournalism-plus-much-more.

'Kuwait Epilogue' underscored how bright a spotlight there is on this photographer, while confirming that there's something exaggerated about all the attention he's getting. The Kuwait pictures are mostly stagey shots of men at work, trying to cap the gushing wells, or at exhausted rest. But they constitute an expression of Salgado's ongoing interest in manual workers – for the last few years, he's been involved in a project called 'The End of Manual Labor' – more than they constitute a narrative of what happened to Kuwait's landscape in the Gulf War. There's no deep observation of the place and its new scars. The oil that's such a looming presence in the photographs and that appears to cover everyone and everything identifies the series as a product of the war, but the images add no special meaning to the sense of ecological devastation trans-mitted over the wires while the war was going on – something they seem to be striving to do. Salgado's portraits of the fire fighters are remarkably similar to his portraits of gold miners; the firefighters just happen to be covered with oil, not mud.

What stood out most about this exhibition was its promotional tone. Two press displays were installed in Plexiglas boxes, one showing spreads from the issue of the *Times Magazine* in which the Kuwait images first appeared, and the other containing an appreciative article on Salgado, from the same issue. You don't come across press clippings as an installational element at many exhibi-tions. It could be argued that there's interest in seeing Salgado's Kuwait images in their original photo-essay format, but why display the article on the

photographer? It's a piece of feature journalism about his life and his work which, though it covers his time in the Gulf, is the type of background article that usually stays in the background, separate from an actual presentation of the work. Just imagine what it would be like if curators regularly displayed magazine articles on artists as part of their exhibitions – a show, say, of Jasper Johns' paintings and, with it, his press clippings. Nor was this the only place in the I.C.P. exhibition that hinted at a collapse of the usual separation between curatorial practice and publicity. Salgado's biography, installed on a placard, ended with something more like an after-dinner speech than like an educational device: for the years 1988 through 1990 – years in which Salgado did a great deal of work – all it cited was a list of awards.

It makes sense that the International Center of Photography is enthusiastic about Salgado's pictures, which are clearly trying to echo the endeavors of the group now referred to as 'concerned photographers' – the group whose humanistic mission was the inspiration for I.C.P.'s founder and director, Cornell Capa, who is the brother of Robert Capa, a hero in the field. (Cornell Capa, in fact, is credited with coining the term 'concerned photography,' and Robert Capa was a founder of Magnum, the prestigious agency of which Salgado is a member.) Yet I.C.P. isn't exceptional in its fanlike attitude toward Salgado's work. From the tone of other recent Salgado projects, including the texts that are part of his books and shows, it's clear that neither he nor his admirers believe his photographs to be anything short of acts of enlightenment, and great pictures to boot, the premise being that they bestow honor on the people in them. Included in this claim is the suggestion that the images are powerful enough to change perceptions. The cult of appreciation that has developed around Salgado sets him up as a photojournalist whose pictures have a transforming power over, say, ethnocentrism, racism, and classism. From Salgado's choice of projects, from his titles, and from the photographs themselves, it appears that he aspires to be a spokesphotographer for forgotten people and also for soon-to-be-lost ways of life – a worthy ambition, but one, unfortunately, that resists the oversimplified yet heavy-handed means by which he attempts to achieve it.

Salgado's subjects are often so weighty, and are so weightily presented, that it is inevitable that his work has come to be credited with weightiness. It's no coincidence that his images of starvation, and of other situations in which human beings undergo intense physical stress – such as slogging in and out of a barren mine – are the ones that have brought him the most notice; subjects like these embody matters of conscience and, by their very nature, pull at the emotions. But other photojournalists have photographed such subjects. It's Salgado's manner – his visual rhetoric – that has given his work so much clout. His compositions, crops, lighting, angles, and toning stand in sharp contrast to the usual lack of insistent style in photojournalism. He goes in for aura. What's more, many of his photographs suggest both religious art and the kitsch products resulting from the commercialization of religion. Salgado is given to including cross-like forms in his pictures, for example, and all too frequently he presents people in a way that implies a connection to saints, martyrs, and various

other figures familiar from Judeo-Christian iconography. It is work that is sloppy with symbolism. And his religiosity seems to be catching. At times, a curator's or a commentator's partisanship can become so extreme that it feels as if the artist's work is being worshipped instead of examined. You can see this happening in the exhibition 'An Uncertain Grace,' and it's there in the book of the same title, which was published last year, by Aperture, when the show opened.

'An Uncertain Grace' is a package deal, with basically the same format, plus or minus a few images, at each museum where it appears. (It is now at the Chrysler Museum in Norfolk, Virginia, and will eventually be seen at San Diego's Museum of Photographic Arts; at Washington, D.C.'s Corcoran Gallery; at Harvard's Carpenter Center; and at the North Dakota Museum of Art, in Grand Forks.) The photographer's proponents may make claims for the power of his pictures, but the presentation of this show doesn't reveal much faith in the viewer's ability to grasp what Salgado is doing without help and hype. The captions that accompany the photographs have an inflated, pseudo-educational tone, and the introductory wall label, written by Sandra Phillips, of the San Francisco Museum of Modern Art, who conceived of and organized the show, begins this way: 'Sebastião Salgado, a Brazilian by birth, is probably the most important contemporary Latin American photographer and one of the most important artists in the Western Hemisphere.' No faint praise here. There's something off-key about the lionizing of the 'artist' that informs 'An Uncertain Grace' (both the show and the book) when one considers Salgado's subjects – particularly the people in the Sahel region of Africa, whom he has photographed, it appears, in order to convey the effect that famine has had on them. The photographs of these people have been fostering discussions of courage, but not the courage of those who really deserve recognition for it. It is Salgado everyone seems to end up admiring – for getting so close to such suffering. (You also hear people discussing the Sahel photographs as if what mattered were whether or not they themselves had the courage to look.)

At I.C.P., 'An Uncertain Grace' was installed so that before you got to the photographs of starvation and death in the Sahel you came upon a statement from the American branch of the French aid organization Médecins Sans Frontières telling you that the group was 'proud to be associated with I.C.P. for this exhibition,' and that Salgado's 'humanitarian concerns parallel our own.' No doubt, the doctors have great respect for Salgado and for his work, and there is plenty of evidence that he is serious in his efforts to help fight starvation. (For his most recent Sahel pictures he was working with the cooperation of Médecins Sans Frontières, and when the photographs were published as a book in France and Spain he donated the profits to it.) But his seriousness cannot eliminate the evident disparities – between claims for the work and what is actually there in the images; between intentions and results.

Certainly, what Salgado is trying to accomplish is difficult to achieve. He wants his portraits from the Sahel to reveal the inhuman scale of the tragedy there,

while also capturing the dignity of the people he is photographing. Further-
more, the images are supposed to work as educational vehicles, as calls to
action. But this is the kind of endeavor that requires an El Greco or a Goya, and
though Salgado is treated as if he were such a visionary, regrettably he isn't one.
In the history of photography, there are many who have tried to use photojour-
nalism to change the world as well as to capture it, and a few have had some
effect. Others have simply been naïve – even deluded – about what they were
doing. Still others are complicated mixtures of high aspirations and presump-
tion. It seems to me that Salgado is one of these.

Salgado's imagery is often linked to the work of a photojournalist
whose pictures include moments of brilliant humanitarian communication:
W. Eugene Smith. Indeed, Smith's work has been a strong influence on
Salgado, and the two men have much in common, most particularly their
passion for making the world 'see' injustice. Smith's photographs of war-
ravaged Saipan and Okinawa, of the leper colony where Albert Schweitzer
worked, and of the mercury-poisoned Japanese fishing town of Minamata are
among the projects of his that remain a touchstone for many who practice
concerned photography. Smith took photographs you can never forget once
you've seen them, and he also took pictures that were heavy-handed and
hackneyed. But Eugene Smith is his own story, and its usefulness to viewers of
Salgado's work lies in something that Smith once said: 'I frequently have sought
out those who are in the least position to speak for themselves. By accident of
birth, by accident of place – whoever, whatever, wherever – I am of their
family. I can comment for them, if I believe in their cause, with a voice they
do not possess.' Such presumption is at the core of what is self-aggrandizing
about Salgado's photography. To quote Smith again, in a moment of clarity
about his work (and he had moments that went in the other direction) he
described his camera and film as 'the fragile weapons of my good intentions.'

Salgado is working in a time very different from Smith's. As has frequently
been remarked, the advent of television – with the resulting loss of mass-
circulation magazines committed to supporting and publishing photo essays –
has meant that photojournalists have few outlets today; there is no way they can
compete with television in terms of immediacy or the public's attention. And
in responding to the remaining magazine opportunities, they do not have the
same sense of authority they had a few decades ago. Even though they never
had real control over the presentation of their images, at least back then there
was a healthy editorial demand for what they did. That has changed, and so has
the way photographs are viewed. For instance, we, today's audience, know that
pictures can 'lie,' and, like the photographers themselves, we assume that
magazines can use pictures to slant things. Meaningful photojournalism today
requires an appetite for challenge, a belief in the power of the medium, and an
internal alarm system against stereotyping. For the first two of these, Salgado
deserves credit, but his work suggests that his consciousness of the deeper issues
of representation in this kind of photography – such as how one's approach can
skew things or how the subjects themselves might feel about being 'honored' –
is only partly developed.

 Still, it's tricky to unravel what is meretricious about his work, because it's all so uncompromisingly *serious*. His dedication to making people visible whom powerful institutions – governments, say, or the media – have typically ignored is strong, and he is aware of how the image of 'the victim' can perpetuate victimization; he features pride instead of its absence. But often there is something else in his compositions: beauty. In fact, 'beauty' is a word one hears a lot when Salgado's photography is discussed, and you can see why people respond to the formal beauty of his pictures. You can also understand and appreciate why he has chosen to challenge the usual clichés about poverty by underlining the beauty in its midst – he means to negate the revulsion that can take over when disease and hunger are on display. But beauty as a formula – and this is what it has become for Salgado – is as much of a cliché as what he's trying to avoid, and as artificial as any other blanket approach. A photographer can't lose with heart-wrenching subject matter like the situation in the Sahel: a fleshless child hoisted up in the air to be weighed; two sick-looking children sucking on breasts that look more like wrinkled pieces of leather than like oases of nourishment; a man bending over a child who has a skeleton's body and an old man's face. Getting our attention with such material is easy; what a photographer does with that material is what counts. Salgado is far too busy with the compositional aspects of his pictures – with finding the 'grace' and 'beauty' in the twisted forms of his anguished subjects. And this beautification of tragedy results in pictures that ultimately reinforce our passivity toward the experience they reveal. To aestheticize tragedy is the fastest way to anesthetize the feelings of those who are witnessing it. Beauty is a call to admiration, not to action.

Salgado's approach has inspired much laudatory writing, such as that by Fred Ritchin, who wrote the main text of 'An Uncertain Grace,' and who is the guest curator of the exhibition. Ritchin's expertise in photojournalism, as well as his long professional relationship with Salgado, which began in 1979, made him a natural choice for these tasks. His knowledge of the work is evident, as is his respect for it, but this very closeness to it seems to have forestalled an overview. To Ritchin, Salgado's use of Biblical themes is impressive, not pretentious, and so is the formalized beauty of the Africans. In fact, he makes a point of the contradictions between the look of the pictures and what's happening to their subjects:

> Fathers march for days with dying children draped across their arms. . . . Children are weighed, suspended as if in the agony of the cross. . . . There is an exalted beauty to the people – an emaciated boy using a cane stands nude before a withered tree on a carpet of sand, a woman with diseased eyes radiates a visionary sadness. A bruising conflict is created between the formal radiance of the imagery and their agonizing content as a proud, attractive people suffers so.

No question, Salgado's depiction of the woman with diseased eyes gives her an

oracular presence. But the fact that her affliction has been turned into some-
thing spiritual-seeming is exactly what's disturbing about the photograph. Yes,
he's trying to counter the fear and horror that her disease can cause others to
feel: he's attempting to attract people to her plight – to involve us in it. And,
yes, it's a 'beautiful' photograph. But Salgado's strategy here fits into a long and
convenient tradition of coupling human suffering and God's will. Finally, the
photograph suggests that the woman's blindness is holy – in other words, that
it needn't be seen as something to cure.

There is a widely felt yearning today for photography and art that *matter*,
and Salgado's work has benefitted from it. But what do his pictures really
succeed in doing? In a photograph of people in a refugee shelter in the Sahel,
two young figures loom in the foreground, one sitting and the other slightly
propped up. Salgado's perspective creates the impression that the viewer is close
enough to touch the boy who is propped up: his elongated body and bald head
stretch along the bottom half of the picture. His bone-thin legs are spread apart,
and his shorts bunch around the tops of his thighs, which have a much smaller
circumference than the shorts seem made for. Yet despite the sculptural image
that he has become in Salgado's photograph, this boy is made of flesh, not
wood. The shock of what he looks like is strong, but Salgado's objectification
of the boy's body makes the image a setup – and, like most setups, it evokes
reactions that are mechanical. Typical of the comments I overheard during
several days of visiting the show at I.C.P. was one made by a young woman
standing in front of this image: 'I can't look at this picture. It makes me cry.'
Yet she looked at it, and she didn't cry. It isn't fair to make Salgado responsible
for how we do or do not respond to the content of his pictures, but there are
certain gimmicks and attitudes in them that seem designed to trigger specific
reactions and reflexes that are insulting to the people being portrayed.

Ritchin explains Salgado's approach this way:

> It is a romantic view that he espouses, one that is loyal to the dignity of
> the person depicted while circumventing some of the complexities of his
> or her existence. But when one juxtaposes the images with their various
> contexts, the lyricism can become particularly searing – the fact, for
> example, that in the Third World 40,000 children die *daily* of diseases we
> in the industrialized world have learned to cure long ago, like measles and
> diarrhea.

The statistics about the children are an effective way for Ritchin to segue out
of the issue of Salgado's romanticism, but they don't resolve the big problem
with his work – the unrelenting application of the lyric and the didactic to his
subjects. His is not photography in which the facts are allowed to sing for
themselves, which is how Lincoln Kirstein once described Walker Evans'
work. Evans' approach to photojournalism was the polar opposite of Salgado's.
As Kirstein so trenchantly put it:

> The most characteristic single feature of Evans's work is its purity, or even
> its puritanism. It is 'straight' photography not only in technique but in the

rigorous directness of its way of looking. . . . It is also the naked, difficult, solitary attitude of a member revolting from his own class, who knows best what in it must be uncovered, cauterized, and why. The view is clinical. Evans is a visual doctor, diagnostician rather than specialist. But he is also the family physician, quiet and dispassionate, before whom even very old or very sick people are no longer ashamed to reveal themselves.

There has been no need for Evans to dramatize his material with photographic tricks, because the material is already, in itself, intensely dramatic. Even the inanimate things, bureau drawers, pots, tires, bricks, signs, seem waiting in their own patient dignity, posing for their picture. The pictures of men and portraits of houses have only that 'expression' which the experience of their society and times has imposed on them. The faces, even those tired, vicious, or content, are past reflecting accidental emotions. They are isolated and essentialized. The power of Evans's work lies in the fact that he so details the effect of circumstances on familiar specimens that the single face, the single house, the single street, strike with the strength of overwhelming numbers, the terrible cumulative force of thousands of faces, houses, and streets.

In general, Salgado's subjects are too much in the service of illustrating his various themes and notions to be allowed either to stand forth as individuals or to represent millions. He's a symbolist more than a portraitist – the people in his pictures remain strangers. It is true that what certain men, women, and children in the Sahel are suffering has overwhelmed them to such a point that they appear to be embodiments of hunger, thirst, and disease. Still, there are choices a photographer makes every time a picture is taken, and Salgado's strategies here consistently add up to aestheticization, not reportage.

While the Sahel photographs stand out because of their distorted humanism, they constitute only one chapter of Salgado's work. 'An Uncertain Grace' is divided into four main sections. There's a section titled 'Diverse Images,' a non-thematically grouped collection of photographs taken between 1974 and 1987 in Asia, Africa, and Europe. There's a group from the worldwide project 'The End of Manual Labor,' begun in 1986. And then, under the heading 'Other Americas,' there's a gathering of images taken in Latin America between 1974 and 1984. In these portraits from Ecuador, Mexico, Bolivia, Peru, Brazil, and Guatemala, Salgado is just as hooked on displaying his artistry in matters of composition as he is in his African pictures. But here it is the picturesque that dominates, rather than beauty. (Actually, the African work, too, offers a number of images in which one can see Salgado pursuing picturesqueness. A couple of the photographs from the Sahel aren't all that different from the chic desert shots in Bertolucci's ponderous film *The Sheltering Sky*.) Some of Salgado's Latin-American photographs recall images made by others – Bravo, Penn, Sander, Arbus – and his attraction to the cross motif really gets a workout in this section. But at least here the religious content is appropriate, not dragged

in, the way it is in the African work. It's still empty, though, because it's still formulaic. Taken as a whole, the 'Other Americas' images — men in ponchos, a village wedding, a fiddler, bright-eyed kids — have that special Salgado weightiness; they're making points, but not very original or interesting ones. And in the group called 'Diverse Images' there are shots very similar to the work of earlier influential photographers such as Cartier-Bresson and Robert Capa. A 1976 photograph of a soldier running in the Spanish Sahara is so close in feeling, if not in detail, to Capa's famous Spanish Civil War picture 'Loyalist Soldier, Spain, 1936' that it almost qualifies as a remake. It's possible, even probable, that Salgado intended his picture as an homage, but he is not a postmodernist appropriation artist, so it's hard to believe that all his derivative works are intended as quotes — certainly, that's not how they've been presented.

'The End of Manual Labor' is perhaps Salgado's largest-scale *Gestammtkun- stwerk* to date. It already includes photographs taken in Cuba, Bangladesh, India, the Soviet Union, North America, South America, and France, and apparently Salgado plans to shoot in forty or fifty locations eventually. From Ritchin's text it appears that 'The End of Manual Labor' is conceived literally as an homage to laborers — he tells us that the project is 'a paean to the end of an era before robots, electronics, and computers take over production.' No wonder that in their earnestness some of these images would look at home in corporate annual reports, or the *Fortune* magazine of the thirties. Occasionally, the content of a photograph — such as pigs waiting in a slaughterhouse — leads one to believe that the project may turn out to be deeper than it seems. But that hope may stem from the over-all confusion in Salgado's work between what is actually present and what he intends.

Salgado himself seems to sense that there's more to his topic than celebrat- ing the worker. Consider his alternative title: 'The Archaeology of Industrializa- tion.' Nevertheless, unlike many works of art that deal with industrialization, Salgado's photographs are basically uncritical of its effects on human beings and on the environment. This is characteristic of his approach — it's his way of being 'sentimental, nostalgic, heroic, lyrical,' as Ritchin puts it. Such a romanticizing of this multilayered subject is almost breathtaking in its narrowness — particu- larly in the light of Salgado's supposed attunement to the lives of the powerless. His stiff photograph of a coal miner in India and his arty depiction of a silhouetted worker in an iron plant in the Soviet Union seem startlingly inadequate when looked at in the context of photographs that have been taken of subjects like these ever since industrialization went into gear. Compare Salgado's 'Archaeology of Industrialization' with Lewis Hine's early-twentieth- century indictment of industrialization's inhumane use of lives. Hine was a photojournalist who did affect injustices: his photographs of children in factor- ies and mills were so lucid and convincing that they can be credited with hastening the creation of America's child-labor laws. Salgado's work here, as in the Sahel, is too aestheticized, too caught up in itself, to fully acknowledge what's happening to others.

Within the workers series there is, however, one group of photographs that

stun the viewer – the pictures of miners in Serra Pelada, in Brazil. Like the Sahel images, these have immediate power. They can evoke awe and horror, for they are of an immense human spectacle: thousands of men working a gargantuan gold mine. Visions of such waves of labor and physical exertion, of a mass of men so jammed together that their backs and sacks and legs look like a repeating pattern, are the stuff of nightmares and of wonder. But even these powerful pictures reveal Salgado's reliance on cliché. There's one shot, for instance, that looks like a gloss on Michelangelo's Sistine 'Creation of Adam' and 'E.T.''s appropriation of it. When I first went to the 'Uncertain Grace' exhibition, I had just seen the film 'Spartacus,' and several of Salgado's other images recalled the more kitschy slave-crowd scenes in that movie. And his use of his favorite sign of the martyr and the miraculous – the cross – mirrors the climactic shots of Kubrick's movie, except that with Salgado there is no Tony Curtis and no Kirk Douglas.

When Salgado's admirers want to make the point that he understands what it is like to be outside the spheres of power, they bring up the fact that he lived in Brazil before moving to Paris. But since when did being a Brazilian qualify someone as the voice of Africa or of India – another assumption that creeps through the Salgado myth? A second aspect of Salgado's earlier life that buoys his reputation as a man deeply in touch with his themes is that he started out as an economist. Fred Ritchin explains in his text how Salgado made the transition from economics to photography: 'It was while on a work assignment [for the International Coffee Organization] in Africa that he decided, on the basis of initial attempts with a camera he borrowed from his wife, that rather than work at the remove of a social scientist he preferred spending more time with the people he was drawn to, photographing them. He found that he could depict them more vividly in photographs than in economic reports.' Vivid Salgado's photographs are, but the people in them, and the situations that he is supposedly penetrating, rarely are.

Actually, Salgado's most vivid image is one that is atypical of his work as it has progressed, and it's not about a subject that seems close to his heart. It's his 'lucky break' picture: an on-the-scene shot of the attempted assassination of President Reagan. Salgado was tracking Reagan on an assignment from Fred Ritchin, who was then picture editor of the *Times Magazine*, and the famous photograph that he took in the instant after the bullets were fired is in almost every way the opposite of the imagery that has led to his current acclaim. It looks like something from a whodunnit movie: the image explodes with energy and action. The punch of the Reagan image comes from our realization that here is a figure of megapower made vulnerable before our eyes. The photographs that have made Salgado's reputation also have punch, but it comes from the pathos of the lives of his subjects.

And therein lies his power over the viewer. This is photography that runs on a kind of emotional blackmail fuelled by a dramatics of art direction. Salgado undoubtedly gets away with so much because of viewers' sympathy and guilt.

What is more terrible than someone starving? What is more tragic than a dead child so thin that his or her body looks like a stick wrapped in a piece of cloth? Unless we have no heart, when we see such things something happens to us. The feeling can last for a moment, it can last forever; it can make us want to help, and it can make us actually help. Salgado's work has produced all these reactions, but I believe that this speaks more for the power of his subjects than for the quality of his work. Two photographs in the 'Kuwait Epilogue' exhibition were almost identical – of a bird covered with oil, drowning in it, as it were, since the bird could no longer fly. We had seen such images during the war; in fact, one just like it, taken by someone else, became a symbol of the madness that the Gulf War was. It is in keeping with Salgado's approach to his work that he picked up on such a 'button pusher' of an image. But the button pushing may not end there. Salgado used the phrase 'paradise lost' in a caption he wrote to go along with one of the bird pictures – and both his image and his reference to paradise reminded me of the more kitschy aspects of Eugene Smith's work. Smith used the phrase 'paradise garden' as a title for a photo-graph, one that ranks among his most famous – and schmalziest – images: two small children walk hand in hand, in a forest, their backs to the viewer. This is greeting-card stuff; it became the emblem of Edward Steichen's 'Family of Man' exhibition, and has been reproduced countless times in advertisements and as a greeting card. Some of Salgado's photographs have appeared in postcard form; as yet, they haven't been reproduced as greeting cards. But who knows? The manufactured poetry that is so dominant an aspect of his aesthetic could turn the people in the Sahel into emblems on greeting cards for all of us who want to express our humanity. These photographs are less than their subjects deserve. We can be sure that if truly appropriate images should ever surface they will not be so 'beautiful' that they could work as packaged caring. Salgado's sentimentalism, for all its earnestness, isn't any kind of breakthrough. Unfortunately, his champions aggravate the bullying quality of his work by presenting it as if it were the Second Coming.

Cynthia Chris

Witkin's Others

(First published in *Exposure* 26.1, Spring 1988)

Joel-Peter Witkin's work frequently prompts horror, disgust, outrage and accusations of perverted exploitation. Cynthia Chris's inevitably provocative essay is unusual in seeing Witkin as a Sadeian rather than a sadist and exploring his imagery accordingly.

The libertines arrange themselves in architectonic configurations, fuck furiously, discharge all together – all fall down. They have arranged themselves as for a group photograph, and it is the most complicated mechanics that must set the erotic machine in motion, mouth against cunt, cock in anus, tongue on testicles, finger on clitoris . . . Like a good housewife organising her store cupboard, Sade wants a place for everything and everything in its place in the regimented pursuit of pleasure.

Suitably garbed for these pornographic occasions in kitsch uniforms of gauze, assembled in voluptuous boudoirs or arranged like sacrilegious offerings upon altars of churches, the libertines perform extra-ordinary tableaux with well-drilled precision. Among this well-populated activity, there is as little room for intimacy as there is upon the football field.[1]

WITH LITTLE modification, Angela Carter's description of the finale of *The Hundred and Twenty Days at Sodom* by the Marquis de Sade (1789) could be applied readily to the photographs of Joel-Peter Witkin. Like Sade's characters, Witkin's models are arranged as for a group photograph, and it is the most complicated mechanics that must set the erotic machine in motion – arm in anus, clips on nipples, carrot on clitoris. There is no more room for intimacy here than upon the football field.

Witkin's altered photographs are representations of some of the most repressed and oppressed images of human behavior and appearance. His subject matter is usually sexual, often violent, and always 'perverse' in the simplest sense of the word, that is, contrary to that which is generally done or accepted. His models pose in tableau vivant style, forever frozen by the camera as living statuary. They run the gamut of possible human and non-human forms: fetus, child, male, female, hermaphrodite, corpse, skeleton, the beautiful, the deformed, the obese, live animal and taxidermic specimen. Usually nude, they are less dressed than entangled in hats, hoods, masks, wings, rubber hoses, flora, fauna, food, and sex toys. Thus accompanied by Witkin's equivalents to Sade's uniforms of gauze, voluptuous boudoirs, and sacrilegious altars, the models perform extra-ordinary tableaux of sexual, religious, and art historical iconography.

Roland Barthes described the photographer's activities as 'a whole gamut of "surprises" . . . for me, the Spectator; but for the Photographer, these are so many "performances." '[2] This description of Witkin's imagery takes into account this notion, whereby the construction of the photograph, from the initial encounter with a model to sessions in the studio and darkroom, is a series of performances of which the photograph is a document.

Witkin's search for models and props is described almost anthropologically, as treks that may take him to locations as obscure as a Florida retirement community for circus and carnival performers, where Witkin found *Melvin Burkhart Human Oddity* (1985), an elderly ex-prizefighter who, as a result of many broken noses, can hammer an eight-inch-long nail into his head without hurting himself.[3] Similarly, Witkin travelled to Philadelphia from his home in Albuquerque, New Mexico, to photograph a fragile wax specimen in a medical school's collection of oddities. Basing *Harvest* (1984) on portraits by the sixteenth century Italian painter Archimboldo, Witkin adorned the death-mask-like head with scallions, pears, a bunch of grapes, an artichoke and other produce, as a dialectical cornucopia of life and death.

In a decorative use of food similar to that in *Harvest*, Witkin strewed carrots from a health-food store across the backdrop and had his model use two as dildos in *Angel of the Carrots* (1981). Here Witkin invokes the relations between food and sex. The inclusion of edible objects in sexual activity could be a playful gesture or a reference to the nurturing and nourishing qualities shared by alimentary and sexual consumption. Or, read absurdly, the photograph could function as a sort of pornographic pin-up for a compulsively oral Bugs Bunny. But the passivity of the woman's pose makes this a disturbing image. Nude, masked, and wearing a cap that makes her appear to be bald, she sits amid more than a dozen objects that penetrate or seem destined to penetrate her, showing neither pleasure nor struggle. Despite her 'angel' status, she, like the carrots, is essentially a prop, another object to be consumed, visually and sexually.

Witkin also conducts a more or less ongoing search in the streets. His method is reminiscent of Vito Acconci's *Following Piece* (1969), but with significant differences. Acconci sighted subjects and tailed them, ending each segment of the performance when the person, still unaware of the artist's surveillance, entered a private building or car. The identity of each participant in the performance remained unknown to both the artist and viewers of the documentation of the piece. Witkin doesn't let go so easily; he has to catch them before they get away so that he can invite them to his studio. His luck is better at some times than others, however. He tells the story, in a somewhat embarrassed tone, of acquiring a phone number from someone he wanted to photograph; unfortunately Witkin forgot the prospective model's name and when he placed the call could only ask for 'the man without legs.' The call resulted in *Man without Legs* (1984).

Since the coffee-table publication *Joel-Peter Witkin: Photographs*, by Twelve-trees Press in 1985, Witkin's search for models has gone public. The afterword to the book is an open letter that reads like a shopping list, addressed to 'people

with unique interests or collections' or physical characteristics of interest to the artist, ranging from unusually large genitals to the wounds of Christ.[4] On at least one occasion, Witkin has concluded a public lecture on his work by reading the afterword, complete with post office box number, as a plea for volunteers.

One of the 'photographic performances' cited by Barthes and applicable to Witkin is the 'contortions of technique . . . (including) deliberate exploitation of certain defects.'[5] While the surfaces of Witkin's finished prints are pristine, the negatives are altered extensively during printing, although without collage or superimposition. He may distort the exposure or chemistry, and add or delete imagery by scratching on either side of the negative. An unwanted body part, like the forearm of *Hermes* (1981), is lopped off in this manner. Praxiteles' *Hermes and Dionysus* (c. 340 B.C.), after which Witkin's picture is modeled, has been damaged and suffers from many broken limbs, as do many Greek sculptures and their Roman reproductions. The amputation is reproduced painlessly by the photographer in his darkroom.

Three arrows scratched onto the negative of *Choice of Outfits for the Agonies of Mary* (1984) point to the model's vulva. They render the photograph maplike, as if all roads lead from the accessories of sadomasochism on the wall behind Mary, to her cunt. Having assumed a mannequin-like pose, she, like the *Angel of the Carrots*, waits passively surrounded by sex toys, among them, a paddle, a cat-o'-nine-tails, boots with stiletto heels, and a hood. Angela Carter offers this explanation of the meaning of sadomasochistic sexuality:

> The whippings, the beatings, the gougings, the stabbings of erotic violence reawaken the memory of the social fiction of the female wound, the bleeding scar left by her castration, which is a psychic fiction as deeply at the heart of Western culture as the myth of Oedipus, to which it is related in the complex dialectic of imagination and reality that produces culture. Female castration is an imaginary fact that pervades the whole of men's attitude towards women and our attitude to ourselves, that transforms women from human beings into wounded creatures who were born to bleed.[6]

The woman is reduced to one symbolic function of her genitalia: that of a wound, as the threat of castration for the male who recognizes sexual difference only in terms of her lack of a penis. Particularly threatening – and particularly desirable – to the male with castration anxiety is his own mother. All roads may seem to lead to her 'female wound,' as if it exists in order to provide some definitive validation of his masculinity, some ultimate primal experience of sex, yet she denies the possibility of the incestuous act with her ultimate unattainability. As for one's own mother, the unattainability of Mary reaches official status with her permanent, sacred, institutionalized virginity, which persists despite the fact that she has given birth. Like a child who knows where babies come from while he refuses to believe that his own mother has sex, Witkin can put Mary through the various 'agonies' of sadomasochism without violating her. *Choice of Outfits for the Agonies of Mary* seems to suggest the notion of literally taking a stab at one's inviolable mothers, biological and religious.

In addition to formal and technical elements, Witkin also adds textual overlays to his imagery. Like all artists, to greater or lesser degrees, Witkin is influenced and inspired by art history and inspired by specific works of art. Formal references to Joan Miró, for example, appear throughout his work. The flat, black, amoeba-like figures that populate Miró's paintings are echoed by the flat, dark shapes of the accessories – masks, head-dresses – that Witkin constructs to adorn his models, as in *La Brassière de Joan Miró* (1982).

But unlike most artists, Witkin is also a copyist who appropriates entire narratives as his own. Many of his poses, like *Harvest* and *Hermes*, are lifted directly from works by other artists. Of course, many of Witkin's contemporaries have taken art history as subject matter. Sherrie Levine, for example, has copied paintings by Miró, Egon Schiele, and Chaim Soutine, and photographs by Walker Evans, Elliot Porter, and Edward Weston; Mike Bidlo has copied paintings by Picasso, George Morandi, and Julian Schnabel, and staged re-enactments of such great moments in art history as a party at Andy Warhol's 'factory' and Jackson Pollock's infamous piss into Peggy Guggenheim's fireplace. Levine's work exists in a critical framework that examines notions of authenticity in relation to historical and market values, and Bidlo seems to be interested in a vicarious experience of what is generally regarded as 'genius.' Exacting reproduction is an essential characteristic of both bodies of work, while Witkin's work uses the original as a theatrical script. Under his direction, the image may be modernized, exaggerated, or parodied to achieve his desired effect, which is always less reproduction than re-interpretation. Models switch gender, as in *Canova's Venus* (1982), which is modeled after Antonio Canova's sculpture *Paolina Borghese as Venus Victorious* (1808). The original, in typical neoclassical fashion, was designed to attribute the features of a Roman deity to the subject of a portrait. By indulging in antique form, the artist could depict an esteemed lady as a seductive nude. This device now seems frighteningly ahistorical. Canova's *Paolina Borghese* takes on only the most refined qualities of a love goddess, but Witkin's is a messier representation. Rather than discreetly covering the model's genitals, here the drapery parts to reveal his penis. The sheet on which he reclines is stained with spots suggestive of blood. Witkin replaces modesty with campiness and respectful discretion with body fluids: appropriating from an appropriation, his picture both colludes with and subverts the meaning of its source.

In *Manuel Osorio* (1982), which is based on Francisco de Goya's portrait *Don Manuel Osorio De Zuniga* (1800), the model even changes species. The little boy is replaced by the corpse of a Rhesus monkey, the kind used in laboratories for experimentation, as well as by organ-grinders. Considering Goya's hatred of the vanities and vices of the royal families he served as court painter, the copy functions as a sort of exposé of his usually more tasteful treatment of subject matter he found objectionable. Unlike Goya, who was bound by his commission to be polite, Witkin is free to bite the hand that fed the painter, free to portray a privileged child as a screeching primate.

Witkin's models, partially screened from view by these formal and iconographical overlays, are objectified to the status of little more than props for still

lifes. It is difficult to believe that the substance of which his models are made is flesh, there is so little alive or sensual about them.[7] In fact, they are never so alive or sensual as when they are dead. *Le Baiser* (1982), in which the right and left halves of an elderly male corpse's head are placed nose-to-nose, lips touching in simulation of a kiss, contains a rare bit of intimacy, the tenderest moment of all found in Witkin's work.

The faces of *Le Baiser* are also rarities in Witkin's *oeuvre* in that they appear unmasked. Van Deren Coke remarks in his catalogue essay for the exhibition *Forty Photographs* that Witkin 'used masks so that the personality of the subject would not interfere with the meaning of an image.'[8] But it seems unlikely that a look at the model's face or eyes would reveal much that is not already articulated in the surrounding layers of information, in the gestures of the pose, in the facial features that are not concealed, and the items, including the mask, that the subject wears or uses. The mask does often obscure the model's identity, a condition without which many of them might be unable or unwilling to pose. The good citizen's fetish, or mere willingness to pose as if he or she had one, can remain private as long as he or she hides behind the shield of a mask.

But the mask serves a more complex function than anonymity. In sexuality, seeing precedes touching. Sexual knowledge, such as the recognition of gender difference, can be acquired visually, but sexual experience is acquired by actual physical contact with the body. From the tale of Oedipus we know that blindness is a metaphorical castration that denies sexual experience, in particular sexual activity that is considered illicit: Oedipus put out his own eyes after realizing that the woman he had married was his mother. He found himself guilty of incest, although neither partner knew of each other's 'true' identity at the time of their intercourse. Witkin, likewise, puts out the eyes of fetishists, hermaphrodites, homosexuals and others guilty of sexual irregularity who appear in his photographs, either with a device worn by the model or by scratches made directly on the negative.

In effect, Witkin castrates his subjects; his scrawls on their faces are equivalent acts of violence. The eyes of the subject remain intact but the mask or the marks do interrupt access to the power of sight. No longer capable of looking back at the photographer, the model becomes effectively impotent, an object of the photographer's gaze. *Hermes* faces the viewer, but his ability to return the gaze, which is usually a feature of the frontal pose, is negated by the marks drawn over his eyes. He is left, literally, without a point of view. The mast functions as yet another layer of material placed between the subject and the object, between the photographer, viewer, and model.

So it is the mask that robs the model of subjecthood and turns him or her into an object, and by doing so the mask protects the viewer. In pornography, the proximity of the model to the camera allows the viewer to close in on her, to imagine himself as a participant in the sex act on display: the Playmate-of-the-Month gives that come-hither look. The camera fragments her body in close-ups and beaver shots not only as an act of violence, as many critical writings on pornography contend, but in the interest of realism, because that is

one's perspective on the lover's body during sex. In Witkin's pictures, how-
ever, the object is framed so as to maintain distance from the viewer. The
viewer can look at the model without this illusion of participation. What might
have become a sexual exploration remains a visual investigation for the viewer.

Even the eye of the crescent moon face in *Woman Masturbating on the Moon*
(1982) must be covered to divest him of the power of the gaze – perhaps to
protect *him* from the sight of *her*. Masked, the moon is unable to see the
woman's genitals, though she straddles him so that her vulva is located precisely
at his eye level; thus he remains unaware of her lack of a penis. In this instance
of masking-blinding, Witkin has devised a means for the woman to take her
pleasure without revealing to her lover the 'wound' that reminds him of the
terrifying possibility of his own castration.

The masks in *I.D. Photograph from Purgatory: Two Women with Stomach
Irritations* (1982) blind the models but then double back to deny their castration.
The women (one's 'stomach irritation' is her advanced pregnancy; the other's
her recent surgery) wear huge anvil-shaped head-dresses, protective shields that
completely hide their faces. Their own eyes are replaced by eyes on the masks:
three on one, four on the other. The fetal corpse in *Counting Lesson in Purgatory*
(1982) wears a similar mask, with one huge cyclopean eye replacing its own.
Ironically, these subjects, each generously endowed with extra (or extra-large)
eyes, have been assigned to purgatory, a realm of punishment and penance.
Their only known transgression is their extraordinary access to the power of
sight.

It might seem that such attention to the assemblage of peculiar performers,
the collection of unusual props, the construction of elaborate sets, and the
adoption of complex narratives would preclude if not theater, certainly its
stepchild, performance art. But Witkin's work is, above all, about repres-
entation. His interest lies not simply in bringing to life the figments of his own
imagination, but rather, in his own words, in the portraiture 'not of people, but
conditions of being.'[9] Witkin's photographs document his investigations of
certain human experiences, providing a lexicon of sexual identities and prac-
tices: the transsexual, the androgyne, the fetishist, the sodomist, the masturb-
ator, the homosexual, the masochist, and others whose sexuality is not
encompassed by 'normal' heterosexuality. As a photographer, Witkin has taken
on a task much like the one that the medical and psychiatric community has
assigned to itself since the nineteenth century, and with much the same
meaning: the classification of the variations within sexuality and the manage-
ment of individuals whose behavior is considered aberrant.

According to Michel Foucault, psychiatry undertook these tasks at a time
when organized religion was losing its power to enforce a morality that would
contain sexuality within conjugality. The doctors stepped into a field where
canonical (and, by extension, civil) law threatened to lose control over those
whose sexualities were condemned as un(re)productive. They would shift the
focus of the discourse on sexuality from the forbidden sexual act – the 'sin' – to
the marginalized sexual identity – the 'pervert.' For example, Foucault writes,
the 'sodomite had been a temporary aberration; the homosexual was now a

species.'[10] This 'incorporation of perversions and new specification of individuals'[11] is described eloquently in Jean-Paul Sartre's biography of Jean Genet. Genet was condemned, Sartre explains, not merely because he stole or because he had male lovers, but because he

> is a thief [and is a homosexual], that is his truth, his eternal essence. And if he *is* a thief [and a homosexual], he must therefore always be one, everywhere, not only when he steals [or commits sodomy], but when he eats, when he sleeps, when he kisses his foster mother.'[12]

This process of classification propelled Genet into a realm occupied by the criminal, the pervert, and various disassimilated individuals: in short, all those who constitute the Other. Later, when Genet became an artist, writing poetry and plays, he never spoke to us '*about* the homosexual, *about* the thief, but always *as* a thief and *as* a homosexual He [invented] the homosexual subject.'[13] With Genet, the object acquired a voice, a point of view; as one who spoke, one who saw, the object became a subject.

Witkin's relation to the Other in his photographs is no such invention. Unlike Genet, he does not invert subject and object; rather, Witkin's photographs incorporate the perversions, they specify the individuals. Each image constitutes a category of Otherness, represented by a marginalized identity whose practices violate the codes that are meant to regulate behavior within society. Witkin is, as Sontag said of Diane Arbus, 'a photographer venturing out into the world to *collect* images that are painful.'[14] Both produced images comprised of 'found' objects from the streets and back alleys; both have used photography to visit the Other and to hold it up like a specimen at a safe distance. Neither speaks to us *as* the Other, but always *about* the Other.

Witkin differs from Arbus in that he is not content with the photographic image's ability to tell the story of each member of his collection of Others. He not only selects the object and photographically documents his (visual) intercourse with it, but continues to act on it, to transform his visual experience by touching the image, by drawing on the photograph. And throughout, he remains at a safe distance. His intercourse with the picture (and, he has stated, his intercourse with his models during the early part of his career) is a commentary on the Other which is its object. It is a performance which allows him to play the role of the Other by playing with it.

Witkin assumes the role of the Other like a white actor in blackface. His lectures, interviews, and publications seem to be performative attempts at self-mythologization. He takes care to publicize the somewhat beleaguered circumstances of his own childhood: his father was an orthodox Jew, his mother a devout Catholic; they divorced over religious differences. His mother's name is Mary, which, rather than mere coincidence, is cited as a source of inspiration for images such as *Choice of Outfits for the Agonies of Mary*. Not the least of Witkin's autobiographical anecdotes is his recollection of witnessing, at age six, a particularly gory automobile accident in which a little girl was decapitated. This event seems to have influenced much of his work, in which images of dismemberment are not uncommon. Yet Joel-Peter Witkin

denies his own perversions and assures us that he is 'normal' enough by mentioning that he is a family man and that he no longer engages in sex play with his models after a photo session, 'but that now he puts all his energy into the negatives.'[15] Like the white actor at the end of the minstrel show, Witkin washes off the Other.

In a culture where sex and death appear with numbing pervasiveness in the news, in pornography, in mass media entertainment, and in advertising, a constantly higher dose of the drug sensationalism is required in order to get any response at all. Witkin has produced imagery that constitutes a very pure form of that drug; in fact, one that may be too strong for many of its usual takers. Initially enticed by the dare of a warning label – even one that is not spelled out – some viewers find Witkin's work too full of images that they have long tried to repress. Some of his most explicit and violent images were not included in the exhibition *Forty Photographs*, perhaps out of consideration for the unprepared gallery- or museum-goer, but, ironically, the label on the cellophane-wrapped Twelvetrees monograph is less a warning than an apology. It reads:

> Due to present censorship factors, the publisher and I have not included several important photographs in this presentation of my work.
> — Joel-Peter Witkin

The book reproduces *Arm Fuck, Testicle Stretch with the Possibility of a Crushed Face* (both 1982), *Autoerotic Death* (1984), and other brutal images; the viewer is left wondering what could possibly offend a censor for whom these images are not too explicit or too controversial. These photographs not only fulfill the viewer's voyeuristic impulse, or desire for a certain amount of horrific imagery; they embark on a full-blown exploration of the dark side, the underside, and the backside of the Other that proves much too grotesque and terrifying for many a viewer.

The pre-operative transsexuals that appear throughout Witkin's work are among the best examples of what happens when one confronts a photographic portrait of the Other's 'condition of being.' Unlike paintings, which can consist of imagery totally fabricated in the artist's imagination, a photograph always brings its referents along to at least some extent. Lurking behind the two-dimensional image hanging on a gallery wall is a real live transsexual, or a real live woman cradling an actual cadaver's head in her arms, or a real live man hammering a nail up his nose. In these pictures, the viewer, first, is given an opportunity to look at a body different from his or her own, a body with full breasts and feminine facial features as well as a penis and testicles. The viewer can even compare the stages of transformation from male to female: the model for *Botticelli's Venus* (1982) has hair on his/her legs and stomach but none on his/her chest; the models for *Madame X* (1981) and *Helena Fourment* (1984) appear to have had all their body hair removed. But the pictures reveal more about our relationship to the transsexual-as-Other than they do about transsexualism itself; they give us an opportunity to examine the meaning of that transformation and the attitude that motivates the voyeurism aimed at the

models. Although Foucault did not specifically discuss transsexuals, he did remark that 'for a long time hermaphrodites were criminals, or crime's offspring, since their anatomical disposition, their very being, confounded the law that distinguished the sexes and prescribed their union.'[16] Those whose sexual preferences confound that law continue to be considered criminals in many states to this day,[17] and those whose anatomy works in tandem with their sexual preference to confound it may be deemed members of the 'wrong' gender by the medical and psychiatric communities, which then may set out not only to 'cure' but to 'correct' the aberrations by means of therapy and surgery. The subject is moved out of some category of Otherness and into some semblance of 'normal' sexuality.

Witkin's crew of libertines perform extraordinary tableaux, and then retire to where they are no longer libertines pursuing sexual freedom regardless of gender or one's personal taste in matters of pleasure. They return to the status of documented, factionalized individuals who are to be corrected or controlled, divested of a voice, effectively castrated, diagnosed according to their perversions, and relegated to the mental institution, the prison, the red–light district, the freak show, the pornography industry, the gay ghetto, the closet, the art object – in short, to the margins of the culture into which all the oppressed are propelled – into the realm of the Other.

Nan Goldin

The Other Side

(Extracted from *Die Andere Seite*, Cornerhouse, Manchester, 1993)

Nan Goldin's 1986 photo-book *The Ballad of Sexual Dependency* positioned her as one of the most incisive photodocumentarists of the 1980s. Abandoning documentary photography's traditional stance as dispassionate observer, she explored her own drama, making a tangential autobiography which influenced and informed a generation of photographers. In this introduction to her 1992 book *Die Andere Seite* Goldin stresses the communality of experience and artwork.

THIS IS A book about beauty. It's about my love for my friends. I first saw them – Ivy and Naomi and Colette – crossing the bridge near the Morgan Memorial Thriftshop in downtown Boston. They were the most gorgeous creatures I'd ever seen. I was immediately infatuated. I

followed them and shot some super-8 film. That was in 1972. It was the beginning of an obsession that has lasted twenty years.

Soon after, I met them again through David, my closest friend, who had started to do drag. From my first night at *The Other Side* – *the* drag queen bar of Boston in the '70s – I came to life. I fell in love with one of the queens, and within a few months moved in with Ivy and another friend. I was eighteen, and felt like I was a queen too. I was completely devoted to my friends; they became my whole world. Part of my worship of them involved photographing them. I wanted to pay homage, to show them how beautiful they were. I never saw them as men dressing as women, but as something entirely different – a third gender that made more sense than either of the other two. I accepted them as they saw themselves; I had no desire to unmask them with my camera. Since my early teens, I'd lived by an Oscar Wilde saying, that you are who you pretend to be. I had enormous respect for the courage my friends had in recreating themselves according to their fantasies.

There was a wide range of gender identities among my friends. Several were pre-op transsexuals, others, like Ivy, never wanted to be women but were into the act of glamour, the fashion. For Naomi, gender was completely malleable: some days she was Naomi, other days he was Frankie. There were several other girls who hung around the queens in those days: Pamela and Naomi were lovers, off and on, and from what I've heard they are still together now, twenty years later; another girl, Susan, was once arrested for female impersonation! During that time I looked in the library for anything written about women who fall in love with drag queens. I found one chapter in an abnormal psychology book from the '50s which said that we were so perverse as to be unclassifiable.

During the two years my friends and I lived together I took pictures of them almost daily. When we picked up the 3 × 5 snapshots at the corner drugstore there was always a competition to see who had the most pictures of themselves in the pile. We went to *The Other Side* every night except Tuesday, even on Thursday for the Bologna Buffet. On Monday nights the queens got into full drag for the Beauty Parade where Boston's legendary M.C., Sylvia Sydney, addressed the audience while the queens modelled and a jury awarded trophies to the most glamorous contestants. Those were the days of cocktails and the nights of *White Russians* and *Golden Cadillacs*. To survive, some of the queens collected welfare, some turned tricks, others sewed costumes for each other or sold antique clothes they found at thriftshops. There were no job opportunities in those days for people who lived in drag; they were even ostracized by most of the gay male community. I supported myself in a Beacon Hill pharmacy serving pills to blue-blooded ex-debutantes. My aspiration was to be a fashion photographer; my goal was to put the queens on the cover of *Vogue*. I started taking a photo course at night, and had my first show in the basement gallery in Cambridge, Mass., in 1973. All my models came to the opening in full drag.

In 1974 I moved out and started going to art school full time. After learning more about technique and equipment, I went back to photograph

my old world. But it didn't work; I was an outsider, it was no longer my home.

In the 1980s two of my closest friends were transsexual. Both were completely absorbed into their gender choices as women and each married her boyfriend. One was a top model in Paris in the mid-'80s and won Girl of the Year. They had my deepest admiration for undergoing surgical re-creation. One of my friends once described to me from her own experience the difference between a male and a female orgasm. That seems to me an enviable wealth of experience to have in one lifetime – to have been in the world in two different skins. But that same friend who changed sex from male to female in her early twenties told me she sometimes regretted the surgery because she felt it was, in part, a way to try to fit into normal society's version of gender – and it takes more courage to remain a queen.

I met a whole new crowd of queens in N.Y. in 1990, again through my friend David and our friend Bruce. My old obsession was reawakened. I developed one fixation after another. I photographed my new friends constantly – at Wigstock, the bars, the dinner parties where I gave slide shows for everyone in the pictures. My relationship to these queens is different; now I am the older one. The social setting has also changed – they are not as marginalized as they were in the '70s but are more incorporated into and appreciated by the gay community. Many have jobs – in bars, and clubs, as make-up artists and hairdressers; some are models in *Vogue*. An old friend saw my new photos and said she felt my 'shock of recognition' in the pictures. I was home again. After years of experiencing and photographing the struggle of the two genders with their codes and definitions and their difficulties in relating to each other, it was liberating to meet people who had crossed these gender boundaries. Most people get scared when they can't categorize others – by race, by age, and, most of all, by gender. It takes nerve to walk down the street when you fall between the cracks. Some of these queens shift genders daily – from boy to girl and back again. Some are transsexual before and after surgery, and among them some live entirely as women while others openly identify themselves as transsexuals. Others dress up only for stage performances and live as gay boys by day. And still others make no attempt at all to fit in anywhere, but live in a gender-free zone, flaunting their third sex status.

The plague of AIDS has affected this community. One of my closest friends in the pictures from the '70s died a few years ago. Due in large part to the AIDS crisis, the attitudes of my friends in the '90s have shifted. The previous glorification of the glamour of self-destruction and substance abuse has been replaced with a will to survive. Some of the queens in these pictures are in recovery from drug and alcohol addiction.

In the last years I've learned more about the varieties of desire that can't be compartmentalized, that can't be defined as either gay or straight. I've met other women who are infatuated with queens and transsexuals but I still haven't found a definition. There is a sense of freedom in having a desire that has never been labelled. As a bisexual person, for me the third gender seems to be the ideal. I've met Kai Kai queens who fall in love with each other.

Some of my friends now have boyfriends. These are not the kind of affairs built upon desperate feeding like those with most of the johns who hang around transvestites. These are real relationships based upon mutual desire and respect.

While living in Berlin in 1992 I had the opportunity to travel to Asia with a German film-maker to work on a documentary about male prostitution and gay culture in Southeast Asia. We spent one month in Manila and three weeks in Bangkok. I made new friends among the many young queens I met. I spent my nights in the bars where they worked modelling, singing, dancing, sometimes stripping, sometimes entertaining customers. In Manila I saw a queen who ate fire, contortionists, and a long skit that involved two men beating up queens for comic relief. One friend took me home to meet her family where she and her boyfriend live with her parents and brother and nieces and nephews. Another teenage queen supports her parents and five siblings in the provinces with the money she makes in her show. These queens haven't been alienated from their families in the way most of the queens I know in the western world have been. In Bangkok the bar workers were aware of and talked about AIDS, and practised safe sex, but in Manila, due to the influence of the Catholic church, I detected widespread denial about the realities of AIDS. The bar *Second Tip* in Bangkok reminded me of *The Other Side*. The queens were beautiful, the shows were lavish productions with numerous costumes. The older queens didn't retire; they managed the bar and performed comedy routines on stage. In Manila they called me 'mother', in Bangkok 'sexy grandma'.

This book is about new possibilities and transcendence. The pictures in this book are not of people suffering gender dysphoria but rather expressing gender euphoria. The people in these pictures are truly revolutionary; they are the real winners of the battle of the sexes because they stepped out of the ring.

Lauren Sedofsky

Time Exposure: The Photographs of Patrick Faigenbaum

(First published in *Artforum*, February 1992, New York)

Patrick Faigenbaum's (1954–) austere portraits of Italian aristocratic families have received wide critical attention. In this essay, Lauren Sedofsky attempts to locate Faigenbaum's methodology within a post-modernist critical context.

NOTICE HOW the seemingly neutral observation that the photographic image retains a trace of something real has evolved in the course of the century into an exquisite thanatology. No sooner is the brevity of this real physical contingency evoked than reality is given up for dead and buried, withdrawn into a vanished past, irretrievable. The mourning and melancholia of Roland Barthes' *Camera Lucida* is only the most sustained, perhaps delirious, example of an understanding of photography as the experience of mutability. It is as if the ideals of Modernism and a radical epistemological pessimism had so divorced us from reality that a flash of the world necessarily set into motion a passing bell.

How do we escape from this infernal preterit, the tense that Barthes so convincingly ascribed to photography? More intricate time relations become apparent as soon as the medium is regarded as a reproductive process. For the imprint, the negative trace, already selective and reactive in what it retains and preserves of refracted light, determines a point of departure for a potentially endless propagation, not in dumb duplication but in a forward movement, through a multiplicity of possibilities, toward an unpredictable singularity: the photographic image. Henri Bergson's idea of 'duration' has returned with a particularly contemporary resonance in the proliferative configurations of molecular biology and chaos theory. But it can be read with equal justification both in the ongoing photographic procedure and in all photographic images, in their incessancy, their dilation of the present moment to encompass an enduring past and a virtual future. Some photographs, however, possess a unique capacity to force a confrontation with duration and, in this way, become entirely emblematic.

In Patrick Faigenbaum's photographs of today's Italian nobility at home in their ancestral Renaissance and Baroque palaces, many might be tempted to see only the voyeuristic pleasure of the voyager-esthete, given to Jamesian ruminations and the worst kind of nostalgia. A dubious pleasure from which none of us is exempt. But something in Faigenbaum's estrangement from all traditional

or commercial principles of portraiture should alert us to a more ambitious aspiration. While it would be absurd to compare him to Nadar or August Sander, for neither characterization nor typology is his intent, he shares with these giants of photography a fearlessness both of the incremental oeuvre and of the long run. His portraits from Naples (1990–91), following those from Florence (1983–84) and from Rome (1985–87), mark only an estimated mid-point in an open-ended course that will extend to Palermo, Syracuse, Noto, and, finally, Venice, where the project was first conceived. Far from the instantaneous and the incidental. Faigenbaum's itinerary injects a temporal dimension into the tracing of a social phenomenon: a rarefied class, its cities, its families, its family members. Suddenly the photographic series parallels and supports an enumeration, an inventory, a census, an index, in 'figure' work never meant to totalize but only to locate the specimen, collect the sample.

What is exceptional in this enterprise is not just the way it recalls the missions, the documentation, the archives that constitute so much of the wealth of nineteenth-century photography, but its overt defiance of the notion of the pastness or the passing of the past. For Faigenbaum has taken as his subject precisely those preeminent symbols of the past that are *still there* and *not about to disappear.* The extant, not the extinct. The lasting, not the last. In edifices built for eternity and the queer genetic persistence of the families that built them, he has found the most potent and poignant evidence of endurance. The endurance of the past in the genetic trace. Like the endurance of the past in the photo-graphic trace.

Much of what startles in these photographs resides in the quality of an encounter. The experience of the pose, so legible in the exactitude of the pictorial organi-zation, lingers in a remarkable *face à face.* To say that Faigenbaum's implicit presence provides an overwhelming counterweight to the image in no way does justice to his thorough subjugation of his subjects. Rarely has a photographer displayed such Velázquez-like temerity, rarely has he exacted such unequivocal attention. The irony of this call to order from outside the frame derives not just from our contemporary acceptance of the artist as the only authentic aristocrat, but, much more forcefully, from Faigenbaum's real identity. Born in 1954, French, Jewish, of modest origins, this uninvited outsider has assumed the role of demiurge and effected a necessary and welcome reversal in the social order. For his fascination with these people bypasses glamorizing and goes straight to the strangeness of what they represent: vestiges, witnesses, traces.

In this minirevolution a freedom is born to fashion a portraiture that entirely rejects our ordinary assumptions about photography's unique suitability to convey a probing likeness. Refusing proximity, Faigenbaum breaks with the fetishism of physiognomy, posture, and gesture. Personalities, individuating characteristics of all kinds, seem to yield to a conception of the human figure in its stark self-evidence. The rare exceptions – a young woman's bowlegs, an oddly crooked smile, an ill-fitting suit – emphasize only the body's recalcitrance, its refusal to obey the laws of an ideal vacuity. Such a harrowing expressionless-

ness recalls nothing so much as the films of Robert Bresson. Like Bresson, Faigenbaum will use the body's status as a cipher in intricate permutations with its surroundings. Like Bresson, again, he will insist on this divestiture as a way of carrying the figure to a plane (is it higher or lower?) both far nobler and more generic: the human, the purely human, with its endless, impenetrable pathos.

Faigenbaum transfers the myth of human interiority to the domestic interior. A hallucinatory, transtemporal humanity inhabits these extraordinary spaces, in which the human figure stands as only one more point of refraction. Why do we feel so compelled to call these photographs 'theatrical'? Yes, the photographic frame doubles as proscenium, the architectural perspective defines a stage, and decoration provides significant props. But these conversation pieces renounce narration or calculated relationships, and isolate the human figure. Here Diderot's 'paradox on the actor' – who is unavoidably himself while 'playing' the character – shifts meaningfully into the paradox of self-representation. In the staging of what may look to some like incipient drama, Faigenbaum has acknowledged a debt to Giorgio Morandi, and his scenography indeed evokes not so much the *tableau vivant* as the still life, the philosopher's genre, according to Diderot, a representation of the disparate in an infinitely complex relay of relations. If this is theater, it is the theater of Brechtian distantiation: a leveler of social hierarchy, a subverter of the dramatic, offering inventories of material conditions and promoting our estrangement from them. Something fundamental about photography is being advanced here. For the 'stop action' so evident in these images amounts to nothing more and nothing less than an interruption of the pose.

At the very heart of the matter in the photographs of Florence and Rome is Faigenbaum's obsession less with the people than the places. While portraiture in a setting may bring to mind Bill Brandt or even Emmet Gowin, the overwhelming preponderance in Faigenbaum's work of spaces laden with connotations critical for the history of art forces us to recognize a more powerful premise: the camera's confrontation with Baroque space. Had such decors not existed, Faigenbaum, like many contemporary photographers, might have had to invent them. In their endurance, these interiors transport across time the historical determinants of a certain idea of the 'pictorial' that the photographer can 'find,' embedded in real material circumstances.

Not that this choice of decor represents an escape from photographic formalism simply through an appropriation of older artistic canons. Faigenbaum isn't trying to *be* Baroque. The placidity, the frontality, the orthoscopic classicism of his images, their apparent 'straightness,' refutes any such hypothesis. But in his obvious effort to harness immensity, to emphasize recession, to underscore backlighting, frame frames, and play with the dissolving of form into shadow, he locates the vital elements for a demonstration of the clarifying effect specific to photography, the medium's optical otherness from the ideal geometric conventions of the camera obscura, so often mistaken for the

camera's forebear. Faigenbaum's insistent inclusion of illusionistic painting inside the photographic image takes on special interest, not as a reminder of ancestral proprietary prerogatives or a recapitulation of the scene, but as a point of demarcation between utterly different registers. His photographs absorb the paintings, their sometimes inordinate dimensions and the immensities they depict (a neat conceit), translating them into the new, abstract 'organicism' of black-and-white tonal gradation. What the Baroque offers Faigenbaum that is absolutely modern, however, is the charged environment, the abundance of detail, that refuses easy allegorizing but imbues the imprinting with the evidential compulsion of pure multiplicity. It is this profusion that permits him to convert portraiture into a synoptic, transgeneric genre, a compendium of portraits, architectural photographs, reproductions of works of art (he has done a series of Roman busts), estate inventories, still lifes (he often enlarges details), and, in Naples, implicit landscapes.

Distantiation demands an expansive time for reflection. So does deep focus. The long exposure – necessary when the lens is maximally closed for greatest depth of field – sections off a region, not of space, but of time, an extensive here and now. This continuum is what the eye explores in the photographic image's incessancy, as it is routed and rerouted through unidentifiable interacting planes, nonlocalizable connections. What Walter Benjamin saw as the aura of the light-dark continuum takes on its full significance in this temporal density. Time spreads across a room in Faigenbaum's photographs, hangs there, with almost palpable materiality. That the human figure should seem devoured by its surroundings results less from real architectural disproportion than from an incorporation into this dimension. A throbbing, a vibration, runs through the figures, the art, the architecture, the furnishings, denying any distinction between animate and inanimate. An ornate lamp, a sofa's velvet cushions, a piece of sculpture, appear as portentous as those temporary tenants of the premises, caught in a genetic mystery. The time continuum, in the way that it elicits both retrospection and prospection, forces us to conclude, as anyone who has ever walked through a *palazzo* must, that the *camera* is a camera: an astonishing repository of centuries of traces, held there in an immutable simultaneity. The rightness of Faigenbaum's conception lies in the metaphoric singularity of this space.

A good deal of the conception of Faigenbaum's photographs rests in the laborious extraction of a singular configuration of relative tonal values from the information stored in the negative. Just as any genetic inheritance holds a range of possibilities before producing a singularity, everything depends here on the future of the trace. Curiously, just this experience of the negative seems visualizable in the extreme darkness of the Florentine and Roman photographs. As if stressing photography's necessary conversion of rigid matter into light-shapes, and the fragility of modulating their luminosity, Faigenbaum plays it close to the edge, nearest the recession of form back into obscurity. Sources of light within the image, however highlighted, seem unable to radiate, unable to

penetrate the overall penumbra. Yet an eerie distinctness cuts through even the most shadowy zones. A potent dose of artistry is to be found in the sumptuousness of these prints.

What happened in Naples really happened only much later, in Faigenbaum's Paris studio. By 1990, most of the Neapolitan aristocracy, much to Faigenbaum's surprise, had long since abandoned their cavernous reception rooms for far humbler quarters. Something in the new, unavoidable proximity of these smaller spaces loosens Faigenbaum's iron grip on his subjects. The poses become more natural. Under Michael Fried's influence, he attempts to detach their gazes from his own vantage point, occasionally encouraging them to withdraw into a pensiveness, even to stare out of the frame. But the irony of influence resides in its unpredictable course. For Faigenbaum's interest in 'distance' and 'time' must, inevitably, surface in a powerful visual form. And it does: in an 'absorbent' surface. Between the spectator and the trace of the real world falls a veil, a scrim, a 'film.' It is as if the numerous open windows in this series were admitting not only the southern light, but sand, stone, and volcanic ash, traces of the ongoing erosion of the coastline. An undifferentiated gray pulverization, of indeterminate depth, floats in the foreground of the image. The density of depth, so striking an emblem of time in the photographs of Florence and Rome, has been displaced, condensed in a depth of density. It is the spectator now who must take some distance in order to retrieve a scene in which the figures have acquired a kind of sculptural, hyperreal relief. To say that there is a groping here for some photographic equivalent of painterly surface seems grossly inadequate. What we are looking at resembles nothing so much as the negative's granular light-sensitive chemical substance in its uncertain, unstable interaction with refracted light. We are, so to speak, inside the camera, witnesses to the dissolving of the physical object into the physical trace. Photography's principle is figured here, in the tension between a 'being there' and 'not being there,' in the oscillation between some clear, transparent vision and an 'absorbing' of the most distant planes.

The milky diffusion of light in the photographs of Naples comes down, in the end, to an afterglow in the darkroom: a pushing of the film, a matt, veiled paper, an extra painted dot to enhance relief, and a third, crucial exposure of the print to ambient light. Between the first exposure and the print, Faigenbaum makes absolute claims on a time-consuming hiatus. What 'has been,' the parcel of reality that launched the whole affair, turns out to have been unknowable, indiscernible, inconsistent, all along, waiting to be revealed, at last, in the photographic image, as what 'will have been.' If photography's generative power has a tense, it is the future perfect.

Jan Avgikos

Cindy Sherman: Burning Down the House

(First published in *Artforum*, January 1993)

It is over a decade since Cindy Sherman began to establish herself as a major photographic artist, a doyenne of the postmodern circuit. Other critics included in this volume – Abigail Solomon-Godeau, Meaghan Morris – have identified the exclusion or occlusion of feminism from the postmodern debate, along with a subsuming of feminist art practice into an agenda which sidelines women. Here, Jan Avgikos aims to retrieve Sherman's work from that process of denial by demonstrating its anchorage in feminist theory.

CONSIDER THE many genres Cindy Sherman has developed in her photographs – film stills, fashion photos, fairy tales, art-historical portraiture, scenes of dummies deployed in sex acts. Consider, too, the critical discourses engaged in her work – deconstructive post-Modernism, the photograph's dialectic of absence and presence, theories of representation. Consistently, Sherman's photography is positioned in the convergence of discourses, rather than squarely in any one of them; and in that convergence, the feminist content of her work emerges. Like her rehearsal and performance of permutations of (her)self, the many feminisms that have been read into her work mirror both shifts in feminist thinking over the years and the current, internecine struggles over sexuality and representation that are erupting within our communities.

Skirting the fray of clashing feminisms, many critics still disclose an entrenched resistance to the idea that Sherman's motifs and thematics are embedded in feminist theory rather than incidental to it – they still recast her gender polemics as a grand concert of 'human' (and 'human' always means 'male') desire. But the cleansing of feminist commentary from Sherman's photography is symptomatic of the very problematics that her work addresses. For example, if we acknowledge femininity as a discursive construction, how can we authentically construe a feminine esthetics and identity apart from the patriarchal framework upon which they are grounded? Rather than assuming a given femininity, Sherman dislodges the operations that have historically defined and imposed the feminine as a social category. Indeed her latest schlock-shock images displaying the broken-down merchandise of a medical-supply house – plastic mannequins endowed with anatomically correct genitalia macabrely animated in pantomimes of sexual fantasy – are emphatically interventional. Hardly indemnified by political correctness, these grimly humorous vignettes deep-throat the politics of pornographic representation. Yet despite their

fun-house horrors of freakish hermaphrodites, postmenopausal Medusas, and decapitated Herculeses, these peep show pictures never stay put as clever carnal cartoons, or even as allegories of alienation. Instead, the seemingly minor questions they raise – Can photos be porn if they don't pass the 'wet test,' if, indeed, the bodies are plastic? – are inseparable from larger, more urgent ones: is the social economy of pornography different from that of art? Is porn antithetical to feminism? Do women see 'differently'?

By framing such questions as dependent on distinctions between artifice and the real (distinctions on which she has long staged her investigations), and by inscribing them within the pornographic, Sherman integrates female identity, representation, contamination, and taboo. By presenting images that ask what's OK, and what's not, in picture-making, fantasy, and sexual practice, she opens wide the Pandora's box that polarizes contemporary feminism. The women crouching as if in fear of discovery, and the plundered female bodies abandoned to vacant lots, in the earlier series, and now the titillating p.o.v. shots of dry, cold sex can only partially be explained by moralizings on the victimization of women in society. For the problems of oppression and objectification that surround pornography do not reside exclusively in the image, but in the very act of looking, in which we ascribe sexual difference.

When we look at photographs, it is through the eyes of the photographer, understood as occupying a masculine position, that we see. The implicit aggression of the photographic act – *aiming* the camera, *shooting* the picture – is literalized when the image examines the female body. In Sherman's photographs, however, active looking is through a woman's eyes, and this ambiguity makes them both seductive and confrontational. Sherman demarcates no privileged space for the female spectator per se, yet the role in which she casts us, as both viewer and subject, parallels the defamiliarizing effects of plastic dummies having real sex. Automatic scopophilic consumption, whether narcissistic or voyeuristic, is interrupted. By rendering the body problematic, and exposing what is conventionally hidden, Sherman infuses the desirous look with a sense of dread and dis-ease.

Sherman heightens the spectacle of the sexual act by isolating genital parts and coding them with fantasies of desire, possession, and imaginary knowledge. The instrumentality of these photographs lies in their tantalizing paradox: offering for scrutiny what is usually forbidden to sight, they appear to produce a knowledge of what sex looks like (hence Sherman's subtle humor in using medical dummies), but simultaneously are not real. The dummies diminish the sense of pliant flesh, distancing the spectator from the body, yet props such as luxurious fabrics focus sensuality. Positioned close to the picture plane, the models invite an intimate viewing relationship. And their placement in splayed, supine, or kneeling positions elicits a fantasy of sexual penetration, even though they are not real.

Many women feel that there is literally no place for them within the frame of porn. Perhaps the most extreme case against pornography is made by Andrea Dworkin, who holds 'pornographers' responsible for 'eroticizing inequality in a way that materially promotes rape, battery, maiming, and bondage,' and for

making a product 'that they know dehumanizes, degrades and exploits women.'[1] Would Sherman's photographs of dummies qualify as pornographic, even though they aren't 'real'? Actually, the 1986 report of the Meese Commission specifically links porn to what is unreal: it is 'representation' of sex that is the problem, not sex itself. To the writers of the report, as soon as sex is inscribed, as soon as it is made public rather than private, it changes in character, regardless of what variety of sex is portrayed.

The underlying logic, as Avital Ronell has remarked, is one of contagion, of 'exposing' people to a contaminant.[2] This is another way of stating the problem with mimesis: an imitation of reality produces the desire to imitate. It is 'representation' that contaminates, and from which women must be protected. The irony is that woman herself has long been identified with the problems of mimesis, representation, and contamination. And when it comes down to it, we know that what censorship really protects is the so-called majority's self-image of normalcy, and that woman, as Ronell observes, is merely a symptom of the law. We know, too, in Pat Califia's words, that within the narrow range of acceptable sexual behavior, nobody comes out looking normal once you know how they fuck and what they think about when they're doing it, and that the totalitarian insistence on sexual uniformity does hidden violence to all us dissidents and perverts, making us ugly before we have even seen ourselves.[3] Still, even for us, Sherman's images have enormous disruptive power.

Although strident compared to the docile female stereotypes of the 'Film Stills,' 1977–80, the deranged female creatures of the earlier fairy tales and mutilation series of the mid-to-late '80s, while sometimes intimating the possession of secret powers, are nonetheless the offspring of earlier Sherman women suspended in passive states of waiting, longing, and abandonment. The current series shows what those women have gotten up to, so to speak, when left to their own dark fantasies. One mannequin willingly lifts her rear end, presumably for a spanking with the nearby hairbrush. Another spreads her cunt wide open to some form of penetration – wide enough for a fist. The implication of S/M practice, sex with inanimate objects, fascination with the perverse, and transgression of the 'nice girls don't – and feminists certainly don't' injunction are all personified by a glowering Medusa/ whore/Venus/Olympia, who menacingly displays her startling red-foam vagina, the invitation promising pleasure for herself alone.

In the '60s and '70s, women using their bodies as subject and site of their art tended to explore feminine identity in relation to nature. Carolee Schneemann, Mary Beth Edelson, Ana Mendieta, and others displayed their sexuality as both natural and empowering. The problem, then as now, is the assumption that we were ever goddesses in the Garden, or, for that matter, that there is a pure state of nature to get back to, a state prior to our contamination by language, or representation, or law. The desire for an 'uncontaminated' expression of female sexuality appears in other guises today, particularly by women who seek to make 'sex-positive' pornographic images that in effect project backward to nature and purity. In adapting pornography for female

audiences, this clean-up operation rejects the 'demoralizing' impurity of the excremental, the improper, the dangerous and disgusting.

Sherman's representation of female sexuality, in contrast, indulges the desire to see, to make sure of the private and the forbidden, but withholds both narcissistic identification with the female body and that body's objectification as the basis for erotic pleasure. Her mechanisms of arousal – rubbery tits, plastic pussies, assorted asses, dicks, and dildos – may deceive momentarily, but finally defeat the proprietary gaze of the spectator, whose desire can only partially be satisfied by the spectacle of artificial flesh. The convergence that Sherman establishes between female identity and artifice, desire, and disgust has been widely interpreted. Some see her sullying of the female form as an argument against the clichés of traditional feminine glamour. Others see it as a pedagogy against violent masculine sexuality, and against images that may incite male aggression. And the idea of the instability of female identity – long a fascination of psychoanalytic theory – has been invoked to suggest that Sherman is ambivalent about her own womanhood.

All of these readings are too simple in isolation; the last of them misinterprets the function of the frame as one that absorbs Sherman herself. From this it is construed that because woman ('Cindy Sherman') is distinguished only by her lack, she can only abhor herself. This argument fails to take into account Sherman's control as director and producer of her own visual dramas. Fantasies of sexual perversion are forever getting confused with real life, but rarely so simplistically. Sherman's porn pictures express no blanket female self-hatred; rather, they engage the age-old designation of woman as essentially monstrous. More specifically, it is not just woman's identity (which, insofar as it is taken to be artificial and unstable, is sensed as antithetical to the rule of law) that is alarming, but her genitals, which emit the smell of death.

Look again at Sherman's images: the 'diseased' cunt, alarmingly red, flayed, unsavory; the severed female torso 'contaminated' by menstrual blood; the frightening Medusa/Olympia whose vagina excretes intestinal or phallic sausages; the doll whose vagina and anus merge into a dark, yawning emptiness. And look, too, at the photographer's enthusiasm for framing female perversity – at her will to disrupt. Sherman portrays no naive notion of pleasurability or purity: her images luxuriate in desire and disgust, which, as Georges Bataille reminds us, are inextricably linked. Marking her bodies as monstrous, she kills all nostalgia for an original state of things – whether the 'original' is identified with respect to distinctions between female and male desire, or is symptomatic of woman's fundamental and a priori 'lack.'

An interlocking network of fetishism and mutilation (a figure of castration) constellates around the body, multiplying the terror and situating the work more insistently in the locale of horror than of erotica. If the images evoke castration anxiety, what is their effect on the woman spectator, who, presumably, cannot lose what she never had? Metaphorically, they represent what is typically displaced, sublimated, or repressed. Sherman's pictures, in fact, flaunt accoutrements immediately suggestive of fetishism. An eroticism ridden with menace is her lure, and artifice her entrapment and dis-ease. In the register of

nightmare, the impulse to debase and violate parallels the impulse to worship and adore.

Hélène Cixous insists that women should mobilize the force of hysteria to break up continuities and create horror. This is not to hark back to some 'natural' state – an effort that masks woman's censored hysteria as though it were an unwelcome disease – or to fall into some other form of 'political correctness,' and the guilt and repressed desire that it triggers. For some, Sherman's displacement of sex to a cartoon level may signal an area in which issues can be investigated from a position of safety. Yet the ugliness and hard-core explicitness of her pictures, part of a politics of demasking, also function on a political level – particularly with respect to feminism. Rather than making a 'sex-positive,' Edenic retreat from that which we think we should not think or do, Sherman complicates libidinal desire. There is nothing fake at all about her vision.

POSTMODERNISMS
AND THE POLITICS
OF LOOKING

Abigail Solomon-Godeau

Winning the Game When the Rules Have Been Changed: Art Photography and Postmodernism

(First published in *New Mexico Studies in the Fine Arts*, reprinted in *Exposure* 231, Spring 1985)

This article was published at a point when a number of photographic artists were rising to prominence under the sign of postmodernism, including Sherrie Levine, Cindy Sherman, Barbara Kruger and Richard Prince. Abigail Solomon-Godeau succinctly traces the genealogy of this generation back to the mid-'60s and the crisis of the modernist aesthetic. Art photography's determined self-elevation and its isolation from wider cultural connections have doomed it to decline; by contrast, artists using photography to engage with the power and multiplicity of the image in society have sought to return it to what Solomon-Godeau calls its 'primary relationship' to the world.

I WOULD LIKE to begin this discussion with a brief consideration of two images: one, a canonical photograph of high modernist art photography made in 1926; the other, a work made in 1979 by a postmodernist artist with no allegiance – either pedagogical, formal, or professional – to art photography *per se*. The first is Edward Weston's study – one of a series – of his son Neil; the second is a rephotograph of the Edward Weston by Sherrie Levine, an artist whose practice for the past six years or so has been to rephotograph photographs or, more recently, paintings and drawings by German Expressionist artists, and to present them as her own.

We may begin by legitimately asking what is the difference between the two works. When reproduced, there very obviously is no difference whatsoever. Were we, however, to put the actual vintage print of Weston's *Neil* next to Levine's rephotographed print and examine them side by side, a certain amount of difference would be apparent. Variations in tonality of the prints, amount of detail, sharpness and delicacy of the forms and shadows, etc., could then be easily distinguished. But inasmuch as most people who can immediately recognize Weston's study of Neil are likely to know it from reproductions in books and magazines, we might also say that the difference between the photograph by Weston and the photograph by Levine does not in any way represent a fundamental or essential one.

What then *is* the difference between these two images? We might begin by stating that while Weston is the *author* of the portrait of Neil, Levine is the thief,

or, put somewhat less baldly, the confiscator, the plagiarist, the appropriator, the *pasticheur*. But to have said that is really to have said very little, because the theft of this particular image is in every sense both obvious and transparent. Even with Sherrie Levine's name typed neatly below the image when it is exhibited, who after all would mistake Levine's purloined *Neil* for the real thing?

But what do we mean when we talk about the *real thing*? Were we referring to Manet's *Olympia* or to Vermeer's *View of Delft* there would be little ambiguity. The real *Olympia* is installed in the Jeu de Paume, in Paris; the *View of Delft* in the Mauritshuis in The Hague. Both are singular, unique. The *real thing* in reference to *Olympia* would never be taken to refer to the actual model – Victorine Meurand – any more than it would be confused with Manet's conception of a Second Empire courtesan. Still less would the real thing be conflated with the reproduction of it in Janson's *History of Art*. Similarly, although Vermeer's *View of Delft* is a minutely detailed view of the city, we know the real thing is not the city, but Vermeer's rendering of it. Are these notions of authenticity and singularity the same when we speak of Weston's study of Neil as the *real thing*?

To answer this query we must begin by acknowledging that although there is but one negative of this individual study of Neil, there are any number of prints made from the negative by Weston himself. Additionally, there exist prints made by Cole Weston bearing the imprimatur of the estate, and presumably printed with the privileged knowledge and insight regarding Weston's formal intentions that such an enterprise would imply. There is also a limited edition of prints made by George Tice some years ago, commissioned (I believe) by Lee Witkin and the Weston estate, of an extreme exquisiteness that would have made Weston *père* quite happy. Finally, there are the scores of reproductions of Weston's *Neil* gracing everything from the cover of *The Male Nude* to the various monographs and exhibition catalogues on Edward Weston or the f/64 group, or the art and history of photography itself. Where then are we to locate the real thing in relation to this particular image?

Carrying the inquiry a bit further, we might here examine the nature and quality of Weston's photograph, which may be justly described as a virtual icon of photographic modernism, an exemplar of Weston's mature style, and a monument to the rigorous and controlled perfection of so-called straight art photography. Certainly the authority and classical beauty of this photograph derives in part from our knowledgeable recognition of precisely that source of beauty Weston drew upon. It is, of course, the stylized perfection of Praxiteles' or Phidias' marble nudes that we see in Neil's living torso: the flesh made art as much as the three dimensions of the body have been transformed into two. Headless, armless, legless, even genital-less, this fragment of Neil speaks primarily of pure form. Its eroticism, while present, is tamed – subordinated to the aesthetic which, in any case, constitutes the historic ground rules for the presentation of the nude. But must we not, in the final analysis, consider the real thing to be, at least in part, the living Neil in the year 1926? And does not this final acknowledgment that this originary point must be – as it is for all

photography – the living world which has been imprinted on paper further problematize the search for the real thing? Sherrie Levine in fact remarked that when she showed her photographs to a friend he said that they only made him want to see the originals. 'Of course,' she replied, 'and the originals make you want to see that little boy, but when you see the boy, the art is gone.' And elaborating on this comment, Douglas Crimp has commented:

> For the desire that is initiated by that representation does not come to closure around that little boy, is not at all satisfied by him. The desire of representation exists only insofar that it never be fulfilled, insofar as the original always be deferred. It is only in the absence of the original that representation may take place. And representation takes place because it is already there in the world as representation. It was, of course, Weston himself who said that 'the photograph must be visualized in full before the exposure is made.' Levine has taken the master at his word and in so doing has shown him what he really meant. The *a priori* Weston had in mind was not really in his mind at all; it was in the world and Weston only copied it.[1]

But Sherrie Levine is concerned with more than making a point about the conditions of representation, more too than underscoring the murky notion of what constitutes an 'original' within a technology of mechanical reproduction. Like Melville's Bartleby the Scrivener, Levine's critical stance is manifested as an act of refusal: refusal of authorship, uncompromising rejection of all notions of self-expression, originality, or subjectivity. Levine, as has been pointed out often enough, does not make photographs; she *takes* photographs, and this act of confiscation, as much as the *kinds* of images she takes, generates a complex analysis and critique of the forms, meanings and conventions of photographic imagery (particularly that which has become canonized as art) at the same time that it comments obliquely on the implications of photography as a museum art.

In earlier work dealing with photography, Levine made copy photographs of reproductions of photographs printed in books or posters, as in the case of the Weston studies of Neil. Alternatively – for example, in her rephotographs of Walker Evans' FSA photographs – she made copy prints of copy prints. Thus, while conceptually creating a photographic hall-of-mirrors effect, Levine cogently demonstrated the contradictions implicit in the assimilation of photography into traditional art discourse. Inasmuch as appropriation functions by putting visual quotation marks around the stolen image, its critical application lies in its ability to compel the viewer to see dialectically. In Levine's rephotographs of Eliot Porter's trees, the mere act of their confiscation, displacement, and re-presentation enables the viewer to grasp immediately the wholly conventional (and, as Roland Barthes would have said, entirely mythological) scheme in which 'Nature' is made to be seen as 'Beautiful.' Unlike the international typologies of industrial structures made by Hilla and Bernd Becher, the Porter photographs are revealed as unintentional typologies; artifacts of culture no less than the Bechers' steel mills and water towers. Similarly,

the rephotographed Walker Evans photographs, whose graininess and obvious screen clearly attest to their already-reproduced status, underline the cultural and representational codes that structure our reading of (respectively) the Great Depression, the rural poor, female social victims, and the *style* of Walker Evans.

Levine's refusal of traditional notions of authorship has social and political implications as well. The word 'author' is etymologically linked to that of 'authority' just as it is to 'authorize.' Historically, the concept of the author is linked to that of property. Copyright legislation protects the property, and in fact Levine's Weston and Porter rephotographs are quite literally illegal works of art. Too, the notion of the author is integrally linked with that of patriarchy; to contest the dominance of the one is implicitly to contest the power of the other. Enacted against the larger art-world context characterized by the cynical (and as has been often noted, predominantly male) effusions of neo-expressionist macho pastiche, Levine's acerbic and deadpan confiscations serve efficiently to expose the hollowness as well as the specious atavism of such work. To refuse authorship itself functions to puncture the ideology of the artist as the bearer of a privileged subjectivity. Levine is thus a kind of guerilla feminist within the precincts of the art world – a position shared by a number of other artists using photography within the postmodernist camp.

I chose to begin this essay with a discussion of Sherrie Levine's work because it illustrates in a rather forceful and dramatic way that the methods and assumptions of traditional art photography and those of various artists employing photography outside the conventional framework of art photography have come to occupy antipodes within photographic discourse and practice. Levine's work often provokes outrage, nowhere more evident than among the ranks of art photographers. If after a hundred and fifty years of upwardly mobile striving, art photography has been definitively validated as a 'creative' fine art, what does it mean that artists such as Levine should so energetically jettison those very values which elevated photography to parity with the other arts? Levine, now in her mid-thirties, has emerged from the art world, as have a considerable number of other artists using photography such as Vikky Alexander, James Casebere, Sarah Charlesworth, Silvia Kolbowski, Barbara Kruger, Richard Prince, Laurie Simmons, Cindy Sherman, and Jim Welling. They are themselves linked to an older generation of artists such as John Baldessari, or for that matter, Andy Warhol. The list could easily be extended to include a wide range of artists using photography since the mid-sixties that would encompass artists as disparate as the Bechers, Victor Burgin, Jan Dibbets, Gilbert & George, Dan Graham, Joseph Kosuth, Ed Ruscha, Jeff Wall and William Wegman. As photography galleries have crumpled left and right (in New York in the last several years, the casualty lists include Light Gallery, Photograph Gallery, Robert Samuels Gallery, and the Photographic Division of Leo Castelli), Cindy Sherman's star, for example, has risen meteorically. As the Photography Department of the Museum of Modern Art drifts into blue chip senility with no less than four Atget exhibitions or feeble resuscitations of formalist schema ('Big Pictures'), artists employing photography are in increasing numbers being absorbed into the mainstream art gallery nexus.

These two simultaneous developments – the ghettoization and marginality of art photography at precisely the moment when the use of photography by artists has become a relative commonplace – deserves some scrutiny. In order to understand the conceptual cul-de-sac that contemporary art photography represents, it is important to trace the assumptions and claims that paralleled (and fueled) its trajectory and then to examine the merit and usefulness of these notions as they exist in the present.

It has long been an uncontested claim in standard photographic history that the work of Paul Strand done in the late teens – and more particularly, its championship by Alfred Stieglitz in the last two issues of *Camera Work* – signaled the coming of age of art photography as an authentically modernist, and hence, fully self-conscious art form. For while Stieglitz himself had for most of his career made unmanipulated 'straight' prints, it was Strand's uncompromising formulation of the aesthetics of straight photography, his insistence that photographic excellence lay in the celebration of those very qualities intrinsic to the medium itself, that has traditionally been viewed as the moment of reorientation and renewal of American art photography.

Stieglitz's epiphanous designation of Strand as the aesthetic heir apparent would seem a reasonable point of demarcation in the art history of American photography. For although the insistence that the camera possesses its own unique aesthetic has been asserted in various ways since the 1850s, the pictorialist phenomenon supplanted earlier concepts of photographic integrity or purity[2] and instead established a quite different aesthetic agenda. This agenda, however, had a pedigree fully as vulnerable as that of the proto-formalist one: specifically, the presumption that photography, like all the traditional visual arts, could lay claim to the province of the imaginary, the subjective, the inventive – in short, all that might be inscribed within the idea of the *creative*.

The specific strategies adapted by pictorialist photographers – be they the retrieval of artisanal printing processes, the appropriation of high art subject matter (F. Holland Day crucified on the Cross, Gertrude Kasebier's Holy Families, etc.), or the use of gum bichromate and other substances, with extensive working of the negative or print and the concomitant stress on fine photography as the work of hand as well as eye – are now generally supposed to constitute an historical example of the misplaced, but ultimately important energies of art photography at an earlier stage of evolution. *Misplaced*, because current 'markers' and print manipulators notwithstanding, contemporary photographic taste is predominantly formalist; *important*, because the activities and production of the Photo-Secession were a significant and effective lobby for the legitimation of photography as art. Thus, if on the one hand, Edward Steichen's 1901 self-portrait, in which the photographer is represented as a painter and the pigment print itself disguised as a work of graphic art, is now reckoned to be distinctly un-modernist in its conception, on the other hand, the impulses that determined its making can be retrospectively recuperated for the progressive camp. Viewed from this position, photography's aspiration to the condition of painting by emulating either the subject or the look of painting was considered by the 1920s and the accompanying emergence of the

post-Pictorialist generation – Sheeler, Strand, Weston and the others – to have been an error of means, if not ends.

What I here wish to argue is that the *ends* of mainstream art photography, what we might consider as its methods or ideology, have remained substantially unchanged throughout all the various permutations – stylistic, technological, and cultural – that it has undergone during its hundred forty year history. Of far greater importance than the particular manifestations and productions of art photography is the examination of the conditions that define and determine them. What needs to be stressed is that an almost exclusive concentration on the stylistic developments in art photography, no less than the accompanying preoccupation with its exemplary practitioners, tends to obscure the structural continuities between the triumphant modernism of its successors. Steichen's tenebrous platinum-and-gum print nude of 1904 entitled 'In Memoriam' might well seem on the stylistic evidence light years away from the almost hallucinatory clarity of Weston's work of the '30s, but Steichen's 'it is the artist that creates a work of art, not the medium' and Weston's 'man is the actual medium of expression – not the tool he elects to use as a means' are for all intents and purposes virtually identical formulations. The shared conviction that the art photography is the expression of the photographer's interior, rather than or in addition to the world's exterior, is, of course, *the* doxa of art photography and has been a staple of photographic criticism almost from the medium's inception. Implicit in the notion of the photographer's expressive mediation of the world through the use of his or her instrument is a related constellation of assumptions: originality, authorship, authenticity, the primacy of subjectivity, assumptions immediately recognizable as those belonging to what Walter Benjamin termed the theology of art. It is the hegemony of these assumptions that integrates within a unified field the photography of Clarence White and Tod Papageorge, the criticism of Sadakichi Hartmann and John Szarkowski. Such is the continuing value and prestige of these notions in photographic criticism and history that they tend to be promiscuously imposed on just about any photographic oeuvre which presents itself as an appropriate subject for contemporary connoisseurship. Thomson and Riis, Atget and Weegee, Salzmann and Russell, Missions Héliographiques or 49th Parallel Survey: all tend finally to be grist for the aesthetic mill, irrespective of intention, purpose, application, or context.

Insofar as such concepts as originality, self-expression, and subjectivity have functioned, at least since romanticism, as the very warranty of art, the claims of art photography were *a priori* ordained to be couched in precisely such terms. 'Nature viewed through a temperament' could be grafted onto the photographic enterprise as easily as to painting or literature and could, moreover, encompass both maker and machine. Thus was met the first necessary condition of the *genus* art photography: that it be considered, at very least by partisans, as an expressive as well as transcriptive medium.

Why then the need for a pictorialist style at all? And to the extent that exponents of art photography since the 1850s had established a substantial body of argument bolstering the claims of photographic subjectivity, interpretive

ability and expressive potential, why nearly half a century later was the battle refought specifically on painting's terms?

Certainly one contributing factor, a factor somewhat elided in the art history of photography, was the second wave of technological innovation that occurred in the 1880s. The fortunes of art photography, no less than those of scientific, documentary, or entrepreneurial photography, have always been materially determined by developments in its technologies, and most specifically by its progressive industrialization.[3] The decade of the 1880s witnessed not only the perfection of photogravure and other forms of photomechanical reproduction (making possible the photographically illustrated newspaper and magazine), but the introduction and widespread dissemination of the gelatino-bromide dry plates, perfected enlargers, hand cameras, rapid printing papers, orthochromatic film and plates, and last but not least, the Kodak push-button camera. The resulting quantum leap in the sheer ubiquity of photography, its vastly increased accessibility (even to children, as was now advertised) and the accompanying diminution in the amount of expertise and know-how required to both take and process photographs, compelled the art photographer to separate in every way possible his or her work from that of the common run of commercial portraitist, Sunday amateur, or family chronicler. In this context, too, it should be pointed out that pictorialism was an international style: in France its most illustrious practitioners were Robert Demachy and Camille Puyo; in Germany Heinrich Kuhn, Frank Eugene, Hugo Henneberg and others were working along the same lines, and in the States, Stieglitz and the other members of the Secession effectively promoted pictorialism as the official style of art photography. And while influences ranging from symbolism, the arts and crafts movement, l'art pour l'art, and Jugendstil variously informed the practice of art photography in all these countries, the primary fact to be reckoned with is that art photography has always defined itself – indeed, was compelled to define itself – in opposition to the normative uses and boundless ubiquity of all other photography.

It is suggestive, too, that the pictorialist and Photo-Secession period involved the first comprehensive look at early photography. Calotypes by David Octavius Hill and Robert Adamson and albumen prints by Julia Margaret Cameron were reproduced in Camera Work, Alvin Langdon Coburn printed positives from negatives by Hill and Adamson, Thomas Keith and Lewis Carroll, and exhibitions of nineteenth-century photography were mounted in France, Germany and Great Britain. These activities were to peak in 1939,[4] the centenary of the public announcement of the daguerreotype, and were to be matched (in fact, exceeded substantially) only in the decades following 1960.

One need not belabor the point to see certain correspondences between the art photography scene of the period of the Photo-Secession and that of the past fifteen years. If gum and oil prints are perhaps not in evidence, contemporary photography galleries and exhibitions are nonetheless replete with the products of 8 × 10 view cameras, palladium prints, platinum prints, dye transfer prints, etc. Such strategies are as much mandated by a thoroughly aestheticized

notion of photography as they are by the demands of the art photography
market. To those who would counter such a categorization with remonstra-
tions as to the increasing shoddiness of commercially manufactured materials
and the need for archival permanence, I would simply reassert that the art
photographer's aspirations to formal invention, individual expression and style
are perpetually circumscribed, if not determined, by manufacturing and pro-
duction decisions. Indeed, the very size and shape of the photographic image
are the result of industrial decisions; the requirements of artists were only taken
into account in camera design for a brief historical moment well before the
industrialization of photography.

When the legacy of art photography passed from pictorialism to what
Stieglitz described as the 'brutally direct' photographic production of Strand
and his great contemporaries, a crucial and necessary displacement of the *art* in
art photography was required. No longer located in particular kinds of subject
matter, in the blurred and gauzy effects of soft focus or manipulations of
negative or print, in allegorical or symbolic meanings, the locus of art was now
squarely placed within the sensibility – be it eye or mind – of the photographers
themselves. Thus from Heinrich Kuhn's 'the photographic instrument, the
lifeless machine, is compelled by the superior will of the personality to play the
role of the subordinate' through Paul Strand's formulation of photography as
instrumental 'to an ever fuller and more intense self-realization' to Walker
Evans' litany of art photography's 'immaterial qualities, from the realms of the
subjective,' among which he included 'perception and penetration: authority
and its cousin, assurance, originality of vision, or image innovation; explora-
tion; invention' to, finally, Tod Papageorge's 'as I have gotten older, however,
and have continued to work, I have become more concerned with expressing
who I am and what I understand,' there exists a continuous strand that has
remained unbroken from *Camera Work* to *Camera Arts*.

But if the strand has remained continuous, the quality of the art photo-
graphy produced has not. Few observers of the contemporary art photography
scene would dispute, I think, the assertion that the work produced in the past
fifteen years has neither the quality nor the authority of that of photographic
modernism's heroic period, a period whose simultaneous apogée and rup-
ture might be located in the work of Robert Frank. Too, it seems clear that
the obsequies for the so-called photography boom may have something to do
with the general state of exhaustion, academicism and repetition evident in so
much art photography as much as with the collapse of an over-extended
market.[5]

The oracular pronouncements of Evans, Stieglitz, Strand, or Weston often
have a portentous or even pompous ring, but the conviction that underlays
them was validated by the vitality and authority of the modernism they
espoused. To the extent that a modernist aesthetic retained legitimacy, credibil-
ity, and, most importantly, functioned as the vessel and agent of advanced art,
it permitted for the production of a corpus of great, now canonical, photo-
graphy. The eclipse – or collapse, as the case may be – of modernism is
coincident with art photography's final and triumphant vindication, its whole-

sale and unqualified acceptance into all the institutional precincts of fine art: museum, gallery, university, and art history.[6] The conditions surrounding and determining art photography productions were now, of course, substantially altered. No longer in an adversarial position, but in a state of parity with the traditional fine arts, two significant tendencies emerged by the early 1960s. One was the appearance of photography – typically appropriated from the mass media – in the work of artists such as Robert Rauschenberg and Andy Warhol as well as its increased deployment by a group of conceptual artists such as John Baldessari. The second tendency was a pronounced academicization of art photography both in a literal sense (photographers trained in art school and universities, the conferring of graduate degrees in photography) and in a stylistic sense: that is to say, the retrieval and/or reworking of photographic strategies now both fully conventionalized and formulaic, derived from the image bank of modernist photography, or even from modernist painting, and producing a kind of neo-pictorialist hybrid.

What was – and is – important about the two types of photographic practice was the distinct and explicit opposition built into these different uses. For the art photographer, the issues and intentions remained those traditionally associated with the aestheticizing use and forms of the medium: the primacy of formal organization and values, the autonomy of the photographic image, the subjectivization of vision, the fetishizing of print quality, and the unquestioned assumption of photographic authorship. In direct contrast, the artists who began to employ photography did so in the service of vastly different ends. More often than not, photography figured in their works in its most ubiquitous and normative incarnations. Thus, it was conscripted as a readymade image from either advertising or the mass media in its various and sundry manifestations in the quotidian visual environment, or alternatively, employed in its purely transcriptive and documentary capacities. In this latter usage, it did service to record site-specific works, objects or events that had been orchestrated, constructed or arranged to be constituted anew, preserved, and represented in the camera image.

It is from this wellspring that the most interesting and provocative new work in photography has tended to come. Although this relatively recent outpouring of art production utilizing photography covers a broad spectrum of concerns, intentions, and widely differing formal strategies, the common denominator is its collective resistance to any type of formal analysis, psychological interpretation, or aesthetic reading. Consistent with the general tenor of postmodern practice, such work takes as its point of departure not the hermetic enclave of aesthetic self-referencing (art about art, photography about photography), but rather, the social and cultural world of which it is a part. Thus, if one of the major claims of modernist art theory was the insistence on the autonomy and purity of the work of art, postmodern practice hinges on the assertion of contingency and the primacy of cultural codes. It follows that a significant proportion of postmodern art based on photographic usages is animated by a critical, or, if one prefers, a deconstructive impulse. The intention of such work is less about provoking feeling, than provoking thought.

In addition to the work of Sherrie Levine with which this paper opened, I would like briefly to consider here the work of four other artists who may be seen as having a shared agenda, albeit with different inflections and emphases. Appropriators all, their work nonetheless ranges from entirely unmediated confiscation, as in the case of Levine, to the recropped, repositioned assemblages of Vikky Alexander and Silvia Kolbowski, to the composed texts superimposed over Barbara Kruger's purloined images, to the heroicized fragments of glossy advertisements that Richard Prince isolates and reshoots.

What gives their work its integrity, its cutting edge, is the common enterprise of 'making the invisible visible' – a goal whose strategies are now determined by a new arena: the world of mass-produced images themselves. In contrast with many of the art movements of the earlier part of the century which promised liberation, the unshackling of vision and perception, these artists are clearly more modest in their goals, more pessimistic in what they conceive of as possible in what Guy Debord termed 'The Society of the Spectacle.' Nonetheless, in compelling a conscious reading of the ideology inscribed in various photographic uses, and in investing strategies that unravel their connotational structures, these artists may be seen as continuing that tradition of art-making which views as its mission the unmasking of appearance by revealing its codes.

In the case of Richard Prince the dialectical, and hence, deconstructive readings effected by Levine's tactics are arrived at by somewhat different means. Taking as his object of inquiry the highly mediated and technologically sophisticated advertising image, Prince has progressively sought to counter the manipulated and often synthetically composed advertising image with a comparable degree of simulation in his own appropriations. In this sense, Kate Linker has proposed[7] that the theoretical model for Prince's practice be located in Jean Baudrillard's concept of the simulacrum, which surpasses representation and reproduction, and instead produces a synthetic 'hyper-reality,' a 'real without origin or reality.' Much of the power of Prince's work derives from his ability to make the concept of the commodity fetish at once concrete and visible. The hyped-up, almost hallucinatory quality of his details of cigarette ads, expensive watches, shimmering whiskey logos, et al., are made to reveal their own strategies of overdetermination. There is an obsessional quality about Prince's work which has little to do with the irony (and its attendant aspect of distancing) that informs much appropriative practice. The element of nightmare that subtly attaches itself to the erotic glitter and voluptuousness of the commodity (or the ambiance of the commodity) is similar in idea to the traditional Christian emblem of Luxuria – the head of a beautiful woman merging into the body of a serpent. Prince's rejection of traditional notions of authorship, while less programmatic than Levine's, have nonetheless originated in a comparable understanding of the conditions of spectacular society. Prince has quite precisely described his relation to authorship (as well as his own working method) in the following text:

His way to make it new was to make it again . . . and making it again was enough for him and certainly, personally speaking, 'almost him.'[8]

The notion of identity as 'almost him' functions as an analogue to a fully conventionalized reality composed of images or simulacra; reality can no more be located in the world than 'authenticity' in the author.

For Silvia Kolbowski and Vikky Alexander the nature of their appropriations, and the operations they make upon them, mark their concerns as more centrally located within feminist discourse. Informed by aspects of psychoanalytic, linguistic, and feminist theory, Kolbowski's *Model Pleasure*, composed of seven discrete but integrally related images, brackets cropped close-ups of five veiled models, with a woman 'veiled' by dark glasses. Through appropriations, cropping, positioning and serial organization, Kolbowski contrives a critical reading of the fashion image calculated to rupture the fictions of such representation. Voyeurism depicted within the series is counterpointed with the spectator's, a strategy that illumines the larger ideological system in which the construction of the female (as different, as Other) inevitably relegates her to the object of the gaze (which is always male) rather than permitting her to be the origin of it. When the image of the woman is presented for woman (as is generally the case with fashion photography) the female viewer must inescapably project her own sexual identity within this narcissistic cul-de-sac of being-looked-at, and hence existing by and for the eyes of men. Similarly, the constellation of sexual mythologies – women as enigma, as mystery – that are integrally bound with objectification and oppression are literally demonstrated in Kolbowski's orchestration of images. The final image – a woman's veiled and smiling mouth, brushed by a male hand – is placed upside down, in order, as Kolbowski explains, 'to make an analogy between the feminine gaze and the woman spoken.' For central to feminist theory is the recognition that woman does not speak herself: rather, she is spoken for and all that that implies: looked at, imaged, mystified and objectified.

Like Kolbowski's, Vikky Alexander's work of the past few years is grounded in a feminist critique of fashion imagery, the ideological terrain in which women are presented not only as ritual objects, but as commodities. Alexander has set herself the conceptual problem of rhetorically re-presenting the given image in such a way that the ritualized aspects of pose or 'look' are thereby accentuated. By repetition and/or format (diptych, triptych, etc.), Alexander compels awareness of not only the codes themselves, but the way they function.

In *Ecstasy*, three identical fashion photographs of a female model alone are alternated with two identical ones depicting a male and female model together. Part of the wit of the piece resides in its play with the notion of quotation itself – as it functions in language as well as tactically – as an artmaking strategy. For in the very act of describing such imagery in language, we must have recourse to the use of quotes in order to indicate its various levels of simulation. Accordingly, we would begin by noting that all the female models display an 'ecstatic' expression. Certainly not the expression of Bernini's St. Teresa, or Titian's

Mary Magdalene, but a more up-to-date version: the conventionalized
ecstasy which has emerged recently in fashion photography: closed, shiny
eyelids, wet, slightly opened mouth. We would then go on to note that the
couple are 'making love.' The quotational act by which the work has been
constructed is thereby made to illustrate and expose the highly mediated
simulation of the images' content. The inclusion of the single model – equally
'ecstatic' – insures our understanding that the depicted ecstasy, no less than the
depiction of the women themselves, is a spectacle. Further, the spectacle of the
ecstatic woman is intimately bound with representational structures of voyeur-
ism, narcissism, and power. By de-naturing such images, Alexander unmasks
them.

Barbara Kruger's work – aggressive, graphic, and occasionally almost brutal –
appropriates not only the images themselves, but the 'look,' address, and
discursive mode of certain types of mass media institutions (the tabloid press,
the billboard, the poster). Kruger's *modus operandi* consists of canny table-
turning, whereby all the communicative tools in the arsenal of power are
deployed against themselves. Appropriating the disembodied voice of patriar-
chal authority (expressed in bold-face type), Kruger then makes superimposi-
tions against found images (usually crude, rather anonymous-looking ones) that
are made to double back against themselves. Very rarely, this is effected by
having the image in some sense contradict the text. For example, a narrowly
cropped image of a man kissing the hand of an (unseen) woman is emblazoned
with the text, 'You reenact the dance of insertion and wounding' with 'dance
of' and 'wounding' in larger, differentiated typeface. More typically, however,
the juxtaposition of Kruger's composed texts and found images creates new and
subversive meanings for both. Thus, utilizing a thoroughly stereotypical image
conventionally signifying mother love – the tiny baby hand clutching the
mother's finger – Kruger distills a far more trenchant observation; 'Your every
wish [in small typeface over the two hands] is our command.' Roland Barthes'
concept of caption and text functioning as anchorage and relay is no-
where more eloquently demonstrated than in Kruger's iconic/lexigraphic
sleights-of-hand. Much of her work is extremely witty (a group of formally
dressed men laughingly giving one of their number a 'going over' is captioned,
'You construct intricate rituals which allow you to touch the skin of other
men'), a strategy as capable of critical analysis as any other.

Differences in emphasis, tactics and degree of appropriation notwithstand-
ing, Alexander, Kolbowski, Kruger, Levine and Prince are artists whose con-
cerns are grounded in the cultural, the political, the sexual. Viewed
individually, collectively, or as sample representatives of postmodernist art
practice, their work contrasts vividly with the parochialism, insularity, and
conservatism of much art photography.

The title of this paper – winning the game when the rules have been
changed – relates to precisely this phenomenon. Having achieved institutional
legitimation as a fine art among the others, art photography remains rooted in
a conceptual impasse of its own making. Most art photographers, particularly
those established within the past fifteen years or so, and now ensconced within

the photography departments across the land, give little thought to the general collapse of the modernism which provided the ballast for the triumphant rise of art photography. The teaching of photography tends to be cordoned off from what goes on in the rest of the art department. So while young painters are reading art magazines and as often as not following developments in film, performance or video, photography students are reading photography magazines, disputing the merits of documentary mode over self-expression, or resurrecting unto the fourth generation an exhausted formalism that can no longer generate either heat or light.

Often the reaction of art photographers to postmodernist photographic work is bafflement, if not a sense of affront. The irony is that photography, a medium which by its very nature is so utterly bound to the world and its objects, should have had, in a variety of ways, to divorce itself from this primary relationship in order to claim for itself a photographic aesthetics.

This paper was originally presented in slightly different form as a public lecture at the Rhode Island School of Design on April 26th, 1983.

Meaghan Morris

Two Types of Photography Criticism Located in Relation to Lynn Silverman's Series

(First published in *Art & Text*, No. 6, 1982; reprinted in Morris's collection *The Pirate's Fiancée*, 1988)

Photographs and two separate levels of text construct an instance of creative criticism that focuses upon landscape, Australian history, looking at photographs . . . One textual commentary relates directly to the photographs, the other situates them.

Meaghan Morris's concern as a feminist and postmodernist critic is with finding new frameworks for cultural givens in order to reposition women beyond them by strategies of rereading and rewriting. In *The Pirate's Fiancée* she argues for a recognition of the vital feminist contribution to postmodern theory as an antidote to the myth of its male manufacture. She cites an abundant literature of feminist criticism and theory that has fuelled postmodern debate, making feminism 'one of the enabling conditions of discourse *about* postmodernism'. Preoccupations with subjectivity and history place Silverman's work cogently within this project.

Collecting ground samples and locating them in relation to the
horizon from where they were photographed

In a translation of a French history of Australia, the prologue begins by defining the continent as vast, harsh and weird. It closes by alluding to Cuvier's comment that Australia is like a fragment of another planet which just dropped on to our globe by chance.

In a book of tearout postcards, one of the most popularly posted images presents a bare horizon line and a signpost saying, NEXT 5,000 MILES NOTHING.

I see Lynn Silverman's photographs as a study in the construction of inland space: how space is made intelligible for us by a play of identity and difference; how cultural systems of interpreting a space can be unsettled by exhibiting the process of framing interpretations; and how landscape photographs induce a curious convergence between what you do when you set out to see the sights, and what you see when look at

In common speech, there are a number of signs combining the variety of flat, dry and largely uninhabited lands of Australia's surface into one single concept of generalized space: the inland, the interior, the outback, out west, the dead heart and – most rich and imprecise of all – the desert.

In each case the speaker (regardless of physical location) articulates the vision of an outsider gazing at an elsewhere.

an ordered sequence of images.

At first glance, you can respond to the pleasures of familiar recognition habits. The eye starts scanning the horizon line, joining up frame to frame in a single track along the series. One movement abstracts a generalization based on the formal similarity of a succession of separate items. The eye then rediscovers difference and precision below that line;

Desert descriptions can never be seen as innocent of cultural reference. 'The desert' is always a preexisting pile of texts and documents, fantasies, legends, jokes and other people's memories, a vast imaginary hinterland which most coastal dwellers like to dream all their lives of seeing in reality one day.

The history of this fantastic area is quite recent. For tens of thousands of years, Australia was merely a real land mass which held a diversity of

the exact details of a flower, a bush, a nest or a cluster of stones can be lingered over in a step by step celebration of the traveller's coded wonder that such unique objects exist.

Both ways of seeing mesmerize. You could go on and on hypnotically linking horizon lines, effacing frames and poring over precious places.

different cultures thriving in separate regions. Today (the time of what Donald Horne has called 'the imperial procession of the white people across Australia'), it makes little difference to insist that much of the inland is not desert at all, or that there are many kinds of desert and that some are white man-made.

In urban imaginations, that space is *there* – immense, unique, invested with meaning, and rather expensive to tour.

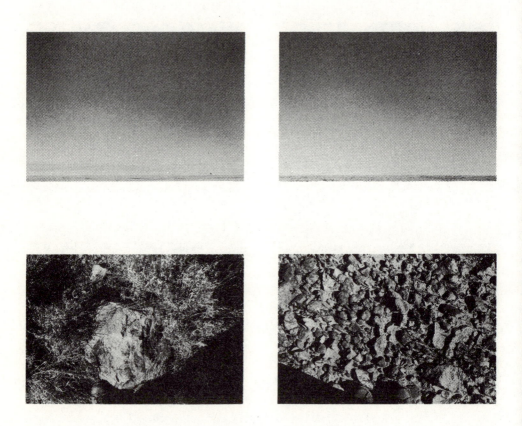

The photographs are very beautiful, and there is no intrinsic reason I can find for the series itself to stop. I imagine that the photographer had her reasons for standing at one spot rather than another, for going home when she did, for choosing one image rather than another; but nothing of this remains in the series, which points instead to the disorienting, dislocating possibilities of endless repetition.

The myth of the inland precedes any deliberate act of seeing it with one's own eyes. In this, no doubt, it is like any other tourist attraction; the myth motivates and structures the visitor's vision of the land. The peculiarity of Australian inland space lies rather in the series of stark oppositions which define it (and which reappear in other contexts as basic problems of Australian history and culture in general): here/there, positive/negative, presence/absence.

The play with the pull of the inland and the urge to fall through an image is checked, however, by the vertical lines of comparison linking pairs of photographs apparently taken while standing in the same place.

They are utterly different, joltingly so; and as the empty immensity of distance there repeatedly confronts the minute detail of surface here, this difference (and the systematic oppositions which produce it) ceases to be

In the Eastern cities, there is a whole cultural industry for promoting the presence of the desert. Television documentaries, postcards, films, the lavish landscape celebrations of books of Australiana, even ecological campaigns keep accumulating and circulating images of wondrous far horizons – which function as so many signposts to another reality, a 'real' Australia.

an effect of a dream of endless, all-embracing space, and appears as the outcome of a predetermined and limited procedure. Our sense of the identity of site binding each pair is itself an outcome, not of nature or visual evidence fixed within the frames, but of the formal arrangement of the series on the wall.

The work then confronts us, not with objective and subjective inter-

Yet their assertiveness responds to a contrasting form of fascination, one depending on doubt, forgetfulness, and the mysteries of the unseen. That space – into which people occasionally vanish – has so little effective reality that it is always on the verge of disappearing; and the routine snapshots of travellers returning are pored over as so many incredible testimonies that the inland might actually exist.

Signposted yet sign-effacing, it is a space accorded the status of a

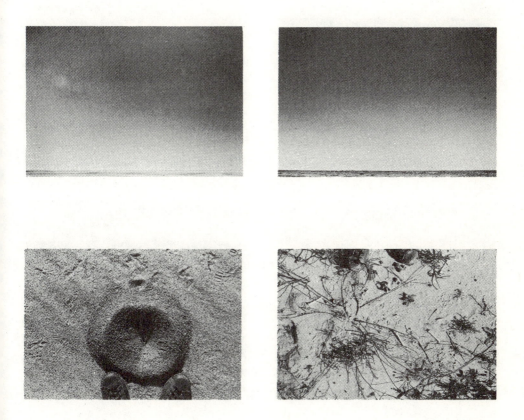

pretations of the same space, but with two different ways of manipulating subject-object relationships. One makes myth, the other makes personal statement; one includes us, the other addresses.

The images of landstrip, horizon and sky seem anonymous, impersonal; all trace of the photographer's presence is effaced. Yet for that reason,

reservoir of places where nothing might be, or anything might happen. In traditional legend, birds fly backwards there; rivers run against nature, the sand spawns fishes, and inland seas are lapping just beyond the dry horizon. In contemporary speculation, lost creatures reappear and vanish; regions belong obscurely to alien powers, while the wasteland hides a monstrous proliferation of caverns breeding new forms of experimental warfare.

subjectivity dominates here; any one of I/you/all of us can take her place and assume that vision. This is the timeless land, 'our' land, laid out ahead alluringly for acts of possession to come – the product of an imperial way of seeing and proceeding.

The ground shots, in contrast, are personal in a way which does not absorb us all into a universal vision of inviting emptiness, and which fills

This aspect of the myth attracts quests, produces the travel patterns of voyagers in search of special realities, evidence, or some new vision. But the enduring seductiveness of the myth resides in the reversibility of its meanings. The inland is also repulsive; an image of a natural dreariness, dullness, desolation and monotony which slowly encroaches upon settlements, and spreads its emptiness by contagion to culture. For a century,

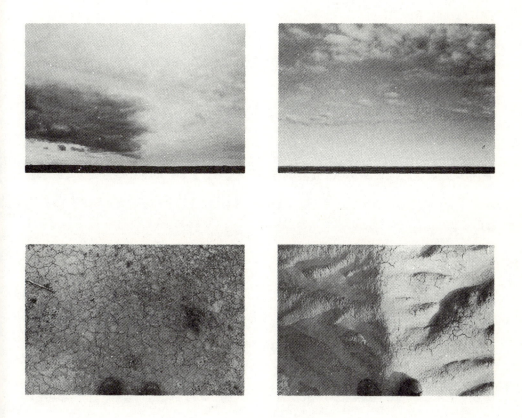

the frame with the clarity of a particular place and time. There has been an event; and the sensibility which found and saw the sheer hilarious difference between the delicate traceries of various patches of cracked earth was not interchangeably yours or mine, but hers. Our one guarantee of identity and constancy comes down to a bit of somebody else's boots.

recurring projects prove that Australia is or is not a cultural desert: poor towns, and unpleasant parts of cities, are not jungles here – but deserts.

The negative desert takes many forms – vacant lot, backyard, quarry, cemetery, dump. The most intimate of all, however, is the desert of school geography: long lists of names, explorers, lifeless rivers and

And looking back to those horizons, you see – of course – that they are not the same at all. A troubling difference emerges, one which is not the product of the purely formal play of a system imposed, but of the order of the variation of different skies seen on different days in different lands.

empty places shrunk to marks on a map, names which can never have any more meaning than hot afternoons in a droning room.

This is the heritage of texts, travel-writing repressed and revitalized in succeeding generations. Documented, measured, mapped and crossed, the inland is viewed through a grid of preestablished procedures of possession. The wanderer, artist, tourist who goes there repeats the great itineraries of the predecessors, follows the broken lines on the map of a

Generalised space disintegrates, the line breaks up, the frames stand out, and the spaces between them point to an absent narrative of a lost itinerary - and what happened (to somebody) along the way.

What remains is a set of tracks. Not the single broken line of the traveller marking a progress on a map; but a double line, an exploration of

trip which has already been made. The generalized space of the inland solicits
an act of repetition which is always, in the beginning, a rediscovery of the same.

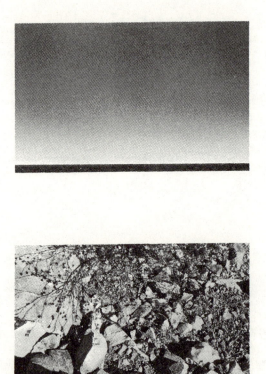

*reversibility the trace of a movement on a strange, still space in which everybody looks
at elsewhere, and somebody looks at here.*

Deborah Bright

Of Mother Nature and Marlboro Men: An Inquiry into the Cultural Meanings of Landscape Photography

(First published in *Exposure* 23.4, Winter 1985. This version reprinted in *The Contest of Meaning*, Ed. Richard Bolton, MIT Press, 1989 & 1992, pp. 125–43)

Bright's essay is a trenchant critique of the post-war appropriation of landscape photography by American formalist curators, and its effective removal from the social and environmental debate. This is a crucial piece of writing which examines and demystifies both a genre and a curatorial/art market process.

I suspect no landscape, vernacular or otherwise, can be comprehended unless we perceive it as an organization of space; unless we ask ourselves who owns or uses the spaces, how they were created and how they change.

J. B. Jackson[1]

LANDSCAPE PHOTOGRAPHY has been enjoying a spectacular resurgence in the coffee table/art book press. During 1984 alone, glossy tomes such as *Landscape as Photograph, Edward Weston's California Landscapes, The Essential Landscape, Second View*, and *An American Field Guide* piled off the presses and into the bookstores. In addition, the Spring 1985 issue of *Aperture* was given over to the topic 'Western Spaces.'

Why landscape *now*? A few conjectures come to mind: it is certainly true that among educated, middle-class audiences, landscape is generally conceived of as an upbeat and 'wholesome' sort of subject which, like Mom and apple pie, stands indisputably beyond politics and ideology and appeals to 'timeless' values. This would sit well in our current conservative cultural climate, where images of the land (conceptual, historical, or literary) from Lakes Tahoe to Wobegon are being used to evoke the universal constancy of a geological and mythic America seemingly beyond present vicissitudes.

But this is too simple an explanation – images of landscape cannot be perceived simply as an antidote to politics, as a pastoral salve to lull us back to some primordial sense of our own insignificance. Nor should they be regarded simply as the loci of our modernist pleasure in arrangements of material objects in ironic constellations – found 'happenings' for the lens whose references to the worlds beyond the frame rivet all attention on the sensibility of the artist.

These two prevalent constructions of landscape remind us that 'landscape' as a subject of visual representation is a distinctly modern phenomenon. The taxonomic term 'landscape' comes from Western art history and refers to a genre of painterly practice that gathered momentum and prestige only in the seventeenth and eighteenth centuries. In the aristocratic classical tradition of painting, landscapes were principally fields for noble action – carefully cultivated gardens suited to the gods and heroes who populated them. With the rise in the seventeenth century of the merchant bourgeoisie in Holland, a new sort of landscape emerged – a seemingly more 'natural' landscape that celebrated property ownership: the working water- or windmill, the merchant ship at anchor, the farmer's field, the burgher's estate. English landscape painting in the eighteenth century followed the Dutch model, though it supplanted the formulaic quality of earlier genre painting with scientific accuracy that reflected the increasing prestige and achievements of empirical science and its off-spring, technology. The word *landscape*, in English, initially referred specifically to Dutch paintings and only later denoted the broader idea of a view or prospect.[2]

Whether noble, picturesque, sublime or mundane, the landscape image bears the imprint of its cultural pedigree. It is a selected and constructed text, and while the formal choices of what has been included and excluded have been the focus of most art-historical criticism to date, the historical and social significance of those choices has rarely been addressed and even intentionally avoided.

To take an example, the 'small-town American' landscape of mass-circulation graphic illustration signifies more than a generic place idealized by Norman Rockwell. It also connotes a semi-rural golden age, a psychological center from which a ruling middle-class minority draws its symbolic identity and nationalistic context – its ideology:

> In this generalized image Main Street is the seat of a business culture of property-minded, law-abiding citizens devoted to 'free enterprise' and 'social morality,' a community of sober, sensible, practical people. The Chamber of Commerce and the Protestant churches are naturally linked in support of 'progress' and 'improvement.' For many people over many decades of our national life this is the landscape of 'small town virtues,' the 'backbone of America,' the 'real America.'[3]

Despite its cultural dominance, this is a landscape in which the major portion of the nation's populace – its urban natives and refugees (including blacks, Hispanics, homosexuals, Jews) – finds no positive reflection but instead oppression.

Thus, whatever its aesthetic merits, every representation of landscape is also a record of human values and actions imposed on the land over time. What stake do landscape photographers have in constructing such representations? A large one, I believe. Whatever the photographer's claims, landscapes as subject matter in photography can be analyzed as documents extending beyond the formally aesthetic or personally expressive. Even formal and personal choices

do not emerge *sui generis*, but instead reflect collective interests and influences, whether philosophical, political, economic, or otherwise. While most art historical/curatorial scholarship has concentrated on the artistic genius of a select few (and the stake in so doing is obvious), it is time to look afresh at the cultural meanings of landscapes in order to confront issues lying beyond individual intuition and/or technical virtuosity. The sorts of questions we might ask concern what ideologies landscape photographs perpetuate; in whose interests they were conceived; why we still desire to make and consume them; and why the art of landscape photography remains so singularly identified with a masculine eye.

In the late-nineteenth-century United States, after the 'Indian problem' had been brutally solved and the frontier ceased to exist, a veritable Cult of Wild Nature flourished, having undergone several evolutionary phases since the continent's discovery by white Europeans. This was characterized by a nostalgia for the red-blooded rigors of a pioneer life that had become obsolete. As with many significant movements in American cultural life, this one emerged from a pragmatic alliance of liberal reform and commercial interests: the first epitomized in the Progressive Movement's precept that the 'nature experience' was a desirable antidote to the unhealthy urban life, and the second in the creation of a middle-class tourist market, first by the railroads and later by the automobile interests.

In the same spirit, efforts to create pockets of arcadian nature in the cities through the institution of landscaped parks and nearby forest preserves reflected an upper-crust cultivated taste for aestheticized nature and that class's conviction that such garden spots could elevate the aspirations and manners of the immigrants and workers who used them. In concert with these programs, wilderness areas began to be claimed and named as refugees of timeless order in a changing world – 'God's gift to the American people' – to be preserved as a legacy for future generations.

The religious overtones in the American attitude toward these wilderness areas is unmistakable. As Kenneth Erickson has pointed out, these landscapes were and still are truly ceremonial in nature, requiring both a code of personal conduct for users (park rules and regulations) as well as ritualized expressions of devotion ('pilgrimages' made on certain holidays and the compulsion to take snapshots of the conventional shrines of Nature). The role of visual icons as both talismans of the original 'experience' and prompters for renewed inspiration seems obvious in such a context.[4]

In 1908 sixty-nine thousand tourists went to worship in the eleven national parks. Twenty years later, the figure had climbed to three million. What kind of landscapes were these tourists so eager to gaze upon? As one historian describes it:

They were not impressed by wilderness itself. They looked instead for the unique, the spectacular, or the sublime, drawing their standards from

stereoscopic views, picture postcards, railroad advertising, magazine illus-
trations, Romantic literature and landscape art. Scenic beauty was an art
form, and its inspiration a preconditioned experience.[5]

The railroads competed ruthlessly for the nature-tourist's dollar by trumpet-
ing the unique visual enchantments of their respective routes. The federal
government published popular National Park Portfolios during the 1920s, which
prepared the general public for its first views of Yellowstone and Yosemite.

As automobile travel became widespread in the 1920s, the Park Service's
Landscape Architecture Division engineered the wilderness to accommodate
the new mobility with planned roads and numbered scenic turnoffs, sited and
designed to conform to conventional pictorial standards. Nature was re-
designed, we might say, for middle-class convenience and efficiency. With the
active participation of government and private enterprise, wilderness scenery
became good business. In this enterprise, photography rapidly surpassed other
modes of graphic illustration to play a central role in merchandizing landscape
for public consumption:

> Sprawling enlargements, reminding prospective travellers of distant attrac-
> tions, were spread like murals across the walls of ticket offices in smoky
> Eastern cities.[6]

These views became the established 'standards' against which all future visual
records of these landscape-spectacles would be measured. It was these 'mech-
anical reproductions' of the chosen shrines that lured tourists into making the
journey to find the Real Thing.[7]

The advent of motion pictures, particularly the Western, created a public
taste for spectacular scenery used as a backdrop for thrilling dramas. The
cowboy movie was firmly established as a genre by the 1920s and succeeded as
no other form in masculinizing the western landscape. 'Away up in the
Canadian Rockies, amid the mighty forces of Nature, a man must be a man
even to survive,' read the press release for James Oliver Curwood's *The Valley
of Silent Men* (1922)[8]; another of his press releases touted a film as 'A Supreme
Test of Manhood That Shows What Real Character Is. It Surpasses Belief and
Overwhelms Our Sense of the Beautiful.'[9] These larger-than-life celluloid
landscapes were mirrored at a humbler level in the roadside attractions of
Western tourist landscapes and became as well a marketing strategy for selling
everything from cigarettes to presidents. Like Philip Morris's Marlboro Man,
today a white-hatted Reagan rides his horse or chops wood for the camera on
his Santa Barbara ranch, a rugged individualist drawn up to specs by Central
Casting.

In the American consciousness, then, the western landscape has become a
complex construct. It is the locus of the visually spectacular, culled from the
total sum of geographic possibilities and marketed for tourist consumption. For
liberal conservationists, it represents the romantic dream of a pure, unsullied
wilderness where communion with Nature can transpire without technological
mediation, a dream that has been effectively engineered out of most modern

experience. Once considered the essential ingredient in character formation, Nature has become commodified; its benefits can be bought and sold in the form of camping fees, trail passes, and vacation packages at wilderness resorts. As geographer J. B. Jackson has pointed out, we come in contact with Nature on a tight, highly structured schedule – holidays and weekends – which is determined not by the change of seasons, but by the routines of urban work.[10] This Nature has been designed to help us absorb its 'benefits' as efficiently as possible: tourist literature and park displays ensure that we are exposed to the peak experiences at the site (sight).

For others, the western landscape is the repository of the vestiges of the Frontier, with its mythical freedom from the rules and strictures of urban social contracts – a place where social Darwinism and free enterprise can still operate untrammeled, where tract houses can sprout in the waterless desert. As one pundit put it, 'For Americans, true freedom is not the choice at the ballot box but the opportunity to create a new world out of nothing: a Beverly Hills, a Disneyland, a Dallas, a Tranquility Base.'[11]

Repressed or unexpressed among these mythical landscapes that conventional photography and Hollywood cinema have served so well is a landscape that cannot be defined strictly by aesthetic or geographical categories. The sort of landscape I am referring to, and which I think photographers might have a stake in revealing, is that landscape which J. B. Jackson has called 'a field of perpetual conflict and compromise between what is established by authority and what the vernacular insists on preferring.'[12] A landscape, in other words, whose construction by culture is made explicit – indeed, whose construction is made the very subject of photographic investigation.

Beauty, preservation, development, exploitation, regulation: these are historical matters in flux, not essential conditions of landscape. The political interests that landscape organization reveals are subjects that the practice of landscape photography has not clearly addressed. Before I speculate on strategies photographers might use to reveal landscape's cultural construction, it would be useful to assess some of the inadequacies in traditional landscape photography.

The dominant landscape aesthetic in museum/gallery photography was self-consciously established as an offshoot of the American purist/precisionist movement in art during the late 1920s and 1930s. A second, West Coast landscape school, founded by Edward Weston and continued more popularly by Ansel Adams and Eliot Porter, represented the continued taste for the picturesque sublime from nineteenth-century European and American painting. This aesthetic was premised on an identification between a mythical Eden and the American landscape and was well suited to the conservative social climate of a post-World War II United States basking in its reborn Manifest Destiny as a world superpower. Popular Sierra Club publications, such as Porter's *In Wilderness Is The Preservation of the World* (1962), celebrated the same sanitized conception of the natural world that Walt Disney promoted in his wildlife films. Porter anchored his vision in literature, specifically the nineteenth-century American Transcendentalists, whose ideal of a uniquely

American wilderness proposed a landscape where deity could be touched through intuition.

The publication of *Aperture* (begun in 1952) and Minor White's eclectic reworking of Stieglitz's Equivalent provided artistic landscape photography with something resembling a theoretical base. Borrowing heavily (via Steichen) from the turn-of-the-century Symbolists, Stieglitz defined a photographic Equivalent as a metaphor for the vision or feeling of the artist rather than as a transcriptive record of the subject. However, as Andy Grundberg has succinctly pointed out,

> For all its virtues in making us engage photographs more closely and complexly, the aesthetic of the Equivalent . . . has one major shortcoming: after asserting that an apparently transparent image of the world is imbued with an individual vision or feeling, it has difficulty defining what that vision or feeling is. Used as a critical instrument, the theory of Equivalence is unable to determine any intended meaning in a photograph. But as a credo, it has served as the dominant aesthetic of American photographic modernist practice.[13]

For Minor White, Ansel Adams, and their generation of art photographers, intuition and expression were the central issues, not visual form. Thus *Aperture* could routinely publish portfolios as stylistically diverse as those of Robert Frank and Frederick Sommer, for 'the final form of the image was of less importance than its evocative meaning.'[14] It was on this slippery beachhead that the *Aperture* forces were eventually challenged and overwhelmed by John Szarkowski's curatorial juggernaut in the 1960s and '70s.

As a landscape photographer and as modernist photography's most influential tastemaker, Szarkowski used landscape photographs extensively to shape and bolster his assertions about photography's essential 'nature.' Employing a formalist vocabulary peculiar to his reading of photography ('vantage point,' 'detail,' and 'frame'), Szarkowski invoked the work of selected nineteenth-century landscape photographers as evidence for his theory of form. In keeping with his notion of photography as a medium with its own irrepressible forms, he proffered these photographers as 'naifs' through whom landscape could be represented photographically without regard for the pictorial formulae of European painting. Szarkowski referred to Timothy O'Sullivan, that seasoned professional, as 'a mutant, native talent,' displaying the 'kind of natural grace by which a great dancer or singer seems possessed.'[15]

In addition to its patronizing tone, such writing sheds no light on the historical circumstances in which O'Sullivan's photographs were produced. Significant issues of patronage, audience, means of reproduction and distribution are neatly elided in favor of a formal theory applied equally to any body of photographs from any historical time and place. Plucked from their historical world of contracts, commissions, stereographs, and stubborn Senators, nineteenth-century photographers like O'Sullivan are thus rehabilitated as the sires of a bloodline of artistic photographers legitimized by a powerful

American cultural institution, the Museum of Modern Art, and its provincial satellites: the Art Institute of Chicago, the Corcoran, the Walker, and now the Getty.

Szarkowski's scholarly legerdemain was nowhere more evident than in his protégé Peter Galassi's much-ballyhooed thesis project, *Before Photography* (1981). Here again, landscape imagery of extraordinary obscurity, culled from both nineteenth-century painting and photography, is used to establish a legitimating art-historical pedigree for 'photographic seeing.' As Abigail Solomon-Godeau put it with her customary bluntness, selective raids on the art history slide library can be used to support any proposition, no matter how absurd. The practice of obscuring historical contexts permits a curatorial theorist to construct a specious history that she then tautologically claims to have discovered.

In the area of landscape photography in particular, Szarkowski's influence seems to have been particularly crippling. As recently as 1981, he published *American Landscapes*, a slender *catalogue raisonée* of photographs from the museum's permanent collection. His brief introductory essay amounts to a roll call of the canonical masters, beginning with Civil War photographers and ending with Frank Gohlke, a designated heir. In some ways, this publication makes far more explicit the limitations of Szarkowski's vision of photography than other, more ambitious catalogues and exhibitions. There is, for example, the question of sexism in dominant curatorial practice: of the forty photographs included in *American Landscapes*, only two are women – Laura Gilpin and Dorothea Lange – both of whom are dead.[16] Each is represented by a single image, while male counterparts such as Harry Callahan and Edward Weston are represented by three and four pictures, respectively. Lange's inclusion seems forced in other ways as well, for her images of landscape are rare and she meant them to be read in context with her images of human activity and the extensive texts she and Paul Taylor wrote to accompany them.

Perhaps no exhibition and catalog were more influential on the course of landscape photography during the past decade than *New Topographics: Photographs of a Man-altered Landscape*, organized by William Jenkins for the George Eastman House in 1975. The aesthetic position enunciated by Jenkins pitted the nine photographers represented (only one woman – half of the Bechers – was included) against both the kitschy Kodachrome versions of wilderness immoralized on postcards and calendars and the touchy-feely Nature worship of the Minor White crowd, which perennially haunts the fringes of art photography.

The *New Topographics* photographers – Robert Adams, Lewis Baltz, the Bechers, Joe Deal, Frank Gohlke, Nicholas Nixon, John Schott, Stephen Shore, and Henry Wessel, Jr. – shun all the conventional norms of beauty and sentiment to which art and kitsch landscape photography appeal. Rather, they present themselves as self-consciously knowing 'naifs,' artless artists working within the tradition Szarkowski has constructed for those nineteenth-century expeditionary photographers who worked 'without precedent,' *without style*. For Jenkins and his photographers, however, 'there is little

doubt that the problem at the center of this exhibition *is* [my italics] one of style.'[17]

In speaking for the photographers he curated (and Robert Adams and Lewis Baltz must have squirmed just a bit at this), Jenkins claims that while their photographs convey 'substantial amounts of visual information,' they are *intentionally* about what is in front of the lens, which he defines as above all *an aesthetic arrangement*, having nothing to do with the cultural meaning of those references. He quotes Robert Adams:

> By Interstate 70: a dog skeleton, a vacuum cleaner, TV dinners, a doll, a pie, rolls of carpet. . . . Later, next to the South Platte River: algae, broken concrete, jet contrails, the smell of crude oil. . . . What I hope to document, though not at the expense of surface detail, is the Form that underlies this apparent chaos.[18]

But there is no Form outside of representation. Formal orders are human arrangements and perceptions, not given essences. Though Jenkins asserts that the photographers 'take great pains to prevent the slightest trace of judgment or opinion from entering their work,' these representations (no less than those from other landscape traditions) are charged with meanings that derive from the race, class, gender, and personal histories of these photographers, which are in turn transmitted to an audience with its own nexus of social and psychic predispositions.

The paradoxical fact that many critics and photographers regard the work of the New Topographers as moving beyond formalist to social critique has more to do, I think, with the impoverished expectations of what passes for social criticism in art than with any theoretical positions assumed by the artists in question. All acquiesce to the notion Szarkowski advanced in *Looking at Photographs* – that 'photographs describe everything but explain nothing.'[19] Jenkins reiterates the substance, if not the economy, of the dictum:

> The important word is *description* for although photography is thought to do many things to and for its subjects, what it does first and best is describe them.[20]

While it may be true that individual photographs are laconic – that they 'explain nothing' – the contexts in which they are produced, distributed, and consumed explain much about how we are to interpret them, including the knotty question of their relationship to the subjects they describe.

As an example, the uses of Stephen Shore's landscape photographs provide a fascinating case study of how different contexts can invite radically different readings of the same image. During the American Bicentennial, the Smithsonian Institution invited architect/theorist Robert Venturi to organize a theme exhibition on cultural symbolism in the American vernacular landscape. The resulting exhibition and catalog, *Signs of Life: Symbols in the American City* (1976), prominently featured Shore's large-format color photographs of small-town and suburban landscapes. One of these had appeared the previous year

in Jenkins's *New Topographics*; another reappeared seven years later in Shore's own monograph, *Uncommon Places* (1983). In Venturi's *Signs of Life*, Shore's photograph of a small Dutch colonial style cottage in a neatly manicured suburban setting appears with the following caption printed beneath it:

> Decorated house fronts are suburban billboards with flags and eagles, foundation planting, doors, porches, roofs and walls, windows, grills, shutters and ornaments as part of the symbolic content.[21]

In the *New Topographics* catalog, the identical photograph is captioned, 'West Avenue, Great Barrington, Massachusetts, 1974.' This laconic place-and-date appellation follows the formula for titling landscape photographs shown and reproduced within art contexts. (Its intentionally nonspecific formula does not customarily include the street name, but in this instance perhaps it sounded more 'topographic.') The modernist premise underlying this second title is, of course, that one does not make photographs *of* things or events, but rather makes pictures to see forms in flat arrangements with their own internal coherence. Making any reference to the world outside the frame beyond the title is deemed superfluous, if not downright distracting.

This refusal of historical context is taken to its extreme by Shore in his own book, *Uncommon Places*. In *Signs of Life*, Venturi's caption of Shore's photograph of a town thoroughfare reads, 'On Main Street, the buildings of one era are transformed by the signs of the next.' In Shore's fine-art monograph, the identical photograph is reproduced with no caption or adjacent image of any sort – only a page number. An index at the back of the book refers each photograph's page number to the conventional formula of place and date. Nothing textual (and thus contextual) is allowed to distract the viewer from an appreciation of the photograph as pure visual form; anything reminding us of the historical contingency of the photographer and/or his subject is rigorously eliminated.

But art venues invariably use external devices to control our reception of a photograph. Mats and frames, neutral walls, discreet labels, high rents, and the gallery hush provoke a palpable reverence before the images, even before we've inspected them closely. In catalogs and monographs, the high seriousness of the images reproduced is constructed through the inclusion of each photographer's resumé. Thus in *New Topographics* we read that photographer Robert Adams received both an NEA fellowship and a Guggenheim grant, in addition to being exhibited at the MoMA, while across the page, Adam's photograph automatically 'confirms' the credentials of 'proven genius' set forth verbally.

I single out Robert Adams because he is the most complex and articulate of the New Topographers and has made no secret of his liberal interest in the social issues surrounding the landscapes he photographs. However, his *logophobia* in the presence of *the image* has resulted in a self-defeating tendency to give lectures and write essays that reveal his passionate feelings about what he photographs while the images themselves remain isolated within museum and gallery spaces whose institutional

discourse tends to suppress expression of social concerns.[22] This balkanization of images and text renders both Adam's written essays and photographs weakened statements; it also remands his photographs to the precincts of Art, there to be admired for their 'attic restraint,' to quote Szarkowski, rather than for their expression of a socially critical point of view.

In a revealing passage in one of his essays, Adams says that one day, after spending weeks making beautiful formal pictures of open-pit mines for a commercial client, he felt impelled to drive eighty miles out of his way to photograph a monument erected by the United Mine Workers to commemorate the massacre of miners and their families by the state militia.

> What I wanted *and knew it was hopeless* were pictures of the monument that would somehow indict the new strip mines to the north. But in most cases the miners there were uninterested in a union and were, for all I had been able to discover of their consciences, now themselves probably members of the National Guard.
>
> I was left at the end of the day with a sense of the uncertainty of evil, of the ambiguity of what photography could do with it, and of the fact of my own limited skills. After years with a camera I had wasted still more time trying to do what it apparently was not given me to do [emphasis added].[23]

Adams's twinges of liberal guilt about working for a corporate client in an industry with a violent union-busting history are, in his eyes at least, absolved by his projecting onto 'the miners' a conservatism and lack of self-interest comparable to that of their bosses – 'they were uninterested in a union and were . . . now themselves probably members of the National Guard.' Adams's abortive pilgrimage to the monument and his recounting of how he tried to make an incriminating picture (and failed) get him off the hook, justify his limitations, and make him look like the good liberal he is – 'It apparently was not given me to do.' One might ask, *given by whom? God? Nature? John Szarkowski?* Who told Robert Adams he could not make photographs 'that would somehow indict the new strip mines to the north'?

Furthermore, for what is Adams indicting the strip mines? Corporate greed? Boom-towns? Immigrant workers? Ravaging the landscape? Even though he does not reveal the precise nature of his distress, any number of indictable situations could be documented photographically, accompanied by explanatory texts and, particularly with Adams's national reputation, published in forums that reached his intended audience(s).

Adams's most recently published attempt to address a 'social issue' while still fetishizing the purely visual is *Our Lives and Our Children. Photographs Taken Near the Rocky Flats Nuclear Weapons Plant* (1984). *Our Lives and Our Children* provides an excellent case study of the poverty of dominant art photographic practice in speaking to specific, material concerns.[24] Photographs seeking to construct social concerns without reference to their status as historical objects become diminished by their 'universalized' status as art objects. It should be obvious that modern patron-institutions (cultural, corporate, governmental), all

justifiable targets of social critique, have a vested interest in keeping art and the critical discourse surrounding it free from overt politics. As Allan Sekula, Hans Haacke, Douglas Crimp, and others have demonstrated, art institutions have been successful in accomplishing this task, both through action – control of funding, endowments, curatorial practice, art-historical scholarship, etc. – and through self-representation – the conventional wisdom that the separation of art and politics is just plain 'common sense,' that the museum, like Art itself, is about timeless and universal concerns.[25]

Returning to landscape, what can photographs of landscapes tell us about how we construct our sense of the world? A comparison of two bodies of landscape photographs made in the same period, of similar subject matter, and addressing similar social concerns will demonstrate the difference between landscape work committed to questioning the conventions of landscape photography and an art photography that merely perpetuates or dissolves them into barren irony. Every critic who has assessed John Pfahl's widely published portfolio *Power Places* has expressed astonishment and some confusion about his apparent lack of political consciousness in making such lush, large-format, *beautiful* pictures of nuclear power plants. Even those who are quite at home with traditional art photographs seem a bit nonplussed when confronted with Pfahl's serene impression of Three Mile Island, reflected in the still, quiet waters of the Susquehanna River early on a sunny morning.

Exhibited without any statement that might anchor his images for the viewer, the photographs bespeak a kind of romantic nostalgia for the picturesque landscape; power plants, like rock formations or ancient trees, can be objects of beauty – the sublimity of the modern atom by the shores of ancient seas. Pfahl's photographs elicit other readings as well: that 'energy' is 'natural' and found in every landscape; that human exploitation of resources is universal and necessary, even in the most primordial, picturesque settings, and so on. As social responses to the issues raised by nuclear-energy development, such readings play squarely into the hands of utilities management, which uses very similar visual images to make precisely these points in corporate propaganda.

If setting up a 'dissonance' between the romantic pastoralism of the landscapes and the potentially dangerous power plants within them was Pfahl's intended strategy, it is not carried through consistently, for he photographs nonhazardous *power places* such as hydroelectric facilities and dams with identical concerns for beauty and formal control. One suspects other motives at work here, namely marketing strategies in the art-collecting world. It is worth recalling that Robert Freidus, Pfahl's New York dealer, has stated explicitly that the 'theme portfolio' is the cornerstone of his art-photography selling success.[26] By combining conventionally beautiful photographs of socially-loaded subjects with a fashionably ambiguous high-tech/political/ecological theme, the work was highly marketable without offending any potential buyer – a corporate client in the energy industry, for example.

In contrast, Lisa Lewenz's *Three Mile Island Calendar* (1984) uses photographs of that power plant within a very consciously constructed political context, wittily appropriating the vernacular Christmas-calendar format as a foil for her serious message. Instead of the conventional Kodachromes of mountain's majesty, we see TMI photographed in gritty black and white from the homes of nearby residents. On the calendar itself, in addition to traditional famous anniversaries and birthdates, Lewenz adds dates of significance to the history of atomic energy, creating oddly provocative juxtapositions. For example, along with 'Father's Day' we read, 'Radioactive Iodine released by Dresden-2 reactor, Chicago, 1970' or 'U.S. Supreme Court rules: NRC can OK nuclear plant without waste study, 1983.' Her inclusion of landscapes *within* the frame of people's homes makes explicit the lurid connection between what lies *out there* and the privacy of our homes. Rather than the fantasy of a landscape world *beyond* society, or only marginally related to society, Lewenz creates an analysis of landscapes as a social production.

By mass-producing her calendar and selling it for an affordable six dollars instead of issuing her photographs as limited-edition, archivally printed art objects priced in the hundreds or thousands, Lewenz makes clear the precedence of the informational over the aesthetic. She also opens up distribution to audiences who would never enter a museum or gallery. It goes without saying that Pfahl makes much more money at what he does than Lewenz; he is a 'success' in current art-world terms and reaps the rewards of steady academic employment and visiting-artist gigs. But Lewenz's calendar demonstrates a successful attempt at moving beyond art photography's limited, inbred audience and its ironic/aesthetic detachment from 'life,' to using landscape images for articulating a clear position on both formal and social issues while reaching a wider public.

Other sorts of positions that might be articulated in landscape photography include land use, zoning, the workplace, the home. Women, I think, have a special stake in documenting this sort of 'social landscape' – one that is quite different in nature from the 'social landscape' delineated in the mid-1960s by Nathan Lyons in his exhibition of that title for the Eastman House. Most landscapes that are used primarily by women – the house, shopping centers, beauty parlors, laundromats, etc. – are designed by men for maximum efficiency and/or to promote consumerism among women. Only recently has the history of an architecture by women for women been rediscovered and advanced. Such an architecture would fundamentally redesign living spaces and workspaces with women's needs in mind – for example, communal day care, private work areas away from family demands, and easy access to other women through horizontal social networks.[27] Such a sense of order-in-space could be analyzed in a feminist landscape photography.

Women might also recoup landscape photography for themselves in response to its present character as a male preserve in art photography. The image of the lone, male photographer-hero, like his prototypes, the explorer and hunter, venturing forth into the wilds to capture the virgin beauty of Nature, is an enduring one.[28] Even those modernist topographers who point their

Deardorffs, Sinars, or Linhofs at 'the works of Man' (as in *a Man-altered Landscape*, to use Jenkins's words, or *The Hand of Man Upon The Land*, to borrow one of David Plowden's headings) fit that archetype. Weston, Porter, Caponigro, Strand, Plowden, Tice, Clift, both Adamses, Baltz, Deal, Divola, Klett – the roster of landscape photography's acknowledged masters could go on and on.

Where are the women? As my comments on Szarkowski hint, their work has been systematically excluded from surveys of landscape photography at major museums. Five years ago, Lustrum Press published *Landscape: Theory*[29] as part of its ongoing 'Theory' series, wherein well-known photographers attempt to explain, with varying degrees of success, what they do. From 'A' (Adams) to 'W' (Weston), all ten of the photographers profiled in *Landscape: Theory* were men.

And the beat goes on: the Spring 1985 *Aperture* survey of Western landscape photography featured the portfolios of eleven men, NASA (which may as well count as a twelfth!), and one woman, Marilyn Bridges. In April 1985 a major landscape exhibition tellingly titled *A Vision of Nature* was mounted by the Photography Department of The Art Institute of Chicago. The curator not only excluded women from his retrospective, but set up a dubious historical account promoting the genius of the six masters represented – Adams (A.), Porter, Stieglitz, Strand, Weston, and White. No less than Marlboro Country, American landscape photography remains a reified masculine outpost – a wilderness of the mind.

Some women landscape photographers, like Linda Connor, have protested the exclusion of women from the canon, but instead of challenging the structures of canon-formation per se, they offer what amounts to an essentialist theory of women's landscape imagery, one that posits a more intimate, emotional response to Nature because women somehow have more affinity with It. According to Connor, women don't possess the acquisitive, manipulative, territorial instincts of men, and this comes through in their pictures of landscape. Additionally, she asserts that women's childbearing capacity 'makes an enormous difference' in how they perceive themselves and their relationship to the world, although she doesn't reveal any specifics.[30]

Ironically, this construction appeals to an old, pancultural assumption that has been used throughout history to devalue women and their cultural production. It holds that because a woman is more involved with the 'natural' functions of reproduction and nurture, she is 'closer to nature' than men. The insidious corollary to this posits that the male's lack of such 'natural' creativity causes him to create 'artificially' through the mediums of technology and symbols. Consequently, maleness and male activities are more highly valued (and this is universally true) for their consciousness and artifice: men *choose* to interact with nature and bend it to their will, while women simply *are* nature and cannot define themselves in opposition to it.

Feminist anthropologists like Sherry B. Ortner have demonstrated how these constructions and their implications operate as universal givens for men *and* women in their perceptions of gender difference.[31] And psychologist Nancy Chodorow has argued convincingly that this notion of sexual difference is not

innate; that it is inculcated within the structure of the family, where gender roles are taught to children by both example and representation at many levels.[32] Rather than further perpetuating these restrictive notions about women's special relationship to nature, feminist photographers might well use their work to subvert conventional masculine constructions of the wilderness and the Marlboro Man.[33] Merely supplementing the limited canonical notions of landscape photography with an–Other, equally limited and ahistorical, may have the short-term effect of populating the walls of 'women's spaces' with a certain easily identifiable style of work, but, as was the case with the first phase of feminist painting in the early 1970s, it will only serve to create new sexist stereotypes or entrench old ones more deeply.

Rather than accepting established art-historical models of landscape photography or looking for alternative but equally universalized 'norms' to replace them, it seems worthwhile to examine instead other disciplines such as urban planning, landscape architecture, and geography. In these disciplines, the environment is approached analytically, photographic evidence is used to make focused cultural statements. Such work, most notably the writings of geographer J. B. Jackson, has already exerted some influence within the photographic community, particularly in the Southwest, his base of operations. The inventive approaches of urban planners like Kevin Lynch and Robert Venturi, who consider the city as primarily a visual space, or the probing essays of cultural geographer David Lowenthal on the significance of cultural memorials, or the extensive use of photographs and visual material by Grady Clay in his book *Close Up: How to Read The American City* – all of these can stimulate reflection on how the landscape is a human organization of space, an historical construction rather than an immutable essence.

Art photographers fear that in such 'analytical' approaches the photograph might lose its primacy of place to a written text, should the two ever be joined. It seems as though part of the Faustian bargain to elevate photography to status of 'art' has exacted a decree that written texts be forever banished from the vicinity of the visual image – that photographs present themselves in the same contentless depoliticized way as modernist paintings have embraced since the 1930s. Ironically, such concessions were instituted in the name of preserving 'the integrity of the image,' the price being the integrity of history! As was pointed out earlier, recent art-historical scholarship has engaged in a wholesale effort to rid historical photographs of their historical functions (has ripped them out of the books and magazines) and presented them instead as autonomous works of art by original geniuses.[34]

It follows, too, that most college-level art photography programs do not include theory[35] and history courses that would require students (1) to formulate coherent statements about what they are doing and why and (2) to write around their photograph(ing). Rather, the student is taught to conceive of him/herself as, in effect, a post-literate Eye that makes photographs 'to see what things look like photographed,' to paraphrase modernism's most-lionized master, the late Garry Winogrand. Small wonder, then, that most art-photography teachers and students are unprepared for and hostile toward any methodology

that demands accountability for what is being shown *in* their photographs in terms of discourses other than that of a disinterested formalism.

If we are to make photographs that raise questions or make assertions about what is *in* and *around* the picture, we must first be aware of what the ideological premises are that underlie our chosen mode(s) of representation. Such awareness will structure the aesthetic, editorial, and technical decisions that are made with the goal of communicating ideas in a provocative (and yes, creative!) way. As part of this program, a reassessment of the museum/gallery system is in order. Many artists have found it necessary to seek other venues for their work. Should the rare fate of 'art fashionability' befall the photographer engaged in socially committed work, s/he must be vigilant about protecting the work from being removed from its own history – from having its captions removed, its tape recorder unplugged, or its sequence jumbled. It goes without saying that any issue-oriented work becomes transformed by history and loses its immediacy with time, but this is no justification for abandoning the work's current cultural task to the first (or highest) bidder.

Landscape art is the last preserve of American myths about Nature, Culture, and Beauty. It is no accident that its resurgence in popular and highbrow art is taking place during a right-wing political period in which big business has virtually free rein over the social and physical environment. Photographs of the strong forms of a Chicago or Pittsburgh blast furnace say nothing about the tragedy of massive unemployment in the Rust Belt or the profit motive of a corporation that rends the social fabric of a company town. How shocking would it be for U.S. Steel chairman David M. Roderick to have a Weston, a Sheeler, or a Plowden hanging on the wall of his corporate headquarters? Or former Interior Secretary Donald Hodel an Eliot Porter? The regrettable truth is that most 'art lovers' wouldn't bat an eye, but instead congratulate the CEO and the Secretary on their good taste, their support of the arts – confident that art was doing its cultural work, 'beautifying and elevating' our *personal* lives!

Landscape has been appropriated by our cultural establishment as 'proof' of the timeless virtues of a Nature that transcends history – which is to say, collective human action. For most photographer-artists, landscape has been reduced to a locus for the experience of the isolated individual. In the words of Lewis Baltz:

> The landscape . . . seems more a set of conditions, a location where things and events might transpire rather than a given thing or event in itself; an arena or circumstance within which an open set of possibilities might be induced to play themselves out.[36]

But landscape needn't serve either of these dominant constructions. If we are to redeem landscape photography from its narrow, self-reflexive project, why not openly question the assumptions about nature and culture that it has traditionally served and use our practice instead to criticize them? Landscape is not the open field of ideological neutrality that Baltz fancies it to be. Rather, it is a historical construction that can be viewed as a record of the material facts of our social reality and what we have made of them.

Jan Zita Grover

Dykes in Context: Some Problems in Minority Representation

(First published in *The Contest of Meaning*, Ed. Richard Bolton, MIT Press, 1989 & 1992)

During the 1980s, writings on the representation of lesbian and gay sexuality in photography were many and varied. Zita Grover's 'Dykes in Context' is perhaps the most scholarly and acute essay currently available to us. A stringent critique of the 'negatives and absences that have played so large a role in determining lesbian picture-making until recently', it examines ways in which lesbianism has been marginalised or exoticised within the media.

Dykography

TWO STORIES:

When I first realized that I could describe myself as a lesbian, I read everything that I could on the subject. After all, I was in training as a young scholar, and library research was the single area of human experience with which I felt entirely comfortable. What was happening to me in my everyday life, on the other hand, was terrifying, if also exhilarating, so I took refuge from it in the library. I was also curious to see what life as a lesbian would hold for me – to investigate, imaginatively, what my future as a lesbian might be. Books being histories, accumulations of experience over time, I thought then that they could answer my questions.

The future, it turned out, looked pretty grim: like everyone else's, my first literary encounter with lesbianism was Radclyffe Hall's *The Well of Loneliness* (1925), from which I learned that self-renunciation and noble suffering (which, like most women, I had already learned at my mother's knee) were the most that I could aspire to. Curiously, I felt a far larger frustration with this book's *form* than with its moral position: it offended me aesthetically. It was a far clumsier novel – less erotically or intellectually satisfying – than those I had come to love and analyze as an undergraduate English honors student. It upset me – this was my first experience of the lesbian's marginality – that I should somehow have to settle for novels that I would otherwise find uninteresting, simply because they were the only ones peopled with lesbian lives. This discontent is still a problem for me twenty-two years later, though I recognize how fortunate I am that this is the strongest experience of marginality I have had.

My second brush with published sapphistry was a peculiar book of popular

sociology by a male author, Jess Stearn. *The Grapevine* purported to examine the lives of a broad cross section of lesbians in America, c. 1964.[1] Once I had finally worked up enough courage to walk up to a counter at the University of California bookstore and brazenly buy it, I read the book eagerly. What I discovered from Stearn was that we were, all of us, damned: some more colorfully than others, some more thoroughly than others, but all damned nonetheless. In his many anecdotal portraits of lesbians across different ages, classes, professions, and regions, Stearn made several things all too clear: fidelity was unlikely, alcoholism probable, promiscuity endemic, loneliness inevitable, and alternatives unthinkable.

Now here's the catch, the whole point of my bringing this up: it was very important to me that my sister, who is eighteen months younger than I, understand something about this new identity of mine. And being an earnest young scholar, and having unearthed this book that (given my own inexperience) seemed to represent exhaustively the world I was now entering, I sent *The Grapevine* off to my sister. I intended it as a sort of teaching aid to the primary text of my new identity as a lesbian. I was twenty years old.

Looking back on this, it surprises me that my sister didn't contemplate a swift mercy killing. Of course, I had no idea then how awful a representation of lesbian lives *The Grapevine* was; in a sort of paradoxical and finally transformative reading, I both accepted its image of lesbians and ignored its gruesome moral in favor of the vivid sense of connection it gave me to women I longed to know. It was 1965, and there were no women's centers, no women's bookstores, no women's publishers as there would be five years later. I was young, I was guiltless, and all the horrors Jess Stearn described lay (if at all) in my future. Beyond adulation of the San Francisco Mime Troupe's guerrilla theater, I was innocent of a politics. So though I did think it odd that a man should have authored a book about lesbian lives, it was difficult for me to see precisely where the problem lay, since the conclusions Stearn drew were identical to those of the only lesbian author I knew of: Radclyffe Hall.

Soon I discovered the popular novels of Ann Bannon and Claire Morgan, and Djuna Barnes's elegant and very literary novel *Nightwood*. Though of varying degrees of interest in the formal terms by which I had been taught to read and value literature, their subtexts matched those of Hall and Stearn: lesbian lives were doomed.

My second story:

In Phoenix twelve years later, a woman I worked with bought her lover a book of photographs for her twenty-seventh birthday. Rita showed me the book after she found it at a mall one day on her lunch hour. It was a book of gauzily-diffused nudes – two elegant-looking women seemingly engaged in lesbian lovemaking: *Sappho*, by J. Frederick Smith.[2] *Playboy, Penthouse, Hustler*, and other men's magazines frequently run similar sorts of photographic features: medium-range and close-up shots of naked or exotically dressed women in close embraces, kissing, coiling about each other like serpents, the crotch or breasts of one of them always curiously pointed, not at the other, but toward the camera and the absent but implied presence of a (male) viewer.

Rita looked at me with such visible pride in her purchase that I did not tell her what I thought of her book. After all, who was I to tell her what she should and shouldn't find erotic, whom she should or shouldn't support through her book buying? But it made me terribly sad to think that that book's distinctly male fantasies about lesbian eroticism should have been the only thing Rita could find in book form that approximated her own sexual focus.

This second incident took place in 1977. Between then and now a number of lesbian institutions have been instrumental in the production and distribution of lesbian photographic representations. These images circulate through publications like the late *Blatant Image, Sinister Wisdom, Conditions, Heresies, Thirteenth Moon, On Our Backs*, through women's centers and alternative galleries, and through the wonderfully complex informal networks that lesbians – feminist and otherwise – have developed throughout the United States and Canada.

Yet I am confronted with a discomforting paradox – rueful, dykey, not politically correct. It is this: that for all our seeming gains in having created our own visual representations – our own visual identity, you might say – something valuable has been lost as well as gained. Those older representations – the illustrated book covers of lesbian pulp paperbacks in the 1940s–60s, the covers of *The Ladder* – despite their fictitiousness, their sexual stereotyping, acknowledged desire, acknowledged the power of lesbian sexuality in a way that much contemporary lesbian self-representation does not.

This is not a conclusion I reach lightly or without great reluctance. I have cross-examined myself: am I simply nostalgic, as if often the case with members of a once-embattled, now partially tolerated or assimilated subculture, for the days when to belong was also to be a social outlaw, a member less of a culture than of a cult? Am I succumbing to that treacherous fantasy of a now-dead organic community, which, as Raymond Williams has wisely reminded us, is already 'always gone'? [3] Or am I perhaps yielding to the ubiquitous fantasy of the middle-aged – finding the period of my own youth more exciting, more stimulating (after all, it was mine) than the present?

All of these speculations are partially true for me. In addition, though, and this is partly the focus of my essay, I think that much of our current self-representation has been effected at the expense of our sexuality, or at any rate of its representation. In seeking to represent the female sexual outlaw, the dyke, as a whole person, many photographers have ceased imag(in)ing her as a hole person.

As I have said, I neither reached this conclusion lightly nor am I pleased by it, but I do think it important to explore, no less for those of you engaged in other struggles of self-representation than for lesbians. For although what I have written thus far may appear to present a merely local problem – perhaps even a purely personal one – I think otherwise: what I am exploring here is the problematic interplay between culturally prevalent forms and what are intended as oppositional practices, between what is expected of us by our own and by dominant groups, between what we are willing to grant ourselves and others of our own/their expectations.[4]

The Hole in Space

M Y FOCUS is the work of a number of lesbian photographers who make photographs for a variety of communities. In 1984 I placed an advertisement in the summer and fall issues of *Afterimage* seeking lesbian images. The advertisement read:

> Submit papers, proposals, slides: On Problems of Representation in Lesbian Photography, for possible exhibition/publication in 1985–86 and for presentation at the 1985 Society for Photographic Education national conference in Minneapolis.

I also wrote to a number of lesbian photographers and lesbian publications that used photographs, explaining the project in detail. In response, I received ten initial query letters and slides for consideration. Through the informal lesbian networks nationwide, I received an additional seven letters and several sets of slides; I also viewed work at the Lesbian Herstory Archives in New York and solicited/discussed a number of photographers' work by phone. Although my notice stated that September 15, 1984, was the cut-off date, I continued to receive work for well over a year, the last from a woman in Waniassa, Australia. Of such is this invisible empire constructed.

It seems important to stress at the outset that Western lesbianism as a cultural identity is itself a product of capitalism and industrialization. Though same-sex love is as old as history, its expression as an exclusive sexual and personal identity in Western societies – an identity whereby its adherents identity ourselves as lesbian and live much of our adult lives exclusively with or among other women-loving women – is peculiar to the late nineteenth and twentieth centuries. Large cities and workplaces have created the conditions of social mobility, population density, and (relative) economic security necessary for lesbians to find each other and to create institutions for ourselves (and likewise, they have made it possible for our enemies to identify us through the growing visibility of our practices and institutions).[5]

In the earliest phase of this process, lesbians produced little in the way of publications or other vehicles for visual imagery. When lesbianism was represented visually, it was largely from without, by men speaking from and for dominant culture: one thinks immediately of the photographic films, peep shows, and photographic card sets of commerce, the lesbian masquerade of the classical Hollywood film, the Parisian photographs of Brassai.

Lesbian visual self-representation in the early twentieth century was limited largely to noncommercial artwork undertaken and distributed informally, from hand to hand, within lesbian subcultures: snapshots made with amateur cameras, private lesbian paintings and photographs by privileged, well-known artists and self-taught amateurs, and later, voluntary labors-of-love like The Daughters of Bilitis's monthly magazine *The Ladder* (1956–72). So far as I know, there were few commercial enterprises involving production, distribution, and exhibition of images from within lesbian communities until very recently.[6] In this

sense, what self-generated images we do have from the first sixty-odd years of this century exist not as commercial commodities but as personal mementoes, private or collective expressions of regard and friendship. They existed, in other words, outside the standard practices of commercial production and circulation, and, as such, their content was not determined primarily by the dominant culture's market values and methods. Alongside them books and images produced primarily to satisfy a heterosexual male market, like *Warped Desire, Sappho*, and *The Grapevine*, have also been collected and treasured by lesbians, their homophobic contents read transformatively and positively, as I had read them in my youth.

By the end of the 1960s, the United States's largest generation had come to adulthood in a wartime boom economy. Alongside the early civil rights movement and partially growing out of a resurgence of feminist and New Left theory and practice, lesbian and gay liberation movements appeared, creating a host of institutions catering to lesbian and gay desire for self-identified culture: community newspapers (such as *The Lesbian Tide, The Advocate, The Body Politic*, New York *Native*, San Francisco *Sentinel*, and *Bay Area Reporter*), magazines (*Sinister Wisdom, Heresies, Thirteenth Moon, Christopher Street*), publishing houses (Spinster's Ink, Daughters, Inc., Naiad Press; significantly, there were fewer gay presses than lesbian ones, a fact attributable at least in part to the easier time that gay men *as men* still have in publishing their manuscripts with mainstream publishers), theater, political organizations, churches and synagogues, singing societies, orchestras, and on.

These subcultural institutions ranged from community-based, not-for-profit collectives to profit-making, capitalist ventures. *The Lesbian Tide* (1971–80) of Los Angeles, for example, was published by an editorial collective that struggled throughout its existence to put out a newspaper combining local and national news and images of interest to lesbians. In contrast, the gay male *Advocate*, published first in the Bay Area and now in Los Angeles, was from its founding intended as a profit-making newspaper run along editorial and advertising lines identical to those of dominant culture's newspapers. The contradictions inherent in circulating and consuming sometimes identical images within such radically different publishing contexts will return to haunt us later.

In any case, both within mainstream and lesbian/gay subcultures, rising personal, social/political expectations and the proliferation of lesbian and gay cultural institutions in the 1970s and 1980s produced a wide variety of uses and meanings for photographs, our main concern here.[7] This demand for images of lesbians and gays – transcriptive photographs for news-reporting purposes, traditional portraits of couples and individuals, pornographic photographs for the rapidly growing gay (and more lately lesbian) commercial porno industry, 'corrective' life-style images for both lesbian/gay and straight audiences – coincided with and has been affected by feminist theory and criticism, as these have successively and variously defined themselves.

One of the most remarkable effects of feminist examinations in the 1970s of the ways women have been visually represented is a widespread, reactive move away from representation of the female body and female sexual experi-

ence. This is more true of visual than of literary and performance repres-
entations, and we need to understand why. As Rosalind Coward has noted,
'speaking about sexuality, and a preoccupation with sexuality, is not in and of
itself progressive,' but neither, for that matter, is silence on the subject. What
one might bear in mind, however, is that either reaction – a speaking out or a
silence – is bound to be taken several ways, according to who is doing
the interpreting. Both dominant and subcultural messages can be read vari-
ously, even contradictorily, for they are read by at least two different con-
stituencies: an intended or *internal* audience and an accidental or *external*
one. Both messages share a number of values/meanings for their audiences –
members of subcultures are, after all, informed outsiders, understanding the
meanings/values attributed to mainstream cultural messages as well as produc-
ing their own more limited ones. But the reverse is not also true: heterosexual
men and women, for example, are not likely to understand the specific erotic
valences of much lesbian and gay sexual imagery.

We need to recognize the problems inherent in serving and interpreting
two cultural 'masters,' rather than stigmatizing the sign-ers as hypocritical or
inconsistent. The latter reaction, unfortunately, is the more common one
around the subjects of both lesbian silence *and* lesbian celebration of sexuality,
with both outside and inside critics condemning either the presence or absence
of lesbian erotica. A further problem is that, as is common in criticism of visual
artifacts, too much attention is paid to what lies within the frame and too little
to the establishing contexts that surround it. This is even more the case when
the photographs in question circulate within the forms of modernist high
culture, wherein photographs are commonly treated primarily as formal argu-
ments.

In the case of the much commented upon antisexuality of much politically
active lesbian writing and photography in the 1970s, one can see the down-
playing of sexuality as a gesture of accommodation toward the heterosexual
world of dominant culture, not only as a correction (reaction) to the prevailing
male construction of the lesbian as perversely and exclusively sexual, but also as
the price of being able to work alongside otherwise discomforted straight
women (the 'lesbianism means making your primary emotional bonds with
other women' tack, which drops out sexuality as one of the engines of lesbian
culture identity) on political issues affecting us all – ERA, abortion reform,
child custody, equal pay, the continued genderization of the job market, and so
on.[8] Within lesbian communities as well, sexuality has been frequently down-
played as the price consciously paid for community. (The emergence in the
1980s of open lesbian s/m communities argues for the possibility of sex as a
bonding rather than atomizing practice.) Within lesbian-feminist subculture,
however, the same period also saw the production of a great deal of writing
and image-making addressing sexuality directly: *The Cunt Coloring Book, Blat-
ant Image*, the graphics of Tee Corinne, Barbara Hammer's films, Samois's s/m
theory/practice manuals, Pat Califia's prose, and more.

This brings us to one of the two central problems I can see in writing about
lesbian, gay, or other minority photographs: defining what it is that defines

them as lesbian, gay, latino, or whatever. Is a *lesbian photograph* an ontological entity, or does it gain its classificatory status through use, nomination, or what? *Whose* use or nomination? Such questions bring us squarely to a consideration of what it means to represent a subject in photographs.

Where We Come From

I remember that in 1972 two women came into my social circle and brought their instamatics. They were feminists and 'just out' and brought their Kodaks to our parties and took snapshots We were embarrassed. All of us too shy to say, 'No. Stop. Don't take pictures here. Don't take pictures of lesbians. Of us. It isn't allowed.' Those of us who vividly remembered photographs being used against lesbians in court, those of us who had ever heard of a custody battle for our children just stopped coming to the parties. The rest of us somehow stayed and survived. We didn't make them stop taking pictures and for the first time since child-hood I had pictures of myself. No myself-at-the-folks-passing-for-straight but of myself.[9]

WHAT DOES IT mean to re-present oneself visually as a gay or lesbian person? Does it produce something like the coverage one finds in a middle-class, dominant-culture magazine like *Time, Newsweek, Life*, where gays – at least post-Stonewall, pre-AIDS gays – were conventionally depicted as clean-cut, shiny-haired, Land's-End *citizens with a difference*? Is it similar to the coverage one finds in a working-class, dominant-culture magazine like *National Enquirer* or *The Star*, where gays wear silver-lamé jockstraps, linesman's boots, and little else, and lesbians T-shirts with cigarette packs (hard) rolled in our shirtsleeves? Or the depictions in, say, middle-class, mainstream gay publications like *Christ-opher Street* and *The Advocate*, where gay men are usually Caucasian, handsome, moustached, short-haired, palpably middle-class consumers? Or *Blue Boy* or *Honcho* – 'hot and hunky' (hairless/hairy)? Lesbians: which representation has greater authority for you: the wanton woman in Victoria's Secret underwear or leather in *On Our Backs* or the jockettes in a photographs of GAA softball players printed in a local bar guide or gay city newspaper? Any of these? All? None?

Obviously, we must ask ourselves a second question, not simply about which cultural institution's representations have authority or resonance or credibility, but *for whom:* for the Moral Majorian seeking proof for his con-tempt; for a parent of a gay seeking evidence that gay lives can be (almost) happy, (almost) normal; for a gay person living a closeted or isolated life, eager for evidence that others of her or his sex, class, race, sexual preference exist as openly gay; for a concerned straight person attempting to understand – to see – something about a gay friend's culture; for a gay or straight fantasy, turn-on, turn-off, daydream, nightmare. This question is in turn complicated by all that we know of ourselves: each of these distinctive audiences lives within

us as well; we are no more homogenous as identities than a stadium full of voters.

The point is that any visual representation is initially addressed through a cultural medium possessing greater or lesser authority to a particular constituency, for whom it may possess a greater or lesser degree of authenticity. As it moves beyond this primary audience, however, it acquires other meanings, other statuses. This is a condition of circulation that no one can afford to ignore. Images in the mass-circulation media, for example, possess a power that is rarely successfully challenged precisely *because* their widespread distribution posits them as representations of widely (and thus popularly) held values. Such images – in the form of advertising, editorial, public service, fashion, sport, or photojournalistic photographs – gain much of their power through the (seeming) simplicity of their means, which seek to limit possible readings in favor of central, market-desirable one(s).

What part of us produces images we might call lesbian? I can see many problems with the sampling of photographs with which I attempt to raise this question. It is heavily weighted toward women self-consciously allied with art/academic photographic institutions (the advertisement in *Afterimage* partially assured that). From my review of the holdings of the Lesbian Herstory Archives and the negatives and prints by many lesbian photographers that I found through other channels, I believe the vast majority of lesbian images are of the record-making variety. Whether recording domestic/private activities or public events in which lesbians figure, such photographs present us with a photographic practice that is specifically lesbian not in its attitudes to issues of representations of sexual and social difference and the contexts in which the work is encountered, but rather in its content: it records social occasions in the lives of women living as lesbians – demonstrations, vacations, concerts, festivals, parties. It does so in a manner identical to that of other social groups, making such photographs lesbian only in the sense that the people recorded therein are self-identified as lesbian.

Rosalind Coward has made a distinction between women's novels and feminist novels that seems useful here:

> It is important to distinguish between [women's] novels . . . not in order to designate one text as progressive in a crude moralistic way – far from it – but because with the increase of feminist involvement in cultural politics we cannot leave unasked the question of how representations work
>
> Feminism can never be the product of the identity of women's experiences and interests – there is no such unity. Feminism must always be the alignment of women in a political movement with particular political aims and objectives. It is a grouping unified by its political interests, not its common experiences.
>
> Finally, I think it is only if we raise . . . questions of the institutions, politics of those institutions, the representations produced and circulated within those institutions and the assessments of those representations that we can make any claim at all to a 'feminist reading.'[10]

This is no idle distinction. We can profit here from observing the vicissitudes of one of the most consistent arguments running through lesbian-feminist literary theory – namely, the question of whether or not there is anything intrinsic to the writing of lesbians that proposes their prose or poetry *as* lesbian and the larger question that points to: whether to define the field of inquiry on the basis of its presumed essence or its operations.

The field of lesbian literature, for example, has been largely defined in terms of authors' biographies (Jane Rule's 1975 *Lesbian Images*), stylistics (Barbara Smith's 1977 article, 'Towards a Black Feminist Criticism'[11]), creative energy (Adrienne Rich's 1979 essay, 'It Is The Lesbian In Us'[12]). The biographical approach has the obvious advantage of grounding the field of inquiry in something highly tangible – the known practices and affectional values of a writer – but it is likely at the same time to be highly reductive, since the biographical details of many authors' lives are unknowable and, more important, do not map simply and reflexively onto a person's art practices. A stylistic, *écriture feminine* approach privileges a particular use of language as if it were *essentially* lesbian rather than a subversive literary strategy equally available to men and women of any sexual identity. Similarly, the proposal that female creative energy is intrinsically lesbian produces a category – lesbian writing – that is so all-inclusive as to be useless for defining a field for inquiry.[13]

My tactic is instead one that arises from the specific historical formations of contemporary urban lesbian-feminism. The field I survey here is one comprised of photographs produced for distribution within the cultural institutions of lesbian subculture and secondarily within mainstream gallery settings, where (art-) accredited lesbians sometimes exhibit their work.

This resolves the question of whether or not to include private record-keeping photographs. Fascinating as they are, they are not intended to, nor do they, circulate through institutions that allow them opportunities to propose themselves as lesbian representations.[14] The photographs I was sent, on the other hand, as well as many that I found in archives, were intended and used within the subculture's institutions – its periodicals, postcards, posters, books, slide shows, and exhibitions. Within these venues, photographs propose certain things about lesbians: the ways we look, behave, *are*. It is these propositions I will address in this paper.[15]

There is no way to know if the photographs I received are representative of politicized lesbian photographic activity as a whole. Nor do I know if it is possible to draw any conclusions from the work that would apply across the field of U.S. lesbian photography. I make no claims to do so.[16]

As a critic, I can see any number of problems in proffering a personal reading of these photographs. The danger is always that such a reading will be so idiosyncratic – compounded out of my private concerns, my inevitably personal and partial consciousness of art and cultural histories, political convictions, and the peculiarly epicene conclusions that the very act of writing produces – that it will serve no purpose other than to clarify certain things for me, at the same time reenforcing for the reader a widely held notion that critics' concerns are too unworldly to constitute anything but a curious form of entertainment.

The most readily available alternative to such a privatized critical reading is the communications model or sociological or audience-response reading based upon quantitative studies of viewers'/readers' reactions to work. This, I think, also has its limitations: the kinds of questions *askable* under such models are limited to fairly simple and reductive ones, as are the possible replies.

What I hope to do here is to steer a middle course between the extremes of a highly personal and highly quantitative approach. I have shown the work I will be discussing to audiences ranging from a single viewer to a seminar group in feminist theory and criticism to a convention audience of approximately two hundred people. In all instances, I have been struck by the similarity of people's initial reactions to the reproductions I used to contextualize current lesbian photographs – that is, the pulp images common in men's magazines and fiction of the 1930s–60s. In contrast, reactions to the self-representations of lesbians differed markedly from audience to audience.[17]

I want to reflect on the material practices of a few lesbian photographers operating simultaneously within two contexts: dominant American culture and urban lesbian-feminist subculture, each of which makes some things easy to do, some difficult, some all but impossible. This is true at the levels of production, distribution, and exhibition of photographs. Though the range and number of lesbian photographers considered here is narrow, I hope that my discussion will prompt wider and deeper investigations, not only by lesbians but by any people who have not spoken through representation but rather have been spoken for.

We will begin by looking at the ways lesbians have been represented in the dominant culture's images, since these are the ones against which lesbian self-representations have primarily been produced and positioned. Happily, this isn't a particularly difficult task to perform: such images are everywhere, forming part of our mass-media image world.

Commercial depictions of lesbians have concentrated exclusively on sexual identity as a function of sexual activity. Lesbians, I need hardly add, are in turn identifiable solely through their sexual activity with one another: a tautological identity. The notion that the model demonstrating a refrigerator, working out on a home-fitness machine, or modeling lingerie might also be a lesbian is unthinkable within the set of assumptions wherein such commercial representations operate, for the lesbian can be identified *as such* only through her sexual activities vis-à-vis another woman (perhaps a lesbian, quite possibly 'a victim,' since the 'true' lesbian is popularly coded as predatory and male-like) – or, to be more accurate, *pre*-activity: at least one of the lesbians in much popular pulp imagery is commonly depicted as still *a woman*: she waits, she yearns, but she doesn't do much. If we look, for example, at the covers of pulp paperbacks depicting lesbian relationships in the 1940s–60s, we find that in these little worlds we are represented as exclusively sexual beings. Typically, we find a couple situated on or near a bed or an open door, with all that those symbols commonly imply of sexual transgression or exploration. Like the pornographic treatment of lesbians in *Penthouse* and *Hustler*, these depictions conventionally pair blonde and brunette, blonde and redhead. Unlike contemporary male fantasy fodder, however, which pairs similarly made-up models of comparable

body type, these pulp paperbacks make explicit allusion to butch-femme dichotomies: what were popularly conceived of as 'male' traits are attributed to one partner (short hair, tailored clothes, piercing stare, wirey, boyish build, dominating position above and behind partner), while the other is commonly depicted as exaggeratedly feminine (*en deshabille* – peignoir, brassiere or slip, frilly underpants – long hair, modestly downcast glance).[18]

As in male pornography, the 'ethereal' blonde is portrayed as passive and feminine – the innocent victim (femme) – while the 'earthy' brunette or redhead is active and masculine – overtly sexual (dominating butch). In looking at twenty-four pulp fiction covers from the Maida Tilchen Lesbian Trash Paperback Collection at the Lesbian Herstory Archives (New York), I found that 63 percent of the illustrations employ dominant/dominated subject positions; 67 percent play a short-haired, boyish butch against a long-haired femme; 88 percent employ a blonde-brunette/blonde-redhead pairing. Such consistency testifies to the marketing potency of these (supposed) signifiers of lesbian eroticism, which in turn suggests the publishers' projection of signifiers potent to *male desire* onto the lesbian. That is, most of the social and sexual differences encoded in these illustrations say more about male illustrators'/editors'/readers' concerns with imposing marks of gender difference on the objects of their desire than they do about lesbian lives.[19] Here, I might add, I am not invoking the putative authority of (my) lesbian experience as a corrective to male representations. Rather, I am interested in the differences between dominant cultural stereotypes of a subculture and that subculture's own stereotypes.[20] The consistency with which *all* audiences can read signifiers intended for primarily male producers/consumers contrasts markedly with the limited ability of heterosexual audiences to interpret quite another set of images produced by lesbian-feminist photographers primarily for lesbian audiences – which only tells us again what we already know in other ways: that subcultures are informed outsiders of dominant (here, of course, male) culture, understanding the signs of its desire very well, in ways that are not true in reverse.[21]

Whenever I show these pulp book covers to audiences, reactions are invariably amused and positive, whether those audiences are primarily heterosexual or gay or lesbian or lesbian-feminist. There is an undeniable pleasure to be found in these images, in the exercise of viewers' ability to read propositions about male desire so clearly; for when the images are presented in large numbers, their fixations become obvious. They also offer the pleasure of nostalgia: a removal of that contemporary ambiguity about sexual identity that makes their comforting male-female polarity appear artless and lost – desirable. But what seems most remarkable about them *in our current image climate* is the very overtness and insistence of their sexual interest. The rapacious gazes, the body postures, the sexually-coded costumes and setting, and the texts propose a narrative of (masculinized) female sexual heat that is missing in *Hustler*'s or *Penthouse*'s versions of lesbian sexuality, where the fantasy's contents, soft focus, and static, iconic presentations remove the depicted activities from the everyday.

In contrast, the pulp paperback covers place their subjects in bars, streets,

college-girl bedrooms, thereby situating desire in everyday life. Pulp titillation appears to have moved male fantasy materials from quotidian encounters with the sexually exotic and challenging to a leisure-world, passive consumption; from the representation of aggressive lesbian sexuality to a 'softer,' more abstract contemporary version. This change in fantasy images coincides with the very real visibility of active heterosexual female and lesbian sexuality just outside the covers of these magazines.

If we turn to visual representations of the lesbian within lesbian subcultural settings, we find a different story. It is compounded of practical applications of feminist (primarily film) theory and of modernist photographic theory and practice as taught and learned within the colleges and universities where so many lesbian photographers learn their craft and aesthetic values – values that do not necessarily serve the historical moment of their intended or accidental audiences as they might hope.

Increasingly in the 1970s, feminist literary and film theory stressed the problematic nature of any representation of the female person. The first and more obvious problem with female representation was that historically women's identity and image have been cut to the measure of male desire. How, feminists have asked, can women re-present ourselves in ways that do not fall into the conventions (and thus the ideology that those conventions partially both mediate and represent) of a patriarchal construction of femininity?

Two principal positions have emerged in response to this question. What has been termed the essentialist position poses a sort of bedrock femininity, long repressed by patriarchal institutions and discourses, which might rise up and reassert itself as we women grope our way into a female-centered consciousness, from which we can then speak our own femininity. Criticism proceeding from this position assumes, whether explicitly or implicitly, the existence of an authoritative *feminine* experience that can speak for and to women and against the constructions that men have placed on women's experience.[22] That this position is ahistorical and metaphysical has become increasingly obvious. If the principal barrier to 'true' femininity could be identified as extrinsic – men and their culture – and the solution therefore simple – women's culture – then Valhalla should have arrived in certain separatist urbane enclaves by 1972. It didn't. Our own Problems with Women clearly were deeper than the dominance of men's culture.

As feminists increasingly incorporated psychoanalytic theory into our analyses of cultural patterns, and as the rifts between white, middle-class, heterosexual feminists and lesbians, poor women, and women of color became more visible, a second position arose. It saw femininity as itself a psychic and social construction, as a constantly shifting, fractured identity, taking on meaning principally as a structuring absence – the absence of masculinity, that symbolic/social presence around which all other gendered identities revolve – that defines itself in relation to or reaction against various historical masculinities. How and to what extent meaning is determined by (which) masculinity is an issue preliminary to any questions of interpretation, however.

As Ann Kaplan has noted, the 'essentialist/anti-essentialist debate is import-
ant since the position one takes determines one's feminist methodology: it
will affect the kinds of questions one asks and the kinds of knowledge one
uses.'[23] Even within a single structuring paradigm, there can be enormous
differences in interpretation. For example, I can point out the differences
between Abigail Solomon-Godeau's and my own readings of the issues raised
by Frankie Mann's attire in Connie Hatch's 'Adapt,' the second segment of
Hatch's slide-tape trilogy *Serving the Status Quo: Stories We Tell Ourselves, Stories
We Tell Each Other*. Both of us operate out of an assumption that personal
identities are culturally forged rather than genetically programmed, but one of
us is heterosexual and one lesbian-feminist. I believe that this difference leads
to according Mann's clothing different meanings, different values. For Abigail,
Mann's 'masculine' haircut and clothes constitute a 'central contradiction that
emerges' between Mann's 'expressed revulsion for all that constitutes the signs
and attributes of masculinity and her assumption of a relatively butch persona.'[24]
This interpretation assumes that Mann's lesbianism is constructed primarily
through reference to signifiers of *masculinity*,[25] which in our culture include
short hair, tailored shirts, and slacks.

However, it is equally possible to begin with the proposition – an argument
central to much lesbian-feminist struggle – that such attributes are signifiers
whose cultural meaning(s) is equally determined by the (sub)culture in which
they are activated, that their play within subculture partially evacuates their prior
or parallel meanings elsewhere. That is, if we consider Mann's 'relatively butch
persona' not in terms of 'socially constructed gender roles that patriarchy has
manipulated for its own ends' (Kaplan, p. 235) but in the lesbian's own terms,
then Mann's no-nonsense clothing, haircut, makeup-free face and physical ease,
far from representing 'nothing so much as the adolescent male colonizing
physical space' (Solomon-Godeau, p. 135), may with equal plausibility signify a
claiming of *human* physical and social power denied women through conven-
tionally 'feminine' dress and deportment, which is the construction that I
and many other (nonessentialist) lesbian writers have placed on the signific-
ance of clothing.[26] Put in other terms, what stands in one context as
signifier of masculinity becomes, to those viewing it from within another, signi-
fier of the non-conventionally female or as the unconventionally female – the
lesbian.

The important thing to note here, since I see it as a way out of the dilemma
also posed by the photographs under consideration, is that as signs move away
from their culturally specific 'climate,' they become constituted as signifiers
pointing to new meanings. What may appear retrograde or progressive, un-
sophisticated or sophisticated, obscure or blatant depends primarily on the
climate for or within which the sign is produced/circulated and the expecta-
tions set for it. I therefore quarrel with a commonly held position within much
feminist cultural, film, and literary criticism in the late 1970s–early 1980s, here
enunciated by Mary Ann Doane in relation to film, as far too generalizing and
pessimistic in its assumptions about the audience's probable reception of images
of women:

Cinematic images of woman have been so consistently oppressive and repressive that the very idea of a feminist filmmaking practice seems an impossibility. The simple act of directing a camera toward a woman has become equivalent to a terrorist act.[27]

Such a position seems unduly pessimistic about the limitations imposed by dominant cultural forms or producers and readers, both as subjects of dominant culture and as possible subjects of subcultures as well. Though sophisticated, it is functionally a model of text production and consumption that leaves no possibility for transformative creation or reception. Instead, it suggests that we are stuck inside a culture that so inscribes patriarchy that the most we as feminists can hope for is to content ourselves with the fissures, the holes, the absences, and the silences within patriarchal discourses.[28]

In contrast to this scenario, subcultures – lesbians, gays, and other minorities – have regularly transformed the materials and values of dominant culture for our own purposes. Doane et al.'s pessimistic scenario is a historical one that may indeed reflect an impasse in narrative cinema for some middle-class European/North American white feminist practitioners and theorists, but it has little to say to the rest of us, who have yet to be self-represented cinematically, photographically, *at all*. Without in any way intending to dismiss the enormous problems in re-presenting female, much less lesbian, sexuality, I nonetheless reject the model that much recent feminist literary and film criticism calls for, a model whose authenticity is guaranteed by its supposed transparency of interest in and attention to the medium's technical/formal apparatus.[29] Such a model is of little practical use outside of those academic and avant-garde circles where formal innovations are considered central to efforts of liberation.

The Heart of the Matter

The pedagogical question crucial to Lacan's own teaching will thus be: *Where does it resist?* Where does a text (or a signifier in a patient's conduct) precisely make no sense, that is, *resist interpretation?* Where does what I see – and what I read – resist my understanding? Where is the *ignorance* – the resistance to knowledge – located? And what can I thus *learn* from the locus of that ignorance? How can I interpret *out of* the dynamic ignorance I analytically encounter, both in others and in myself? How can I turn ignorance into an instrument of teaching?[30]

I TURN NOW to the photographs I was sent, found, collected during the last several years. This is not intended as a formal analysis but rather as an inquiry into the cultural work they do. Unless we begin to understand the comple constraints on lesbian photographers in the face of both subcultural and mainstream values and practices, we run the risk of dismissing their work as 'unadventurous,' 'old-fashioned,' 'not-on-the-cutting-edge,' and other art-in-a-vacuum pronouncements. It is crucial to understand that the conditions

under which work makes its way into the world operate to make some work likely, some possible, some virtually unthinkable, some makeable but unshowable. This is what interests me – that point of intersection between what the producer makes or attempts to make and the world that receives it.

In her important study of the nineteenth-century American novel, *Sensational Designs*, Jane Tompkins explained that her 'assumption in each instance has been that the text is engaged in solving a problem or a set of problems specific to the time in which it was written, *and that therefore the way to identify its purposes is not to compare it to other examples of the genre*, but to relate it to the historical circumstances and the contemporary cultural discourse to which it seems most closely linked.'[31] Tompkins's assumption and method seem equally applicable to the matter at hand – an elucidation of the cultural work of lesbian-feminist photographs. But I am conscious that to address the photographs in this way flies in the face of most photographers' and readers' expectations of what will get said about them.

Those of us who are interested in photographs nominated as 'personal' or 'art' images are accustomed to hearing them discussed formally, which is a heritage of photography's arrival in the academy in the late 1960s, when the simplest way of paving over the painful differences among images and their readers – and to claim for them the seriousness of modern art – was to discuss them using agreeably vague and democratic terms like *intensity, originality, genius, formal purity, line, movement*.[32]

Being aware of the tyranny of readers' – and my own – expectations about such matters, I have found myself resisting writing what might be thought the central section of this article, namely, a consideration of the photographs themselves. Even that phrase, *photographs themselves*, seems to privilege the images as the heart of my project.

My resistance has taken a classic form: it has taken me over a year to write this section of the article, and even as I write, even as you read it, the slide between an honorable (expected) intention and what I am in fact doing is evident: the prefatory material I consider critical to a discussion of the photographs has extended itself indefinitely, pivoting endlessly around what may appear to you as a hole, a vacuum. I feel an anticipatory guilt toward the photographers who sent me their work, trusting that I would *analyze* it, only to find that I am doing something quite different; I feel a similar anxiety about my readers, who expect no less; and yet (*Yes, but. . . .*) I am convinced otherwise. There is a reason for resisting the expected here, something to be learned from it. Wrapping and rewrapping the photographs in these many layers of historical circumstance seems the only way I can shape what would otherwise be an unsatisfying and academic approach to them.

Analyzing the formal strategies deployed in these photographs would 'explain' only how a particular representation is constructed visually; and it is the representation *as a sign, an argument* in the world, that interests me. This emphasis points us away from that enclosure measured by what lies within each photograph's frame, the province of most academic criticism of photographs; it points us instead to a field constituted very differently: the concrete, historical

sites *in which the photographs are encountered* by different people, sites where they establish their meanings.[33] Thought about this way, both the presences and absences in these photographs become more lucid: we can read images as sites of consensus or resistance to cultural prescriptions/proscriptions, as locuses of contending discourses, such as those of academic art photography and dominant and subcultural politics, rather than as isolated acts of individual creativity.

Central to all these photographers' work is a conviction that it is a positive act to represent lesbian lives, that, in the words of Tee Corinne, 'The images we see, as a culture, help define and expand our dreams, our perceptions of what is possible. Pictures of who we are help us visualize who we can be.'[34]

Who the *we* that is speaking and spoken to is, of course, a core problem to this statement as well as to the picture-making that follows from it. The *we* the seven photographers discussed below use to position themselves within lesbian subcultures varies widely, as do the *we*'s addressed. But in teasing out those *we*'s, the rationales, strengths, and limitations of these different approaches become more understandable.

All of the photographers I discuss here work against something of a vacuum in lesbian self-imagining. During the 1950s and 1960s, when the oldest of them were in their childhood and adolescence, these photographers had access to few representations of dykes from within our own communities; the images with the widest circulations appeared in *The Ladder*, a long-running lesbian monthly produced by the national organization The Daughters of Bilitis.[35]

Two things about *The Ladder*'s graphics are particularly striking for viewers in these post-Stonewall, (hopefully not post-) feminist days: their emphasis on the dyke-beneath-the-lady – the tomboy hiding behind, or hopelessly striving to emulate, the 'feminine' woman – and a gender differentiation as implacable as that supposed to obtain in heterosexual social relations: short-haired, flat-shoed, pants-wearing women eyeing or hand-in-hand with longer-haired, high-heeled, skirted femmes.

Lived experience is far more complicated than any representations of it can ever be, and I well remember the dilemmas that these images referred to in my own and others' lives, and how untidy and inconsistent our solutions to them were. The connection between such images and our experiences was wistful, romantic, and very allusive. It was the product of an era in which even to speak about our lesbianism *among ourselves* was to court personal and public disaster: the magazine was mailed anonymously and its cover art was sufficiently allegorical to make its subject matter a puzzle piece to 'outsiders.'

Joan E. Biren (JEB) of Washington, D.C., Tee Corinne of Sunny Valley, Oregon, Nancy Rosenblum of Los Angeles, and Danita Simpson of Detroit are lesbian photographers whose work has been produced and distributed largely for lesbian audiences. With the exception of Corinne, their circulating work is dominated by formal and informal portraits, many of them of women alone, signed by their occupation or public identity (Rosenblum's *Betsy Skidmore, 29, tennis instructor; Jean Pittman, 30, furniture maker;* JEB's portraits in *Eye to Eye*). By removing the most conventional marker of lesbianism – another woman

who reminds the viewer of the lesbian's sexual choice – such images propose lesbianism as a social or essential identity rather than exclusively a sexual one. Inclusion of names, ages, and occupations emphasizes the subjects' being-in-the-world, filling in the social absences in prior representations for both lesbians and other audiences. At the same time, by positioning these socialized subjects within an avowedly lesbian context – a book or slide show on lesbian people/lesbian identities – distributed through primarily lesbian communities, these photographs remind us of the dual nature, sexual and social, of their subjects.

Even the formal portraits of couples in these photographers' work appear as repudiations of a preeminently sexual identity: it is their stability as social units that is emphasized. Unlike male-produced images of lesbians – and here I confess that I must compare apples and oranges, for I'm talking about formal portraits on the one hand and porn on the other[36] – these photographs all but eliminate the sexual components. Unlike pulp paperback covers, *Penthouse* or *Hustler* spreads, Rosenblum's, Simpson's, and Biren's photographs avoid seduction, overt sexuality, and hierarchical organization of the subjects (as those have been conventionally defined in formal portraiture). Where women touch at all, it is in a friendly, nonerotic manner. Particularly in Simpson's case, there is as much information about the couples' domestic settings as about them; the comfortable clutter of their living rooms (not a bedroom or boudoir in sight) invites us to speculate about taste and personality rather than sexual practices.

Yet the claim of 'this is what is' sits uneasily in light of other decisions evident in the photographs. The subjects seem to be placed for the sake of the framing: chairs pulled into centers of rooms, uncluttered backgrounds. Most of the subjects look directly into the camera, they rarely or barely smile, and their bodies are composed, at rest. (Rosenblum's use of the 4 × 5 camera and Simpson's use of medium format with great depth of field make relatively long exposures necessary, which partially explains the static quality of these portraits.) Their formality attests to the status these photographers aspire to: the making of propositions about what is desirable (home, furniture, pets, lives in common) rather than signs of what has been permanently achieved. The positive reactions such photographs meet with when circulated outside the particular communities of the women pictured (as in JEB's nationally circulating slide shows) but still within lesbian subculture attests to the ways in which such photographs function culturally for lesbian viewers: as evidence that coupledom, domestic stability, and single lesbianhood can be achieved.

The photographs circulate primarily within lesbian settings – women's centers, coffee-house galleries, books from women's presses – where they function primarily as signs of the emergence and new public-ness of lesbian subculture, their intended audiences. But these are not the only viewers the photographs have, nor the only reactions possible to them. In contrast, non-lesbian audiences may be struck by a variety of other qualities in the images: their formal conventionality, as if photographic portrait strategies hadn't altered since 1915; a nineteenth-century technique imposed on a distinctly late-twentieth-century social phenomenon, the urban, 'out' lesbian couple or

individual; their romanticism — lesbian life, whether singly or in couples, portrayed as a self-satisfying, orderly, above all *stable* existence (a quality that these portraits share with other formal portraits, though not one commonly credited to lesbian lives).

The situation with Simpson's bar photographs is somewhat different, pointing up the confusions that result when subcultural images circulate outside their primary 'terrain.' Made for her master's degree project at Wayne State University, these portraits followed a shooting/editing strategy common to both art photographers (Lee Friedlander, Garry Winogrand, Larry Fink) and amateurs — party pictures taken under very low lighting conditions in which the image reveals itself only during the microsecond illumination of the electronic flash and later in the printed images themselves.

For Simpson, this almost-random method of shooting functioned as a guarantee that 'the images are not voyeuristic — for it's impossible to be such with an electronic flash in a darkened bar.'[37] Such an ethical concern with the motivations or consequences of shooting, however naive or displaced it may be, differentiates the lesbian photographer's position and dilemma in chronicling her community and circulating images of it beyond that community from the position of art photographers bringing the same methods to bear on mainstream social events. This isn't to say that I think Simpson's photographs are comparable to those of Friedlander and company in formal inventiveness or visual complexity, the criteria by which those images are customarily judged. To do so is to miss my point entirely: criteria of meaning alter as one reads from specific community to specific community. In this case, Simpson attempted to have it two ways — to make photographs that were specifically recognizable within an art/academic context as kin to Friedlander et al.'s as well as within her own lesbian community.

Her method and site produced a spontaneity and casualness that her black-and-white portraits do not; what these qualities mean, however, depends on who is doing the reading. For a lesbian audience, the bar means darkness, drinking, flirtation, public declarations of affection, sexual interest, sexual identity, aggression. The images that arise from these conditions read for lesbian audiences as explicit celebrations of sexuality between women. For an art/academic audience, these emphases are replaced by technical and formal considerations: the color balance of the printing, the pleasing ambiguity (or displeasing literalness) of the image. Such criteria can serve interests at pains to ignore lesbian issues, as Simpson herself discovered (see below).

The strategies at work in the majority of photography courses in art schools, liberal arts colleges, and universities make it easy for instructors and students to find ways around discussing the cultural meanings (such as the sexual or political content) in photographs. It is the dubious achievement of an institutional emphasis on formal strategies and material techniques that leaves the sociocultural balance of power addressed *by students* in their work unknowledged and therefore undiscussed by their mentors. This, I emphasize, is not purely a function of instructors' or institutions' timidity, racism, homophobia, or sexism: it is equally a sign of the dreadful structural limitations of a

pedagogical method that consigns everyone's social propositions to the edge of consideration, that colludes with much else in our culture to aestheticize uncomfortable questions about and challenges to how power operates in the world. Students work within a formalist/technical system that is the dominant one in formal education today. The students' own concerns, on the other hand, particularly those of feminists, gays and lesbians, and other minorities, are frequently emergent challenges to as well as reactions against dominant culture's forms and concerns.[38] There is a constant slide within individual practitioners between the forms and values of mainstream culture and those they invent or inherit from their own, smaller communities. I see such pulls, such contradictions, in the photographs presently under discussion. The very ambiguity of Simpson's bar pictures allows them to be easily read in ways that cause straight audiences less difficulty; the rhetoric of academic art photography encourages the seeking of private, idiosyncratic meaning on the grounds that photographs are an index of individual sensitivity (and, in a case like this, of collective social resistance). These are values that lesbian photographers both embrace and reject, like everybody else.

Tee Corinne, also academically trained as an artist (MFA, Pratt Institute, 1968), makes positive-image photographs of lesbians – 'lifestyle or culturally evocative/variant' images – and formal portraits, many of which have been used as book-cover illustrations and back-of-book author's portraits. She has, however, also published a large number of explicit sexual images and what she terms 'sexually symbolic' images.

Corinne's need to protect the subjects of her portraits has figured significantly in determining what work she felt she could do:

> I chose lesbian writers who were public or 'out' about their affectional preferences and who used lesbianism as the subject of their texts. I felt that these women could afford to be part of my project and could benefit from the attention.[39]

Functionally, Corinne sees this work as showing 'real people whose lives can be understood as patterns, role models, imaginary and sometimes real mentors.' For this reason, she says, 'whenever possible I photograph the same person in different years. I want to show how we look and how we change in age, these women who love women, who survive without hiding.'[40]

'Variant or lifestyle images,'[41] according to Corinne, are

> those that show people looking or acting different from the stereotypical norm for their gender. Thus women wearing neckties, men's hats and jackets, and/or assuming traditionally masculine stances, smoking or engaging in men's work all signal 'emancipation' and 'otherness.' Lesbians are, within our society, 'other,' 'variant' and 'outsider' and have generally had to be 'emancipated,' meaning self-supporting.

These 'lifestyle images' appear less often in Corinne's work than her portraits and 'body work.' The latter rests on a seemingly stable, universalizing base – 'flowers as symbols of women's genitals,' flowers as 'labial forms in nature,'

standing for what is everywhere yet repressed.[42] The cover for Joanna Russ's *On Strike Against God*, for example, 'shows a solarized image of a woman's hand cradling and stroking a simple orchid. I wanted to imply sexuality between women without actually showing it.'[43] Similarly, *Women Eating Flowers*, a photograph from a portfolio appearing in *The Advocate*, stands for that which remains otherwise unrepresented: women eating other women.

When Corinne has produced photographs explicitly depicting women having sex with each other, she has abstracted sex acts through solarizations, flipped negatives, and negative images. This deliberate obscuring arises out of her concern for 'afford[ing] my models some measure of privacy' rather than prurience.[44] Unlike J. Frederick Smith's models – or, for that matter, Vanessa Williams, the former Miss America, who posed for 'lesbian action' photos subsequently sold to *Playboy* – whose identity resides in their professed status *as actors*, Corinne's subjects are acting out their personal lives, which are paradoxically more in need of protection than the public behavior of models.

Here again, the social difficulties that would follow upon identification as a lesbian have molded the photographer's decisions to a considerable degree, resulting in a body of work on sexuality that is inevitably understood in terms familiar to art/academic analysis and that in fact looks coy and sentimental by those institutions' standards. It is work that displaces sexual feelings onto acceptable symbolic replacements so as to 'afford some measure of privacy' and that elaborates 'images complex enough that people would want to stay with them for a long time, puzzle them out.' These heavily manipulated images function not only as protection for individual models' identity, but also as a correlative for the status of the public lesbian: present yet invisible, out yet hidden, provocative yet in need of protection.

More than other photographers whose work is intended primarily for lesbian audiences, Corinne has chosen to consciously resist prior modes of representing lesbians:

> One problem that I kept in mind was that in avoiding the BODY BEAUTIFUL as exhibited in the pseudo-lesbians of David Hamilton or J. Frederick Smith, I ran the risk of reinforcing negative myths, i.e. that lesbians are women who cannot attract men because they do not conform to society's standard of beauty.[45]

Corinne's attempts to challenge what Rosalind Coward terms a 'regime of representations'[46] do not challenge dominant cultural assumptions about beauty *in women*. Despite her 'questioning assumptions about beauty' – 'Do I succeed in making beautiful images of skinny women, fat women, women with scars, with glasses, older women, disabled women?' – definitions of physical beauty, like photographic meaning, lie somewhere outside the image's frame.

The slippage between 'beautiful images' and 'beautiful women' is clearer in Corinne's best-known photographs, her 'sexually symbolic' images, which obscure those practices and body parts that are most tabooed, most problematic, through technical feints: solarizations, flipped negatives, multiple images. A muted voice and near invisibility, in one sense, are preserved here: the

dream-like condensations and displacements block or slow down an explicit sexual reading. Corinne's use of a 'distanced, universalized and romanticised [sic]'[47] approach to female sexuality, drawing upon a long tradition of 'feminine' iconography, gives her work a currency outside lesbian communities that the other work I've discussed doesn't have: her 'sexually symbolic' images have appeared in the heterosexual journal of soft erotica *Yellow Silk* as well as in the (more) rough-sex lesbian journal *On Our Backs*. Though the impetus for Corinne's approach to sexual imagery might stem in part from political and social concerns for her primarily lesbian subjects/audience, the images neither challenge nor address lesbian sexuality explicitly.

In her portraits and life-style images, however, Corinne has produced a body of work that looks squarely at lesbian identity. Its ways of doing so are sufficiently subtle as to be perhaps invisible to many outside viewers: how revolutionary could it be (as is the case with her cover illustration for *Toothpick House*, published by Naiad Press) to see two women embrace enthusiastically on the cover of a book?

If you need to think about the answer to that question, consider the work of Lynette Molnar, which I first saw while serving as a juror of photography grants for a state arts council. The discussion about Molnar's work, which culminated in a compromise whereby I could unilaterally give money to her project over the objections of the other two jurors, is a good object lesson in some of the problems that subcultural work encounters when it attempts to make its way into the larger world.[48]

Molnar's *Familiar Names and Not-so-familiar Faces* consists of a series of photomontages in which images of the photographer and her female lover are stripped into existing reproductions: a Nikon ad, the Ward and June Cleaver family of *Leave It To Beaver*. The montage is deliberately not very convincing: it is quite obvious that the two figures have been imported from some other world and pastiched into these mainstream settings. The scale and the repetitiveness of the same figures embracing in a variety of commercial settings enforce the artificiality of the insertion, producing a sense that this is an act of defiance, a clumsy and not altogether successful fusion of two different universes. Anyone living the life of an informed outsider will recognize that this is precisely the position that we occupy – culturally and politically, if not economically. Molnar's work struck me as a clever objectification of both the aspiration and reality of the uncloseted lesbian.

The reaction of the other two arts council jurors was very different. Looking at the work primarily *in terms of what lay within the frame*, they rejected it on the basis of its technical flaws ('She hasn't even varied the size of the two female figures'; 'The figures don't look as if they are really integrated into the scene') and formal deficiencies ('Why didn't she change the pose of the two figures? It's too repetitive').[49] When I objected that these seeming limitations became challenges and virtues, given the paucity and distortions of most images depicting lesbians, my fellow jurors' resistance took the form I've described above: *We're judging photographs, not social revolutions.* And of course photographs are never instruments in/of social revolutions: they exist in a world apart.[50]

The misunderstanding Molnar encountered in taking her work before the general public, even though they 'read' fluently to members of her subculture, is a common experience among lesbian photographers addressing lesbian issues in work that they exhibit outside their communities. Danita Simpson had similar experiences, as did Kaucyila Brooke. Brooke's work is highly metaphoric. She creates tableaux that reject the pretext of representing her subjects' 'lives,' employing them instead as actors. The darkly printed images are, she says, about relationship: 'some of the ways our nurturing fostering community can at times hold us back.'[51] Brooke rejects the need expressed by Biren, Rosenblum, and Simpson to represent positive images to the lesbian community: 'I decided early on that I need not present propaganda of an idealised lesbian life-style.' Instead, she concentrates on metaphorical reconstructions of various relationship patterns – jealousy, possessiveness, extreme romanticism – as she perceives them at work in her community.

The work functions efficiently inside the subculture for which it is made, in part because of the seeming authenticity of her actors' postures, gestures, looks, and personal styles. But the very qualities that helped authorize the work for lesbian viewers worked against it when she showed the work outside that community, in a Tucson art gallery. The signifiers of her actors' lesbianism were interpreted by mainstream audiences as signifiers of something else – masculinity:

> Because many of the women that I photograph exist outside the culturally defined norms already[,] they do not exhibit the posturing, posing, gazing and costuming usually used to distinguish one sex from the other. . . . Sometimes the uninitiated het[erosexual] viewer thinks that the women in my pictures are in fact men.[52]

Again, the problem is not one of misinterpreting the entire sign – the metaphorical content – of the image but rather the gender identification to which Brooke intended that content to refer. And despite the clearly *staged* nature of Brooke's photographs, issues of confidentiality made it impossible to include several of the images I wished to use to illustrate this essay. Identification *as a participant* in these images, Brooke wrote, could severely damage several of her subjects' lives.[53] Of how many identities in the United States today could it be said that portraits and staged tableaux could cause damage? Should it be any surprise that so little photography addressing lesbian issues and identity is in circulation?

Susan Maney's *Two Women Fall in Love by the Sea* circumvents this difficulty by using found images. The work takes two forms: an album of postcards, snapshots, and greeting cards assembled over handwritten captions and wall-sized photomontage panels with text. The scraps of narrative in the piece move back and forth across space and time: Florida, Europe, family homes in the northeast United States. At least three generations of female couples enjoy themselves under the same tropical skies and exotic tree. *Two Women* invests its subjects with a (magical) tradition and history: real, historical couples (for so the snapshot photographs propose) occupy those cottages, hold hands for the

camera, walk upon that beach. By placing her real couples in imaginary (lesbian) relationships and (imaginary) landscapes, Maney asks several questions about sexual identity and the nature of photographs' truth-telling: Were the women these snapshots refer to actually lesbians? What would have constituted marks of lesbianism in their class, their era, their locale? What are the elements in Maney's use of these photographs and in the photographs' content that allows us to read them as lesbian images now?

As fanciful as Maney's work is, its content reads much less ambiguously for mainstream (art) audiences than the seemingly more straightforward work discussed earlier. Partially this is because Maney uses text, which identifies her concerns poetically but clearly. Partially it is the work's form, which is both familiar to and problematic for most adults: the family album with its gulf separating life-as-seen-in-snapshots and life as lived.[54] Maney goes beyond questions of reality and appearance as they raise themselves in every family (that happy family beaming in front of the new Buick; that car Dad bought just before he and mother split up and that he rode away in) to include questions about sexual identity. But she does so in a way that provides the pleasures of gallery art – with complexity of form, huge scale, color, gallery sponsorship. Her work can do this in part because of the assumptions Maney can make about her primarily art-gallery audiences – their supposed willingness to approach the work as a puzzle, as a personal expression to be decoded. The pleasures associated with visiting galleries do not frequently include confrontations with lesbian content – to date, *sexual difference* has ventured no further off the curatorial track than male and female heterosexuality[55] – so the danger to Maney's academically sophisticated work lies precisely in the likelihood of its lesbian content being ignored in favor of its formal inventiveness.

Getting Around

THIS BRINGS us to the question of what sites for exhibiting lesbian photographs are possible and what meanings attach to the choice of site(s). Particularly in the case of an outlaw minority's self-representations, we must distinguish carefully among the various possible audiences and sites of reception in exploring what work the images do.

There are basically three ways that lesbian still photographs circulate beyond small circles of friends. The first is through the institutions created by lesbian-feminist communities: women's centers; coffee houses; literary, art, and political journals; community newspapers; alternative gallery spaces; and the *ad hoc* 'production companies' – groups of local women who agree to undertake the production of traveling slide shows, films, and lectures. These institutions are primarily not-for-profit, collectively run ventures, and their primary, sometimes exclusive, audiences are women. This eliminates several problems for producers of lesbian imagery: the need to safeguard the privacy of subjects and to make the terms of the work comprehensible to an extra-subcultural audience, one that does not necessarily share the producer's and primary audience's values. At the

same time, it introduces what some producers see as another problem: the possibility of marginalizing their work, of limiting its possible audiences.

The second method for distributing lesbian imagery is through mainstream art/academic gallery systems. Since the early to mid-1970s, there have been a sufficient number of traditional and alternative gallery settings – college/university, library, community center, not-for-profit experimental, artists' co-op, and mainstream commercial – to provide at least an illusion of access to photographers. And in fact several of the photographers who sent me work do show their photographs in such settings. At times there is even overlap in these venues: for example, in Chicago two of the artists' cooperative galleries are run by women's, and largely feminist, committees. In terms of the services and spaces provided, there is often little difference between what is offered at the not-for-profit and commercial galleries of an American city.

For image producers, the difference between these two systems lies in the mechanisms through which each system builds and reaches its audiences and the composition of those audiences. In mainstream gallery settings, the audience is primarily heterosexual and, while assumed to be liberal, presumably does not share the producer's view of lesbianism as a positive identity. Nor does a mainstream gallery setting promote the sorts of expectations that lesbian-feminist or other minority cultural settings usually do: that the work will be discussed in that setting, that it is indeed there *to provoke discussion*. Museum, gallery, and library settings often set up the opposite set of expectations: the work is there to be savored privately; the print on the wall is its producer's end-product, not a step along the way to some collective (however temporary) resolution of personal and social issues.[56] Thus although the photographer who chooses to exhibit lesbian work in traditional settings gains access to a wider audience than she would have within lesbian-feminist settings, she is likely to claim it at the expense of one level of meaning in the work: its exploration of sexual identity. Because she cannot protect her subjects' identities in a mainstream setting, she may have to compromise or limit her depictions to subjects who are entirely 'out' in their lesbianism or obscure identifying marks in her subjects. If she regards her work as a form of speaking to straight audiences, she may also find herself, as several women who sent me work stated they did, engaging in a self-censoring that screens out those aspects of lesbian identity most likely to be offensive to a heterosexual audience.

The third method of distributing work is one that is only now developing: commercial magazines and videotape services with reproduction and distribution capabilities far exceeding the artisanal output of photographers distributing their work through galleries and informal lesbian networks. Where a single, highly successful lesbian-feminist photographer taking her slide show on the road may reach five thousand women in a year, a single issue of *On Our Backs* claims to reach ten thousand subscribers per issue.[57] This method of distribution, in turn, presents its own limitations: in a magazine organized for commercial survival, much less profitability, the images that get published will be those the editors feel have the greatest probability of selling space to advertisers and selling copies to individual consumers. Like photographs in traditional gallery spaces, images in a lesbian

commercial publication or videotape are distributed to a relatively uncon-
trolled audience, so protecting the identity of models, for example, cannot be
an issue.

To a much greater degree than makers of heterosexual photographs, the
producers of lesbian images must foresee, plan, and control not only the
production but also the distribution of their images. This is so because there are
so many possible negative social repercussions to a woman's being represented
as a lesbian. That is, although a woman might, for example, readily permit
herself and her child to be photographed and the image exhibited or published
as a representation of, say, 'a single parent and child,' the same photograph
shown or published as part of a series on 'lesbian mothers' could easily open her
to child-custody battles; to censure at work, among friends or family; to
religious shunning; or to problems with immigration status, complications with
pending lawsuits, and so on.[58] From the point at which she decides to photo-
graph subjects as lesbians, the lesbian photographer is making political choices
that affect the social well-being of her subjects as well as herself. Thus her plans
for producing the photographs are frequently integrated from the beginning
with a plan for distributing or exhibiting them that will ensure her subjects'
(relative) privacy.

This relatively untrodden ground was addressed in the first issue of the late
The Blatant Image (1981), which as a primarily lesbian-oriented periodical
devoted to feminist photography published several sample releases reflecting
the complex social implications of lesbian self-identification. In the one created
by Tia Cross, women could grant permission for their likenesses to appear in
any or all mass-market publications, feminist publications, lesbian publications.
They could also choose to be identified as lesbians in any of the categories or
in none. Ruth (Ikeler) Mountaingrove's release explicitly limited her rights to
produce subjects' images only in 'magazines, books, and newspapers connected
with the Women's Movement and/or in exhibits or in private sale to individual
women.' Lynda Koolish's release provided room for the subject to specify the
uses that she would agree to.[59] As an alternative, JEB, author of *Eye to Eye:
Portraits of Lesbians* (Glad Hag Books, 1979), distributes her work primarily in
the form of slide shows, a decision that partially solves the problem of limiting
access to sympathetic audiences:

> You have to be responsible to the women in your images – or people end
> up feeling as if they've lost control. One of the problems of the distribu-
> tion – and we're a very mobile community – is that I don't work at the
> pace where I can take a photograph one moment and use it the next.
> Sometimes it's six years later. I've had people sign my release and say, 'You
> can use this picture anywhere but Cincinnati.'

JEB has structured her slide show containing images of nudity and explicit
sexual acts so that those images appear in the second hour, at which point men
in the audience are asked to leave: 'I figure that after an hour they're probably
ready to leave anyway. And it's important that my subjects feel that their
privacy is being protected.'[60]

JEB came to photography from New Left politics, which may account in part for her sophisticated understanding of the implications of various distribution and exhibition vehicles in structuring audience responses:

> Part of the definition of Lesbian photography that I am offering depends upon the photograph being viewed in a context 'continuous with that from which the camera removed it'; for example, in our homes, women's centers and Lesbian bars and restaurants. In this way the photograph will be comprehensible as Joanne Kerr has explained, 'because of the reference to shared experience, rather than shared knowledge of artistic convention.'[61]

Like many feminist and oppositional filmmakers and photographers, JEB found it necessary to develop new methods of getting her work circulated and discussed and has relied chiefly upon informal or alternative networks. Her book *Eye to Eye* was self-published and distributed, as is her new one;[62] her slide shows are produced by women who undertake the responsibility for local production in their own communities and find space, do publicity, and build audiences. Under such circumstances, audiences come not just to look but to stay and discuss what they have seen, thus making the viewing experience different from what it would be in a conventional gallery. Art-making and viewing are continuous with everyday life and are used to celebrate and analyze community, both in the representations being exhibited and in the interactions between audience and producer. This is quite different from most audiences' expectations of what viewing art is for. In this respect, Biren's work raises the same issues that Annette Kuhn has identified in feminist filmmaking:

> The objective of working with audiences is to effect some transformation in the passive receptivity characteristic of spectator-text relations in dominant cinema, rather perhaps than simply to create another mass audience for a different kind of film. Work with audiences might therefore involve active efforts to make films available for distribution, to work in unexpected or unfamiliar ways – to render them accessible to audiences and to generate debates around cinematic representation.[63]

The chief disadvantage to such a method of distribution is the flipside to its principal advantage: audiences can be built up only slowly and in small numbers. Mass-distribution routes, such as through periodicals and electronic media, are possible only in a limited sense. No women's presses publish four-color work (one of the reasons JEB decided upon slide shows was so that she could exhibit her color work); reproductions are usually few and poor in quality; series of photographs are commonly broken up and scattered through the text as illustrations rather than grouped together, where they could constitute an argument of their own.[64] Electronic media, because of the high capital costs of equipment and post-production, and distribution channels even narrower than those for still photographs, are the province of art/academic work and commercial erotica – both subsidized media in their own ways.

Some of the photographers I dealt with have rejected the material

limitations of the undercapitalized women's presses and alternative exhibition sites
in favor of venues chosen for the very conventionality of their audience and
programming. Madge Matteo, for example, chose to exhibit her work in main-
stream art/photography galleries rather than principally gay/lesbian ones[65] out of a
belief that traditional gallery audiences are 'fairly intellectual' and thus ready to be
confronted by 'intimate and tender' portraits of gays and lesbians. Her task, as she
sees it, is one of education, of 'reaching out to the straight world.'[66]

Some of the costs of such a strategy are obvious. Although Matteo began
photographing gays/lesbians in 1978 and ended up with hundreds of subjects,
in 1981 she had to 'weed out' images of anyone not willing to have his or her
image exhibited before the mixed audiences she wanted to reach. She ended up
with fifty-seven subjects. 'Your picture isn't going to do me any good because I
can't show it,' she found herself telling people, 'I want to show my work where I
want to show it.'

A second, and perhaps more far-reaching cost of the decision to exhibit in
mainstream galleries is the narrowed range of what lesbian-feminist photogra-
phers conceive as acceptable subjects and treatment. As Matteo notes:

> I hoped that my photographs could serve as an early step toward overcom-
> ing stereotypes toward homosexuality. I reasoned that the demonstration
> of personal behavior and emotional interactions between homosexuals
> might overcome a slight degree of ignorance on the part of my viewers.[67]

Such theoretical acceptance was contingent upon avoiding what she termed
'stereotypes – flaming queens, flannel-shirted lesbians. . . . I didn't want to
reinforce straight stereotypes. . . . I don't want our culture to be reflected that
way.'[68] Danita Simpson has expressed similar thoughts about the work she
showed in art galleries:

> I viewed my work as an opportunity to provide positive reinforcement in
> a society that simultaneously negates and exploits our lifestyle. This leads
> to the second reason – that of public education. I feel that individuals fear
> and hate that which they don't understand. By viewing my work, I hope
> to combat the homophobia prevalent in our society. If people begin to
> realize that lesbians are 'everyday' folk . . . perhaps acceptance will replace
> hatred.[69]

In Simpson's case, self-censuring took the form of 'as a matter of principle
declin[ing] photographing the women in black leather with rings through their
nipples.'[70]

Simpson's color photographs made in women's bars record what most
urban lesbians would recognize as sexual exuberance and cruising; but among
larger audiences, the photographs' meanings were apparently lost, overlooked,
or deliberately misunderstood:

> Evidence of how far we have to go was demonstrated when my work was
> shown as part of my MFA project. Individuals were not quite sure what
> they were looking at – was this simply women in a bar or portraits of

'friends'? Not one review of the show dared say images of lesbians. Were they really unsure (they don't look like dykes?) or were they just afraid of putting that word – lesbian – in print? Someday, perhaps, these questions won't be of concern.[71]

For the time being, however, these questions are of concern. If representations of lesbian lives can be addressed/dismissed as 'life-style' photographs, with all the illusionistic parity that phrase evokes, if representations of lesbian people must exclude women whose appearance might match heterosexual gallery-goers' most negative stereotypes of lesbians, then it seems to me that we have won at best a pyrrhic victory.

More important, such strategies do not address the level at which stereotypes themselves are constructed – in ideology, that 'imaginary relationship of individuals to their real conditions of existence.'[72] Looked at this way, we must recognize that a stereotype, whether positive or negative, performs cultural work that reinforces existing social relations; this cannot simply be undone by offering another stereotype in its place – the gay/lesbian as a WASP/Jew/his-panic/black/Asian with a difference – unless the new one provides a more compelling and satisfying explanation.[73] In the case of dominant culture's stereotypic notions of lesbians, the asexuality of so much recent 'public' lesbian portraiture does not effectively challenge or replace mainstream beliefs ('lesbians are women who make it with other women'; 'lesbians are women who look like/wish they were men') with socially useful alternatives ('lesbians are women who look like everybody else,' 'lesbians are amiable, capable-looking women').

We must ask ourselves whether a gallery setting – by which I mean that serene, white- or gray-walled secular temple where no one talks in a normal tone of voice, where few people crowd together, and where heated discussion is generally unknown – can provide the appropriate site for producing any of the reactions that lesbian photographers express a wish to produce. John Berger, Hans Haacke, and Martha Rosler have all undertaken studies of art gallery visitors,[74] and though their methods and interrogations differed, their projects produced similarities: visitors to galleries represent a narrow segment of the American and British public; they are socially and politically more liberal (as well as financially better off) than average; they tend to be people who are themselves professionally involved in the arts; they see the gallery as a site apart from the messy contingencies of everyday life. When these perceived characteristics of gallery audiences and spaces are combined with the 'educated' gallery-goer's expectation that modern art will provide her/him with a 'purely' aesthetic experience, there is little likelihood that gallery audiences expect or are willing to participate in a communal experience that demands they rethink social categories (dyke, faggot) that have served the status quo very well.[75] In fact, Danita Simpson's experience would suggest that rather than confront difficult social categories, viewers in a traditional gallery setting may instead overlook or deny the very presence of those categories, as happened when her photographs were ambiguously and evasively characterized as 'life-style' images.

By the same token, the distance established in modernist art settings between Art and everyday life also contributes to a visitor's qualified acceptance of *outré* imagery within a gallery setting; there is, after all, comparatively little social threat to visual proposals far removed from the world in which the viewer habitually lives.[76] Even more important, Berger, Haacke, and Rosler have confirmed what we all suspected and must factor in as the most critical problem in showing minority imagery to majority viewers: the work reaches a very small (if socially and culturally powerful) audience confirmed in its own sense of liberality, and I question the value of tailoring our self-representations to the cut of such an audience's sensibilities. If doing so means having to factor *out* 'the women in black leather with rings through their nipples,' the 'flaming queens [and] flannel-shirted lesbians,' we need to ask ourselves at what price we are seeking acceptance – and to whom we are conceding the right to authorize it.[77]

Afterword

IN THE last few years there has been an enormous amount of discussion and activity within lesbian and lesbian-feminist communities on sexual expression – a public reclaiming of the open, raw sexuality that so captivates audiences viewing those old pulp paperbacks I described earlier. Lesbian video production companies (Blush Productions, Tiger Productions) make and distribute lesbian porn cassettes; *On Our Backs* has grown and encountered competition (*Bad Attitude*); lesbian s/m, once a polarizing and largely stigmatized practice in lesbian/feminist communities, now has what amounts to institutional status – regularly announced rap groups, classes, meetings, and socials in most large U.S. cities.[78]

I haven't discussed any of these welcome signs of sexual pleasure, confidence, and experimentation in this essay. What I have sought to explore here instead have been the structuring *absences* and *negativities* that have played so large a role in determining lesbian image-making until recently – absences of money for production and distribution, absences of wide audiences and sites for exhibition; negations of personal identity, security, and pride fostered by mainstream culture – and the inventiveness and resolution with which lesbian photographers have resisted institutionalized homophobia and gynophobia.

Laura Mulvey

Dialogue with Spectatorship: Barbara Kruger and Victor Burgin

(First published in *Creative Camera*, Summer 1983. Reprinted in Mulvey's collection *Visual and Other Pleasures*, Macmillan, 1989)

A much earlier essay by Laura Mulvey, 'Visual Pleasure and Narrative Cinema' (1975) had a seminal influence on feminist cultural theory and the development of ideas about how the mechanisms of male voyeurism meshed with cinematic narrative structures. Mulvey's psychoanalytic analysis of the processes of looking is here applied to photography, in the work of Kruger and Burgin, both of whom engage the viewer through images and text, and by reference to the act of looking.

Mulvey draws her argument back to cinema and the pleasurably enigmatic dream states produced by the work of certain directors. This brings her, via Surrealism, to cinema's early history and Méliès' world of the marvellous, which took its inspiration from ghost photography as well as from the stage tricks and pantomime of nineteenth-century theatre (something Rosalind Krauss writes about elsewhere in this book, in 'Tracing Nadar'). If cinema calls up the Freudian unconscious by way of early photography's example, postmodern photographic strategies, Mulvey suggests, can still find productive spaces there.

BARBARA KRUGER'S exhibition *We Won't Play Nature to Your Culture* and Victor Burgin's book *Hotel Latone* are such different kinds of work that at first it seems almost arbitrary to discuss them together, or just a simple exploitation of the fact that both use words and photographs in juxtaposition. Kruger's enormous enlargements of found photographs are cropped and manipulated for rhetorical effect, then slashed across with words that evoke the pain and anger of sexual oppression. The words are sometimes a silent cry of personal pain, sometimes a slogan of political anger. The images are elusive, like the last fragment of a dream that stays in the memory. These two elements, word and image, are bound together by frames painted bright red. The size is important, echoing the persistent theme of power relations in the works themselves, leaving the spectator both overwhelmed and exhilarated as he or she is faced with a series of possible relations with the image on the wall. To look at the works in a catalogue is an experience of loss. The blown-up, grainy texture of the actual works seems to disintegrate the images from within, and adds to their mystery. Just as the scale of the Kruger work is significant, so it

seems suitable that *Hotel Latone* should have a book format (although it
originated as an exhibition in Calais in 1982). The photographs are precise and
clear so that the reader, or looker rather, has to scan the images and reflect on
their smallest detail. It is possible to turn the pages, follow the story's given
sequence and then flip back or forward to discover a pattern or repetition. The
images and the text put themselves at the reader's disposal, and need time, in
their strangeness, to be thought about. It is a more obviously private experience
than that of a gallery. *Hotel Latone* is in three, unmarked, parts and tells a story
of impossible desire. Burgin makes narrative and visual use of condensation and
displacement (Freud's terms for the mechanisms used by the unconscious to
evade repression) and draws on myth to expand his frames of reference. He can
thus interweave the vicissitudes of the individual psyche with collective fantasy
and with the mechanics of his own creative process.

Burgin and Kruger share a concern with spectatorship and the act of
looking, the point at which the psychodynamics of voyeurism and the power
relations of masculinity and femininity can affect a work of art. Both artists use
language, in particular personal pronouns, to make visible and explicit the
process of exchange between an art object and its spectator. This mode of
address positions the subject and affirms identity. Burgin treats sexual identity
as a trap, a destiny not set in motion by biology but by the construction of
sexual difference through the Oedipus complex. Kruger emphasises the ambi-
valence of sexual identity. Both artists make important contributions to the
aesthetics of sexual politics or, rather, they use sexual scenarios to attack
patriarchal politics. Behind this project lies the conjuction between femin-
ism and psychoanalysis that had such a sweeping influence over the 1970s
avant-garde. Work on, and with, theory became an element within artistic
practice, influenced the negative aesthetics of the time, and generated notori-
ously difficult art work that seemed to need special commitment or privi-
leged knowledge in order to be understood. Pleasure as a factor in art went into
crisis.

We Won't Play Nature to Your Culture and *Hotel Latone* mark a new
departure, a different kind of challenge to the spectator, a twist to the specta-
tor's 'work' on the text. Emotion and reverie are central themes in the content
of the works but also are the essential means of understanding and deciphering
them. This is not a backward move into subjectivity or intuition, but a
structured exchange between text reader and the collective fantasy that has
produced text and reader alike. Collective fantasy is generated by a collective
unconscious, not the Jungian collective unconscious, but a pool of raw material
common to all who share a similar induction into sexual difference, experiences
of castration anxiety, the Oedipus complex and, indeed, the psychic drives.
Collective unconscious is what myth grows from, the raw material of repression
and its return in popular fantasy and narrative. Myth, with its ritual and
safeguarding function, transforms this experience of pain and desire and recon-
ciles it with terms that can fit social reality.

The Kruger and Burgin works are about desire and sexual difference and
our understanding (or misunderstanding) of both under patriarchy. Kruger

starts with sexual oppression but goes beyond to arrive at the point encapsulated by Luce Irigaray: 'What I desire and what I am waiting for, is what men will do and say if their sexuality gets freed from the empire of phallocentrism'. Burgin's *Hotel Latone* seems to be feeling a way to an answer, examining the male unconscious from within the point of view of 'masculinity'. He opens up a void that is concealed by the masquerade of masculinity under patriarchy. Looking at *We Won't Play Nature to Your Culture* and *Hotel Latone*, it is possible to feel that the old 'difficult' concepts no longer need difficult presentation. Psycho-analytic discourse has become the source of fascinating images that are about the psychic life of the mind and about the power of images, but these images must also produce reverie and flashes of recognition similar to the experience of looking at a *trompe-l'oeil* or just grasping a *déjà vu*. The reading process is not easy or intuitive but it is not didactic either.

Barbara Kruger's works in *We Won't Play Nature to Your Culture* can be viewed or read on various levels. They have an immediate, emotional impact. But they can also be taken, more slowly, as a complex comment on the place of scenario and representation in male–female relations under patriarchy. She builds on the feminist analysis of representation as political, and on feminist appropriation of psychoanalytical theory as a means of understanding oppres-sion. However, her images go further, both in language and visual material. The obvious vulnerability of the would-be resistant female complements a rigid, and therefore brittle, male control. Patriarchy freezes woman into repre-sentation and, in doing so, fossilises man. Woman's vulnerability recurs as a motif a number of times, in essence in 'I can't look at you and breathe at the same time' which combines woman's exclusion from active looking with a grainy texture (that of the water and the photographic surface). The female figure swims backstroke, exposed and defenceless against imminent disintegra-tion. 'Your gaze hits the side of my face' shows the reverse side of the problem. Here the threat of destruction is emphasised by a statue's mask-like perfection and its smooth, white surface. An exterior, like a shell (both self-protective and exhibitionist), shields the object of gaze ineffectively from an act of aggression. Voyeurism slips into sadism, but the female profile remains inert. In these two images the act of articulation, the words themselves, seem to hold the moment of disintegration at bay, for a split second at least. And the photograph's inherent stillness reflects the way that time stands still at a moment of fear.

'I am your slice of life' and 'I am your almost nothing' evoke another kind of disintegration, a retreat into a cliché that ironically restates masochistic self-denial in love. Like the photograph itself, cliché freezes a scenario. Kruger reproduces the cliché-metaphor literally and surprisingly in the image. The texture, the pierced surface, the delicately dissolving hair evoke the pain of self-effacement. The tension in 'We won't play nature to your culture' and 'I will not become what I mean to you' is rather different. Here the elements in the image contradict each other, as the visuals actually do represent a 'becom-ing' and a 'playing'. The moment held in suspense is like a flash of resistance, but none the less impotent. This time the impotence is due to generalised, socialised forces at work in which femininity is assigned a place, willy-nilly.

The cliché text again is a resistance and this time the language of the oppressor is undermined by the negative.

Although woman is conventionally fetishised into cultural material (verbal, visual) and this semiotic fact is a starting-point for Kruger's work, it is not its finishing-point. The images do not describe or show. They elicit a response from the spectator that is emotional in addition to intellectual recognition of a political discourse. The image/word relationship is a montage or collision; one does not illustrate the other. In a series centred around the sadistic, violent aspects of patriarchy, the word/image relationship is more literal. Her analysis of power ('You transform power into pose') emphasises cultural authority, and its destructiveness ('You divide and rule', 'Your manias become science', 'You have searched and destroyed'). The cliché phrases are brought to life through anger and accusation but the spectator is not forced to dream.

At this point the work would seem to reproduce a personal and political dichotomy equivalent to male and female spheres: public/private and emotion/politics. This could be a reiteration of the feminist rhetoric that was so necessary to establish woman's articulation of oppression, but there are crucial fissures that break up the ground between these two opposing worlds. 'Keep us at a distance' and 'We are the failure of ritual cleansing' suggest that the oppressed are also a threat. Woman cannot be completely colonised and man is not completely in control. Male power has its own vulnerability in 'Your property is a rumour of power' and 'Your life is a perpetual insomnia'. It is as though man, in exercising patriarchal power and freezing woman into spectacle, has also turned himself into a masquerade that can crack. And this brings in its wake an empty, frightening sexuality. Here the images regain a complexity and resonance, a sense of loss due to the rigidity of the masculine and feminine opposition.

Numbness, inability to feel, pervade the images while the accompanying words carry accusation from the political into the personal sphere which, this time, is masculine ('You are seduced by the sex appeal of the inorganic', 'You delight in the loss of others', 'Your pleasure is spasmodic and shortlived', and 'You re-enact the dance of insertion and wounding'). In these works the words have grown and dominate the visual text, but the poignancy of juxtaposition is as vivid as in those that evoke feminine complicity and resistance. The images are once again an incitement to dream, desire and rebel against loss. Power is a trap that alienates, both into the making of history and transforming the other into pose, but is almost nothing in personal terms.

Hotel Latone uses travel as a metaphor for the movements of the unconscious. The book starts in a hotel. This is a literal 'displacement' of the characters that evokes the Freudian concept of displacement, which Burgin appropriates both as a formal device and a theme. Like a dream, the text and the photographs represent the way that repressed material struggles to find expression by latching onto objects, images, words, anything that seems to allow it to speak. This displacement is a means of articulating the unspeakable, but its language is distorted and symbolic. Displacement is crucial for the mechanism of fetishistic denial, also an important theme in *Hotel Latone*. The

third photograph is of female feet in high-heeled shoes, the classic fetish object sought by the gaze that wants to know but refuses to accept female 'castration'. The book associates fetishistic fixing with the look. The text 'In December everything is frozen, petrified for all time' is alongside a photograph of a man standing still in the street, staring fixedly off image. A woman stepping off the pavement behind him is caught in mid-movement, bringing to mind Burgin's previous writing on the relationship between the photograph and fetishism. Thus, fetishism and the look, as well as being central to the content of the book, reflect back on photography itself. Condensation of theme, theory and form again echoes the workings of the unconscious.

Condensation is the term used to describe a point in a dream which is overdetermined by several meanings or references, like a pun. But because it acts as a point of intersection, a nodal point, it can spark apparently random lines of association or thought, that then generate new movements or developments in a story-line. In *Hotel Latone* the story-line develops with abrupt changes of time and place that are reminiscent of the dream work. The man in the street photograph is followed immediately by 'In that empty cabin, in those silent woods' alongside the interior of a hunting lodge. The connotations evoked by the photograph's strange space and *mise en scène* make it into an image of the male mind. This, in turn, is accompanied by 'Silent and all-encompassing woods which press against the window-panes' alongside a photograph of two men. The posture and look of one at the other expresses repressed homosexual desire. The following page 'As in a fairy tale' shifts the angle of the shot in the hunting lodge to frame the trophies on the wall. Once again the theme of a fetish object returns, this time represented by the dead animals and inanimate litter of objects that figure the stuff that inhabits the male unconscious.

The second section of the book, still using the mechanisms of condensation and displacement, revolves around castration anxiety. Here one text and accompanying photograph are literally displaced and separated one from the other by two pages. The photograph itself is now represented as an object lying on a table top. The motifs running through this section are associated with the ease with which masculinity masquerading as phallic power can crack and collapse, especially when faced with a role reversal of the socially demanded 'masculine' and 'feminine' positions as 'active' and 'passive'. An active woman is a threat. Phaedra's tragic and destructive love for Hippolytus, the passive object of her desiring gaze, is mentioned here as a point of reference. Next, a photograph of broken Greek columns and a headless statue of a woman appears alongside 'The effort of holding the camera to her eye in the noon heat is causing perspiration to run into the hollow of the eye-piece', emphasising the perverse activity and unaccustomed effort for a woman to be in this position of active looker.

The final section of the book uses the Latona myth, once again as a point of condensation. The Latona fountain in Versailles is the nodal point, starting off a line of thought around fetishisation of woman as representation. It is as though masculinity in crisis, or under threat, was forced necessarily to turn the

threatening object, woman, into stone, 'petrified for all time'. The sculpture, like photography, has frozen movement and gesture. But another element is brought into play by the Latona myth. (This throws light retrospectively on Phaedra, who, as Hippolytus's stepmother, transgressed the incest taboo.) To quote Bachofen's *Myth, Religion and Mother Right*:

> Matriarchal is the Lycian Apollo, whose mother is Latona queen of the swamp bottom, and who dwells in the land of his birth only during the six dead winter months; patriarchal is the Hellenistic god exalted to metaphysical purity, who rules over Delos during the six life-giving summer months.

(Latona's other child, Artemis, is the protector of the Amazons and virginity.) Iconographically, Latona represents the mother as an image of loss. Loss of pre-Oedipal oneness with the mother and the woman's body as source of castration anxiety effect a split between male desire and its object, that is then fixed and frozen in woman as image, safe and possessable.

> He had not previously noticed the image. It reminded him of a passage from Sade, where the heroine is posed on a pedestal surrounded by a moat. Her admirer can cause the pedestal to turn by means of a remote control: he may look but he has no means of approaching her.

In the end the woman recognises this scenario, sadly, and the fact that she herself has, by now, little or nothing to do with male desire. The crisis of sexual difference, with castration at its core, leaves male and female out of sync. They cannot be symmetrical or complement one another. The book ends with photographs of birth, 'condensing' a number of themes. Birth is the first moment of placing 'a boy' or 'a girl'. The last page has the same text as the first, thus using the birth image to suggest the cyclical, endless repetition of human drama. But the birth scene is also a means of revealing the ultimate point of horror: the mother's genitals (the Medusa's head).

I have described and given a fragmentary, partial reading of aspects of *We Won't Play Nature to Your Culture* and *Hotel Latone* that struck me forcibly and moved me. This raises the question of reading and the validity of a reading. I decoded the images by allowing myself to day-dream about them rather than interpret them. This brings back the issue of text and reader exchange through the shared fears and fantasies of the collective unconscious. I would like to use Bunuel's *Notes on the Making of 'Un chien andalou'* in this context:

> The sources from which the film draws its inspiration are those of poetry, freed from its ballast of reason and tradition. Its aim is to provoke in the spectator instinctive reactions of attraction and repulsion. *Un chien andalou* would not have existed if the movement called surrealist had not existed. For its 'ideology', its psychic motivation and the systematic use of the poetic image as an arm to overthrow accepted notions, correspond to the characteristics of all authentically surrealist work. This film has no intention of attracting or pleasing the spectator; indeed, on the contrary, it

attacks him, to the degree that he belongs to a society with which surrealism is at war . . .

The producer–director of the film, Bunuel, wrote the scenario in collaboration with the painter Dali. For it, both took their point of view from a dream image, which, in its turn, probed others by the same process until the whole took form as a continuity. It should be noted that when an idea appeared the collaborators discarded it immediately if it was derived from a remembrance, or from their cultural pattern, or if, simply, it had a conscious association from an earlier idea. They accepted only those representations as valid which, though they moved them profoundly, had no possible explanation . . . NOTHING in the film, SYMBOLISES ANYTHING. The only method of investigation of the symbols would be, perhaps, psychoanalysis.

Although *Un chien andalou*, and particularly its surrealist framework, is in many ways unlike the works discussed here, Bunuel's statement brings up relevant ideas that can be expanded and adapted. The combination of emotion and structure allows individual reverie to coexist with group or collective unconscious, to produce a poetics within the rigour of psychoanalytic theory. In Freudian terms this process would be similar to that of the Oedipal drama as a generalised scenario through which everyone negotiates their trajectory; or, on a linguistic plane, a *langue* which allows each speech act to be an individual *parole*.

In *Un chien andalou* one is confronted with a series of reverie-producing images, that, according to the passion or repression of particular spectators, can produce different responses. There is no correct reading. A process of disturbance (or, as Eisenstein put it, 'shocks', or 'montage of attractions') is programmed into the work, but its effect is not predetermined. The starting-point is curiosity. A mysterious image sets up an enigma which offers pleasure through the very process of decoding. Solving a riddle is as basic a source of aesthetic pleasure as spectatorship, but the pleasure is intellectual rather than visual. At this point in time, when the pleasures of spectatorship seem hopelessly compromised by the interface between sexual difference and the component instincts of sexuality (as Freud describes in *Three Essays on Sexuality*) enigma offers a new point of departure. This process carries the spectator into his/her psychic structure. The image itself only 'works' if its mystery or enigma generates introspection, or, indeed, an equally telling resistance. Decipherment is demanded, clues are offered, but the reveries and associations of ideas are specific to the individual. However, the shared psychic structures that trigger off the individual response bring the pleasures and anxieties of reverie back inexorably to problems of repression and desire as shared and social.

A reverie-generating image must avoid idiolect and the various pitfalls offered, in this context at least, by artistic self-expression. The spectator is not invited to share the artist's insights, dreams or experiences (as, for instance, in Cocteau's *Le Sang d'un poète* or Maya Deren's *Meshes of the Afternoon* which have an aesthetic and cultural importance of a different kind). This relation

between image and reverie is closer to that of popular culture, Hitchcock's movies, for instance, or fairy stories. But there is an important political difference between the avant-garde and the popular. The popular can disturb, bring difficult material to the fore, cause returns of the repressed, but tends to reconcile contradiction in the last resort. Both the popular and this kind of avant-garde privilege 'trigger' images over artistic expression and establish a terrain in which terrors and fascinations produced by taboos, repressions and complexes find material and concrete form in art, story-telling or any other suitable form of representation. The teller and the listener are separated by skill perhaps, but dream the same dreams and share the same dreads. A 'poetics of psychoanalysis' is important here. The 'trigger' images say more than can ever be put into either descriptive words or realist imagery. The unconscious too, due to censorship or repression, cannot 'speak' itself literally or rationally, and the achievement in this kind of art is to make a poetics of the 'unspeakable'. This was Bunuel's aim and he also recognised its political implications. The post-feminist art has taken the surrealist project into a new politics. The individual dreamers are confronted with the structures of patriarchy as they are brought into touch with their own psychic patterns. The starting-point is political.

The emphasis that both artists place on sight brings up another important interface between aesthetics and psychoanalysis: the special qualities associated with photography. Vision, pleasure in looking as a component instinct of sexuality (the area of interest to Kruger and Burgin) bear no relation to seeing as the means of perceiving the real world. Sight as a drive attaches itself to pleasure-giving, or anxiety-alleviation. Objects become symptoms, referring back to the psyche, as it robs them of their true nature as material things and gives them a new meaning and significance. Women have always been the favourite objects at the receiving end of this magical transformation process. In its history, photography has been usually associated with sight as perception of the real, a record of material existence. Kruger and Burgin free the photograph from its command over historic time and space. Its indexicality now refers to things which, although real and concrete, are not actually visible. Much more than still photography, the cinema, with its devotion to fiction and the fantastic, has used the indexical aspect of photography to slip in and out of the visible world and find concrete images for those realities of emotion that cannot be seen, while being often excessively felt.

The cinema has materialised fears, anxieties and desires that inhabit our minds and the world about us like a modern version of the medieval spirit world, stalking our lives as unseen presence. The cinema absorbed photographic play with tricks and narrative fiction that had amused the nineteenth century, leaving still photography pure but perhaps denuded. Méliès, for instance, was introduced to the magical potential inherent in film by the successful genre of ghost photography. In making Méliès a patron saint, the surrealists recognised the link between his project to materialise the world of fairy stories, spirits and primitive science fiction and their project to materialise another invisible world: that of the Freudian unconscious. The use Burgin

makes of still photographs in *Hotel Latone* revives this project. At the same time he brings photography back to narrative and to the tableau, a privileged or overdetermined moment in a longer story. Kruger's use of photography emphasises the frozen moment of a scenario in a different manner that has been discussed very productively by Craig Owens in *The Medusa Effect*.

These aspects of the works that extend or push against the limits of the ascetic aesthetics of the 1970s, in particular the 'poetics of psychoanalysis' and 'dematerialisation' of photography, are assisted by language. Both *We Won't Play Nature to Your Culture* and *Hotel Latone* exploit ambivalence in language, especially the essential ambivalence that belongs to shifters of time, place and person. Burgin uses the indeterminate 'they', 'that', 'she', 'he', mostly as mechanisms on which to pivot the story into different directions, as carriers of condensation. In Kruger the personal pronouns have an important significance. While the fact that the artist/narrator is a woman suggests at first glance a straight construction of identity – 'I' = woman and 'you' = man – the intrinsic ambivalence of the shifter breaks down both stable subject position and secure sexual identity. Whatever the implications contained by the connotative elements in the image may be, a 'you' is an address and the addressee is the viewer, male or female. This carries the masochistic and exhibitionist motifs in the sexual scenarios further; the spectator is necessarily in a masculine position as looker-on and looker-in and looker-at. 'He' controls as voyeur, whatever 'his' sex. But the 'I' also demands identity and as the looker 'you' are addressed as you read the text, the 'he' among the spectators can be transformed by an identification with the first person, and the 'she' among the spectators can then identify with the feminine position given by the image. But rather than establishing, once again, the active–passive dichotomy that echoes masculine–feminine as a binary opposition, Kruger's use of language breaks down that dualistic topology to explore, not a space in between the two, but a non-space in which one term is freed from its function of defining the other.

Kruger takes her images beyond demand and refuses the 'desire and wait for' in Irigaray's ironic and laconic comment. Simultaneously, Burgin's *Hotel Latone* represents an unease, an exasperation with the traps of male sexuality 'within the empire of phallocratism' and the politics that accompany it. In retreating far back, exploring the mechanics of the 'masculine' unconscious, this strategy opens up new ground, an alternative to the sexuality that can only challenge itself by reversal.

Susan Butler

Between Frames

(First published in *British Photography: Towards A Bigger Picture*, Ed. Mark Haworth-Booth and Chris Titterington, Aperture, New York, 1988, pp. 31–9)

Susan Butler's essay first appeared in *Towards A Bigger Picture*, which accompanied an exhibition curated by Mark Haworth-Booth at the Victoria and Albert Museum in London in 1988. The exhibition was shown at what proved to be a pivotal point in British photography and presented the work of new colourists like Martin Parr, Anna Fox and Paul Reas together with the postmodernist works of Mari Mahr, Mitra Tabrizian and Susan Trangmar, set against the traditionalism of documentarists like Phillip Jones Griffiths, Thurston Hopkins and Edwin Smith. Butler's text is a bold attempt to resituate British photography within a postmodernist aesthetic.

BETWEEN FRAMES and across contexts, in gaps, overlaps, areas of suspension and transitivity – in such spaces, circulating between individual works and traversing national positions, some intriguing relations emerge. One unexpected collision: in 1987 the appearance, in Britain, of Keith Arnatt's series *Miss Grace's Lane* and, in America, of images by Cindy Sherman, two sets of color photographs showing terrains of scattered fragments, landscapes of dissolution. Arnatt's images are patently descriptive photographs of a dumping ground near Tintern, Gwent, while Sherman's are staged setups, images of disintegral selves dispersed within varied settings – a summer beach, an autumnal wood. Despite their different modes of construction, these two sets of work seem somehow to have backed into one another; do their similarities of appearance indicate anything more than simple coincidence?

A more implausible juxtaposition: recent works by Olivier Richon in Britain and Astrid Klein in Germany. Formally, the imagery of these two artists could not be more different, although a high degree of manipulation is evident in each instance. Gritty, harsh, and chilling, Klein's pictures evoke a post-nuclear atmosphere scarcely imaginable other than through the complex photographic techniques by which the images are generated. There is a sinister ambiguity in Klein's vaguely human forms, which often seem opaque and translucent at once, and which appear in a space that is undefined yet airless. Her large, disorienting photographs discomfit the viewer immediately. Clean and precise, Richon's photographs invite the spectator with lush color and simple, clear-cut forms, in the uncomplicated space of tabletop setups. But nothing here is given in itself. The rhinoceros in one picture is a tiny toy model, the reclining lady in another a plastic figurine, and both replicas are set

in curious relations to other familiar objects. No less than Astrid Klein's photographs, these too deny satisfactions of conventional reading in favor of a state of suspension in which the viewer's relation to the image and the nature of reading are placed in question.

The issue of reorientation within conditions of representation has become an increasingly important concern for a number of people working in Britain. In many cases this concern connects their work with that of artists in other countries, as well as with current debates about representation. Central to all this is the reworking of existing cultural frames of reference, from the complex metonymic/metaphoric implications of Arnatt's images to the shifting outlines of Sue Arrowsmith's explorations of process in her work, and the different uses of framing in work by Richon, Susan Trangmar, Yve Lomax, and Susan Hiller. Hannah Collins's staged, environmental images further extend certain issues of framing; like much of the other work here, they ask viewers to consider issues posed visually in broader contexts of social and subjective positioning within culture and its systems of representation.

From Miss Grace's Lane to Howlers Hill

SUNSET AT the rubbish dump. A burnished light suffuses this terrain with an intimate glow familiar from the miniature Arcadian landscapes of Samuel Palmer, the nineteenth-century English visionary painter and protege of William Blake. Keith Arnatt has known the works of Palmer since boyhood; indeed, he often calls this set of pictures his 'Polythene Palmers' – partly with regard to his own use of plastic paper and the intense chromatics of Fuji film. In this coexistence of painterly and technological references, one begins to gain some idea of the ironic and emotional filters brought to bear in Arnatt's imagemaking. Other painterly allusions besides Palmer might be read here; in one image a mash of decaying plastic rubbish bags creates a kind of post-Impressionist palette: juxtapositions of blue–black and rust that could be the surface of murkily reflective waters, perhaps something from late Monet. In another picture bursting trash bags suggest dystopic cornucopias, spilling forth their disintegrating contents in limitless plenitude.

Through the figure of the rubbish bag/cornucopia, a partial shift of genre is suggested, from landscape to still life. Arnatt's endgame in Arcadia changes scene, the local dumping ground of Miss Grace's Lane forsaken for Howlers Hill, an extensive landfill site near Coleford in the Forest of Dean. Here plastic rubbish bags stretch for many acres, 'glittering like jewels in the landscape' as their surfaces catch the light. For Arnatt, the fascination of such contemporary artifacts as plastic trashbags lies partly in their historical implications: one could not have made pictures of this kind twenty-five or thirty years ago simply because many of the objects and materials did not exist then as part of daily life.

Moving in close on the proliferating debris of consumer society, Arnatt discovers in the Howlers Hill material new emotional registers. The rich colors

(browns, blues, reds, golds) and the extravagant draperies of deteriorating plastic recall Venetian and Baroque painting; as these associations come to inform the work, a darker and more decadent atmosphere is evident. The photographer admits to intentionally making these images difficult to read. Seeing exceeds knowing as forms and objects lose the discreteness of their shapes. Phantasmagoric elements enter, as ghostly simulacra, often facelike configurations, appear and recede amid the illegible chaos of disintegration. The mind substitutes metaphors of the known in an imaginative effort to overcome the breakdown of rational cognition, but one cannot describe these images with any precision – they slough off language. Identification fails, and with it identity: in this wasteland entire categories of human functioning collapse into one another as the objects that supported them are obliterated.

With the Howlers Hill pictures, Arnatt succeeds in a kind of indexing of the unintelligible; what the camera registers so accurately, the eye perceives but may not recognize. These pictures are located at the edges of apprehension, in both senses – of an attempt to comprehend, and of anxiety in the face of the unknown and indecipherable.

The Ghost in the Machine

MORE SCENES from English life, in Susan Trangmar's *Untitled Landscapes*: a medieval church, the parking lot of a supermarket, the interior of a museum, a view of tower blocks – a few stops on what might be a guided tour, judging from the ever-present figure that leads the way. Rather like the person pointing in scenic postcards, the figure – a woman – seems to direct our view. How has she determined this itinerary? What might these places mean to her? What difference would it make if one were to meet her in the museum rather than the church? In the supermarket parking lot rather than the zoo? What could one make of her in each instance? Which stories might fit each changing scene, would they add up to a unified impression, a single image? Is she stacking the odds against this?

If she seriously means for me to look at these landscapes, why does she so often interfere with the view? If she is, as one begins to suspect, the photographer, why won't she behave properly, resume that invisible position which allows one to look unhindered, to enter the scene? Personally, I'd gladly do away with her; I commit little murders like this all the time, without even thinking. But the emergence of this insistent figure, which reveals photography's impossible fantasy of invisible, omnipotent seeing, points in fact to a repressed suicide within this fantasy. The flat surface of the photograph can only show me as viewer where I cannot be, never was or can be no longer, where I am nothing. The photograph is a limit, not an extension. Having thus negated the viewer's 'presence' in the scenario of landscape, this unknown woman might at least show her face, accede to the order of the portrait. But this is not to be, either; she will not dismantle one fantasy only to comply with an

untenable fiction of exchanged glances. What maddens is her refusal either to disappear, to function as absence, or, as presence, to be revealed, available. Trangmar's particular use of the cipher of Woman in *Untitled Landscapes* disrupts the usual rules and roles of representation. Through this resistant usage, the artist confuses and questions photography's subjectivities – the self-contained individual, as traditionally pictured in the portrait; the viewing subject privileged, through the device of perspective, as a cohesive identity, with a right to a clear view, a full explanation; and the photographer as an unseen presence directing the view.

The World is a Fabulous Tale

– TOLD AND RETOLD, framed and reframed, repeated and multiplied in its retellings. Is this the same as saying that its ways of telling are multiple, too? Can the ways of telling themselves be retold, the Same Old Stories be made to yield new, and different, ones? In *Divergent Series* Yve Lomax pursues these questions through her deconstructive experimentation with multiple narrative lines and representational space.

Using montage techniques to abut one image against another, to produce the confrontation of frame with frame, Lomax draws attention to the way framing constructs a view and positions the viewer in relation to it. This basic structure points to other structures which can be identified by the viewer – who already frames the work within a series of expectations. Take, for example, the fact that many of the images in Lomax's earlier series *Open Rings and Partial Lines* (1984–85) are grouped in panels of three photographs, framed horizontally: a classical formation which activates expectations of left-to-right reading, chronology, cause and effect – in short, the familiar story structure of narrative, as Subject, Predicate, Object, or Beginning, Middle, End. But within this three-part structure, patterns of pure design and abstraction appear, undermining the perspectival logic of the descriptive photographs; by combining found photographs and newly made ones Lomax disrupts the single dramatic moment, creating cinematic effects of flashback, flash-forward, or jump cut. The sight line – the logic of the look in search of its object – may be played with or against left-to-right reading; its imperative defies the rule of the frame, leaps impossible gaps in pursuit of implausible objects. Engaging the viewer's glance, it multiplies positions of identification within the imagery, splitting subjective response into plural perspectives.

The extended format of *Divergent Series* allows a wide range of issues (including nature vs. culture and the sexual politics of looking) and of moods to enter in. Whether the tenor of the work is humorous or serious, the viewer's role in constructing it is vital. Lomax may be just gaming (to use the title of Jean-François Lyotard's book) – but she always imagines an equal partner, as adept as herself at reorganizing the rules, replaying a set of given possibilities to generate new ones.

A Fiction of Reading

A YOUNG WOMAN gazing at a book. A familiar scene: think of Vermeer, of Fragonard. But this young woman looks with plastic, opaque eyes toward a book more than twice her size, containing a text whose title mocks both her sightlessness and the viewer's greedy look, Diderot's *Lettre sur les aveugles* (Letter concerning the blind). Appropriately the picture is entitled '*Perspectiva artificialis.*'

Another unknown woman: who is she? Olivier Richon's image shows a replica of a nude sculpture by the Italian artist Canova of Pauline Bonaparte (Napoleon's sister) posing as Venus. A real woman concedes her form to myth, to a simulacrum of male desire. So much for the pursuit of origins. This succession of framings and fakeries, ever more distant from any point of pure origin (problematic at best in Canova's sculpture), typifies the movement of displacement within the *Iconologia* series as a whole. As replica, myth, icon, simulacrum displace the referents for which they supposedly only stood in, reference itself becomes a fiction; the signifiers are set free.

Richon undermines the correspondence between sign and meaning (except at the most superficial level), in an openly rhetorical manner, through an elliptical theater of obsolescent symbols. Writing of this tactic, Michael Newman comments, 'Roland Barthes has described the photograph as "a message without a code": for Richon it is rather a code without a message insofar as his practice is to subvert the model of communication.'

One could go into mourning for meaning, lament the loss of the 'true' image (really the loss of ourselves as the privileged subjects of its knowledge). Or one could take pleasure here in the sheer allure of the image, its self-proclaimed masquerade, and the free play of allusion to allusion detached from the 'real' world, circulating across texts, across framings. This rhetorical stance flaunts a certain dandyism; but it spares us photography's old long-faced expression, its mask as the image of truth.

Retracings

S UE ARROWSMITH'S imagery is both photographic and autographic, indexical and gestural, for she works largely between photography and painting. Relying on her own self-image, often in a tentative relation with preexisting cultural representations, she explores possible elaborations of the self in the spaces between images, between media.

'Her Familiar Dancing' is one of several images made in 1984 in which Arrowsmith combined photographic emulsion, charcoal, and paint (always black or white, of the commonest household variety) on canvas. In these works a negative of an earlier self-portrait was exposed onto the canvas – sometimes more than once, in order to stain it more deeply. The charcoal drawing and the painting both condition, and are conditioned by, the photographic image; the canvas, absorbing all these processes, mediates their rival possibilities.

In other works gestures are literally photographic, made through the drawing of light. In 'One, Two, Three, Nine' (1985), a composite image of nine large contact prints, luminous contours of changing positions of the artist's body are outlined by exposed areas of darkness. In feeling and procedure, this light drawing has parallels with charcoal drawings in which Arrowsmith traces and retraces a succession of contours and movements of her body onto a sheet of paper. In both cases the drawing or outlining which creates an image, an object, is a self-determining movement by the artist: a physical moment of subjectivity.

A notion of dance – of an aesthetic, self-delineating yet fleeting gesture – seems implicit in this work. Shifting outlines, whether photographic, painted, or drawn, suggest the possibility of transformation, of change. This feeling is what marks Arrowsmith's particular coming to terms with representation. If the desire for representation or mirroring is an unavoidable part of the processes of identity, and if a representation is inevitably only a semblance of something displaced, that has escaped, then perhaps it is better this representation should be self-created, maintaining a measure of indeterminacy.

Incognito

EVADING identification, continually relocating her own blurred image, Susan Hiller uses the demotic, democratic medium of the photobooth to generate multiple images of self. Subverting the conventional, reductivist use of this crudest mode of portraiture, she refuses to produce an Official Version: the single image, primarily used on an identity card, that passport by which one accedes to the Order of Things, the Order of the Day. Her time is midnight; place, Baker Street. Underground London, Nighttown, at a crossroads near the center of a vast network of connections, a nodal point exploding into divergent lines: Metropolitan, Bakerloo, Jubilee, Circle. Millions of people in transit everyday, in this night under day.

There are sudden illuminations in subterranean chambers as flashbulbs pop behind the curtains. But the subject turns aside, lowers her head, will not be precisely centered, clearly seen. She rehabilitates those usually censored selves the photobooth spews out, retrieves their plural moments, blows them up to larger-than-life proportions. She tattoos the faces with indecipherable script, unwilling that the spectator should see from the outside a face that she inhabits but does not see from the inside.

Resisting representation, but attesting to the desire for utterance, this script does not assume a singular 'I.' Hiller draws upon Surrealist traditions of automatic writing which erode notions of individual authorship. And indeed, she patterns her own movements in these pictures on the evasive gestures she discovered in images other people had made in the photobooths. These shared gestures and indecipherable scripts move toward a more collective sense of identity and propose a language of spontaneity, beyond individual control.

Heartland

HOW TO address questions of orientation, of locating oneself in relation to place; of locating the photographic in relation to communication, to imagination? Over the past few years Hannah Collins has proposed within her work a series of subtly shifting positions with regard to the idea of place – sometimes as a particular geographical location, sometimes in the more generalized sense of a social space. *Evidence in the Streets* (1985) was derived from a specific ground – an area in the east end of London known as London Fields – and a personal perspective, as the artist attempted to locate her relation to this place in which she was living. Aware that her connections were tenuous and incomplete, she avoided a documentary approach which might have constructed an impression of more direct, immediate contact.

Having no long-term history of her own in the area, she discovered in the local library images of wartime damage to buildings in the neighborhood. By printing these wartime documents in large scale, with monochrome tint, she resurrects and distances these images, as if in memory. Without presuming to a full understanding of the history of the neighborhood, Collins was able to recover at least a partial sense of place now largely lost to public consciousness.

Both personal and distanced, *Evidence in the Streets* marked Collins's developing preoccupation with socialized spaces. Since then she has pursued this concern primarily through images of staged interiors, very pared-down settings, presented environmental-size in black and white. The scale of these pictures seems to invite a kind of imaginary entry while making the viewer aware of the unexpected intrusion of the image and its proposed space into another, pre-existing space. These works, by setting up confrontations between spaces, implicitly ask viewers to reevaluate their perceptions of both the 'represented' space and the actual space, which also embodies a cultural or social *mise-en-scene*. In both instances, it is as if one were intersecting an ongoing narrative: what might the script, the text of this space be? What relations does it privilege or preclude, what modes of imagination does it foster or preempt? What different readings of it might be possible?

The persistence of questions similar to these in the works discussed here links them not only with each other but with current preoccupations with representation, interpretation, and knowledge. In the conflict between an empirical or pragmatic view based in presence and immediacy and one which privileges the role of language and cultural framing as a precondition of knowledge, the status of the photographic image is bound to be a matter of contention, insofar as the photographic, unlike other modes of representation, bears the trace of what it depicts. As the inheritor of what Yve Lomax has called 'the power of glimmering visibility,' it seems to retain something of the immediacy of direct sensory impressions and through this 'aspires to a union of presence and absence.' The photographic makes us forget its status as medium – that which comes between – as well as the preconditions of framing, cultural,

mechanical, psychological, contextual, that qualify its indexical relations. Yet a normative notion of the photographic as giving unmediated access to the real is precisely what allows the photograph to impart its verifying illusion to fictional or staged events, and the relation of the index also permits the medium to absorb, recombine, and reproduce both its own preexisting images and the imagery of other visual media, reducing all these elements to its own terms in nonreciprocal relations.

As both index and construct, the photographic image provides fruitful if constantly shifting ground within which problems of reading and knowing can be reconsidered at different levels and in changing contexts – its potential relocations would seem to be indeterminate, its epistemologies multiple. The spectrum of possibilities discussed above favors work that critically disrupts reading the image with regard to the more general issue of framing. But other important work to do with framing is also to be found in a British context: Karen Knorr's series *Gentlemen*, which reverses the politics of looking within a critique of British social hierarchies; Helen Chadwick's 'One Flesh,' which plays off the contemporary medium of xerography against traditional religious imagery reconceived in favor of the feminine. Roberta Graham's huge lightbox images also have implications of the sacred, as she combines painting and drawing techniques with photography to suggest an interiorized perspective of the body. Like Graham, Verdi Yahooda is involved in making visible, using methods of framing and reformatting within photographs of personal and domestic objects to revalue them under a ceremonial aspect. Mari Mahr's series *A Few Days in Geneva* relocates the photographic image in a context of subjective memory and reverie, combining her own photographs with objects or elements of staging that bring performative and sculptural aspects into the rephotographed final images.

As little as three or four years ago, much of this work might have been considered 'fringe interference,' an intervention between traditions of British documentary and a newer school of highly didactic and theoretical image-text work mostly centered about the Polytechnic of Central London. Now it is becoming increasingly common to discover in group exhibitions a wide spectrum of differing ways of working with photography as a means of exploring the medium's recordative, fictive, and critical capacities.

Jane Gallop

The Pleasure of the Phototext

(First published in *Afterimage*, April 1985)

Looking first at Roland Barthes's *The Pleasure of the Text*, Jane Gallop takes his idea of the active reader and considers its applications to the photographic rather than the literary text. Turning to his *Camera Lucida*, she explores the literal meaning of the *punctum* (Barthes's term for the piercing detail that prompts reverie and narrative curiosity) and extends this into a reflection on the relation between photography and sexuality.

I'D LIKE TO talk about the word 'in' in the phrase 'sexuality in art and the media.' That word 'in' implies a relationship of container and contained, a relationship in which sexuality is something interior to – contained within – art or the media, something that is represented. It implies that sexuality is something that is within the work of art rather than in some relation the viewer or the artist has to the work of art. Is that how we want to think about the relation between sexuality and art? Do we want to think about it as something that is represented in art, as something whose image we see in a work of art, or do we want to think about it as somewhere else?

I entitled my talk 'The Pleasure of the Phototext,' which is close to the title of a book by Roland Barthes, *The Pleasure of the Text*.[1] I inserted the *photo* because I am not going to talk too much about the literary text, the text as a piece of writing, but I am going to make reference to some of Barthes's ideas about the sexuality of reading, about the eroticism of a certain relation with the text, as those ideas show up in his book on photography, *Camera Lucida: Reflections on Photography*,[2] written seven years after *The Pleasure of the Text*. That word 'of' in Barthes's title is actually ambiguous: it can refer to the pleasure in the text, which the text contains, but it can also refer to the pleasure the text affords us, the pleasure the text offers. The play of that which is within and yet offered is what I would like to propose as an alternate preposition, an alternate spatial model, to the 'in.' So, rather than sexuality *in* art, the pleasure *of* the phototext.

In order to think about the relation between inside and outside, I want to quote a passage from *The Pleasure of the Text*, from a chapter entitled 'Representation.' 'Certainly, it happens very often that representation takes as its object of imitation desire itself.' Barthes has just asserted that the erotic relation to the text, the pleasure of the text, is different from representation, but he, of course, recognizes that one of the things that often gets represented is pleasure – erotics, sexuality, desire. He is not trying to deny that the whole history of representative art, of representative literature, is a history whose themes have often been those of desire and sexuality.

Certainly, it happens very often that representation takes as its object of imitation desire itself; but then, this desire never leaves the frame, the picture [his word is *tableau*, which could also mean scene]; it circulates among the characters; if there is an addressee, his addressee remains interior to the fiction. (. . . Representation is just that: when nothing comes out when nothing leaps out of the frame: of the picture [*tableau*, scene], the book, the screen.)

It is noteworthy that this is also one of the few places in *The Pleasure of the Text* where Barthes mentions other media besides writing. His formulation implies that the relation of representation works the same for the book, the screen, and the picture. Barthes defines representation as a case in which something remains totally inside.

Barthes is writing *against* representation, which for him is a means of containing and co-opting desire, pleasure, sexuality. He defines it as a situation in which nothing comes out, where everything remains inside, where nothing leaps out of the frame. Of course there may be desire, there may be sex (sex is, after all, the commonest theme of art and literature), but it is all contained within. The desire circulates, but it circulates among the characters; it does not come out. It is addressed from one character to another; it is not some relation that might include the artist, that might include the viewer.

In *Camera Lucida*, Barthes is no longer specifically talking about pleasure, but he is specifically talking about photography, and in that book he defines two elements of the photograph. One is the *studium*. It is what we might call the theme or the subject of the picture, what the photographer is trying to say, but it also has to do with ideas and general culture. According to Barthes, the *studium* can be interesting, significant, and important, but a picture that has only a *studium* is like representation: everything is enclosed within the field of the picture, and nothing comes out. Then there is a 'second element' that Barthes says, 'comes and breaks up the *studium*.' If you think of the *studium* as a kind of enclosure, breaking it up suggests breaking something open, allowing seepage. 'This time,' he continues, 'it's not me who goes after it (like I invest with my sovereign consciousness the field of the *studium*), it's it that goes off from the scene, like an arrow, and comes and pierces me.' When Barthes tries to define the other element of the photograph, he refers to something that goes off from the scene, precisely something which is not within representation, not within the frame, within the scene. Barthes refers to this element in striking terms: 'it goes off from the scene, like an arrow, and comes and *pierces me* (emphasis mine).'

There is a lot of work in film theory on voyeurism – numerous analyses that describe how the gaze is an aggression upon that which is seen. Barthes's consideration of photography does not concur with the notion that the photograph as object of the gaze is passive while the viewer is in an active, even aggressive, relationship to it. In this relationship there is a passive and an aggressive term which are often lined up as female and male, as so often we line up aggressive with male, passive with female. In Barthes something quite

different *sometimes* happens, but not all the time. He says, in fact, that a picture which is all *studium* is just a passive object: inert, immobile, lying there. But when there is that second element, the element that breaks up the *studium*, something happens which is quite the opposite of the relationship which occasions complaints about the male gaze and the female object of the gaze. Something happens: the second element goes off from the scene like an arrow and comes and pierces the viewer. There is a reversal: something in the photograph is aggressive and penetrates the viewer.

Barthes has not yet named the second element. He continues: 'A word exists in Latin to designate that wound, that prick, that mark made by a pointed instrument . . . I will thus call it *punctum* . . . The *punctum* of a photo, it's that accident which, in it, stings me.' He is talking about something that hurts him: wounds, stings, pierces. He mostly uses the Latin word to name it, but when he wants to define the Latin word, the French equivalent he gives it is *piqûre*, which I am amused to find can be translated as 'prick.' Not, of course, our vulgar word for the male genital, but the word for something that pierces, something that wounds.

My point is not that it is original to see the viewer as passive. Susan Sontag in her book *On Photography* writes: 'One is vulnerable to disturbing events in the form of photographic images in a way that one is not to the real thing. That vulnerability is part of the distinctive passivity of someone who is a spectator twice over, a spectator of events already shaped, first by the participants and second by the image maker.'[3] What interests me is the particular kind of passivity that Barthes is talking about. The piercing arrow brings us close to a tradition of a certain mystic discourse in which otherness enters you in some way that is ecstatic. Ecstasy etymologically derives from the Greek *ekstasis*, from *ex-*, 'out' + *histanai*, 'to place.' Thus, it means something like 'placed out.' Ecstasy is when you are no longer within your own frame: some sort of going outside takes place. In Barthes's *The Pleasure of the Text*, he talks about the most intense form of pleasure, which he calls *jouissance*, which can be translated as 'ecstasy.' (Richard Miller translates it as 'bliss.') The *punctum* which is not in all photography but is in his favorite photographs, the ones that move him, produces something like a *jouissance*, an ecstasy.

In *Camera Lucida*, the imagery used to describe this ecstasy carries connotations of pain. The arrow reminds us of Cupid's arrow, of a tradition in which love comes from the outside and not according to your intention, attacks you, pierces you, changes you, takes you outside yourself, puts you in a state of passivity that (at least in the Western tradition) is seen as a violation of the body, a penetration of the self, something dangerous and threatening and yet at the same time terribly pleasurable, something wonderful.

Later in the book, Barthes once again explains how the *punctum* works, this time by means of a contrast between cinema and photography: 'The cinema has a power which at first glance photography has not: the screen (Bazin noted) is not a frame, but a mask; the character who leaves it continues to live.' Once again we encounter the notion of something that goes outside the frame, something that is not still, immobile within the frame but that leaves it and

continues to live. Barthes continues: ' "A blind field" [Bazin's term] incessantly doubles the partial vision.' The idea here is that in photography everything is contained within the photograph, whereas in cinema things continue to live outside the field of vision, and that continuity which we cannot see, Bazin calls the 'blind field.' Barthes continues: 'Now, before thousands of photos, including those that possess a good *studium*, I don't sense any blind field: everything that happens within the frame dies absolutely, once outside that frame.' This is Barthes's definition of the bad photograph: the photograph with a good *studium*, with good intentions, good ideas, the well-made photograph, but the photograph where everything is within the frame and does not continue to live outside the frame. He is talking about a kind of violence; he uses the word 'dies.' He is not talking about death within the frame, or about the representation of violence; he is using violent imagery for something representation does. He is talking about what happens when a photograph has a good *studium* but no *punctum*. As soon as there is a *punctum*, however, a 'blind field' is created or divined. A *punctum* thus does the same thing that cinema does. I will not go into whether or not this is how cinema works. What interests me is this image of the photograph where everything is contained within the frame and the photograph where things continue to happen outside the frame.

Barthes cites a photograph by James Van der Zee of a black family of three, in which the *punctum* is a necklace one of the women is wearing. 'Because of her round necklace, the Negress in her Sunday best has, for me, an entire life outside her portrait.' The *punctum*, by breaking open the *studium*, breaks open a sterile enclosure which does not allow anything to pass through, and allows what Barthes calls 'life' to pass through, to permeate the frame.

What Barthes calls 'life' has something to do with a kind of eroticism that he valorizes in this book. He has a strong sense of good and bad in eroticism. At various points in *Camera Lucida*, as well as in *The Pleasure of the Text*, he contrasts erotica and pornography to the detriment of the latter. What Barthes valorizes has something to do with the 'life' that passes outside the frame. Continuing to talk about this 'blind field,' he comes to talk specifically about eroticism: 'The presence of this blind field is, I believe, what distinguishes the erotic photo from the pornographic photo.' For Barthes, pornography is pure *studium* whereas the erotic occurs when there is a *punctum*. 'Pornography ordinarily represents the sex-organ, it makes it into an immobile object (a fetish), to which we burn incense, like a god that doesn't leave its niche.' This kind of erotic relationship in which the sex-organ is represented within the frame is sexuality *in* art, and it is described negatively by being likened to religion, by being represented as a god that does not leave its niche, to which we burn incense (in this context, a quite provocative image). For Barthes, pornography is a self-enclosed image: it is sexuality contained, sexuality that does not leave its frame. The viewer can worship it in a kind of masturbatory way but can neither touch it nor be touched by it.

He continues: 'For me, no *punctum* in the pornographic image; at most it amuses me (and still, boredom comes fast). The erotic photo, on the contrary (it's its very condition) does not make the sex-organ a central object; it can very

well not show it; it draws the spectator out of its frame.' That last phrase is
ambiguous in French. It could also read: it draws the spectator out of *his* frame.
The word would be the same in French. There is a double meaning here: the
sense of *two* things coming out of their enclosures. (I do not agree that
pornography always makes the sex-organ a central object nor that in erotic
photography the sex-organ is never a central object. I think that is a false
distinction as it is based upon what goes on within the frame. I am much more
interested in the distinction between pornography as 'a god that doesn't leave
its niche' and erotica as 'drawing the spectator out of the frame').

Barthes continues: 'and it's in this way that this photo, I animate it and it
animates me.' It is in this way, because of the *punctum*, because the erotic photo
draws the spectator out of its frame, out of his frame, out of her frame (all of
which are perfectly legitimate translations of Barthes's French). With the erotic
photo, 'I animate it and it animates me.' Earlier Barthes seemed to define the
spectator as passive, as, indeed, a victim of aggression, and yet now his
definition seems a lot more complicated, a complex of activity and passivity.
There is some sort of reciprocal activity occurring where one is both the subject
and the object of the verb 'animate,' a verb that echoes this notion of life that
Barthes talks about. Behind all of this is the contrast between that which dies
outside the frame and that which continues to live outside the frame, animation
as opposed to the inanimate. The erotic photograph is different finally not
because of what occurs inside the photograph, not what is represented, but
precisely because something occurs between the photograph and the viewer: a
relation of reciprocity, if one can imagine a reciprocal relation with a photo-
graph, a relation of mutual animation.

A few pages earlier Barthes writes that the *punctum* is 'what I add to the photo
and which nonetheless is there already.' On the other hand, it is 'what I add to the
photo,' implying a highly active viewer who puts something there, who is in some
way creating the photograph. However, what he is creating is something that is
already there, something that is *in* the photograph. In the late '60s, Barthes's great
move in literary criticism was his promotion of the notion of active reading as
opposed to passive consumption. He called for a kind of reading in which the
reader actively contributes to the text, in a sense, writes the text. Yet this is, finally,
a subtle activity. He is not talking literally about writing; we know what writing is
and that is not the kind of reading he means.

In relation to photography this means adding to the photograph something
which is already there. This suggests a contact we might call 'active passivity,'
an active viewing in which one contributes to seeing something that is really
out there. This 'active passivity,' this complex, is what he is trying to gesture
toward, or at least what I am trying to gesture toward, because, after all, this is
my reading of his book, and I may be all too actively adding things which I only
hope are already there. I would have it that he gestures toward some sort of
contact with alterity, some sort of contact with something that is out there in
the world already, that is not simply a projection, but that we nevertheless do
not just take in as purely passive consumers. That is how I understand this
notion: 'I animate it and it animates me.'

I am trying to read *Camera Lucida* by means of an analogy between viewing a photograph and some sort of erotic relation to an 'other.' I am (or he is) trying to think around a way to touch, to contact, to encounter the real of the other. As I have said, when Barthes talks about the sting and the wound and the arrow that pierces me, he is pointing to a tradition of mysticism. In Western thought, mysticism is the great tradition of openness to alterity, of total receptivity to being overwhelmed by otherness. But there is something else here that I find interesting because I am not really interested in a purely passive relation. There is also the relation of the 'I animate it and it animates me,' the relation of what I add to the photograph which is nonetheless *already* there. In sex the subject must desire, must fantasize, must imagine. Things must come from the mind and cause one to view the other as the object of desire. Yet, at the same time, there is also a wish to encounter the other as something real, out there, beyond one's fantasies, not the god in the niche to whom we burn incense, not the pornographic image, but a relation to some real other. This wish is at play in the notion of the *punctum*: something that leads us outside of the frame.

The analogy interests me not simply because I am interested in sex, not simply because sex is the topic of this series, but because it seems a suggestive way to talk about photography. It is often said that photography is a strange hybrid of nature and art of art and the real. Photography is art like sex is fantasy, desire, imagination. It is one's own ideas projected onto the world, shaping and distorting the world, framing the world and making it into an object of art or an object of desire. Photography is also something else. Besides being art, it seems to have some quite special relation to the real.

Photography interests Barthes because of this special relation to the real. He says that the photograph necessarily always takes its referent with it, takes the thing in the world that it refers to with it. Photography is at once representation, and yet also, some sort of direct registration of the real. According to Barthes: 'The photo is literally an emanation of the referent. From a real body, that was there, rays went out that came to touch me, me who is here . . . the light, although impalpable, is certainly here a carnal medium, a skin that I share with he or she who was photographed.' For Barthes the photograph is magical because what gets registered on the film actually comes from the real object. I am not sure that this is exactly how photography works, that we are actually looking at a record, or that the object really comes and touches us. Barthes's sense of photograph is both very mystical and very naive.

In the passage just quoted, Barthes uses a number of metaphors related to the body: the skin, touch, the carnal. It seems to me that this body imagery bespeaks his attempt to think some relation to the real, to the body that is really out there, the referent if you like, to some thing that touches him. He is trying to think some relation to the referent through a notion of erotic contact, hence the difference between the body that touches me and that god in his niche to whom I burn incense without any real contact. There is a real body, the rays, the light which is a skin that touches me. Yet, this still implies the passivity of

the spectator and the activity of either the photograph or the photographic object, its referent. But then there is the last part of the sentence, 'the light, a skin that I share with he or she who was photographed.' The image of sharing a skin is extraordinary. If you say something touches you, there is a subject and an object of that verb, which has an active and a passive meaning. But if you are sharing a skin, there is another relation.

At the end of the sentence Barthes writes that he shares the skin 'with he or she who was photographed.' That locution might not sound too unusual to us because nowadays we are all pretty careful to say 'he or she,' or that sort of thing. But Roland Barthes is an author who never talks about sexual difference, who never sexually differentiates his erotic objects when he describes them. To my knowledge, this is the only place in his work where he sexually differentiates: he actually uses two pronouns, a masculine and a feminine pronoun. The inelegance of 'he or she,' of the double pronoun, is not only a recognition of sexual difference, but, I think, it also signals an attempt to talk about the real.

I am pursuing the idea of a relation between sexuality and the medium of photography, which is not sexuality *in* photography, but is something like the sexuality *of* photography. In August 1984 I heard Leslie Bellavance, a Milwaukee artist and teacher, make a similar point: 'Erotica and photography have what seems to be parallel paradoxes. The erotic paradox is the meeting point of dependence and independence. The photographic paradox is the meeting point of nature and art.' Bellavance's paradoxes resemble Barthes's statement that the *punctum* is what I add that is already there. The erotic paradox is this strange combination of dependence and independence. In order to be erotic, the object must depend on the viewer, on the aroused one, on our fantasies, our imagination, our constructs, our framing, and yet, the object must also remain independent, still real, still other. Eroticism itself is a relation to something that is very much part of our imagination, our projection, our desires. Our eroticism is what is most narcissistic or most imperialistic in our relation to the world, and yet, there is also some relation between our desires and something that is really out there, that is independent of our fantasies.

Bellavance defines the photographic paradox as the meeting point of nature and art. Nature is a word we have used for a long time to talk about what is out there, outside of culture, outside of our constructions, our frames, outside of our art. In *On Photography*, Sontag writes that photographs 'trade simultaneously on the prestige of art and the magic of the real. They are clouds of fantasy and pellets of information.' My goal here is to provoke you to think toward a relation between sexuality or eroticism and photography, a relation between two 'paradoxes,' two contradictory projects, two perhaps impossible projects, in which neither one is contained within the other, a relation of the 'of' or the 'and,' rather than of the 'in'. I do not want to talk about the representation of sexuality *in* photography. Nor do I want to reduce photography to a manifestation of sexuality. I would rather attempt to think about what it is in the photographic project which uncannily resembles the paradox of sexuality.

In his explanation of the *punctum*, Barthes says:

Certain details could 'sting' me. If they don't, it's undoubtedly because
they were put there intentionally by the photographer the detail that
interests me is not, or at least not rigorously, intentional, and probably it
must not be; it finds itself in the field of the thing photographed like a
supplement at once inevitable and obliging; it does not necessarily attest to
the photographer's art.

A lot of photographers would resent that statement and they would not be
wrong. Barthes is interested in that element in the photograph which he does
not think the photographer intended. He actually waffles about it; the issue
seems pretty complicated for him. He says, 'the detail that interests me is not,'
which sounds like a decisive, negative assertion, but then he adds, 'at least not
rigorously, intentional, and probably it must not be.' There is something about
the question of the intentionality of the interesting detail that seems to trouble
him. Early in *Camera Lucida*, Barthes states that there are three ways to talk
about photography: from the point of view of the photographer, from the point
of view of the person photographed, and from the point of view of the viewer.
He then says that he will not talk about it from the point of view of the
photographer because he is not a photographer. This is consistent with
Barthes's larger project, at this stage of his career, that is, the project of a subjec-
tive science, a science in which he speaks from his own subjective experience.
It stands in marked contrast with Sontag's book *On Photography* in which,
although not a photographer either, she writes about photography from
her notion of the photographer's point of view.

Sontag may be hard on photographers, constantly talking about their
appropriative desire, but Barthes's relation to the photographer is ultimately, if
more subtly, aggressive. He is saying: I am interested in *my* relation to the
photograph; I am not interested in your relation to the photograph. That is not
all: he is most interested in the things that he thinks *he* adds to the photograph.
It may be 'already there,' but if the photographer did not intend to put it there,
it *therefore* constitutes some relation to the real. The erotic relation to the
photograph, like so many other erotic relations, may produce a certain kind of
rivalry. Thus, Barthes lays claim to the most erotic place in the photograph, the
punctum. He proclaims: it is mine, it is not the photographer's. I put it there. It
is there already, but that is the erotic paradox: what I put there is already there.
This could be the less seemly side of Barthes's erotic relation to the photograph,
or even the less seemly side of every viewer's relation to the photograph. This
is the moment in eroticism when we say: Yes, yes, I am open to otherness; I
want to encounter you, but I do not want you to encounter anyone else! This
is my relation to you!

As unseemly as it may be, when viewed from this jealous angle, I want to
examine further the notion of the questionable intentionality of the *punctum*.
The poster for this series, 'Sexuality in Art and the Media,' is a photograph by
Harry Bowers, *Black and White #6*. To discuss its *studium*, it is a photograph of
a naked man and a clothed woman, which clearly quotes from the history of

representational art. But for me, finally, the object of greatest fascination, the point which takes me outside the frame and whose intentionality remains uncertain, is neither the man's naked body nor the woman's clothed body. Both these bodies, however attractive, are within the frame of representation. The object that most draws out my imagination is the wedding ring on the man's finger. I find myself wondering whether the photographer wanted it there, or did not realize it was there, or was indifferent. What it does to me bears out Barthes's notion of something that seems to have a 'blind field' and lives outside the frame. Because of it, this naked man – coded there as an object for my desire, as an object of my gaze – seems to have a (sexual) life and history outside the frame. Because of it, he is not just an object to whom I burn my incense, but he is also a 'real person.'

In the passage that I quoted before in which Barthes defines what happens in the erotic photo, he continues: 'The *punctum* is thus a sort of subtle outside-the-field, as if the image flung desire beyond what it offered to view: not only toward "the rest" of the nudity, not only toward the fantasy of a practice, but toward the absolute excellence of a being, body and soul mingled.' I am embarrassed by the phrase 'absolute excellence of a being, body and soul mingled.' These sorts of words are not in fashion in the post- and anti-humanist circles where Barthes is read. 'Soul' is not a word intellectuals and critics use much anymore. The embarrassment caused by the phrase 'body and soul mingled' is like the embarrassment I feel when I say that the man's wedding ring makes him a 'real person.' The phrase 'real person' is an attempt to indicate that he exists, that he has a life that goes outside the frame. The question is, what is beyond the frame. I think we run into trouble when we start talking about what is beyond the frame. We get into a kind of troubling essentialism and start talking about 'souls' and the 'absolute excellence of being.' I am wary of positing what is outside the frame, because when we posit that, we are once again within a long tradition of ontological and metaphysical projection – projection of what God is, what the real is, what the noumenal world is beyond phenomena. Photography and eroticism both occupy a space that is neither quite outside nor inside the frame, but are rather in some very conflicted and powerfully dynamic relation to inside and outside. In this space we confront the paradoxes of dependence and independence, nature and art, nature and the real, what I add and what is there already, what animates me and what I animate. For me, finally, that is the sexuality *of* art and the medium of photography.

Karen Knorr

Interview: Fetishism of Black-and-White and the Vulgarity of Colour

(First published in *Marks of Distinction*, Thames and Hudson, London, 1991, pp. 124–31)

Karen Knorr was one of the most significant postmodernists to emerge from the radical photography department of the Polytechnic of Central London in the early 1980s. This interview emphasises the major shift taking place in British photography – the intertwining of practice and theory – during these years.

Fetishism of Black-and-White and the Vulgarity of Colour

Why, in your earlier black-and-white work, did you choose a uniform format for all your images? What determined the choice of typographies?
All my black-and-white work from 1979 to 1985 was produced on a 6 × 6 square format which results in a certain quality that has been called fetishistic. When I studied photography in Britain there was a critique that led to a rejection of the fine-grain, seamless quality of the fine-art photographic print. The perfect print was considered to be a problem in that it gave form dominance over content. There was this cult of the fine-art print which endowed it with quasi-magical properties, as in the work of Joshua Cooper, Minor White and Edward Weston. I have reacted to this 'art for art's sake' cult in that my photographs have always attempted to deal with content. Yet I have always maintained that the fetishistic aspect of the print, which after all gave it its seductive power and allure, was a necessary component in its ability to be persuasive or to make a point. So there is this compromise with fetishism in all my work. The 'reality effect' that it produced was essential to the work.

What you call uniformity, I call structure. In order to build a series, there had to be certain conceptual *a priori* notions. Certain devices were repeated in order to indicate that the photographs were constructed. The same lighting, lens and camera positions were used throughout the series. In the *Belgravia* series I wanted to refer to a particular genre of interior photography that one can find in *House and Garden*. To have done that in colour would have been too close to the reference. I felt that black-and-white would give the work more of an edge. I wanted to create another type of social documentary that did not fall into naïve theories of reflective realism in which the photograph was

seen to have a one-to-one relation with the 'world out there'. In a sense, there is this paradox of wanting to use realism against itself.

That brings us to the use of text in the work. For every series I decided to use a different typeface, in order to differentiate the 'voices' in the text and to avoid a certain homogenizing effect. I did not want the images to be seen as an illustration of the text or vice versa. Both image and text, although working together, had to have a certain autonomy which pointed to their construction. I did not want the text to be naturalistic any more than the image. Both had to 'defamiliarize' or 'distance' our identification with what is represented. That is why I capitalize certain words, break up the text and arrange it so that it resembles advertising copy.

After several series in black-and-white, how and why did you decide to work in colour?
I found the unnatural colour of the cibachrome process ideal because of its vulgar or commercial connotations. *Connoisseurs*, my latest work, is after all an attempt to parody received ideas of beauty and taste in British High Culture. The canon in fine-art photography is to a great extent determined by 'straight photography'. The aesthetics of the fine-grain black-and-white print is what comes to most people's minds when they think of exhibition photographs. The American School of Photography, with its Masters of Photography approach, established an academy which favours the single print in its own right and in isolation. Photographers such as Weston and Adams exemplify this 'purely visual' approach. *Connoisseurs* is not 'straight photography' and it is presented as a set or series.

The Series as a Form

Why have you worked in series since 1979? What makes the serial form possible? What does it represent for you — what form of visual discourse?
The reason I work in series is in order to contest the dominance of the single print, which still reigns supreme amongst certain photography connoisseurs. The notion of one print standing in for the whole work and the tendency to impose an authorial presence or personal style over meaning is still a view common to critics and curators.

Another reason is that, when working with humour and irony, one needs to frame or contextualize the 'statements'. A tension has to be set up by repetition in the pose or angle of view. It is the series as context that produces the irony. The image-texts on their own become literal, losing their humour. The series as a form is flexible and, depending on the exhibition space, can be anything from six to twenty image-texts. It all depends on what aspects of the work I want to focus on, what 'stories' I want to highlight. The series becomes narrative by juxtaposition. It is, nevertheless, a fragmented narrative with no fixed ending or beginning. This aspect is emphasized by the work being exhibited in a gallery, whereas it would be quite differently presented in a book. Unfortunately, photographic work tends to be more linear in book form.

There is also another narrative which is not a narrative in the classical sense. A 'third meaning' similar to film montage is produced between images and texts. There is also the *punctum*,' which produces readings of the image which cannot be controlled by my intentions.

As for the form of visual discourse, it is mixed, not purely visual, in that the 'figural' is always contaminated by the 'discursive' and vice versa.

Where does a series begin and end? When it is finished?

A series develops as the product of research which includes reading the journals, books and newspapers that my 'social actors' read in order to establish the appropriate 'voice'. There are certain preconceived notions that I may start out with and which may be developed or discarded, depending on a process which includes reading academic journals (even textbooks on economic theories), as well as fieldwork which involves observing people and situations 'on location' in order to get the pertinent pose or gesture.

Parallel to the literary, discursive aspect of research, 'genres' such as the portrait, still life and landscape in photography are examined. There is an attempt to understand what values underpin the relevant genre (for example, in portraiture its humanist underpinnings equate it with 'character' or 'person-ality') which in turn leads to an intervention or critique of the genre. *Belgravia* and *Gentlemen* take issue with the conventions of portraiture by rejecting the cult of the personality that results from naming the subject. Traditionally portraits are about individuals. There is a strong tradition of the famous and the great which leads to photographic exhibitions of 'The Great British'. Hence the work is about attitudes which are 'classed' as much as 'gendered', not about particular individuals.

The work finishes once the questions have been answered. For instance, in *Gentlemen* I wanted to examine 'patriarchy' and chose the gentlemen's club as the symbolic space in which to contextualize attitudes which undermine and exclude women. What I found out was that things were not so clear-cut. There are contradictions. Women may collude in the oppression of their own sex for the sake of power. There are male-identified women who are relegated to the status of 'gentlemen' and are considered 'clubbable'. The most obvious example is Margaret Thatcher. There was a certain amount of embarrassment caused in clubland by the election of Thatcher, compounded by the fact that most clubs, including the Carlton (the 'true-blue Tory club'), did not allow women full membership. Anthony Lejeune summarizes this attitude by writing in his introduction to *The Gentlemen's Clubs of London*, 'Socialists, like women on the whole, are not clubbable'. A ripple of horror pervaded clubland when Ken Livingstone became leader of the Greater London Council. Yet there was a time when these clubs, founded as coffee houses, were suspected of anti-monarchist and republican tendencies. Although I have not much sympathy for the politics represented by most of these 'gentlemen', nevertheless I was allowed to photograph in a less restricted fashion at Brooks's (once a Whig club) after it had been established that I was a 'Republican' – although I did have to emphasize my disagreement with Reaganomics! In the end *Gentlemen* became

an examination of the contradictions within 'patriarchy'. A woman appears surrounded by men in one of the photographs and underneath there is a text alluding to the virtues of 'community life'. It begs the question: Whose community?

Text and Image

Printed with the image, what is the relation between the text and the photograph? Which precedes or leads the other? Which completes or explains the other?
The text, printed on the surface of the photographic paper, is literally photography, writing with light. The text is image in this sense as much as the photograph is image. The difference is in the register of the sign. Language is more 'arbitrary', compared to the photograph which is 'motivated' or linked to its referent. The photograph is 'indexical'; like a footprint, it refers to something having been there. Of course, the photograph is a construct, it mediates and is highly conventionalized. Although there is no language of photography, we can argue that there is a rhetoric of the image which can be built into a genre. We all recognize distinctions between photo-journalism and fashion photography.

Roland Barthes writes of two kinds of relationship between image and text. In his essay *The Rhetoric of the Image* he describes the linguistic message in relation to the photograph. 'Anchorage' ties meaning down by answering questions like 'What is it?'. It explains the image. 'Relay' opens up the image to other meanings which are not apparent or visible in the photograph. It is the latter which interests me most.

Neither image nor text comes first. Neither explains or completes the other. Both add to each other.

What is the syntactic relation between text and image? Who speaks — the subject, a third person in 'voice-over' or you?
There is no language of photography in the sense of sentence-governing rules like syntax. We do not place photographs in order from left to right. Objects photographed are not arranged like words, although photographs may trigger associations just as words do in poetry. Photographers are highly skilled manipulators who learn different 'vocabularies' that cover lighting, choice of film, lens, etc. All these produce recognizably different types or 'genres' of photographs. Interiors are not photographed in the same manner for *The World of Interiors* as they are in a campaign for the homeless. Photography works more at the level of discourse. We are no longer referring to the level of the sign (word) but to beyond the sentence, which is more like semantics. I think it useful to think of a semantics of the photograph. It is a question of how meanings are produced and interpreted in a photograph. Through technique and context we can control some meanings. Others are more difficult to pin down — those which deal with the unconscious and those parts of our personal histories which we tend to project upon the image. In my work there are two discourses, one visual and the other textual, colliding against each other.

Are the texts to be seen as captions or titles for the photographs? Why produce work exclusively in the domain of image and text?
Rather than 'captions' or 'titles', I prefer the mythological connotations of the French word '*légendes*'.

Why image and text?
In order to slow down the spectator's pace of consumption, creating a 'slow-motion reading' which leaves room for reflection. Viewers tend to devour images without digesting them. People rarely look at photographs for more than ten seconds, the length of a long film take.

Romantic or Agnostic Modernist

In a text in 'Camera Austria'[2] you ask yourself whether you are a romantic or an agnostic Modernist. How do you answer today?
I try to resist the polarization inherent in such categories as Modernism/Post-Modernism. Contrary to some rumours, despite doubts about the 'enlightenment project', we are not witnessing the end of the 'social'.[3] New technology has not brought with it equality. Women are not equal to men. There is this sense in the aftermath of Modernism that we can indulge in an orgy of absolute indifference, equivalence and interchangeability.

I prefer the notion of Modernity, which implies an ongoing project and takes into account history and memory. Art does not develop independently of criticism and it is up to us to define what form this Post-Modernism will take and whether it could still be an arena of resistance to 'common sense'.

Yes. Agnostic in the context of the high church of Modernism as defined by Clement Greenberg. To him the task of self-criticism in art 'became to eliminate from the effects of each art any and every effect that might conceivably be borrowed from or by the medium of art. Therefore each art could be rendered "pure" and in its "purity" find the guarantee of its standards of quality as well as of its independence.'[4] And agnostic in Charles Jencks's classification in his book *What is Post-Modernism?*[5] And definitely combative.

Again, referring to the same text, what constitutes a Post-Modernist photographic method?
If Post-Modernism is an incredulity towards 'metanarratives' or 'grand narratives', one strategy may be the use of irony or double coding or parody. Paralanguage rather than metalanguage, as Olivier Richon and John X. Berger put it in the introduction to their book *Other than Itself.*[6]

It is important that certain artistic methods, which are as much a writing, another cinema and another photography, should break down distinctions between theory and practice. There must be a possibility of constructing other stories, of 'telling stories without endings', to quote Laura Mulvey.[7]

Contemporaneity is defined by positions of resistance which cannot be taken for granted – by protean practices whose changing forms are determined

by the issues the work addresses, by its context and by the historical moment of its making.[8]

Photography and its History

Since your work has its element of social conscience – if not of social criticism – and since it also has an analytical and semiological dimension, is it legitimate to see in it references to historical kinds of photography too?

Yes, there is a documentary tradition which precedes my work, such as the work of Jacob A. Riis in the 1880s who set out to record the misery of the poor in the slums of the Lower East Side of New York. He was among the first in America to use flash powder, which enabled him to record in pitiless detail the squalor of the interiors and showed under what wretched conditions these poor immigrants lived. His most famous book was *How the Other Half Lives: Studies among the Tenements of New York* (1890). Also August Sander's systematic classification of the German people interested me in its emphasis on social position and class rather than on 'personality' or 'character' (*Faces of Our Time*, 1929). Walker Evans grouped his work in series and in his collaboration with the writer James Agee, *Let Us Now Praise Famous Men* (1941), photographs and text were considered 'equal, mutually independent and fully collaborative'. More recently Robert Frank, Diane Arbus and Bill Owens (*Suburbia*, 1972) all use the series as a form in which to get the message across. There is nothing original in my work and it wilfully quotes these precedents.

Perhaps where it differs is that it photographs environments which have not had as much exposure as the poor or the exotic in the social-documentary tradition. We can no longer naïvely believe in the objectivity of the document. What we can do is play upon the reality effect, which is part of photography's power. The 'Family of Man' approach to photography, which depicts all humans as being essentially the same, is problematic in that it naturalizes any cultural or sexual difference under what can today be called a 'colonizing gaze'.

Is it legitimate to say that you use different historical genres such as the 'still life', 'portrait', 'landscape' and 'tableau vivant'?

Yes. The *Belgravia* series and *Gentlemen* addressed the conventions implicit in portraiture by rejecting the personality cult linked to society portraiture and portraits of the great and famous, such as the work of Karsh and Arnold Newman. It is non-portraiture in that it eschews the proper name. These are 'portraits' which use images with text to refer to particular attitudes, which are classed as much as they are sexed. It is not the individual that is the focus, but rather the social group and its prejudices that are being parodied in a highly artificial way. For this reason the images attempt to show, through the *mise-en-scène*, a set of gestures in which a whole situation can be read. In a sense it is using a Brechtian strategy, i.e., the concept of social gesture or action. As Barthes puts it, 'Not every gesture is social; there is nothing social in the

movements a man makes in order to brush off a fly; but if this same man, poorly dressed, is struggling against guard dogs, the gesture becomes social'. The gesture would become social if an immaculately dressed man, wearing those garments proper to his station as a gentleman, brushed a fly off his suit as he entered a squalid interior. It is a matter of contextualizing certain 'poses' or gestures.

In *Country Life*, I proposed a 'criminology' of the upper classes in the manner of a detective who finds clues at the scene of the crime. In this sense the still life becomes not just an attractive arrangement of objects but a material indicator of an attitude, a life-style. The objects stand in (metaphorically) for something not directly shown but alluded to, the leisurely pursuits of the gentry.

Perhaps more appropriate here would be the notion of the emblem where the meaning emerges through the interplay of a title and an image. Yet there is also the landscape as a genre which appears. Nature in *Country Life* is a garden, cultural in the sense that everything is arranged in a series of picturesque vistas. I chose the garden as a place in order to emphasize that it is private property and holds certain intentions (which are not neutral or natural), be they political or personal commemoration.

Rather than *tableau vivant*, reference to the eighteenth-century conversation piece would be more appropriate. The three elements of greatest importance in a conversation piece are the environment or surroundings, the relationship between the people and between them and their surroundings, and the function that these elements define. In *Gentlemen* these three elements appear: a set of comparisons is being made between the people and their environment and between objects such as paintings. Conversation (from Latin *conversatio*) means living in a place with other people, which leads to association, talk and finally to familiar discourse. It was a genre used by painters such as Hogarth against the 'high art' of history painting on the one hand and idealized portraiture on the other.

Which kind of current photography interests you, and how do you see your work in this context?
All kinds of photography interest me: art, fashion, editorial, journalism. And not only photography. I am interested in 'cultural forms' which break down distinctions between 'high art' and 'low art', media images and 'fine art'. These forms may be literary, filmic or painterly, but have in common a critical project that defines itself according to its context, historical and institutional.

Current photography with its ethos of 'photography for photography's sake' I find limiting, as well as its technical obsessions. Photography can be a method of describing physical and behavioural phenomena. The question is how to find an appropriate visual form which can adequately comment on and describe contemporary money culture. I no longer see my work as addressing specific photographic concerns. I am increasingly drawn to pre-photographic traditions such as the emblem and the *vanitas* still life. At present I am researching seventeenth-century Dutch art. Its links with commerce and the merchant class I find particularly relevant concerning my choice of subject matter.

DECOLONISING
THE IMAGE

Lucy Lippard

Partial Recall

(Extracted from *Partial Recall*, Ed. Lucy Lippard, The New Press,
New York, 1992, pp. 13–33)

Historian and theoretician Lucy Lippard explores the debate which
surrounds the portraiture of Native American peoples. In Lippard's
book *Partial Recall*, this introductory text (from which an excerpt is
printed here) is followed by twelve essays by Native Americans in which
issues of history, memory and representation are explored.

Doubletake:
The Diary of a Relationship with an Image[1]

First Take

Sam[p]son Beaver and his Family. This lovely photograph of Stoney Indian
Sam[p]son Beaver was taken by Mary Schaffer in 1906. She was a writer,
naturalist, photographer and explorer who lived and worked in the Rockies
for many years. Mary Schaffer is one of several notable women who visited
the area early in the century and fell captive to the charm of the mountains.
 – Caption on contemporary postcard from Banff, Canada.

I AM SURPRISED by this photograph, which seems so unlike the conventional
images I've seen of Native people 'taken' by white people. It is simple
enough – a man and woman are smiling warmly at the photographer while
their little girl smirks proudly. The parents are seated comfortably on
the ground, the man with his legs crossed, the woman perhaps kneeling. The
child stands between them, closer to her father, holding a 'bouquet' of
leaves. Behind them are signs of early spring – a tree in leaf, others still
bare-branched.

I'm examining my deep attraction to this quiet little picture. I have been
mesmerized by these faces since the postcard was sent to me last month by a
friend, a Native Canadian painter and curator who found it in a taxidermy/
Indian shop (he was bemused by that conjunction). Or maybe I am mesmer-
ized by the three cultural spaces between the Beaver family and Mary Schaffer
and me.

They are not vast spaces, although we are separated at the moment
by a continent, national borders, and eighty-four years. They consist of the

Mary Sharples Schaffer Warren, *Sampson, Frances Louise, and Leah Beaver,* 1907. (Courtesy the Whyle Museum, Banff, British Columbia, Canada.)

then-present space of the subjects, the then-present, but perhaps very different, space of the photographer, and the now-present space of the writer in retrospect, as a surrogate for contemporary viewers. Or perhaps there are only two spaces: the relationship between photographer and subjects then, and between me/us and the photograph now. I wonder where these spaces converge. Maybe only on this page.

Good photography can *embody* what has been seen. As I scrutinize it, this photograph becomes the people photographed – not 'flat death,' as Roland Barthes would have it, but flat life. This one-way (and, admittedly, romantic) relationship is mediated by the presence/absence of Mary Schaffer, who haunts the threshold of the encounter. I am borrowing her space, that diminished space between her and the Beaver family. She has made a frontal (though not a confrontational) image, bringing her subjects visually to the foreground, into the area of potential intimacy. The effect is heightened by the photograph's remarkable contemporaneity, the crisp 'presentness' which delivers this image from the blatant anthropological distancing evident in most photographs of the period. The Beavers' relaxed poses and friendly, unselfconscious expressions might be those of a contemporary snapshot, except for the high quality of the print. At the same time, they have been freed from the 'ethnographic present' – that patronizing frame that freezes personal and social specifics into generalization, and is usually described from a neutral and anonymous third-person perspective. They are 'present' in part because of their undeniable personal

presence. A certain synchronism is suggested, the 'extended present' or 'eternal present' cited by N. Scott Momaday, among others.

What would happen to the West, Johannes Fabian has mused, 'if its temporal fortress were suddenly invaded by the Time of its Other'? [2] I think I've been invaded. I feel as though I know these people. Sampson Beaver and his wife seem more familiar than the stiff-backed, blank-faced pictures of my own great-grandparents, the two pairs who went west in the 1870s and 1880s, among those pushing their way into others' centers from the eastern margins of the continent. [3] Five years ago, while I was despairing of ever finding the structure for a book about the cross-cultural process, I dreamed I was climbing a vast grassy hill toward a weather-beaten wooden cabin at the top; on its steps sat three Native people, silently encouraging me to keep going. Although they were elderly, the expressions on their faces were those of the young Beaver family in this photograph.

As I begin, I'm also looking at this triple portrait cut loose from all knowledge of the people involved – an aspect that normally would have informed much of my own position. With only the postcard's caption to go on, my response is not neutral, but wholly subjective. I'm aware that writing about a white woman photographing Native people is a kind of metaphor for my own position as an Anglo critic trying to write about contemporary Native North American art. I'd rather be Mary Schaffer, a courageous woman in long skirts who seems to be trusted by this attractive couple and their sweetly sassy child. How did she find her way past the barriers of turn-of-the-century colonialism to receive these serene smiles? And I want to be Sampson Beaver and his (unnamed) wife, who are so at home where they are, who appear content, at least in this spring moment.

Second Take

I showed the picture and my 'diary' to a friend, who said she was convinced that the real relationship portrayed was between the photographer and the child, that the parents liked Schaffer because she had made friends with their little girl. Certainly the photograph implies a dialogue, an exchange, an I/eye (the photographer) and a *you* (her subjects) – and *we* the viewers, if the photographer would emerge from beneath her black cloth and turn to look back at us. At the same time, the invisible (unknowable) autobiographical component, the 'viewpoint' provided by the invisible photographer, 'writer, naturalist, . . . and explorer, who lived and worked in the Rockies for many years,' is another factor that shaped what is visible here. I have written to the Whyte Museum of the Canadian Rockies, in Banff, for information about her.

The cultural abyss that had to exist in 1906 between the Beaver family and Mary Schaffer was (though burdened by political circumstances and colonial conditioning) at least intellectually unselfconscious. It may have been further diminished by what I perceive (or project) as the friendly relationship between them. The time and cultural space that usually distances me – self-consciously but involuntarily – from historic representations of Another is also lessened

here. Schaffer's photograph lacks the rhetorical exposure of 'authenticity.' But the Beavers are not universalized into oblivion as 'just folks,' either. Their portrait is devoid of cuteness, and yet it has great charm. Despite the inevitable veneer of exoticism (a function of the passage of historical time and the interval implied by the dress of almost ninety years ago), it is only secondarily quaint. This is not, however, the Edward Curtis view of the Noble Savage, staring moodily into the misty past or facing the camera forced upon him or her with the wariness and hostility that has been co-opted by naming it 'dignity.'

It is now common to observe that one of the hegemonic devices of colonialism (postcolonialism is hardly free of it either) has been to isolate the Other in another time, a time that also becomes another place – The Past – even when the chronological time is the present. Like racism, this is a habit hard to kick even when it is recognized. Schaffer's photograph is a microcosmic triumph for social equality as expressed through representation. The discontinuity and disjunctiveness that usually characterize cross-cultural experience are translated here into a certain harmony – or the illusion thereof. This is a sympathetic photograph, but it is not, nor could it be, empathetic. (Is it possible to honestly perceive such a scene as idyllic within the dystopian social context?) The three figures, despite their smiles and amicable, knowing expressions, remain the objects of our gazes. We are simply lucky that this open, intelligent gaze has passed into history as alternative evidence of the encounter between Native and European, of the maintenance of some human interaction in the aftermath of genocide.

The Beavers' portrait seems a classic visualization of what anthropologists call 'intersubjective time.' It commemorates a reciprocal moment (rather than a cannibalistic one), where the emphasis is on interaction and communication; a moment in which subject and object are caught in exchange within shared time, rather than shouting across history from their respective peaks. The culturated distance between photographer and photographed, between white and Native, has somehow been momentarily bridged to such an extent that the bridge extends over time to me, to us, almost a century later.

This is the kind of photograph I have often used as an example of the difference between images taken by someone from within a community and by an 'outsider.' I would have put it in the former category. Yet it was not taken by a Stoney, but by an adventurous white lady passing through the northern Rockies, possibly on the quest for self (or loss of self) in relation to Other and Nature that has been a major theme in North American culture.

The Beaver family (I wish I knew the woman's and child's names) is clearly among friends, but the picture might still have been very different if taken by a Native insider. Of course we have no way of knowing what that image might have been. A press release from the American Indian Community House Gallery in New York in 1984 set out some distinctions between non-Indian and Indian photographers; among them: 'These photos are not the universal images of Indians. They are not heroic, noble, stoic, or romantic. What they do show is human warmth and an intimacy with their subject. . . .'[4] This is the feeling I get from the Beavers' portrait. Am I just kidding myself? Over-identifying with Mary Schaffer?

Another explanation for Native avoidance of photography raises old taboos – the 'photos-steal-your-spirit syndrome,' which is not, in fact, so far off. The more we know about representation, the more obvious it becomes that photography *is* often a spirit snatcher. I 'own' a postcard which permits me to 'have' the Beaver family in my house. The Oglala warrior Crazy Horse never allowed his photograph to be taken, and it was said of those Native leaders who did that 'they let their spirits be captured in a box' and lost the impetus to resist. Contemporary AIM leader Russell Means has described the introduction of writing into oral traditions as a destructive 'abstraction over the spoken relationship of a people.' As Dennis Grady observes, the camera was another weapon in the wars of domination:

> How fitting it must have seemed to the victims of that process – the natives of North America, whose idea of 'vision' is as spiritual as it is physical – when the white man produced from his baggage a box that had the power to transcribe the world onto a flat paper plane. Here was a machine that could make of this landscape a surface; of this territory, a map; of this man, this woman, this living child, a framed, hand-held, negotiable object to be looked at, traded, possessed; the perfect tool for the work of the 'wasi'chu,' the greedy one who takes the fat.[5]

Our communal 'memory' of Native people on this continent has been projected through the above-mentioned stoic (*numb* is more like it), wary, pained, resigned, belligerent, and occasionally pathetic faces 'shot' by nineteenth- and early twentieth-century photographers like Edward Curtis, Adam Clark Vroman, and Roland W. Reed – all men. Looking through a group of portraits of Indians from that period, I found one (*Indian with Feather Bonnet*, c. 1898) in which the expression was less grim, more eye-to-eye; the photographer was Gertrude Käsebier. The photographs by Kate Cory (a 'midwestern spinster' who came to Arizona at age forty-four), taken in the Hopi village where she lived for seven years, also diverge from the general pattern as do Nancy Wood's contemporary images of Taos Pueblo and some of Laura Gilpin's works. All of which suggests empathy as a factor in the relationship between race and gender lurking in this subject.

Of course Mary Schaffer, despite her gender, was at least indirectly allied with the oppressors. She may have been an 'innocent' vehicle of her class, her culture, and her times. She may have been a rebel and independent of some of its crueler manifestations. Less likely, she may have known about the then-new 'comparative method' of anthropological investigation, which was to permit the 'equal' treatment of all human culture in all times and in all places (though, of course, it failed to overturn the edifice of Otherness on which it was built). She may have been an enthusiastic perpetrator of expansionism.

Perhaps this photograph was already tinged with propaganda even at the time it was taken. Perhaps Mary Schaffer herself had an ax to grind. She may have been concerned to show her audience (and who were *they*?) that the only good Indian was not a dead Indian. Perhaps this portrait is the kind of 'advocacy image' we find in the production of leftist photographers working in

El Salvador. The knowledgeable, sympathetic tourist is not always immune to cultural imperialism. I wonder if Mary Schaffer, like so many progressive photographers working in poorer neighborhoods and countries, gave her subjects a print of this photograph. Was it their first, their only image of themselves? Or the first that had not disappeared with the photographer? Is a curling copy of this picture given a place of honor in some family photo album or on the wall of some descendent's home?

I'm overpersonalizing the depicted encounter. To offset my emotional attraction to this image, let me imagine that Schaffer was a flag-waving imperialist and try to read this image, or my responses to this image, in a mirror, as though I had taken an immediate dislike to it. Can I avoid that warm gaze and see in these three figures an illustration of all the colonial perfidy that provides its historical backdrop? Do Sampson Beaver and his family look helpless and victimized? They are handsome, healthy people, perhaps chosen to demonstrate that Indians were being 'treated well.' The family is seated on the ground, perhaps placed there because the photographer was influenced by stereotypical representations of the 'primitive's' closeness to the earth. The woman is placed at a small distance from her husband and child – like a servant? They are smiling; perhaps Schaffer has offered the child a treat, or the adults some favor. Still, it is hard to see these smiles as solely money-bought.

A virtual class system exists among the common representations of an Indian family from this period: the lost, miserable, huddled group outside a tipi, the businesslike document of a neutrally 'ordinary' family, or the proud, noble hold-outs in a grand landscape, highlighted by giant trees or dramatic mesas. For all the separations inherent in such images, there is no such thing as 'objectivity' or neutrality in portrait photography. Personal interaction of *some* kind is necessary to create the context within the larger frame of historical events. Even the Schaffer photo is 'posed.' And the pose is an imposition, since Native people had no traditional way of sitting for a portrait or a photograph; self-representation in that sense was not part of the cultures. But at least the Beaver family is not sitting bolt upright in wooden chairs; Sampson Beaver is not standing patriarchally with his hand on his wife's shoulder while the child is properly subdued below. Man and wife are comfortable and equal as they smile at the black box confronting them, and the little girl's expression is familiar to anyone who has spent time with little girls.

Today I received some scraps of information about the Stoney Indians, who were Assiniboine, offshoots of the Sioux. (The name is an anglicization based on the Ojibwa word *assine*, which means stone.) They called themselves Nakodah and arrived in the foothills of the Rockies in the eighteenth century, in flight from smallpox epidemics. With the advent of settlers and the founding of Banff, the Stoneys were forced into a life of relatively peaceful interaction with the townspeople. In the late nineteenth century, Banff was already a flourishing tourist town, boasting a spa and the annual 'Indian Days' powwow, begun in 1889. The Whyte Museum there has a massive archive of photographs of the Native people of the Rockies (including this one, and one of Ginger Rogers on vacation, sketching Chief Jacob Twoyoungman in a Plains headdress).

Eventually forced to live off of tourism, the Stoneys were exploited but not embattled. And Mary Schaffer, for all her credentials, was a tourist herself.

Last Take

The books ordered from Banff have finally arrived. I dove into them and of course had to revise some of my notions.

The Beaver family photograph was taken in 1907, not 1906; not in early spring, but in late September, as Schaffer was completing a four-month expedition to the sources of the Saskatchewan River. Having just crossed two turbulent rivers, she and her companions reached the 'Golden Kootenai Plains,' (the Katoonda, or Windy Plains) and, weaving in and out of yellowing poplars, they

> spied two tepees nestled deep among the trees. . . . I have seen not one but many of their camps and seldom or never have they failed to be artistic in their setting, and this one was no exception. Knowing they must be Silas Abraham's and Sampson Beaver's families, acquaintances of a year's standing, I could not resist a hurried call. The children spied us first, and tumbling head over heels, ran to cover like rabbits. . . . Above the din and excitement I called, 'Frances Louise!' She had been my little favorite when last we were among the Indians, accepting my advances with a sweet baby womanliness quite unlike the other children, for which I had rewarded her by presenting her with a doll I had constructed. . . . Love blinded the little mother's eyes to any imperfections, and the gift gave me a spot of my own in the memory of the forest baby. . . . In an instant her little face appeared at the tepee-flap, just as solemn, just as sweet, and just as dirty as ever.[6]

It was this group of Stoneys (members of the Wesley Band) who the previous year had given Schaffer her Indian name: Yahe-Weha, Mountain Woman. Banned from hunting in the National Parks, they were still able to hunt, trap, and live beyond their boundaries. In 1907 she remained with them for four days. Of this visit she wrote:

> When I hear those 'who know' speak of the sullen, stupid Indian, I wish they could have been on hand the afternoon the white squaws visited the red ones with their cameras. There were no men to disturb the peace, the women quickly caught our ideas, entered the spirit of the game, and with musical laughter and little giggles, allowed themselves to be hauled about and pushed and posed in a fashion to turn an artist green with envy. . . . Yahe-Weha might photograph to her heart's content. She had promised pictures the year before, she had kept the promise, and she might have as many photographs now as she wanted.[7]

Sampson Beaver's wife Leah was no doubt among the women that afternoon. He was thirty years old at the time, and she looks about the same age. In the latently desirous language of the tourist, Schaffer described him crouching to light his pipe at a campfire:

> . . . his swarthy face lighted up by the bright glow, his brass earnings and
> nail-studded belt catching the glare, with long black plaits of glossy hair
> and his blanket breeches. . . .[8]

It was Sampson Beaver who then gave Schaffer one of the great gifts of her
life – a map of how to reach the legendary Maligne Lake, which she had
hitherto sought unsuccessfully – thereby repaying his daughter's friend many
times over. He drew it from memory of a trip sixteen years earlier, in symbols
– 'mountains, streams, and passes all included.' In 1908 Schaffer, her friend
Mollie Adams, 'Chief' Warren (her young guide, whom she later married), and
'K' Unwin followed the accurate map and became the first white people to
document the shores of Chaba Imne (Beaver Lake), ungratefully renamed
Maligne for the dangerous river it feeds. In 1911 she returned to survey the lake
and its environs, which lie in what is now Jasper National Park.

Mary Sharples Schaffer Warren (1861–1939) was not a Canadian but a
Philadelphian, from a wealthy Quaker family. Her father was a businessman and
'gentleman farmer,' as well as an avid minerologist. She became an amateur
naturalist as a child and studied botany as a painter. In 1894 she married
Dr. Charles Schaffer, a respected, and much older, doctor whose passion was
botany and with whom she worked as an illustrator and photographer until his
death in 1903. After completing and publishing his *Alpine Flora of the Canadian
Rocky Mountains*, she conquered her fear of horses, bears, and the wilderness,
and began her lengthy exploring expeditions, going on horseback with pack
train deep into the then mostly uncharted territory for months at a time.

Schaffer's interest in Indians and the West had been awakened when, as a
small child, she overheard her cousin Jim, an army officer, telling her parents
about the destruction of an Indian village in which women and children were
massacred; afterwards he had found a live baby sheltered by the mother's dead
body.[9] This story made a profound impression on Mary, and she became
obsessed with Indians. In her mid-teens she took her first trip west, met Native
people for the first time, and became an inveterate traveler. The Canadian
Rockies were her husband's botanical turf, and for the rest of her life Schaffer
spent summers on the trails, photographing, writing, and exploring. She finally
moved to Banff, and died there.

When Schaffer and Mollie Adams decided to take their plunge into the
wilderness, it was unprecedented, and improper, for women to encroach on
this steadfastly male territory. As Schaffer recalled,

> . . . there are times when the horizon seems restricted, and we seemed to
> have reached that horizon, and the limit of all endurance – to sit with
> folded hands and listen calmly to the stories of the hills we so longed to
> see, the hills which had lured and beckoned us for years before this long
> list of men had ever set foot in the country. Our cups splashed over. We
> looked into each other's eyes and said: 'Why not! We can starve as well
> as they; the muskeg will be no softer for us than for them . . . the waters
> no deeper to swim, nor the bath colder if we fall in' – so – we planned a
> trip.[10]

These and many other hardships and exhilarations they did endure, loving almost every minute of it, and documenting their experiences with their (often ineptly hand-colored) photographs of giant peaks, vast rivers, glaciers, and fields of wildflowers. When they were returning from the 1907 expedition, they passed a stranger on the trail near Lake Louise who later described the incident:

> As we drove along the narrow hill road a piebald pack-pony with a china-blue eye came round a bend, followed by two women, black-haired, bare-headed, wearing beadwork squaw jackets and riding straddle. A string of pack-ponies trotted through the pines behind them.
> 'Indians on the move?' said I. 'How characteristic!'
> As the women jolted by, one of them very slightly turned her eyes and they were, past any doubt, the comprehending equal eyes of the civilized white woman which moved in that berry-brown face. . . .
> The same evening, in a hotel of all the luxuries, a slight woman in a very pretty evening frock was turning over photographs, and the eyes beneath the strictly arranged hair were the eyes of the woman in the beadwork who had quirted the piebald pack-pony past our buggy.[11]

The author of this colonial encounter was, ironically, Rudyard Kipling.

As Lévi-Strauss has pointed out, the notion of travel is thoroughly corrupted by power. Mary Schaffer, for all her love of the wilderness (which she constantly called her 'playground') was not free from the sense of power that came with being a prosperous 'modern' person at 'play' in the fields of the conquered. At the same time, she also expressed a very 'modern' sense of melancholy and loss as she watched the railroad (which she called a 'python') and ensuing 'civilization' inching its way into her beloved landscape. More than her photographs, her journals betray a colonial lens. She is condescendingly 'fond,' but not very respectful, of the 'savages' who are often her friends, bemoaning their unpleasantly crude and hard traditional life. In 1911, for instance, her party passed 'a Cree village where, when we tried to photograph the untidy spot, the inhabitants scuttled like rabbits to their holes.' In 1907, on the same Koontenai Plains where she took the Beavers' portrait, her camp was visited by 'old Paul Beaver,' presumably a relative of her darling Frances Louise. He eyed their simmering supper 'greedily,' but

> our provisions were reaching that point where it was dangerous to invite any guests, especially Indians, to a meal, so we downed all hospitable inclinations and without a qualm watched him ride away on his handsome buckskin just as darkness was falling.[12]

For all its socially enforced static quality, and for all I've read into it, Mary Schaffer's photograph of Sampson, Leah, and Frances Louise Beaver is 'merely' the image of an ephemeral moment. I am first and foremost touched by its peace and freshness. I can feel the ground and grass, warm and damp beneath the people sitting 'here' in an Indian summer after disaster had struck, but before almost all was lost. Despite years of critical analysis, seeing is still believing to some extent – as those who control the dominant culture (and

those who ban it from Native contexts) know all too well. In works like this one, some of the barriers are down, or invisible, and we have the illusion of seeing for ourselves, the way we never *would* see for ourselves, which is what communication is about.

Carole Naggar

The Unveiled: Algerian Women

(First published in *Aperture* 119, Summer 1990)

Existing fictions, histories and public testimonies to the Algerian War have run counter to a willed amnesia about shameful events in French history. Likewise, with Marc Garanger's portraits of Algerian women, published in the early '80s. These were coercive images, an aspect of the French military presence. Without knowledge of this context a viewer might hastily place them within the frame of Arab 'exotica' that has been constructed in the West as a visual tradition. They are, instead, instances of war photography, and, as Carole Naggar observes, have a repressive function similar to that of the camera's use against the Paris Commune. Naggar's piece appeared in a special 'Cultures in Transition' issue of *Aperture*.

What are you trying to pacify? The walls?

– A Muslim to a young draftee

VIRTUALLY FORGOTTEN today, the Algerian War (1954–1962) was for France somewhat like what the Vietnam War was for the United States: a painful era, woven with errors and official denial, unconsciously repressed so that even today, French people find it difficult to confront directly. In 1960, when Marc Garanger, a twenty-five-year-old draftee, started taking photographs, it had been lingering for six years. For two years before, it had been on the front page of all the French dailies, at the heart of all conversations. France was split into two factions that drifted further apart every day. On one side, the supporters of *Algérie française*; on the other, a growing part of French youth, and intellectuals such as Jean-Paul Sartre, Simone de Beauvoir, and Francis Jeanson, a founder of a support network for the National Liberation Front (FLN), *Jeune Resistance*. In February 1960, several members of the network were arrested, and Jeanson, wanted by the police, held a clandestine press conference: 'We must break the cycle of the abominable complicity that has allowed forty-five million French people to

accept the slaughter and torture, through intermediaries, of ten million Algerians.'

The Algerian War has scarcely been documented in France. One could even describe the French response to the war as one of collective amnesia, so rare have testimonies about it been, at least until the last few years. Garanger's two books (*Femmes Algériennes*, 1982, and *La Guerre d'Algérie*, 1983) are notable exceptions to this willful forgetting. In fact, Garanger is to date the only photographer to have published even a single monograph on the war.

In 1960, Garanger landed in Kabylia, in the small village of Ain Terzine, about seventy-five miles south of Algiers. Like many politically conscious young men, he had put off his departure for the army as long as possible, hoping that the war would come to an end before he would have to go. In a recent interview he recalled this time: 'War was a heartbreak, photography a mode of survival. My life had already started: I left a wife and a daughter behind me.' Though a primary school teacher by training, Garanger had been photographing professionally since 1950. When he went into the Army he was soon selected as his regiment's photographer.

But while French opinion progressively evolved towards the acceptance of Algerian independence, the French army, already frustrated by its defeat in Indochina, could resign itself to losing face and leaving. At stake for the army was a symbolic victory: the crusade of the free world against international Communism, French Algeria being to them the last remnant of France's past grandeur.

By then the war was almost over. At the head of the army, General Maurice Challes attacked the center of FLN support. Perched in the mountains like eagles' nests, the villages were occupied by approximately two million people who had joined the FLN since 1954. To deprive the rebels of their contacts with the village people, Challes decided to transfer the population. Says Garanger: 'The French army had adopted "pacification" as a strategy: they demolished the farms and isolated villages, they knocked down everything, they pulled down the roofs.' Once the houses had been leveled, the civilian population was forced to build their own 'regroupment villages' around the military outposts. 'They were concentration camps really,' Garanger recalls, 'encircled with barbed wire, closed at night, and supervised from observation posts.' This brings to mind similar operations described by Philip Jones Griffiths in his 1971 book on the Vietnam War, *Vietnam, Inc.*

At certain hours it was possible to go out of the camp. Garanger always went around to the same five or six villages where he had met the local civilians: 'They were the only ones who interested me: how could they survive under the conditions that they had been given? It was to survive and to express my disagreement that I took photographs.

'One day the camp major decreed that the inhabitants of the villages must all have identity cards. Naturally, he asked the military photographer to make these cards. Either I refused and went to prison, or I accepted. I understood my luck: it was to be a witness, to make pictures of what I saw that mirrored my opposition to the war. I saw that I could use what I was forced to do, and have the pictures tell the opposite of what the authorities wanted them to tell.

'Berber or Muslim, the women came from the neighboring villages: Ain Terzine, Bordj Okhriss, the Mezdour, the Meghine, Souk el Kremis. They had had no contact with Europeans whatsoever. People who live there are half-nomadic shepherds. The climate in those parts is very hot and dry in the daytime, cold at night, with snow in winter. The people have a very hard life; it shows in their faces.

'When I arrived for the sittings, there would be a detachment of armed men with machine guns across their shoulders, an interpreter, and the commander. The women would be lining up. Each in turn would sit on a stool outdoors, in front of the whitewashed wall of the house – the *mechta*. I would come to within three feet of them. They would be unveiled. In a period of ten days, I made two thousand portraits, two hundred a day, mostly of women. They were from fourteen years old to no age. They had no choice in the matter. Their only way of protesting was through their look.

'It is this immediate look that matters. When one discharges a condenser, a spark comes out: to me, photography involves seizing just that instant of discharge. In these sessions I felt a completely crazy emotion. It was an overwhelming experience, with lightning in each image. I held up for the world a mirror, which reflected this lightning look that the women cast at me.

'Only one woman refused to sit down. She shouted insults at all the French who were there. She was a very old woman. The officer asked the interpreter: "What did she say?" He covered for her: "Don't worry, she's nuts." This was the only time I ever saw the women. My photographs were used for the identity cards for a year and a half.'

At one point Garanger's major 'started screaming, stirred up the staff: "Come and see these macaques, they look like monkeys!" ' Their identity defied him completely – or else he would not have used Garanger's pictures. But 'even the stupidity of officers has limits,' says Garanger, who also recalls how one colonel had asked him to photograph Bencherif, an FLN leader, after he had been arrested. This photo was to be printed on the back of flyers that were to be dropped by parachute in a French campaign to bring the FLN into disrepute with the Algerian population. But Bencherif's dignity when handcuffed, the defiance of his look, would not have helped the colonel's scheme. He knew this, and as a result the flyer was printed and distributed without a picture.

The major's perspective on the portraits was obscene, a kind of rape. This rape was not the first that the Algerian women had to suffer: the first rape was the unveiling itself. The veil – in Arabic *hijab*, 'what separates two things' – has complex meanings in Islam. Al Hallaj, a commentator on the Koran, writes that it is 'a screen interposed between the searcher and his aim, the probationer and his desire, the archer and his target. . . . It is not God that wears a veil, but His creatures. God has clothed the creatures with the veil of their name' because 'if He were to uncover reality for them, they would die.' God's face itself is said to be veiled by 'seventy thousand curtains of light and darkness.' To the woman, a symbol of divine beauty in Islamic poetry, one does not talk except through a veil.

In the Western world, a veil is only for hiding; in North Africa and the Middle East, men are used to deciphering the face of a veiled woman through her veil. Where a Westerner would see only a sketch, Arabs can guess the minutest details of a face and can say honestly of a veiled woman who passed in the street how beautiful she was. For an Algerian woman, the veil is inseparable from the face. It may be taken off within the secrecy of the walls, among women or between husband and wife, but never publicly in front of a stranger, particularly if he is an infidel. The veil is like a second skin, and the unveiling does more than lay the face bare: it flays it. The humiliation of having one's face uncovered is to an Algerian woman as great as imposed nudity would be for a prisoner in a concentration camp. On that level Garanger's portraits symbolize the collision of two civilizations, Islamic and Western.

There is another rape in this confrontation, and it is photography's. In Islam, representation is forbidden. A portrait is *hasuma*, shameful. For these women only their husbands, their siblings, their children, their friends and the woman who tattooed the blue marks against the evil eye on their chin, nose, and forehead, had known their face before. But in front of Garanger's camera all at once the taboo is destroyed. The veil is pulled down on their shoulders. Under their black, heavy, dishevelled hair, here are their feverish cheeks, the fire of their insulted gaze. The protective tattoos are exposed. Maybe as a challenge, the women wear their best ceremonial dress, their silver jewelry. The white wall they stand in front of, guarded by a soldier, is a kind of execution wall, the camera a weapon through which a murder is performed: exposing them to everyone's look, stealing from them their freedom that was linked to secrecy.

Pushed from behind, they enter the twentieth century in its most frightening aspect: they are identified so they can be controlled, supervised, repressed. This was also the case in 1848 when Eugène Appert, in Versailles prison, made hundreds of portraits of Communards that were then put into the file of the military police, or when Alphonse Bertillon invented his descriptive files (front and profile) in 1887 for the archive of the Service of Judicial Identity. Out of these early examples grew the idea that a photographic record of the identities of a complete population might be useful. In October 1940 the Vichy regime finally carried out this idea, making everybody submit to a control that until then had been applied only to 'dangerous minorities.'

Looking at Garanger's photographs we may think of this history of identity photographs and especially of those identity cards on which in 1942 the word 'Jewish' was imposed. Thus the portraits become an image of a more general suffering. Behind them I also see in a watermark all the violence of the Algerian War: beatings, tortures, imprisonments, humiliations.

So why is it that, being victims, the Algerian women do not appear to be such? It seems to me that, paradoxically, a space of freedom is enacted in these portraits. They are the contrary of what has been called 'modern' in photography: although they were taken in an instant, they are not snapshots. The models are fully conscious. The Algerian women, never photographed before and probably never to be photographed again, recall in the stiffness of their pose

and the intensity of their look the beginnings of photography. So upsetting are these portraits that we think of the first daguerreotypes: some viewers, thinking that the images could return their gaze, were afraid of these minuscule faces. But, where the sitters in daguerreotypes had a strong desire to be photographed, what we read here is a refusal. Saying no, the women seem to add: 'Even if you have photographed us, we remain uncontrollable.'

A few months later, in December of 1960, the U.N. declared the right of the Algerians to independence. In March 1962 this right became a fact. What happened to the identity cards? Says Garanger, 'I had the list of the women's names [but lost it]. As for the identity cards, they must have been torn up when independence arrived.'

In the twentieth century the image of war has changed drastically, becoming at once broader and more precise. Since the Spanish Civil War, photographs have shown us not only armies confronting each other, but the wider repercussions of broader, more diffuse conflicts: lines of refugees, prisoners in camps, hungry children, torture. Modern war is documented as much by suggested violence as by violence seen directly. An example of this is a photograph made by Shomei Tomatsu, in Hiroshima, of a beer can that the atomic explosion has bent and squashed into an unrecognizable form, like a flayed body by Chaim Soutine. Similarly, Garanger's pictures, of civilians rather than soldiers, depicting psychological rather than physical violence, tell us more about the Algerian War than photos of torture or lynching would.

Looking like the landscapes of Little Kabylia, of smooth or furrowed sand, the women's faces tell us about the difficulties of their lives, but they also tell us that they will not yield. Their angry look is the 'evil eye' that they cast to protect themselves and to curse their enemies. These defiant looks tell us of France's coming defeat and shame. Though we do not know the names or ages of these women, these glaring gazes alone guarantee their real identities. We are as if tattooed by them, and the burn persists.

Judith Mara Gutman

Through Indian Eyes

(First published in *Aperture*, 88, 1982)

Since the Renaissance Western cultures have universalised the rules of
monocular perspective, assuming depth and distance in the image as the
natural product of vision. The camera was to inherit this optic. But
'points of view' are the product of culture and history. Judith Mara
Gutman investigates how other, non-Western, ways of seeing have
affected photography despite this dominance.

EIGHTY-EIGHT-YEAR-OLD P. J. Cherian, a Saint Thomas Christian and a
photographer in Cochin, sat royally. He held his chin aloft, grasped his
black umbrella with interlaced fingers and steadied it between his legs.
We were looking at some one-hundred-year-old photographs I had brought
with me to Cochin, in southwest India. Mr. Cherian edged closer, especially
interested because fire had wiped out his studio's old photographs five years
before, and because many of the ones I had brought were of an area just north
and east of where we sat, the western edge of the great Hyderabad state.
Suddenly he stopped, stroked his pointed beard and smiled. 'You know who
that is?' he asked. I was puzzled. I had thought we were looking at the same
photograph, but I did not see anyone. 'The man on the left,' he continued,
either ignoring my silence or bypassing it gracefully, 'is Salar Jung II, Laiq-Ali
Khan, and the one to the right is Munir ul-Mulik II, son of Salar Jung I and half
brother of Salar Jung II.' And then he relaxed back in his chair.

I did not see those brothers. And as much as I have looked at this picture
since, I could never describe it as a picture of two people. It's mainly of a
building, of a building that preempts so much of the picture plane that it
virtually wipes out the sky.

In the portrait of the two half brothers I got lost in a mixture of perpen-
diculars and horizontals. The more I looked at the picture, the more I noticed
my attention slipping below a horizon line. For Western standards the horizon
line signals a center of gravity, a point of stability. But here, even a contempor-
ary Westerner, proud of a post-Picasso capacity for sophisticated perception,
feels uncomfortable. Most of us in the West, and most Indians today, assume
that three-dimensionality is, and always has been, a partner-in-arms to photo-
graphy, that the camera's natural, automatic, inclination is to see into the
distance. Yet here was a photograph in which the space was so flattened, and
the picture plane so 'disorganized,' that even the subjects of it could not be
identified.

The camera arrived in Calcutta in 1840, just seven months after Louis-

Jacques-Mandé Daguerre publically unveiled it to the world in Paris in 1839. By the 1860s when equipment was generally available in all of the Western world's major cities it was also available in Bombay and Calcutta, the two nineteenth-century Indian ports that carried on India's traditional role as merchant to the world. These cities helped turn India into the 'jewel' of the British Crown, symbol of Britain's control of the world's trade. Glass, for instance, from Chance, a manufacturer in England, the 'best' glass available for camera lenses and glass plates, according to an 1861 article in *Photographic Notes*, one of the respected journals during photography's early days, could be bought in both Bombay and Calcutta. There was even competition between the cities; glass was half the price in Calcutta that it was in Bombay in 1862. Clearly, Indian photographers had caught the same fever as others around the world and even used the same equipment. But, in using it, they produced a different imagery; different, at least, to Western eyes; the patterns and compositions of Indian photographs had been part of Indian painting for centuries.

Mario Bussagli writes, in *Indian Miniatures*, that a painting was commonly seen from 'two different points of view,' and Stuart Cary Welch, curator of Islamic Art at The Metropolitan Museum of Art describes, in *Room for Wonder*, how 'façades and walls . . . are seen head on . . . while the gardens, courtyards, and watercourses are shown as though viewed by a flying bird'. This dual use of the picture plane describes exactly what was going on in the photograph of the two half brothers. A low-level aerial perspective was used for a pool of water in the foreground, while the building was seen head on.

Hundreds of photographs like the portrait of the two half brothers exist all over India, and in most of them 'gigantic' or 'ugly' foreground features, forbidden by such nineteenth-century Western journals as the *Practical Photographer*, loomed. Sometimes a tree, sometimes a person blocked the path between viewer and subject. In the West most of us have laughed at photographs like these, thinking of them as 'mistakes,' recalling an occasion when the photographer stood there, waving a person from the foreground, trying to get him out of the way so he could keep the path between himself and the subject smooth and open.

In 1876, Mr. Girish Chandra De, a photographer in Banares, took a photograph of this kind of the Maharaja of Banares with Prince Albert, when Albert visited the subcontinent. Spirals of hookahs inch their way across the foreground, blocking the view. Today, we can appreciate the eccentricity of the image: with the hookahs upstaging the dignitaries, the photograph offers the right kind of irreverence, even a flicker of rebelliousness. Some contemporary photographers have even composed photographs accentuating the offbeat character of such foreground features by permitting or forcing the feature to move, thus blurring it.

Pictures like these, though, ruffled nineteenth-century Western, especially Victorian, propriety – in India and out. Seeing the British prince so intimately connected with smoking, which meant opium smoking – that nagging intrusion into Victorian illusions of a well-ordered society – was abhorrent. Moreover, the photograph's structure, the offbeat structure that is so appealing today,

offended Victorian aesthetics. Lost in the hookah's whirls, the prince could not be reached through accepted routes and standard patterns. When British judges looked at photographs submitted for an annual competition in 1871 at Poona, ninety miles from Bombay, they raved about the beautiful photographs that British colonial photographer Samuel Bourne and his partner Shepherd submitted. Disheartened, the judges turned from the unfortunate photographs by the 'native photographers,' disappointed that the Indians seemed not to have learned this new craft of photography 'properly,' even though the colonial administration had opened departments for teaching it in the Bombay and Madras Schools of Art.

The eye should be 'gracefully' led through a photograph, the *Indian Journal of Photography* said in 1886. It should not have to radically scale a building, be plummeted down steps or jump through steep hollows and then turn around to get to the point of a picture. 'Rounded lines' were preferred; the photographer would do well to 'avoid angularity.' 'Verandah posts and rails' the article went on, 'making themselves obtrusive' were 'confusing.' Photographers should carefully select objects, it warned, so they were 'agreeably disposed.' This spirit was tantamount to a kind of social responsibility; it reinforced the belief that the photographer was a guide, steering viewers through reality. All of these stipulations had one objective: to focus attention on the main 'subject' of the photograph. In nineteenth-century photographs made by Westerners, velvet textures, made rich by mellowed light, surround a central figure, isolating it in Edwardian splendor. Whether the central object is a person, church, or castle, it stands apart.

The Indian photographers, journalists, palace retainers and workers, stall keepers in bazaars, and household secretaries (those ubiquitous managers of property of former Maharajas) I met all seemed to know this, as if it was collective knowledge. Time after time when I told them that it looked as if Indian and European photographers used the camera differently, they would say, 'Oh, you mean . . . the Europeans photographed one thing.' A man in Trivandrum, the city near the southern-most tip of the subcontinent, which literally oversees the crossflow of the Arabian Sea and Bay of Bengal, sat on a high rock as we talked. He pointed to a small stone about twenty feet ahead of us. Smoothing down the scrub and pebbles in front of us and tapping the air as if to reach the one small stone, he called, 'Out there. They photographed one thing and everything went to that one object.' But more than just focusing their cameras at 'one thing,' Western photographers organized the picture field so the viewer would travel through a picture's elements until coming to rest at a central object.

By the end of the century, picture organization had become more complex. As the *Practical Photographer* said in 1893, the central figure had to be 'poised in such a way as to secure the greater variety of gliding and undulating lines.' The *Practical Photographer* even suggested that a person's 'warts' and 'ugliness' be included. Did not Rembrandt, it reminded its readers, produce magnificent portraits because he incorporated these conflicting elements? John Ruskin, spokesman for Britain's critical thinking in the arts by the end of the

century, even suggested a model approach for incorporating conflict into a
work of art. 'Straight and rigid lines' should be admitted to the building of
architectural monuments, he said in *The Stones of Venice*. They could send the
eye into magnificent entreaties with Magnificence Itself. Was that not one of
Gothicism's great virtues? 'But,' he warned, 'there is error in excess . . . those
lines must be fused to moderating influences.' Complexity of person and image
should exist, but should be properly balanced. Complexity and conflict should
only challenge a central figure, not drown it out.

Warts and ugliness may have been Victorianism's contribution to photo-
graphic thinking, just as a more complex photographic composition may have
become a metaphor for nineteenth-century British society. Britain's booming
new middle classes only entered the fringes of established power – as adminis-
trators in India, for example, and not as overseers of established enclaves in
London. Ruskin called for *moderating* influences, and, in much the same spirit,
Victorianism admitted some of Britain's screaming new voices, but contained
them. It was as if Victorianism evolved into Edwardianism by allowing disrupt-
ive elements to play in the foreground, rise to excessive and rich heights at the
edges, and then slip into the quiet passages circling around the central figure.
By the end of the century, Thomas Carlyle, a weathervane of critical
nineteenth-century British thought, appealed for greater central control in
Britain. Meanwhile, in one of the world's greatest acts of empire, Queen
Victoria became Empress of India in 1876, rising with character, complexity,
and conscience to the helm of Britain's farthest-flung, most successful point of
dominion. Elevated by excited contradictory passages smoothed into a velvet
glow, she now stood at the crossroads of the world. Challenges, disruptions,
conflicts, and complexities were magnificent because they heightened the
role and place of the central figure – in reality, as in photographic imagery. But
it had nothing to do with the order that had organized Indian visual repre-
sentation for centuries.

Pictures appear all over India. The bazaars are filled with them. Faces from
movie posters peer out across the great squares, as mightily as they sweep into
tight narrow streets. In the South movie posters are rolled along on what are
essentially roller skates. Also in the South and even in South Indian sections of
major northern cities, the mother or oldest daughter of a family paints or chalks
a fresh lively decoration in front of the house every day. The practice is still
maintained even in the most sophisticated families.

When photography came to India, its realistic representation did not
supplant old notions; it worked with them. While Western photographers left
their images in untouched or lightly tinted state, Indian photographers incor-
porated photographs as part of painted images, so that it is sometimes difficult
to tell what is photographed and what is painted. The real and earthly nature of
an image through photography enhanced the painted, conceptualized notion of
how a person should look: a priest could be both saintly and earthly. Both
qualities were important for his image, and painted photographs, rather than
unpainted ones, communicated 'likeness' and 'ofness' in Indian culture. The
combination encompasses a much broader range of territory than any separate

painting or photograph does. The photographed eyes in a portrait stare intently, while the painted interior creates a soft, sublime quality. In making a photograph an integral part of the image, the painter more effectively conveyed the earthly part of the conceptualization.

Yet, even as painted photographs seem to be the most direct interpretation of ideas on the one hand, they seem to lurk at least partly in the unconscious on the other. For example, in an image of a painted musician, the chair is a recognizable tangible object, but, for all the support it gives in the image it could just as well not be there. The musician floats in space. He's person and personage, fact and symbol. People float in Indian paintings, and many photographic patterns grew out of painters' longstanding conventions. Still, it is startling to see a photographed image that incorporates tangible reality gain power and character through an artificial device – not through its photographed reality. Seeing a person suspended in undefined space at the same time defined space is left 'unused' deepens the image's impact on the subconscious.

What I recognized in the painted photographs was an incomprehensible tension. A whole range of what I can only call 'incomprehensible' *shikar* photographs taken in Kashmir in the 1880s reverberate with that tension. The *shikar* was originally a hunt for elephants, in which elephants transported hundreds of bearers, shots, and nobles into the jungles. Capturing an elephant was a way of capturing a magnificent range of power, a power that seemed incomprehensible to the Western mind. It was a symbolic triumph.

When Vishinath, an old *shikari* and photographer from Kashmir, photographed animals after a hunt in 1905, he gave them a range of human and animal characteristics that enhanced the symbolism of both. One deer looks up from its carcass, draped and adorned. In another photograph, a young bearer lies down next to a tiger. In another, hunters back up against the year's catch on a trophy room wall in such flattened space that the live huntsmen merge with the dead trophies, contrasting with a range of live animals in front. Thus the picture is composed of live people, live animals, and dead animals, all meshed into a compressed, flattened space. As if all that weren't enough, a *photograph* of a live animal is pasted onto that down-front scene. The dividing line between life and death.

Fragments of what we call the unconscious in the West were never relegated to the *un*conscious in India. They were part of the conscious, part of normal, daily life, ordinary in the ways we in the West think of tangible reality as ordinary. The death of a person was not really his death, as we in the West think of it, but another stage in his life. Terminology reflects this, as when Indians refer to the dead as 'expired' – only a person's physical presence has ceased. It is as if Surrealism was always a superfluous concept in India, as if an Indian understanding of reality in the nineteenth century included Surrealism – what we in the West had to devise in the twentieth century.

Unlike Western photographs, nineteenth-century Indian photographs permit people to possess seemingly opposite characteristics, such as rebelliousness and submissiveness. The camera penetrated what a nineteenth-century

European sensibility considered a 'wall' and called private. It was as if there were no privacy, as if the secret corners of a person or a setting were as exposed as the available, obvious, and identifiable areas. Facets of a setting that a European would have downplayed are here elevated.

In 1891 the Maharaja of Jodhpur ordered a Census of Occupations, a document with approximately seventy photographs. The exotic volume was produced in a handblocked Hindi text, the photographs pasted next to the appropriate description. In close-ups the photographer flattened the space, making each area of interest in the picture field equally important. In one photograph of a dung-cake seller, the texture of his dung cakes (which look like pancakes and are used for fuel) gives a rich sensual look. At the same time, his eyes are penetrating and his robes and clothes take on a luxurious look as if they were silk. In another, the languid arms and legs of each of many shepherds face in different directions, forming a composition with several separate pockets of interest – so contrary to the rhythm that lyrically and smoothly connects the different parts of a Western image. It's as if the eye outside the picture – our eye – could be thought of as a series of microscopes, with each 'microscope' exposing and enlarging each individual unit in the photograph.

By exposing the utterly *un*conscious part of a life as clearly and unequivocably as they exposed the tangible part, Indian photographers produced a rarity: the first known photographic documents to have recorded systematically the life of ordinary people.

Indian photographers worked all over the subcontinent, in cities, bazaars, courts. By 1870, there were photographers in Bombay, Calcutta, and in Madras. The courts in Travancore, Tripura, and Jaipur all hosted departments of photography. In Tripura, the Maharani as well as the Maharaja photographed, and Tripura developed unique procedures for using cyanotypes, 'blue' photographs printed on blueprint paper that were popular all over the world from about 1890 to 1905. At the turn of the century, many Indian photographers called themselves 'State' or 'Royal' Photographic Companies. ('Royal,' of course, referred to the immediate Maharaja and not to the British throne.) The state and royal houses were often the new incarnations of court painters, and they became the most successful carriers of this Indian vision, producing the most varied examples of this vision.

But the vision itself was probably kept alive by the bazaar photographers, by the people who instinctively picked up the camera, or learned directly from their fathers and grandfathers. Still untouched by Western standards today, these photographers do just what they have always done. In fact, they probably play a crucial role in keeping the vision alive, in the way that press photography acts as a catalyst for photographic imagery in the United States.

A bazaar photographer in Hyderabad today still has a Dentist/Photographer sign up, and probably still operates as both. A photographer in Jaipur who stands along with a dozen other photographers in front of Jaipur's Wind Palace (once a palace and now a government building) and photographs with a nineteenth-century wet-plate camera is probably the grandson of a bazaar photographer, as are most of the others. When Ram Singh, the Maharaja of

Jaipur in the 1860s and 1870s, kept a department of photography in his court, this contemporary photographer's grandfather set up his camera in the garden outside the palace, he was one of dozens who similarly tried to attract Sunday strollers. The Maharaja himself seemed to have used Western sensibilities in taking photographs, while the grandfather of this photographer carried on with an Indian sensibility, just as his grandson does today. He poses his subjects with a nineteenth-century understanding of reality, trying to make the image vacant of feeling so he can pose it according to old principles, just as his grandfather did with the same camera. And he reaches down a long black sleeve under the camera's hood, developing the image on glass before making a paper negative and print.

What became increasingly clear to me as I studied Indian photographs and Indian photographers was that the 'peculiar' Indian way of making photographs derived from an Indian way of seeing life. Most perspectival depiction results from an individual composing the scene, looking in from outside. Developed during the Renaissance, this concept of the individual naturally emphasizes *his* physical vision; where and what he saw. Perspectival views and vanishing points derived from this fusion of individual physical vision joined to cultural aims. Indian photographs generally do not have vanishing points, and, even if there is a perspectival dip or an exaggerated perspective, it is usually linked to a second plane of flatness. Life does not slip away to the distant future for the Indian photographers. Indian image makers do not need vanishing points. The Indian photographer saw a scene as if he were cloaked in the robes of society, as if he were roaming over a range of 'vantage points' outside the picture, which resulted in a multifocused picture. It is as if a multiple-headed photographer, representing society, took the photograph.

In Cochin, Mr. Cherian sat for hours with that umbrella between his legs, as if he were creating an image of himself for his own mind. Apprenticed to Ravi Verma, a South Indian painter who introduced modeling and chiarascuro techniques to Indian painting, Mr. Cherian carried some of those techniques over into painting of photographs. Many of the images he has turned out are so charcoaled and so developed into another kind of imagery that they are barely recognizable as photographs. As I looked at him, I saw that his fingers gripped his umbrella much as warriors had gripped their swords, especially in sculpture. He had transposed a symbol of mastery into his mastery of the camera, and now sat in his old age, transposing it into the handiest tool at hand, his umbrella. When it seemed that we had covered as much ground as possible, Mr. Cherian proudly turned to me and said, 'You know, I developed a special plate with the Dahlmeyer Company in Bombay. Who needs all that space? All that space on the bottom of the picture and all that space on top? All that empty space?'

I knew the Westerner's answer, of course. Samuel Bourne needed it. He needed it for guiding viewers through agreeable passages, created out of the same Nilgiri Hills that Cherian and Doroswamy, his partner, crossed back and forth. Johnston and Hoffman needed it for leading viewers into satisfactorily cool lyrical looks at the 'native types,' the same 'natives' so exposed by the Indian photographers in the 1891 Census.

Mr. Cherian did not need it. He did not even call it foreground. It was the bottom, and it was the top. 'It's all wasted,' he said and proudly went on to tell me how he had developed two 5 × 12 inch plates from the standard 10 × 12 inch plate and two 6 × 15 inch plates from the larger 12 × 15 inch plate, both having been standard equipment throughout India. The smaller 5 × 12 inch was called the 'Royal Standard' after his studio, the larger called the 'Royal Deluxe.'

So when his son, manager of the Royal today, takes a photograph of this year's graduating class, the faces of the people reach right out to the edges, no wasted space beneath their feet, no empty space above their heads.

Coco Fusco

Essential Differences, Photographs of Mexican Women

(First published in *Afterimage*, April 1991)

What do we understand by 'otherness', within the context of multi-culturalism? Coco Fusco argues that a stress on difference through Euro-American eyes, however benevolent, can lead to oversimplifications. Cultural homogeneity can be too easily taken for granted. In answer to such assumptions, Fusco looks at the complex discourses employed in the work of some Mexican photographers.

The place of otherness is fixed in the west as a subversion of western metaphysics and is finally appropriated by the west as its limit-text, anti-west.

– Homi K. Bhabha, 'The Other Question'[1]

AFTER A DECADE of multicultural debates, the gap between 'the other' and its many potential referents still constitutes an arena of semiotic confusion. Now that consciousness of cultural specificity has been somewhat institutionalized within art criticism, elision of 'the others' has given way not to immediate understanding but to the myriad difficulties of reception and contextualization. In exhibitions, conferences, and writings that address issues of cultural and ethnic difference, artists and their work are often grouped together in ways that presume the interchangeability of their 'differences' of race, class, culture, and media. What is an apparently benevolent gesture of paying attention, for example, to women of color often carries within it a

reductive equation of distinct aesthetic sensibilities, making it seem as if cultural and ethnic difference from a white, Euro-American norm were the determining factor of any work positioned outside that framework.

If we take the implications of recognizing difference seriously, then we must understand that the designation of and even the very concern with otherness are culturally relative. Still, within the art world a strong impulse persists to erase the distance between an artist's representation of his or her own cultural identity and a self-conscious aesthetic inquiry into the social and psychological construction of difference from a dominant culture. The multicultural paradigm as we now know it demands that its 'others' (which include most of the world) conform to recognizable standards of 'difference' that rarely question the power relations that define those distinctions. To my mind this constitutes multiculturalism's most fundamental flaw.

Nonetheless, not even the power of this Western cultural imperative to designate the cultural other as its antithesis can transform reality into convenient dualisms. The gap that continues to exist between the fixed theoretical paradigm (Western self/non-Western other, etc.) and the contradictory and categorically distinct cultural terrains to which it is applied bears comparison to what Homi K. Bhabha has called, in reference to colonial discourse, the 'syntax of deferral.' He writes of the 'slippage between the Western sign and its colonial significance which emerges as a map of misreading that embarrasses the righteousness of recordation and its certainty of good government.'[2] In art-historical discourse this could be transliterated as follows: the slippage between the Euro-American designation of 'difference' and its signification in 'other' contexts opens a space for misreading that defies any attempt to maintain the legitimacy of the mainstream terminology.

As important as recognizing the contextuality of cultural and ethnic difference is a critical awareness of the very concept's contextuality. It is Euro-American postmodernism's stress on difference together with the growth of racial and ethnic 'minorities' in these parts of the world that have propelled the question of 'the other' to the forefront of first-world cultural debates. But the contemporary demographics and colonial histories of the northern and southern halves of the Americas have contributed to radically distinct interpretations of 'otherness.' In Mexico, for example, the term 'the other' conjures a different set of signifieds. It refers not so much to the third-world 'foreigner-outsider' as to the indigenous peoples that existed there prior to the Conquest and the cultures that form the symbolic foundation of contemporary national identity. The term also refers to the external Other – i.e., Mexico's northern neighbor – a construct that 'legitimates' the myth of Mexican cultural homogeneity that has been levied throughout the twentieth century as a defense against the invasion of American consumer and entertainment culture. The Mexican dynamic, then, between cultural difference and national identity diverges widely from that of North America.

In raising these problems, I do not mean to suggest that Mexican artists working outside the geographic boundaries of Europe and North America operate without any awareness of Euro-American concerns. Dependency on

'foreign' legitimation and markets in the visual arts has had a profound effect on Mexican cultural production of the last decade. Many artists, recognizing the appeal of 'difference,' have perfected an aesthetic practice of recycling recognizable Mexican signs for export. In a humorous critique of this phenomenon the Proceso Pentagono collective held a performance/garage sale in Mexico City in the fall of 1990, in which reproductions of works by Frida Kahlo were sold as 'raw material for a New Mexican Art.'

Nonetheless, the issue of cultural identity has its own complicated history within Mexico and its own discursive history within Mexican photography. While the sign of *la mexicanidad* (Mexican-ness) plays a central role in photographic imagemaking, no consensus exists as to the referent. Furthermore, the coexistence of radically disparate social and cultural realities that characterizes postmodern Mexico further destabilizes any fixed relation between identity and image or between cultural identity and 'otherness.' To get a sense of the range of representations that articulate the interplay between identity, difference, and otherness in Mexican photographic representation, I will compare Graciela Iturbide's series on the Juchitecas with work by two of her contemporaries, Mexican photographers Lourdes Grobet and Yolanda Andrade.[3]

All three of these artists choose elements of Mexican 'popular' culture (which does not equate with, but at times overlaps, mass culture) as their focus. Like the majority of photographers in Mexico, they are members of the largely white intellectual sector of a country that is overwhelmingly racially and culturally mestizo, where the existence of dozens of ethnic groups and racial hybrids makes it difficult to reduce 'difference' to a binary system. Due in part to gross economic disparities between social groups, and perhaps also to the lack of participation in cultural debates by indigenous peoples, class distinctions mark progressive discourses more than distinctions of race, ethnicity, or gender do.

This does not mean that racism and sexism are nonexistent or that they are not articulated in photography. What it does mean is that the experience of race and gender is less likely to be separated from that of culture and class than it is in North America. Cultural discourses on identity are largely absorbed by a nationalist problematic; that is, what it means to be Mexican. It has even been argued that culture has become a terrain for the imaginary resolution of 'difference'; for example, between largely urban, middle-class artists and audiences and the sometimes rural, 'popular' masses that are at the center of Mexican photography. Instead of separating their solidarity with these 'other' women from other issues and turning female representation into a distinct project, Iturbide, Grobet, and Andrade integrate their sense of gender identification into these larger social and aesthetic concerns. Furthermore, extensive critical discourse on racial and sexual difference in photography, or for that matter in other visual arts, is generally elided in part because there is no institutional infrastructure, no network of galleries, art schools, and specialized publications to support such work. A confluence of factors, then, attracts these Mexican photographers to *lo popular* and *lo mexicano*. However much the object of their search may have been adapted to contemporary realities, the project

itself remains profoundly marked by the nationalist romanticism that emerged in the wake of the Mexican revolution.

Dominated at the onset by the style of photographer Manuel Alvarez Bravo and cinematographer Gabriel Figueroa, a school of imagemaking assumed hegemonic prevalence in Mexico by mid-century, to the point of becoming a stereotype. We know that Mexico – rural, timeless, brimming with natural beauty and supernatural belief, brought to us in glorious black and white. Its protagonists are the reticent campesino and the mysterious *indigena*, fantastic survivors of the past. I do not mean to suggest that rural, non-'Western' Mexico does not exist, but rather that its diminishing social presence in the post-modern age makes its symbolic weight all too apparent. For an increasingly urbanized middle class these figures offer psychological resolution to its existential dilemma; to be truly Mexican and save oneself from the decadence and *malinchismo*[4] associated with modernity, one need only identify with them. During the golden age of Mexican cinema, superstar Maria Félix donned indigenous costumes in more than one of her films as a sign of rebellion against the patriarchal mores of the middle class. In contemporary Mexico, where the airwaves are saturated with images of blond and beautiful American 'others' and local peroxide-induced simulations, a nationalist vision of a better, purer Mexico is marshaled by sectors of the left and the right. Mexican cultural identity develops within the dynamic of attraction to and rejection of these two images of 'otherness' – the rural, indigenous past and the present and future threat of 'gringoization.'

Several critiques of cultural nationalism have developed in Mexico in recent years. Social anthropologist Roger Bartra, in his book *La jaula de la melancolia* (The cage of melancholy), argues that regardless of the prior or present existence of a real rural Mexico, the lyrical fiction operates as the collective fantasy of a country in the process of modernization.[5] Others have noted that the official celebration of Mexico's indigenous peoples has always gone hand in hand with their exploitation. Cultural critic Carlos Monsiváis suggests that the influence of conceptual art of the 1970s has made it difficult not to perceive how that nationalist myth has been constructed and how certain schools of Mexican art have perpetuated it. This awareness of the symbolic dimension of the supposedly mimetic representations of Mexican culture, he claims, together with the rapid growth of urban popular culture and the increasing Americanization of everyday life in the '70s and '80s, has made it untenable for the majority of Mexicans to equate the myth with any actual sense of cultural identity.[6]

Whatever criticisms may exist in Mexico, images of rural, indigenous life still exercise tremendous influence on the North American imagination. They stand for the radical otherness many here seek as an antidote to overdevelopment. They camouflage the more conflict-ridden encounters with real-life Mexican Americans. For some they confirm that somewhere there exists a world unspoiled by American corporations and soldiers. For others they assure that air conditioning, beauty products, and VCRs do make for a better life. These readings almost inevitably prescribe truths about 'Mexican-ness' to the

images in question or fault the photographer who does not satisfy the desire for images that verify a 'real' Mexico. Eugenia Parry Janis, for example, in the book *Women Photographers*, claims that Iturbide's work is 'too theatrical, . . . strives too much after surrealist effects. . . . Iturbide's women associate comfortably with monsters in a way that likens them to monsters themselves, heroines of tooth and claw.'[7]

It is worth noting that, far from monstrous, the iguanas whose use Janis addresses are considered a delicacy in Mexico; that they are also used for medicinal purposes; and that vestiges of pre-Colombian lizard worship still exist in Juchitàn. Janis deploys a common ethnocentric strategy; in using a morally inflected aesthetic judgement she betrays her reluctance to engage with these culturally different representations. At the same time I would stress that her irritation is provoked by the awareness that the culturally different reality she seeks in these photographs has been rendered mythical and, I might add, without any apparent dissimulation. While I do not think that all American critics would agree with Janis, I would suggest that the apparently 'documentary' style of these photographs hides this process of mythification and in so doing facilitates their entry into a North American repertoire of cultural 'difference.' And in this sense, intentionally or unintentionally, the exponents of cultural nationalism in Mexico dovetail with the North American positivist quest for work that transparently reveals the essential 'otherness' of 'non-Western' culture.

All this contributes to how we take in Iturbide's series on Juchitán. The photographs are unquestionably of extraordinary quality. I am struck by the combination of candor and dignity in the women's faces, in contrast to the deferential demeanor of the men. The women literally and figuratively fill the frames; they are central to nearly every picture, every ritual, and every life-sustaining activity. The pride with which they carry their stocky figures, their elaborate braids, and even the wrinkles of old age bespeaks codes of attractiveness and sensuality that have little to do with ours. Only Magnolia, the transvestite, seems to be concerned with Western aesthetic conventions. Inside their homes the women make altars for themselves and their loved ones. The public sphere activity appears to exist to further comradery between women. And those friendships are represented as just as important to the women as their male partners, if not more so. These women seem to radiate spiritual integrity.

It is practically impossible not to notice the aesthetic influence of Alvarez Bravo in this work – Iturbide filters those visual poetics through a feminine sensibility and an impressive ability to divest her subjects of any shyness and to engage their gaze. So strong is her identification with her subjects that many photos give the impression of having been requested or staged by the women themselves. And yet were it not for the synthetic fabrics used for some of the clothing, one might wonder in what time period these Juchitecas live. Modernity is barely hinted at in this hermetic world free of conflict. There is hardly a sign of industry or technology in these pictures, not even a wristwatch. One shot of a car window with children peering in, their faces pressed to the glass, lets you know how unusual it is to find cars in Juchitán.

What many may not be able to glean from the photographs is that Juchitán is in the state of Oaxaca, the region of Mexico with the largest, most varied indigenous population, the lowest standard of living, the highest rates of illiteracy, malnutrition, and unemployment, and the highest rate of emigration to the capital and to 'el Norte.' None of these factors appears to have affected the subjects of these photographs. I do not mean to suggest that they should, but their absence further underscores the editorial processes that transform these photographic 'documents' into mythical symbols of Mexican cultural identity. Furthermore, Juchitán's women have acquired near-mythic status in Mexico as a vestige of an ancient meso-American matriarchal society. For many female members of the urban intelligentsia, Juchitán is a pre-Colombian proto-feminist paradise on earth, and evidence for the claim that sexism is a European perversion of Mexico's 'natural' order, an argument not infrequently heard in populist progressive sectors.

I cannot speak to Iturbide's intentions; I am more interested in how these photographs function in relation to each other to create a sense of 'another' place, and what relationship they establish with the viewer-outsider. The Juchitán series is one of many in which Iturbide concentrates on locales. An individual photograph in the series may be appreciated and even analyzed formally, but the work's primary significance is in the 'story' that is formed by the sequence, in which the inhabitants determine the 'difference' or distinctiveness of the place. That Iturbide has returned to Juchitán for extended periods of time over several years suggests an intent to forge a relationship with her subjects that would preclude objectifying or sensationalizing them.

Iturbide shares the practices of immersion in a particular environment or community and narrative construction of meaning with her contemporary Lourdes Grobet. Iturbide chose the real but symbolically overdetermined terrain of Juchitán to create a kind of blueprint for a Mexican feminist imaginary. Grobet has concentrated in the last decade on prime examples of the stylized expressiveness of popular culture – La Lucha Libre (Mexican wrestling) and El Laboratorio de Teatro Campesino e Indigena de Tabasco, an experimental theater troupe of peasant and indigenous actors that often adapts and presents Western works in indigenous languages. Grobet makes no attempt to mask the fact that these practices are part of modern Mexico; but it is significant that these activities are visible evidence of the simultaneous persistence and transformation of pre-Colombian culture. Here *lo popular* reflects the transformative processes of modernization – what was once part of everyday life remains but becomes a specialized profession.

Grobet's images of women constitute a definitive presence in these series. She captures the actresses from Tabasco in moments of intense concentration and reflection, displaying the costumes and body paints they were required to design from natural materials as part of their training. Moving from the protected environment of the theater lab to the urban sprawl of the city, Grobet traces multiple manifestations of these theatricalized renderings of 'Mexicanness.' Her photographs recall Octavio Paz's characterization of Mexicans in *El laberinto de la soledad* (The labyrinth of solitude, 1950) as perpetual mask bearers,

people who wear one self but hide another – but her subjects all focus on projecting their notions of cultural identity, however syncretic. It is difficult to say whether the *conchera* (dancer) with her synthetic costume, a mainstay of street culture in the *zocalo* of the capital, is more or less 'realistically Mexican' than the mestiza intellectual who watches. One might ask which is more traditional or theatrical: the intellectual's poncho, the mask made by an indigenous actress, or the *conchera*'s glittery garb.

Grobet's interest in the theatricality of urban popular culture has also led her to the wrestling ring, where she has produced the most extensive documentation in Mexico of this extremely popular sport. Her work on the female wrestlers, *luchadoras*, is unique. Their involvement in a sport like the *lucha libre* often surprises viewers, and aware of this, Grobet represents them affirmatively, underscoring the powerful female presence in working-class social and economic activity. At the same time that she champions the female wrestlers' physical prowess, Grobet seeks out ways to reveal their vulnerability and sense of femininity, defying the butch stereotype of the *marimacho* (an overly masculine female). Her attraction to the drama of the ring does not prevent her from delving into the *luchadoras'* private lives to reveal their triple burden as nighttime wrestler, daytime worker, and full-time mother. In absolute complicity with her subjects, she only photographs those wrestlers who wear masks with them on, even outside the ring; the photographer maintains the mystery of their identity that is part of their cachet in the ring, while her subjects continue their theatrical posturing for the camera outside the ring. For Grobet, the 'difference' that makes one Mexican is found in these dramatic acts; her subjects perform, paint themselves, display themselves, and mime fighting in a seemingly endless whirl of activity. In her work *la mexicana* moves from earthy icon to ludic dissimulator with a heart.

Yolanda Andrade's subjects also perform and display, but their resources come from the ready-made world of urban mass culture, their references are more eclectic, and it's more difficult to discern the traces of the past in them. The series of photographs in her book *Los velos transparentes, las transparencias veladas* (Transparent veils, veiled transparencies) forms an asphalt landscape strewn with the result of urban performances: youngsters with painted faces create their version of punk; androgynous figures with plastic masks hide their real faces in order to project a constructed self-image. Nonetheless, live people are only a small part of a world filled with inanimate human figures. Statues, portraits, mannequins, life-sized figures of saints, and paper skeletons act like extensions of the quintessential Mexican mask, mediators that also remind one of the space between the identity and projected self-image of an individual or of the culture. A number of those projections are feminine but are clearly separate from the representation of female subjects; vehemently anti-essentialist, Andrade explores the transmutability of femininity in the urban public spaces of Mexico City.

The act of embellishment, of creative appropriation and reworking of already existent materials, in Andrade's photographs becomes an expression of how her culture recontextualizes and absorbs 'difference' as part of its own

self-image. Many of the objects and figures in these images are reproductions of European and North American artworks and artifacts that take on different meanings in this 'other' space. Andrade seeks the most ironic, if not unmediated, juxtapositions and presents them as ciphers, evidence of people's responses to living in colliding worlds. Simply by setting these objects apart, placing them at the center of her lens, she transforms them into contemporary versions of ancient monuments; the pictures are elliptical documents, she seems to say, of what people are constantly leaving behind as traces of themselves.

We never know who these things belong to. Andrade postions her viewer as a flaneur who catches glimpses of an uncanny cityscape but never gets beyond the surface. The street experience she recapitulates in her engagement with the viewer is one of defamiliarization, of following a series of related images without ever knowing the provenance of things. Out of this encounter one cultivates an attitude of distant affection rather than intimate connection. Grobet and Iturbide, on the other hand, go to great pains to connect artifact with maker, identity with person, and people with their place. They both retain an interest in preserving unity, in creating an identification with their subjects, in erasing that 'difference,' so to speak. Grobet looks for the actions that demonstrate how her characters constantly remake themselves. Iturbide evokes a rhetoric of essence; her Juchitecas seem to transmit what they are by simply being there.

It may be more difficult to assimilate Grobet's and Andrade's work into an American viewing context – the issue of cultural identity is far more submerged; and Andrade's hybridized world filled with cultural debris may be a bit too much like our own. Iturbide's Juchitán, on the other hand, is recognizably and comfortingly 'different' – a closed universe of serenity held up for our contemplation. Furthermore, although all three identify their work as progressive, oppositional cultural practice, none of them calls photographic discourse into question by putting it at the center of her inquiry. And while they address differences within the same culture, they do so without foregrounding the issue of ethnic or cultural otherness, neither their own nor that of their subjects, as we in this part of the world might. The reduction of the meaning or use value of their work in terms of that problematic occurs in their reception here, not there. To interpret their work as transparently applicable to our cultural debates misconstrues the very constitution of identity and the function of noncommercial photography in a context other than our own.[8]

Anne-Marie Willis

A Strategy of Appearances – The Australian Bicentenary

(First published in *Ten.8*, No. 30, 1988)

Anne-Marie Willis wrote this piece as the first half of a two-part article co-authored with Tony Fry. In a year that produced a plethora of celebratory images, Willis looks at how photographic imagery has been employed to construct a sense of Australian history and national identity which appropriates a range of historical experience into an Anglo-centric version of the past.

The Past in the Present

APPEARANCE and national identity, photography and Australia – the order in which these things are mentioned is not arbitrary: appearances come first, they pre-figure the 'real'. National identity, popularly considered to emerge from 'the land' and 'the people' is not natural or authentic but something that is actively constructed in modern nation states. In fact, a good deal of their credibility rests on putting into place images of national distinctiveness. It is an activity carried out with particular vigour in post-colonial societies, such as Australia. Images of nation are fictions-in-circulation that serve to mediate imagined and lived communal lives.

Components of national identity are products of the category itself more than they are possession of distinct cultures. National identity has become a genre, seen in its clearest form in the government-made promotional film: typically, this is a fast moving cavalcade of spectacular imagery – of what is thought to be an appropriate mix of modernity and tradition.

The concept of national culture is even more recent that than of the nation state. Towards the end of the nineteenth century new nation states began the process of appropriation of *regional* traditions and appearances into amalgams of claimed *national* distinctiveness. The process has never stopped – the imagery keeps on coming and keeps on being re-made and re-modernised. Appearance is crucial in the colonial culture (which by definition is marginal) whether this is 'keeping up appearances', not wanting to appear 'behind the times', or the assertion of independence through a different look. Hence the contradictory desire of cultural producers in Australia who want to produce work which is at once local (yet not provincial like the movie, *Crocodile Dundee*), and in step with an international (post-) modernism.

Photographic imagery has been crucial in the construction of national

identity, with genres and styles imported from elsewhere and used unaltered to promote and dramatise, for example 'Australian fashion', 'Australian products' or, the story of 'Australian industry'. But all of these have been either mythological figures, brief moments or even footnotes in Australia's economic history. The country is not a republic and its fortunes have been tied alternately to Britain, the USA and increasingly now, to Japan. In the light of this failure to achieve either political independence or effective economic self-management in the modern world the appearance of independence has become crucial. While official rhetoric has been exhorting Australians for the past few years to be proud, pull together, 'buy Australian', and so on, increasingly, corporate promotion has become a site for the manufacture of national identity. The concept 'Australia' is invoked to sell everything from beer to take-away chicken and cat food, and to construct corporate images. For instance, the extractive industries multi-national, BHP, presents itself as 'the quiet achiever', with imagery of modest Australians working in tough outback conditions. The favoured images of this market-place national identity are outdoors, sporting, physical, masculine and Anglo.

In the Bicentennial year, official versions of national identity may be less aggressively mono-cultural and sexist than the down-market commercial versions; careful attention is given to including a diversity of faces in publicity material. But the occasion itself, despite official denials, is centred on the celebration of the British invasion of the Australian continent. The highlight event, in terms of official presence, national and international media attention, was the spectacle of vintage sailing vessels in Sydney Harbour, exactly 200 years after Captain Phillip's fleet of convicts and goalers landed on the East coast of Australia. Understandably, Aboriginals have objected to the whole concept of a white celebration of the invasion of their continent, particularly as official recognition of this historical fact has never been given, for example in the form of treaty or compensation.

The Appearance of History

Anglo settlement is given privileged place in official and unofficial productions: it is named as 'heritage'. References to 'national character' and the 'typical Australian' always assume an Anglo-Celtic population. The significant non-Anglo communities are presented as a marginal addition to this; and within the discourses of multi-culturalism, they are presented as picturesque *difference* through food, dancing and exotic national costumes. The recycling of historical photographs is a particularly powerful device for the naming of this Anglo-colonial history as the national heritage. Images of pioneers, gold rushes, frontier towns, stockmen, sheep shearing, men marching off to war, 'little Aussie battlers' are found in endless pictorial histories, promotional displays, TV specials, advertisements, usually accompanied by narratives that tell of the hard work of building a nation. The style of imagery, the rapid succession of photographs dissolving into one another to form a chronological sequence unified by the text is so predictable that both history and national identity

lose their specificity and become genres within entertainment and popular education.

In these contemporary fictions of identity, photographs are cut adrift from a singular location in time/history, becoming shifting signs capable of telling almost any story. This is, of course, the normal use of photography in contemporary culture; the mobility of photographs allows them to have no fixed 'correct' place and meaning. Photographs, as many have noted, are incomplete utterances, portable signs awaiting animation and sense within larger narratives. If this is so, we need to question the historian's desire to work against what s/he perceives as the contemporary a-historical use of photographs by returning photographs to their 'original context' – that historical moment closest to the time the photograph was made. This project has had polemical value in undermining the art history of photograph: for example, it reveals the arbitrariness of the designation of Jacob Riis and Lewis Hine as 'artists', by acknowledging the centrality to their work of the social reform ethos. Beyond this the contextualist approach is of limited value. The 'original context' for many historical images in circulation today is unrecoverable; a photograph taken in the 1880s may have had limited circulation in a small community – maybe no larger than a family in the case of carte-de-visite portrait. It is appropriated 100 years later, has new meanings attached to it and circulates, via electronic media, to millions of people. Once this has happened, no amount of historical research can ever return it to the 1880s. It has become a contemporary image, imbricated in the consciousness of millions, it has become part of popular culture and memory.

A more productive response to the appropriation of photographs into discourses of national identity is that of recording: taking such photographs and making them tell different stories: The history into which they can be inserted does not need to be based upon some notion of an allegedly accurate past, but needs to be consciously aware of the contemporary nature of all historical accounts, and of the value of contemporary critical readings of the past. In the case of Australia, historical photographs need to be made to speak in a narrative of a colonial history rather than the history of a nation: they need to speak of the deceptions of that history (the misrecognition of Australia as independent nation), and the role that photographic imagery has played in these processes. The notion of the photograph as evidence can be reworked: photographs can be used as evidence of the way they are used as evidence to validate constructions of history; and they can be used as evidence in new critical histories. We need to understand how specific genres of photography intersect with historical processes: for example an understanding of advertising photography cannot be separated from its instrumental function in the formation of the consumer as a modern subject specific in time and place.

Here as Elsewhere

In a colonial context photography is always implicated in a process of claiming and making claims – new land for settlement, peoples to be made docile, signs of 'enterprise', 'progress' and 'civilisation' in far-flung territories. This is one

story of photography in its early years in the Australian colonies. Up until at least 1900 (and in a more repressed way thereafter) every image has 'elsewhere' as an absent signifier. So, life in the colonies is either like it is 'back home' in England, complete with gracious houses, ordered gardens, fine public buildings and respectable leisure pursuits; or it is other – rugged, tough, expansive, unordered.

The documentation of signs of progress, both for consumption in the colonies themselves and for overseas audiences provided a profitable business for many early photographers. O.W. Blackwood produced an album of Sydney banks in the 1850s to demonstrate Sydney's 'commanding position in the world of commerce', suggesting that businessmen send copies to 'friends in Europe as specimens of the progress made in Art and Architecture in Sydney'. Photography could represent the colonies as civilised so they would be noticed in Europe. Thus the New South Wales Government Printing Office, which employed a team of photographers, produced a lavish album for presentation to Queen Victoria in 1882. The images were carefully selected to show, in the words of the official report, the 'cultivated aesthetic tastes of the community, the resources of the colony and enterprise of its inhabitants . . . and the solid bases upon which we are building up the fabric of our national wealth'.

In the 1870s the German immigrant gold miner Bernard Otto Holterman displayed gigantic panoramas of Sydney Harbour and New South Wales at international expositions to promote immigration and investment in the colony. The hope that the spectacle can encourage development lives on: Expo 88 in Brisbane is the latest manifestation of a marginal culture's desire for international recognition.

Fine buildings, flourishing ports, productive gold fields – these were the images that denied the double violence upon which the Australian colonies were built – the punishment of convicts and the dispossession of Aboriginals. Some images in their very organisation appear to speak of an ideal of order and regularity, such as those taken by itinerant photographer Fred Kruger. Other images can be read in terms of local particularity – the small towns whose modest shops are proclaimed as significant by huge ornamental signs and mock grandiose facades. This genre of photography, which often includes people standing proudly in front of the crudely constructed buildings, are particular favourites of the national identity genre – a well known series from the gold rush towns of Hill End and Gulgong has even been used on the Australian ten dollar note. They are claimed as 'distinctively Australian'; yet they are generic frontier images, similar scenes having been recorded by photographers in all parts of the Empire.

By the 1890s photographic imagery was produced to slot into discourses of national identity. The enterprising Charles Kerry travelled all over New South Wales recording the rolling paddocks, huge flocks of sheep, wool sheds and large homes of wealthy land owners – for their own consumption at first, but later he printed and sold the same images as 'typical' Australian scenes. His imagery jumbled together the properties of wealthy squatters (land owners), small scale struggling farmers and the itinerant rural workers (drovers and

shearers) upon whose labour the large land-holder was dependent. Kerry &
Co's imagery was concerned with quaint characters and picturesque scenes;
there were no commercial reasons for using this imagery to indicate class
distinctions or explain historical processes. Since then, those who have appro-
priated his imagery have left it historically mute: they use it to re-make a
simplistic notion of Australian heritage as the struggle of 'man on the land'. But
again, the rhetorical figure of the pioneer is common to many colonial societies.
When looked at closely, so many claims about the 'distinctively Australian'
dissolve away.

Subduing the native population was carried out mainly by violence (mas-
sacres in more remote parts of Australia are still within living memory) but
visual imagery also played a role. A series of Euro-centric constructions have
been imposed on Aboriginal culture – from the 'noble savage' of the earliest
voyages, to the mocking illustrations of drunken fringe dwellers favoured by
graphic artists in the mid nineteenth century; from anthropological depictions
of Aboriginals as remmants of the past, to racist cartoons still found in the
popular press, and the neo-colonialist appropriation of Aboriginal culture as a
sign of modernised Australian style. The work of nineteenth century photo-
grapher J.W. Lindt, which was popular with European scientific societies, gave
visual form to the notion of Aboriginals as people belonging only to the past.
He posed groups in his studio as if they were wax dummies in a museum
diorama; they sit passively surrounded by artifacts of their own culture to which
they appear to have no relation – objects and people that have been appropri-
ated as props in a grotesque display of subjugation. The spirit, if not the precise
visual form of Lindt's photography, lives on in the present. At any tourist shop
in Sydney one can purchase postcards of the 'wild man' appearance of tribal
Aboriginals – images of a 'living primitivism' – souvenirs in the tourist's
itinerary of consuming the exotic.

National(ist) Culture

Institutions of high culture are also active in the national identity industry and
nationalistic back-readings and recodings of the imagery of the past. The
Australian National Gallery recently mounted a Bicentennial Photography
Exhibition which brought together over a thousand photographs taken in
Australia from the 1840s to the present (including some of the images repro-
duced with this article). Here the Bicentennial theme is lowered onto a huge
diversity of imagery, not in order to tell the story of the nation in pictures but
to produce an instant photographic heritage; this is the domain of national high
culture in which the sub-text is not so much 'celebration of a nation' as
celebration of 'Australian creativity' (never mind that the genres and visual
conventions are from elsewhere, and in many cases are expedient echoes of
more developed European and American practices).

The Australian National Gallery (and its extensive photography collection)
was founded in an earlier moment of cultural nationalism: in the Whitlam era
of the early 1970s high culture was seen as the pathway towards an updated,

more sophisticated image for Australia that would command overseas attention and legitimise the comparatively high levels of government funding of the arts and the film industry. Photography has had a special place in this scheme. It was funded as an art form, an idea that seemed novel and mildly adventurous to cultural administrators at the time. The Australian Centre for Photography (ACP) was established towards these ends and over its 14 year history, although with changing directors, styles and intermittent claims to being a facilitator of critical practices, it has continued to fulfil its role as the promoter of young talent and rite of passage to the heartland of national culture at the Australian Gallery. The ACP's journal, *Photofile* (the only independent photography journal in the country), claims to be committed to issues of power and politics of race and gender, but its central concern is the national coverage, through extensive reviews, of gallery-based exhibitions of the work of individual photographers. In the final instance, it is the bringing into being and nurturing of national high culture (with the constant desire for international recognition) that is the unspoken objective of most cultural workers in Australia. This commitment operates as a meta-politics making other political differences less significant and creating what seems like an unlikely consensus across apparently opposed positions. The search for national identity takes on more sophisticated forms and opposes itself to the crude official and corporate versions. But an unspoken nationalism operates as a limiting factor on nearly all aspirations towards critical practices; and it is that very preoccupation with identity which is a central problem in photography, as in other areas of cultural production in Australia.

Jewelle Gomez

Showing Our Faces – A Century of Black Women Photographed

(First published in *Ten.8*, No. 24, 1987)

Research into Afro-American photographic history began to gain momentum in the 1970s. The work of important photographers like James Van DerZee and Roy de Carava was highlighted and the role of the local document and the family album revalued. Archives and photographic collections like the one at the Schomburg Center for Research in Black Culture grew in scope and significance. Simultaneously, there was an interrogation of how different kinds of images shaped a sense of black identity.

Jewelle Gomez's article appeared in a special issue of *Ten.8*: *Evidence – New Light on Afro-American Images*. She looks at how media and advertising images represented black women to themselves and how her own family pictures speak to her across the generations.

> 'We are everywhere and white people still do not see us.
> They force us from sidewalks.
> Mistake us for men.
> Expect us to give up our seats to them on the bus.
> Challenge us with their faces.'
>
> Cheryl Clarke, *Living as a Lesbian*

HER'S was a broad, grinning face. The teeth gleamed with a startling health below her flat nose and nostrils that flared with joy at serving. The bandana, which covered her head, was perennially bright red. Her full lips were parted around those teeth and always appeared just about to issue a jolly welcome. The darkness of her skin was chocolate rich in contrast to the generally bland-coloured and bland-tasting foods for which she was used in advertisements: pancakes, cornbread.

'Aunt Jemima' was an image of black women which was reproduced and perpetuated in advertisements, cartoons, literature and movies made by film stars from Mae West (*She Done Him Wrong*) to Julie Harris (*Member of the Wedding*). For whites, the image of Aunt Jemima represented a return to the past when the world could be made safe by a pair of large black arms and a glistening smile. She was comforting, non-threatening and betrayed none of the white man's carnal desire which lurked behind his admiration of her. For

Afro-Americans this image became a symbol of the insidious destruction of the black race, the means by which black people could be reduced to functionaries of white fantasies and be deprived of any life experience that was purely personal, purely black. While the cigar store Indian (a traditional advertising icon) seemed remote and even dignified in its stereotypic, Native American solemnity, Aunt Jemima could only be a figure of derision: the greasy kitchen ghost not really present until her services were needed and invisible even then. I saw the eye-rolling deprecation and heard Mae West's 'Beaulah, peel me a grape!' everytime I used a package of pancake mix. I laughed at her embarrassingly large breasts and mindless smile.

As a child in the 1950s I could not look inside the image and see the African bones under those high cheeks. It was simply a bandana on her head not the American adaptation of the West African *gele* head-wrap. The gleam of her teeth was only selfless accommodation – not the contrast of white against African skin, not survival. We were all children then, not so long ago, and didn't see what was behind the caricature. We felt only the pain of what had been done to us in the name of white America. Aunt Jemima was a reflection of what U.S. citizens imagined or wanted us to be and true to the American penchant for extremes there was little subtlety. For the black woman the virgin/whore dichotomy in that fantasy panorama reaches its most ridiculous proportions when looking at how Afro-American women are pictured in the United States over the past one hundred years.

An examination of the image of Afro-American women in photography has to consider several aspects of the topic. First, because of the racism inherent in the political and social system of the United States, Afro-Americans frequently act in *reaction* to white America's behaviour toward us. A look at the literature of a most exciting and pivotal period in black American literature, the Harlem Renaissance (1920–1929) reveals that much of the work done then was an attempt to prove to whites that we too were human. Black women were the perfect vehicle for redemption. The work of many writers (like Jessie Fauset and Nella Larsen) featured the fair-skinned or 'passing' heroine who possessed an extraordinary (for that time) education, was from a hard-working, middle-class family and whose aspirations mirrored (usually fatally) those of her white counterpart. This adventurous but essentially defensive depiction inevitably affected the way that we presented ourselves to others, our own self-image and who we looked to for role models.

Our presentation of ourselves is just as surely tied to the technological advancements of the art of photography as it is to the political and economic activity of this country. Although Afro-Americans have appeared to be outside the mainstream, in fact, we too are a part of the uniquely American flow of events. For black Americans the portrait studio which sustained the legend of the Wild West and documented the elegance of modern living, was crucial to legitimizing our claim to full citizenship. In 1899 when George Eastman developed the flexible film and roll holder that made amateur photography feasible, he gave Afro-Americans an additional chance to represent ourselves for ourselves – candidly and lovingly, an opportunity not fully explored before.

In this equation are also the frequently contrasting views offered by commercial and non-commercial images. What the pancake-mix box said about who I was remained a major departure from what I saw in my own family albums filled with photos of five generations of women. Reconciling the two views is a life's work for the Afro-American woman.

Charles H. Caffin said in his book, *Photography as a Fine Art*, in 1910, that '(the photographer) must also have sympathy, imagination and a knowledge of the principles upon which painters and photographers alike rely to make their pictures.' Sympathy and imagination are elemental concepts in the discussion of any art form but it's hard to envision a white photographer in America at the turn of the century with either of these crucial ingredients as he sits down to photograph a former slave, a freedman, a plains Indian, an Afro-American woman. We were still an unknown quantity. Our humanity was still being debated in the parlours and back rooms of the people that had power over our lives. The black photographer of this period held in his (and many times her) hands a simple yet magical key to the re-discovery of Afro-American history and to the recreation of black people as full human beings in this society.

As an adolescent I cringed at the unexplainable shame of a bandana-topped Aunt Jemima but this image was soon counteracted by a number of other, equally narrow, visions. In the 1960s Johnson Publications produced some of the most important picture magazines in America. When black women trooped to the beauty parlours to have our hair fried to look deceptively straight and manageable we consumed, along with *Look*, *Life* or *Photoplay*, the magical words of *Ebony* and *Jet* magazines. Even *Bronze Thrills* was, in all of the tawdriness of its confessional *oeuvre*, a needed purveyor of our female sexuality. The magazines functioned somewhat like the apologist, black novels of the Harlem Renaissance. They represented images that indicated our conformity to American values of beauty, success and consumption and tried to teach us ways that we could achieve acceptability if we had not already done so. Every month we read about the importance of the lives of famous black achievers: stars, political leaders, pioneers in the arts and sciences. But the pages delivered wildly contradictory images. We were able to examine how their lives were just like our own, as black people. That commonality was used to inspire a sense of worth in our inherent blackness, yet that blackness was frequently submitted to comparisons with whiteness and found wanting. On one page we celebrated the image of America's first black vamp, Dorothy Dandridge, sitting backstage about to go out and work her black magic; on another we were assaulted by the relentlessly degrading advertisements for wigs, skin bleaching creams and hair straighteners. While the magazine claimed to be devoted to our blackness it exhorted us to 'Relax with Raveen.' 'Relaxing' became the euphemism for the new hair straightening process which would banish the shame of our attempts to erase our distinctive black traits and emulate the standards of those who hated us. *Ebony* and *Jet* were full of curly or sleek-topped women. The phenomenon was so extraordinary that even the fashion models, usually anonymous, became famous in our communities. Lois Bell, Helene Williams, Naomi Sims were as well-known as the products they sold. The magazines confirmed

that, yes, we too could excel, be famous, be part of the fantasy world because the famous were not just Bette Davis or Marlon Brando but others just like us. Black performers like Lena Horne, Dorothy Dandridge and Eartha Kitt were treated like royalty in the glossy pages of black magazines. Meanwhile white American magazines paid little attention to this subterranean network of black people except in the case of 'the first', a genre unto itself in the U.S. Jackie Robinson, the first black in modern times to play major league baseball, became a legend by being a first; so too did many black women. Dorothy Dandridge was buried under the glamour of being the first black woman to be nominated for an Academy Award as best actress. Magazines regularly featured the first black stewardess for Trans World Airlines or the first black woman hired to work at the national capital's botanical garden during World War II; the first black woman to play at Wimbledon or to run in the Pennsylvania State Relay Races. The image of a black woman sports figure carried a double power. It documented the growing acceptance of Afro-Americans in the white arena. And it also indicated black women's ability to shed the strictures of femininity. Black women track stars of the 1960s were a thrilling reality for me. Their celebrity was never the result merely of a gift of nature: straight teeth, fair skin, long hair. Track stars were solitary obelisks of achievement. They trained, they shaped their bodies and their future. They were allowed to sweat, to exhibit heroism and reveal pain. But being 'firsts' inevitably deprived us of any individualized image within our own communities or within ourselves. We continued to appear as reflections of someone else's needs.

In the 1950s the Carnation and Pet Milk Companies sponsored a long series of advertisements extolling the virtues of their 'poor people's' product, canned evaporated milk. The ads featured black women and their children and were displayed prominently in supermarkets in black neighbourhoods nationally. But as far as most of America was concerned black women were still mothers only to white children. The image of the mammy or Aunt Jemima prevailed in commercial media despite all attempts to broaden that perspective until the Civil Rights Movement of the 1960s. The impact of television and newspaper coverage of another face of the Afro-American led magazines to begin using black models and addressing topics involving Afro-Americans. Advertisers began to identify a new consumer of their products. Increased revenue made black seem, if not beautiful, at least profitable.

The only other consistent photographic representations of black women, (from the 1930s through the 1950s), came from government sources such as the Department of Labor, the Department of Public Education, the National Youth Administration and the Workers Progress Administration, all of which documented the presence of Afro-Americans in American society for archival and journalistic purposes. National black organisations also created and promoted the use of documentary photographs. Both black and white newspapers and magazines occasionally printed posed pictures of black women who moved into white collar jobs or the women who became part of the World War II workforce as a result of the shortage of male workers. These events remained

curiosities and didn't expand the image of who black women really were in the national consciousness.

But from the first known black photographer in the United States, Jules Lion, born in France about 1816, Afro-Americans have been consistently documenting and celebrating our lives. The community photography studio became an intrinsic part of how we communicated with each other. Much of what was communicated was similar to the uplift literature of the Harlem Renaissance: black women posed stiffly in elegant fashions proving to themselves and to the rest of the world that they too were 'civilized.' But that was not the only message photographs could bear. Among the pictures I have of my family (going back to my great, great-grandmother, Sarah) is a revealing photograph of her daughter, Grace, who raised me. Grace sits in a car before a studio pastoral backdrop, her face touched by a slight, mischievous smile. Her unknown companion clowns casually for the camera with a cigarette dangling from his lips and his cap turned backward in anticipation of the rockin' rappers of today. The picture is mounted on a practical postcard which my grandmother, Lydia (Grace's daughter) tells me is of a type regularly sent to friends. In the picture Grace shyly reveals a sensual intelligence common in most of her 'likenesses.' Even in less posed shots she maintains this stalwart amusement. Her mother, Sarah, remained suspicious of the camera. Her Native American heritage warned against the picture maker's ability to steal our souls. But Grace's pleasure is centred. She may be cautious but still she offers herself to the camera's eye. These photos reveal a wide range of moods, personalities, physical types, material means and feelings meant to be shared with family and friends, not just to stand as symbols.

A great number of black photographers set up studios or trooped around the neighbourhoods, lugging great box cameras, dark cloths and tripods and many of them were women. In her new book, *Viewfinders*, Jeanne Moutoussamy-Ashe discusses the black women photographers who practiced their craft as early as the turn of the century. The book includes beautiful reproductions of their work as well as pictures of the photographers. Eslanda Robeson, wife of Paul Robeson, maintained an active career as did Jennie L. Welcome, sister of famed Harlem Renaissance photographer, James Van DerZee. Ashe, a professional photographer for 11 years, has her own chilling stories about her survival in a male dominated field. But one experience she had while assembling the material for her book is particularly telling. She interviewed Winifred Hall Allen, a contemporary of the late Mr. Van DerZee, in her small apartment. There she found three boxes of negatives stored at the top of a closet. They were infested with cockroaches and Allen had to be persuaded to let Ashe take some of the negatives away to clean them up. The three boxes represented less than half of her collection. The rest she'd destroyed feeling that they had no value. Her sense of the prevailing culture's sentiments about their lack of worth was, of course, sadly accurate. But the sympathy and imagination that Charles Caffin identified as crucial to the art of photography certainly can be seen in the work of Allen and the other black women Ashe profiles in her book.

The independence of a good number of women during World War II

helped to roll back that tenuous quality of our sense of self-worth. The return to 'normalcy' of the post-war period did not send all women back to their kitchen aprons. It provided an incubation period so that when the explosion of the Black Arts movement hit the U.S.A. in the 1960s, black women were ready for new roles. We had seen those photos of our mothers glowing with self-sufficiency in the 1940s, we were ready to be the 'warrior-queens' that the Black Power movement demanded. As much as clothing, hair is a major clue to the expanded perception of self that black women were experiencing in the 1960s. Straightened hair gave way to the old-fashioned, rediscovered corn rows that we'd all worn as children. Or for the really daring there was the 'Afro' or natural hair cut. Although the majority of black women were (and are, *Ebony* still receives high advertising revenue from Ultra-Sheen and the Rose Morgan Wig Co.) straightening their hair, the natural came to symbolize rebellion and pride. The image of black women in advertising, news photos, even family snapshots became much more confrontational. We were no longer merely subjects of a labour study, manipulated symbols of a dying culture or the 'first' something. We projected an image we'd held of ourselves privately; the camera couldn't escape it, sympathetic photographer or not. When an actress like the late Kimako Baraka prepared her head shot for auditions, she had no need to limit her presentation. The full-face, unwavering stare, the close-cropped, natural hair all intimated Baraka's independence and intelligence. She created the image in collaboration with the photographer.

Looking over the five generations of Afro-American and Native American faces in my family, the boundless variety of people that we are is inescapable. We wear the red bandana, the *gele*; the sleek skirt and tapered pants. Our hair is pressed to patent leather or kinky, processed or dreadlocked. Black women have often been cheated of that spectrum of who we are by a narrow, European-American perspective of beauty and by a need to veil the black past and keep us feeling rootless and ancillary. The feminist movement began to lift that veil with its emphasis on looking to our foremothers for clues to their and our survival. The establishment of a number of lesbian archives in the U.S.A. gave concrete expression to the impulse to retrieve the images of women who had gone before.

Over the past ten years black women have made a comeback in the commercial arena after a hiatus in the '70s. This has been a decidedly mixed blessing. There is less likely to be a bandana now. But most periodicals, including *Essence*, a fashion magazine for black women, still favour light-skinned, straight-haired models. Even record album covers, which are now reflecting the personal fantasies of the artists like Tina Turner or Aretha Franklin, are designed solely within white standards of beauty. A singer who appears sepia-skinned onstage can look amazingly *café au lait* on the cover of her latest release. But in the '80s you can find photos of black women advertising airlines both in uniform and in wet T-shirts. They wear the short skirt of a break-dancer or the tight-lipped banker's smile that emulates the 'standard' model. The swing to either of these extremes is one we can weather.

Establishing a new perspective sometimes requires going out on drastic limbs far enough to get a real view.

When the extremes begin to fold back onto themselves, threatening to drown me in their oppressive weight, I run home to my grandmother, Lydia. Under her bed in a sturdy box she keeps the history. Carefully wrapped in tissue paper, secure in plastic bags, lie the photographs of one hundred years of black womanlife. We pore over them together. She tells me the stories she remembers again and again: how Grace's buckskins were stolen; the night she and my mother, Dolores, faced down the local toughs; what Sarah's cooking tasted like. Stories told so that I can remember them and pass them on. Those black faces are an index to the memories of who we really are. She saved them because, unlike Winifred Hall Allen, she was certain they'd be important again.

Someday.

Bibliography

Deborah Willis-Thomas: *Black Photographers 1840–1940, A Bio-bibliography*. New York, Garland Publishing Inc., 1985.

Valencia Hollins Coar (Ed): *A Century of Black Photographers 1860–1960*. Providence, Rhode Island, Rhode Island School of Design, Museum of Art, 1983.

Charles H. Caffin: *Photography as a Fine Art*.

Cheryl Clarke: *Living as a Lesbian*. Ithaca, New York, Firebrand Books, 1986.

Jeanne Moutoussamy-Ashe: *Viewfinders, Black Women Photographers*. New York, Dodd, Mead & Co., Inc., 1986.

Chester Higgins Jr. and Orde Coombs: *Some Time Ago, a Historical Portrait of Black Americans from 1850–1950*. Garden City, New York, Anchor Press/Doubleday, 1980.

Grateful acknowledgement is made for the assistance of Cheryl Shackleton and Deborah Willis-Ryan of the Schomburg Center for Research in Black Culture.

MEMORIES
AND FICTIONS

Liz Heron

Gateway to a Labyrinth

(First Published in *Creative Camera*, October 1988)

This piece was written by way of reviewing Richard Powers' *Three Farmers on their Way to a Dance*, a novel taking its title from that of a famous photograph by August Sander. It is a photograph with a singularly acute relation to the imaginary; Powers builds a novel around it, and Wim Wenders' fleeting use of it in *Wings of Desire* marks its mute eloquence, the stories it might speak. Of course, Sander's title is itself a beginning, a prompt to a fiction.

IN 1929, some sixty of August Sander's photographs were published under the title *Antlitz Der Zeit* (Face of Our Time), a volume meant as a preliminary to *Man of the Twentieth Century*, Sander's encyclopaedic record of Germany's social types, whose publication was halted by Nazi persecution. Alfred Döblin, author of *Berlin Alexanderplatz*, wrote an introduction, describing the book as a cultural history and a sociology of the past thirty years, its individual portraits building a comparative picture of class and economic divisions.

But he ends with these words: 'Whole stories could be told about a lot of these pictures; they invite us to do so. They are material for authors . . . He who knows how to look will be enlightened more effectively than through lectures and theories. Through these clear and conclusive photographs he will discover something of himself and others.'

Richard Powers' novel *Three Farmers on their Way to a Dance* takes up the invitation with an enthusiasm so total it seems a literal test of Döblin's claim. Sander's role as archivist of his time, when a few modernist blueprints still lay on the century's drawing board, is not so much overlooked as absorbed into the book's giddy project of summing up the century as it rushes to a close – from a necessarily fast-moving vantage point. It is narrated through a postmodern sensibility alive to photography's role in that history; as a technology that has spawned other technologies – industrial, military, informational – now gripping the world in a global embrace.

The historical novel that quizzes history can therefore easily accommodate photography as a major protagonist. *Three Farmers* is a genuinely fertile novel of ideas, something still rare enough in contemporary fiction to make it forgiveable that the novel largely alternates with the ideas, its manic narrative spliced with expository, essayistic sections rather than the two being integrated. At the same time, digressive mini-theses are hung all over the place on miscellaneous narrative hooks; febrile speculations that maybe should have been resisted. But

their alibi is, after all, the book's fixation on the century's accelerating speed and energy, and the resulting spider's web of public and private connections spun across it.

At the web's centre is a single photograph, and the narrator-hero's obsession with it. 'Three Farmers on their Way to a Dance' is one of Sander's best known portraits, and undeniably compelling enough to prompt an infinity of stories, multiple alternatives to those imagined by the author. His concern with the nature of this compulsion not only reverberates with the ideas of one of the century's major European intellectuals, Walter Benjamin, whose writings on photography have afforded incalculable insights, but the novel also proposes an apotheosis of certain aspects of these writings; notably, the photograph's relationship to time.

For the novel's narrator, 'Three Farmers on their Way to a Dance', photographed by Sander in the Westerwald in May 1914, becomes the gateway to a labyrinth linking past and present, memory, association and the great events of the century – through the imagined details of the farmers' lives. His first encounter with it has the mysterious, almost Proustian quality which is characteristic of how an old photograph can affect us; some memory or association is deeply stirred, but it remains just out of reach.

Within the same image different eyes will read different truths. We edit and build our own meanings, we extend them beyond the frame. But the image is the starting point. Why does it move us? Not only do its anonymous figures intrigue and tantalise with an arrested fragment of a whole life otherwise unknown, but its simultaneous closeness and distance brings us back to ourselves and our own time. In Benjamin's words, it prompts 'an irresistible urge to search . . . for the tiny spark of contingency, for the Here and Now . . . to find the inconspicuous spot where in the immediacy of that long-forgotten moment the future subsists so eloquently that we, looking back, may rediscover it.' Time collapses.

This effect is in part the result of what Benjamin calls the 'optical unconscious': the camera's capacity to reveal unfamiliar detail unseen by the naked eye. It is through such a heightened physiognomy of the visual world that forgotten associations may be awakened. The camera also has the capacity to provoke that eerie sensation of the viewer's gaze returned across the decades, the joining thread that goes back to the subject's glimpse of transcience, and time gathered into a moment that will have a future audience; meeting the camera's gaze with an unconscious leap forward to face them. In Richard Powers' novel this perception breeds a premonitory vision in the eyes of the three farmers, in the look crossing the seismic abyss of the First World War that cuts through the novel's historical labyrinth and its meditations on the promise and the wreckages of the machine age.

Benjamin wrote that it was out of the wreckages and refuse of official history that an alternative experience of time and history could be created – one that allows the life of the emotions and the senses. The imagination becomes vital. Sander's 'Three Farmers' is a significantly more suggestive photograph than his later Weimar period portraits, whose subjects look out at us from the

nearer edge of the cataclysm, but often with the modernistic detachment of Neue Sachlichkeit, which underwrites their remoteness rather than their closeness. 'Three Farmers . . . ' makes a fleeting appearance in Wim Wenders' recent film *Wings of Desire* – where desultory angels hover for eternity over mortal life, curious and sorrowful witnesses to its particularities of love and death, their distance from its immediacy of feeling and sensation conveyed by monochrome.

Their estrangement of course, oddly parallels our own, from ourselves and our time, here on the surfaces of the late century's world, where Richard Powers' hero frantically slides about in pursuit of the photograph's enigma. Reminding us that it is among that legion of phantoms, fixed momentarily by the camera, that we can find one way 'to read what has never been written'.

Susan H. Aiken

Isak Dinesen and Photo/Graphic Recollection

(First published in *Exposure* 23.4, 1985)

Certain photographs have the power of an embryonic fiction. Roland Barthes' idea of the *punctum* – the compelling, often marginal detail that stirs curiosity in the viewer – offers one way of analysing this effect. A great many kinds of photographs (portraits, photojournalism, even barely peopled landscapes . . .) suggest an arrested moment in some narrative. Susan H. Aiken's essay reflects on literary authorship and photography in relation to the writer Isak Dinesen.

Photography has something to do with resurrection . . . the survival of this image has depended on the luck of a picture made by a provincial photographer who, an indifferent mediator, himself long since dead, did not know that what he was making permanent was the truth – the truth to me.

– Roland Barthes, *Camera Lucida*

The importance of the account was not lessened but augmented with time, as if . . . the greatest wonder about it was that it did not change. The past, that had been so difficult to bring to memory, and that had probably seemed to be changing every time it was thought of, had here been caught, conquered and pinned down before his eyes. It had become History; with it there was now no variableness neither shadow of turning.

– Isak Dinesen, *Out of Africa*

THIS YEAR marked the centennial of the birth of Karen Blixen (1885–1962), the Danish author known to the English-speaking world as Isak Dinesen. Under that pseudonym, she authored some of the finest literary works of this century – among them *Seven Gothic Tales* (1934), *Out of Africa* (1937), and *Winter's Tales* (1942). In the world of photography, she is perhaps best known from the many striking portraits made of her in old age by photographers like Cecil Beaton, Richard Avedon, and Peter Beard.[1] Now *Out of Africa*, her haunting, luminous memoir of her seventeen years as a coffee farmer in Kenya early in this century, has been made by Sydney Pollack into a motion picture, with Meryl Streep and Robert Redford. The following essay is a reflection on another kind of picture – a photograph that, ordinary in itself, assumes powerful iconic significance in its unique and intricate connections to her authorship. In speculating on these connections, I hope also to illuminate some of the salient interactions possible between photography and literature.

I

Here and there, in some older houses, old faded daguerreotypes still hang on the walls. . . . They seem to us to be very simple. . . . compared with the artistic and skillful portraits made in later days. . . . Here was a photograph that at one time had been 'the last word,' a very modern portrait. . . . Today it is just a part of cultural history. The small yellowed surface has acquired depth, an admonishing perspective. We hold in our hand a symbol of the structure and ideology of an epoch.

– Isak Dinesen, 'Daguerreotypes'

HOW MIGHT a photograph and a text, closely associated in time, space, and historical import, elaborate 'readings' of each other? [2] Or, more precisely, how might the viewer, mediator of both image and text, through reading them interactively discover in each some key(s) to the meaning of the other? I experienced with great vividness the possibilities of such a reciprocal hermeneutics during the summer of 1984 when, having travelled to Denmark to study the unpublished manuscripts of Isak Dinesen for a book I am writing about her, I was taken by her former secretary Clara Selborn to Rungstedlund, Dinesen's birthplace and residence from the time of her return from Africa until her death. The 'text' in question is, in fact, her entire narrative corpus. The photograph is a formal portrait, made in England by an anonymous photographer sometime between 1905 and 1910, of her lover, Denys Finch Hatton. What follows is an attempt to disentangle some of the filaments of their interwoven histories, so powerfully embodied for me that afternoon in August as I stood in her study, surrounded by the books that once surrounded her, and gazed toward the window beside the desk where she wrote. There, on the sill, stands the photograph.

In one sense, it is an utterly ordinary image, a conventional formal portrait of a young man in his early twenties, dressed with studied Oxonian casualness in a tweed jacket loosely buttoned over shirt and tie. Yet even by conventional standards, the figure is arresting. Most obviously, the face, its chin resting lightly on the uplifted hand in a standard pose of portraiture, is strikingly good looking; Julian Huxley, recalling their years at Eton, claimed that 'Finch Hatton . . . was without doubt the handsomest boy in the school.'[3] But the classical features are less compelling than the expression, at once engaging and aloof, elusive. In both the biological and the cultural senses, the figure bespeaks good breeding. In his attitude of nonchalant self-assurance he displays a sense of wholeness, an *ease* that needs no one, nothing, beyond himself. Here the spectator is at once attracted and rebuffed, encountering in that gaze a bemused regardlessness for anyone's regard. Here too one reads a wry distance from the photographer's exertions, the hint of an ironic amusement at the occasion of the 'sitting' in which the sitter allows himself to be so captured by the camera's lens. Within its frame, the portrait is multiply reframed by the window's rectangles. Outside, beyond the picture, one can see the shore road that runs between Copenhagen

and Elsinore, the strand bordering the waters of the Øresund, and, across the sound, the coast of Sweden. The photograph, then, appears to be the entrance onto an immense expanse, a spatial openness of view that belies the confines of its multiple enclosures.

It also became to me that day the opening onto a vast imaginative expanse. For despite all my carefully-nourished academic skepticism about the Great Person, as I stood in that room where Isak Dinesen had worked — holding in my own hands a book filled with inscriptions made by hers — and looked at that portrait of her lover, I shared for a moment the naive wonder Roland Barthes records of first seeing a photograph of Napoleon's brother: 'I am looking at eyes that looked at the Emperor!'[4]

II

> Everything in this world must be paid for. . . . The very fact of possessing something or having possessed something that is of such immense value to one, brings its own terror with it.
>
> — Isak Dinesen, *Letters from Africa*

KAREN DINESEN — known as 'Tanne' from earliest youth — had not intended to be a writer. Despite the gifts already evident in the early plays and stories she wrote to amuse herself and her family, authorship was at most for her a sort of game. Her serious ambitions lay elsewhere. Stifled by the bourgeois confinements of life in Denmark — which, for a young woman of her class, held few options outside the domestic — and inspired by the visions of escape she had absorbed from her late father, a widely-travelled adventurer who had once lived as a trapper among the Chippewas in the North American wilderness, she began to dream of the possibilities of a life outside the ordinary bounds of European society.[5] In 1913, at the age of twenty-eight, she agreed to marry a distant Swedish cousin, Baron Bror von Blixen-Finecke, in order to emigrate with him to British East Africa, reputedly a land of endless possibilities for settlers unafraid of hardship. As he would later write of the decision: 'The human imagination is a curious thing. If it is properly fertilized it can shoot up like a fakir's tree in the twinkling of an eye. Tanne knew the trick, and between us we built up in our imagination a future in which everything but the impossible had a place. The promised land which hovered before our eyes was called Africa . . .'[6]

The marriage turned out to be disastrous: Blixen, a compulsive womanizer, infected her during their first year together with the syphilis from which she would suffer for the rest of her life. But the dream of Africa itself endured. In Kenya's vast landscapes and teeming wildlife, and especially in her relationships with the Africans themselves, she found a previously unimaginable meaning for her life. She would later recall it thus: 'I sailed into the heart of Africa and into a *Vita Nuova*, into what became to me my real life. Africa received me and made me her own.'

As the Dantean allusion here suggests, it was in Africa that she also found

her true vocation as an artist, a teller of tales who discovered in the land the
nurturing matrix of her creativity. Africa became the place – psychological as
well as geographical – where she could at last 'speak freely and without
restraint' ('Mottoes,' p. 7):

> Of all the idiots I have met in my life . . . I think that I have been the biggest.
> But a certain love of greatness, which could not be quelled, has kept a hold
> on me, has been 'my daimon.' And I have had so infinitely much that was
> wonderful. She may be more gentle to others, but I hold to the belief that I
> am one of Africa's *favorite children*. A great world of poetry has revealed itself
> to me and taken me to itself here, and I have loved it. I have looked into the
> eyes of lions and slept under the Southern Cross, I have seen the grass of the
> great plains ablaze and covered with delicate green after the rains, I have been
> the friend of Somali, Kikuyu, and Masai, I have flown over the Ngong Hills, –
> 'I plucked the best rose of life, and Freja be praised.'[8]

It was in Africa, too, that she found Denys Finch Hatton.

Everyone knows stories of those extraordinarily charismatic figures who,
too intent on living to pause for the creation of permanent monuments to
themselves, leave little but legends behind. As Dinesen herself would put it,
'There are some . . . who have the gift of 'making myths'; their personalities
remain alive in people's consciousness, . . . and the particular kind of poetry
they represented or expressed goes on gathering or maturing around them;
people continue to add to it' (*LA*, p. 394). So it was with Denys Finch Hatton.
Summaries tell us little: 'Denys Finch Hatton (1887–1931), English officer,
trader, and safari leader in Kenya, second son of the thirteenth Earl of Winchel-
sea.' Thus reads a typical biographical entry (*LA*, p. 455). But those who knew
him praised him in terms that, to a contemporary skeptical sensibility, sound
almost impossibly laudatory. As his biographer nicely expresses it: 'he suffered
all his life from adulation.'[9] 'The catalog of his perfections, talents, and eccen-
tricities,' writes Judith Thurman, 'could well be compacted into the word
princely. As one who apparently had no peer, he was the elusive object of much
fantasy' (p. 153). Widely acknowledged as one of the greatest white hunters of
his day (the other, ironically, being Bror Blixen), he had in 1910 left England,
where his careers at Eton and Oxford were already legendary, to escape what
he perceived as the stuffiness and conventionality of an aristocratic British
existence, seeking in Africa the space – both topographical and psychological –
that he would crave all his life. Toughened by life in the wilds, he resembled,
according to one of his friends,

> a sinuous-limbed dog-puma indolently sunning himself . . . until such
> time as vigorous action was imperative. . . . One got the impression
> that he could bring anything he undertook to a fortunate issue. . . . He had
> . . . courage . . . but was [not] reckless, combining the audacity of
> some old-time Elizabethan with the wisdom and foresight of the son of
> Laertes. . . . I liked the look of his scholarly appearance, which had also
> about it the suggestion of an adventurous wanderer, of a man who knew

every hidden creek and broad reach of the Upper-Nile, . . . and who had watched a hundred desert suns splash . . . the white-walled cities of Somaliland.'

<div align="right">(Trzebinski, pp. 113–14)</div>

Among his other interests, Denys had a lifelong involvement with photography. His mother, Anne ('Nan') Cordrington Finch Hatton, Countess of Winchelsea, was one of the pioneers of portrait photography in England during the second half of the nineteenth century. Under her tutelage Denys himself became a highly skilled amateur photographer, maintaining his darkroom in Kenya in the home of a friend. Best known for his pictures of wildlife, he formed the vanguard of the movement to transform hunting safaris into photographic expeditions and wrote articles for the London *Times* on wildlife photography as the preferable alternative to the indiscriminate slaughter that, with the advent of hunting from motorized vehicles, was occurring with increasing frequency.[10] Perhaps the most beautiful of all the photographs of Isak Dinesen during her African years, now in her study like the portrait of Denys himself, was probably made by him sometime in 1919. The image is a *tour de force* of chiaroscuro: a slim, elegant woman dressed in a riding habit and a wide-brimmed hat that shadows her eyes, holding a single rose and gazing into the distance away from the camera lens, she stands in the dapple of light and shade beneath trees on her farm, her Scottish deerhound by her side. Behind her, the fields blaze in the sun. When, decades later, she published *Shadows on the Grass*, her second book on Africa, it was this, her favorite photograph of herself, that she chose for it.[11]

Here is one of Karen Blixen's earliest references to Denys, from a letter to her brother written near the end of World War I: 'If you should get to France as a pilot it is just possible that you will meet someone called Denys Finch-Hatton, who is also a pilot on the French front, and that would make me very happy. For I have been so fortunate in my old age to meet my ideal realized in him' (*LA*, p.89). And later: 'That such a person as Denys exists, – something I have indeed guessed at before, but hardly dared to believe, – and that I have been lucky enough to meet him . . . compensates for everything else in the world . . . ' (*LA*, p.171).

In their love affair, which began shortly after their first meeting in 1918 and endured for the next thirteen years, she reenacted her sense of fusion with Africa itself, that "landscape that had not its like in all the world"[12]

> Denys had watched and followed all the ways of the African Highlands, and better than any other white man, he had known their soil and seasons, the vegetations and the wild animals, the winds and smells. He had observed the changes of weather in them, their people, clouds, the stars at night. Here in the hills, . . . standing bareheaded in the afternoon sun, gazing out over the land, . . . he had taken in the country, and in his eyes and his mind it had been changed, marked by his own individuality, and made part of him.(*OA*, p.356)

Both unions were invested, for her, with the quality of myth.

More significantly still, and in related ways, Denys served, like Africa, as a catalyst for her imagination. First an intellectual companion and mentor ("Denys taught me Latin, and to read the Bible, and the Greek poets, . . ." *OA*, p. 226), he later filled a more important role: he became the primary audience for her earliest major narratives:

Denys Finch Hatton had no other home in Africa than the farm, he lived in my house between his Safaris, and kept his books and his gramophone there. When he came back to the farm, it gave out what was in it; it spoke, as the coffee–plantations speak, when with the first showers of the rainy season they flower, dripping wet, a cloud of chalk . . . Denys had a trait of character which to me was very precious, he liked to hear a story told. For I have always thought that I might have cut a figure at the time of the plague of Florence. Fashions have changed, and the art of listening to a narrative has been lost in Europe. . . . Denys, who lived much by the ear, preferred hearing a tale told, to reading it; when he came to the farm he would ask: 'have you got a story?' I had been making up many while he was away. In the evenings he made himself comfortable, spreading cushions like a couch in front of the fire, and with me sitting on the floor, cross-legged like Scheherazade herself, he would listen, clear-eyed, to a long tale, from when it began until it ended. ' (*OA*, pp. 225-26)

These 'stories' were the beginning of *Seven Gothic Tales*.

Hannah Arendt has suggested curiously that, had this life continued, Dinesen would never have become a writer, preferring to remain instead merely 'the mistress' of Denys Finch Hatton.[13] Leaving aside the reductiveness of this view of Dinesen's rich life in Africa, I would rather venture that, had Denys not existed, Dinesen would have had to invent him. In some real sense, she *did* invent him, not only as the beloved of heart's desire, the symbolic male equivalent of Africa itself, but – again like Africa – as a necessary artistic fabrication: the figure of the ideal listener whose active attentiveness, like a silent answer, enabled her to fulfill her own genius:

The family of Finch-Hatton . . . have on their crest the device *Je respond-eray*, 'I will answer.' They have had it there for a long time, I believe, since it is spelled in such antiquated French. . . . I liked this old motto so much that I asked Denys . . . if I might have it for my own. He generously made me a present of it and even had a seal cut for me, with the words carved in it. The device was meaningful and dear to me, . . . for an answer is a rarer thing than is generally imagined. There are many highly intelligent people who have no answer in them . . . – you may stroke them or you may strike them, you will get no more echo . . . than from a block of wood. And how, then, can you yourself go on speaking? In the long valleys of the African plains I have been surrounded by sweet echoes, as from a sounding board. . . . I never spoke without getting a response.' ('Mottoes,' pp. 6–7)

Whatever the merits of Arendt's assertion, it is in any case rendered moot by subsequent events. For this life did not go on. Though Dinesen had desired

'to live and die in Africa' (*OA*, p. 352), years of recurrent drought and locusts, climatic difficulties arising from the high altitude of her land, and plummeting world coffee prices finally pushed the farm to bankruptcy. Despite her heroic struggles against the odds, she was forced at last to recognize that the 'impossible' – the source of her most 'terrible nightmares' (*LA*, p. 417) – had become reality: she must sell the farm and leave her home there forever.

But the worst was yet to come. On May 14, 1931, Denys Finch Hatton's Gipsy Moth, which he had flown on an expedition to the coast, crashed and burned.

> I looked out for Denys on Thursday, and reckoned that he would fly from Voi at sunrise and be two hours on the way to Ngong. But when he did not come, and I . . . had things to do in Nairobi, I drove in to town. Whenever I was ill in Africa, or much worried, I suffered from a special kind of compulsive idea. It seemed to me then that all my surroundings were in danger or distress, and that in the midst of this disaster I myself was somehow on the wrong side, and therefore was regarded with distrust and fear by everybody. . . . On this Thursday in Nairobi the nightmare unexpectedly stole upon me, and grew so strong that I wondered if I were beginning to go mad. There was, somehow, a deep sadness over the town, and over the people I met, and in the midst of it everybody was turning away from me. . . . I drove up to the lovely old Nairobi house of Chiromo, at the end of the long bamboo avenue, and found a luncheon party there. But it was the same thing at Chiromo as in the streets of Nairobi. Everybody seemed mortally sad, and as I came in the talk stopped. . . . I thought: These people are no good to me, I will go back to the farm. Denys will be there by now. We will talk and behave sensibly, and I shall be sane again and know and understand everything.
>
> But when we had finished luncheon, Lady McMillan asked me to come with her into her small sitting room, and there told me that there had been an accident at Voi. Denys had capsized with his machine, and had been killed in the fall.
>
> It was then as I had thought: at the sound of Denys's name even, truth was revealed, and I knew and understood everything. (*OA*, pp. 348–51)

She buried him in the Ngong Hills, at the place they had once laughingly chosen as their common gravesite: 'There was an infinitely great view from there: in the light of the sunset we saw both Mount Kenya and Kilimanjaro. . . . Now Africa received him, and would change him, and make him one with herself' (*OA*, p. 356).

III

I am the reference of every photograph, and this is what
generates my astonishment in addressing myself to the
fundamental question: why is it that I am alive here and now?
— Roland Barthes, *Camera Lucida*

The storyteller has borrowed . . . authority from death.
— Walter Benjamin, 'The Storyteller'

To COMPARE oneself with Scheherazade is to make the act of creation
inseparable from the idea of death. Dinesen's implicit connection of Denys
with the Sultan Shahryar suggests the darker side of their relationship — elided
in *Out of Africa* but repeatedly acknowledged in her letters. For Denys, as his
biographer acknowledges, had 'an instinctive fear of commitment.'[14] Though
for a time he indeed 'had no other home in Africa' than hers, he had also a
'wanderlust of mind and soul, a physical inability to remain for any length of
time in one place.'[15] More often absent than present, he stayed away for months
at a time on safari or on return visits to England. Thus the few weeks or months
they had together each year were always charged for her with the poignancy of
impending loss. On one level, then, her stories might be seen as a form of
seduction, made to keep at bay the little 'death' she experienced each time he
left (*LA*, p. 224). Thurman suggests that Dinesen 'made a virtue' of Denys's
refusal of commitment, 'writing of their friendship as a "love of parallels,"
scorning those lovers . . . who took possession of each other's lives. . . . But . . .
she also suppressed a neediness that she wanted to disown.' Thus she used 'the
erotic power of narrative . . . to test her power to enchant, to hold in thrall — and
thereby to survive' (pp. 184–5, 187), as though storytelling were a kind of love
potion. 'Real art,' she would write in a letter to her mother, 'must always
involve some witchcraft' (*LA*, p. 181).

It might appear supremely ironic, then, that at last it was not the death of
Scheherazade herself in this bewitched and bewitching dialectic, but that of her
'princely' auditor, which put an end to her oral narratives. Yet for Dinesen that death,
the staggering literalization of all prior departures, in its coincidence with her loss of
Africa, seemed at first but the inauguration of her own death-in-life:

> During my first months after my return to Denmark from Africa, I had
> great trouble in seeing anything at all as reality. My African existence had
> sunk below the horizon. . . . The landscapes, the beasts and the human
> beings of that existence could not possibly mean more to my surroundings
> in Denmark than did the landscapes, beasts and human beings of my dreams
> at night. Their names here were just words. . . . Fate had willed it that my
> visitors to the farm by that time had already gone. . . . Denys Finch-Hatton
> had set out before myself. . . . There they were, all of them, nine thousand
> feet up, safe in the mould of Africa. . . . And here was I, walking in the fair
> woods of Denmark, listening to the waves of Øresund. . . . [16]

What brought her back to life was more storytelling. For it was at this time that she transformed those seductive, multi-layered narratives, concocted first for her lover, into what readers now know as *Seven Gothic Tales*. And if, in one sense, she herself had been literally constituted as artist by the combined magic of Africa, her own genius, and her relationship with Denys Finch Hatton, she would now reverse that process, creating, through the magic of words, both Africa as mythic landscape (*Out of Africa* appeared three years after *Seven Gothic Tales*) and lover as ideal audience – the figure of the attentive listener/reader implicit, like the haunting presence of the storyteller, in her fictions.

It is in this context that the photograph on the windowsill of her study becomes symbolically connected with her authorship. According to her secretary Clara Selborn, each night 'before going to bed' Dinesen 'invariably went to the study and closed the door behind her and then opened the door to the courtyard and stood there quietly for awhile.' After having witnessed this ritual 'for fourteen years,' Clara asked Dinesen its meaning. 'On the side of the desk in the study hung a framed map which showed the farm and the Ngong Hills. Every night [she] looked at the map and at her photograph of Denys. The courtyard door faced south – toward Africa.'[17]

Dinesen had once remarked that she could not create 'until I had heard my own voice, seen myself in that mirror that is the person to whom one is speaking' (*LA*, pp. 288–9). In some sense Denys's photograph, forever suspending his animation within an eternal world of youth and privilege, seems to have represented that vital 'mirror' through which she could see – *reflect on* – herself as woman/author. The portrait, then, might be read as a kind of presiding avatar over the scene of her writing, assisting her reinvention of herself as Scheherazade.

Walter Ong has observed that 'the writer's audience is always a fiction.'[18] That statement becomes multiply applicable when the 'audience' is symbolically epitomized in a photograph. For the portrait of the dead man is, of course, the quintessence of the 'fictional.' Posed as 'himself,' the subject becomes his own mask, thus anticipating the further 'deaths' that transform him into a spectral image on photographic plate, film, or paper. From this perspective the photograph is in many senses what Barthes calls 'the dead theater of Death.' Yet Dinesen made it also a theater of ongoing life, a symbol of her self-staging – *re-creation* – as author, perpetually through her writing resurrecting both herself and her dead lover. By 'translating' the body represented in the photograph into a body of writing (one of the literal meanings of *translate* is, significantly enough, to move a body from one place to another), she symbolically deferred the finality of his death, opening the brackets that had appeared to frame him. Through writing, then, Dinesen re-membered him in both senses of that term, re-called him through the fiction of the 'reader' without whose silent 'answer' no author can 'go on speaking.'

Ironically, of course, this spectral exchange committed her to another kind of 'death': by turning herself, as she put it, into 'printed matter' (*Essays*, p. 196), she necessarily became, long before her physical death, as much a fictive artifact as the photograph of her lover. If, as Barthes suggests, the photograph effects a

return of the dead, so, one might say, does a text, forever haunted by the ghostly authorial presence for which it substitutes and of which, in several senses, it is the re-presentation. Whatever else it may effect, writing, like photography, always assaults us as a *surrogate* for something forever lost. By its very presence, it signifies an absence. In her fictions Dinesen would repeatedly play on this paradox.

Not in her writing alone did this simultaneous self-creation/annihilation occur. In her life as well she elaborately staged herself, revelling in role-playing that, like her literary pseudonyms and the labyrinthine complexities of her tales, concealed or put in question the existence of a 'real' Karen Blixen. In the years before her death, her body had become wasted and emaciated by the syphilis contracted from her husband, which attacked the spinal nerves that control digestion, causing her at last literally to die of starvation. Yet ever the actress (the mask and masquerade are, significantly, among the most frequent symbols in her texts), she gallantly made the most even of these effects. She charact-erized her writing as 'disease turned into loveliness'[19]; in a related fashion, she also fabricated her fragile, disease-wracked body into a living work of art, crafting herself as sybil or witch – literally *making a spectacle* of herself. 'Every photograph is a fake from start to finish,' Edward Steichen once remarked.[20] So, Isak Dinesen would write, is every person, seen from the observer's point of view: 'Your own self, your personality and existence are reflected within the mind of each of the people whom you meet, . . . into a likeness, a caricature of yourself, which still lives on and appears to be, in some way, the truth about you. Even a flattering picture is . . . a lie.'[21] Ambivalent about photography ('I do not see eye to eye with the camera' – *SG*, p. 58), she nevertheless anticipated by her playful self-imaging the photographers who would find in her such a compelling icon.

Of their portraits, perhaps the most famous was made by Cecil Beaton in 1959, when Isak Dinesen had come to America to give a series of readings. Against a white background, her gaunt figure, dressed completely in black, is arranged into a startling, oblique silhouette, reminiscent in its sinuousity of an Aubrey Beardsley print. The face is carefully composed, in several senses of the word; she has, both literally and figuratively, *made herself up*, and Beaton, remaking her image, multiplies that fabrication. A wry, ironic smile hovers about her mouth. The eyes beneath the shadow of the cloche are haunting – huge and black, their darkness intensified by the stark whiteness of the mask-like face and the kohl with which she outlined them – another kind of self-inscription. Turned away from the viewer, they gaze beyond the frame – or inward, perhaps, to some secret space of the mind.

IV

... in a good play, an exit is not a disappearance
 – Isak Dinesen, 'Mottoes of My Life'

... it seems to me that my old daguerreotypes may ... contain certain, perhaps obscure insights – the hints of hitherto unsuspected concatenations.

 – Isak Dinesen, 'Daguerreotypes'

THESE IMAGES, then, are the remains of 'Isak Dinesen': a signature; a body of texts; the haunting figure in a photograph. The chair beside the desk is empty. The picture of Denys Finch Hatton stands in the window, a mute witness to that absence. Text and portrait: storytellers both. The picture in its multiple frames, the window, and the view beyond suggest not enclosures, but thresholds. Windows and frames are alike in being neither inside nor yet wholly outside that which they define or divide, but the sites where such oppositions are temporarily held in suspension, rendered problematic. Just so the photograph – a paradoxical suspension of past and present, absence and presence, truth and fiction, artist and artifact, life and death – defies simple formulations. Just so Dinesen's narratives – with their multiple frames, their many voices, their plural significations – elude all simple critical categorizations. If photograph and text, to use her term, 'mirror' each other, then what they (re)produce in their reciprocal speculations is no single representation, but images of infinity.

Into this place of reflections comes the critic, adding yet another frame – of reference, of limit, of threshold – another point of view that reconstitutes, via the act of reading, the meaning of the scene. And standing there beside her empty chair, reflecting on text and picture, I too was caught in my turn, reproduced as an image on film, as my companion, Christopher Carroll, made photographs of the books, the picture, the desk – and their spectator. Now, even as I write these words, I imagine the irony of a further displacement: for the imaging continues in this text, where all of us are remade, in this very moment, by your reading. More images, more writing – from the place of death, 'an infinitely great view.'

Annette Kuhn

Remembrance

(First published in *Family Snaps: the Meanings of Domestic Photography*, Ed. Jo Spence and Patricia Holland, Virago, London, 1991, pp. 17–25)

In this essay, Annette Kuhn discusses family photography and the intervention and importance of memory. She views the family album as an important tool in the reconstruction of a personal history, searching among its cast of characters for meaning and explanations.

THE SIX-YEAR-OLD girl in the picture is seated in a fireside chair in the sitting-room of the flat in Chiswick, London, where she lives with her parents, Harry and Betty. It is the early 1950s. Perched on the child's hand, apparently claiming her entire attention, is her pet budgerigar, Greeny. It might be a winter's evening, for the curtains are drawn and the child is dressed in hand-knitted jumper and cardigan, and woollen skirt.

Much, but not all, of this the reader may observe for herself, though the details of time and place are not in the picture: these are supplied from elsewhere, let us say from a store of childhood memories which might be anybody's, for they are commonplace enough. The description of the photograph could be read as the scene-setting for some subsequent action: one of those plays, perhaps, where the protagonists (already we have four, which ought to be enough) will in a moment animate themselves into the toils of some quite ordinary, yet possibly quite riveting, family melodrama.

All this is true, up to a point. Photographs are evidence, after all. Not that they are to be taken at face value, necessarily, nor that they mirror the real, nor even that a photograph offers any self-evident relationship between itself and what it shows. Simply that a photograph can be material for interpretation – evidence, in that sense: to be solved, like a riddle; read and decoded, like clues left behind at the scene of a crime. Evidence of this sort, though, can conceal, even as it purports to reveal, what it is evidence of. A photograph can certainly throw you off the scent. You will get nowhere, for instance, by taking a magnifying glass to it to get a closer look: you will see only patches of light and dark, an unreadable mesh of grains. The image yields nothing to that sort of scrutiny; it simply disappears.

In order to show what it is evidence of, a photograph must always point you away from itself. Family photographs are supposed to show not so much that we were once there, as how we once were: to evoke memories which might have little or nothing to do with what is actually in the picture. The photograph is a prop, a prompt, a pre-text: it sets the scene for recollection. But if a photograph is somewhat contingent in the process of memory-production, what is the status of the memories actually produced?

Prompted by the photograph, I might recall, say, that the budgie was a gift from Harry to his little girl, Annette; that underneath two layers of knitted wool, the child is probably wearing a liberty bodice; that the room in which the photo was taken was referred to not as the sitting-room but as the lounge, or perhaps occasionally as the drawing-room. Make what you will of these bits of information, true or not. What you make of them will be guided by certain knowledges, though: of child-rearing practices in the 1950s, of fashions in underwear, of the English class system, amongst other things.

What I am saying is: memories evoked by a photo do not simply spring out of the image itself, but are generated in an intertext of discourses that shift between past and present, spectator and image, and between all these and cultural contexts, historical moments. In all this, the image figures largely as a trace, a clue: necessary, but not sufficient, to the activity of meaning-making; always signalling somewhere else. Cultural theory tells us there is little that is really personal or private about either family photographs or the memories they evoke: they can mean only culturally. But the fact that we experience our memories as peculiarly our own sets up a tension between the 'personal' moment of memory and the social moment of making memory, or memorising; and indicates that the processes of making meaning and making memories are characterised by a certain fluidity. Meanings and memories may change

with time, be mutually contradictory, may even be an occasion for or an expression of conflict.

On the back of this photograph is written, in my mother's hand: 'Just back from Bournemouth (Convelescent) [*sic*]'. In my own handwriting 'Bournemouth' has been crossed out and replaced with 'Broadstairs', and a note added: 'but I suspect the photo is earlier than this'.

If, as this suggests, a photograph can be the site of conflicting memories, whose memory is to prevail in the family archive? This little dispute between a mother and a daughter points not only to the contingency of memories not attached to, but occasioned by, an image, but also to a scenario of power relations within the family itself. My mother's inscription may be read as a bid to anchor the meaning of a wayward image, and her meaning at some point conflicted with my own reading of the photograph and also irritated me enough to provoke a (somewhat restrained) retort. As it turns out, my mother and I might well both have been 'off in our memories, but in a way this doesn't matter. The disagreement is symptomatic in itself, in that it foregrounds a mother–daughter relationship to the exclusion of something else. The photograph and the inscriptions point to this 'something else' only in what they leave out. What happens, then, if we take absences, silences, as evidence?

The absent presence in this little drama of remembering is my father. He is not in the picture, you cannot see him. Nor can you see my mother, except in so far as you have been told that she sought to fix the meaning of the image in a particular way, to a particular end. In another sense, however, my father is very much 'in' the picture; so much so that my mother's intervention might be read as a bid to exorcise a presence that disturbed her. The child in the photograph is absorbed with her pet bird, a gift from her father, who also took the picture. The relay of looks – father/daughter/father's gift to daughter – has a trajectory and an endpoint that miss the mother entirely. The picture has nothing to do with her.

Here is another story: about taking a photograph indoors at night in the 1950s, on (probably slow) black-and-white film in a 35mm camera. My father knew how to do this and get good results because photography was his job: he was working at the time as, if you like, an itinerant family photographer; canvassing work by knocking on likely-looking (that is to say, 'respectable' working-class) doors, taking pictures of children in the parents' homes or gardens, and developing and printing them in a rented darkroom. This must have been the last moment of an era when, if people wanted something better than a blurred snapshot from a Box Brownie, they would still commission photographs of their children. The photo of me, no doubt, is the sort of picture Harry Kuhn might have made for any one of his clients.

Stylistically speaking, that is: for at this level the picture eschews the conventions of the family photograph to key, perhaps, into professional codes of studio portraiture; or into the cute-kiddie-with-pet subgenre of amateur photography. The peculiar context of this picture's production lends it very

different cultural meanings, however, and imbues it with a kind and an intensity of feeling a professional or hobbyist piece of work would scarcely evoke. In this image, Harry's professional, his worldly, achievements are brought home, into a space where such achievements were contested, or at best irrelevant. In this photograph, my father puts himself there, staking a claim: not just to his own skills, to respect, to autonomy; but to the child herself. In this picture, then, Harry makes the child his own daughter. Later on, my mother would assert that this was not so, that Harry Kuhn was not my father.

Thus can a simple photograph figure in, and its showing set the scene for the telling of, a family drama – each of whose protagonists might tell a different tale, or change their own story at every retelling. What I am telling you – 'my own story' – about this picture is itself changeable. In each re-enactment, each re-staging of this family drama, details get added and dropped, the story fleshes out, new connections are made, emotional tones – puzzlement, anger, sadness – fluctuate.

Take my mother's caption to the picture – I don't know when it was written – and my own alteration and footnote, added because I believed she had misremembered a key event of my childhood. At eight years old (two years, that is, after the picture was taken) I was sent off to a convalescent home in Broadstairs, Kent, after a bad bout of pneumonia and a spell in hospital. The adult Annette took the apparent errors of time and place in her mother's caption (by no means an isolated instance) as yet another manifestation of obsessive (and usually 'bad') remembering; as an attempt by her mother to force others' memories into line with her own, however off-the-wall these might be. A capricious piece of power-play, if you like, but – given the transparent inaccuracy of the details – easily enough seen through.

Another, and more disturbing, reading of my mother's inscription is available, however: possibly the biographical details are correct after all, but refer not to me, the ostensible subject of the picture, but to my mother herself. Around the time the photograph was taken, she had suffered an injury at her job as a bus conductor, and been sent by London Transport to convalesce at the seaside. Is this perhaps the event to which the caption refers? If so, my mother is pinning the moment of a photograph of her daughter to an event in her own life.

In the first reading, my mother writes herself into the picture by claiming the right to define the memories evoked by it; and by omission and commission negates my father's involvement in both the photograph and the family. In the second reading, my own involvement as well as my father's is negated, as the caption constitutes a central place for the writer herself in a scenario from which she is so clearly excluded: my mother thereby sets herself up as both enunciator of, and main character in, the family drama.

The intensity of feeling attaching to these stories greatly exceeds the overt content of the tales of dissension and deception in the family I seem to have unearthed: utter rage at my mother's egomaniac powermongering; sadness at the nullification of my father's stake in the picture/the family; joy in the possibility of remembering his nurturing me; grief over his loss of power and

over my loss of him, for I was soon to become, in effect, my mother's property. My use of this photograph as a piece of evidence, a clue – as material for interpretation – is an attempt, then, to instate and enact if not exactly a father's, then certainly a daughter's, version of a family drama.

A photograph bearing a huge burden of meaning and of feeling, this one – to use Roland Barthes's term – *pierces* me. It seems to utter a truth that goes beyond the *studium*, the evidential, however intricately coded. My desire is that the little girl in the picture be the child as she is looked at, as she is seen, by her father. A friend who has not heard these stories looks at the picture, and says: There is a poignancy about her absorption with her pet; she looks lovable with her floppy hair ribbons and warm woollen clothing. Perhaps Harry Kuhn, in giving the child the gift of a living creature, and even more so in the act of making this photograph, affirms not merely a dubious paternity, but also that he loves this child. This photograph, I want to believe, is speaking a relation that excludes her, resists – perhaps finally transcends – my mother's attempt to colonise its meaning.

The stories, the memories, shift. There is a struggle over who is to have the last word – me; my father, the father who figures in my desire; my mother, the monstrous mother of my fantasy. With only one of the characters still alive to tell the tale, there is unlikely ever to be a last word, as the struggle over the past continues in the present. The struggle is now, the past is made in the present. Family photographs may affect to show us our past, but what we do with them – how we use them – is really about today, not yesterday. These traces of our former lives are pressed into service in a never-ending process of making, remaking, making sense of, our selves – now. There can be no last word about my photograph, about any photograph.

Here, then, is one more story: about a family album; about the kinds of tales (and the kinds of families) family albums construct; and about how my photograph was put to use once upon a time, and still survives to be used today, again and again.

Family photographs are quite often deployed – shown, talked about – in series: pictures get displayed one after another, their selection and ordering as meaningful as the pictures themselves. The whole, the series, constructs a family story in some respects like a classical narrative – linear, chronological; though the cyclical repetition of climactic moments – births, christenings, weddings, holidays (if not deaths) – is more characteristic of the open-ended narrative form of soap opera than of the closure of classical narrative. In the process of using – producing, selecting, ordering, displaying – photographs, the family is actually in process of making itself.

The family album is one moment in the cultural construction of family; and it is no coincidence that the conventions of the family album – what goes in and how it is arranged – are, culturally speaking, rather circumscribed. However, if the family album produces the family, produces particular forms of family in particular ways, there is always room for manoeuvre within this, as

within any other, genre. People will make use of the 'rules' of the family album in their own ways.

The one and only family album in my family is a case in point. It was made by me at the age of eight, when I collected together some snapshots with a few studio portraits and some of my father's relatively professional efforts, stuck them in an album (whose cover, significantly, sports the legend: 'Memory Lane'), and captioned them. Even at such an early age, I obviously knew all about the proper conventions of the family album: photos of myself, my parents, and a few of other relatives and of friends are all set out in chronological order – starting with a picture of me at six months old in the classic tummy-on-the-rug pose.

The eight-year-old Annette clearly 'knew', too, what a family album is for. If she was putting together her 'own' history, this sought to be a history of a family as much as of an individual; or rather, of an individual in a family. The history constructed is also an expression of a lack, and of a desire to put things right. What is being made, made up for, by the work of the album is the 'real' family that the child's parents could not make: this particular family story starts not with a wedding, but with a baby. The album's project is to position that baby, that child, the maker, within a family: to provide itself/herself with a family. Giving herself the central role in the story told by the album, the child also gives herself a family: not only positioning herself within a family, but actually bringing it into being – authoring it, parenting it.

Now, as I tell this story, I can set an interpretation of an eight-year-old girl's preoccupation with photographs alongside a reading, today, of a picture that figures in the collection she put together – a portrait of the same child, a couple of years younger, raptly involved with the pet bird perched in her hand. My mother's reading of that portrait is at odds not only with my present understanding(s) of it but also with the little girl's account, in the photograph album she made, of herself and of the family she wanted.

Whilst my 'Memory Lane' album contains a number of photographs of me as a baby and a toddler with my father, there are few early pictures of me with my mother. There is no way of knowing whether this is because no pictures of me with my mother were actually made, or whether it is because certain images were selected for the album in preference over others. Whatever the explanation, the outcome is that, in a child's first years, a father–daughter relationship is foregrounded at the expense of that between a mother and daughter. Just as Harry's photograph of Annette excludes Betty, so too does the family album marginalise her. Or at least seems to try to: my mother does make more frequent appearances in its later pages, though still not often with me. Both these observations speak of conflict: between my father and my mother over me; between my mother and me over the 'truth' of the past. In all these struggles, my project was to make myself into my father's daughter. My mother's project – in an ironic twist of the oedipal triangle – was to cast herself as my only begetter. Not, however, with complete success: had her story carried the day, you would not now be reading mine.

My stories are made in a tension between past and present. I have said that a child's making a family album was an expression of, and an attempt to come to terms with, fears and desires; to deal with a knowledge that could not be spoken. These silences, these repressions, are written into the album, into the process of its making, and into actual photographs. All the evidence points in the same direction: something in the family was not right, conflicts were afoot, conflicts a little girl could not really understand, but at some level knew about and wanted to resolve. Solving the puzzle and acknowledging *in the present* the effects *in the past* of a disturbance in the family must be the necessary conditions of a retelling of the family story in its proper order.

As clues are scrutinised and pieces fitted together, a coherent story starts to emerge from the seeming contingency and chaos of a past hinted at by these fragments – a photograph, a photograph album, some memories. A coherent story not only absorbs the listener, but – being a moment in the production of self – satisfies the teller as well, for the moment at least.

Family photographs are about memory and memories: that is, they are about stories of a past, shared (both stories and past) by a group of people that in the moment of sharing produces itself as a family. But family photography is an industry, too, and the makers of the various paraphernalia of family photography – cameras, film, processing, albums to keep the pictures in – all have a stake in our memories. The memories promised by the family photography industry are characterised by pleasure and held-off closure – happy beginnings, happy middles, and no endings to all the family stories. In the way of these things, the promises point towards the future: our memories, our stories, *will* be. They *will* be shared, they *will* be happy – the tone of the seduction is quite imperious. With the right equipment to hand, we will make our own memories, capture all those moments we will some day want to treasure, call to mind, tell stories about.

The promise is of a brighter past in the future, if we only seize the chance today to consume the raw materials of our tomorrow's memories. This past-in-the-future, this nostalgia-in-prospect, always hooks into, seeks to produce, desires hingeing on a particular kind of story – a family story with its own forms of plenitude. The subject position publicly offered is, if not quite personal (consumption is, after all, a social activity), always in the 'private' realm of household and family. All this is familiar enough to the cultural commentator. But the discourses of consumerism form just one part of a bigger picture, one moment in a longer – and probably more interesting – story about the uses of family photography.

Desire is an odd thing. If it can be called upon, even if it can be harnessed to consumption, it can also be unruly and many-sided. It can run behind, or ahead of, the better past tomorrow promised by the family photography industry; it can run somewhere else entirely; it can, perhaps, not run at all. When we look at how family photographs may be used – at what people can do with them once they have them – past and present and the tension between them insert themselves into an equation weighted a little too much towards a certain sort of future. This can stir things up, confuse matters – possibly productively. Just as there is more than one way of making photographs, so

there is more than one way of using them. If, however commonplace, my pictures and my stories are not everybody's, my uses of the one, and my method of arriving at the other, could well be.

My thanks to students in the Autobiography and Female Identity class at the City Lit, London, 1987–8; to the University of Glasgow Photographic Unit; to Ann Game for discussion and comments; and to Jo Spence and Rosy Martin for their example.

Notes

Gisèle Freund

Photography During the July Monarchy, 1830–1848

1. Cf. *Moniteur universel*, 16 June 1839.
2. Jean Jaurès, *Histoire socialiste*, 'Le règne de Louis-Philippe.'
3. Cf. E. Levasseur, *Histoire des classes ouvrières et de l'industrie en France*, Paris, 1903.
4. Jean Jaurès, *op. cit.*
5. Cf. E. Levasseur, *Histoire du commerce de la France*, Paris, 1911.
6. Cf. Karl Marx, *Le 18 Brumaire de Louis Bonaparte.*
7. Cf. Karl Mannheim, *Ideologie und Utopie*, Bonn: F. Cohen, 1929.
8. Cf. Karl Marx, *op. cit.*
9. Cf. Session of 1839 (Nouvelle Législative), Paris, 1839.
10. Cf. *Bibliographie politique et parlementaire des députés* (Guide des électeurs) by one of the editors of *Le Messager*, Paris, 1839, p. 145.
11. Cf. Victor Fouque, 'Niepce, la vérité sur l'invention de la photographie,' Chalon-sur-Saône, 1867.
12. Ibid.
13. Letter from Niepce to Lemaître, 23 October 1828.
14. Cf. Arthur Chevalier, *Étude sur la vie et les travaux scientifiques de Charles Chevalier*, Paris, 1862.
15. On 8 December 1827, Niepce had already tried unsuccessfully to publicize his invention in a speech to the London Royal Society.
16. Cf. Isidore Niepce, *Histoire de la découverte improprement nommée daguerréotype*, Paris, 1841.
17. 'There is much talk about Daguerre's invention. Nothing is more amusing than the explanations of this wonder proposed by our scientists of the salon. Daguerre should be reassured that his secret will not be stolen. . . . This discovery is truly worthy of great admiration, but we do not understand anything about it. It has been overexplained to us.' *Lettres parisiennes*, 12 January 1839, by the vicomte de Launais. *Oeuvres complètes de Mme Emile de Girardin*, vol. IV, pp. 289–90.
18. Gay-Lussac, *Rapport de la séance du 30 juillet de la Chambre des Pairs Historique et description des procédés du daguerréotype et du diorama*, concerning Daguerre's Paris, 1839.
19. Cf. *Moniteur universel*, 16 June 1839.
20. Cf. *Comptes rendus des séances de l'Académie des sciences*, second semester, 1839.
 Another example of state support of new and useful inventions is the subsidies granted to the railroads. These were in the hands of a few members of the financial aristocracy. The Chambers voted for the authorization to build the railroads, including the length of the concession, the dividends to be paid, and the state subsidies. It should not be forgotten that the representatives of the financial aristocracy had a decisive influence in the Chambers and that it was in their interest to realize these projects (parliamentary debates, 1824–47).
21. The Academy 'just received the approval of the most distinguished and honored English scientists, most notably Herschel, Robinson, Forbes, Wats, Brisbane.' *Comptes rendus des séances de l'Académie des sciences*, 15 June 1839.
22. *Comptes rendus des séances de l'Académie des sciences*, 19 August 1839, vol. IX, pp. 257–66.

23. 'We shall soon see beautiful prints that were once found only in the living rooms of rich amateurs, decorate even the most humble residence of the worker and the peasant,' *La Revue française*, 1839.

24. Cf. *Comptes rendus des séances de l'Académie des sciences*, 1839.

25. Ibid.

26. Cf. *Le Feuilleton du siècle*, 1839; *le Feuilleton national*, 1839; *la Gazette de France*, 1839; and similar publications.

27. Cf. Daguerre, *Historique et description des procédés du daguerréotype et du diorama*, Paris, 1839.

28. Cf. *Comptes rendus des séances de l'Académie des sciences*, second semester, 1839.

29. 'The photogenic images, as delightful as they are, leave something to be desired, especially the portraits.' E. Foucaud, *Physiologie de l'industrie française*, Paris, 1844, p. 179.

30. Gaudin and Leresbours, *Derniers perfectionnements apportés au daguerréotype*, Paris, 1842.

31. Richard Rudisill, *Mirror Image, the Influence of the Daguerreotype on American Society*, Albuquerque, N.M.: University of New Mexico Press, 1972.

Gen Doy

The Camera Against the Paris Commune

1. For useful information and illustrations relevant to Fenton's trip to the Crimea as a war photographer cf. John Hannavy, *The Camera goes to War. Photographs from the Crimean War 1854–1856*, Edinburgh: The Scottish Arts Council, no date. Further fascinating material on the whole question of the 'documentation' of war can be found in: P. Knightley, *The First Casualty*, London: 1975, now published in paperback by Quartet books.

2. Gisèle Freund, *Photographie et Société*, Paris: 1974, p. 60.

3. J. Bruhat, J. Dautry, E. Tersen et al., *La Commune de 1871*, 2nd edition, Paris: 1970, p. 31. For those who read French, this is the best single book on the Commune.

4. Ibid., p. 36.

5. J. Daubié, *La Femme pauvre au XIXe siècle*, Paris: 1866, pp. 50–51.

6. Ibid., pp. 294–295.

7. Gisèle Freund, op. cit., pp. 61–62.

8. E. Schulkind (ed.), *The Paris Commune of 1871. The View from the Left*, London: 1972, p. 159.

9. Gisèle Freund, op. cit., p. 104, states that this is the first time photographs were used in this way. By now, of course, this is common practice.

10. J. Bruhat, J. Dautry, E. Tersen et al., op. cit., p. 36.

11. S. Edwards (ed.), *The Communards of Paris 1871*, London: 1973, p. 166.

12. From: *Paris Incendié. Album Historique*, Paris: 1871, introduction by H. de Bleignerie, commentary by E. Dangin.

13. Many of these photographs taken for the Versailles police authorities are reproduced among the many useful illustrations in: A. Dayot, *L'invasion, le siège, la commune 1870–1871. D'après des peintures, gravures, photographies, médailles autographes, objets du temps*, Paris: 1901.

14. An album of the original photographs of women prisoners taken by Appert at Versailles is in the Bibliothèque Marguerite Durand, Place du Panthéon, Paris V. This library has lots of valuable information on women's history in France.

15. L. Chevalier, *Labouring Classes and Dangerous Classes in Paris during the first half of the nineteenth century*, London: 1973, pp. 83 ff., produces some useful information concerning public executions in France. In the early 1830s, public executions were moved from the Town Hall square out into the slum areas of working-class Paris. Also, they were held at dawn instead of in the afternoons. Various reasons were given by the authorities for these changes, but the

general idea seems to have been to make the death of the criminal a sordid, degrading, surreptitious event, as opposed to a public spectacle which conferred a certain status on the victim. Chevalier quotes Delvau, writing in 1865, towards the end of the Second Empire, who compares most unfavourably the 'Illustrious criminals' traditionally executed in front of the Town Hall, with the 'scum' now put to death ignominiously in the slum districts to the south of Paris. This perhaps gives some indication as to why the Versailles authorities made a public example of so few Communards (relatively speaking). They were unwilling to give them publicity beyond what was absolutely necessary as a warning to would-be socialists. For example the courts at Versailles passed 270 death sentences on Communards, whereas somewhere between 25,000 and 40,000 had been killed on the spot in working class districts during Bloody Week. For statistics cf. P. Lissagaray, *Histoire de la Commune de 1871*, Paris: Maspero, 1976, pp. 25–26.

16. Gisèle Freund, op. cit., pp. 60, 69.

Maria Morris Hambourg

Extending the Grand Tour

1. Bridges cited in Nissan N. Perez, *Focus East: Early Photography in the Near East (1839–1885)* (New York: Abrams, 1988), p. 50.
2. John Ruskin, *The Stones of Venice*, vol. 2, *The Sea-Stories* (London: Smith Elder and Co., 1853), p. 156.
3. Quoted in Kenneth Hudson, *A Social History of Archaeology: The British Experience* (London: Macmillan, 1981), p. 71.
4. Du Camp received his commission on October 20, 1849. For details see Michel Dewachter and Daniel Oster, eds., *Un Voyageur en Égypte vers 1850: 'Le Nil' de Maxime Du Camp* (Paris: Sand/Conti, 1987), pp. 14ff.
5. Letter from Flaubert to his mother, January 5, 1850, Cairo, cited in Francis Steegmuller, trans. and ed., *The Letters of Gustave Flaubert, 1830–1857* (Cambridge, Mass.: Harvard University Press, 1981), p. 109.
6. Tripe's case is exemplary. When the British government replaced the East India Company following the Mutiny, Tripe's position as official photographer for the Madras presidency came under review. His work as a photographer, initially undertaken for the company, was judged exorbitant by the government; consequently, Tripe was relieved of his position and returned to active duty. See Janet Dewan and Maia-Mari Sutnik, *Linnaeus Tripe: Photographer of British India, 1854–1870* (exhib. cat., Toronto: Art Gallery of Ontario, 1986), p. 17.
7. Samuel Bourne, writing in *British Journal of Photography*, March 18, 1870, pp. 28–29.

Rosalind Krauss

Tracing Nadar

1. This situation is presented in my 'Notes on the Index: American Art of the '70s,' *October*, nos. 3 and 4 (Spring and Fall, 1977).
2. See Nadar, 'My Life as a Photographer,' p. 9.
3. In his essays on photography, Roland Barthes analyzes these limitations, which he attributes to the status of photography as 'a message without a code.' See 'The Photographic Message'

and 'Rhetoric of the Image,' collected in *Image, Music, Text*, New York, Hill and Wang, 1977.

4. Honoré de Balzac, 'Traité de la vie élégante,' *Œuvres Complètes*, Vol. XX, Paris, Editions Calmann Levy, 1879, p. 504.

5. Gilbert Malcolm Fess, *The Correspondence of Physical and Material Factors with Character in Balzac*, Philadelphia, University of Pennsylvania (Publications: Series in Romantic Language and Literature), 1924, p. 90.

6. The examples are everywhere. One, from the 1833 *Théorie de la démarche*, goes: 'Nevertheless, Lavater said, before I did, that since everything in man is homogeneous, one's gait must be at least as eloquent as one's physiognomy; bearing is the physiognomy of the body. Of course this is a natural deduction from his initial premise; everything about us corresponds to an internal cause.' Balzac, *Œuvres Complètes*, Vol. XX, p. 572.

7. In order to locate physiognomy at that point of convergence that it established for itself, and staunchly maintained, between anatomy, psychology, and moral philosophy, it is useful to consider Charles Darwin's need finally to attack this 'science' in the 1870s. In his study *On the Expression of the Emotions in Man and Animals* (1872) Darwin launches an assault on physiognomy as one of the principal strongholds of the opposition to the theory of evolution. Operating on the principle that many of man's facial muscles were put in place solely for the purpose of 'expressing' his inner states, physiognomy based its investigations of this unique musculature on the belief that it was species-specific. That is, there was a mutual reinforcement between the idea that each species, man included, had come into existence in its present condition, and the notion that the musculature of the human species had been specially fashioned as the instrumentality of a unique capacity to feel and to express, which man shared with none of the lower animals. This capacity arose not simply from a psychological structure far richer and more complex than that of other species, but, ultimately, from the soul. In an argument such as this one, blushing, for example, is taken as a manifestation of a moral life not shared by lower animal orders.

8. Johann Caspar Lavater, *L'Art de connaître les hommes par la physionomie*, Vol. I, Paris, Depélafol, 1820, p. 127.

9. Erich Auerbach, *Mimesis*, Princeton, New Jersey, Princeton University Press, 1968, p. 472.

10. Aaron Scharf, *Creative Photography*, London, Studio Vista, 1965, p. 25.

11. Nigel Gosling speaks of Nadar's own scruples about participating in this industry: 'He was rarely tempted (as his son was later to be) to exploit his talent in banal journalism and publicity pictures, and rarely accepted commissions for the ever-popular deathbed pictures (Victor Hugo and the gentle poetess Mme Desbordes-Valmore were exceptions).' See Gosling, *Nadar*, New York, Alfred A. Knopf, 1976, p. 13.

12. Immanuel Kant, *Dreams of a Spirit Seer*, trans. John Marolesco, New York, Vantage Press, 1969, p. 76. This treatise was first published, anonymously, in Königsberg in 1766.

13. Ibid., p. 94.

14. Kant's motives for undertaking *Dreams* . . . are discussed by Marolesco in his introduction to the translation.

15. Ralph Waldo Emerson, *Representative Men: Seven Lectures*, Boston, Phillips Sampson and Company, 1850, p. 115.

16. Thus Swedenborg writes, 'Man is a kind of very minute heaven corresponding to the world of spirits and to heaven. Every particular idea of man, and every affection, yea, every smallest part of his affection is an image and effigy of him.' Cited by Emerson, *Representative Men*, p. 116.

17. William Henry Fox Talbot, *The Pencil of Nature*, facsimile edition, New York, Da Capo Press, 1969, introduction, n. p.

18. Ibid.

19. Published as *Human Comedy* by Thames & Hudson, London, 1982.

20. In the same years both Gautier and Duranty were writing with a similar relationship in mind. Professor Wechsler has kindly called my attention to this material which is presented and analyzed in her study.

21. In his analysis of Mallarmé's essay '*Mimique*,' Jacques Derrida examines this notion of the mime's gestures as a kind of writing, which becomes, in Mallarmé's words, '. . . *soliloque muet que, tout du long à son âme tient et du visage et des gestes le fantôme blanc comme une page pas encore écrite.*' See 'La double séance,' in Derrida, *La dissémination*, Paris, Editions du Seuil, 1972, p. 222.

Ute Eskildsen

Germany: The Weimar Republic

1. August Sander, letter to Erich Stenger, 21 July 1925, Fotohistorama Collection, Leverkusen.

2. See August Sander, *Menschen des 20: Jahrhunderts*, ed. Ulrich Keller and Gunther Sander, Munich, 1980.

3. Hagen Schultz, *Die Deutschen und ihre Nation Weimar Deutschland 1917–1933*, Berlin, 1982, p. 39.

4. Harm Schröter, Verena Schröter and Lars Lambrecht, 'Die wirtschaftliche Entwicklung der Weimarer Republik' ('The economic development of the Weimar republic'), in *Weimar Republik*, Berlin, 1977.

5. Max Burchartz, 'Neuzeitliche Werbung' in *Die Form*, notebook 7, 1925, pp. 138–9.

6. B. W. Randolph, *American Education in Advertising and Marketing*, Gebrauchsgraphik, 3rd year, notebook 2, 1926, p. 3.

7. See also 'Publizistische Medien' in *Weimar Republik*, Berlin, 1977, pp. 349–69.

8. Tim Gidal, *Deutschland: Beginn des modernen Photojournalismus*, Lucerne, 1972, p. 22.

9. Siegrid Kracauer, *Das Ornament der Masse*, Frankfurt, 1977, p. 34.

10. See Sperling, *Repertoire des journaux et des périodiques*, no. 53, 1927.

11. Willi Munzenberg, *Erobert den Film*, Berlin, 1925, p. 6.

12. Joachim Büthe, Thomas Kuchenbuch, Günther Liehr, Friedhelm Roth, Jan Thorn Prikker, Alois Weber, Richard Weber, *Der Arbeiter Fotograf*, Dokumente und Beitrage zur Arbeiterfotografie, 1926–1932, Cologne, 1977, p. 34.

13. *Der Arbeiter Fotograf* II, notebook 5, p. 5, 1928.

14. Willy Stiewe, *Das Pressefoto als publizistisches Mittel*, Leipzig, 1936, p. 120–1.

15. *Der Arbeiter Fotograf* III, notebook 7, 1929.

16. Babette Gross, Willi Munzenberg, *A Political Biography*, Michigan State University Press, 1974, p. 163.

17. Peter Panther (alias Kurt Tucholsky), *Ein Bild sagt mehr als 1000 Worte*, UHU, 3rd year, notebook 2, 1926/27, p. 83.

Varvara Stepanova

Photomontage

1. The term 'production art' was used frequently in the early 1920s among the Soviet avant-garde. It signified the merging of artistic and technical skills in the hands of an 'artist-constructor' whose goal was to create functional, utilitarian products. The terms 'production art' and 'constructivist art' were often employed interchangeably.

2. The word 'polygraphy,' as employed in the Soviet Union during the 1920s, refers to the use of typographic and photographic elements for the design of printed works such as posters, illustrated books and magazines, and advertisements.

3. Ivan Alexandrovich Aksenov (1884–1955) was a critic of literature and art who was especially close to the avant-garde painter Alexandra Exter and the artists of the pre-revolutionary 'Jack of Diamonds' group. The book cited was never published.

 It should be noted that other Russian artists besides Rodchenko, notably Gustav Klucis, also worked extensively with photomontage in the early 1920s.

4. The book referred to is Mayakovsky's poem *Pro eto* (1923).

Rosalind Krauss

The Photographic Conditions of Surrealism

1. *Florence Henri Portfolio*, Cologne, Galerie Wilde, 1974, introduction by Klaus-Jürgen Senbach.

2. Stanley Cavell, *Must We Mean What We Say?*, New York, Scribners, 1969, pp. 226, 236.

3. The seminal text is Jacques Derrida, *Of Grammatology*, trans. Gayatri Chakravorty Spivak, Baltimore, Johns Hopkins, 1974.

4. The references throughout this paragraph are to Rubin's attempt, at the time of the Museum of Modern Art exhibition *Dada, Surrealism, and Their Heritage*, of which he was curator, to produce a concise synthetic statement which would serve as a theory of surrealist style. See William Rubin, 'Toward a Critical Framework,' *Artforum*, vol. V, no. 1 (September 1966), 36.

5. André Breton, 'Le Surréalisme et la peinture,' *La Révolution surréaliste*, vol. 1 (July 1925), 26–30. The complete series of essays was collected in Breton, *Surrealism and Painting*, trans. Simon Watson Taylor, New York, Harper & Row, Icon edition, 1972. Further references are to this translation.

6. Breton, *Surrealism and Painting*, p. 68.

7. Ibid., p. 70.

8. André Breton, 'Océanie' (1948), reprinted in Breton, *La Clé des champs*, Paris, Sagittaire, 1953, 1973 edition, p. 278.

9. Thus, Breton insists that 'any form of expression in which automatism does not at least advance undercover runs a grave risk of moving out of the surrealist orbit' (*Surrealism and Painting*, p. 68).

10. Ibid.

11. Ibid.

12. In Breton's words, 'The emotional intensity stored up within the poet or painter at a given moment. . . .' (*Surrealism and Painting*, p. 68).

13. Ibid., p. 2.

14. Ibid., p. 4. Breton goes on to express his distaste for what he calls photography's positivist values, asserting that 'in the final analysis it is not the *faithful* image that we aim to retain of something' (p. 32).

15. The protest was against attitudes like that of Ribemont-Dessaignes, who, in introducing a 1924 Man Ray exhibition, honored 'these abstract photographs . . . that put us in contact with a new universe.'

16. This question had begun, 'The photographic print . . . is permeated with an emotive value that makes it a supremely precious article of exchange' (*Surrealism and Painting*, p. 32).

17. Walter Benjamin, 'Surrealism: The Last Snapshot of the European Intelligentsia,' in *Reflections*, trans. Edmund Jephcott, New York, Harcourt Brace Jovanovich, 1978, p. 183.

18. Pierre Naville, 'Beaux-Arts,' *La Révolution surréaliste*, vol. I (April 1925), 27. It was in deference to Naville and others that, when later in the year Breton launched his support of the enterprise of the fine arts, he had nevertheless to begin by referring to 'that lamentable expedient which is painting.'

19. Man Ray, *Exhibition Rayographs 1921–1928*, Stuttgart, L.G.A., 1963.

20. In a text introducing Ernst's *Fatagaga* photomontages, reprinted in Max Ernst, *Beyond Painting and Other Writings by the Artist and His Friends*, New York, Wittenborn Schultz, 1948, p. 177.

21. John Heartfield, *Photomontages of the Nazi Period*, New York, Universe Books, 1977, p. 26.

22. Ibid.

23. Louis Aragon, 'John Heartfield et la beauté révolutionnaire' (1935), reprinted in Aragon, *Les Collages*, Paris, Hermann, 1965, pp. 78–79.

24. In Walter Benjamin, 'A Short History of Photography,' trans. Stanley Mitchell, *Screen*, vol. 13, no. 1 (Spring 1972), 24.

25. Cited in Dawn Ades, *Photomontage*, New York, Pantheon, 1976, p. 19.

26. Louis Aragon, 'La Peinture au défi,' in *Les Collages*, p. 44.

27. Derrida, *Of Grammatology*, p. 18.

28. Claude Lévi-Strauss, *The Raw and the Cooked*, trans. J. and D. Weightman, New York, Harper & Row, 1970, pp. 339–340.

29. Ibid. See Craig Owens, 'Photography *en abyme*,' *October*, no. 5 (Summer 1978), 73–88, for another use of this passage in the analysis of photography.

30. Louis Aragon's 1925 definition of the Marvelous reads, 'Le merveilleux, c'est la contradiction qui apparaît dans le réel' ('Idées,' *La Révolution surréaliste*, vol. I [April 1925] 30).

31. André Breton, *L'Amour fou*, Paris, Gallimard, 1937, p. 13.

32. Ibid., pp. 35–41.

33. László Moholy-Nagy, *Vision in Motion*, Chicago, 1947, p. 206.

34. See my 'Jump over the Bauhaus,' *October*, no. 15 (Winter 1980), 103–110.

Therese Lichtenstein

A Mutable Mirror: Claude Cahun

1. Claude Cahun, *Aveux non avenus*, Paris: Éditions du Carrefour, 1930.

2. See Maurice Nadeau. *The History of Surrealism*, trans. Richard Howard, Cambridge: Belknap Press/Harvard University Press, 1989, pp. 196–198.

3. Cahun translated into French some of Havelock Ellis' writings on sexuality.

4. I am indebted for the biographical information in this article to Virginia Zabriskie and to François Leperlier, and want to thank both for their generosity in talking to me about Cahun. See Leperlier, *Claude Cahun: lécart et la métamorphose*, Éditions Jean Michel Place, Paris, 1992 – the first major book on the artist. See also, for instance, Edouard Jaguer, *Les Mystères de la chambre noire: Le Surréalisme et la photographie*, Paris: Flammarion, 1982, pp. 108–109. *L'Amour fou: Photography and Surrealism*, ed. Rosalind Krauss and Jane Livingston, New York: Abbeville Press, 1985, p. 205, perpetuates the story that Cahun died in a concentration camp; *Anxious Visions*, ed. Sidra Stich, New York: Abbeville Press, 1990, p. 237, corrects this misinformation, but many details of her biography remain unknown.

5. Baron von Aufsess, *The von Aufsess Occupation Diary*, ed. and trans. Kathleen J. Nowlan, Chichester, Sussex: Phillimore & Co. Ltd., 1985, pp. 61–62.

6. Simone de Beauvoir, *The Second Sex*, New York: Vintage Books, 1974, p. 268.

7. See Peter Bürger, *Theory of the Avant-Garde*, trans. Michael Shaw, Minneapolis: University of Minnesota Press, 1984.

8. Recent revisionist texts on the women of Surrealism include Whitney Chadwick, *Women Artists and the Surrealist Movement*, Boston: Little, Brown, and Co., 1985, and *Dada/Surrealism* no. 18, University of Iowa, 1990. Curiously, these books make little mention of Cahun – who does, however, appear in more broadly revisionist books such as Krauss and Livingston and Stich.

9. Claude Lévi-Strauss, *The Way of the Masks*, trans. Sylvia Modleski, Seattle: University of Washington Press, 1982, p. 144.

10. For a more extended discussion of masquerade see, for instance, Joan Riviere, 'Womanliness as a Masquerade,' *Formations of Fantasy*, ed. Victor Burgin, James Donald, and Cora Kaplan, New York and London: Methuen, 1986, pp. 35–44; and Mary Ann Doane, 'Film and the Masquerade: Theorising the Female Spectator,' *Screen* 23 nos. 3–4, September/October 1982, pp. 74–87.

11. Wolfgang Kayser, *The Grotesque in Art and Literature*, trans. Ulrich Weisstein, New York: McGraw Hill Book Co., 1966, p. 184.

12. See Jacques Lacan, 'The Mirror Stage,' *Écrits*, New York: W. W. Norton, 1977, pp. 1–7. The mirror stage occurs between the ages of 6 and 18 months, when the child comes to understand that there is a difference between itself and its mother by recognizing itself in the mirror. To compensate for the new sense of a lack of wholeness and union with the mother, the child sees the mirror reflection as an ideal image. The moment is one of both an illusion of wholeness and an apprehension of a divided self, a moment of recognition and misrecognition. For a brilliant discussion of Lacan's mirror stage see Elizabeth Grosz, *Jacques Lacan: A Feminist Introduction*, New York: Routledge, 1990, pp. 34–41. See also Jurgis Baltrušaitis, *Le Miroir Rélocations, science-fiction et fallacies*, Paris: Éditions du Seuil, 1978.

13. See Baltrušaitis, *Anamorphic Art*, trans. W. J. Strachan, New York: Harry N. Abrams, Inc., 1977.

Abigail Solomon-Godeau

The Armed Vision Disarmed

1. *The New Vision: Forty Years of Photography at the Institute of Design* (Millerton: Aperture, 1982), 10.

2. Ibid.

3. Alexander Rodchenko, 'Against the Synthetic Portrait, for the Snapshot' (1928), reprinted in *Russian Art of the Avant-Garde: Theory and Criticism 1902–1934*, ed. and trans. John E. Bowlt (New York: The Viking Press, 1976), 167.

4. 'Contemporary Art and the Plight of Its Public,' in Leo Steinberg, *Other Criteria* (New York: Oxford University Press, 1979), 5.

5. The comparison is often drawn between the critical methods of the Russian Formalists and the contemporary work of the American New Critics. Addressing this correspondence, Fredric Jameson has written: 'While both the American and Russian critical movements are contemporaneous with a great modernistic literature, although both arise in part in an attempt to do theoretical justice to that literature, the Formalists found themselves to be contemporaries of Mayakowsky and Khlebnikov, revolutionaries both in art and politics, whereas the most influential literary contemporaries of the American New Critics were called T. S. Eliot and Ezra Pound. This is to say that the familiar split between avant-garde art and left-wing politics was not a universal, but merely a local, Anglo-American phenomenon.' *The Prison House of Language* (Princeton: Princeton University Press, 1972), 44. The

standard text in English on the Russian Formalists is Victor Erlich, *Russian Formalism* (Gravenhage: Mouton, 1955).

6. Alexander Rodchenko, 'From the Easel to the Machine,' reprinted in *Rodchenko and the Arts of Revolutionary Russia*, ed. David Elliott (New York: Pantheon Books, 1979), 8.

7. [For a thorough, thoughtful, and provocative discussion of the evolution from constructivism to productivism, with particular attention given to Rodchenko's problematic career, see Benjamin H. D. Buchloh's 'From Faktura to Factography,' in *October 30* (Fall 1984), 83–120.]

8. Osip Brik, 'From Pictures to Textiles,' in Bowlt, *Russian Art of the Avant-Garde*, 245.

9. Andrei B. Nakov, 'Le Rétour au matériaux de la vie,' in *Rodchenko* (Paris: Arc 2, Musée de l'Art Moderne de la Ville de Paris, 1977), n.p., my translation.

10. Cited in Bowlt, *Russian Art of the Avant-Garde*, 152.

11. Cited in Alexander Lavrentiev, 'Alexander Rodchenko,' in Elliott, *Rodchenko and the Arts of Revolutionary Russia*, 26.

12. [See Buchloh, 'From Faktura to Factography,' for an excellent discussion of the Worker's Club and Pressa exhibitions. At least two other monographs on Rodchenko have appeared since the writing of this essay: S. O. Kahn-Magomedev, *The Complete Rodchenko* (Cambridge: The MIT Press, 1986), and Alexander Lavrentjev, *Rodchenko Photography* (New York: Rizzoli, 1982).]

13. A valuable discussion of strategies of photographic defamiliarization may be found in Simon Watney, 'Making Strange: The Shattered Mirror,' in ed. Victor Burgin, *Thinking Photography* (London: Macmillan Press, 1983), 154–76.

14 The influence of Dziga Vertov on Rodchenko was immense, as indeed it was on most of the radical Soviet avant-garde. Rodchenko worked with Vertov on several projects, including the design of the titles for *The Man with a Movie Camera* and posters for Vertov's *Kino-Pravda*.

15. Both quotations from Bowlt, *Russian Art of the Avant-Garde*, 167.

16. Cited in Elliott, *Rodchenko*, 24. A selection of the letters between Rodchenko, Boris Kushner, and others, debating the implications of photographic point of view and staking out the terms of conflict between radical formalism and other positions including socialist realism, may be found in *Creative Camera International Yearbook*, ed. Colin Osman (London: Gordon Fraser, 1978). Victor Burgin examines the implications of these debates for photographic theory in his essay 'Photography, Phantasy, Function,' in Burgin, *Thinking Photography*, 177–216.

17. Cited in John Willett, *Art and Politics in the Weimar Period: The New Sobriety, 1917–1933* (New York: Pantheon Books, 1978), 76.

18. Cited in Herbert Molderings, 'Urbanism and Technological Utopianism: Thoughts on the Photography of the Neue Sachlichkeit and the Bauhaus,' in *Germany: The New Photography, 1927–1933*, Selected and Ed. by David Mellor (London: Arts Council of Great Britain, 1978), 89.

19. Ibid., 92.

20. Ibid., 93. However, it is important to distinguish between advertising practices developed in the Soviet Union and those in Weimar Germany. Discussing the advertising work produced by the artistic partnership of Mayakowsky and Rodchenko, Szymon Bojko has indicated, in effect, why this advertising practice may not be compared with the advertising industry of Germany or the U.S.: 'The need for visual advertising appeared as a result of the coexistence on the national scene of the nationalised and private sectors. The real sense of NEP advertising was not so much commercial, since there was still a scarcity of goods, but for propaganda purposes. The aim was to stress the dominating role of the nationalised commerce and services. In this way Mayakowsky understood advertising and he wrote propaganda poems and slogans for it. . . . All Moscow was dominated by products of the partnership who signed themselves as "advertising constructors." ' Szymon Bojko, 'Productivist Life,' in Elliott, *Rodchenko*, 81.

21. Carl Georg Heise, preface to *Die Welt ist Schön*, in Mellor, *Germany: The New Photography*, 9.

22. Ibid., 10.

23. Ibid., 14.

24. Walter Benjamin, 'A Short History of Photography,' ibid., 72.

25. Cited in Reyner Banham, *Theory and Design in the First Machine Age* (Cambridge: The MIT Press, 1981), 313. The use of the telephone to order the paintings may, however, have been a retrospective invention, according to Lucia Moholy, Moholy's long-suffering first wife/editor/darkroom assistant: 'When the panels, carried out in an enamel technique on a metal base, among them three different sizes of identical colours and composition, were finally delivered [by the enamel factory], Moholy-Nagy was satisfied, more than satisfied: he was enthusiastic. . . . His buoyancy exceeded all bounds. . . . It did not surprise me, therefore, when, overcome by emotion, he exclaimed – I distinctly remember the timbre of his voice on this occasion – "I might even have done it over the telephone!" ' Lucia Moholy-Nagy, *Moholy-Nagy: Marginal Notes* (Krefeld: Scherpe Verlag, 1972), 75–76. Thanks to Christopher Phillips for this reference.

26. Karel Teige, cited in *Bauhaus 1919–1928*, eds. Herbert Bayer, Walter Gropius, and Ilse Gropius (New York: The Museum of Modern Art, 1952), 91.

27. László Moholy-Nagy, 'Photography Is the Manipulation of Light,' reprinted in Andreas Haus, *Moholy-Nagy: Photographs and Photograms* (New York: Pantheon Books, 1980), 47.

28. Cited in *The New Vision*, 16–17.

29. Moholy-Nagy, *Painting, Photography, Film* (Cambridge: The MIT Press, 1969), 28. Originally published as *Malerei, Fotographie, Film*, vol. 8, Bauhausbüchen. For a suggestive and provocative discussion of the implications of the prevalent view of the camera as a supplement to optical vision, see Rosalind Krauss, 'Jump Over the Bauhaus,' *October 15* (Winter 1980), 103–10.

30. Between Moholy's departure from the Bauhaus in 1928, and his appointment as director of the New Bauhaus in Chicago, it seems probable that his politics, professional ambitions, and art practice were all variously transformed. In Amsterdam, where he initially emigrated in 1934, he worked primarily as an advertising photographer and a design consultant. Supported by Sir Herbert Read, the following year he moved to London, where he designed window displays for Simpson's of Piccadilly, and worked as a graphic designer for British Royal Airlines and London Transport. He also designed the (never used) light decorations for Alexander Korda's film *The Shape of Things to Come* and produced three photographically illustrated books.

31. Arthur Siegel, 'Photography Is,' *Aperture*, vol. 9, no. 2 (1961), n.p. This special issue of the magazine entitled 'Five Photography Students from the Institute of Design, Illinois Institute of Technology,' contained portfolios by Ken Josephson, Joseph Sterling, Charles Swedlund, Ray K. Metzker, and Joseph Jachna.

32. *Harry Callahan*, ed. and with an introd. by John Szarkowski (Millerton: Aperture in association with the Museum of Modern Art, 1976), 12.

33. Ibid., 11.

34. Ibid.

35. Helen Gee, *Photography in the Fifties: An American Perspective* (Tucson: The Center for Creative Photography, 1980), 5.

36. Szarkowski, *Callahan*, 9.

37. For a detailed discussion of the de-Marxification of the American art-world intelligentsia, and the rapprochement of the abstract expressionist program with Cold War liberalism see Serge Guilbaut's 'The New Adventures of the Avant-Garde in America,' *October 15* (Winter 1980). [This essay has since been incorporated in Guilbaut's book *How New York Stole the Idea of Modern Art from Paris: Abstract Expressionism, Freedom, and the Cold War* (Chicago: University

of Chicago Press, 1983).] See too the following essays relevant to the political uses of abstract expressionism and its relation to Cold War liberalism: Eva Cockcroft, 'Abstract Expressionism: Weapon of the Cold War,' *Artforum* no. 12 (June 1974), 39–41; Carol Duncan and Alan Wallach, 'MoMA: Ordeal and Triumph on 53rd Street,' *Studio International*, vol. 194, no. 1 (1978), 48–57; Max Kozloff, 'American Painting during the Cold War,' *Artforum*, 13 (May 1973), 43–54; Jane DeHart Matthews, 'Art and Politics in Cold War America,' *American Historical Review*, vol. 81, no. 41 (October 1976), 762–87; David and Cecile Shapiro, 'Abstract Expressionism: The Politics of Apolitical Painting,' *Prospects*, vol. 3 (1976), 175–214.

38. I am thinking here, for example, of Walker Evans's two-year association with the Farm Security Administration, Berenice Abbott's WPA-funded documentation of *Changing New York*, and Paul Strand's involvement with Frontier Films.

39. Andy Grundberg, 'Photography, Chicago, Moholy, and After,' *Art in America*, vol. 64, no. 5 (September–October 1976), 34.

40. Ibid., 35.

41. Aaron Siskind, 'Credo,' in *Photographers on Photography*, ed. Nathan Lyons (New York: Prentice-Hall, 1966), 98.

42. Aaron Siskind, from 'Photography as an Art Form,' an unpublished lecture delivered at the Art Institute of Chicago (November 7, 1958), printed in Lyons, *Photographers on Photography*, 96.

43. Aaron Siskind, 'Thoughts and Reflections,' interview in *Afterimage*, vol. 1, no. 6 (March 1973), 2.

44. Ibid.

Carol Squiers

Looking at Life

1. Otha C. Spencer, 'Twenty Years of *Life*: A Study of *Time, Inc.'s* Picture Magazine and its Contributions to Photojournalism' (unpublished Ph.D. dissertation, School of Journalism, University of Missouri, 1958), p. 102, quoting Paul Deutschman's unpublished history of *Life*'s first ten years.

2. W. A. Swanberg, *Luce and His Empire*, New York: Charles Scribner's Sons, 1972, p. 15.

3. Swanberg, p. 57, quoting a *New York Herald-Tribune* notice.

4. Swanberg, p. 59.

5. Swanberg, p. 60.

6. John Kobler, *Luce: His Time, Life and Fortune*, New York: Doubleday & Co., 1968, p. 57.

7. John K. Jessup (ed.), *The Ideas of Henry Luce*, New York: Atheneum, 1969, p. 42.

8. Kobler, p. 5.

9. Swanberg, p. 145.

10. Swanberg, p. 91.

11. Wilson Hicks, *Words and Pictures*, New York: Harper & Brothers, 1952, p. 85.

12. Kobler, p. 105.

13. Swanberg, p. 145.

14. Hicks, p. 42.

15. Roland Barthes, *Camera Lucida*, trans. Richard Howard, New York: Hill and Wang, 1981, p. 38.

16. Hicks, pp. 60–61.

17. Hicks, p. 79.

Andrea Fisher

A Crisis in the Intimate

1. Dorothea Lange contributed to the file from 1935 to 1939, Marion Post Wolcott from 1938 to 1942, Louise Rosskam from 1940 to 1943, Martha Macmillan during 1941, Marjorie Collins from 1942 to 1943, Pauline Ehrlich during 1944, Ann Rosener from 1942 to 1943, and Esther Bubley from 1941 to 1943.

2. *One* of Esther Bubley's images is reproduced in Roy Stryker and Nancy Woods, *In This Proud Land: America 1935–1945, as seen in the FSA Photographs* but is passed over without mention in the text.

3. In 1938, photographs which Walker Evans had taken for the FSA were presented alone by the Museum of Modern Art in New York under the title 'American Photographs.' And in 1936 and 1939, Berenice Abbott's pictures of New York, taken as documentary for the Work Progress Administration under the New Deal, appeared in Museum of Art exhibitions entitled 'New Horizons in American *Art*' and '*Art* of Our Time.'

4. William Stott, *Documentary Expression and Thirties America*, Oxford University Press, New York, 1973, pp. 78–9.

5. James Agee and Walker Evans, *Let Us Now Praise Famous Men*, Houghton Mifflin, Boston, 1929, reprinted 1980, p. 11 and p. 13.

6. For more extensive discussion see W. Kozol, 'The Ideology of Gender and the Farm Security Administration,' unpublished thesis, 1985, UCLA.

7. Ruth Milkman, 'Women's Work and Economic Crises: Some Lessons of the Great Depression,' *Review of Radical Political Economy*, Vol. 8, No. 1, 1976, pp. 75–7.

8. For example, cover *Labor Defender: America's Only Labor Pictorial*, February 1934.

9. Ibid., '1,250,000,' April 1930.

10. Ibid.

Lee Miller

The Siege of St Malo

1. This note is hand-written in dark blue ink with a dip pen on two sides of a 133 × 103mm scrap of (French?) paper, much folded.

2. Lee was almost certainly unaware this was in fact one of the first ever strikes using Napalm which was still top secret. When her film was developed by *Vogue* back in London the negatives were confiscated by the censor, but later returned.

Jan Zita Grover

Star Wars

1. Fox Butterfield, *The New York Times Magazine* (Feb. 13, 1983), pp. 26–35, 45–51.

2. The tenor of these fictions can be suggested here by noting that 'Zebra's Men's Adventures' also publishes a mercenary series (*Bush Warfare, Death Lust!*, etc.), 'The Survivalist Series' (*The Nightmare Begins, The Doomsayer*, etc.), and a Samurai series (*Samurai Steel, The Sword of Hachiman*).

3. Philip Caputo, *Horn of Africa* (New York, 1980; repr. New York: Dell, 1981), p. 381.

4. Although the use of Vietnam atrocity photographs to reinforce opposition to the war is well known, there also exists a Pentagon-supplied photostory that ran in William F. Buckley's right-wing *National Review* – 'Vietnam: "The Photographs We're Never Asked For..."' (Oct. 18, 1966), pp. 1048–51: 'When *National Review* approached the Pentagon to secure photos of Vietcong atrocities, an official said, "You're the first people who ever asked for these." The photos on these four pages are clear – and, we know, sickening – evidence of atrocities outlawed by all laws of war, which have left Vietnam covered with butchered and desecrated corpses.' The photographs, of course, could plausibly represent either American or Vietnamese atrocities, or both.

5. *Death in the Making: Photographs by Robert Capa and Gerda Taro*, translated by Jay Allen (New York: Covici-Friede, 1938). A horribly apt title; Capa's co-author and lover, Gerda Taro, was crushed by a tank during a Loyalist retreat while the book's photographs were being made.

6. One can look, *e.g.*, at the Crimean War photographs of Fenton, Robertson, Beato, and Langlois; the Civil War coverage of American photographers; the work of Jimmy O'Hare in Cuba and during the Japanese-Russian War; and at the National Archives photographs of the First World War and see essentially this same approach used again and again.

7. Capa, *Image of War* (New York: Grossman Publishers, n.d.), p. 78.

8. The use of these photographers' work in the popular press – *e.g.*, *Life*, *Look*, Paris *Match*, *Du*, etc. – is another story, one in which the ideologies of publishers, editors, and picture-services, as well as national political and social climates play a profound role. Here I am aiming at a far more modest goal: an understanding of the rhetorical strategies of photos/text in publications largely controlled by the photographers themselves.

9. David Douglas Duncan's *War without Heroes* (1970) employs the conventions of photographer-as-witness with the telling exception of the irony that is otherwise so pervasive in booklength coverage of the Vietnam War. In some ways, Duncan's attitudes toward war seem closer to a pre-World War One idealism. Marc Riboud's *Face of North Vietnam* (New York: Holt, Rinehart and Winston, 1970) treats the war only by implication, concentrating instead on showing us the 'human side' of 'an unknown enemy.' 'Freed from any national inhibitions,' as the cover copy describes him, Riboud creates an ethical appeal through personalizing his subjects. Only the text by Philippe Derillers develops the book's polemic explicitly.

10. John Morris, 'John Morris: A Photographic Memoir,' *Exposure*, Vol. 20, No. 2 (Spring 1982), p. 28.

11. John Morris, 'Preface,' *And/Or* (New York: Harper & Row, 1967), p. 7. The echo in Morris's words of Steichen's 1955 'Family of Man' exhibition is no coincidence; both men shared a vision of photography as a means of fostering a pan-humanism. 'People are people the world over,' as Morris put it.

12. Morris, p. 7.

13. *E.g.*, many of the domestic shots were made in the 1950s and so had absolutely nothing to do with the differences between peace and war in the 1960s.

14. John Morris piously asserts that 'The Peace pictures were taken Here – back home. . . . Some are far from placid, for the book does not make the soporific assumption that Peace is the potion that automatically dissolves all ills.' However, only two of the domestic images imply a less than rosy suburban image of American life: Ken Heyman's expressionless Latino waif behind broken windows and Danny Lyon's photograph of a black civil-rights marcher in the stranglehold of a white policeman. So much for the minority dream stateside; in white middle-class America, though, there's plenty o'peace.

15. *New York Times Book Review* (Oct. 8, 1967), p. 42.

16. Morris, p. 7.

17. Both *Newsweek* and *Time* published summary portfolios of war photographs: 'A War without Winners' (*Newsweek*, Feb. 5, 1973, p. 19), 'Remembrance of Things Past' (*Newsweek*, May 5,

1975, pp. 36–42), and 'Photos that Brought the War Home' (*Time*, Nov. 6, 1972, pp. 20–21). Both *Newsweek* articles included the photographs of police-chief Loan, the Larry Burrows wounded G.I., the Sawada fleeing family, and Robert J. Ellison's marines entrenched at Khe Sanh. The *Time* gallery included the same Burrows, Sawada, burning monk, and Haeberle My Lai shots as *Newsweek*. See also 'Pictures to Remember,' *The Nation* (Feb. 19, 1968), p. 229.

18. Paul Fussell, 'The War as Ironic Action,' *The Great War and Modern Memory* (New York and London: Oxford University Press, 1975), pp. 7–8, 35.

19. *Anatomy of Criticism* (1957; repr. Princeton: Princeton University Press, 1971), p. 41.

20. Ibid.

21. See, *e.g.*, Michael J. Arlen, 'Living-Room War' (*New Yorker*, 1966), 'Television's War,' 'A Day in the Life,' 'Television and the Press in Vietnam; or, Yes, I Can Hear You Very Well – Just What Was It You Were Saying?' (all *New Yorker*, 1967), repr. in Arlen, *Living-Room War* (New York: Penguin Books, 1969), and Arlen, 'The Falklands, Vietnam, and Our Collective Memory,' (*New Yorker*, Aug. 16, 1982, pp. 70–75). In this latest meditation on war and television, Arlen speculates (p. 73) on the mutual co-opting of the military and press, the results of which in Vietnam were a largely 'stylized, basically distanced overview of a distant conflict which was composed largely of scenes of helicopters landing, tall grass blowing in the helicopter wind, American soldiers fanning out across a hillside on foot' – in other words, *a scenario*, nightly, narcotically repeated. *Cf.* Michael Herr, *Dispatches* (1977, repr. New York: Avon Books, 1980), pp. 199–201 and 223–26, for another description of the Vietnam War-as-a-movie.

22. Herr, pp. 223–24.

23. Morley Safer, the CBS television correspondent in Vietnam, was singled out by Michael Arlen (*New Yorker*, Aug. 16, 1982, p. 73) for his singular willingness to visit hot spots in the war and to appear on-camera looking frightened and human – affected by what he saw. Safer reviewed Duncan's paen to the U.S. Marines in Vietnam, *War without Heroes*, for *Saturday Review* (March 27, 1971, p. 34) and remarked of it: 'David Douglas Duncan's photographs do not shock, nor do they illuminate. The text does not advance one's knowledge of Vietnam, of the war, or of the conflicts that beset the men fighting it . . . here we see pictures of war without discrimination. They tell us less than the brief film excerpts included in the television newscasts. *War without Heroes* is in fact no better and no worse than the divisional yearbooks that military units publish and sometimes pressgang the troops into buying.'

24. *Death in the Making*, captions to close-ups of faces, n.p.: 'They grew up together in the villages, worked side by side in the shops, the laboratories, and now fight side by side to hold what they won. They laugh often at memories of the past and when they talk of the future they smile proudly.'

25. Page, *Nam* (New York: Alfred A. Knopf, 1983), p. 32.

26. See, *e.g.*, Jury, pp. 18–19, 67, 100; Griffiths, pp. 182–83; Page, pp. 27, 31, 33, 35.

27. See, *e.g.*, Griffiths, pp. 8–9, 158–59, 164–65.

28. Ibid., pp. 156–57, 158–59.

29. Ibid., p. 4.

30. Ibid., p. 98.

31. Peter S. Prescott, 'The Private War,' *Newsweek* (Nov. 1, 1971), p. 92. Griffiths was also reviewed in America by the *Library Journal* (1972) and in England by Richard West, 'Goya in Vietnam,' *New Statesman* (March 3, 1972), p. 283. West, who worked as a correspondent in Vietnam alongside Griffiths, remarks that Henri Cartier-Bresson called Griffiths's work 'the greatest description of war since Goya.'

32. Reactions to Griffiths's book (rather than to his photographs) are still mixed: of two photojournalists who know and have worked with Griffiths whom I interviewed at 'The War

Show,' one feels that *Vietnam, Inc.*'s text is 'regrettable' because it 'blew Griffiths's credibility as a reporter,' while the other felt it was 'admirable [because] it advanced a point-of-view, something that photojournalists are not exempt from and need to have to be good.'

33. Jury, p. 4.
34. *E.g.*, Jury, pp. 11, 13, 14, 21, 43 . . .
35. Ibid., pp. 74–75.
36. Ibid., p. 15: 'The fact that they wear love beads and peace medallions doesn't mean that they can't fight. . . . Often their opposition to the military has nothing to do with the moral aspects of Vietnam. It's just that they pick up a battered copy of *Life* magazine and see everybody else skinny-dipping at Woodstock, and that's a hell of a lot better than "greasing gooks," fighting malaria, and maybe going home in a plastic bag.' If Jury is to be believed, the discontent fomented by photojournalism during the war didn't flow only from Vietnam to the U.S.; it was a two-way street.
37. Herr, pp. 252–53, 254. In his haute-hype introduction to Page's *Nam*, William Shawcross says that 'things began to look up [for Page] in 1977 with the publication of Michael Herr's Vietnam book, *Dispatches*. Page is one of the main characters and, as he himself says, the success of the book began to mythologize him. . . . *Dispatches* led to a revival of interest in Page's work.'
38. Herr, p. 252.
39. Page, p. 51.
40. Ibid., p. 21.
41. Ibid., p. 73.
42. Griffiths, pp. 194–99.
43. Page, p. 77.
44. The heightened contrast and unpretty color of Meiselas's color xeroxes give them more bite than the sensual color reproductions in the published work.
45. Tim Page was slated to participate in 'The War Show' but declined at the last minute because of the March 1983 publication-date of *Nam*.
46. As a point of interest, in 1977 Charles Desmarais, now director of the California Museum of Photography at the University of California/Riverside, assembled a large number of snapshots from Vietnam, using the same methods of solicitation that Barlow did. Desmarais's slides from these photographs were shown in Los Angeles the week after 'The War Show' opened during a Vietnam veterans' conference held at the University of Southern California.

Mary Warner Marien

What Shall We Tell the Children?

1. The current edition of *The History of Photography* (1982) is referred to as the fifth edition by Newhall in his preface, and is cited here as Newhall V. Other editions are *The History of Photography* (1964), cited as Newhall IV; *The History of Photography* (1949), Newhall III; *Photography: A Short Critical History* (1938), Newhall II; and the original catalogue, *Photography: 1839–1927*, Newhall I.
2. Lewis Mumford, 'The Art Galleries: Prints and Paintings,' *New Yorker*, April 3, 1937, p. 67.
3. In 'The Judgment Seat of Photography' (*October*, no. 22, Fall 1982, pp. 27–63), Christopher Phillips provides a lengthy assessment of the 'cultural transformation of photography into a museum art,' and Beaumont Newhall's involvement with the process. I agree with Phillips's

finding about the 'formal isolation and cultural legitimation of . . . photography,' but not with his assessment of the role Newhall's history texts have had in it. Phillips throws a wider net, including Newhall's other books and his museum work; I have tried to assess the general histories. Still, we read some of the same material differently.

4. Newhall I, p. 41.

5. Ibid., p. 75.

6. Ibid., p. 44.

7. Ibid., p. 45.

8. Newhall II, p. 9.

9. Mumford, 'The Art Galleries: Prints and Paintings,' p. 67.

10. From the March 1975 interview with Beaumont Newhall published in Paul Hill and Thomas Cooper, *Dialogue with Photography* (New York: Farrar/Straus/Giroux, 1979), p. 392, hereinafter cited as *Dialogue*.

11. Newhall III, p. 152.

12. Ibid., p. 166.

13. The term is not original with Hal Foster, Newhall quotes John Grierson's use in *On Documentary* (1946) in the last three editions of his *History*.

14. Newhall III, pp. 174, 178.

15. Ibid., p. 74.

16. Ibid., p. 211.

17. Ibid., p. 225.

18. Newhall IV, p. 197.

19. Ibid., p. 200.

20. Edgar Wind, 'The Mechanization of Art,' in *Art and Anarchy* (New York: Alfred A. Knopf, 1964), pp. 68–84.

21. He has, of course, published a book of readings titled *Photography: Essays and Images* (1980).

22. Newhall V, p. 85.

23. Newhall IV, p. 161.

24. Newhall II, p. 9.

25. Newhall V, p. 173.

26. Ibid., p. 294.

27. Ibid., p. 292.

28. *Dialogue*, p. 405. It is interesting to note that Newhall illustrates Moholy-Nagy with a photomontage and ink work in the 1982 edition.

29. Abigail Solomon-Godeau, 'Winning the Game When the Rules Have Been Changed – Art Photography and Postmodernism,' *Screen* 25, no. 6 (Nov.–Dec. 1984): p. 94, reprinted on pp. 305–17 of this volume.

30. Beaumont Newhall, 'Documentary Approach to Photography,' *Parnassus* X, no.3 (March 1938): p. 3.

31. Ibid., p. 4.

32. Ibid.

33. Ibid., p. 5.

34. Beaumont Newhall, 'Program of the Department,' *Bulletin of the Museum of Modern Art* VIII (Dec.–Jan. 1940–41): p. 4.

35. See, for example, Larry Schaaf, 'A Classic Revisited,' *History of Photography* 7, no. 4 (Oct.–Nov. 1983): p. 330.

36. Rosenblum, p. 10.

37. Ibid., p. 601.

38. Ibid., p. 157.

39. Ibid., p. 10.

40. In *History of Photography* 8, no. 4 (Oct.–Dec. 1984): pp. 249–75.

41. Rosenblum, p. 495.
42. *Dialogue*, p. 402.
43. See, for example, A. Hyatt Mayor in *Magazine of Art* 44 (April 1951): p. 157, and *American Artist*, no. 29 (Feb. 1965): p. 20.
44. A celebrated case is A. D. Coleman's complaint that Newhall neglected the work of William Mortensen. See A. D. Coleman, *Light Readings: A Photography Critic's Writings, 1968–1978* (New York: Oxford University Press, 1979), p. 256 n.
45. *Dialogue*, p. 405.
46. Ibid., p. 399.
47. Roger Scruton, 'Photography and Representation,' *Critical Inquiry* 7, no. 3 (Spring 1981): p. 602.
48. *Times Literary Supplement*, Jan. 3, 1986, p. 5.
49. Newhall I, p. 40.
50. See Alan Trachtenberg's account of the problem in 'The American West Comes Out of the Closet – Partially,' *American Quarterly* 37, no. 2 (Summer 1985): p. 306.
51. David E. Nye, *Image Worlds: Corporate Identities at General Electric, 1890–1930* (Cambridge, MA: MIT Press, 1985). See pp. 161 n. 1, 164 n. 1. Incidentally, Nye didn't find Barthes helpful either.
52. Andy Grundberg, 'Two Camps Battle over the Nature of the Medium,' *New York Times*, Aug. 14, 1983, sec. H, p. 24.

Val Williams

Crowned with Thorns

1. Peter Jay and Peter Turner were interviewed for the British Library National Archive's Oral History of British Photography project.

Catherine Lord

What Becomes a Legend Most

1. Letter to Robert Benton, art director of *Esquire* (c. October 1959), quoted in Thomas W. Southall, 'The Magazine Years: 1960–1971,' in *Diane Arbus: Magazine Work*, ed. Doon Arbus and Marvin Israel (Millerton, NY: Aperture, 1984), p. 156, hereafter referred to as *Magazine Work*.
2. I quote Anonymous, the Knopf copywriter who provided the dustjacket blurb for *Diane Arbus: A Biography*, by Patricia Bosworth (New York: Knopf, 1984), and, respectively, from the dustjacket of *Magazine Work*, Peter Bunnell, Hilton Kramer, and John Szarkowski. In 1978 Esther Luttikhuizen marketed as soft sculptures both *Identical Twins* and *Prom Couple (New York Times*, November 20, 1978). Arbus, Marilyn Monroe, Billie Holiday, Virginia Woolf, Janis Joplin, and Sylvia Plath were the subjects of the 1974 play *Disquieting Muses* reviewed in the *New York Times*, February 21, 1974). MGM, which bought the rights to the Bosworth book, reportedly asked Diane Kurys, of *Entre Nous*, to direct the feature. See *New York Times*, January 29, 1984, and Liz Smith in the *Daily News*, June 20, 1984, for more trade gossip.
3. Diane Arbus, 'Hubert's Obituary: Or This Was Where We Came In,' unpublished text, 1966, *Magazine Work*, p. 80.

4. Laura Mulvey, 'Visual Pleasure and Narrative Cinema,' *Screen* 16:3 (Autumn 1975), p. 7.

5. Unless otherwise indicated, the information in this section is drawn from my entry for Diane Arbus in *Notable American Women: The Modern Period*, ed. Barbara Sicherman and Carol Hurd Green (Cambridge: Harvard University Press, 1980). The information about Renée Sparkia's career is taken from Bosworth, pp. 117–19.

6. Bosworth (p. 68) says that David Nemerov provided only a fraction of the equipment he had promised; she offers no documentation for the statement. In Allan Arbus's account, David Nemerov helped them enormously. (Interview with the author, September 12, 1977.) In Howard Nemerov's version, Allan Arbus 'from early on after the War felt fashion photography as a burden, part entailed by his family's staking him to all that expensive equipment when he got out of the Army.' (Letter to the author, October 28, 1977.)

7. Confusion remains about all these dates in the late 1950s. Bosworth dates Arbus's study with Model to 1958; Allan Arbus (ibid.) to 1959; Southall to 1957. The latter date, given Southall's access to Arbus's records, seems the most reliable. It is not clear when Diane Arbus actually moved to her own apartment. Southall doesn't mention it; Bosworth fudges it. Arbus had moved, certainly, by the early months of 1960.

8. 'The Vertical Journey: Six Movements of a Moment within the Heart of the City,' *Esquire* (July 1960), pp. 102–7, and 'The Full Circle,' *Harper's Bazaar* (November 1961), pp. 133–37, 169–73.

9. Documentation for the exhibition was provided by Allan Porter, 'The John Simon Guggenheim Memorial Foundation: Fellows in Photography, 1937–1965,' *Camera* (April 1966). There had been, then, a total of 30 fellows. Lest 1937 seem an arbitrary date, remember that it was the year the first Guggenheim was awarded to a photographer, who happened to be Edward Weston.

10. 'Telling It As It Is,' unsigned, *Newsweek* (March 20, 1967), p. 110. *Newsweek* also codified the nice-rich-girl-courts-danger motif: 'I'm a little foolhardy rushing in to explore all these freaky things, but dangers of violence – rape, murder – are more moving and less frightening than making a living at fashion photography.' In addition, Jacob Deschin reviewed the show for the *New York Times* (March 5, 1967); Chauncey Howell for *Women's Wear Daily* (March 2, 1967); Max Kozloff for *The Nation* (May 1, 1967); and Marion Magid for *Arts Magazine* (April 1, 1967).

11. Doon Arbus, 'Diane Arbus: Photographer,' *Ms.* (October 1973), pp. 43–53.

12. A transcript of the class is in the archives of the Visual Studies Workshop, Rochester, NY. The Terkel interview (December 1969) is in the archives of WFMT, Chicago, and is quoted here courtesy of WFMT.

13. *Picture Magazine* 16 (1980), provides these statistics. Robert Stevens's 'The Diane Arbus Bibliography,' *Exposure* 15:3 (September 1977) is an invaluable, annotated summary of Arbus's press coverage.

14. Marvin Israel, 'Diane Arbus,' *Creative Camera* (May 1974), pp. 164–73. See also Peter C. Bunnell, 'Diane Arbus,' *Print Collectors Newsletter* 3:6 (January–February 1973), p. 130.

15. *Picture Magazine* 16 (1980). The claim of a scoop is not, strictly speaking, true: at least two of the photographs had been published in mass-circulation magazines, as opposed to the art press: though the photographs appear untitled in *Picture*, Arbus had photographed Mrs. T. Charlton Henry and Amy Arbus for *Harper's Bazaar*. See *Magazine Work*, pp. 31, 70–71.

16. Douglas Davis, 'Two Faces of Arbus,' *Newsweek* (October 22, 1984).

17. Terkel interview.

18. Griselda Pollock, 'Artists, Mythologies and Media – Genius, Madness and Art History,' *Screen* 21:3 (1980), pp. 58–59.

19. In scanning Bosworth's footnotes, I found no mention of, for example, Susan Sontag's 'Freak Show,' *New York Review of Books* (November 15, 1973), revised and reprinted as 'America, Seen through Photographs, Darkly,' in *On Photography* (New York: Farrar, Straus and

Giroux, 1977), or Hollis Frampton's 'Incisions in History/Segments of Eternity,' *Artforum* (October 1974).

20. Bosworth cites an interview she conducted with Model, but she seems to rely mostly on an unpublished, undated interview conducted by Phillip Lopate.

21. Symptomatically, Bosworth never fails to remind us, with ghoulish precision, of lost investment opportunities in the photo print market: for example, if you'd bought a Model for $15.00 in the mid-50s, it would be worth $1000 now (p. 127).

22. Terkel interview. Arbus uses the phrase to describe Russek's, and, by implication, the entire milieu in which she grew up.

23. Anne W. Tucker, in 'Arbus Through the Looking Glass,' *Afterimage* 12:8 (March 1985), pp. 9–11, is quite clear about Bosworth's factual errors.

24. In addition, the nudist camp photographs were commissioned, partially paid for, and unpublished by *Esquire*, which also commissioned, and did not publish, a series that yielded *Tattooed Man at a Carnival, Albino Sword Swallower at a Carnival,* and *Girl in Her Circus Costume (Magazine Work,* pp. 164–65, 170). Arbus, judging from her correspondence with Peter Crookston, also tried to sell him on rephotographing the 'Jewish giant' that eventually yielded one of her better-known images.

25. *Magazine Work,* p. 5.

26. 'The Magazine Years: 1960–71,' *Magazine Work,* p. 170.

27. Terkel interview.

28. The figures on Arbus's output are from *Magazine Work,* p. 5. The following letter from Doon Arbus to Prentice-Hall is in the archives of the Museum of Modern Art, New York: 'It is very important to me that my mother's photographs be seen as photographs in the context of her own work and those of other photographers, and not as illustrations. Therefore, I have consistently refused to allow them to be reproduced in connection with any books or articles dealing with any subject other than photography itself.' (Doon Arbus to Helen Maertens, July 2, 1975). As I have noted, the Estate of Diane Arbus gave reproduction rights to *Picture Magazine* in exchange for the withholding of a text. A related situation is Shelley Rice's 'Essential Differences: A Comparison of the Portraits of Lisette Model and Diane Arbus,' *Artforum* 18:9 (May 1980), pp. 66–71, which appeared without any illustrations. Ingrid Sischy offered the following editorial explanation: 'There are no illustrations of work by Diane Arbus or Lisette Model to accompany the following analysis by Shelley Rice because permission would be granted only on the condition that the article be read before a permission decision could be reached. *Artforum* is not willing to accommodate compromising stipulations' (p. 66). Sischy's stand was rare; most art publications will go to any length to avoid printing straight text.

<div align="center">

Amy Rule

Tina Modotti: Letters to Edward Weston
</div>

1. *The Daybooks of Edward Weston,* volume 2, p. 108, January 26, 1929.
2. *The Daybooks of Edward Weston,* volume 2, p. 110, February 21, 1929.
3. Mildred Constantine, *Tina Modotti: A Fragile Life,* New York, Rizzoli, 1983, pp. 152–53.

<div align="center">NOTES TO LETTER 29.3</div>

1. Between September 17 and Modotti's previous letter, Weston's solitary life in Carmel had become more crowded and busy. Ramiel McGehee, Sonya Noskowiak, as well as his three sons, Brett, Neil, and Cole, were all staying with him.

2. Modotti may be referring to Tehuantepec, a relatively inaccessible city in Oaxaca, noted for the richness of the Zapotecan culture preserved there. According to Frances Toor's *Guide to Mexico* (New York: Robert McBride, 1936), the town is famous for its beautiful, tall, and talented women, the 'Tehuanas.' Modotti photographed these women on one of her trips to the region. (See also Constantine, pp. 115, 126.)

3. Dr. and Mrs. Witte were friends of Modotti and Weston in Mexico.

4. Modotti exhibited at the Universidad Nacional Autónoma de Mexico in December 1929.

5. Jose 'Pepe' Magrina was arrested and imprisoned briefly for the assassination of Mella.

6. Diego Rivera wrote to Weston later in September asking him to send advice on where to exhibit his paintings in the United States. He added that he was sending a photograph of one of his canvases to Dr. Cecil. (Diego Rivera to EW, September 21, 1929, Edward Weston Archive)

7. Jake Zeitlin, Los Angeles dealer in photographs and rare books.

8. Diego Rivera married Frieda Kahlo (1907–1954) in August 1929. Kahlo was a member of the Mexican Communist Party for many years. The exiled Leon Trotsky stayed in her home from 1937–39. Political involvement did not interfere with her dedication to painting, however, and she continued producing works of painful personal honesty up to her death. In 1982, Whitechapel Gallery in London sponsored a joint exhibition of her paintings and the photographs of Tina Modotti.

NOTES TO LETTER 30.1

1. On February 5, 1930, an attempt was made to assassinate the newly elected president of Mexico, Pascual Ortiz Rubio.

2. This quote from Friedrich Nietzsche, 'What does not destroy me, makes me stronger,' was used later as a motto by the Nazis in Hitler Youth training centers. During the 1920s, Nietzsche was quoted with enthusiasm by members of the avant garde such as Isadora Duncan who used some of his words on the title page of her autobiography. The era's selective reading of Nietzsche produced a foundation for the 'new paganism' but did not incorporate his concepts of authoritarianism that were cherished by later propagandists. Edward Weston, like many of his generation, read Nietzsche. He copied Nietzsche's words in his quotation file that is preserved today in the Weston Archive. Some of them he saved are:

> Artists should not see things as they are: they should see them fuller, simpler, stronger: To this end, however, a kind of youthfulness, of vernality, a sort of perpetual elation, must be peculiar to their lives.
> Art and nothing else! Art is the great means of making life possible, the great seducer to life, the stimulus of life.

3. Manuel Alvarez Bravo came to Modotti's house on the day she was packing to leave the country. He helped her and she gave him some of her photographs.

NOTES TO LETTER 30.2

1. Modotti's stationery is printed with the image of an arrangement of scythe, ear of corn, and bandolier. This photograph was shown in her December 1929 exhibition at the Universidad Nacional Autónoma.

NOTES TO LETTER 30.4

1. During this period, Weston was very busy with exhibitions at galleries in New York and Houston, a project for *Touring Topics* magazine, and with visitors to Carmel such as Mabel Dodge

Luhan and Willard Van Dyke. His daybook records that he was also going through an intense period of refining his ideas on 'essence revealed direct without the fog of impressionism.' (*The Daybooks of Edward Weston*, volume 2, p. 154, April 24, 1930).

2. The use of glass plate negatives versus film negatives in the 1930s in the United States and Europe depended upon the photographer's type of work, attitude to new products, and upon the local availability of flexible film negative stock. Both Marion Palfi and Andreas Feininger, who were working in Germany in the 1930s and whose negative collections are now in the archives of the Center for Creative Photography, were using glass plates *and* film negatives in the 1930s. Edward Weston, Sonya Noskowiak, and Louise Dahl-Wolfe, who were working the United States during the 1930s and whose negative collections are also at CCP, were almost exclusively using film negatives during the same time.

3. 'Estridentistas' were artists and revolutionaries, including Diego Rivera and Luis Quintanilla, whose activities and publications were an expression of the nationalist cultural movement in Mexico in the 1920s. Their first manifesto, issued in 1921, linked them ideologically to futurism in their fondness for literary puns and admiration for technology.

4. Vittorio Vidali, custodian of Tina Modotti's estate in Trieste, stated that only about ten photographs exist from her stay in Berlin. [Vittorio Vidali, *Tina Modotti: Photographs* (Westbury, NY: Belmark Book Co., 1982) p. 31].

5. Modotti gave an informal exhibition of her work in the studio of Lotte Jacobi sometime during this period.

Roberta McGrath

Re-reading Edward Weston

1. Unless otherwise stated, all quotes are Weston's from N. Newhall (ed.), *The Day Books of Edward Weston*, vols. I & II, Aperture, 1973.

2. C. Beaton and G. Buckland, *The Magic Image*, Weidenfeld and Nicolson, 1975, p. 159.

3. C. Duncan, 'Virility and Domination in Early Twentieth Century Avant-garde Art', *Art Forum*, December 1973, p. 36.

4. E. Marks and I. De Courtivron (eds.), *New French Feminisms*, Harvester, 1980, p. 152.

5. S. Freud, 'Femininity', *New Introductory Lectures on Psychoanalysis*, Pelican Freud Library, vol. II, 1972, p. 149.

6. H. Frampton, 'Impromptus on Edward Weston, Everything in its Place', *October* no. 5, 1978, p. 49.

7. N. Newhall (ed.) op. cit., p. x.

8. C. Wilson, *Edward Weston Nudes*, Aperture, 1977, p. 115.

9. R. Coward, *Patriarchal Precedents*, Routledge and Kegan Paul, 1983, p. 1.

10. C. Metz *Psychoanalysis and Cinema*, Macmillan, 1982, pp. 58–60.

11. F. Reyher (ed.), 'Steiglitz–Weston Correspondence', *Creative Camera*, October, 1975, p. 334.

12. C. Wilson, op. cit., p. 8.

13. F. Reyher (ed.), op. cit., p. 335. (It is also well known that it was Steiglitz who stressed the importance of 'straight' photography to Weston in 1922. '. . . a maximum of detail with a maximum of simplification, so Steiglitz talked to me and Jo (Hagemeyer) for hours', Weston File, MOMA, NY.

14. B. Newhall, *Supreme Instants: The Photography of Edward Weston*, Thames and Hudson, 1986.

15. 'Photography has long been considered a mass-production medium from the standpoint of unlimited duplication of prints . . . not the mass-production of duplicates, but the possibility for the mass-production of original work', Weston File, MOMA, NY.

16. For Weston, woman was still in the realm of the imaginary. 'I was meant to fulfil a *need* in many a woman's life as each in turn fertilises etc.', N. Newhall.

17. B. Maddow, 'Venus Beheaded: Weston and His Women', *New York Magazine*, February 24th, 1975.

18. H. Frampton, op. cit., p. 62.

19. Ibid., p. 68.

20. N. Newhall (ed.), op. cit., vol. I, p. 151.

21. L. Mulvey, 'Visual Pleasure and Narrative Cinema', *Screen*, vol. 16, no. 3, 1975, p. 6.

Cynthia Chris

Witkin's Others

1. Angela Carter, *The Sadeian Woman and the Ideology of Pornography* (New York: Pantheon, 1978), pp. 145–146.

2. Roland Barthes, *Camera Lucida: Reflections on Photography* (New York: Hill and Wang, 1981), p. 32.

3. This and subsequent descriptions are derived mainly from a lecture by Joel-Peter Witkin at The School of the Art Institute of Chicago, March 18, 1986. Many are included in the Introduction by Van Deren Coke to the exhibition catalog *Joel-Peter Witkin: Forty Photographs* (San Francisco Museum of Modern Art, 1985).

4. Joel-Peter Witkin, *Joel-Peter Witkin: Photographs* (Pasadena, CA: Twelvetrees Press, 1985), unpaginated.

5. Barthes, p. 33.

6 Carter, p. 23.

7. Paraphrased from Carter, p. 138: 'Flesh has specific orifices to contain the prick that penetrates it but meat's relation to the knife is more random and a thrust anywhere will do. Sade explores the inhuman possibilities of meat; it is a mistake to think that the substance of which his actors are made is flesh. There is nothing alive or sensual about them. Sade is a great puritan and will disinfect of sensuality anything he can lay his hands on: therefore he writes about sexual relations in terms of butchery and meat.'

8. Coke, p. 9.

9. Witkin, unpaginated.

10. Michel Foucault, *The History of Sexuality: volume I: An Introduction* (New York:Random House, 1978), p. 43.

11. *Ibid.*, p. 42.

12. Jean-Paul Sartre, *Saint Genet: Actor and Martyr* (New York: Pantheon, 1983), p.18.

13. *Ibid.*, p. 587.

14. Susan Sontag, *On Photography* (New York: Farrar, Strauss and Giroux, 1977), p. 36.

15. Max Kozloff, 'Contention Between Two Critics About a Disagreeable Beauty', *Artforum 6* (February, 1984), p. 51.

16. Foucault, p. 38

17. In 1986, the United States Supreme Court voted to uphold a Georgia statute that prohibits private oral and anal sex between consenting adults. Twenty-four states have similar laws. At this point in history, canonical and civil law have regained a certain amount of power to enforce a morality that would contain sexuality within conjugality. These laws name the organs of reproduction as the exclusive source of pleasure, and all else as forbidden.

Jan Avgikos

Cindy Sherman: Burning Down the House

1. Andrea Dworkin, letter to the editor, *The New York Times Book Review*, 3 May 1992, p. 15.
2. See Avital Ronell, interviewed by Andrea Juno, *Angry Women*, San Francisco: Re/Search Publications, 1991, pp. 127–53.
3. Pat Califia, *Macho Sluts*, Boston: Alyson Publications, Inc., 1988, p. 16.

Abigail Solomon-Godeau

Winning the Game When the Rules Have Been Changed

1. Douglas Crimp, 'The Photographic Activity of Postmodernism,' *October 15*, Winter 1980, pp. 91–100. An indispensable essay on the subject, to which my own is much indebted. Crimp discusses at some length Levine's position within post-modernist theory and practice. See also Rosalind Krauss, 'The Originality of the Avant-Garde: A Postmodernist Repetition,' *October 18*, Fall 1981, pp. 46–66.
2. The Société Francaise de Photographie, for example, from its inception in 1851 forbade any retouching on the photographic submissions to its regular exhibitions.
3. See in this light, Bernard Edelman, *Ownership of the Image: Elements for a Marxist Theory of Law*, London, 1979.
4. In 1937 the important exhibition on the history of photography was mounted at the Museum of Modern Art which resulted in Beaumont Newhall's now-standard text, *History of Photography*. For a discussion of the significance of this exhibition, see Christopher Phillips, 'The Judgment Seat of Photography,' *October 22*, Fall 1982, pp. 27–63.
5. See Carol Squiers' discussion, 'Photography: Tradition and Decline,' *Aperture 91*, Summer 1983, pp. 27–76.
6. An examination of these two related phenomena may be found in Douglas Crimp's 'The Museum's Old/ The Library's New Subject,' *Parachute 22*, Spring 1981, pp. 32–37.
7. Kate Linker, 'On Richard Prince's Photographs,' *Arts Magazine*, November 1982, pp. 121–123.
8. Richard Prince, *Why I Go to the Movies Alone* (NY, 1984).

Deborah Bright

Of Mother Nature and Marlboro Men

1. J. B. Jackson, 'Concluding with Landscapes,' *Discovering the Vernacular Landscape* (New Haven: Yale University Press, 1984), p. 150.
2. John Stilgoe, *Common Landscape of America, 1580 to 1845* (New Haven: Yale University Press, 1982), p. 24.
3. D. W. Meinig, 'Symbolic Landscapes,' *The Interpretation of Ordinary Landscapes*, ed. D. W. Meinig (Oxford: Oxford University Press, 1979), p. 167.
4. Kenneth A. Erickson, 'Ceremonial Landscapes of the American West,' *Landscape* 22:1, p. 39.
5. Peter J. Schmitt, *Back to Nature: The Arcadian Myth in Urban America* (New York: Oxford University Press, 1969), p. 155.
6. Ibid., p. 148.

7. See Dean MacCannell, *The Tourist: A New Theory of the Leisure Class* (New York: Schocken Books, 1976), p. 45: 'It is the mechanical reproduction phase of sacralization that is most responsible for setting the tourist in motion of his journey to find the true object.'

8. Schmitt, *Back to Nature*, p. 150.

9. Ibid., p. 151.

10. J. B. Jackson, 'A Puritan Looks at Scenery,' *Discovering the Vernacular Landscape*, p. 63.

11. Frederick Turner, 'Cultivating the American Garden,' *Harpers*, August 1985, p. 50.

12. J. B. Jackson, 'Concluding with Landscapes,' p. 148.

13. Andy Grundberg, 'Ansel Adams: the Politics of Natural Space,' *The New Criterion* (November 1984), p. 150.

14. Jonathan Green, 'Aperture in the Fifties: The Word and the Way,' *American Photography: A Critical History 1945 to the Present* (New York: Harry N. Abrams, 1984), p. 71.

15. Jonathan Szarkowski, *American Landscapes* (New York: The Museum of Modern Art, 1981), p. 7.

16. For a succinct summary of the systematic discrimination against women by the photography establishment, see Catherine Lord, 'A Thorn is a Thorn is a Thorn,' *Exposure* 22:2 (Summer 1984), p. 40.

17. William Jenkins, 'Introduction to *The New Topographics*,' reprinted in *Reading Into Photography*, ed. Thomas Barrow et al. (Albuquerque: University of New Mexico Press, 1982), p. 51.

18. Ibid., p. 55.

19. John Szarkowski, *Looking at Photographs* (New York: The Museum of Modern Art, 1973), p. 72. Szarkowski ascribes these words to Henri Daumier, the French visual satirist whose devastating cartoons lampooned the Louis-Philippe government and the bourgeoisie. One can only surmise that Daumier spoke with sarcasm – to mock photography's limitations as a means to reveal political truths. Alas for Szarkowski and the modernists, this has become its great virtue.

20. Jenkins, 'Introduction,' p. 53.

21. Robert Venturi, *Signs of Life: Symbols in the American City* (Washington, D.C.: The Smithsonian Institution, 1976).

22. See Martha Rosler, 'Lookers, Buyers, Dealers, and Makers: Thoughts on Audience,' *Exposure* 17:1 (Spring 1979), pp. 10–25. Reprinted and revised in Brian Wallis, ed., *Art After Modernism* (New York: The New Museum of Contemporary Art, 1984), pp. 311–39.

23. Robert Adams, *Beauty in Photography* (New York: Aperture, 1981), p. 66.

24. For a trenchant review of *Our Lives and Our Children*, see Abigail Solomon-Godeau, *Exposure* 22:3 (Fall 1984), p. 53.

25. See Marx and Engels, *The German Ideology*, 3rd revised edition (Moscow: Progress Printers 1976), pp. 68–69. For the ruling class 'is compelled . . . to present its interest as the common interest of all the members of society, that is, expressed in ideal form: it has to give its ideas the form of universality, and present them as the only rational, universally valid ones.'

26. Michelle Bogre, 'Robert Freidus,' *American Photographer* (November 1984), p. 72.

27. See Gwendolyn Wright, *Building the Dream: A Social History of Housing in America* (Cambridge: The MIT Press, 1981). Also, Dolores Hayden, *The Grand Domestic Revolution* (Cambridge: The MIT Press, 1981), and *Re-designing the American Dream* (New York: Norton, 1984).

28. Peter Beard comes to mind as a contemporary figure who literally combines the personae of great white hunter and great white photographer.

29. *Landscape: Theory* (New York: Lustrum Press, 1980).

30. Charles Desmarais, 'Linda Connor,' *CMP Bulletin* 2:2 (1983), p. 12.

31. Sherry B. Ortner, 'Is Female to Male as Nature Is to Culture?' *Women, Culture and Society*, ed. Rosaldo and Lamphere (Palo Alto: Stanford University Press, 1974), p. 67.

32. Nancy Chodorow, 'Family Structure and Feminine Personality,' *Women, Culture and Society*, p. 43.

33. See Christopher L. Salter, 'The Cowboy and the City: Urban Affection for Wilderness,' *Landscape* 27:3 (1983), p. 43.

34. See Douglas Crimp, 'The Museum's Old/The Library's New Subject,' *Parachute* 22 (Spring 1981), pp. 32–37, and Griselda Pollock, 'Artists Mythologies and Media – Genius, Madness, and Art History, *Screen* 21:3 (1980).

35. As Simon Watney points out, in the average art-photography program 'theory' is almost . . . invariably understood as a *technical* category, covering the study of sensitometry, photo-chemistry, and so on.' Simon Watney, 'Photography-Education-Theory,' *Screen* (January–February 1984), p. 67.

36. Lewis Baltz, 'Landscape Problems,' *Aperture* 98 (Spring 1985).

Jan Zita Grover

Dykes in Context

1. *The Grapevine* (New York: Macfadden-Bartell, 1965).

2. *Sappho: the Art of Loving Women* (New York: Crown Books, 1975).

3. Williams is speaking, in *Culture and Society, 1780–1950* (1953), of the persistence of the idea of past societies better integrated, more peaceful and happy, than the present: utopias projected not into the future but into the past. 'This is, I think,' he says, 'a surrender to a characteristically industrialist, or urban, nostalgia – a late version of medievalism, with its attachments to an "adjusted" feudal society. If there is one thing certain about "the organic community," it is that it has always gone' (p. 259). As a sexual and therefore something of a social outlaw (being female rounding out the triple estrangement from dominant cultural values), I of course favor a somewhat more giddy version of utopia – Monique Wittig's, perhaps – but as a historian, I think I do not confuse Wittig's fantasy with the 1950s and 1960s, when I grew up in San Francisco.

4. Raymond Williams's idea on transformations/contestations within culture, first advanced in *The Long Revolution* (1961) and discussed further in *Raymond Williams: Politics & Letters* (London: New Left Books, 1979), p. 146, is useful here: 'One should not underestimate the degree of internal transformation within the apparent continuity of these immensely pro-longed belief-systems. Every key crisis in the society as a whole provoked great conflict in the system, which responded with reinterpretation, redistribution of emphasis, in many cases even positive denial. These responses then tended to form new configurations of residual, dominant and emergent religious feeling [he is discussing developments within Christianity from the Middle Ages through the Industrial Revolution]. *The result is typically a simultaneity of multiple different relations between the presumed belief-system and the actually operative social system.*'

5. John D'Emilio, 'Capitalism and Gay Identity,' in *Powers of Desire: The Politics of Sexuality*, ed. Ann Snitow et al. (New York: Monthly Review Press, 1983), p. 105; see also Jeffrey Weeks, 'Capitalism and the Organisation of Sex,' *Homosexuality: Power and Politics* (London: Allison and Busby, 1980), pp. 11–20. For a more politicized analysis of gay/lesbian ghettoization, see Tom Waugh and Chuck Kleinhaus, 'Gays, Straights, Film and the Left: A Discussion,' *Jump Cut* 16 (1977), reprinted in *Jump Cut: Hollywood, Politics, and Counter-Cinema*, ed. Peter Steven (New York: Praeger, 1985), p. 282.

6. Tee Corinne has found lesbian images made in Paris for the erotic book industry in the early twentieth century, but has little information about their makers. Corinne, letter to JZG, 6 November 1985. See Christina Cassidy, 'A Short History of Lesbian Publications,' *Native*

(New York), July 28, 1986, pp. 22–23; Fran Koski and Maida Tilchen, 'Some Pulp Sappho,' *Margins* 223 (1975), pp. 41–45, for a similar overview on pulp novels.

7. I take it as a premise of the analysis that follows that photographs have no discernible intrinsic meaning; like fluids, they take their shape or meaning from the contexts in which they are placed or found. This proposal is discussed at length below.

8. Adrienne Rich's 1976 talk, 'It is the Lesbian in Us . . .', delivered at a panel meeting of the Women's Commission and Gay Caucus of the Modern Language Association, is a perfect case in point. Her use of the term *lesbian* in this talk pointed at emotional bonding between women at the expense of the explicitly sexual: 'That reality was nothing *so simple and dismissible* as the fact that two women might go to bed together' (my emphasis). In her afterthoughts on the talk, Rich states, 'One lesbian asserted that if "the lesbian in us" was to become a figurative term, she, as a woman who had been oppressed for physically expressing her love for women, wanted another name for who she was. . . . I was trying to invoke . . . the self-chosen woman, the forbidden "primary intensity" between women, and also the woman who refuses to obey, who has said "no" to the fathers.' *On Lies, Secrets, and Silence: Selected Prose, 1966–1978* (New York: W. W. Norton, 1979), p. 202. For a historical survey of feminist and lesbian accommodations/challenges to dominant constructions of sexuality, see Jeffrey Weeks, *Sexuality and its Discontents: Meanings, Myths and Modern Sexualities* (London: Routledge & Kegan Paul, 1985), esp. chapters 2 and 8. Weeks is the most consistently perspective critic of ideas about sexual identity writing in English today.

9. Carol Seajay, 'Visual Conceptions: A Review of Two Slide Shows,' *Off Our Backs* (March 1980), pp. 18–19.

10. 'This Novel Changes Lives: Are Women's Novels Feminist Novels? A Response to Rebecca O'Rourke's Article 'Summer Reading,' *Feminist Review* 3 (1980), pp. 56, 63. See also Annette Kuhn on the distinctions between films made by women and feminist films, the latter incorporating 'the crucial determinants of their reception: . . . the institutional context within which they are positioned' into their practice. *Women's Pictures: Feminism and Cinema* (London: Routledge & Kegan Paul, 1982), p. 195.

11. *Conditions: Two* (1977).

12. Rich, *On Lies, Secrets, and Silence.*

13. For a practical guide to, if not a theoretical overview of, lesbian feminist literary criticism, see Bonnie Zimmerman, 'What Has Never Been: An Overview of Lesbian Feminist Criticism,' *Making a Difference: Feminist Literary Criticism*, ed. Gayle Greene and Coppélia Kahn (London: Methuen & Co., 1985), pp. 177–210. An elegant example of lesbian-feminist literary criticism can be found in Catherine R. Stimpson's 'Zero Degree Deviancy: The Lesbian Novel in English,' *Critical Inquiry* 8:2 (1981), repr. in *Writing and Sexual Difference*, ed. Elizabeth Edel (Chicago: University of Chicago Press, 1982), pp. 243–59. See also, the lesbian issue of *Signs* 9:4 (Summer 1984).

14. An exception to this is the National Lesbian Slide-show Competition, held biannually by Horizon, a lesbian social club in Binghampton, NY, to which Joan E. Biren of Washington, D.C., drew my attention in a lengthy phone conversation. According to Biren, many of the entries are made up of snapshots, which would propel these images into the class that I am trying to outline here. Conversation with JZG, 4 November 1985. Another possible exception is the bar bulletin board, where the authenticity and value of snapshots *as lesbian documents* is guaranteed by the social institution in which they circulate.

15. In a more essentialist formula for defining lesbian photography, JEB, 'The Photographer and the Viewer,' *Blatant Image* (1980), p. 54, states that making photographs for showing in lesbian venues 'allows us to share our life experiences through our art' in contrast to 'making images for non-Lesbian audiences,' which 'forces us to make different images because we must rely so heavily on the common experience of art to communicate.'

Biren addresses the difficulties of her definition both here and at greater length in a

revision of this article published in *Studies in Visual Communication:* 'We could discuss which (if either) is a Lesbian photograph: the picture of a flower I made for my (non-Lesbian) mother's birthday present or male photographer Skrebenski's book cover portrait of Lesbian author Rita Mae Brown? But consideration of these questions is so new that I believe we will gain the most by focusing on the most clearly Lesbian situation first' (p. 85).

16. JEB, who has conducted lesbian photography workshops throughout the United States for the past several years, remarked that most of the representations of lesbians that she sees at her workshops and traveling slide shows are snapshots made by people with no training or identification as photographers. As this essay you are reading expands (as I intend it to), I shall address such snapshot work, some of which can be found in the Lesbian Herstory Archives in New York 'and in other gay and lesbian history archives. I hope to analyze the kinds of cultural work such images do for their makers and primary viewers.

17. In the smallest groups, as one would expect, people's reactions were more subtle and complex than in large groups. The seminar group (mixed lesbian and heterosexual female feminists), for example, had both the time to reflect upon their reactions to the images and the habit of 'reading against the grain,' which comes more vividly into play under the expectations of a theory criticism seminar. The large audience, on the other hand, enjoyed the peculiar momentum large groups have in responding en masse.

18. See Michael Norday, *Warped* (New York: Beacon Books, 1955); Sheldon Lord, *The Sisterhood* (New York: Softcover Library, 1970); Guy des Cars, *The Damned One* (New York: Pyramid Books, 1956); Carol Emery, *Queer Affair* (New York: Universal Publishers, 1957); Kay Addams, *Warped Desire* (New York: Beacon Books, 1960); Nan Keene, *Twice As Gay* (n.p.: After Hours Book, 1964); Fletcher Flora, *Strange Sisters* (New York: Pyramid Books, 1960); John Dexter, *Dyke Diary* (San Diego: Candid Reader/Corinth, 1967); Carla Josephs, *The Off-Limits World* (New York: Domino Books, 1965); Sheldon Lord, *21 Gay Street* (New York: Midwood Enterprises, 1967). These and over three hundred more paperback novels make up the Maida Tilchen Lesbian Trash Paperback Collection at the Lesbian Herstory Archives, New York. See also Gene Damon [Barbara Grier,] 'The Lesbian Paperback,' *Tangents* 1:9 (June 1966), pp. 4–7; 1:10 (July 1966), pp. 13–15, for a history of lesbian mass-market fiction in the United States.

19. Or maybe the object of desire is closer to hand: another man, whose desirability needs to be projected onto a woman. See Eve Kosofsky Sedgwick, *Between Men: English Literature and Male Homosexual Desire* (New York: Columbia University Press, 1985).

20. Cf. T. E. Perkins, 'Rethinking Stereotypes,' in *Ideology and Cultural Production*, ed. Michele Barrett et al. (London: Croom Helm, 1979), pp. 135–59; p. 141: 'The strength of a stereotype results from a combination of three factors: its "simplicity"; its immediate recognisability (which makes its communicative role very important), and its implicit reference to an assumed consensus about some attribute or complex social relationships. Stereotypes are in this respect prototypes of "shared cultural meanings". They are nothing if not social. It is because of these characteristics that they are so useful in socialisation – which in turn adds to their relative strength.' I am indebted to Simon Watney for introducing me to this article.

See also Sander Gilman, 'What are Stereotypes and Why Use Texts to Study Them?' in *Difference and Pathology: Stereotypes of Sexuality, Race, and Madness* (Ithaca: Cornell University Press, 1985), pp. 15–35, for a psychoanalytical exploration of stereotypes that provides a base and balance to Perkins's sociological reading.

21. This doesn't mean that heterosexual men – or for that matter, gay men – cannot find images of lesbians arousing. What I'm getting at is the fact that we understand the springs of male desire in a way that they do not appear to understand the sources of ours.

22. This position is exemplified by many critical essays and anthologies analyzing literary and film images of women, particularly a number written in the late 1960s to mid-1970s. Kate

Millett's *Sexual Politics* (1969) is the *ur*-text here; it was followed in feminist literary studies by *Images of Women in Fiction: Feminist Perspectives*, ed. Susan Koppelman Cornillon (Bowling Green, OH: Bowling Green University Press, 1972), *Feminist Literary Criticism: Explorations in Theory*, ed. Josephine Donovan (Lexington: The University Press of Kentucky, 1975), and *The Authority of Experience: Essays in Feminist Criticism*, ed. Arlyn Diamond and Lee R. Edwards (Amherst: The University of Massachusetts Press, 1977), and in feminist film studies by Marjorie Rosen, *Popcorn Venus: Women, Movies and the American Dream* (New York: Coward McCann & Geoghegan, 1973), and Molly Haskell, *From Reverence to Rape: The Treatment of Women in the Movies* (New York: Holt, Rinehart & Winston, 1973).

23. Ann Kaplan, 'The Hidden Agenda: Re-Vision: Essays in Feminist Film Criticism,' *camera obscura* 13/14 (1985), pp. 235–36.

24. 'Reconstructing Documentary: Connie Hatch's Representational Resistance,' *camera obscura* 13/14 (1985), pp. 135–37.

25. *Masculinity* is not itself a metahistorical category either, for that matter; when opposing it to femininity, we should also be aware that in current usage it also subsumes a great many other classes: heterosexual, European/Northern, Christian or of Christian descent; and usually bourgeois, politically and/or culturally.

26. See Joan Nestle, 'Butch-Femme Relationships: Sexual Courage in the Fifties,' *Heresies* 12 (1981), pp. 21–24. For references to further lesbian discussion on the significance of masculine signifiers, see Nestle, 'The Fem Question,' *Pleasure and Danger: Exploring Female Sexuality*, ed. Carole S. Vance (London: Routledge & Kegan Paul, 1984), pp. 239–40, n. 1. See also Tee Corinne's remarks below.

27. Mary Ann Doane, 'Woman's State: Filming the Female Body,' *October* 17 (1981), p. 21. For other examples of this position, see Elizabeth Cowie, 'Women, Representation and the Image,' *Screen Education* 23 (1977), pp. 15–23; Claire Johnston, 'The Subject of Feminist Film Theory/Practice,' *Screen* 21:2 (1980), pp. 27–34; Laura Mulvey, 'Visual Pleasure and Narrative Cinema,' *Screen* 16:3 (1975), repr. Brian Wallis, ed., *Art After Modernism: Rethinking Representation* (New York: The New Museum, 1984), pp. 361–73.

28. The most eloquent statements of this strategy are by French feminists Hélène Cixous, Luce Irigaray, Xaviere Gauthier, and the Julia Kristeva of *Desire in Language* (U.S. 1980). Readily available excerpts from their work can be found in *New French Feminisms: An Anthology*, ed. Elaine Marks and Isabelle de Courtivron (New York: Schocken Books, 1981).

29. The most vigorous challenges to the Lacanian psychoanalytic/semiotic/*écriture féminine* theorization of text formation and reception have come from the left: Christine Gledhill, 'Developments in Feminist Film Criticism,' *Quarterly Review of Film Studies* (1978), rev. and repr. in Mary Ann Doane et al., *Re-Vision: Essays in Feminist Film Criticism* (Frederick, Md.: American Film Institute/University Publications of America, 1984); Stuart Hall, 'Recent Developments in Theories of Language and Ideology: A Critical Note,' in *Culture, Media, Language: Working Papers in Cultural Studies, 1972–79* (London: Hutchinson/Centre for Contemporary Cultural Studies, University of Birmingham, 1980), pp. 157–162; Richard Dyer, *Stars* (London: British Film Institute, 1979), *Gays and Film* (London: British Film Institute, 1977), and 'Male Gay Porn: Coming to Terms,' which appeared in *Jump Cut* along with a number of other articles arguing for transformative readings and uses of pop-cult materials. *Jump Cut* and its writers, most notably Chuck Kleinhans and Julia Lesage, have been central to the challenges to what Stuart Hall calls 'screen theory' in the U.S.

30. Shoshana Felman, 'Psychoanalysis and Education: Teaching Terminable and Interminable,' *Yale French Studies* 63 (1981), pp. 30–31. Emphases are Felman's.

31. Tompkins, *Sensational Designs: The Cultural Work of American Fiction 1790–1860* (New York: Oxford University Press, 1985), p. 38.

32. A much-discussed parallel situation obtained in teaching literary history and criticism in the immediate post-World War II era to a generation of college students (GIs) lacking any other

social cement than their common experience in the armed services. See Richard Ohmann, *English in America* (New York: Oxford University Press, 1976); Raymond Williams, *Politics and Letters* (London: Verso, 1981), pp. 80–83, 241–42; *Re-Reading English*, ed. Peter Widdowson (London: Methuen, 1982).

33. The notion that a photographic image's meaning or use is primarily adducible from what lies within its frame is one of the most durable ideas perpetuated by academic discourse on photography. Like popularized New Criticism in academic literature programs, formalist criticism of photographs serves to pave over the very real differences among viewers (differences of sex, race, class, education), to mystify art production, and to diffuse or obscure any political content intended by the photographs' maker. This is an aspect of academic criticism that is not lost on students; see, for example, the comments of Doreen, a third-year student at Columbia College, Chicago, in J. Z. Grover, 'Putting Feminism in the Classroom,' *Exposure* 23:2 (Summer 1985), pp. 26–27. In saying this, I recognize the historical role played by analytic criticism in legitimizing the academic study of photography; what makes its use maddening today is the refusal of its practitioners to recognize it as a historical rather than universal practice – a critical strategy that may have outlived its usefulness.

34. Corinne, 'Lesbian photography – a personal and public exploration' (unpublished manuscript, 1985), p. 1.

35. For a detailed description of *The Ladder*, see Gene Damon and Jan Watson, *Index to The Ladder* (Reno: The Ladder, 1974).

36. If there are male photographers out there making portraits of lesbian couples outside of bed, won't you please come forward? I'd hate to mischaracterize your work.

37. Simpson, letter to JZG, 6 October 1984.

38. See Griselda Pollock, '*Art, Art School, Culture,*' *Block* 11 (Winter 1985–86), pp. 8–18, and Simon Watney, 'Photography-Education-Theory,' *Screen* (London) 25:1 (January–February 1984), pp. 67–72.

39. Corinne, 'Some thoughts and questions about – and a few personal solutions to – problems of lesbian photography' (mimeograph, n.d.), p. 3.

40. Corinne, 'Lesbian photography – a personal and public exploration' (mimeograph, n.d.), p. 6.

41. If, like me, you suspect that *life-style* has come to be a codeword for *queer*, I'd love to hear from you: how far back can you trace this usage? Partially as an homage to Raymond Williams's *Keywords*, partially because the concept is so useful, I would like to write a gay/lesbian *Keywords*; *life-style* would figure in it prominently, I suspect.

42. Corinne, 'Lesbian photography,' p. 4.

43. Ibid.

44. Ibid.

45. Corinne, 'Some thoughts and questions,' p. 2.

46. Coward, 'Sexual Violence and Sexuality,' *Feminist Review* 11 (1982), p. 11.

47. Corinne, 'Lesbian photography,' p. 2.

48. Jurors' deliberations are frequently confidential; in this case, the state – Ohio – has a sunshine law covering the council's grant deliberations, so our arguments were carried out before an audience of about forty photographers and other members of the public. I thus feel no scruples about mentioning the substance of this incident.

49. I recorded these comments in my notes on the jurying; 12 April 1985.

50. Molnar has since produced these images as greeting cards, which are sold through lesbian channels.

51. Brooke, letter to JZG, 31 October 1984.

52. Ibid.

53. Brooke to JZG, July 1987.

54. The most eloquent and extended discussion of the contradictions inherent in most domestic photography can be found in Jo Spence, *Putting Myself in the Picture: A Political Personal and*

Photographic Autobiography (London: Camden Press, 1986). See also J. Z. Grover, 'Jo Spence,' *Afterimage* (February 1988).

55. For example, the New Museum's *Difference* show (Fall 1985), curated by Kate Linker, which Martha Gever (editor, *The Independent*) succinctly characterized as the '*same old difference* show.'

56. Moreover, work that proposes itself as *about* social issues (in its presentation or treatment of controversial subject matter) is unlikely to be given exhibition in traditional galleries to begin with, unless its treatment can be annexed to artistic categories like genius, daring, nightmare – the stuff of marketing.

57. Given the magazine formula of five readers per copy, this means that *On Our Backs* reaches approximately fifty thousand readers each quarter, easily exceeding the reach of other distribution methods within lesbian subculture.

58. I would like to thank JEB for her eloquent description of the wide variety of social repercussions she has met with in the experience of her portrait subjects.

59. *The Blatant Image* 1 (1981), p. 89.

60. JEB, conversation with JZG, 4 November 1985.

61. JEB, 'Lesbian photography – Seeing Through Our Own Eyes,' *The Blatant Image* 1 (1981), p. 52. The quotations, respectively, are from John Berger's *About Looking* (New York: Pantheon, 1980) and Joanne Kerr's unpublished doctoral dissertation 'Art and Community: a Sociological Study of Contemporary Feminist Art' (University of California, Irvine, 1980).

62. *Making a Way: Lesbians Out Front* (Washington, D.C.: Glad Hag Books, 1987), distributed by Spinster's Ink.

63. Kuhn, *Women's Pictures: Feminism and Cinema*, p. 191.

64. JEB, conversation with JZG, 4 November 1985.

65. Matteo has also shown her photographs in a gay/lesbian photography exhibition in San Francisco.

66. Matteo, unpublished paper (n.d.), p. 6.

67. Matteo, conversation with JZG, 5 November 1985.

68. Ibid.

69. Simpson, letter to JZG, 4 September 1984.

70. Simpson, letter to JZG, 6 October 1984.

71. Simpson, letter to JZG, 4 September 1984. Included with this letter was an undated newspaper review by Khristi Sigurdson commenting on Simpson's bar photographs: 'Other mediums represented include a series of *candid lifestyle photographs* by Danita Simpson. Simpson captures scenes of everyday life with a blunt but humane eye. Each leaves a sharp, clear image, not unlike that of photographic luminary Ansel Adams' (italics mine).

72. Louis Althusser, 'Ideology and Ideological State Apparatuses (Notes toward an Investigation), [1970],' in *Lenin and Philosophy and Other Essays* (London: New Left Books, 1971), p. 162. An important discussion of the impact of ideological formations on women and students, both germane to my discussion, is Judith Williamson's 'How does girl number twenty understand ideology?' *Screen Education* (London) 40 (Autumn/Winter 1981–82), pp. 8–87.

73. Cf. Perkins, 'Rethinking Stereotypes,' *op. cit.*

74. Berger, *Ways of Seeing*, Hans Haacke, 'John Weber Gallery Visitors' Profiles 1 and 2 [1972],' *Framing and Being Framed* (Halifax: The Press of the Nova Scotia College of Art and Design, 1975), pp. 15–36, 39–58; Martha Rosler, 'Lookers, Buyers, Dealers and Makers: Thoughts on Audience,' *exposure* 17:1 (Spring 1979), revised in Brian Wallis, ed., *Art after Modernism*, pp. 311–339.

75. Particularly now that because of AIDS there is a greater need for sexual scapegoats than before. See Nancy Krieger and Rose Appleman, *The Politics of AIDS* (Oakland, CA: Frontline Pamphlets, 1986); Richard Goldstein, 'The Uses of AIDS,' *Village Voice* (5 November 1985), pp. 25–27; Simon Watney, *Policing Desire: Pornography, AIDS, and the*

Media (London: Methuen, 1987; Minneapolis: University of Minnesota Press, 1987); Watney, 'The Rhetoric of AIDS,' *Screen* (London) 27:1 (January–February 1986), pp. 72–85; and Cindy Patton, *Sex and Germs: The Politics of AIDS* (Boston: South End Press, 1985).

76. Robert Mapplethorpe's *success de scandale* photographs of gay male fist-fucking and s/m sexual practices fall into this category.

77. This is all too reminiscent of the scrambling for crumbs that other sexual minorities have experienced; for example, the controversy in the mid to late 1970s among political gay men about drag queens, whose giddy visibility appeared to threaten the new and always-perilous tolerance that urban, white, middle-class gays (most notably in San Francisco and New York) were beginning to build in their city enclaves. Should political gays disavow their screaming sisters as betrayers of the revolution in order to construct an image of gays as responsible and butch, or should they see drag queens as the 'cutting edge' of the gay movement, bellwethers for tolerance on the part of both the subculture and the dominant culture?

78. See *What Color is your Handkerchief? A Lesbian S/M Sexuality Reader* (Berkeley: SAMOIS, 1979); *Coming to Power*, edited by members of SAMOIS (Boston: Alyson Publications, Inc., 1981; rev. ed. 1982); and the feminist anti-s/m, anti-porn rejoinder *Against Sadomasochism*, ed. Robin Ruth Linden, Darlene R. Pagano, Diana E. H. Russell, and Susan Leigh Starr (East Palo Alto, CA: Frog in the Well, 1982). The imbroglio in the last two years over anti-porn ordinances spearheaded by Andrea Dworkin and Catherine MacKinnon and countered by anti-anti-porn feminists from F.A.C.T. (Feminist Anti-Censorship Task Force) are part of this story as well. In late 1986 F.A.C.T. published a book of porn photographs, *Caught Looking: Feminism, Pornography, and Censorship* (republished Seattle: Real Comet Press, 1987): 'We chose images that are both strong and appealing. We also included images that would impart a history of the envisioning of sex. And, ultimately, like all consumers of pornography, we chose those images we found erotically powerful, the pictures that turned us on. . . . Consider for yourself the pleasures of looking and imagining.'

Jane Gallop

The Pleasure of the Phototext

1. Roland Barthes, *Le Plaisir du texte* (Paris: Seuil, 1973). Translations mine. Richard Miller has translated this book as *The Pleasure of the Text* (New York: Hill and Wang, 1975).

2. Roland Barthes, *La Chambre claire: Note sur la photographie* (Paris: Gallimard Seuil, 1980). Translations mine. Richard Howard has translated it as *Camera Lucida: Reflections on Photography* (New York: Hill and Wang, 1981).

3. Susan Sontag, *On Photography* (New York: Dell, 1977), p. 169.

Karen Knorr

Interview: Fetishism of Black-and-White and the Vulgarity of Colour

1. *Punctum* is a concept introduced by Roland Barthes in *Camera Lucida* which pertains to the aspect of the photographic image, the detail which may move or 'pierce' the spectator. It refers to the workings of the unconscious in that details in the photograph may trigger off a series of associations or emotions. This is contrasted with the *studium*, the conventional aspect of the image informed by culture and education.

2. Knorr, Karen, 'Photography: Modernity and the Contemporary' in *Camera Austria*, No. 27, 1988 (pp. 47–55).

3. In the sense of liberation struggles for a better quality of life and equal opportunities for all, regardless of race and gender. One could argue that old systems still thrive in England, such as the English class system with its old-boy networks which operate in clubland and the City.

4. Greenberg, Clement, 'Modernist Painting' in *Modern Art and Modernism: A Critical Anthology*, Paul Chapman Publishing Ltd, London, 1988 (pp. 5–6).

5. Jencks, Charles, *What is Post-Modernism?*, Saint Martin's Press, New York, 1986 (pp. 42–43).

6. Berger, John X., and Richon, Olivier, eds, *Other than Itself*, Cornerhouse Publications, Manchester, 1989 (Introduction).

7. Mulvey, Laura, 'Changes: Thoughts on Myth, Narrative and Historical Experience' in *Visual and Other Pleasures*, Macmillan, London, 1989 (pp. 159–75).

8. Solomon-Godeau, Abigail, 'Living with Contradictions: Critical Practices in the Age of Supply Side Aesthetics' in *Screen*, Vol. 28, No. 3, Summer 1987 © S.E.F.T.

Lucy Lippard

Partial Recall

1. This essay was originally written for *Poetics of Space*, an anthology edited by Steve Yates, University of New Mexico Press. My thanks to the late Jon Whyte of the Whyte Museum in Banff, author of *Indians in the Rockies* (Banff: Altitude Publishing Ltd., 1985).

2. Johannes Fabian, *Time and the Other*, p. 35.

3. They were Frank Worthington Isham and his wife Mary Rowland, and Rev. Roselle T. Cross and his wife Emma Bridgman. Between them, they spent years in Dakota Territory, Colorado, Wyoming, Nebraska, and Washington.

4. Press release from American Indian Community House, New York City, publicizing a traveling exhibition of Native photographers.

5. Dennis Grady, 'The Devolutionary Image: Toward a Photography of Liberation,' *S. F. Camerawork* (16:2–3, Summer/Fall 1989), p. 28.

6. E. J. Hart, ed., *Hunter of Peace: Mary T. S. Schaffer's Old Indian Trails of the Canadian Rockies* (Banff: Whyte Museum, 1980), p. 70.

7. Hart, *Hunter of Peace*, p. 71.

8. Hart, *Hunter of Peace*, p. 72.

9. This sounds like a description of the 1864 massacre of Cheyenne and Arapaho at Sand Creek, in Colorado. A photograph exists of a sad-looking little girl, dressed in elegant European clothes, inaccurately described as the sole survivor of the massacre, later adopted by white people.

10. Hart, *Hunter of Peace*, p. 17.

11. Hart, *Hunter of Peace*, p. 2.

12. Hart, *Hunter of Peace*, p. 69.

Coco Fusco

Essential Differences, Photographs of Mexican Women

1. Homi K. Bhabha, 'The Other Question,' *Screen* 24, no. 6 (Winter 1983): pp. 18–36.

2. Homi K. Bhabha, 'Sly Civility,' *October*, no. 34 (Fall 1985): p. 73.

3. While concentrating on images of women might seem arbitrary, it is important to keep in mind the centrality of female representations to the iconography of *la mexicanidad*; identity is guaranteed by the mother, who, as the archetype *la chingada*, has been violated by the foreign invader.

4. *Malinchismo* refers to the inclination toward favoring the foreign, a term derived from the legends surrounding La Malinche, the indigenous woman who became the lover and interpreter of the Spanish conquistador Hernán Cortés.

5. Roger Bartra, *La jaula de la melancolia: identidad y metamorfosis del mexicano* (The cage of melancholy: identity and metamorphosis of the Mexican) (Mexico City: Grijalbo, 1987).

6. Carlos Monsiváis, catalogue essay, *Yolanda Andrade: los velos transparentes, las transparencias veladas* (Yolanda Andrade: transparent veils, velied transparencies) (Villahermoso, Mexico: Gobierno del Estado de Tabasco, 1988).

7. Eugenia Parry Janis, 'Her Geometry,' in *Women Photographers*, ed. Constance Sullivan (New York: Harry N. Abrams, Inc., 1990), pp. 24–25.

8. An earlier version of this essay was presented at the San Francisco Museum of Modern Art on January 17 at the conference 'Gender and Modernism: American and European Photography between the Two World Wars.'

Anne-Marie Willis

A Strategy of Appearances – The Australian Bicentenary

1. For a more detailed account of these processes see 'The Modern Janus' in Tom Nairn, *The Break-up of Britain*, New Left Books, 1979, and Benedict Anderson, *Imagined Communities*, Verso, 1983.

Susan H. Aiken

Isak Dinesen and Photo/Graphic Recollection

1. These photographs are reproduced in Clara Svendsen, *The Life and Destiny of Isak Dinesen*, ed. Frans Lasson (New York: Random House, 1970). See also Richard Avedon's photographs in Truman Capote, *Observations* (New York: Simon & Schuster, 1959); and Peter Beard, ed., *Longing for Darkness: Kamante's Tales from Out of Africa* (New York: Harcourt Brace Jovanovich, 1975).

2. Such a question, of course, must be qualified by a recognition of the problems inherent in applying this textual metaphor to photography. As Rudolf Arnheim observes in 'On the Nature of Photography,' *Critical Inquiry* 1 (September 1974), 159, 'To speak of "reading" a picture is appropriate but dangerous . . . because it suggests a comparison with verbal language, and linguistic analogies . . . have greatly complicated our understanding of perceptual experiences everywhere. . . . The underlying assumption is that a message can be understood only when its content has been processed into the discontinuous, standardized units of language, of which verbal writing, signal codes, or musical notation are examples' (p. 158). But this is itself a reductive description of language, as Arnheim admits later (p. 159): 'not even a verbal message is coded, only the means of conveying it.' Moreover, the very possibility of writing about photographs suggests that not only the photographer, but the

critic as well, *constructs* a picture's 'meaning'; the photographer through visual and mechanical means, the critic through words.

3. Julian Huxley, *Memories*, vol. 1 (London: Allen & Unwin), p. 52. See also Errol Trzebinski, *Silence Will Speak: A Study of the Life of Denys Finch Hatton and His Relationship With Karen Blixen* (London: Heinemann, 1977), p. 42.

4. *Camera Lucida*, trans. Richard Howard (New York: Hill and Wang, 1981), p. 3.

5. Among major sources for information on Dinesen's life are Svendsen, *The Life and Destiny of Isak Dinesen*; Judith Thurman, *Isak Dinesen: The Life of a Storyteller* (New York: St. Martin's Press, 1982); Parmenia Migel, *Titania: The Biography of Isak Dinesen* (New York: Random House, 1967); and Isak Dinesen, *Letters from Africa, 1914–1931*, ed. Frans Lasson, trans. Anne Born (Chicago: University of Chicago Press, 1981).

6. Bror von Blixen-Finecke, *African Hunter*, trans. F. H. Lyon (New York: Knopf, 1938), p. 5.

7. Isak Dinesen, 'Mottoes of my Life,' *Daguerreotypes and Other Essays* (Chicago: University of Chicago Press, 1979), p. 6.

8. Letters from Africa, pp. 416–17; hereafter cited in my text as *LA*.

9. Trzebinski, p. 43.

10. Trzebinski, pp. 243–47. The *Times* articles appeared in 1928 and 1929. See especially 21 January 1928.

11. Trzebinski, pp. 152–3. The photograph is reproduced in *Life and Destiny*, p. 91.

12. *Out of Africa* (New York: Random House, 1937), p. 3. Hereafter cited in my text as *OA*.

13. 'Introduction' to Dinesen's *Essays*, pp. viii–ix.

14. Trzebinski, p. 133.

15. Ibid., p. 196

16. Isak Dinesen, *Shadows on the Grass* (New York: Random House, 1960), pp. 112–14. Hereafter cited in my text as *SG*.

17. Migel, p. 180. Cf. Svendsen, p. 15. Recently Clara Selborn added that in Dinesen's last years, 'she kept another photograph of Denys on the windowsill, one which showed him at the time she knew him' (Clara Selborn, Personal Communication, 22 October 1985).

18. *Interfaces of the Word: Studies in the Evolution of Consciousness and Culture* (Ithaca, N.Y.: Cornell University Press, 1977), p. 53.

19. 'The Diver,' *Anecdotes of Destiny* (New York: Random House, 1958), p. 12.

20. 'Ye Fakers,' quoted in Kendall L. Walton, 'Transparent Pictures: On the Nature of Photographic Realism,' *Critical Inquiry* 11 (December, 1984), 246.

21. Isak Dinesen, 'The Roads Round Pisa,' *Seven Gothic Tales* (New York: Random House, 1934), p. 166.

Additional Notes on the Contributors

BERENICE ABBOTT (1898 – 1991) was born in Springfield, Ohio. She studied sculpture in New York, Berlin and Paris, where she worked as an assistant to Man Ray from 1923 to 1925. In 1929 she returned to the US and began her project of photographing New York City, its architecture, people and disappearing townscape. This resulted in the exhibition *Changing New York* (1937). She is best known for this work and for her Paris portraits of the 1920s, but her aesthetic was very much informed by her studies as a scientific photographer.

DAWN ADES is an art historian. Among her books are *Dada and Surrealism* (1974), *Dali* (1982) and *Francis Bacon* (1985).

MARGARET BOURKE-WHITE (1904–71) was *Life* magazine's most successful photo-journalist. She became particularly distinguished in the 1940s as a war photographer. Her many books about her life and career include her 1963 autobiography *Portrait of Myself*.

DEBORAH BRIGHT is Associate Professor of Photography and Art History at Rhode Island School of Design. She is also a widely exhibited photographic artist. She is currently at work on an anthology of writings and works, *The Passionate Camera*, as well as on a collection of her own essays.

SUSAN BUTLER lectures on the MA Fine Art course at Cardiff Institute and in Cultural Studies at Newport School of Art. She edited *Creative Camera* from 1984 to 1986, and in 1989 curated *Shifting Focus*, a major touring exhibition of international photo-based work by women.

JULIA MARGARET CAMERON (1815–79) This British portrait photographer lived and worked on the Isle of Wight. Her close-up portraits astounded the Victorian photographic establishment, which viewed her with both admiration and suspicion.

CYNTHIA CHRIS's writing on independent film, video, performance and visual art have appeared perviously in *Afterimage*, *Exposure*, *High Performance*, the *Independent*, and

P-Form. She co-edited the book *Women, Aids and Activism*, published by South End Press of Boston in 1990. She currently lives in New York City.

A fashion photographer born in California, LOUISE DAHL-WOLFE (1895–1990) was principally known for her work for *Harper's Bazaar* under the editorship of Carmel Snow.

GEN DOY is Senior Lecturer in Art History and Theory at De Montfort University (formerly Leicester Polytechnic). She has research interests in Marxist theory and the representation of women. Her book *Studies in Women, Class and Representation* was published by Berg Publishers in 1995.

UTE ESKILDSEN has been director of the photographic department at the Folkwang Museum in Essen since 1979. Her exhibition programme has focused on the connections between photohistory and contemporary photographic practice, and she has established a related collecting policy.

ANDREA FISHER is an artist, writer and curator. In 1987, she curated the exhibition *Let Us Now Praise Famous Women* for the National Museum of Photography, Film and Television in Bradford, Yorkshire.

COCO FUSCO teaches in the department of art and art history at Colgate University, Hamilton, New York.

NAN GOLDIN is an American artist using photography. She has exhibited throughout the USA and Europe. Her publications include *The Ballad of Sexual Dependency* (Aperture 1986) and she has curated a number of exhibitions, including *Witnesses Against Our Vanishing* (1989), a show about the effect of AIDS on the community.

JAN ZITA GROVER lives in Minneapolis, MN, and Wascott, WI, where she is currently writing about cultural history and photographic records of the great North Woods. She prefers life above 48 degrees North.

JUDITH MARIA GUTMAN is writing a full-scale biography of Alfred Stieglitz. She has received close to a dozen grants and awards, written over a half dozen books and some 100 articles. She has lectured throughout Asia, Europe, and the United States, and is Adjunct Professor at the Graduate Faculty of The New School for Social Research.

ALICE HUGHES (1857–1939) was the daughter of the painter Edward Hughes, and first took up photography to record her father's work. She made her own portraits from 1892 onwards and became a successful society and royal portraitist.

KAREN KNORR is an artist and teacher. She was born in Germany of mixed Polish-American and German-Norwegian descent. She studied photography at the Polytechnic of Central London, where she cultivated the awareness of post-structuralist theory and aesthetics that informs her work. She has exhibited widely in solo and group exhibitions.

ROSALIND KRAUSS is Professor of Art History at Columbia University in New York City. Co-founder and co-editor of *October* magazine, her books include *Passages in Modern Sculpture* (Viking 1977), *The Originality of the Avant-garde and other Modernist Myths* (MIT Press 1985) and *The Optical Unconscious* (MIT Press 1993).

For some years a freelance writer, lecturer and critic, ANNETTE KUHN is now Reader in Film and Television Studies at the University of Glasgow. Her book *Family Secrets* was published by Verso in 1995.

DOROTHEA LANGE (1895–1965) This documentary photographer became distinguished while working on the Farm Security Administration project in the USA during the 1930s.

THERESE LICHTENSTEIN is an art historian and critic who lives in New York City and teaches at NYU. She has contributed articles to *Artforum, Art and Text*, and *Psychoanalytic Psychology*. Her book, *Behind Closed Doors: Hans Bellmer's Dolls in the Context of Nazi Germany*, was published in 1995.

LUCY LIPPARD is a writer and activist who lives in New York City, Boulder, Colorado and Georgetown, Maine. Her many books on contemporary art include *Mixed Blessings: New Art in a Multicultural America* (1990) and, as editor and contributor, *Partial Recall* (1992).

CATHERINE LORD writes about cultural politics in Los Angeles. She is Professor of Art and Women's Studies at the University of California, Irvine.

ROBERTA MCGRATH lectures in photography at the University of Westminster, London.

LEE MILLER (1907–77) was born in the USA, but lived most of her life in England, France and Egypt. She was established as a staff photographer for *Vogue* in London during the war, and gained accreditation as a War Correspondent in 1943. She stopped writing in 1946 and gave up photography in 1954.

LUCIA MOHOLY was born in Prague in 1894. She lived in Germany until 1932, then moved to Paris and finally to England in 1934, where she became a British citizen. After studies in Prague, Weimar and Leipzig, she was active at the Bauhaus. In Britain she lectured and worked as a freelance photographer, subsequently specialising in scientific aspects of the medium. Her work has been shown in group and individual exhibitions all over the world.

MEAGHAN MORRIS is an Australian critic and essayist. A collection of her essays *The Pirate's Fiancée* was published in 1988.

MARIA MORRIS HAMBOURG is Curator in Charge of the Department of Photographs, The Metropolitan Museum of Art, New York. She is co-author, with John Szarkowski, of *The Work of Atget* (Museum of Modern Art, New York) and of *The New Vision* and *The Waking Dream* (Metropolitan Museum of Art).

LAURA MULVEY is a film theorist and critic whose essays have been widely republished and also collected in *Visual and Other Pleasures* (Macmillan 1988). She has also made films in collaboration with Peter Wollen, among them *Riddles of the Sphinx, AMY!*, and *The Bad Sister*. She is now a lecturer in film at the University of East Anglia.

Born in 1951, CAROLE NAGGAR is a painter, curator, poet and writer. Among her recent publications are *Dictionnaire des Photographes, William Klein, Photographe etc*, *George Rodger en Afrique, Le Bain* and *Mexico Through Foreign Eyes*, the accompanying volume to a show that she co-curated. Since 1986, she has lived in New York with her husband and two children.

As Acting Curator of Photography at the Museum of Modern Art, New York 1942–45, NANCY NEWHALL (1908–74) directed exhibitions by Paul Strand and Edward Weston. She was the editor of Edward Weston's *Daybooks* and author of *The Eloquent Light*, a biography of Ansel Adams.

AMY RULE is the Head Archivist at the Center for Creative Photography in Tucson, Arizona. She has published numerous articles, bibliographies and reviews in *Exposure*, *History of Photography, The Archive*, and *Visual Resources* magazines.

LAUREN SEDOFSKY is a writer living in Paris.

INGRID SISCHY was the Editor-in-Chief of *Artforum* magazine from 1979 to 1987 and has been the Editor-in-Chief of *Interview* magazine since 1989. She has been a staff writer for the *New Yorker* since 1988.

ABIGAIL SOLOMON-GODEAU is Robert Stirling Clark professor of art at Williams College, Williamstown, Massachusetts. A collection of her essays, *Photography at the Dock*, was published in 1991.

SUSAN SONTAG is one of America's best known writers. Her books include three novels: *The Benefactor, Death Kit*, and, most recently, *The Volcano Lover*, as well as a collection of stories, *I, etcetera*. Among her non-fiction books are four collections of essays: *Against Interpretation, Styles of Radical Will, On Photography* and *Under the Sign of Saturn*. She has also written and directed films and staged plays in the US and Europe.

JO SPENCE (1934–92) began her career as a commercial portrait photographer, but political commitment drew her into documentary work in the 1970s, when she became involved in collaborative exhibition and publishing projects, among them the magazine *Camerawork*, of which she was co-founder. Her books include a photo-autobiography, *Putting Myself in the Picture* (Camden Press 1986). She was a pioneer of photo-therapy and applied similar explorations to her work on the politics of health and the experience of illness in the wake of a cancer diagnosis.

CAROL SQUIERS is a widely published critic and has contributed numerous articles to *Aperture*.

ANNE WILKES TUCKER is Gus and Lyndall Wortham Curator of Photography at the Museum of Fine Arts, Houston, where she has worked since 1976. She founded the Photography Department at the museum and has curated two dozen exhibitions.

DOROTHY WILDING (1893–1976) Active from the 1920s to the 1960s, this British society and portrait photographer was typical of the self-made, entrepreneurial woman photographer of the inter-war years. She established studios in London and New York, and was published extensively in magazines and newspapers.

MADAME YEVONDE (1893–1975) Pupil of the celebrated Edwardian studio photographer Lallie Charles, Madame Yevonde was a pioneer in colour photography, using the Vivex process. She operated a studio in the West End of London from the late 1920s onward, producing fantastical compositions of women posed as characters from myth and legend in her 1935 series *Goddesses and Others*.

Copyrights and Permissions